THE
AMBASSADOR JOHN L. LOEB JR.
DANISH ART COLLECTION

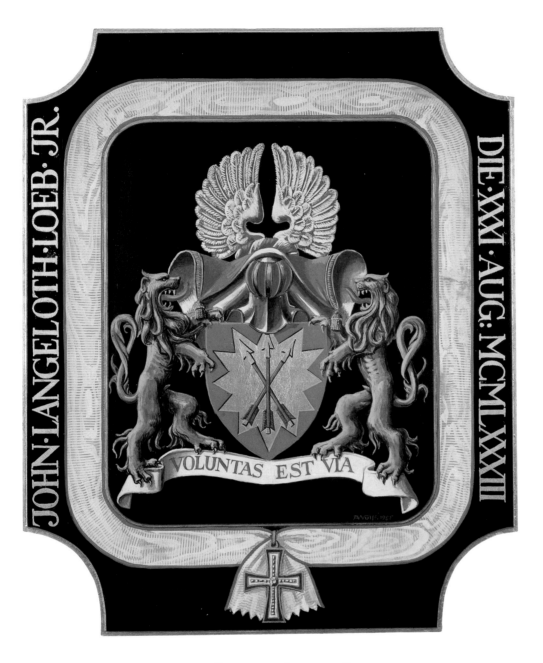

The coat of arms of
AMBASSADOR JOHN L. LOEB JR.
bestowed by
HER MAJESTY, THE QUEEN OF DENMARK,
MARGRETHE II
with the Grand Cross of the Order of the Dannebrog

August 31, 1983

THE
AMBASSADOR JOHN L. LOEB JR.
DANISH ART COLLECTION

REFLECTIONS

… an extraordinary achievement in collecting. For its comprehensiveness and excellence, there is nothing like this collection outside of Denmark.

CHARLES RYSKAMP · *Director Emeritus*
Pierpont Morgan Library and the Frick Collection, New York City

Scandinavian art in general and Danish art in particular are being increasingly recognized and appreciated. John Loeb's collection of Danish paintings is a superb example of this genre.

RICHARD E. OLDENBURG · *Honorary Chairman, Sotheby's (North and South America)*
Director Emeritus, The Museum of Modern Art, New York City

John's passion for Danish culture has enhanced Danish-American friendship for a generation. This magnificent catalogue of 147 works of art by 68 Danish artists continues a remarkable tradition.

PETER MARTINS · *Ballet Master-in-Chief*
New York State Theater, New York City

Ambassador Loeb's catalogue of his singular art collection will be a tremendous boon for advancing interest in Danish art.

ROBERT ROSENBLUM · *Professor of Fine Arts*
New York University, New York City

This beautiful catalogue will lure the initiate to investigate Danish pictures. The biographies of the painters and the appendices are unusually comprehensive.

LORD POLTIMORE · *Chairman, 19th Century European Paintings*
Sotheby's, London

Inspired by Kirk Varnedoe's 1982 exhibiton "Northern Light," and encouraged by Varnedoe himself, John Loeb has assembled one of the most definitive collections of three centuries of Danish painting.

RICHARD L. FEIGEN · *Feigen Gallery, New York City*

John Loeb's catalogue will open the eyes of the American public to the extraordinary beauty and charm of Danish painting.

EDWARD GALLAGHER · *President*
American-Scandinavian Foundation, New York City

… a readable and beautifully produced introduction to these remarkable 18th, 19th, and early 20th-century Northern painters.

WARREN ADELSON · *Adelson Galleries, New York City*

John Loeb's catalogue records a significant collection of Danish paintings and is a must-have for Danish art enthusiasts.

AMBASSADOR EDWARD E. ELSON · *Former U.S. Ambassador to Denmark*
New York City

THE
AMBASSADOR JOHN L. LOEB JR.
DANISH ART COLLECTION

Foreword by John L. Loeb Jr.
Introduction by Suzanne Ludvigsen

Contributors: Elisabeth Fabritius, Benedicte Hallowell,
Suzanne Ludvigsen, Peter Nisbet, Mette Thelle
& Torben Thim

JOHN L. LOEB JR.
NEW YORK · 2017

Design and Production
Jerry Kelly · New York, New York

Printing
The Studley Press · Dalton, Massachusetts

Primary Photography
Orcutt and Van Der Putten · New York, New York

Additional Photography
Jan Van Steenwijk · Bedford, Massachusetts
Graydon Wood · Philadelphia, Pennsylvania

Copy Editing and Manuscript Oversight
Kathy L. Plotkin · New York, New York

ISBN 978-0-9762043-0-5

LIBRARY OF CONGRESS CONTROL NUMBER: 2004115282

TABLE OF CONTENTS

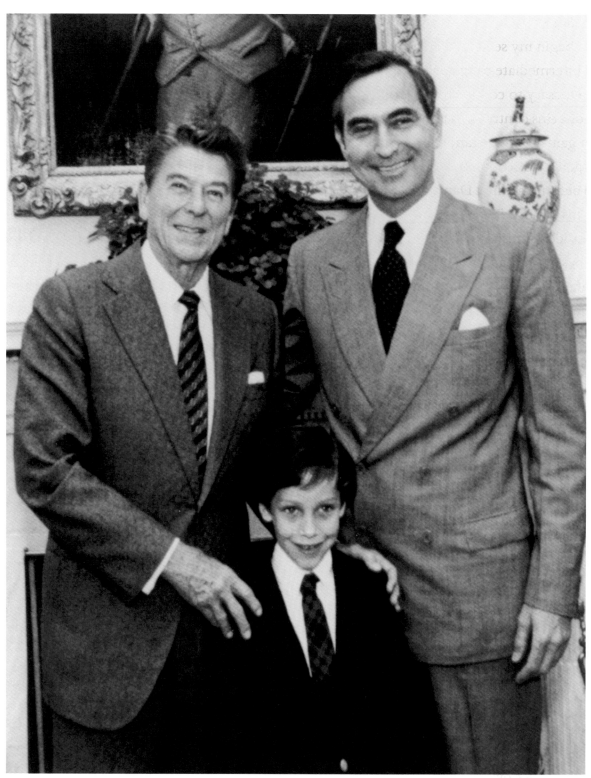

President Ronald Reagan gave a warm send-off in the Oval Office at the White House to the newly appointed ambassador to Denmark, John L. Loeb Jr., just before he left to take up his Copenhagen post in late summer, 1981. Ambassador Loeb's enthusiastic six-year-old son, Nicholas, was on hand for the historic occasion.

FOREWORD

The year was 1981. President Reagan had recently appointed me to serve as the United States Ambassador to the Kingdom of Denmark, and I had just moved to Copenhagen to begin my service. The Danish government was strongly objecting to NATO's decision to place intermediate-range ballistic missiles in Western Europe. It was NATO's position that this was necessary to counterbalance the threat from the Soviet Union's arms buildup. Although the issue of arms control was paramount to my mission, as an ambassador, it was also important for me to gain an understanding of the culture of Denmark. Thus, when I was invited to the foremost gallery of contemporary Danish art by the owner, Jacob Asbæk, I was delighted to accept. Jacob became my first Danish art mentor, and my first acquisitions were contemporary paintings from his gallery. These acquisitions helped to brighten the basement of Rydhave, the official ambassadorial residence. In that basement I created a small gallery of contemporary Danish art. (The basement had previously been converted into a bomb shelter to protect Dr. Werner Best, the infamous Nazi ruler of Denmark during World War II, who had lived in Rydhave during the German occupation.)

As time went by I fell more and more in love with Danish art, especially that of the late 18th, 19th and early 20th centuries. In fact my enthusiasm resulted in what I am told is the largest collection of Danish art outside Denmark, a total of 147 works representing 68 artists.

My passion for collecting art is not surprising. One could say it is even in my genes. I had the pleasure of being surrounded by great art my whole life. Over the years of their long lives, my late parents assembled one of America's greatest collections of Impressionist art. The collection was ultimately sold on behalf of the John Loeb Family Charitable Foundation at Christie's in 1997 for the then-record sum of $95,000,000. Also, my mother's cousins Philip and Robert Lehman, and my great-grandfather Adolf Lewisohn, gave their respective collections of some of the world's greatest paintings to the Metropolitan Museum of Art—and I knew those collections well.

Interestingly enough, it was my great-grandfather Lewisohn who provided me with an ancestral Danish connection. His ancestors lived in the town of Rendsburg until 1758. Rendsburg was then in the duchy of Holstein, of which the Danish King Frederik V was the duke. Rendsburg is now part of Germany, namely the federal state of Schleswig-Holstein.

I had no specific intention of creating a major collection of Danish art. Nevertheless I found myself spending weekend after weekend at Copenhagen's art museums and galleries. I soon discovered Denmark's most outstanding collection of 19th century Danish art, assembled by the great tobacco merchant Heinrich Hirschsprung (1836–1908). He systematically collected the art of his contemporaries over the course of 40 years. This remarkable and beautiful collection is housed in a lovely Copenhagen building known as the Hirschsprung Museum. Mr. Hirschsprung's commitment to Danish national art was inspirational to me, especially when one considers that most of

the other great Danish collectors of that time bought primarily French and German paintings.

I so admired the work of the artists Mr. Hirschsprung collected that, in the years that followed, I have generally modeled my "acquisition policy" after his choices. I took him as my personal mentor (though he had long since died), deciding that any painter he considered outstanding enough to be in his collection was welcome in mine. His collection is one of the finest and most encyclopedic collections of Danish 19th-century art in the world. I have also been influenced by the late, great art historian Kirk Varnedoe (1946–2003), the Curator of Painting at the Museum of Modern Art from 1988 to 2001 and a recipient of a MacArthur Fellowship. His 1982 *Northern Light* exhibition, which was mounted at New York City's Brooklyn Museum and at Washington, DC's Corcoran Museum, encouraged and inspired me.

Through the years I have also been ably guided by my dear friends at the Bruun Rasmussen art auction house in Copenhagen, Jesper and Birthe Rasmussen, their son Frederik, and Birte Stokholm, head of Rasmussen's Old Masters Paintings.

In 1984, enamored of the painter Vilhelm Hammershøi (whose stature has since grown exponentially worldwide), I bought my first Vilhelm Hammershøi, named *Woman Placing Branches in a Vase on a Table*, later to be known as part of the famous "Strandgade Series" (painted when the artist and his wife lived at Strandgade 30, a building still in existence).

At the time, Danish newspapers heralded the purchase as the highest price ever paid for any Danish work of art—1,000,000 Danish kroner or US$85,000. Hammershøi has grown enormously in prestige and stature, not only in Denmark and Scandinavia, but worldwide.

In 1999 two of my passions crossed: collecting Danish art, and the study of genealogy. I discovered a portrait of a distant relative of mine in a Danish auction catalogue. At that time his identity was not known by the seller nor by the auction house. Seeing the portrait, I was sure I knew the subject of the painting. That was because a photographic reproduction of the painting had been sitting in a place of honor in my living room for years. He was an eminent forebear of mine.

Sure enough, upon further research, the C. A. Jensen painting for sale proved to be that very same ancestor—Joseph Hambro, a critically important part of Denmark's financial history. He was a key figure in helping to stabilize Denmark's economy in the early 1800s after the Napoleonic wars, and subsequently founded the world-famous Hambro Bank in London. Joseph Hambro's grandfather and my five-times great-grandfather are one and the same. I went on to buy the portrait.

It was the custom in the early 19th century for artists to paint replicas of their own work. Researchers for the material of my catalogue have told me that the portrait I purchased is the original of the three nearly identical Joseph Hambro portraits painted by C. A. Jensen. An almost identical one has for nearly two centuries hung in the Copenhagen Stock Exchange.

Despite the guidance of mentors along the way, in the end I have bought only the paintings I either truly loved or greatly respected. Beyond the thrill of the chase a collector always relishes, I have the pleasure of living daily with these lovely paintings. I am able to retreat from the frenetic pace of New York to the quiet of my home, where I can enjoy the stillness and tranquility of these

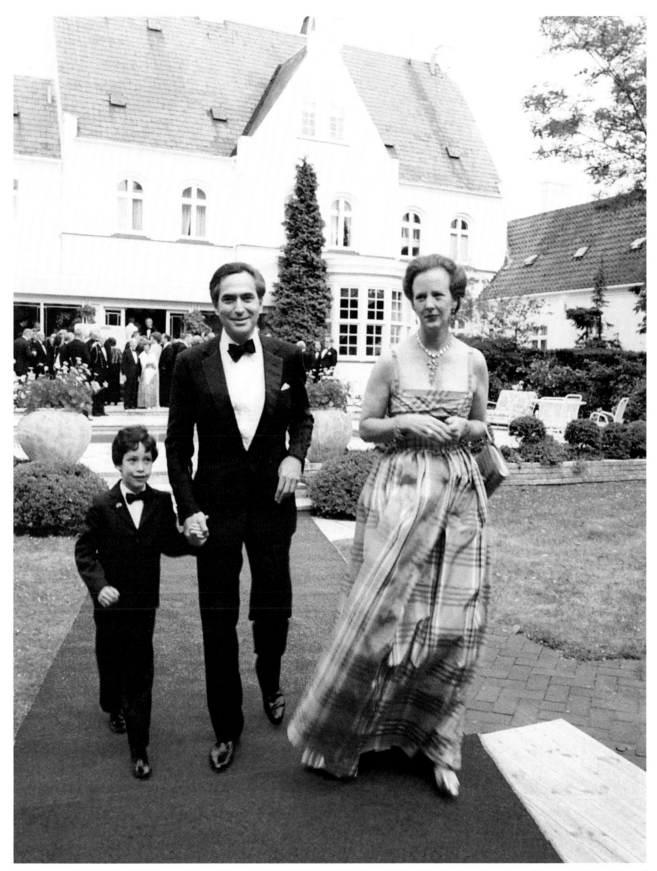

On June 14, 1982, Her Royal Highness, Queen Margrethe II, and His Royal Highness, Prince Henrik, were the guests of honor at a dinner hosted by Ambassador John L. Loeb Jr. at Rydhave, the official U.S. ambassadorial residence in Denmark. Pictured here, the queen is being escorted by the ambassador and his young son Nicholas to the tented outdoor festivities held next to the residence. Rydhave is visible in the background.

Vice President George H. W. Bush and Barbara Bush were guests of Ambassador John Loeb Jr. at the American ambassadorial residence, Rydhave, during their visit to Denmark in the summer of 1983. Here, the ambassador and vice president share a relaxed moment.

wonderful works of art. In gazing at the quiet of a Vilhelm Kyhn pastoral, or returning the charming glance of P. S. Krøyer's wife Marie in Bertha Wegmann's stunning portrait of her, I find myself at peace.

Late in the year 1999 I persuaded art historian Benedicte Hallowell, the Bruun Rasmussen representative in the United States, to take on the coordination of an eventual catalogue raisonné I was planning to produce. I had met her in 1994 when she was helping museum curator Peter Nisbet, at Harvard's Busch-Reisinger, produce an exhibit of a portion of my collection entitled *Danish Paintings of the Nineteenth Century*. Ms. Hallowell's organizational ability, artistic background, and the fact that she is half Danish all convinced me she was the right person for the project.

In turn, Ms. Hallowell engaged three talented Danish art scholars, Elisabeth Fabritius, Suzanne Ludvigsen, and Mette Thelle, to whom I am forever grateful, to do the background studies. Dr. Fabritius is currently writing biographies of both Anna Ancher and her husband Michael, along with a book about Anna Ancher's pastels (whose work she compares with Degas). I am glad to have works by both of the Anchers well represented in my collection. Ms. Ludvigsen's book on the painter *Dankvart Dreyer, His Life and His Art*, with a summary in English, is being published by the Society of Publication of Danish Memorials. It is expected to be in print by 2006. Mette Thelle has co-authored a book on the famous flower painter J. L. Jensen.

Ms. Hallowell, who is also one of this catalogue's contributors, then enlisted the talents of Professor Glyn Jones, a noted British academician and Danish translator, who has so ably translated the writing of these researchers.

Part of my motivation to publish this catalogue stems from my long-held desire to help the world to know and love Danish art as I do. In 1982 a great opportunity to do just that occurred. That year the U.S. National Endowment for the Humanities, together with the National Endowment for the Arts, funded an international cultural program called Scandinavia Today. It was cosponsored and organized by the American-Scandinavian Foundation, located in New York City, as well as by the Smithsonian Institution. It included a wonderful exhibition from all five of the Scandinavian countries. It was my great pleasure to accompany His Royal Highness Prince Henrik of Denmark (husband of Her Majesty, the Queen of Denmark, Margrethe II) to the United States on a trip to promote Danish culture in general, as well as Danish paintings in particular. We visited New York City, Washington, DC, and Minneapolis-St. Paul on behalf of the Scandinavia Today tour. Subsequently Professor Varnedoe, then at New York University's Institute of Fine Arts, who organized the exhibit, became the senior curator at the Museum of Modern Art.

In April 1991, the Honorable Peter Dyvig, then Danish Ambassador to the United States (and Denmark's most brilliant diplomat—at various times he also served as ambassador to England and France, and headed the Danish Foreign Service), suggested I give a talk about Danish art at the Smithsonian Institution. A longtime friend of mine, starting from my term in Denmark, he had been asked to provide a recommendation for a speaker to take part in a Smithsonian resident associate progam entitled "The Golden Age of Scandinavian Art" (moderated by Karen Alexis). I accepted with pleasure. My lecture was called "Nineteenth and Twentieth Century Danish Art: A Personal Collection," accompanied by a slide show. I spoke of the special cultural conditions and aesthetic ideals, as well as the cultural history my paintings embody. It was a memorable evening. I will never forget that, at a dinner held afterward at the Danish embassy, Richard Allen, former national security adviser to President Reagan, warmly praised my lecture, saying to a reporter, "I learned a great deal from the lecture and I also learned that I ought to go back to school under his [John's] tutelage. I could get some real substance from him as a mentor."

During these last several years I have been sponsoring Danish art lectures at the American-Scandinavian Foundation in New York City, inviting such knowledgeable speakers as Professor Robert Rosenblum of the New York University Art Department, Professor Patricia Berman of the Wellesley Art Department in Massachusetts, and Dr. Elisabeth Fabritius, specialist on the Skagen artists' colony. Their lectures have helped educate the public about the beauty and significance of Danish art.

Gradually the art world is awakening to the value of Danish art, which is still not as well known outside of Scandinavia as it should be. It is an art of high quality. Its special cultural conditions and aesthetic ideals are unique, and its artists demonstrably show strength of artistic vision on a par with the artists of the great European nations. It is ironic that Denmark is known

worldwide for its glorious Flora Danica porcelain china, for its Jensen silver, for its exciting modern furniture, for its philosophy and literature (such as that of Kierkegaard and Hans Christian Andersen), for its architecture (Arne Jacobsen, Jørn Utzon), and for its classical Bournonville ballet. The one artistic area that has not been fully recognized has been its paintings.

Suzanne Ludvigsen, the art historian who has written a great many of the commentaries as well as the introduction to this catalogue, has observed that in forming my collection I've followed a desire to illustrate the historical development of Danish art. More poignantly, she commented that I may have been searching for what might be called "the Danish soul."

I think she is right.

AMBASSADOR JOHN L. LOEB JR.

January 2005

INTRODUCTION

The 147 works in the Loeb collection reflect a large part of the history of Danish art over rather more than 200 years, as seen by an American who lived in Copenhagen from 1981 to 1983 as his country's ambassador.

It is always interesting to study the composition of a private art collection. The choice of pictures and sculptures rarely adheres to the same constrictions observed by museums; the private collector follows his own interests and often makes his selections on the basis of intuition and love, rather than take heed of established opinions. And yet, a pattern almost always unwittingly arises in the constant dialogue between the statement made by the pictures and the collector's experience of his acquisitions.

The composition of the Loeb collection seems to some extent to have been dictated by the desire to illustrate the general historical development of Danish art, perhaps seen in relation to contemporary intellectual currents outside Denmark. However, the selection of the works in this catalogue also suggest a search both for some human response of a personal nature and, more generally, for what might be called the Danish soul.

On the basis of the first criterion, the paintings in the Loeb catalogue are arranged chronologically according to the years in which it is believed they were painted, artist by artist. A great effort on the part of the researchers has been made to include the historicity of both the painters and their paintings.

The oldest painting in the collection is by Nicolai Abildgaard, showing Alexander and Diogenes, and is presumably from the 1780s; it is a splendid example of the art of the first history painter of note to be trained in the Royal Danish Academy of Fine Arts.

The most recent work in the Loeb collection is a surrealistic watercolor from 1983, paying minute attention to detail and portraying a little girl in the midst of an enigmatic dream, painted by Henrik Lerfeldt.

The year 1754 saw the founding of the Royal Danish Academy of Fine Arts in the baroque palace of Charlottenborg, where it is still based. Besides Abildgaard, one of the first generation of Danish professors was the portraitist Jens Juel, who had also been among the Academy's earliest pupils. He is represented in the Loeb collection with a fine work painted sometime during the 1780s.

C. W. Eckersberg, who became a professor in the Academy in 1818, was of major significance for the development of the Copenhagen School. The collection includes a beautiful washed drawing executed during the artist's student days in Paris, as well as one of his favorite subjects, a naval frigate under sail.

Two of Eckersberg's contemporaries, the landscape artist J. P. Møller, and the flower painter J. L. Jensen, are represented in the collection. There are two paintings by Møller, one of which at

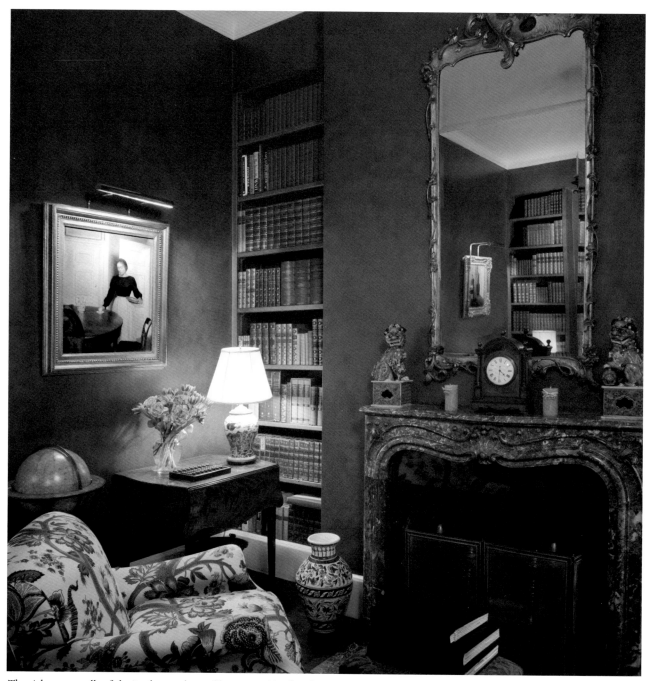

The rich green walls of the Loeb town house library provide a handsome contrast for the subtle nuances of Vilhelm Hammershøi's *Interior, Woman Setting Table,* one of three from the Hammershøi Strandgade Series in the Loeb collection.

one time belonged to King Christian VIII, and twelve flower and fruit pieces by Jensen. This exquisite collection within the collection is remarkable partly because Jensen's oeuvre is only now being fully examined within the history of Danish art.

Works by several of Eckersberg's most gifted pupils, of whom Martinus Rørbye, Constantin Hansen, Christen Købke, and Wilhelm Marstrand deserve special mention, also form part of the Loeb collection. There is an 1836 painting by J. P. Møller's pupil, the landscape artist Frederik Sødring, who found his motif at Rønneby waterfall at Blekinge in Sweden, which is of particular

interest because a fragment of this picture is reflected in the mirror in Christen Købke's famous portrait of Sødring that hangs in the Hirschsprung Museum in Copenhagen.

Eckersberg's great interest in classical marine painting left its traces, though we find a more romantic slant in the work of painters such as Anton Melbye and C. F. Sørensen, both of whom are represented here—the latter with a lively plein air study.

The painter Johan Petersen, perhaps better known in the United States than in Denmark, was more influenced by Eckersberg's style of painting than was the case with Melbye and Sørensen. However, this influence came only indirectly through his own teacher, Carl Dahl, who had been taught by Eckersberg. There is an example of this in a beautiful ship portrait of an American frigate at anchor, presumably painted in 1861.

Two model paintings in the collection witness the teaching of Eckersberg. One by L. A. Smith of a girl seen from behind, standing before a mirror, is painted in the presence of the master himself. Eckersberg's version of the motif is one of the treasures of the Hirschsprung Museum. The other painting of a young girl undressing, by Joel Ballin, is also the result of a session where the teacher and several other pupils were present. At this occasion Eckersberg also painted his version of the motif.

One of Eckersberg's colleagues at the Academy was Professor J. L. Lund. Together with the first real art historian in Denmark, the influential N. L. Høyen, Lund was of great importance to a group of young landscape artists belonging to the "Golden Age of Danish Painting." Outstanding among these were P. C. Skovgaard, J. Th. Lundbye, Dankvart Dreyer, and Vilhelm Kyhn. With the exception of Dreyer, they are all well represented in the Loeb collection.

N. L. Høyen made himself the advocate and passionate spokesman for a national pictorial art. His thoughts on Danishness in an art bereft of foreign interference finally led to his famous lecture, *On the Conditions for the Development of a Scandinavian National Art*, which he delivered to the Scandinavian Alliance in Copenhagen in 1844. He said that it was not only the Danish landscape that was to be discovered, praised, and painted; the life of the ordinary people was also to be portrayed with emphasis on their unique national character. Such was the aim of painters like Julius Exner, Christen Dalsgaard, Carl Bloch, and to some extent Otto Bache, all of whom appear in the Loeb collection.

The painter Hans Smidth went his own way. So did the 15-years-younger L. A. Ring, whom art history assigns to the generation of realists. Both executed restrained, unadorned representations of landscapes and everyday life, the former mainly in Jutland, the latter in Zealand. Especially the works by L. A. Ring are some of the best art in the collection.

National romantic portrayals of the countryside and slightly idealized genre pictures, of which there are a number in the Loeb collection, disappeared from Danish art at the end of the century, as Høyen's influence waned. Around 1880, the era dubbed the "Modern Breakthrough" began. Characterized by a degree of realism hitherto virtually unseen, together with a free and virtuoso use of the brush and a resplendent treatment of light and color, these paintings are

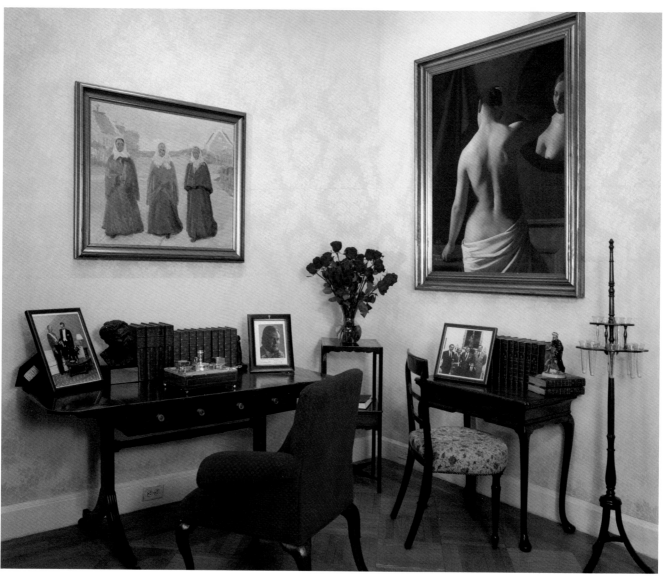

One of three Anna Ancher paintings in the Loeb collection is shown here on the left wall of a corner of the living room in the Loeb town house: *Three Women on the Way to Church*. On the right we see the magnificent *Female Model Before a Mirror,* by L. A. Smith, a very talented student of the renowned Danish Golden Age painter C. W. Eckersberg. Eckersberg's own very similar painting, executed alongside his students in an 1841 summer class, is one of the most beloved in Denmark.

mainly inspired by French art. This new work is plentifully represented in the Loeb collection, with outstanding works by artists including Bertha Wegmann, Anna and Michael Ancher, and P. S. Krøyer. Works deserving special mention by Krøyer are his loving portrait of his young bride Marie (1889) and his magnificent self-portrait, painted a good ten years later on the beach at Skagen.

Other works that must be highlighted are by Krøyer's gifted pupils Harald Slott-Møller and Vilhelm Hammershøi. The 1888 painting by Slott-Møller is a charming, light-filled painting of two fully dressed young women paddling in a shallow stretch of sea. The remarkable loner in Danish art, Hammershøi, obviously a favorite of Loeb's, is represented by no less than nine paintings. Three exquisite works executed in the artist's apartment in Strandgade in Copenhagen around the turn of the century are truly memorable.

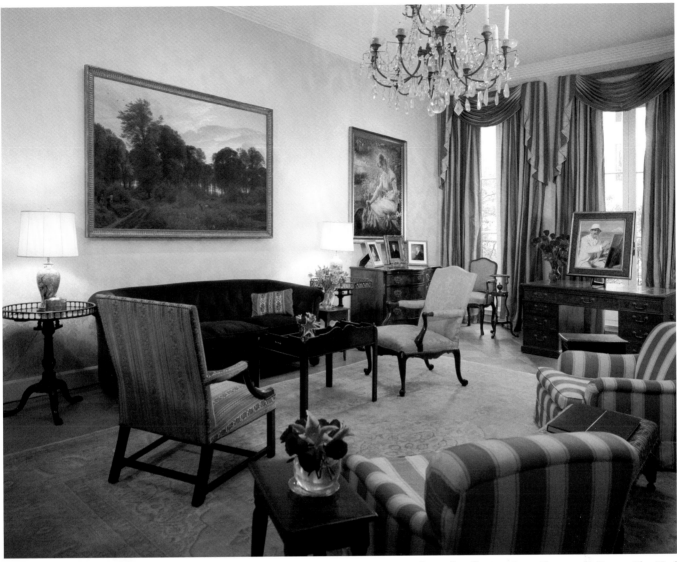

The high ceilings of the Loeb town house accommodate two of the larger paintings in the Loeb collection: Peter Skovgaard's *Forest with a Herd of Fallow Deer and Two Girls,* and Bertha Wegmann's *A Young Woman Sitting in a Boat.* The young model in the latter happened to be the famously beautiful and artistically talented future wife of artist Peder Krøyer. Krøyer's *Self-Portrait, Sitting by His Easel at Skagen Beach* has been placed in a dramatic position on a large desk, appropriately not far from his wife.

A handful of contemporary paintings tell us a little about what was taking place in Danish artistic life in the 1970s and 1980s. For instance, we find two works by the COBRA painter Egill Jacobsen, a powerful iron sculpture by Robert Jacobsen, and a dazzling portrayal of a dancer by Hans Voigt Steffensen. Mention must also be made of a work by the versatile artist Kurt Trampedach, a poetical watercolor of his son Jonas, and Peter Bonnén's small two-part bronze sculpture with its remarkable magical aura.

There is a certain rather unusual quality about the Loeb collection, because a substantial number of works in his collection are from a period in Danish art in which no foreign collector previously appears to have been interested. These are the national romantic landscapes so beautifully exemplified by five late works by Vilhelm Kyhn, and genre art such as Christen Dalsgaard's charming portrayal of a very young girl in national dress, as she writes a letter.

Vilhelm Kyhn's works, with motifs from the whole of Denmark, are compelling because they sprang from the artist's deep love of his native land and because throughout his long life he fought to combat foreign influence on Danish painting, along the lines of the art historian N. L. Høyen's vision.

Artists in Denmark in the decades following 1850 were divided into two mutually antagonistic parties, consisting of followers of Høyen on one side and those with a broader European horizon on the other, the two groups popularly known as the Blonds and the Brunettes.

Marstrand, Constantin Hansen, P. C. Skovgaard, Dalsgaard, Exner, Bloch, and Kyhn were among those belonging to the Blondes, made up of loyal disciples of the Eckersberg tradition and the "nationals." (As a young man, Otto Bache was attracted by the new French movements, but he was never able to disengage his art from N. L. Høyen's influence.) There are examples from both the Blonds and the Brunettes in the Loeb collection, but it is remarkable that the national, Blond painters are particularly well represented. In the text accompanying Christen Dalsgaard's *Young Girl Writing* of 1871—and repeated by him with three variants, one of which was exhibited in the World Fair at Paris in 1878—a comprehensive account has been given of the French and Danish views on the manner of painting in Danish national romantic art. (Dalsgaard's picture was one of the quite small number of Danish pictures to be singled out and praised, but also sharply criticized as an example of the overall Danish contribution, by critic Paul Mantz in the newspaper *Le Temps*.)

In his *Kunstens Historie i Danmark (The History of Art in Denmark)*, written between 1901 and 1907, Karl Madsen, who had started as a painter and in time became an art historian and museum director, gently and subtly restored to the national romantic painters the respect due them, explaining that at that time critics abroad were not at all interested in any Danish art after Eckersberg—who had studied in Paris—and his perhaps most talented pupil, Christen Købke. Karl Madsen believed that the reason for the negative view of Danish paintings held by French critics in 1878 was to be found in the fact that Dalsgaard's young girl's letter was addressed to the wrong recipient. You had to be Danish to understand its message:

> *For us Danes, despite all the formal shortcomings, it tells with understanding and feeling of the special quality and beauty of our nature, of the joys and sorrows of the people; it tells both of tender, wistful dreams and of determined efforts to reach lofty goals; it also tells all the wise and beautiful thoughts of a great and rich artistic soul.*

It has been said that art is ultimately only what one human being confides to another. The composition of the Loeb collection shows an unusual sensitivity to the confidences shared in the national art from the second half of the 19th century.

This receptiveness to an erstwhile statement on the Danish soul bears witness to an accomplishment worthy of an American ambassador to Denmark.

SUZANNE LUDVIGSEN
Fjellebro, Denmark
January 2005

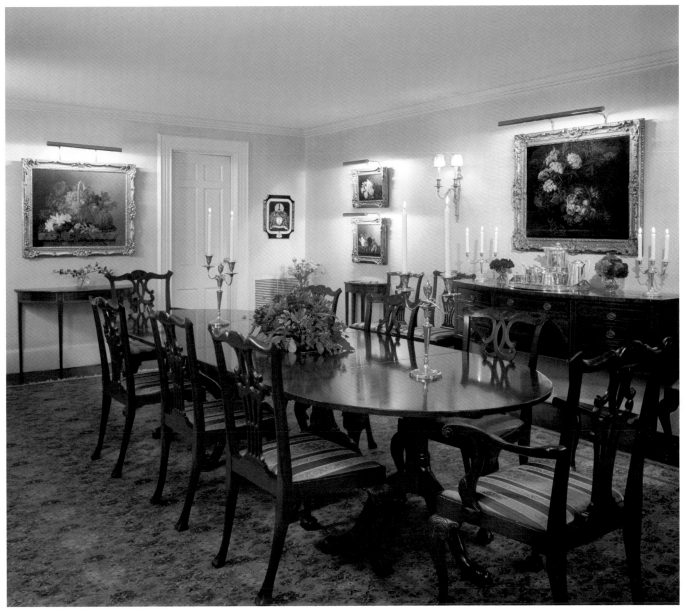

Only paintings by the renowned Danish flower artist, J. L. Jensen, grace the stately dining room of Ambassador John Loeb's five-story Manhattan town house. The large painting at the rear of the room is the painter's *Basket of Flowers and Fruits*. Two smaller works hang together on the far wall, *Pink Roses and Lilies* (top), and *Basket of Flowers and Fruits* (below). *Basket with Roses, Pink Carnations, and Fuchsia* hangs above the buffet.

CATALOGUE PROJECT COORDINATOR
RESEARCHER AND CONTRIBUTOR

Benedicte Hallowell (B.H.)

American representative, *Bruun Rasmussen Kunstauktioner* 1997–present

Sotheby's, London, 1987, 1989–1990

Butterfield & Butterfield, San Francisco, 1998

Honorary curator of exhibition *Christine Deichmann: Greenland Artist,* Radcliffe College, Schlesinger Library, 1997

Curatorial assistant to director of the Busch-Reisinger Museum for exhibit *Danish Paintings of the Nineteenth Century, from the Collection of Ambassador John L. Loeb Jr.* Busch-Reisinger Museum, Harvard University Art Museums, 1994

M.A. Harvard University Extension School. Concentration in Fine Arts, Thesis: *Skagen, Denmark: Unspoiled Motifs and Blue Northern Skies, 1993*

B.A. Boston University. Major: Art History, 1989

RESEARCHERS, CONTRIBUTORS, AND EDITORS

Elisabeth Fabritius (E.F.)

Freelance researcher, curator, and lecturer on art history

Specialist, Skagen Artists' Colony (1825–present)

Board member and scientific associate, Helga Ancher Foundation (Michael and Anna Ancher's House Museum, Skagen)

Member, ICOM-CIDOC

Consultant to Statens Museumsnævn (Board of Danish Museum) planning the computerization of Danish art museum documentation, 1979–82

Editor and head archivist, *Weilbachs Kunstnerleksikon,* 1981–97

Author, artist biographies in:

 Dansk Biografisk Leksikon

 Dansk Kvindebiografisk Leksikon

 Weilbachs Kunstnerleksikon

 Den Store Danske Encyklopædi

Author, books and articles, among others:

 P. S. Krøyer's Photographs, ed. M. Saabye, Den Hirschsprungske Samling 1990 (in English)

 Michael Anchers Ungdom 1865–1880, Skagen 1992 (summary in English)

 Michael Ancher og det Moderne Gennembrud 1880–1890, Skagen 1999 (summary in English)

 Anna Ancher, the Pastels, Copenhagen 2008

Curator of major exhibitions and catalogues, among others:

 Michael Ancher 1849–9. Juni-1999 Michael og Anna Anchers Hus and Skagens Museum 1999 (catalogue in Danish and German)

 Skagen og Kerteminde, to kunstnerkolonier, Michael og Anna Anchers Hus and Johannes Larsen Museet, Kerteminde 2004

Mag. Art. 1974, History of Art, University of Copenhagen

 Thesis: *Neoclassical architecture in Denmark 1750–1800, 1974*

Suzanne Ludvigsen (S.L.)

Freelance curator and lecturer on art history

Board member, Faaborg Museum, Faaborg

Ad hoc staff member of Kunsthallen Brandts Klædefabrik, Odense

Curator or author of major exhibitions and catalogues:

Anna Syberg, Faaborg Museum, 1984

Dankvart Dreyer, Kunstforeningen, Copenhagen, and Fyns Kunstmuseum, Odense, 1989

Hist hvor Vejen . . . (The island of Funen depicted by Danish artists during 200 years) Kunsthallen Brandts Klædefabrik, Odense, 1996

Danish Paintings of the Golden Age, Artemis Fine Arts, Inc., New York, 1999

Author of essays on art in various newspapers and books:

Article *Bysbørn,* about Dankvart Dreyer and his first circle, in *Fynske Minder* Annual 2002 of the Museums in Odense

Maleren Dankvart Dreyer, vol. I–II, Copenhagen, 2008

DeFortryllede træer. Møde med træerne i Palle Nielsens grafiske værk, Copenhagen, 2010

Exam. Art. 1995 in History of Art, University of Copenhagen

RESEARCHER AND CONTRIBUTOR

Mette Thelle (M.T.)

Freelance curator, 2000–present

Museum curator at museums in Esbjerg, Randers, and Odense, 1986–1999

Lecturer and teaching assistant at the Institute for Art History, Aarhus University, 1975–85

Exhibition and research in Danish 18th and 19th century entries for Weilbach's *Kunstnerleksikon*

Author of major exhibitions and catalogues:

Vilhelm Lundstrøm, 1993

H. A. Brendekilde, 1995

H. C. Andersen som Billedkunstner, 1996

Kristian Zahrtmann, 1999

Articles: "With Loving Greeting"

"Sub Rosa," Charlottenborg Exhibition Hall, Copenhagen, 2000

"Den naturlige påmindelse" in Lin Rosa Spaabæk and Mette Thelle (eds.), *Frederik VIIIs Palæ,* Copenhagen 2010, p. 177–183.

Mag. Art. 1974, History of Art, University of Aarhus

TRANSLATORS (DANISH TO ENGLISH)

Walton Glyn Jones

Professor Emeritus of Scandinavian Studies, University of East Anglia, UK

Professor of Scandinavian Studies, University of Newcastle upon Tyne, 1973–86

Professor of Literature, University of the Faroe Islands, 1979–81

Lecturer and Reader in Danish, University College London, 1956–73

M.A., Ph.D., University of Cambridge, 1954

Knight of the Order of Dannebrog, 1994

Author of numerous books and articles on Danish, Faroese, and Finland-Swedish literature

Co-author with wife, Kirsten Gade:

 Blue Guide Denmark

 Danish. A Grammar

 Colloquial Danish

Translator of numerous publications for leading Danish art museums and institutions including:

 Louisiana, The Danish Museum of Decorative Art

 The Danish Royal Silver Room, Edition Bløndal, The Hirschsprung Collection

 The Ordrupgaard Collection, ARoS Aarhus Kunstmuseum, Esbjerg Kunstmuseum,

 Skagens Museum, Statens Museum for Kunst, Thorvaldsens Museum

Literary translations include:

 Hans Christian Andersen: *The Fairy Tale of My Life*

 William Heinesen: *The Black Cauldron*

 Svend Aage Madsen: *Days with Diam*

Edith Tvede Byg-Fabritius

Film director and screenwriter

International BA 2015, Communication and Global Studies, University of Roskilde

Head of Super8, the Independent Film School of Western Denmark, 2016

Screenplay Consultant, SDU, University of Southern Denmark

SPECIAL CONTRIBUTIONS AND ASSISTANCE

Peter Nisbet (P.N.)

Daimler-Benz Curator, Busch-Reisinger Museum, Harvard University Art Museums

Senior Lecturer in History of Art and Architecture, Harvard University

Author of numerous publications on museum history, theory, and practice as well as Russian and Soviet Modernism, German Modernism, and related topics, and many exhibition catalogues including *Danish Paintings of the Nineteenth Century from the Collection of Ambassador John L. Loeb Jr.,* 1994.

Ph.D. Yale University, 1995

B.A. Cambridge University, 1978

Torben Thim (T.T.)

Landscape architect, author, rosarian, and Danish artist

Garden plans at Château Caïx (detail), Cahors, France, for Her Majesty the Queen Margrethe II and His Royal Highness Prince Henrik, at the palace of Graasten (detail), for Her Majesty Queen Ingrid, the Zoo of Odense and several Danish manor houses

Author of books and articles on historic roses:

> *Historiske roser fra Løve,* 1986, and Copenhagen, 2004
> *Historiske roser,* Copenhagen, 1998
> Contributor to *Den Store Danske Encyklopædi*

Biography in *Weilbachs Kunstnerleksikon*

ACKNOWLEDGEMENTS

Benedicte Hallowell would like to thank the Danish contributors and editors Elisabeth Fabritius, Suzanne Ludvigsen, and Mette Thelle. Jane Abdy and Poul Vad were very helpful with her research.

Elisabeth Fabritius would like to thank Søren Agerskov, Inge Mejer Antonsen, Marie-Louise Berner, Ebbe Gotfredsen, Else Lofthus, Susanne Meyer-Abich, Claus Olsen, Hanne Poulsen, Margareta Ramsay, Birte Stokholm, Anette Sørensen, and Poul Vad.

Suzanne Ludvigsen would like to thank Mette Bruun Beyer, Charlotte Christensen, Jette Christiansen, Ole Christoffersen, Erik Fischer, Sys Hindsbo, Hans Ludvigsen, Jens Peter Munk, Hanne Poulsen, Bente Scavenius, Marianne Saabye, and Gitte Valentiner.

Mette Thelle would like to thank Torben Thim for referring her to the article in *Illustreret Tidende* about Princess Augusta.

The contributors and editors would also like to thank Danmarks Kunstbibliotek (Danish National Art Library) with the Archives of Weilbachs Kunstnerleksikon, Det Kongelige Bibliotek (The Royal Library), the library of the Statens Museum for Kunst (The National Museum for Art), and the public libraries Frederiksberg Kommunes Hovedbibliotek and Ringe Bibliotek.

CATALOGUE NOTES

• The paintings in this catalogue are listed only in the table of contents and are presented in the book artist by artist. The artists' names appear alphabetically (using the English alphabet) rather than chronologically. Their biographies precede their paintings.

• Dimensions of the paintings are in inches with centimeters in parentheses, height preceding width. The works have been carefully studied for signatures and monograms; if none were found, no mention is made. Parentheses are around the date of a painting when a particular date is presumed or documented other than by signature.

• The biographies contain references to *Weilbach*, the title of the Danish national dictionary of artists' biographies, which encompasses painters, sculptors and architects from ancient times to the present day. Art historian Philip Weilbach (1834–1900), Librarian of the Royal Danish Academy of Fine Arts Library (now Danish National Art Library), wrote and edited the first edition published in 1877–1878 under the title of *Dansk Konstnerlexikon*. The spelling of the artists' names follows the standards established in *Weilbach*.

• Authorship of each biography and article is noted with the contributor's initials.

• The writers have indicated the sources of their research under the caption of "Literature" at the end of each painter's biography and at the beginning of each commentary about a painting. Most of these sources are books written in Danish, and their titles have *not* been translated. For those interested in reading books in English about 18th- and 19th-century Danish art, a supplementary bibliography has been provided.

• Birth and death dates of other important artists or people in related fields have been included in the texts; however, the dates of any painter represented in the Loeb collection are referenced only preceding their biographies and preceding the articles about their paintings; they are not repeated within the texts.

• For the most part, the original text has been written in Danish and translated by a British scholar, who has maintained the flavor and Danish locution of the contributors. Any words or phrases possibly needing explanation for an American reader have been foot-noted or listed in Appendix A or B. Danish locations and names of museums, though printed in Danish, are not italicized.

CATALOGUE

THE AMBASSADOR JOHN L. LOEB JR.

DANISH ART COLLECTION

NICOLAI ABRAHAM ABILDGAARD

COPENHAGEN 1743 – SORGENFRI 1809

Abildgaard is one of the major figures in the history of Danish art, the first history painter of note to be trained in the Royal Danish Academy of Fine Arts, founded in 1754. His contribution as professor and director there and as "Painter to the Court" marks him as the figure to whom Denmark owes its national art, dating from the Enlightenment philosophy of the 18th century. He occupies a prominent place internationally among the history painters of his day.

Though Abildgaard grew up in difficult financial circumstances, he was reared in a cultured bourgeois family. After graduating from grammar school, his father, Søren Abildgaard, made his living by drawing antiquities. Traveling around the country, he drew copies of historical relics such as sepulchral monuments and inscriptions during the warm weather months and then made fair copies of them during the winter, an undertaking financed by one of the king's ministries. Nicolai's brother, Peter Christian Abildgaard (1740–1801), was a pioneer in the field of veterinary surgery, leaving a large scientific output not only writing but also as a teacher. He was the founder of one of the first veterinary schools in Europe.

Nicolai Abildgaard first became a journeyman painter, subsequently entering the Royal Danish Academy of Fine Arts, where he passed quickly through the various classes. At the end of his training in 1767, he was awarded the major gold medal and thus the Academy's major travel grant for six years of study abroad. By then he had proven himself both independent and ambitious. It was obvious to the governing body of the Academy and to the king's advisers that he was gifted as a history painter, an important element in the justification for the Academy's existence.

Abildgaard made a thorough study of the objectives of history painting—to depict subjects from literature, history, mythology, and religion and to present an idea by means of a figure composition. Even before he left Denmark he was well read and spoke several languages. The teaching at the Academy in Copenhagen was influenced by the fact that the first professors there were French or had been trained in France and Rome and belonged to the most radical neoclassicists of their generation. Among them were figures such as Johannes Wiedewelt (1731–1802), who had lived with the famous art connoisseur J. J. Winckelmann (1717–1768) for a number of years. So Abildgaard was familiar with the artistic debate of the period before arriving in Rome and had the background to adopt an independent position.

Abildgaard spent the years of 1772 to 1777 in Rome studying antiquities and the Renaissance masters. He thought the most highly of Raphael, but he also admired Michelangelo. His studies show a predilection for the violent, emotional manifestations of both Hellenism and mannerism, which were new approaches that interested the young artists in Rome at that time and found expression in an idiom marked by pathos. It is found among his friends, the Swedish sculptor Johan Tobias Sergel (1740–1814) and the idiosyncratic Swiss-British painter J. G. Füssli (1741–1825). Like Füssli and the

Sturm und Drang writers, for instance J. W. Goethe (1718–1791), who was of a similar age, Abildgaard now started to read Shakespeare and Ossian, as is reflected in his choice of motifs.

Toward the end of his stay he sent home a painting that sums up the benefit of his studies abroad: Snakebitten Philoctetes, *the Greek hero writhing in agony. This placed him at the center of the pre-Romantics and caused a considerable sensation in the Academy in Copenhagen, where it was evidence of his status as the philosophizing artist with a mastery of ideal history painting. On his way home, he spent three months in Paris, studying modern art and classical French history painting.*

In 1778 he was appointed professor at the Royal Danish Academy of Fine Arts, where he, as director and a teacher, became a great influence on the art of his time. Prior to that appointment, Abildgaard had been entrusted with the task of painting a series of pictures of Danish kings for the Great Hall in Christiansborg Palace, the residence of the absolutist king, Christian VII, the center of the government and administration of the realm. The iconographic programme for the hall had long been determined: a national historical homage to the ruling dynasty, the Oldenburgs, who came to power in 1448. Abildgaard was to illustrate the achievements of the Oldenburg kings in ten panels, each a good three metres (about ten feet) high. He chose, and had approved by the king, a chronological sequence of paintings in which the individual kings are represented in allegorical, narrative settings.

In the period up to 1791 Abildgaard produced the ten panels, splendidly demonstrating the power and glory of the dynasty. After this, the grants for further decorations were stopped, to the artist's great frustration. It was as the tool of absolutism that Abildgaard created this nationalist epic, although he himself was a cosmopolitan and free thinker sympathetic to the ideas of liberty and equality that led to the French Revolution in 1789. Unfortunately only three of the great pictures making up this pièce de résistance have survived, as the palace burned down in 1794. The remainder are known only from descriptions and small painted compositional sketches (Statens Museum for Kunst). "Now my name is burning!" Abildgaard is said to have exclaimed in despair when the great palace stood in flames. Things were not totally bad; the royal family continued to make use of his skill, but his time as an official history painter was indeed past.

Alongside the demanding decorative task, Abildgaard taught, ran the Academy, painted and drew continuously, and fulfilled a number of commissioned works. A key to the understanding of his art is to be found in his large library, in which he continued to expand his learning. The library was an object of interest in Copenhagen, and after his death his books were incorporated into the Royal Danish Academy of Fine Arts Library, where most of them have been preserved. Abildgaard used a host of literary sources as inspiration for his paintings. Only a few of his most important works need be mentioned here: the blind old Ossian *(Statens Museum for Kunst),* Socrates and His Demon *(c. 1784, Ny Carlsberg Glyptotek), the* Niels Klim *series after Ludvig Holberg (c. 1785–1789, Statens Museum for Kunst), and the motifs from Apuleius's* The Golden Ass *(1808–1809, Statens Museum for Kunst).*

Abildgaard's private life was troubled. He was a quarrelsome person and had few friends. Understanding for his learning and his ability was very limited; he felt isolated and was only happy at his

work. *His first wife left him after a marriage lasting but a few years, and soon after it ended, his little son died. During the less stringent period of censorship in the 1780s, he engaged in political debate, expressing radical points of view and producing satirical pictures. His library was found to contain the American Constitution and pamphlets from the French Revolution. In the 1790s he created a work publicly expressing his attitude in the* Frihedsstøtten (Freedom Column) *in Vesterbrogade, Copenhagen, the monument commemorating the liberation of the peasantry brought about by the "people's friend," Crown Prince Frederik, who in 1784 took power in place of his deranged father. But the heir to the throne did not appreciate the learned history painter.*

In the 1790s Abildgaard demonstrated an unusual originality as an architect and designer. He designed interiors in one of the Amalienborg palaces for the king's half brother, the heir presumptive; these contained overdoors¹ and furniture inspired by antiquity. Abildgaard was assisted in this work by his pupil Bertel Thorvaldsen (1770–1844). He established a close and warm friendship with the son of the heir presumptive, Christian Frederik, later King Christian VIII. The prince appreciated his intellect and in 1809 spoke at his funeral. Small decorative buildings of Abildgaard's design were erected in the newly landscaped gardens at the palaces of Sorgenfri and Frederiksberg. Shortly after 1800, he created a colorful interior with paintings after Voltaire's Le Triumvirat *in a house in Nytorv at Copenhagen.*

Abildgaard was deeply depressed when the French Revolution came to an end, toward 1800. Press censorship was tightened in Denmark and allegories were prohibited, so his sequence portraying Justice, Theology and Philosophy, *1800 (Statens Museum for Kunst), which represents his bitter political testament, was never made public. Abildgaard's last ten years were cheered by a new and happy marriage which produced three children. For their home at Charlottenborg he painted four scenes from Terence's* The Girl from Andros, *each with a background of antique architecture, in which his mastery of perspective was fully demonstrated (Statens Museum for Kunst).*

In Abildgaard's day, very few people were able to appreciate his contribution. His elitist learning had no real relevance for the new age that came after him in the Royal Danish Academy of Fine Arts with C. W. Eckersberg and the Golden Age painters, whose views were completely different. Only with the new Danish and international research at the end of the twentieth century did the depths of Abildgaard's work and his true significance gradually achieve recognition.

<div align="right">E.F.</div>

LITERATURE: Bente Skovgaard, *Maleren Abildgaard*, Copenhagen 1961; Robert Rosenblum, *Transformations in the Late Eighteenth Century Art*, Princeton 1967; Bente Skovgaard, *Abildgaard, Tegninger*, The Royal Collection of Prints and Drawings, Statens Museum for Kunst, 1978; Erik Fischer, *Abildgaards kongebilleder i Christiansborgs Riddersal*, in *Kunstmuseets Årsskrift for 1992*, Copenhagen 1992, pp. 4–39 (summary in English pp. 154–156); Patrick Kragelund, *Nicolai Abildgaard, kunstneren mellem oprørerne*, I–II, Copenhagen 1999 (summary in English); Charlotte Christensen, *Maleren Nicolai Abildgaard*, Copenhagen 1999.

¹*Overdoor:* a picture or carved panel or other decoration over a doorway or door frame.

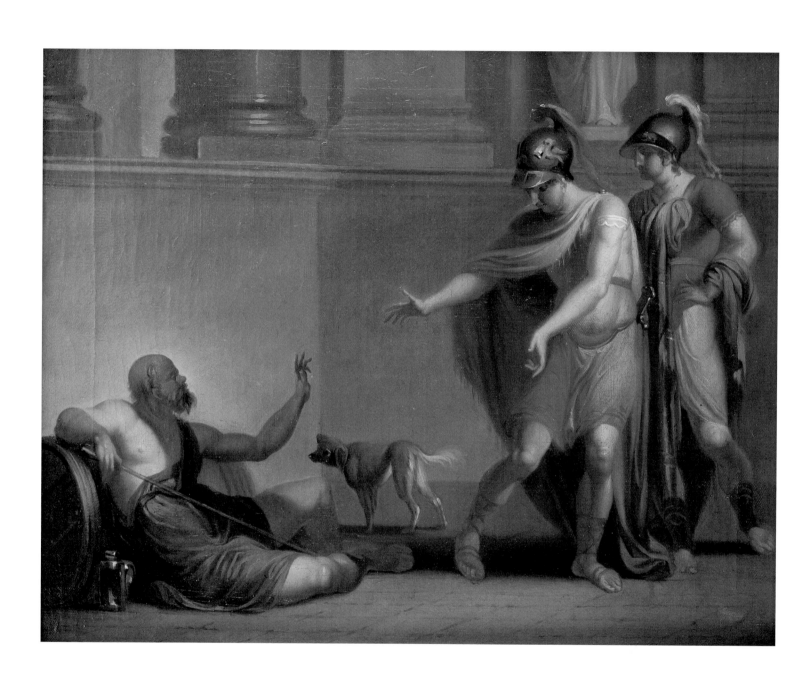

4]

NICOLAI ABILDGAARD
1743–1809

1. *Alexander and Diogenes*
(Alexander og Diogenes)

Oil on canvas, 17 x 21 in. (43 x 53 cm)

PROVENANCE: Winkel & Magnussen, Auction 281, 1941, lot 30 (described as *A Conversation with Socrates*), dimensions given as 16½ x 20½ in. (42 x 52 cm) (ill.); Bruun Rasmussen, Auction 712, 2002, lot 1431 ill.

EXHIBITED: Bruce Museum of Art and Science, Greenwich, Connecticut, and The Frances Lehman Loeb Art Center, Vassar College, New York, *Danish Paintings of the Nineteenth Century from the Collection of Ambassador John L. Loeb Jr.*, 2005, no. 2, ill.; Scandinavia House, New York, *Danish Paintings from the Golden Age to the Modern Breakthrough, Selections from the Collection of Ambassador John L. Loeb Jr.*, 2013, no. 1.

LITERATURE: Patricia G. Berman, "Lines of Solitude, Circles of Alliance, Danish Painting in the Nineteenth Century," in *Danish Paintings of the Nineteenth Century from the Collection of Ambassador John L. Loeb Jr.*, Bruce Museum 2005, p. 14.

This scene illustrates an anecdote told by the ancient author Plutarch in *The Life of Alexander*, Chapter 14. The episode is also found in Valerius Maximus's *The Words and Deeds of Famous Men*, which Abildgaard owned; there is a mark by the story in his copy of the book.[1]

King Alexander the Great of Macedonia (356–323 B.C.) was one of the most famous rulers of antiquity; as a military commander he created an empire stretching from Greece in the west to Egypt in the south and to the borders of India in the east. The story tells that Alexander met the philosopher Diogenes at Corinth and offered to grant any wish he might have. To this Diogenes merely replied, "Move aside a little, you are shading the sun," an answer that made Alexander react with amazement and respect. The reply was typical of Diogenes from Sinope (d. ca. 320 B.C.), who founded the school of philosophy known as the Cynics, inspired by Socrates. Its followers rejected the social and political system of the day, considering material goods to be of no consequence and personal advantage to be morally questionable.

The painting depicts the exchange of words between the two principal figures, each gesticulating. Alexander stands on the right together with his companion. In accordance with the story, Alexander is dressed in magnificent clothes: a long, draped cloak, armor, and a helmet adorned with a feather. His companion wears a similar costume but in more subdued colors, dominated by violet. Diogenes lies at the left with his lamp beside him, resting against the barrel in which he lived, according to tradition. The sunlight is coming from the right, so that Alexander's shadow clearly falls on Diogenes, who with his raised left hand is making his reply. The features of Diogenes and his stature are strongly reminiscent of those of the philosopher Socrates, whom he consciously sought to imitate, not least in his contempt for a presentable appearance. The philosopher's dog can be seen in the background, its sensitively suggested body language revealing that the artist had a good knowledge of these animals, which are often included in his pictures. The dog is indispensable for this particular picture, as the word cynic is derived from the Greek word for "dog." The main figures are brought out by the brilliant colors of their dress. The ochre, blue, red, and green are in contrast to the simple background of columns dominated by cool shades of gray.

The motif had been well known in academic European painting ever since the 17th century, and Abildgaard had already shown an interest in Diogenes while studying in Rome, where he copied the

philosopher's figure from Raphael's *The School of Athens* in the Vatican. Precisely at the time of Abildgaard, when Enlightenment philosophy was at its peak, the moral attitudes of the Cynics had achieved a renewed relevance.

The motif: Abildgaard painted Alexander's meeting with Diogenes on several later occasions; two, perhaps three, variants by him are known in three different formats. The artist's widow owned one of them, and she showed the painting at the exhibitions of Abildgaard's works in Copenhagen in 1809 (no. 40, as "original painting") and in 1817 (no. 36, as "completed painting," i.e., by the artist). This must be identical to the one that was auctioned in 1850 after her death (no. 15). The dimensions of this are given as 15 x 20 inches, slightly narrower than the painting in the Loeb collection.

The largest version was shown in the Abildgaard exhibition in 1916 at the Copenhagen Art Society as no. 58 (21⅔ x 26¾ in. or 55 x 68 cm), then owned by the composer Hakon Schmedes, the present owner unknown. A photograph of it[2] reproduces a composition resembling the Loeb collection picture, but this painting is so clumsy that it is not likely to have been painted by Abildgaard himself. It is surprising that the organizer of the exhibition, Leo Swane, subsequently director of Statens Museum for Kunst, included it at all, but he suggests later that it must have been a copy.[3] In addition, the upright variant of the motif (18¼ in. x 13¾ in. or 46.5 x 38 cm, signed), which includes only the main figures, was also shown in the 1916 exhibition as no. 62. There Alexander is seen from behind wearing a toga-like costume, while Diogenes is seen from the front, half naked in a draped garment, sitting by two Doric columns and once more with Socrates's features. It is assumed to be the last of the three variants and is painted in a rather sketchlike fashion. Nordjyllands Kunstmuseum at Aalborg acquired it as a donation in 1957.

The painting in the Loeb collection is still well preserved, with its original canvas, stretcher, and nails from the 18th century. It must be considered a replica of the signed painting that was in the Arne Bruun Rasmussen auction no. 458, 1984, lot 1, the dimensions of which are very close to this one (16¼ x 21¾ in. or 41 x 53 cm), present owner unknown. In a studio like Abildgaard's it was common practice in the 18th century for several copies of a picture to be painted. Judging by a black-and-white photograph, the signed version and this replica are indistinguishable from each other.

This variant of the motif in the Loeb collection is undoubtedly the best of those painted by Abildgaard. There is such expressiveness in the figures' gestures that the artist has even succeeded in giving expression to the irony in the Cynic's reply to the king. The way in which Alexander's body is turned and the position and details of the hands, especially the bright red of the fingers, are typical of Abildgaard and are found in others of his paintings. An assured earlier provenance is not known, nor is there any documentation to confirm the date of the painting, which, with reservations, is judged to be the end of the 1780s (Bente Skovgaard) or the 1790s (Patrick Kragelund).[4] This painting or the signed version is reproduced in the Danish national encyclopedia, *Den Store Danske Encyklopædi*, vol. 5, Copenhagen, 1996, p. 148, as an illustration to the article on Diogenes.

E.F.

[1] P. Kragelund, *Abildgaard*, 1999, p. 103. The artist's copy is preserved in the Royal Danish Library, Danish National Art Library.

[2] In the Royal Danish Library, Danish National Art Library.

[3] In his article "Bemærkninger om Abildgaard som Maler" ("Remarks on Abildgaard as a Painter") in *Kunstmuseets Aarsskrift XXIV*, 1937, p. 26.

[4] I am grateful to Bente Skovgaard, Patrick Kragelund, and Charlotte Christensen for comments, advice, and guidance in my work with this painting.

ANNA KIRSTINE ANCHER, NÉE BRØNDUM

SKAGEN 1859 – SKAGEN 1935

Anna Ancher became acquainted with art through the painters visiting her family's hostelry in Skagen, where she grew up. Situated at the northernmost tip of Denmark, Skagen 150 years ago was a poor market town at the "back-of-beyond"; there was no harbor and no access by road or rail led to it, so it was almost completely isolated from the rest of the country. Nevertheless, Anna Ancher became one of the most famous of Danish artists, the first woman painter to be mentioned on a par with the male counterparts of her time. Her prolific artistic gifts were born in her, and her mother was convinced that this was because the famous writer of fairy tales, Hans Christian Andersen (1805–1875), was for the first and only time a guest in the Brøndum Inn on the night she was born.

In May 1833 and 1847, Skagen received visits from the Danish Golden Age painter Martinus Rørbye, who like Andersen was fond of visiting unfamiliar parts, and during the 1860s and 1870s increasing numbers of artists began visiting the place. Anna studied the results of their work intensely, and in secret she herself began to paint. In 1874 the young figure painter Michael Ancher arrived; he was still a pupil in the Royal Danish Academy of Fine Arts and was overwhelmed with enthusiasm for Skagen and the motifs he found there. Although Anna was then only fourteen years old, the spontaneous liking the two felt for each other soon turned into love.

From the start, Michael Ancher and the other artists visiting Skagen encouraged her talents and gave the girl her first professional guidance. Her family, which belonged to the Skagen bourgeoisie, enabled her to spend three winters receiving private instruction in Vilhelm Kyhn's private school of painting in Copenhagen. During the summers she painted on her own in Skagen, in close contact with her fiancé Michael Ancher. The year 1879 was a decisive one for Anna. On visiting the Charlottenborg exhibition, she had her first direct experience of French art and was especially taken with a painting by J. F. Millet (1814–1875) owned by the brewer Carl Jacobsen; Millet's work became of great importance to her. That same summer, Skagen became the meeting place for various painters with European experience, including the Norwegians Christian Krohg (1852–1925), who had trained in Germany, and Frits Thaulow (1847–1906), who was fascinated with the new fashions in French art that were moving in the direction of a more true-to-life and objective portrayal of reality. The ideas appealed to Anna, who intuitively changed her painting style. During the spring of 1880 at the age of twenty, she made her debut in Charlottenborg, exhibiting a painting of an old man carving a stick, a work that attracted decidedly positive reactions both from the press and her artist friends.

Plein air painting had come to Scandinavia, and during the following summers Skagen attracted a number of outstanding Danish, Norwegian, and Swedish painters who brought about the Modern Breakthrough in Danish painting. The "Skagen Painters" became a familiar concept, and among them Anna was considered an equal, herself contributing to the movement with important paintings

such as Pigen i køkkenet, *1883–86, (The Maid in the Kitchen),* now in Den Hirschsprungske Samling, *and* Blind kone i sin stue (Sunshine in the Blind Woman's Room) *in several versions.*

In 1880 she married Michael Ancher, who throughout his life supported her in her professional career. Quite unusually for the time, he understood and respected her talent as the more important of the two. There was no need for her to take care of household chores to any great extent. The couple had many of their meals in Brøndum's hostelry, where her family also gave their help and support when their daughter Helga was born in 1883. So in spite of her marriage, Anna Ancher had no difficulty in painting and exhibiting, which she continued to do throughout her life.

Typical of Anna Ancher's art is her concentration on the visual, coloristic, and human aspects. She preferred simple motifs, which she painted over and over again with small variations, for instance a young woman sewing and seen in profile against a wall lit by sunlight or reflections. Her exposure to the work of Monet in Paris in 1885 quickly made itself felt in her art in the form of a dissolution of the motif, while a coloristic definition of the picture became characteristic of her subsequent work. After her death, a number of spontaneous oil sketches—visual notes showing how intensely preoccupied she was with studying color, light, and people—were found among her belongings and now form a part of the Michael and Anna Ancher museum house in Skagen.

Anna usually painted close to her home in Skagen Østerby. Her works are realistic, at once powerful in expression and yet unpretentious. She showed a predilection for old women and children, often seen in relation to each other. The fishermen's wives, whose features and figures were marked by the toils of a hard life, are rounded figures, harmonious in themselves, and Anna Ancher reproduced the gentle charm of the children with the same rare empathy. She portrayed her own mother, to whom she was very close, in a large number of paintings and drawings.

In a small number of cases, Anna Ancher undertook large pictures containing many figures: in 1890, En begravelse (Funeral) *in Statens Museum for Kunst, and in 1903,* Et missionsmøde (A Revivalist Meeting), *Skagens Museum, portraying a lay preacher speaking in the open air, surrounded by a crowd of listeners either sitting or lying on the dunes.*

Right from the early days of her career, Anna Ancher was recognized as an artist on an equal footing with her male counterparts, and so she was naturally included in the major Scandinavian exhibitions in the 1880s and 1890s, in international exhibitions, including Chicago in 1893, and in a large number of other official Danish exhibitions abroad. In contrast to the other Skagen painters, Anna Ancher's work has retained its popularity in Denmark over the years and has probably never been more highly rated than now, when a public outside Scandinavia is also learning to appreciate her.

E.F.

LITERATURE: Karl Madsen, *Skagens Malere og Skagens Museum,* Copenhagen 1929; Walter Schwartz, *Skagen i nordisk Kunst,* Copenhagen 1952; Heide Grape-Albers (ed.), *Anna Ancher, Malerin in Skagen,* Niedersächsisches Landesmuseum, Hanover 1994 (containing texts by Heide Grape-Albers, Christine Refflinghaus, Elisabeth Fabritius, and Claus Olsen); Elisabeth Fabritius in *Weilbach,* vol. 1, Copenhagen 1994; Elisabeth Fabritius, *Anna Ancher, the Pastels,* Copenhagen 2008; Christian Gether et al. (eds.), *Anna Ancher,* Museum of Modern Art, Ishøi 2011 (in English, texts by Anna Rygg Karberg, Lars Skinnebach, Lilian Munk Rösing, Elisabeth Fabritius, et al.).

ANNA ANCHER
1859–1935

2. *Young Girl Reading a Letter,* 1902
(Ung pige, der læser et brev)

Oil on canvas, 24 x 18 in. (61 x 46 cm)

Signed and dated lower left: A Ancher 1902

PROVENANCE: Attorney Victor Fischer, Ovenlyssalen, Bredgade 34, Copenhagen, Auction 7.3., 1916, lot 27, ill. p. 6 (unpaginated); Winkel & Magnussen, Auction 121 (Hugo Lützau's estate), 1932, lot 124, ill. p. 6 (described as *Ung pige læser et brev*); Bruun Rasmussen, Auction 581, 1992, lot 68, ill. p. 55.

EXHIBITED: Charlottenborg, 1903, no. 16; Scandinavia House, New York, *Danish Paintings from the Golden Age to the Modern Breakthrough, Selections from the Collection of Ambassador John L. Loeb Jr.*, 2013, no. 3.

LITERATURE: Inge Mejer Antonsen (ed.), *Michael and Anna Ancher's House, A Short Guide to the Collections*, The Helga Ancher Foundation, Skagen 1998 (on the motif).

Anna Ancher rarely painted outside Skagen Østerby, where she was born and brought up and where she lived throughout her life. She preferred to paint individual figures indoors. Most often she chose women from the fishing population of Skagen as her models, but this painting is different in that it portrays a young girl of the bourgeoisie. She stands reading a letter in a well-lit interior, which gives the picture a narrative content, something rarely seen in Anna Ancher's work. When reproduced at that time by Axel Vincents Kunstforlag, the painting was given an anecdotal title: *Letter from Home.*

The golden-haired model appears to be the artist's own daughter Helga—who was nineteen years old in 1902—and the interior is recognizable as the artist's own home at Markvej 2 in Skagen. In 1967 the house was opened as a museum under the name of Michael and Anna Ancher's House, one of the few artists' homes from this time preserved in its original state. When the Anchers bought their house and moved into it in 1884, this room with its two south-facing windows was at the center of the small old wing. The South Room, as it is called, was used as a living room, and when there were guests, a dining room. In time, all the walls were covered with paintings and drawings of the artists' family and their friends.

The girl in the painting stands at the easternmost of the two windows, by the mahogany sewing table, which is still in the same place today. So is the fine 18th-century looking glass which can just be discerned on the right in the painting, where a Louis XVI console table is almost hidden beneath the bright green leaves. This was later moved to the West Room and replaced by a bookcase, which now stands between the windows.

Anna Ancher often painted here in the South Room, doubtless because of the good lighting. In this picture, the powerful late morning sunlight falls especially on the letter, which gives support to the narrative element, but it also falls on the light summer curtains and the geranium on the window ledge, one of the artist's favorite flowers. At the same time, the girl's face and the room are indirectly illumined by the brilliant sunshine outside. The light green leaves and the light blue sky outside suggest early summer.

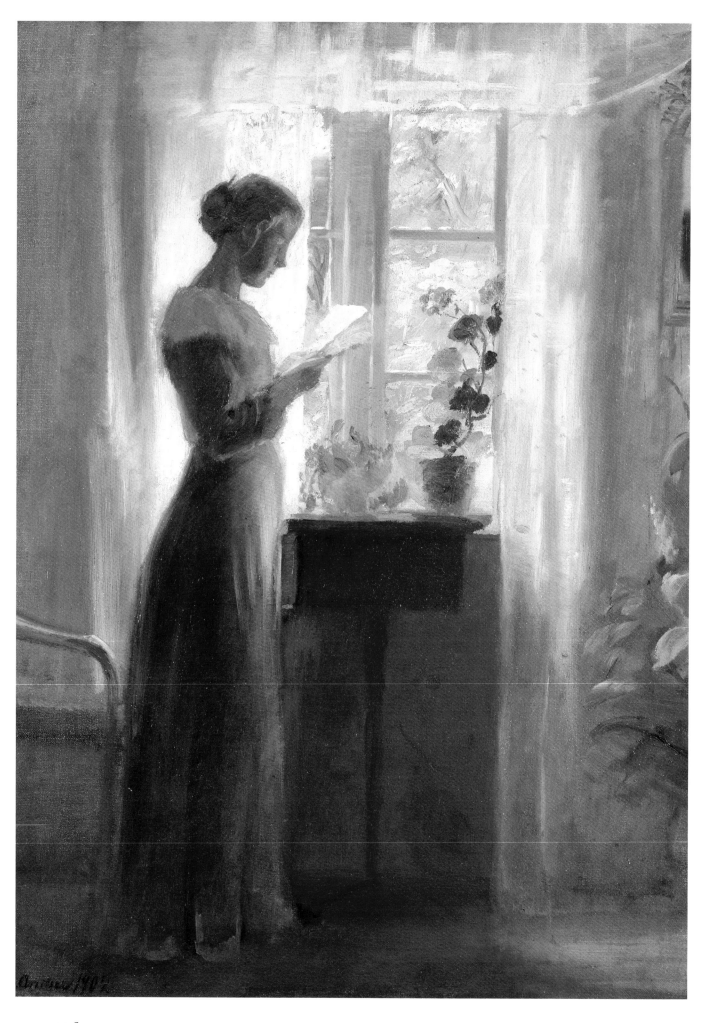

Anna Ancher painted similar motifs on various occasions, for instance *Interior,* 1899, in the museum Den Hirschsprungske Samling, where the young girl is looking at herself in a mirror.

At about the same time, Anna Ancher painted two of her most important works from the South Room. *Breakfast Before the Hunt*, from 1903, portrays Michael Ancher seated on the sofa, eating his breakfast in the early morning light; in 1904 came *Interior with Poppies*, a painting of a family friend, pianist Lizzy Hohlenberg, reading by the table in front of the white wall.

Anna Ancher also painted in the West Room and the North Room, but she was most fond of using the small room known as "The Skylighted Room" on the north side of the house. Not until 1913 did she acquire a proper studio, when Ulrik Plesner (1861–1933) built a modern wing for them on the north side of their house.

<div align="right">E.F.</div>

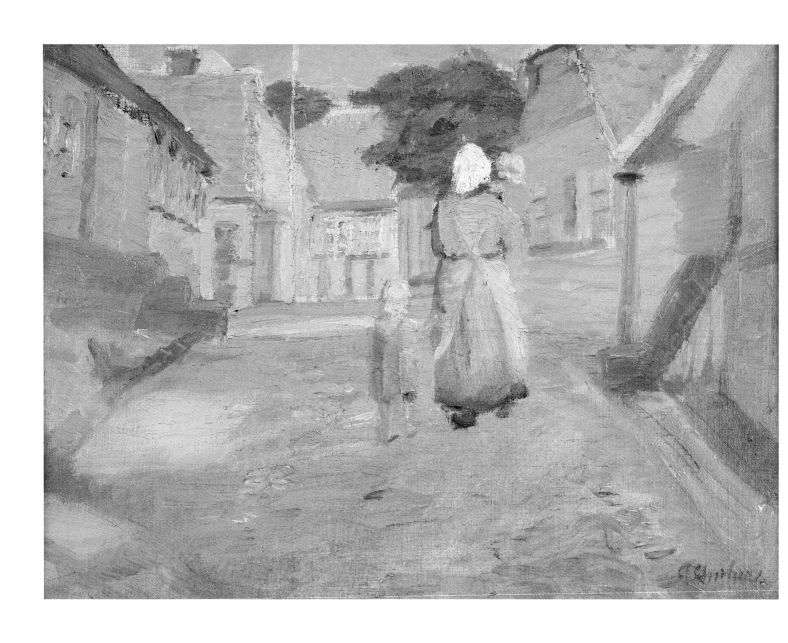

ANNA ANCHER
1859–1935

3. *A Street in Bornholm with a Mother Walking with Her Children,*
c. 1915

(En gade på Bornholm med en mor, der går med sine børn)

Oil on canvas, 11 x 15 in. (28 x 38 cm)

Signed lower right: A. Ancher

PROVENANCE: Kunsthallen, Auction 398, 1991, lot 3 (described as *Moder med to børn*).

EXHIBITED: Harvard University Art Museums, *Danish Paintings of the Nineteenth Century from the Collection of Ambassador John Loeb Jr.,* 1994, no. 1.

LITERATURE: Peter Nisbet, *Danish Paintings of the Nineteenth Century from the Collection of Ambassador John Loeb Jr.,* Busch-Reisinger Museum, Harvard University, Cambridge, Massachusetts, 1994, ill., p. 11.

Anna Ancher often accompanied her husband Michael when he visited his native island of Bornholm, Denmark's most easterly point, on the Baltic Sea just south of Sweden. In contrast to the rest of Denmark, Bornholm consists of red granite, which produces variations in terrain and thus also in the streets of the small towns, where great differences in level are encountered. This particular picture is thought to be of Grønnegade in Rønne, looking toward Toldbodgade.

The dramatic appearance of the rocky landscape attracted other Danish artists as well. In the West Room in the Anchers' museum house, there are two small paintings of the Bornholm coast painted by Vilhelm Kyhn in 1843. And the marine artist Holger Drachmann (1846–1908) took countless motifs from Bornholm for a period of ten years starting in 1866. Laurits Tuxen visited the island in 1876, and Peder Mønsted often painted there.

Like Skagen, Bornholm enjoys a particularly strong light, which at the beginning of the 20th century attracted some of the best Nordic Modernists. The paintings of Karl Isakson (1878–1922) and Edvard Weie (1879–1943), executed in Bornholm and Christansø, broke new ground in Danish art.

For Anna Ancher, color was the most important element, and this picture is about the various shades of red in the walls and roofs of the houses contrasted with the cool blue, gray, and green shades of the street, repeated in the woman's dress. The choice of the street seen in linear perspective is strikingly suggestive of the series of paintings Anna Ancher executed late in life from Østerbyvej in Skagen, where she painted several versions either of the road alone or with little girls walking and playing. Here, too, it was the combination of the pink, bluish, and golden colors that fascinated her.

This painting appears never to have been exhibited other than at the Busch-Reisinger exhibit in 1994. So far, no other paintings by Anna Ancher can be identified as having been painted in Bornholm.

E.F.

ANNA ANCHER
1859–1935

4. *On the Way to Church*, c. 1928

(På vej til kirke)

Oil on canvas, 28 x 33½ in. (71 x 85 cm)

Signed lower right: A. Ancher

PROVENANCE: Bruun Rasmussen, Auction 695, 2001, lot 1055, ill.

EXHIBITED: Charlottenborg Efteraarsudstilling, *Anna Ancher, Mindeophængning*, 1935, no. 66 (described as *Paa Vej til Kirke*, c. 1928); Bruce Museum of Art and Science, Greenwich, Connecticut, and The Frances Lehman Loeb Art Center, Vassar College, New York, *Danish Paintings of the Nineteenth Century from the Collection of Ambassador John L. Loeb Jr.*, 2005, no. 34, ill.; Scandinavia House, New York, *Danish Paintings from the Golden Age to the Modern Breakthrough, Selections from the Collection of Ambassador John L. Loeb Jr.*, 2013, no. 2.

LITERATURE: Patricia G. Berman, "Lines of Solitude, Circles of Alliance, Danish Painting in the Nineteenth Century" in *Danish Paintings of the Nineteenth Century from the Collection of Ambassador John L. Loeb Jr.*, Bruce Museum, 2005, p. 21.

The motif in this painting is of three women from Skagen walking to church on a sunlit road in Skagen Østerby late in the day. There are suggestions of rapid movement as they approach the painter, side by side, clothed almost identically in dark dresses, long skirts, shawls, and cloaks, with white scarves around their heads. They thus form a strong contrast to the dazzling light colors seen on the road, the houses, the dunes, and the sky, where pink, light blue, and light green are dominant.

The countless shades of color found in the farthest outskirts of Østerby at Skagen, where the town borders on the vast stretches of heath leading to Grenen, often tempted Anna Ancher in the latter part of her life. From about 1915 she painted numerous studies and more carefully finished pictures without figures on the sandy tracks out there.

In the 1920s, modern dress was not yet common among the older women of the humble folk, but the three in Anna Ancher's painting are dressed in such a conservative manner that it must be assumed they belonged to Indre Mission. This strict, almost pietistic Christian persuasion had from the 1870s become very widespread in Denmark, especially in the poorer areas far from Copenhagen. In Skagen, where the people were so often faced with death at sea, the movement gained many adherents, and the town was, in a way, divided into two camps. Anna Ancher knew Indre Mission at close quarters because her mother and sisters were deeply committed to the movement. In 1903 she painted *Et missionsmøde A Field Sermon*, a large picture of many figures listening to a lay preacher as he addressed the people of Skagen sitting in the lee of a high dune; it is now in the Skagens Museum.

Anna Ancher was to all appearances a woman with a religious faith, but at the same time she associated with a group of freethinkers. Otherwise, she would never have thought of painting the grotesque contrast between the approaching women in their somber dress and the wealth of color in the calm, sun-drenched landscape.

E.F.

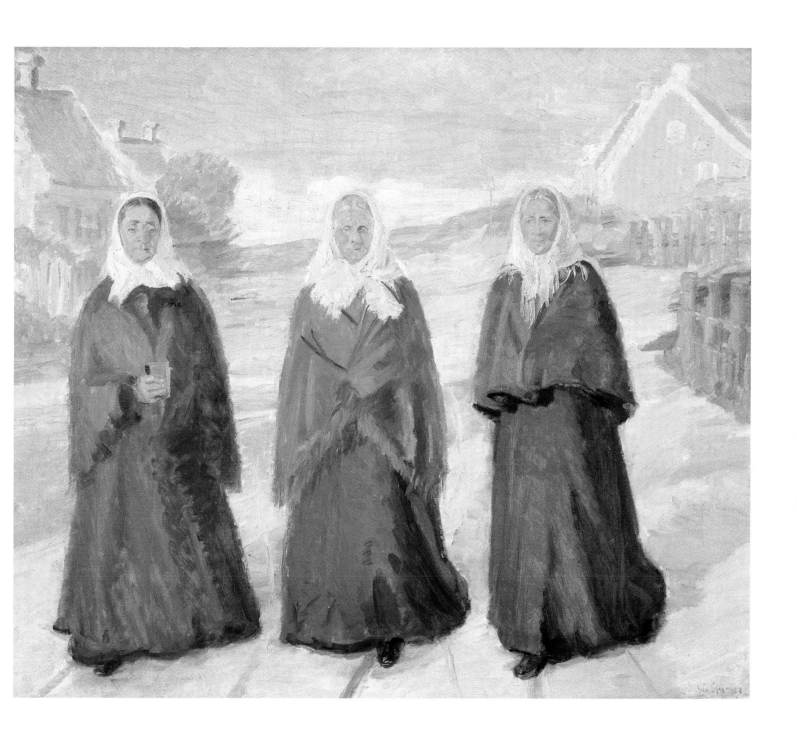

MICHAEL PETER ANCHER

RUTSKER PARISH, BORNHOLM 1849 – SKAGEN 1927

Strength of purpose, ambition, and industry were the qualities that ensured Michael Ancher a place among the best in his generation. The path by which he became a successful figure painter was long and difficult. At the age of fifteen he was forced to leave the grammar school in Rønne on the island of Bornholm on account of his father's bankruptcy. He found work in the administration office of the Kalø estate in Jutland, where the beautiful surroundings attracted many landscape artists. In Jutland Ancher encountered Theodor Philipsen (1840–1920) and Vilhelm Groth (1842–1899), and he was seized by a desperate longing to become an artist himself.

In 1871 he was admitted to the Royal Danish Academy of Fine Arts, where he made rapid progress, but he never managed to take the final examination. In 1874 he made his first appearance in the Spring Exhibition in Charlottenborg, and when he visited Skagen for the first time that summer, he became filled with such enthusiasm about the people and natural surroundings of the place that he decided to develop his skills there by virtue of his own efforts. Playing a part in this decision was his falling in love with Anna Brøndum, who was then only fourteen years old but whose artistic talent he immediately perceived.

Eventually his goals were met. In 1880 Michael Ancher achieved a unique success with his breakthrough painting Vil han klare Pynten? (Will He Round the Point?), *which was purchased by the king. That same summer he and Anna were able to celebrate their wedding in Skagen, when she was twenty-one.*

In 1879 Michael Ancher had his first opportunity to see French art when the brewer Carl Jacobsen of the Carlsberg Breweries exhibited his then-modest private collection in Copenhagen. A painting by J. F. Millet (1814–1875) made a powerful impression on both him and Anna, and that summer Skagen was visited by artists with European experience: Karl Madsen (1855–1938) as well as the Norwegians Frits Thaulow (1847–1906) and Christian Krohg (1852–1925), who brought realism, naturalism, and plein air painting with them. During the summer of 1880, and under their inspiration, Ancher painted the first sunshine picture in Skagen, Figurer i et landskab (Figures in a Landscape), *now in the museum Den Hirschsprungske Samling, portraying an old man and a young woman sitting on the sand, thereby manifesting himself as a painter of the Modern Breakthrough. The painting made both Ancher and Skagen known among the modern Scandinavian plein air painters, who in succeeding years congregated in Skagen and there formed the colony of artists that came to be known as the "Skagen Painters."*

Michael Ancher was thus already established as a modern painter when P. S. Krøyer arrived in Skagen in 1882 and the place's character changed for good. Ancher rightly feared competition; his monopoly as "the" Skagen painter had been broken, though the two rivals nevertheless became close friends.

Ancher now moved in several directions. He continued painting naturalist sunshine pictures from Skagen Østerby, in which the main emphasis is on color, mood, and the human element. In addition he produced many monumental compositions presenting fishermen as lifesavers, for instance The Lifeboat is Taken through the Dunes, *1883. At the same time he continued painting his traditional motifs centered on the lives of ordinary people, and this produced a secure income for him.*

Ancher was over thirty years old before he went abroad. In 1882 he visited Berlin, Dresden, and Vienna, where he saw paintings by Rubens (1577–1640), Rembrandt (1606–1669), Pieter de Hooch (1629–1683), and Vermeer (1632–1675), which made an indelible impression on him and made their mark on his art, as is seen in major works such as En syg ung pige, *1882 (A Sick Girl, in Statens Museum for Kunst), and the monumental* En barnedåb (A Baptism), *painted 1883–1888, now in Ribe Kunstmuseum. Ancher never renounced the classical demands on composition, but with his experience of the study of reality ensuing from plein air painting, he created a modern, national figure painting which ensured him a prominent place in the history of Danish art.*

The 1890s brought new movements in art, and the time when Ancher formed part of the avant garde was past. Although he was not uninfluenced by developments, there were longer intervals between his major works, for which illness was also partly responsible. Nevertheless, the family portrait Juledag 1900 (Christmas Day 1900), *from 1903, in the Skagens Museum, and* Kunstdommere (Art Critics), *from 1906, in the Museum of National History at Frederiksborg Castle, must be mentioned as striking exceptions.*

Road and rail connections to Skagen were established in 1890, bringing tourists and holiday makers in hitherto unknown numbers. Many of them commissioned portraits, and others bought Ancher's paintings in the summer exhibitions in Skagen. The great public interest in the peak period of the Skagen Painters in the 1880s led to Ancher's writing his memoirs in the form of notes containing precise descriptions that also reflect his warm sense of humor. They formed the basis of the first book on the Skagen Painters written by Alba Schwartz (1857–1942).

By 1900, Ancher was one of the most famous and celebrated painters in Denmark, with countless marks of honor to his name. He took part in official exhibitions abroad, including the World Fairs in Paris in 1889 and 1900 and Chicago in 1893. (In 1895 Ancher exhibited in the United States at the Art Institute of Chicago, the Cincinnati Museum Association, and the Twelfth St. Louis Exhibition.)

Ancher was among the founders of Skagens Museum in 1908 and lived to see a long-awaited building completed before he died in 1927.

E.F.

LITERATURE: Karl Madsen, *Skagens Malere og Skagens Museum*, Copenhagen 1929; Elisabeth Fabritius, *Michael Anchers ungdom 1865–1880*, Skagen 1992; Elisabeth Fabritius in *Weilbach*, vol. 1, Copenhagen 1994; Peter Nisbet, *Danish Paintings of the Nineteenth Century from the Collection of Ambassador John L. Loeb Jr.*, Harvard University Art Museums Gallery Series no. 8, Cambridge, Massachusetts 1994, pp. 10–11; Bente Scavenius (ed.), *Krøyer and the Artists' Colony at Skagen*, National Gallery of Ireland, Dublin 1998; Elisabeth Fabritius, *Michael Ancher og Det Moderne gennembrud, 1880–1890*, Skagen 1999; Elisabeth Fabritius (ed.), *Skagensmaleren Michael Ancher 1849–9. Juni–1999*, Skagen 1999; German translation, *Michael Ancher, Maler in Skagen, 1849–9. Juni–1999*, Skagen 1999.

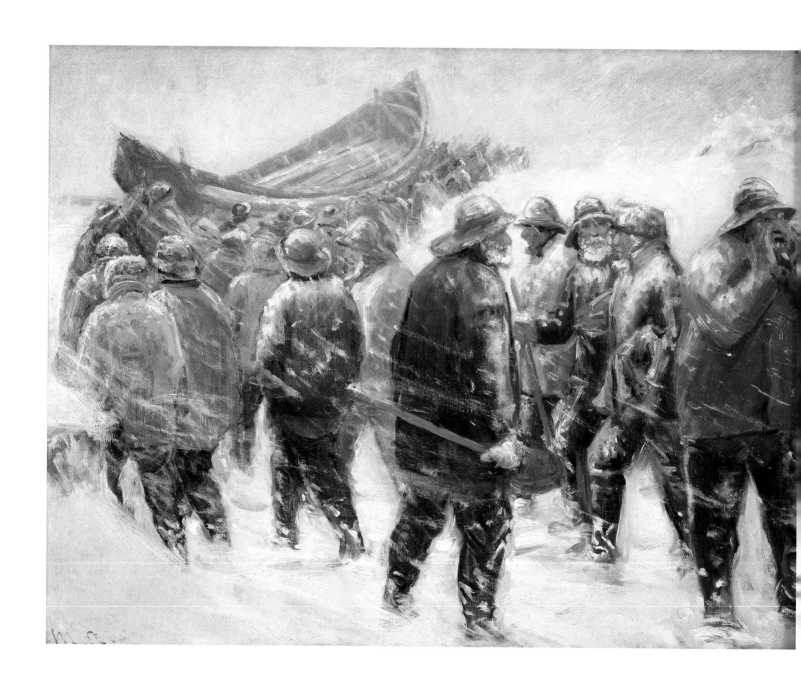

MICHAEL ANCHER
1849–1927

5. *Sketch for "Taking the Lifeboat Through the Dunes,"* 1883
(Skitse til "Redningsbåden køres gennem klitterne")

Oil on canvas, 18 x 22¾ in. (46 x 58 cm)

Signed with initials lower left: M.A.

PROVENANCE: Arne Bruun Rasmussen, Auction 454, 1983, lot 244, ill. p. 179 (described as *Redningsbåden går ud i snestorm*).

LITERATURE: Elisabeth Fabritius in Elisabeth Fabritius (ed.), *Skagensmaleren Michael Ancher 1849–9. Juni–1999*, exhibition catalogue Michael og Anna Anchers Hus, Skagens Museum, 1999 (on the composition); Elisabeth Fabritius, *Michael Ancher og det moderne gennembrud 1880–1890*, Skagen, 1999, chapter II.4; this painting ill. p. 112, oeuvre no. 277; Patricia G. Berman, *In Another Light, Danish Painting in the Nineteenth Century*, New York, 2007, ill. p. 143.

This compositional sketch is very close to the finished painting, which measures 5⅔ x 7¼ ft. (171 x 221 cm). It was purchased by Nationalgalleriet (subsequently Statens Museum for Kunst), Copenhagen (Fig. A), at the Charlottenborg exhibition 1883, where Ancher had enjoyed a success. The painting portrays the Skagen lifeboat crew on its way out toward the shore with the huge boat that in Ancher's day was rowed out to shipwrecked sailors by a large lifeboat crew. It is winter; the snow is lying on the dunes, with their withered, yellow lyme grass; the sky is leaden and gray. Two major wrecks occurred at the end of 1881, and these may have inspired Ancher to choose this particular motif. The Skagens Museum owns an 1882 sketch of dunes in snow.

Ever since his arrival in Skagen in 1874, Michael Ancher was fascinated by the drama of the frequent life-saving actions; he warmly admired the heroism the fishermen demonstrated time after time by risking their lives. Sometimes they succeeded in their rescue efforts, though at other times drowning was the result both for themselves and the shipwrecked. Between 1876 and 1895, Ancher created an epic series of large-scale, carefully composed paintings depicting the stages of a rescue operation, culminating in a gigantic work, *The Drowned Man,* 1895 (Statens Museum for Kunst). These large-scale paintings are highly realistic, but in their harmonies they are at the same time deeply rooted in the Western European painting tradition and thus representative of the renewal of Danish figure art, which was Michael Ancher's contribution to the Modern Breakthrough of the 1880s.

In this sketch, Ancher has experimented to see whether the motif could be achieved in a snowstorm.

E.F.

FIG. A Michael Ancher
Taking the Lifeboat through the Dunes, 1883
5⅔ x 7¼ ft. (171 x 221 cm) Statens Museum for Kunst
Two major shipwrecks at the end of 1881 might have inspired Ancher to choose winter for this motif. In November 1882 he made a painting of snow-covered dunes with withered lyme grass beneath a leaden sky. There is inspiration from the art of the Renaissance and the Baroque behind the composition of the finished painting, which nevertheless has a very realistic effect.

MICHAEL ANCHER
1849–1927

6. *Sketch for "The Girl with the Sunflowers,"* 1889
(Skitse til "Pigen med solsikkerne")

Oil on canvas, 17 x 15⅔ in. (43 x 39 cm)

PROVENANCE: The painter Viggo Johansen; Winkel & Magnussen, Auction 194 (Viggo Johansen), 1936, lot 2, ill. p. 6; Winkel & Magnussen, Auction 386 (Hans Tobiesen), 1954, lot 1, ill. p. 6; Arne Bruun Rasmussen, Auction 453, 1983, lot 8, ill. p. 39 (described as *Pigen med solsikkerne, Maren Brems*).

EXHIBITED: Charlottenborg, *Michael Ancher*, 1928, no. 38; Harvard University Art Museums, *Danish Paintings of the Nineteenth Century from the Collection of Ambassador John Loeb Jr.*, 1994, no. 2.

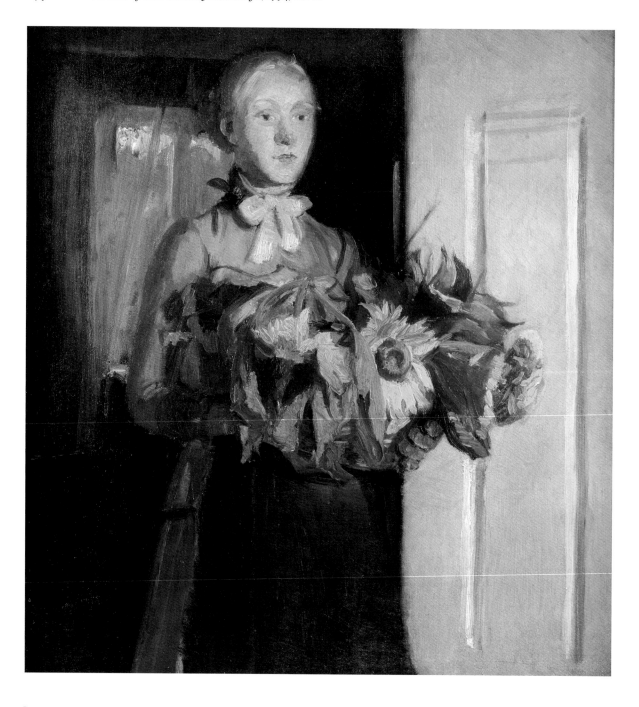

LITERATURE: Hanne Westergaard in *1880-erne i nordisk kunst*, Copenhagen, 1986; exhibition catalogue Nasjonalgalleriet, Oslo, Nationalmuseum, Stockholm, Amos Anderssons Konstmuseum, Helsinki, Statens Museum for Kunst, Copenhagen, pp. 50–53 (on the motif); Peter Nisbet, *Danish Paintings of the Nineteenth Century from the Collection of Ambassador John Loeb Jr.,* Busch-Reisinger Museum, Harvard University, Cambridge, Massachusetts, 1994, ill. and discussed p. 11; Elisabeth Fabritius, *Michael Ancher og det Moderne Gennembrud 1880–1890*, Skagen, 1999, no. 417, discussion chapter IV.3.

This sketch is very close to the finished painting, one of the artist's most important works. *The Girl with the Sunflowers*, 3⅓ x 3 ft. (101 x 95 cm), painted in 1889 (Fig. A), was purchased by Statens Museum for Kunst in 1928 after the artist's death.

A young girl standing with a copper vessel filled with sunflowers is a simple everyday motif, which the artist has made monumental by means of the arrangement and grouping within the framework of the picture. The girl is standing indirectly illuminated on the threshold between two rooms. Behind her, from the darkness inside, there is a glimpse of the garden, bathed in fierce sunlight. Warm, golden brown colors dominate the picture and form a powerful contrast to the window and the conspicuously bright shades of blue in the sheer curtains.

Michael Ancher was a great admirer of the Dutch painters from the Golden Age of Dutch painting, Pieter de Hooch (1629–1683) and Vermeer van Delft (1632–1675), a debt to the 17th century he gladly acknowledged. The fact that here, for the first time, he allowed one shade of color to dominate is undoubtedly due to familiarity with the color harmonies of James McNeill Whistler (1834–1903).

The artist had long left his youth behind when he first went on a short visit to Paris in 1885. He was not able to have a prolonged study-visit there until 1889, when he and Anna Ancher spent six months. That year Paris was hosting the great world fair. Here they made a much closer acquaintance with French art as a result of the retrospective special exhibition of 100 years of French art, and they supplemented this with studies in the Louvre. They also saw the Danish section, in which they themselves were exhibiting, as well as the exhibitions of art from many other countries. There was ample opportunity for discussions with their many artist friends who were also in Paris, and to make new acquaintances.

The Girl with the Sunflowers was painted during the summer afterward, when Ancher had returned home to Skagen filled with new impressions. The girl in the painting is Maren Brems, the family maid. The flowers grew in the Brøndum family's old garden, close to the old garden house, Michael and Anna's first home. The art historian Hanne Westergaard has suggested that the artist's interest in sunflowers might be related to van Gogh (1853–1890), who during these same years was painting sequences of this spectacular flower and with whom a few Danish painters had connections. E.F.

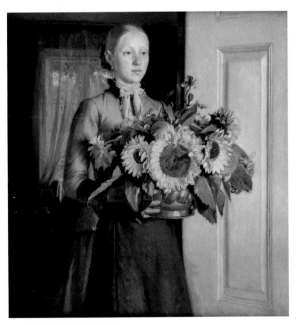

FIG. A Michael Ancher
The Girl with the Sunflowers, 1889
(Pigen med solsikkerne)
Oil on canvas, 3⅓ x 3 ft. (101 x 95 cm), Statens Museum for Kunst. There is a second version of the motif in the Michael and Anna Ancher house, now a museum in Skagen.

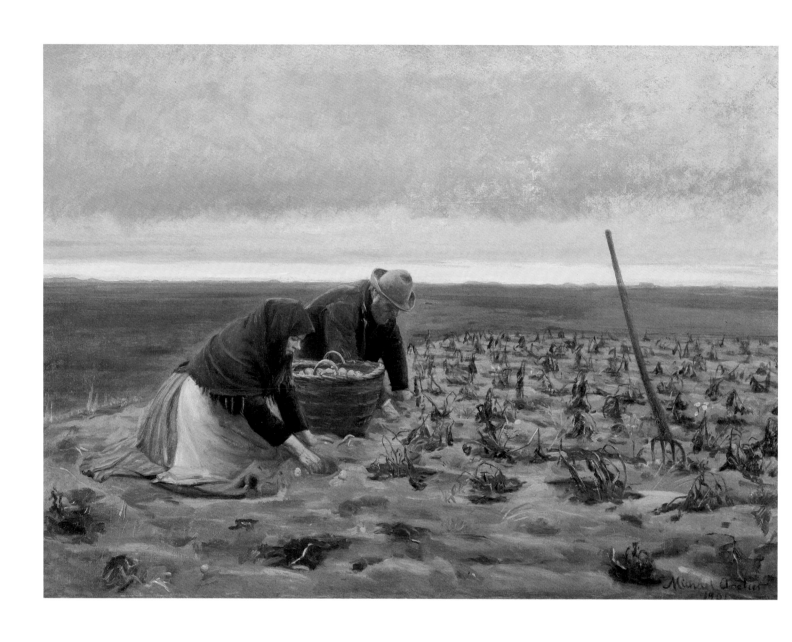

MICHAEL ANCHER
1849–1927

7. *Potato Harvest,* 1901

(Kartoffelhøst)

Oil on canvas, 31½ x 42½ in. (80 x 108 cm)

Signed and dated lower right: Michael Ancher 1901

PROVENANCE: Arne Bruun Rasmussen, Auction 452, 1983, lot 13, ill. p. 15.

EXHIBITED: Probably Charlottenborg, 1902, no. 12; Scandinavia House, New York, *Danish Paintings from the Golden Age to the Modern Breakthrough, Selections from the Collection of Ambassador John L. Loeb Jr.*, 2013, no. 4.

In former times, the population of Skagen was obliged to live primarily on the fish they caught. The sandy moorland stretches around the town were suitable only for grazing cattle, and agriculture was limited. An exception was the undemanding potato, which grows well in just this sort of sandy soil.

Here Ancher gives a detailed pictorial description of the right conditions for potato growing. The brown moorland vegetation takes up most of the painting, while the spot where the potatoes are being dug up is almost pure sand, gray and cold.

After the 1890s, an increasing number of moorland pictures make an appearance in Ancher's oeuvre, often, as here, populated by people at work in dramatic sunset light. Some of his moorland pictures appear to have a Symbolist character, for instance the 1915 painting *Young Harvester Returning Home from the Outfield* (carrying a scythe over his shoulder), in Statens Museum for Kunst. They can be seen as examples of Ancher's lifelong inspiration from such French painters as J. F. Millet (1814–1875) and Jules Breton (1827–1906).

E.F.

MICHAEL ANCHER

1849–1927

8. *Moorland Landscape, Skagen, Figures in the Foreground*

(Hedelandskab, Skagen med personer i forgrunden)

Oil on canvas, 15 x 20 in. (38 x 51 cm)

Signed with initials lower right: M.A.

PROVENANCE: Bruun Rasmussen, Auction 526, 1989, lot 93, ill. p. 102 (described as *Udsigt over fladt landskab med gående personer*).

Location unknown.

It is no longer possible to localize the motif that has tempted Michael Ancher here. The houses in the background have probably been pulled down or moved, as frequently used to happen. But it was painted at Skagen, presumably close to Skagen Østerby, which in Ancher's day was surrounded by large expanses of moorland. Ancher was a great nature lover, frequently hunting and spending much of his time outdoors while observing the colors and lighting in the imposing landscapes around Skagen. Michael Ancher's interest in landscapes and cloud formations, as painted here, gradually increased over time. A great many detailed studies of landscapes have been preserved in Michael and Anna Ancher's museum house, in Skagen.

E.F.

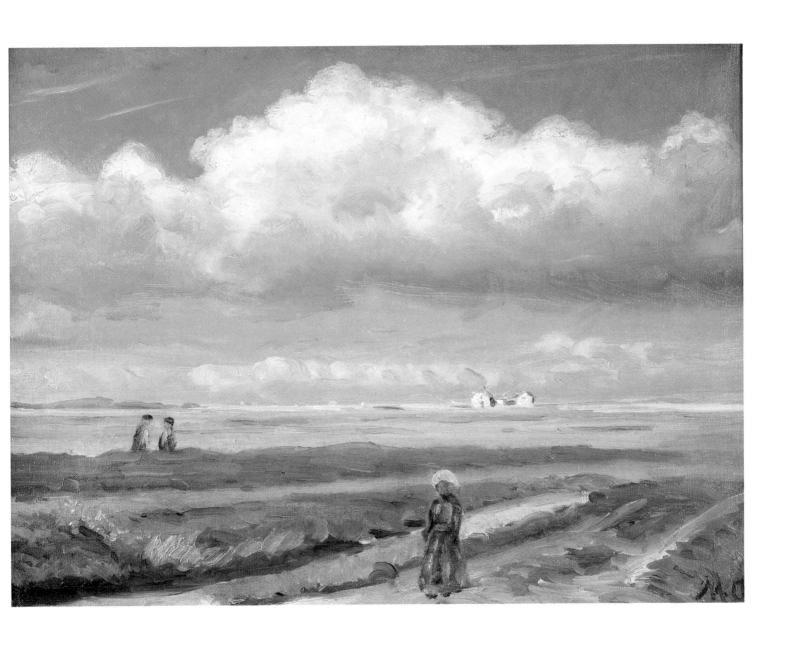

MICHAEL ANCHER
1849–1927

9. *Portrait of the Artist's Wife, the Painter Anna Ancher*
(early 1900's)

Oil on canvas, 34⅗ x 26⅘ in. (88 x 68 cm)

PROVENANCE: Arne Bruun Rasmussen, Auction no. 178 (Helga Ancher's estate), 1965, lot 98; Bruun Rasmussen, Auction 729, 2004, lot 1267, ill.

EXHIBITED: Scandinavia House, New York, *Danish Paintings from the Golden Age to the Modern Breakthrough, Selections from the Collection of Ambassador John L. Loeb Jr.*, 2013, no. 5.

The marriage between Anna and Michael Ancher was a long and happy one, not only in a banal sense but also because Anna was one of the few women of her generation to be given the possibility of developing fully as an artist. At the end of the 19th century, when social equality was still unknown, women normally had to abandon their careers when they married, and many of their talents were lost. Things were different in the Ancher family, where Michael Ancher actually encouraged his wife to paint and exhibit. He admired her talent and acknowledged that it was greater than his own. Although she was ten years younger than he and only 14 when they first met, he always valued her opinion. Nor did any professional jealousy arise between them, as otherwise happens in many marriages between artists. She was likewise respected by the other Skagen painters, who looked on her as a professional and equal. So Anna Ancher could confidently enjoy being an artist and came to exude the self-confidence reflected in this portrait.

Anna was not tall, but she always stood very straight, which together with her personal qualities gave her a natural dignity. Her characteristic profile, due in part to breaking her nose as a child, contributed to this dignity. Michael Ancher often chose her profile when he painted her, for instance in the head and shoulders portrait of 1878, painted on the occasion of their engagement and in the dignified full-figure portrait of 1884 (Den Hirschsprungske Samling).

The same applies to the portrait in the Loeb collection, in which Anna is wearing a black dress with a medieval-type silver belt such as was fashionable at the time.[1] A necklace can be seen on the high-necked blue dickey, a chain holding an anchor fastened as a brooch, presumably a symbolic gift from her husband, whose surname in Danish literally means "anchor." This brooch is seen in numerous paintings but has apparently not survived. The pose in this portrait is somewhat reminiscent of that in the one Michael Ancher was commissioned to paint by the Charlottenborg Exhibition Committee (now in the Museum of National History at Frederiksborg Castle).

The Loeb collection portrait of Anna was among the 200 paintings that left the Anchers' house on the occasion of the first of the two auctions that, in accordance with the will of their daughter Helga Ancher, were held in order to finance the restoration of the house and the works of art so that the artists' home could open as a museum. There is a smaller portrait of her there today that must have been painted on the same occasion. Her dress and the accessories are the same, but in that one Anna Ancher is seen full face.

E.F.

[1]A large amount of such jewelery was made at the end of the 19th century, and this belt has been preserved in the Michael and Anna Ancher's House museum. I am grateful to the art historian Inge Mejer Antonsen for this information.

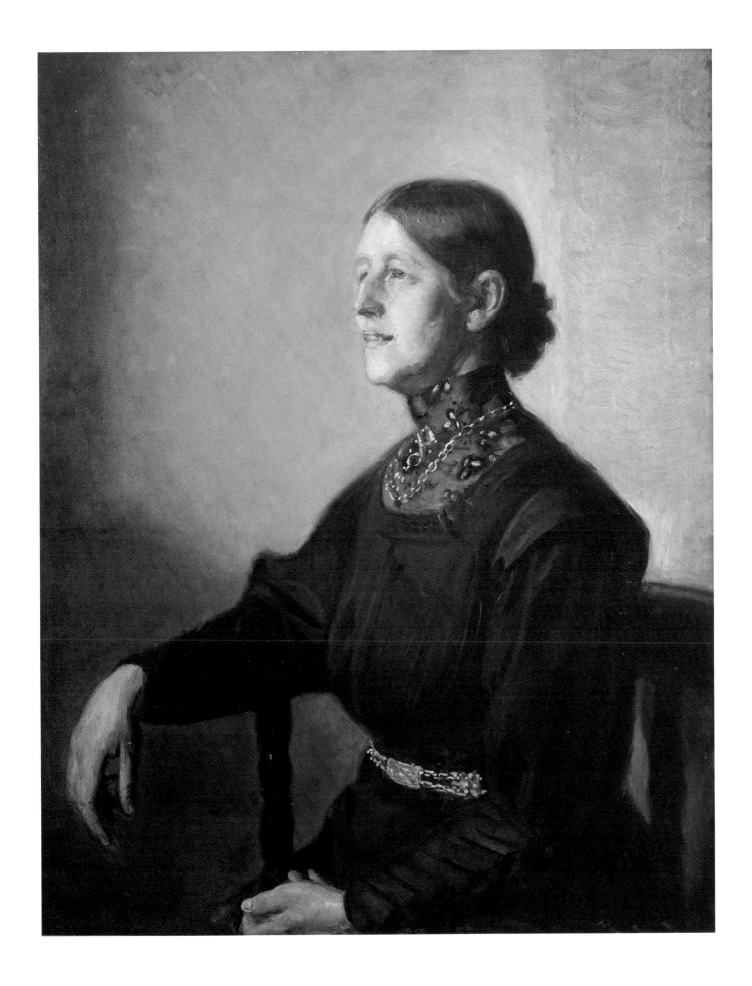

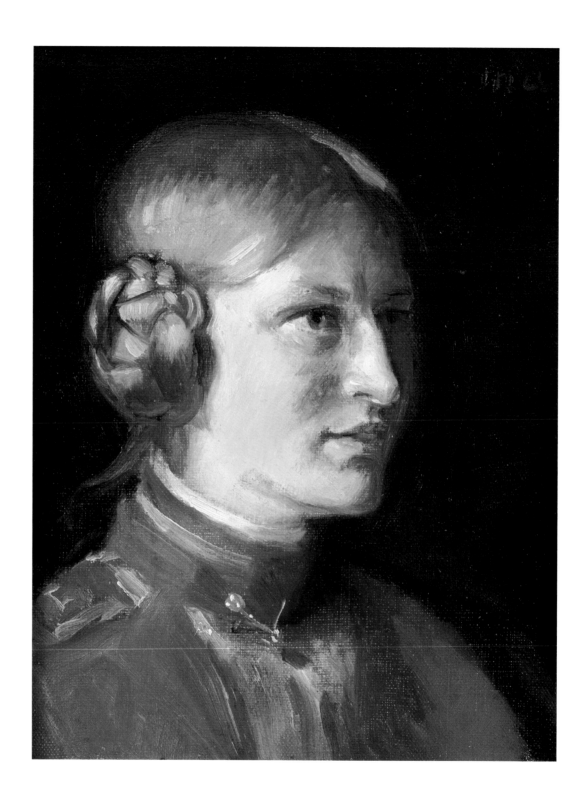

28]

MICHAEL ANCHER
1849–1927

10. *Portrait of a Young Girl in Red Dress,* after 1900
(Portræt af en ung pige i rød kjole)

Oil on canvas, 9½ x 7½ in. (24 x 19 cm)

Signed with initials top right: M A

PROVENANCE: Bruun Rasmussen, Auction 526, 1989, lot 102, ill. p. 106 (described as *Portræt af lyshåret ung Skagenspige*).

The portrait of the smiling young girl is, thanks to its broad brush strokes and bold choice of color, typical of Michael Ancher's portrait style after 1900. It is not known who the girl is or whether the picture represents a preparatory sketch for a larger work.

E.F.

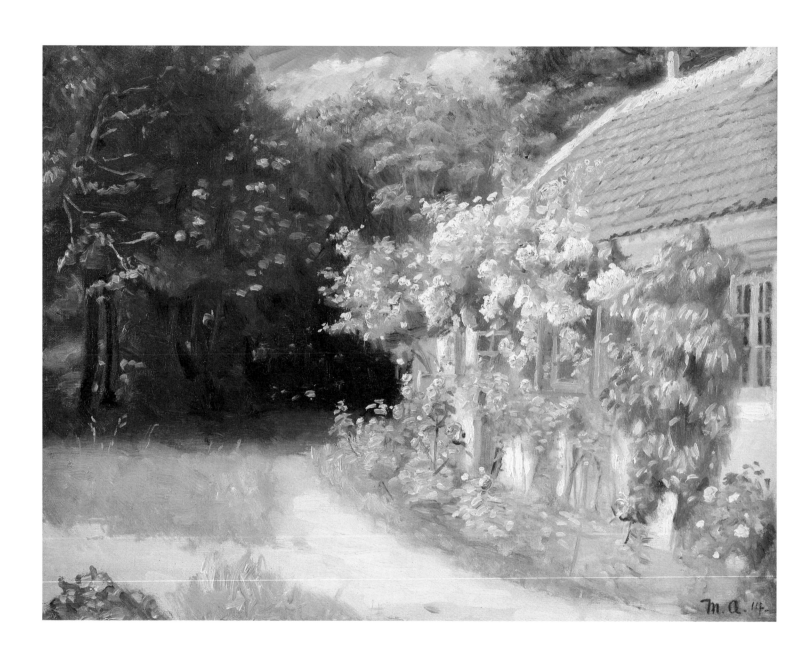

MICHAEL ANCHER
1849–1927

11. *The Old Garden House, summer 1914*

(Det gamle Havehus, sommer 1914)

Oil on canvas, 18½ x 26⅔ in. (47 x 68 cm)

Signed with initials and dated lower right: MA 14

PROVENANCE: Bruun Rasmussen, Auction 454, 1983, lot 24 (described as *Fra kunstnerens have på Skagen, sommer*).

LITERATURE ON THE MOTIF: Alba Schwartz, *Skagen før og nu*, I–II, Copenhagen, 1912–13; Sys Hartmann (ed.), *Huse i Skagen*, vol. 2, *Kappelborg og Østerby*, Skagen Kommune og Fredningsstyrelsen, Copenhagen, 1982; Elisabeth Fabritius, *Michael Anchers ungdom, 1865–80*, Skagen, 1992.

A Skagen house amidst all the profusion of summer flowers in brilliant sunshine was a motif that was likely to engage Michael Ancher, especially in the latter part of his life. The lush flowers are typical of Skagen, for roses grow well in sandy soil. They are enhanced by the trees in the background, the height and fullness of which are rare in Skagen. The love radiated by the picture becomes more understandable when we know that the charming, skewed wing not only had a special significance for Michael Ancher himself but also played a role in the history of Skagen. This is where the artist lodged when he came to Skagen for the first time in 1874, because the building served as the Brøndum hostelry as well as the Brøndum family home that summer. (The original hostelry had burned down, but was soon rebuilt.)

When Michael Ancher married Anna Brøndum in 1880, the section of the building to the left was fitted out for them, and during the first years of their happy marriage they lived behind the windows seen in the picture. In a painting of the sitting room from 1883, called *Dagens arbejde bedømmes (Judging the Day's Work*, in Statens Museum for Kunst), they have portrayed each other discussing a painting on the easel. And it was in one of the doors in this house that Michael Ancher also painted a full-length portrait of Anna while she was expecting Helga. Shortly afterward their daughter was born here, and the entire colony of Scandinavian artists came to offer their congratulations.

In 1884, the Anchers bought another old house situated only a few minutes' walk away at Markvej 2, now the Michael and Anna Ancher's House museum. The "old garden house" became once again a kind of annex to the Brøndum hotel. The garden house, the hotel, and all its equipment were left to Skagens Museum in 1932 as a bequest from Anna Ancher's brother, Degn Brøndum, who then owned the hotel.

This painting shows the south face of the old garden house, that like the gabled ends, is built of brick. The whitewashed cornice with its concave molding is no longer visible. The north side of the building, on the other hand, is covered by boards painted red. In 1941 and later, the house was restored by the architect Viggo Steen Møller (1897–1990) to house the changing exhibitions of modern art in the Skagens Museum, such as one held by Michael and Anna's only daughter, Helga Ancher, in 1953. The house is still used today for exhibitions.

E.F.

MICHAEL ANCHER
1849–1927

12. *Fisherman's Wife Knitting on Skagen Beach*
(Strikkende fiskerkone på stranden)

Oil on canvas, 31 x 24⅔ in. (79 x 63 cm)

Signed with initials lower right: MA

PROVENANCE: Arne Bruun Rasmussen, Auction 453, 1983, lot 9, ill. p. 49.

(An almost identical version, 31½ x 26 in. [80 x 66 cm], signed lower right: M. Ancher, was sold at auction, Kunsthallen, 14.10. 1944, lot 9).

EXHIBITED: Scandinavia House, New York, *Danish Paintings from the Golden Age to the Modern Breakthrough, Selections from the Collection of Ambassador John L. Loeb Jr.*, 2013, no. 6.

LITERATURE: Patricia G. Berman, *In Another Light, Danish Painting in the Nineteenth Century*, New York, 2007, ill. p. 158.

From the time that Ancher first came to Skagen in 1874, the sea off Skagen challenged him. In his younger years he was most frequently tempted by storm and surf; in his later years (when he painted this picture) he painted mainly calm seas. Whereas Krøyer preferred the evening twilight, Ancher from the start chose the warm, reddish light of sunset. This is seen in *A Lay Preacher Holding a Service on Skagen Beach*, 1877 (Skagens Museum), which like the present work contains the frequently repeated motif of a fisherman's wife sitting on a boat. Through lifelong practice, Michael Ancher mastered the depiction of the famous Skagen light at all times of the year. Here he has been intrigued by the contrast between the cool blue of the deep shadows and the sunlight falling on the sand. The model is known from other studies and larger paintings.

E. F.

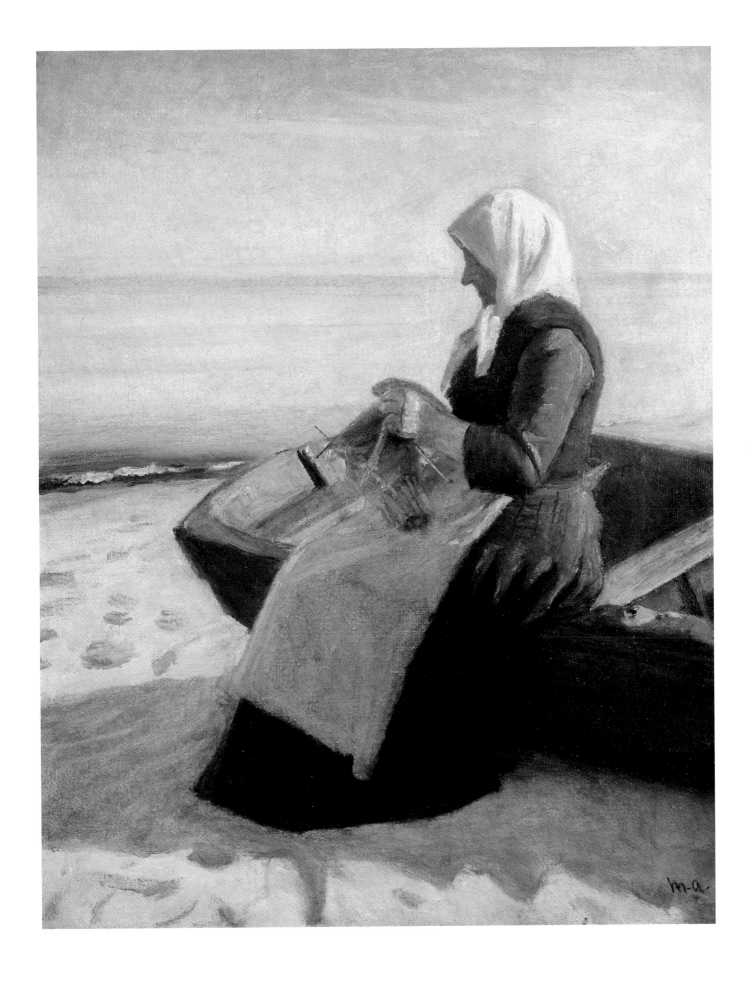

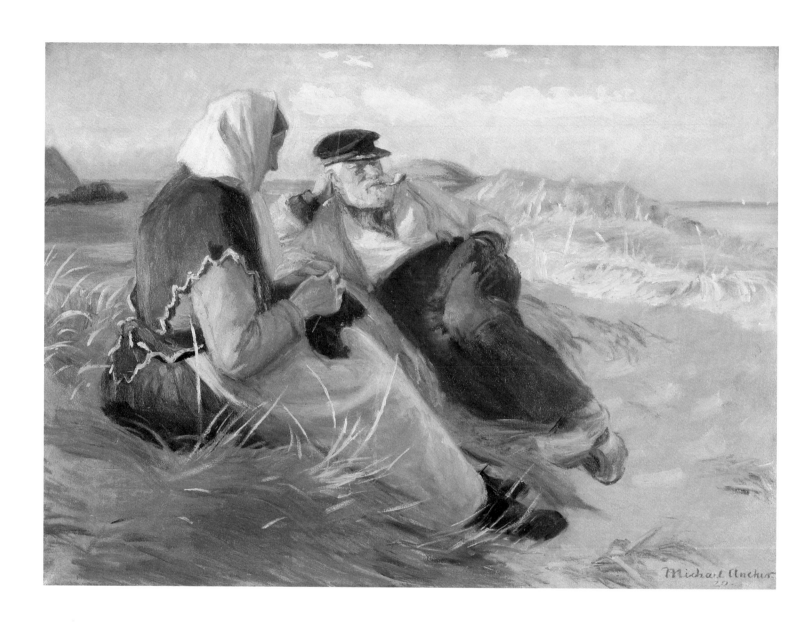

MICHAEL ANCHER
1849–1927

13. *Fisherman Anders Velle and His Wife, Ane, on Skagen Beach,*
1920

(Fiskeren Anders Velle og hans kone, Ane, ved Skagens Sønderstrand)

Oil on canvas, 31 x 43¾ in. (79 x 111 cm)

Signed and dated lower right: Michael Ancher 20

PROVENANCE: Arne Bruun Rasmussen, Auction 453, 1983, lot 7, ill. p. 37.

EXHIBITED: Kunstforeningen, *Michael Ancher*, 1949, no. 72 (described as *Fiskeren Anders Velle og hans kone*).

The unusual landscape and unique light on a summer evening at Skagen beach near Østerby can still be experienced today. This is where Michael Ancher found his first motifs in 1874 when he came to Skagen, subjects enough to last him the rest of his life. Right from the start, the local citizens of Skagen caught his interest. As a figure painter he was trained and encouraged to study the lives and activities of ordinary people. But in contrast to so many other painters, who regarded their models only as objects, Ancher immersed himself in their milieu and thereby won the hearts of the people of Skagen. Through his marriage to Anna Brøndum he had found a home, where he won respect not only for his diligence and his daily work at the beach (no matter what the weather) but also for his understanding and honest portrayals of the everyday lives of the people of Skagen.

E.F.

AUGUSTA OF HESSEN-KASSEL
(PRINCESS AUGUSTA)

COPENHAGEN 1823 – COPENHAGEN 1889

Princess Augusta was of a princely German family but grew up in Copenhagen. Her mother, the landgravine[1] Louise Charlotte of Hessen-Kassel, was the sister of the Danish king, Christian VIII. Her father, the landgrave Wilhelm of Hessen-Kassel, was the commanding officer of the Copenhagen garrison. The family lived in one of the palaces at Amalienborg (formerly Brockdorff's), where the royal family now resides. Their home was a meeting place for Danish court circles, especially after Frederik VII's controversial marriage to the commoner Countess Danner.

Augusta was the youngest of three children. In 1842, her elder sister Louise, who also painted, married the later King Christian IX, founder of the present House of Glücksborg. In 1854, Princess Augusta married Baron Carl Frederik Blixen-Finecke (1822–1873), who owned estates both in Denmark and Sweden: Næsbyholm in Scania, Nydala in Småland, and Dallund in Funen. (There is a story to the effect that the later French emperor Napoleon III had paid court to her some time earlier.) Blixen-Finecke was the Danish foreign minister under Frederik VII from 1859 to 1860 during which period he tabled some extremely controversial proposals on the Scandinavian succession, then a major problem.

Princess Augusta was a lively person who loved to entertain on a large scale. She and her husband installed a French garden on one of their estates, and at her more modest widow's residence, the Villa Augusta outside Elsinore, flowers played an important part of her life. (The Villa Augusta was in a converted sugar refinery just south of the town and has since been demolished.)

Our knowledge of Princess Augusta's training and activities as a painter is extremely limited. Both she and her sister received tutelage in art from J. L. Jensen. The two sisters might have inherited a talent for painting from their mother, an able watercolor artist.

Princess Augusta exhibited Hydrangea *in the Women Artists' Retrospective Exhibition at Charlottenborg in 1920.*

M.T.

LITERATURE: "Princesse Augusta," *Illustreret Tidende,* July 27, 1889; Bo Bramsen: *Huset Glücksborg i 150 år,* I-II, Copenhagen 1975, vol.I, p. 103 passim.

[1] A landgravine is the wife of (or a woman holding the rank or position of) a landgravin, a German count or noble ruler by hereditary right of a German castle or town and its adjacent lands.

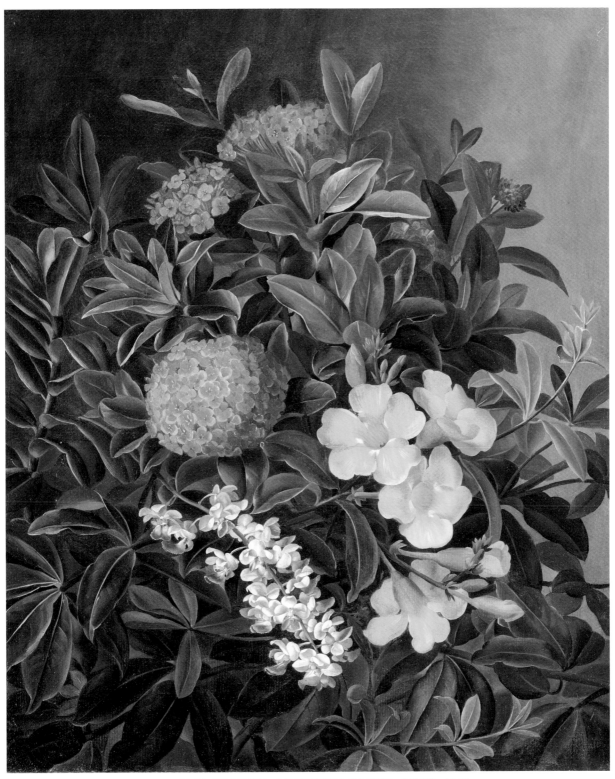

14. PRINCESS AUGUSTA OF HESSEN-KASSEL, *Still Life with Flowers*

PRINCESS AUGUSTA OF HESSEN-KASSEL
1823–1889

14. *Still Life with Flowers*

(Blomsterstilleben med rød ixora, gul allamanda og orkidégren)

Oil on canvas, 30 x 21⅔ in. (66 x 54 cm)

Inscribed on stretcher: Prinsesse Augusta

PROVENANCE: Bruun Rasmussen, Auction 581, 1992, lot 26, ill. p. 29.

This is one of the types of flower painting depicting the flowers at close quarters, such as is also found in some of J. L. Jensen's compositions. The combination of yellow and purple was typical of the age. Together with the red hydrangea, the effect is one of discordance and dissonance in the color and does not suggest a composition unquestionably seeking harmony.

M.T.

The following flower species are seen in the painting:

Looking from top to bottom: *Hydrangea hybrida,* "Hortensia," *Allemanda cathartica L.,* "Golden Trumpet," and possibly an orchid.

The princess has probably made a "guess what it is" painting with three different varieties growing on the same bush, which itself seems to be an evergreen *Prunus,* "Cherry Laurel."

T.T.

OTTO BACHE

ROSKILDE 1839 – COPENHAGEN 1927

Between 1850 and 1900, Otto Bache was a highly regarded and extremely productive historical painter. He worked on classical foundations, and a large proportion of his oeuvre was known in his day through reproductions, something that ensured him continuing popularity. Bache was conservative in the best sense of the word, restrained and charming, not merely "able and solid" as he has been described. His many commissions were for works conforming closely to the wishes of his clients, and his brush had to be guided by duty, even though in his youth he had been among those who took an interest in modern French painting.

Otto Bache was the son of a grocer and as a child showed such an unusual gift for drawing that by the age of ten he was already being sent to the Royal Danish Academy of Fine Arts, where he had Wilhelm Marstrand as his teacher and from which he graduated at the age of seventeen. In his early youth he worked as a genre and portrait painter. On a scholarship from the Academy, he studied in Paris (1866–1867) and was given responsibility for the Danish art section in the world fair. Karreheste, Paris (Cart Horses, Paris), *painted during this period, shows how receptive he was to new impressions, but he never managed to accept the revolutionary new art forms that soon followed. He spent 1867 to 1868 in Italy.*

In Denmark, a portrait commission from a Danish landowner became Bache's introduction to a social class committed to the national questions of the day and to buying and commissioning art. Fresh commissions opened up the possibility for his development as an animal painter. Et kobbel heste uden for Lindenborg Kro, 1878 (A Group of Horses Outside Lindenborg Inn), *which was bought by King Christian IX, won him great acclaim. In 1881, the landowner Count Mogens Frijs commissioned* Slutningen af parforcejagten på Frijsenborg, 1882 (The End of the Hunt at Frijsenborg), *an impressive work in a large format with numerous horses, horsemen, and hounds, completed in 1883.*

Bache's name is especially associated with Frederiksborg Castle at Hillerød, originally built in the 16th and 17th centuries. This royal castle burned down in 1859, with the tragic result that two-thirds of the royal collection of portrait paintings going back to the 16th century were lost. It became a matter of national importance to rebuild the castle, the reconstruction of which is due to the architect F. Meldahl (1827–1908). I. C. Jacobsen (1811–1887), the brewer who earned a vast fortune in the Carlsberg Breweries, saw it as his duty to make a contribution, and he donated enormous sums of money with the intention of fitting out the castle as a museum of national history, a task in which he was successful.

In the age of historicism, this was done by reconstructing historical interiors in which original art from an earlier age and new historical paintings should together recall the history of Denmark as it was seen in the age of national Romanticism. Bache's first commissioned work in 1882 was the dra-

matic De sammensvorne rider fra Finderup efter mordet på kong Erik Klipping (The Conspirators Ride Away from Finderup after the Murder of King Erik Klipping). *In 1887 followed the colossal* Christian IVs kroningstog gennem København (Christian IV's Coronation Procession through Copenhagen), *and into the 1890s he painted large portraits of the heroes of the Schleswig wars, often portraying them in the heat of battle.*

Otto Bache became a recognized success around 1880; he became a professor and later director of the Royal Danish Academy of Fine Arts, exhibiting at Charlottenborg and in the great official exhibitions of the time.

E.F.

LITERATURE: Peter Christensen, *Otto Bache*, Copenhagen 1928; Albert Fabritius (ed.), *Maleren Otto Bache, Erindringer*, Copenhagen 1964; Mette Bligaard, in *Weilbach*, vol. 1, Copenhagen 1994.

OTTO BACHE
1839–1927

15. *Flag Day in Copenhagen on a Summer Day, in Vimmelskaftet,*
after 1892

(Der flages, sommerdag i Vimmelskaftet)

Oil on canvas, 17⅔ x 22 in. (45 x 56 cm)

Signed lower left: Otto Bache

PROVENANCE: Arne Bruun Rasmussen, Auction 465, 1984, lot 53.

EXHIBITED: Bruce Museum of Art and Science, Greenwich, Connecticut, and The Frances Lehman Loeb Art Center, Vassar College, New York, *Danish Paintings of the Nineteenth Century from the Collection of Ambassador John L. Loeb Jr.*, 2005, no. 21, ill. p. 73 and cover back; Scandinavia House, New York, *Danish Paintings from the Golden Age to the Modern Breakthrough, Selections from the Collection of Ambassador John L. Loeb Jr.*, 2013, no. 7.

LITERATURE: Patricia G. Berman, "Lines of Solitude, Circles of Alliance, Danish Painting in the Nineteenth Century" in *Danish Paintings of the Nineteenth Century from the Collection of Ambassador John L. Loeb Jr.*, Bruce Museum 2005, p. 24; Patricia G. Berman, *In Another Light, Danish Painting in the Nineteenth Century*, New York, 2007, p. 239, ill. p. 236.

The luminescent, almost impressionistic style of this work might be due to his recollection of the World Exhibition in Paris in 1878, when Otto Bache was among the Danish participants. It is possible that on that occasion Bache saw Monet's *La rue Montorgueil, Fête au 30. juin 1878,* a lively, scintillating picture of festive crowds in a Parisian street decorated with flags.[1]

Bache is considered the first Danish painter to be attracted by the new French art, to which he had his eyes opened in Paris as early as 1866. According to the landscapist Godfred Christensen (1845–1928), Otto Bache was the first artist to create "a stir among the young" in Copenhagen by talking about the radical ways of painting in France. But he was not able to enrich his own art by means of this painting technique, which allowed the brush to work freely and gently without creating sharp outlines and which prioritized brilliant light and a vibrant fullness of color in preference to veracity and wealth of detail. He was too tied to the still-pertinent national program of N.L. Høyen and too inhibited by the general fear of "being splashed with alien varnish."[2]

The title of Bache's painting is misleading, as the motif is not one of Vimmelskaftet itself but of Amagertorv looking down past the tall trees in front of one of the oldest churches in Copenhagen, Helligåndskirken — the Church of the Holy Spirit — to Vimmelskaftet in the distance. Both Amagertorv and Vimmelskaftet are part of the medieval *"Strøget,"* a nickname for the long, narrow sequence of streets linking the two most important squares, Kongens Nytorv and Rådhuspladsen, in the center of Copenhagen.

Copenhagen City Museum *(Københavns Bymuseum)* claims that the flags were flying to mark the golden wedding anniversary of King Christian IX and Queen Louise, on May 26, 1892. A photograph presumably taken that morning is of an identical motif, except that it was taken at street level and the scene is devoid of people. The approximate dating is derived from this.[3] Christian IX, the first Danish king belonging to the house of Glücksborg, was born in 1818 and reigned from 1863 to 1906. He was blamed for the 1864 defeat in the war with Prussia and Austria, although he had in fact tried to prevent it. Despite a great deal of political turbulence at home, he became much loved by the people in the course of his long reign.

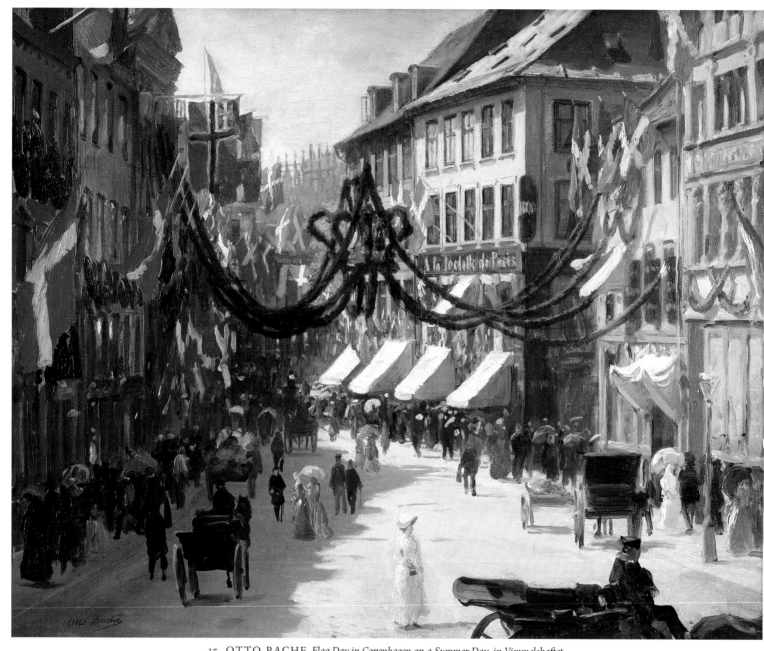

15. OTTO BACHE *Flag Day in Copenhagen on a Summer Day, in Vimmelskaftet*

Christian IX is perhaps best remembered today for his nickname, "Europe's father-in-law," which he was given because his many children married into various royal and princely houses. For instance, one of his sons, Prince Vilhelm, became king of the Hellenes under the name of George I. The second oldest daughter, Princess Dagmar, became Empress of Russia, and another daughter, Princess Alexandra, became Queen of England.

It is probable that Otto Bache himself saw Copenhagen decorated with flags and festoons on that beautiful day in May 1892 when the capital celebrated the aging king and queen. But it is not possible to determine for certain whether he painted his picture during the actual event or several years later, using the photograph as his model and adding to it a vivacious, sunlit street scene deriving from memory and his imagination.

S.L.

[1] Claude Monet (1840–1926), *La rue Montorgueil, Fête au 30. juin, 1878*, Musée d'Orsay.

[2] Finn T. Frederiksen in *Mødested i Paris – 1880'ernes avant garde*. Randers Kunstmuseum, 1983, p. 7. On N. L. Høyen, see note 6 on Christen Dalsgaard's *En pige, der skriver (Young Girl Writing)* in the Loeb collection.

[3] Copenhagen City Museum. Photograph with motif from Amagertorv taken May 26, 1892, 6½ x 9⅕ in. (16.4 x 23.3 cm). I am grateful to archivist Mette Bruun Beyer for this information.

JOEL JOHN BALLIN

VEJLE 1822 – COPENHAGEN 1885

A good deal of information is available about the painter and engraver Joel John Ballin. He was born in the Jutland town of Vejle in 1822, the son of a Jewish candle maker, and died in Copenhagen in 1885. At the age of eleven he went to Copenhagen, apprenticed as an artisan painter. At the same time he attended classes in the Royal Danish Academy of Fine Arts until 1844, the last two years in the life school with J. L. Lund and later C. W. Eckersberg as his teachers.

At the age of nineteen, Joel Ballin exhibited for the first time at Charlottenborg with his painting The Procession in the Synagogue at the Feast of Tabernacles (Processionen i Synagogen ved Løvsalsfesten), *which today belongs to the Jewish community of Denmark. Very few other paintings are known by this artist, who nevertheless left a large graphic oeuvre of high quality.*

It cannot have been long after the summer course with Eckersberg that Ballin decided to give up figure painting and instead seek a career as a chemotypist. In 1846 he went to Leipzig for further training as a graphic artist and to take part in developing the chemotype method along with its inventor, Danish photographer C. Piil.

Two years later, Joel Ballin went to Paris, where he was to spend the next twenty-two years. By means of various scholarships and grants from home, he was able to train himself further in the French capital as an engraver and copperplate artist while attending classes in painting in the École des Beaux-Arts from 1849 to 1851.

He gradually gained a considerable reputation, first as a copperplate artist working mainly on French paintings and portrait photographs and then with other graphic techniques. From 1858 he began to work with a "manière noire," which led him on to a "manière mixte," a mixture of etching, burin, and knurling which best re-created the textural effect of a painting. This was a method he also used for various reproductions of the works of Danish artists that were published by Kunstforeningen in Copenhagen.

In September 1870, Joel Ballin moved to London with his family on account of the troubles resulting from the Franco-Prussian War. Thirteen years later he returned to Copenhagen, where he remained until his death two years later.

From 1841 until 1882, though interspersed with a few breaks of a several years, he showed works in the Charlottenborg exhibitions. Ballin was awarded a gold medal in the Paris Salon in 1861; the following year he was appointed a Knight of the Order of Dannebrog. In March 1877 he was made a member of the Royal Danish Academy of Fine Arts in Copenhagen. He participated in the Paris World Fair in 1878.

S.L.

LITERATURE: Lise Svanholm in *Weilbach*, vol. 1, Copenhagen 1994.

JOEL BALLIN
1822–1885

16. *Study of a Model, Young Girl Undressing, 1844*
(Modelstudie, en ung pige klæder sig af)

Oil on canvas, 46 x 36¼ in. (117 x 92 cm)

PROVENANCE: Bruun Rasmussen, Auction 682, 2000, lot 1424, ill. p. 29 (described in the auction catalogue as painted by Julius Exner, 1825–1910 [*malet af Julius Exner*]). The following research proved the painting to be that of an Eckersberg student, now believed to be Joel Ballin.

EXHIBITED: Bruce Museum of Art and Science, Greenwich, Connecticut, and The Frances Lehman Loeb Art Center, Vassar College, New York, *Danish Paintings of the Nineteenth Century from the Collection of Ambassador John L. Loeb Jr.*, 2005, no. 8, ill.; Scandinavia House, New York, *Danish Paintings from the Golden Age to the Modern Breakthrough, Selections from the Collection of Ambassador John L. Loeb Jr.*, 2013, no. 8.

LITERATURE: Marianne Saabye (ed.), *Den nøgne Guldalder, Modelbilleder af C. W. Eckersberg og hans elever*, Den Hirschsprungske Samling, 1994 (English translation and summary), pp. 134–137;[1] Patricia G. Berman, "Lines of Solitude, Circles of Alliance, Danish Painting in the Nineteenth Century" in *Danish Paintings of the Nineteenth Century from the Collection of Ambassador John L. Loeb Jr.*, Bruce Museum, 2005, p. 16; Patricia G. Berman, *In Another Light, Danish Painting in the Nineteenth Century*, New York, 2007, p. 56, ill. p. 55.

The excellence of this Loeb painting, which is similar to those painted of the same model by three other students in the same summer class in 1844, taught by Royal Danish Academy professor C. W. Eckersberg, prompted the Bruun Rasmussen Gallery to assume that it was from the brush of the renowned Julius Exner. Following the Bruun Rasmussen auction, the owner of the Exner version wrote to gallery officials, enclosing a photograph of it and explaining that the painting they had sold was not the one by Exner, because it was in his possession.

But who would be the artist of the painting in the Loeb collection if not Julius Exner? C. W. Eckersberg was a professor at the Royal Danish Academy of Fine Arts from 1818 until his death 1853. Among the many innovations he introduced into the teaching was the study of a naked female model, something that previously had not been permitted. It was Eckersberg, too, who was in charge of the special summer course in painting from the life. This was introduced because in an adjudication for a competition among the students for the annual money prize, it had been noted that they were not good enough at painting from life. The summer courses, mainly after naked female model painting started at the academy in July 1839 and under Eckersberg's instruction, continued every year for the next eleven years. The professor's diaries contain brief but informative comments on the duration of the course, the names of the students, the type of models, etc.

So we know that in June 1844 Eckersberg chose a new female model who, with a few interruptions occasioned by illness, posed for the teacher and four students until September—135 hours in all. The students were Joel Ballin, Julius Exner, Geskel Salomon (1821–1902), and, exceptionally, a private female pupil by the name of Caroline Behrens. (Women were normally not allowed to attend academy classes at that time.)

The very extensive catalogue for the 1994 exhibition *The Naked Golden Age (Den nøgne guldalder)* in Den Hirschsprungske Samling contains the entire entry from Eckersberg's diary concerning this summer class and also contains a color reproduction of Eckersberg's own study of the new model (Fig. A). Furthermore, the catalogue contains black and white photographs of one of the pupil's paintings (Fig. C) and a drawn

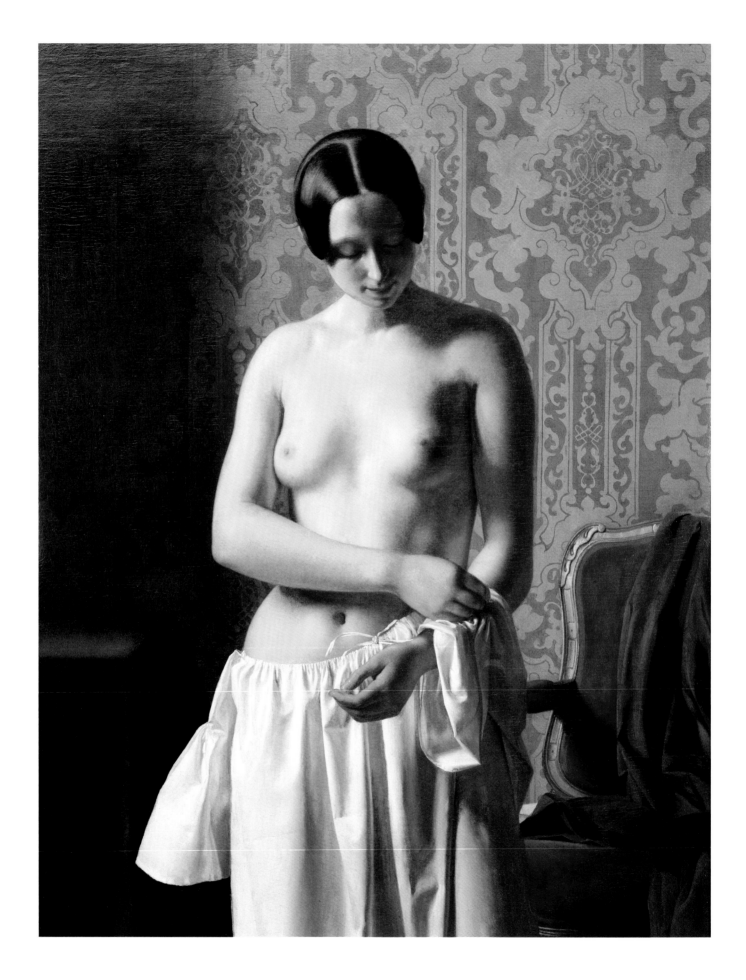

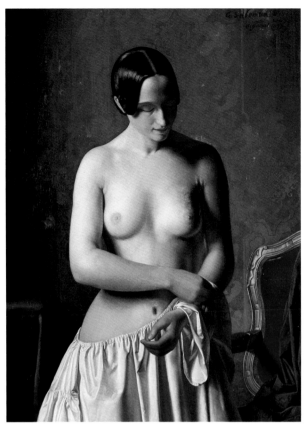

FIG. A C. W. Eckersberg
Study of a Model, Young Girl Undressing, 1844
Oil on canvas, 13½ x 11⁹⁄₁₀ in. (34.2 x 30.2 cm), private owner

FIG. B Geskel Saloman
Study of a Model, Young Girl Undressing, 1844
Oil on canvas, 50¾ x 40⅓ in. (129 x 102.5 cm), private owner

preparatory study for it. From these reproductions it can be seen that the life study in the Loeb collection was executed that same summer of 1844, with the same model in the same pose referred to above.

But who painted it? Two of the four pupils can be excluded. After the exhibition in Den Hirschsprungske Samling, several other hitherto generally unknown life studies were discovered. These included two finished versions of *Young Girl Undressing*: one the above-mentioned model by Julius Exner[2] and the other by Geskel Saloman (Fig. B),[3] both painted in 1844.

This means that three of the five works from the summer course in 1844 can now be identified as having been painted by Professor Eckersberg (Fig. A) and his students Julius Exner and Geskel Saloman (Fig. B).

Unless other pupils participated in Eckersberg's summer course in 1844, or unless some of them produced more than one submission relating to the assignment—something that cannot be entirely excluded—we can conclude that the last two life studies were painted by Caroline Behrens and Joel Ballin respectively.

A close examination of the five versions of *Young Girl Undressing* shows various differences. Apart from the fact that the model is seen from different angles depending on where the artist was standing while painting, we observe that there is also variation in the furniture and the wallpaper in the background.

The wallpaper and the red upholstered chair beside the model appear to be identical in the Exner, the Saloman, and the work in the Loeb collection. In contrast to his pupils, Eckersberg has painted a slightly

FIG. C (named as Fig. 10 in the catalogue *The Naked Golden Age*)
Possibly by Caroline Behrens
Study of a Model, Young Girl Undressing, 1844
Oil on canvas, 18 x 13⅓ in. (46 x 34 cm), present owner unknown

more precise version of the wallpaper and a chair without gilt paint. In addition, he has amused himself by providing his work with a bare table on which there is a cheval glass.[4] This latter clearly reflects a section of the wallpaper. The teacher's painting is much smaller than those of his pupils, as was almost always the case in teaching situations.

As for the other model-painting reproduced in the Hirschsprung catalogue, and the drawn preparatory study for it, there seem to be indications that this could have been Miss Behrens's work (Fig. C). We see the same chair as in the other studies, but here it appears behind the model on the left of the picture, which might indicate that she has been viewed from a position some distance from the male academy pupils. With certain reservations this could be interpreted as courtesy to a less practiced and perhaps somewhat self-conscious private female pupil.

In Figure C, there is neither a table with a mirror as in Eckersberg nor a table covered with a green cloth as in the other model studies. Figure C is somewhat larger than Eckersberg's picture and a good deal smaller than the works by the other pupils. The drawn study reproduced in the Hirschsprung catalogue and the accompanying painting (Fig. C),[5] of which the latter's whereabouts are unfortunately unknown, appear to be the work of a less accomplished and more timid hand than the Loeb collection study and is therefore more likely attributable to Caroline Behrens.

Unfortunately, scarcely anything is known about this private woman pupil. She is not mentioned in any work of reference, and Eckersberg refers to her presence on only three other occasions: on June 14 and 15, 1844, he notes that she is given instruction in perspective drawing; between December 5 and 9 she draws a

portrait of Emilie, the professor's daughter. After this we encounter her name only once more, four years later, when between July 4 and September 22, 1848, she is said to be drawing after "the antique plaster head."[6]

On the basis of the information available today, it can be deduced that the Loeb collection's *Study of a Model, Young Girl Undressing* (*Modelstudie, En ung pige klæder sig af*) was painted by Joel Ballin. Ballin eventually carved out a splendid career abroad as a copperplate engraver with special skills. If he had continued as a painter, his reputation would scarcely have spread beyond the borders of Denmark, although he was talented, as this piece in the Loeb collection undeniably indicates.

On October 7, 1844, Professor Eckersberg showed the works by his three male pupils to the Academy Assembly, which inspected them "with particular interest."

S.L.

[1] Suzanne Ludvigsen would like to thank Marianne Saabye, director of Den Hirschsprungske Samling, for her important help in identifying the version of *Study of a Model, Young Girl Undressing*.

[2] Current owner unknown, no photo available.

[3] Geskel Saloman (1821–1902) was of Jewish-Swedish extraction. After training in Copenhagen, he moved to Gothenburg in Sweden, where he became a very popular portraitist and established his own school of painting.

[4] A full-length mirror with a frame by which it may be moved or tilted.

[5] Cat. 64 in the catalogue *The Naked Golden Age*, p. 137: Pupil of Eckersberg. *En ung pige klæder sig af.* 1844, Lead pencil, gray hatching. 8⅘ x 66⅛ in. (225 x 168 mm). Inscribed by unknown hand: *Eckersberg del 1844,* private collection. Preparatory study for Fig.C.

[6] Extracts from C. W. Eckersberg's diaries, index of Eckersberg's private pupils by Hanne Jönsson in *C. W. Eckersberg og hans elever,* Statens Museum for Kunst, Copenhagen 1983, p. 56.

CARL HEINRICH BLOCH

COPENHAGEN 1834 – COPENHAGEN 1890

Carl Bloch was considered the most promising young artist of his day, fulfilling artistic ideals to a rare extent and indeed even surpassing them. He entered the Royal Danish Academy of Fine Arts in 1849 shortly after the deaths of J. Thomas Lundbye and Christen Købke and only shortly before Danish artistic life was also to lose C. W. Eckersberg, who stood as the epitome of the Danish Golden Age. With the recognition of the advent of a new generation it was natural that great expectations should be placed on the young artists showing ability as figure painters. As a pupil of Wilhelm Marstrand Bloch learned a more relaxed and more grandiose compositional technique than was the norm in painters of the Golden Age. This included the use of two-point perspective, which Marstrand had from classical Venetian painting and used frequently in his later work. Bloch, among others, was later to show himself to be one of the master's distinguished heirs in the use of two-point perspective.

After attending the academy, Bloch spent the customary years in Italy where, using Marstrand as his model, he painted a number of narrative genre pictures. These included some depicting monks in comical situations, but there was also important work, such as Fra et romersk osteria, 1866 (From a Roman Hostelry), *in Statens Museum for Kunst. It portrays two beautiful Italian women partaking of a meal with a man who is demonstrating his jealousy in a way that confirms a northern European's notions of the Italian temperament. Bloch also early revealed himself to be an excellent portraitist.*

However, his real ambition was to gain a reputation as a figure painter in the grand historical style. He was completely successful in this. Within the space of only two years he painted three important works of vast dimensions that awoke the unreserved admiration of his day: Samson i Filistrenes trædemølle, 1863 (Samson in the Philistines' Treadmill), Jairi datter, 1863 (Jairus's Daughter), *both in Statens Museum for Kunst, and finally the now-lost* Prometheus' befrielse, 1864 (The Freeing of Prometheus), *commissioned by the Danish-born King George I of the Hellenes. All bore the stamp of an overwhelming and hitherto unseen power of expression. Yet another well-known important work is* Kong Christian II i fængslet på Sønderborg Slot, 1871 (King Christian II Imprisoned in Sønderborg Castle), *in Statens Museum for Kunst. In addition to learning from the Italian High Renaissance and Baroque figure art, Bloch also derived inspiration from Netherlandish painting, of which he had first-hand experience, especially works by Rembrandt van Rijn (1606–1669), who became the object of renewed interest during this period. A little later, he decorated the prie-dieu in Frederiksborg Castle chapel and contributed several major works as decorations to the great hall in Copenhagen University in Frue Plads.*

From 1850 to 1880 Bloch was the leading figure among the younger Danish history painters. In his youth he belonged to the group of "national" painters, but he later became one of the internationally oriented artists known as "Europeans." His success was a beacon in this period of spiritual and polit-

ical decline resulting from Denmark's being obliged to relinquish southern Jutland and the Duchies to Germany in 1864.

However, all the conditions for his enormous success broke down quite unexpectedly, and Bloch was not to harvest its fruits. The young artists of the 1870s rebelled against the authorities and turned to France to seek new inspiration. The artistic ideals of the time were quickly transformed, and about 1880 the Modern Breakthrough in painting was a fact. Almost at once Bloch fell completely out of fashion, and it was of no avail that the staunchly conservative academy appointed him a professor in 1883. The pupils left the academy for Kunstnernes Frie Studieskoler. *Carl Bloch was not forgotten but rather became the object of hate as an outstanding representative of historicism in painting. A contributory factor was undoubtedly his use of intense artistic effects both in motif and in color. Nevertheless, Bloch had a large graphic oeuvre that still enjoyed respect.*

E.F.

LITERATURE: Julius Lange, *Nutidskunst*, Copenhagen 1873, pp. 203, 260–274; Emil Hannover in Karl Madsen (ed.), *Kunstens Historie i Danmark*, Copenhagen 1901–07, pp. 340–347; Rikard Magnussen, *Carl Bloch*, Copenhagen 1931; Jørgen Sthyr, *Dansk grafik 1800–1910*, Copenhagen 1949; Marianne Marcussen in *Weilbach*, vol. 1, Copenhagen 1994.

CARL BLOCH
1834–1890

17. *The Artist's Parents, Mr. and Mrs. J. P. Bloch, in Their Sitting Room, 1855*

(Kunstnerens forældre i dagligstuen)

Oil on canvas, 21½ x 18¾ in. (55 x 48 cm)

Signed lower left: Carl Bloch 1855

Inscribed on back: *J.P. Bloch 1795–1874, Henriette Bloch 1805–1891*

PROVENANCE: Dr.med. O. Bloch; Kunsthallens Auction A/S, 8–9/10, 1936, lot 9, ill. p. 4; Manufacturer L. Thobo-Carlsen, Odense (1944–45) (described as *Kunstnerens forældre*); Arne Bruun Rasmussen, Auction 107, 1959, lot 62, ill. p. 11; Bruun Rasmussen, Auction 623, 1996, lot 145, ill. p. 67; Bruun Rasmussen, Vejle, Auction 55, 1997, lot 1415, ill. (described as *Kunstnerens Forældre, Grosserer I. P. Bloch og Hustru i Dagligstuen*).

EXHIBITED: Kunstforeningen, Copenhagen, *Arbejder af maleren Carl Bloch*, 1921, no. 9; Fyens Stiftsmuseum (after 1978 Fyns Kunstmuseum), Odense, year unknown; Charlottenborg 1954, *Kunstakademiets jubilæum, dansk kunst gennem 200 år*, (no number); Bruce Museum of Art and Science, Greenwich, Connecticut, and The Frances Lehman Loeb Art Center, Vassar College, New York, *Danish Paintings of the Nineteenth Century from the Collection of Ambassador John L. Loeb Jr.*, 2005, no. 9, ill.

LITERATURE: Rikard Magnussen, *Carl Bloch*, Copenhagen, 1931, no. 29, ill. p. 15; Herman Madsen, *Kunst i Privat Eje, I-III*, Copenhagen 1944–45, vol. III, p. 277, ill.; Herman Madsen, *200 Danske Malere og deres Værker*, Copenhagen, 1946, vol. I, p. 247, ill.; Patricia G. Berman, *In Another Light, Danish Painting in the Nineteenth Century*, New York, 2007, p. 126, ill. p. 127.

Carl Bloch was only twenty-one when he painted his parents in the splendid sitting room in their home, where the mother is sitting in the window niche with her knitting while the father, the elegant silk and clothing merchant—with a long pipe in his left hand and his right hand hidden beneath his waistcoat—is leaning nonchalantly against the mahogany arm of the Biedermeyer sofa.

In interpreting the pictorial relationship between the parents, writer Herman Madsen suggests that the wife has just interrupted her knitting to give her husband a quizzical look. Perhaps he has just dropped some sarcastic comment that has caused her to contradict him. The merchant and his wife were not happy that their son wanted to be an artist, but surely this work, painted several years before Carl Bloch's first prolonged journey abroad, convinced them of his unquestionable talent. Even at this early stage of his career, the artist makes effortless use of a number of diagonal perspective constructions that were subsequently characteristic of his work. They create depth in the picture, as also do various other subtle details, such as the impression of expanded space deriving from the mirror image and the meandering patterns in the carpet.

We note Thorvaldsen's Christ[1] on the console of the mirror; we can dream of a sail on the lake in the mountain landscape on the wall. With this inventiveness and delight in narrating, combined with the many light and shadow effects, Carl Bloch amplifies the dialogue between his parents and adds to the picture something of the genre character required by the age. The tradition of the Eckersberg school and of the young artist's teacher, Wilhelm Marstrand, can clearly be seen here.

S.L.

[1]The sculptor Bertel Thorvaldsen (1770–1844) decorated Vor Frue Kirke, the Cathedral Church of Our Lady in Copenhagen, with works including marble statues of Christ and the twelve Apostles. The 1821 figure of Christ was erected in the cathedral in 1839.

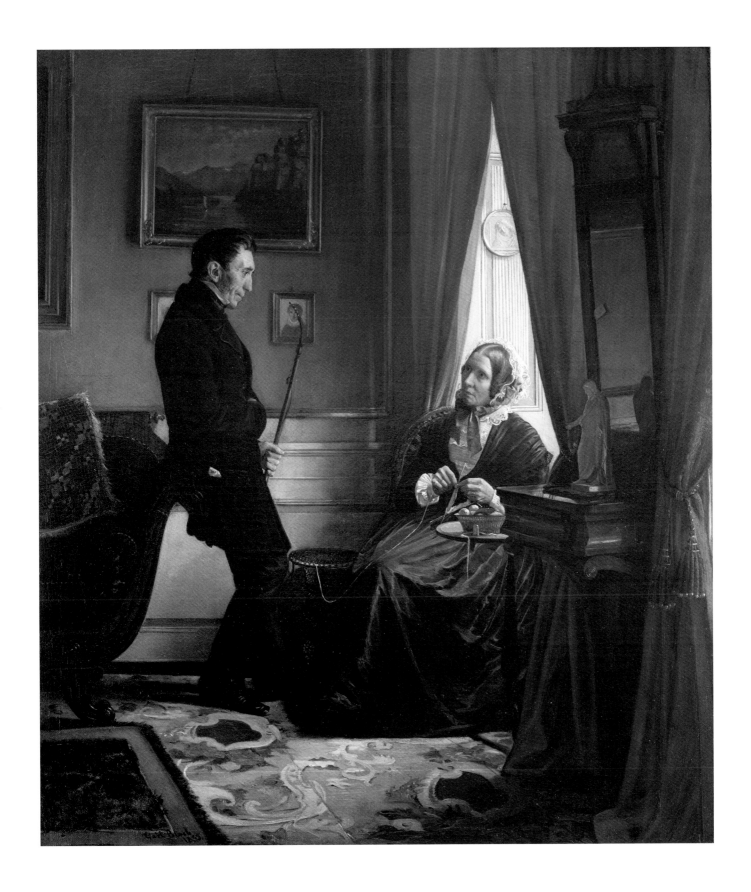

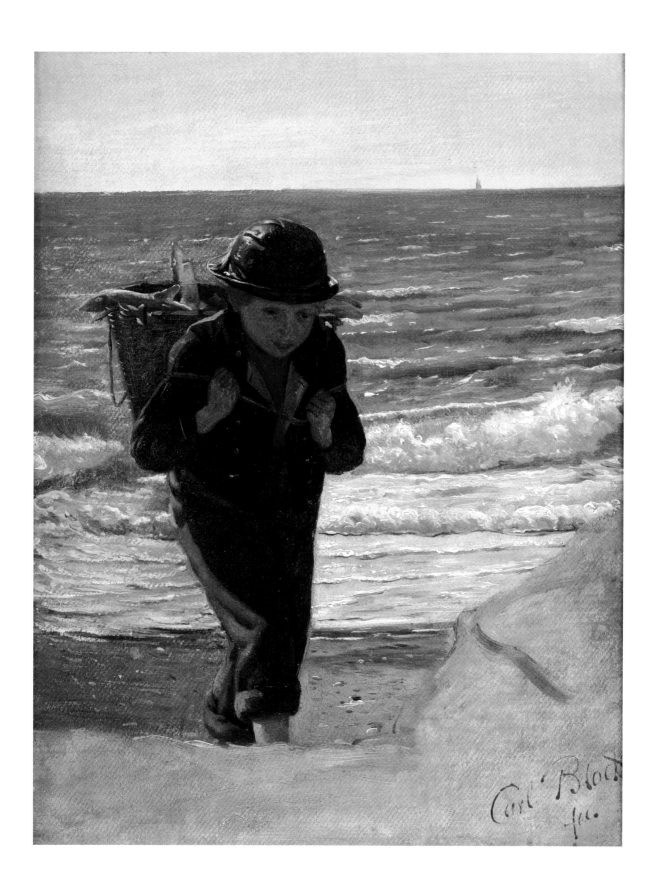

CARL BLOCH
1834–1890

18. *A Fisherboy*, ca. 1856
(En fiskerdreng)

Study for Magnussen no. 40 and 43

Oil on canvas, 12½ x 9⅔ in. (32 x 25 cm)

Signed lower right: Carl Bloch fec.[1]

PROVENANCE: Kunsthandler Chr. Larsen (1921); Arne Bruun Rasmussen, Auction 453, 1983, lot 25 (described as *Fiskerdreng med en kurv fisk på ryggen*).

EXHIBITED: Kunstforeningen, Copenhagen, *Arbejder af maleren Carl Bloch*, 1921, no. 19.

LITERATURE: Rikard Magnussen, *Carl Bloch,* Copenhagen 1931, no. 44.

A Fisher Boy is one of a number of preparatory works for a larger, carefully composed portrayal of *Fishermen from the West Coast of Jutland* with a motif from Vestervig, (Magnussen no. 40, Fig. A), first exhibited at Charlottenborg in 1857 and later repeated in a slightly smaller format (Magnussen no. 42).

The boy carrying the fish on his back is also found in another preparatory work for this painting. This has the same title but is also known as *Hjemkomsten fra Havet (Return from the Sea)* or *Fiskeren og hans dreng vender hjem (The Fisherman and His Boy Return Home)* (Magnussen no. 43, Fig. B).

The Loeb collection sketch is the only one to take as its main motif the intrepid little boy laboriously lugging the basket of shining fish.

S.L.

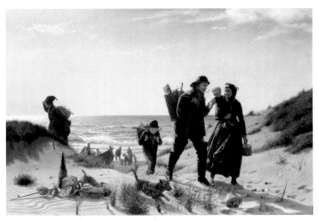

FIG. A Carl Bloch
Fishermen from the West Coast of Jutland, 1857
Oil on canvas, 45¼ in. x 66⅛ in. (115 x 168 cm), present owner unknown (Magnussen no. 40).

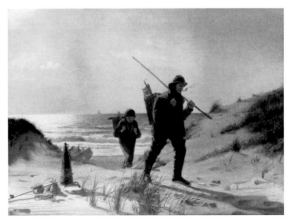

FIG. B Carl Bloch
The Fisherman and His Boy Return Home, 1859
Oil on canvas, 16⅛ x 23¼ in. (41 x 59 cm), present owner unknown (Magnussen no. 43).

[1]Abbreviation for fecit from the Latin meaning "made by" or "executed by."

PETER HERLUF BONNÉN

BORN FREDERIKSBERG 1945

Peter Bonnén is the son of an architect. His mother was the modiste Tone Bonnén, who received a permanent testimony of praise in the form of a poem by the Danish writer Suzanne Brøgger (1981). His partner is a Tivoli stallholder, the daughter of a confidential clerk and a female entertainer. There is thus fertile soil for vision and fantasy in Bonnén's everyday life, and his artistic work leaves no room to doubt this.

From 1961 to 1962 he was trained in the then recently established Experimental School of Art known informally as Eks-skolen. It was founded in Copenhagen by the art historian Troels Andersen (b. 1940) and the artists Poul Gernes (1925–1996), Roger Martin Pring (b. 1929), Jens Jørgen Thorsen (1932–2000), and Richard Winther (b. 1926). In reaction to the French art that had been a major influence on Danish artistic life for generations, these artists turned toward Germany and the United States and their most recent abstract expressionism and pop art. Teachers and pupils resolved all questions of form and content employing an open-minded approach with which they aimed in common to make art conscious of itself and to launch it into the community. The actual work process was considered more important than the result, and the collective was placed above the individual. In association with the school there were experimental exhibitions such as happenings, various non-traditional undertakings, and considerable publication activity. In addition to Bonnén, a large number of various artists have been associated with Eks-skolen, such as Per Kirkeby (b. 1938), Bjørn Nørgaard (b. 1947), Stig Brøgger (b. 1941), and others. The school has never actually closed, but most of its activities faded out at the beginning of the 1970s.

Peter Bonnén made his first appearance in 1962 with assemblages made up of motorcar scrap and slates. The following year he exhibited for the first time in "The Summer Exhibition" (Sommerud-stillingen).

The Danish Arts Foundation (Statens Kunstfond) was established in 1964. The foundation is an institution whose aim is to promote Danish creativity in the fields of pictorial art, decorative art and design, literature, and music. It achieves this partly by awarding grants to artists, purchasing works of art, and financing the decoration of public buildings. The year following its establishment, the Kunstfonden purchased Peter Bonnén's nonfigurative Skulptur i 6 dele (Sculpture in 6 Parts). *This led to an antimodernist movement, Rindalism, started by the abattoir worker Peter Rindal, who did not believe that the state should provide funds for the purchase of incomprehensible and apparently useless works of art.*

Sculpture in 6 Parts *became the start of the sculptor's characteristic form figures executed in iron or COR-TEN, steel, in which two or more blocks or columns erected in pairs form a sculptural environment. In addition, the individual blocks are often further split and placed with their fractured surfaces facing each other at a precisely calculated distance that is not so great as to prevent it being*

clear that the two parts of the sculpture belong together; the distance between them is so small that a tension is created between the parts. They look as though they are about to be joined together by magnetism but are relentlessly held apart by imaginary energies. The spaces between the parts of the sculpture thus become the significant fields of tension in the sculptural group, intensifying the observer's experience of extreme mobility.

From 1964 and throughout the 1970s, Bonnén was occupied with concept and pop art, often with a humorous undertone. He also executed a number of minimalist sculptures in fluorescent acrylic. In 1975, he planted a field of corn on Nikolaj Plads, a square in the center of Copenhagen, as a kind of rural art manifestation.

In 1988, Bonnén made his first appearance as a painter. The simplification down to the absolute minimal that is characteristic of all his work is also encountered in his paintings, which consist of module-like divided surfaces fitted together to form large overall systems.

However, it is as a sculptor that Bonnén will be remembered, not least for his monumental 1985 decoration of the park surrounding Western Zealand County Council Offices (Vestsjællands Amtsgård) at Sorø, consisting of two tall groups of sculptures executed in reddish brown COR-TEN steel. The groups are dispersed in uniform column-like formations and anchored in a precisely calculated rhythmical arrangement that is static and dynamic in equal parts.

One of Bonnén's latest and perhaps most fascinating works is a mighty, multivalent granite sculpture consisting of three black blocks hacked out of one gigantic mass of granite and worked in a varying play of polished hard surfaces (on the fronts and backs) and soft-looking rough-hewn sections (the outer and inner surfaces).

The sculpture towers like a colossal portal in three tempi and sizes. The largest measures 12½ feet high x 13¾ feet wide (3.8 metres x 4.2 metres). The gigantic pieces of stone are placed in a carefully contrived relationship both separating and uniting them, maintaining a witty and ceaseless dialogue between the stones themselves and the spot on which they stand.

Between 1964 and 1967 Peter Bonnén was an energetic and enterprising chairman of the Summer Exhibition (Sommerudstillingen). He has been a member of the Council of the Royal Danish Academy of Fine Arts for a number of years, and from 1980 to 1983 was president of the Academy. Since 1973 he has headed the Society for Art in the Workplace (Foreningen Kunst på arbejdspladsen).

Bonnén has been awarded various grants and distinctions, including a Danish Arts Foundation Three-Year Bursary (1974–1977) and the Eckersberg Medal in 1989.

S.L.

LITERATURE: Jens Jørgen Thorsen in *Kunst*, no. 1, 1970; interview with Peter Bonnén; Grethe Grathwohl, *Peter Bonnén*, Galerie Asbæk, Copenhagen 1978; Leila Krogh in *Kunst i rummet*, Copenhagen, 1989; Pia Kristine Münster in *Weilbach*, vol. 1, Copenhagen 1994.

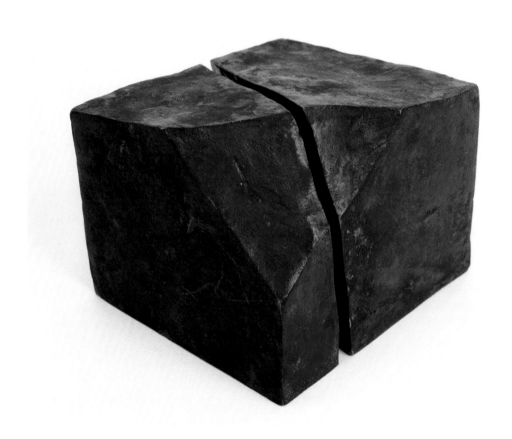

PETER BONNÉN
B. 1945

19. *Sculpture in Two Parts*, 1983
(Skulptur i to dele)

Bronze, 3¼ x 4 x 3¾ in. (8 x 10.5 x 9.5 cm)

Signed with Magic Marker: "Peter Bonnén 83" on the larger piece and "P B 83" on the smaller piece.

PROVENANCE: Galerie Asbæk, Copenhagen.

EXHIBITED: Galerie Asbæk, *Peter Bonnén*, Copenhagen 1984.

In her discerning and knowledgeable work on Peter Bonnén, Grethe Grathwohl defines an artist as the person who has retained his sensitivity to the appearances of the surrounding world, the person who sees and brings out their various qualities and characters, such as the meeting between what is hard and what is soft, the run of the line in a tile that has been broken, the distance between blocks—and for whom it is a matter of urgent necessity to convey these experiences to other people.

"Peter Bonnén passes on his impressions and his preoccupation with the surrounding world through his art," Grathwohl writes. "His preoccupation with meetings between shapes, fractures in shapes, the space between shapes, reaches us through an intense and sensitive work with the line flows, positioning and dimensioning."[1]

Both the artist's most recent work in black granite, outside the Department of Geophysics in Copenhagen, and the Loeb collection's quite small two-part bronze figure illustrate the meeting between separate units in such a way that the viewer is enriched by an experience beyond the representative. In nonfigurative art as in music, we are not distracted by the narrative content of the work but can freely surrender ourselves to wonderment and gradual understanding.

We wonder at the imaginary forces that appear to wish to unite the two parts of the sculpture and at the same time to keep them apart. We come to realize that it is the distance between the two blocks that causes this tension, and together with the surrounding space, the tension is a significant and equal participant in the sculptural manifestation.

A continuous triangular fracture on the corner is felt to be a vulnerable opening. The power of the work is increased by its minimalist size. The sharp edges of the parts of the sculpture are treated in such a way that the shapes appear to be in gentle motion, like breaths, and this enhances their character of independent and yet cohesive beings living their own quiet life.

S.L.

[1] Grethe Grathwohl, *Peter Bonnén,* Galerie Asbæk, Copenhagen 1978.

HANS ANDERSEN BRENDEKILDE

BRÆNDEKILDE 1857 – JYLLINGE 1942

H. A. Brendekilde's father was a smallholder[1] and clog maker, and he himself was apprenticed as a stonemason. He then attended the Royal Danish Academy of Fine Arts in Copenhagen, graduating as a modeler in 1881, though he turned to painting immediately afterward. He exhibited for the first time at Charlottenborg as early as 1883 with Fra landsbyen (From the Village) *and quickly gained recognition; in 1886 he was awarded his first academy scholarship.*

Brendekilde made the leap from countryside to city at the very moment when the painters of the Modern Breakthrough were discovering contemporary French painting: the Barbizon School and the peasant painters J. F. Millet (1814–1875) and Jules Bastien-Lepage (1848–1884). Millet came from a farming family, which makes his figures far more vividly alive than those produced by the traditional genre painters of the time, for whom the farming community was only a subject for painting. During the upheaval of the 1880s, Brendekilde, like other young artists such as N. P. Mols (1859–1921) and L. A. Ring, with their roots as common folk, modeled himself after these French artists, becoming an exponent of a modern, realistic art created on the basis of his own personal background. In this he also resembles both Anna and Michael Ancher.

Like Ring, Brendekilde often brought out social aspects and thus caused a stir with Udslidt, 1889 *(Worn Out), in Fyns Kunstmuseum, which is so extreme in expression that it has been called highflown. When the 1880s drew to a close, Brendekilde emulated developments in the 1890s by producing a number of religious paintings in which the narratives, in the spirit of realism, are set in the primitive surroundings of the common people. Brendekilde's motifs were always taken from life in the country districts. In a technical sense he was uncommonly gifted, as seen in his depictions of landscapes, houses, and flowers. At a time when his fellow artists considered genre motifs to be old-fashioned, Brendekilde experienced great popular interest in his idyllic narrative pictures, which he continued to paint for the rest of his long life.*

Brendekilde exhibited throughout his life at Charlottenborg and took part in official Danish exhibitions abroad, including the World Fairs in Paris in 1889 and Chicago 1893 and the Guildhall in London in 1907. Later, the Society for National Art (Foreningen for National Kunst) in particular has shown his works.

E.F.

LITERATURE: Herman Madsen, *Fynsk malerkunst*, Odense 1964; Peter Michael Hornung, *Realismen, Ny dansk kunsthistorie*, vol. 4, Copenhagen 1994; Erik Brodersen in *Weilbach*, vol. 1, Copenhagen 1994; Mette Thelle, *H.A. Brendekilde 1857–1942*, Fyns Kunstmuseum, Odense 1995; Gertrud Hvidberg-Hansen, *Brendekildes billedverden*, Odense 2001.

[1]A smallholder was an owner of a small piece of land detached from a cottage, hired or owned by a laboring man, and cultivated to supplement his main income.

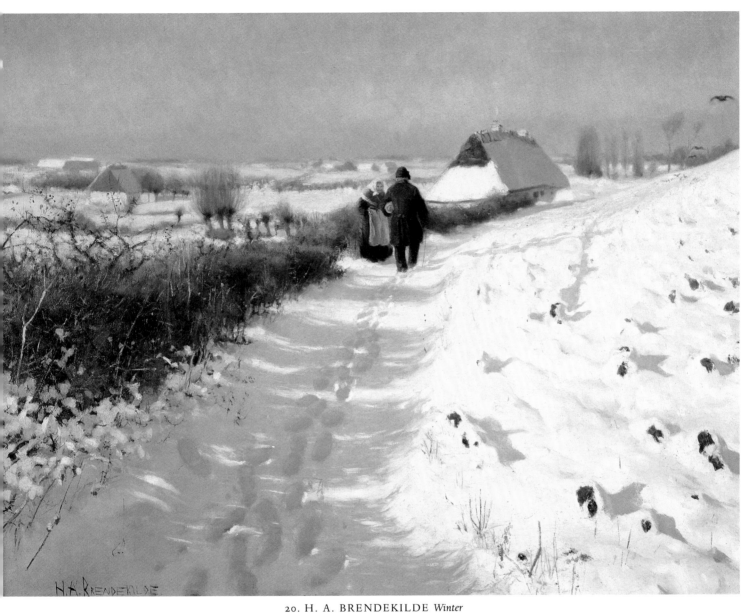

20. H. A. BRENDEKILDE *Winter*

H. A. BRENDEKILDE
1857–1942

20. *Winter*

(Ved Vintertid)

Oil on canvas, 28⅔ x 37 in. (73 x 94 cm)

Signed lower left: H.A. Brendekilde

PROVENANCE: Mr. Oscar Wandel, Frederiksholms Kanal 24, Copenhagen; Kunsthallen, Auction 228, 1958, lot 17, ill. p. 9; Arne Bruun Rasmussen, Auction 448, 1983, lot 238, ill. p. 205; Arne Bruun Rasmussen, Auction 452, 1983, lot 33, ill. p. 23.

EXHIBITED: Munich, *Internationale Kunstausstellung*, 1891, no. 2735; Guildhall, London, *A Selection of Works by Danish Painters*, 1907, no. 64; Bruce Museum of Art and Science, Greenwich, Connecticut, and The Frances Lehman Loeb Art Center, Vassar College, New York, *Danish Paintings of the Nineteenth Century from the Collection of Ambassador John L. Loeb Jr.*, 2005, no. 19, ill. p. 30–31, 69.

Winter was not dated, but it might have been painted at the end of the 1880s somewhere near Næstved in Zealand, where Brendekilde went to live in 1885.

Many of the artist's early works show obvious traces of social realism inspired by contemporary French painting and bear the marks of Brendekilde's own poverty in childhood and youth. However, the artist's style gradually developed into idyllic genre paintings, each making some clearly expressed point. The numerous works of this kind almost always invite the viewer to participate in some story implicit in the painting. The present instance is the portrayal of a meeting between a couple, perhaps sweethearts in their youth, in the winter of their lives. The tracks in the snow reveal that he has stopped, hesitated, and perhaps turned around, but has then decided to continue his course toward the waiting woman.

Fine light and delightful colors underline the scenery's mood of assurance and encourage the hope of a happy union.

S.L.

OSCAR CONRAD CARLSON

COPENHAGEN 1840 – DYBBØL 1864

Carlson's father was a master shoemaker, probably of Swedish descent. Even as a child, Oscar Carlson evinced a great desire to draw. After his confirmation he was allowed to receive instruction in drawing at Frederik Helsteds Institut in Copenhagen. From there he was graduated to the Royal Danish Academy of Fine Arts, where he had instruction from 1856 to 1861, part of the time as a pupil of Professor Niels Simonsen (1807–1855).

Oscar Carlson's first works to be exhibited at Charlottenborg were a model figure, for which he was awarded the minor silver medal, and a painting entitled Parti fra et skovløberhus i Dyrehaven (View from a Forester's House in Dyrehaven), *executed the same year and portraying the same area as the picture in the Loeb collection.*

The promising young artist, whose special talent was painting scenes of everyday life, was not granted much time in which to paint. In the autumn of 1863 he was called up for war service and was killed during the defense of Dybbøl the day before his twenty-fourth birthday.

During the second Schleswig war against Prussia and Austria, like a number of other artists (including Otto Bache and Vilhelm Rosenstand, both represented in the Loeb collection), Carlson made drawings that were subsequently reproduced as woodcuts portraying life in the battlefield for the magazine Illustreret Tidende.

S.L.

LITERATURE: Herman Madsen, *En ukendt maler, Oscar Carlson og hans kunst,* in *Kunst,* 8.5.1955; pp. 226–228; Kirsten Nannestad in *Weilbach* vol. I, 1994.

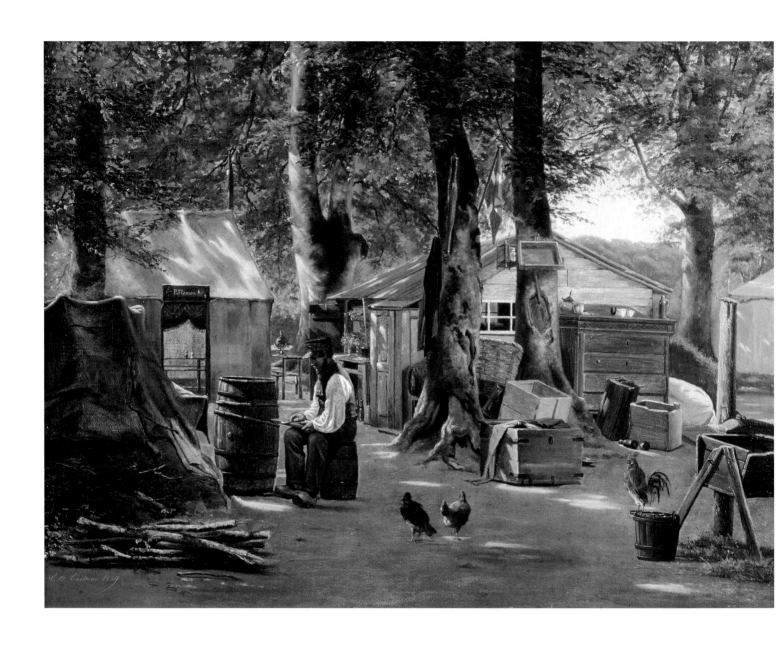

OSCAR CARLSON
1840–1864

21. *From Dyrehavsbakken, 1859*
(Fra Dyrehavsbakken)

Oil on canvas, 16 x 21¼ in. (41 x 54 cm)

Signed and dated lower left: C.O. Carlson 1859

PROVENANCE: Arne Bruun Rasmussen, Auction 393, 1979, lot 223, ill. p. 19; Arne Bruun Rasmussen, Auction 452, 1983, lot 37, ill. p. 27 (described as *Telte og boder på Dyrehavsbakken*).

EXHIBITED: Bruce Museum of Art and Science, Greenwich, Connecticut, and The Frances Lehman Loeb Art Center, Vassar College, New York, *Danish Paintings of the Nineteenth Century from the Collection of Ambassador John L. Loeb Jr.*, 2005, no. 10, ill.

Very few works are known by the talented Oscar Conrad Carlson, who is almost forgotten today because he was granted so few years in which to work. He left no great artistic production behind him. The Charlottenborg exhibitions note only six works, one of which, *En erklæring* (*A Declaration*) was exhibited after his death.

This picture of a corner of Dyrehavsbakken to the north of Copenhagen seems to portray the morning after a fair. The almost chaotic composition with a piling up of amusing and narrative details is kept in check by many parallel perpendicular lines. The viewer's gaze is led along the tree trunks up into the fresh green foliage, then brought down to the cooper sitting half asleep, and then to the poultry. The peaceful, somewhat lethargic atmosphere following a day of hectic activity is fondly and humorously reproduced.

With its array of color and fine light effects, this picture forms an elegant contribution to the large number of portrayals of Dyrehavsbakken in Danish art.

S.L.

NIELS CARL MICHAEL FLINDT DAHL

FAABORG 1812 – FREDERIKSBERG 1865

Carl Dahl was born in the coastal town of Faaborg in Funen, training from 1830 as a house painter. Eager to become an artist, he moved to Copenhagen in 1835, where he entered the Royal Academy of Fine Arts. During his six years there, he was the pupil of landscape painter J. P. Møller (1783–1854) but learned the rules of perspective from G. F. Hetsch (1788–1864). Most important for his development and career, however, was the time he spent as a pupil of C. W. Eckersberg (1783–1833), who taught him marine painting as well as how to draw figures. Dahl quickly made a career as an artist. His first painting, exhibited at the Charlottenborg exhibition in 1837, inspired a landowner from Funen to give him a private bursary, and he was also supported by the king, Christian VIII, who eventually bought several of his marine paintings. Dahl had a special talent for perspective and became a teacher in this discipline at the Royal Academy from 1842 to 1848 while continuing to exhibit at Charlottenborg. From 1840 to 1852, he held a post as a teacher in drawing at the Danish Naval Academy. His intimate knowledge of ship construction and rigging details made him much admired as a marine painter, and he was of great help to Eckersberg, who lost much of his sight in his late years. In 1849, Dahl won the Neuhausen Prize with a painting of ships passing Kronborg Castle in Elsinore.

During the First Schleswig War (1848–50), Dahl sailed with the navy to the battlefields at sea, where he made sketches, later to be transformed into paintings. He did the same thing in 1864 during the Second Schleswig War. In 1852 he was awarded the traveling bursary of the academy and visited Germany, Holland, Belgium, Paris, and the south of France. Later he studied the North Atlantic waters on a trip in 1862 to the Faroe Islands aboard the steam frigate Jylland. *Most of his work is marine art, but he also painted topographic motifs and a few of everyday life, such as* Two Peasants Visiting Thorvaldsen's Museum.

*Paintings by Dahl are in the Statens Museum for Kunst (*The Rhoads of Lisbon, *from 1843), the Thorvaldsen's Museum (*The Frigate *Thetis and the Corvette* Flora *at the Teje River, Lisbon, 1844) and the Museum of National History at Frederiksborg Castle. Drawings are at the Handels og Søfartsmuseet, Kronborg, Elsinore.*

E.F.

LITERATURE: J. P. in *Illustreret Tidende*, 1864–65, pp. 241–43 (obituary); Philip Weilbach, *Konst og Æsthetik*, Copenhagen 1870, p. 190; Holger Drachmann in *Nyt dansk Maanedsskrift*, 1870, p. 447f.; Emil Hannover, *Eckersberg*, Copenhagen 1898, p. 302; F. Meldahl and P. Johansen, *Det kongelige Akademi for de skønne Kunster 1700-1904*, Copenhagen 1904, p. 244f.; Jørgen Paulsen, *Billeder fra Treaarskrigen*, Frederiksborg 1952, pp. 26, 28, 40, no. 9, 46, 159; Hanne Jönsson (ed.), *C. W. Eckersberg og hans elever*, Statens Museum for Kunst 1983, p. 93f, no. 101; Kasper Monrad in *De ukendte Guldaldermalere*, Kunstforeningen, Copenhagen 1982, p. 40, no. 34; Hanne Poulsen, *Danske skibsportrætmalere*, Copenhagen 1985, p. 117; Hanne Poulsen in *Weilbach*, vol. II, Copenhagen 1994.

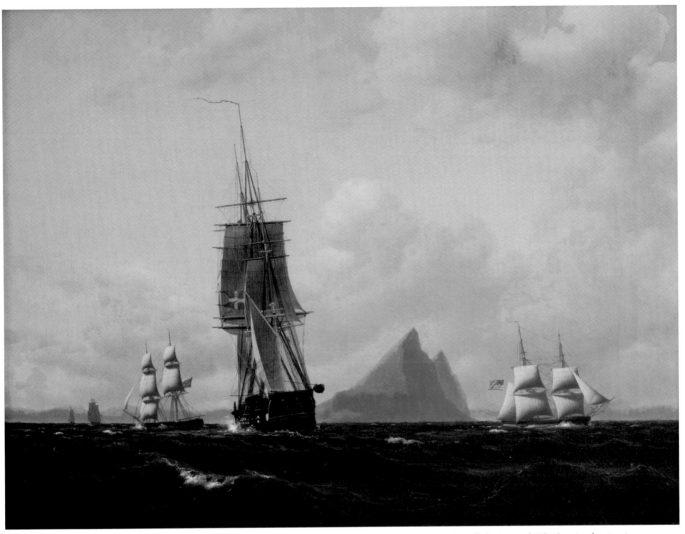

137. CARL DAHL *The Frigate* Thetis, *a Danish Naval Brig and a Brig under American Flag off the Coast of Gibraltar* (early 1840s)

CARL DAHL
1812–1865

137. *The Frigate* Thetis, *a Danish Naval Brig and a Brig under American Flag off the Coast of Gibraltar* (early 1840s)

(Fregatten Thetis, *dansk orlogsbrig og brig under amerikansk flag ud for Gibraltar)*

Oil on canvas, 19⅓ x 25½ in. (49 x 65 cm)

Not signed nor inscribed

PROVENANCE: Bruun Rasmussen, Vejle, Auction 113, 2008, lot 323, ill.

For this marine painting, Carl Dahl chose the waters near Gibraltar, the huge mountain in southern Spain opposite the town of Tangier on the African coast. The Straits of Gibraltar have a great strategic importance, as this narrow passage is the only one connecting the Mediterranean Sea and the Atlantic Ocean. Since 1713, Gibraltar has been a colony of the British crown, and so it remains today.

In 1840, the artist took his first trip on a Danish man-of-war, traveling from Denmark to Lisbon in Portugal, where he depicted some American frigates in the waters outside the harbor. The journey went farther south, and it is believed that this painting is a result of studies he made on board.

The dominant feature of the painting is the tall Danish frigate *Thetis* seen from backboard aft. A fresh northeastern wind fills its brown sails as it makes its way to the Atlantic Ocean following some other ships, which are seen at a distance. It has just passed a brig sailing under the American flag and heading for the Mediterranean. The full starboard side of this brig is visible, and the sunlight and shadow in the curving white sails are beautifully rendered. The wind is rather strong and there is white spindrift on the water's surface.

The horizon in the painting is fairly low, permitting us to see the ships clearly against the sky. The painting technique and colors chosen are much influenced by C. W. Eckersberg, especially the dark green water and the huge clouds giving life to the motif. In the distance between the two main ships the cliffs of Gibraltar add a dramatic note to the motif, contrasting with the lower coastline of Spain at either side.

The frigate *Thetis* was built in Copenhagen in 1840, measuring 155 x 38 feet. It served during the Second Schleswig War and ended its service the same year, 1864, being cut up ten years later. It did not sail in the Mediterranean before 1842, so obviously Dahl painted this Gibraltar sea scene after returning home, using sketches made at sea. The artist had studied nature closely and learned how to make use of his sketch material so well that he conveys the idea of tall, speedy vessels on a fresh, windy day in the Straits of Gibraltar.

E.F.

CHRISTEN DALSGAARD

KRABBESHOLM NEAR SKIVE 1824 – SORØ 1907

Christen Dalsgaard never traveled outside Denmark. The story of his life can be divided into two chapters, the first deriving from northern Jutland, the second from Copenhagen and especially central Zealand.

The artist was born in the small Renaissance mansion of Krabbesholm, which, together with its adjoining land, was in the possession of his parents, Jens Dalsgaard and Christiane Rasmussen. Krabbesholm, now a public high school, was built in the middle of the 16th century. It looks out on the southeastern part of the Limfjord in the thinly populated north Jutland region of Salling, close to the market town of Skive. Various features of Christen Dalsgaard's upbringing presumably became engraved in his mind and made their mark on his artistic development.

He was one of nine children. Three of them died as infants and one at the age of fifteen; a grown sister reached the age of only twenty-one. Despite the burden of these sorrows, and irrespective of the fact that throughout her life Dalsgaard's mother suffered from such severe rheumatism that she had to be carried around, the artist's parents were able to create a harmonious, stimulating childhood and upbringing for the four remaining brothers.

That Christen became an artist was due to his innate talent, but he was presumably also encouraged from home to cultivate his abilities. The great hall of the mansion is decorated with resplendent colorful rococo decorations on the ceiling and walls executed in 1759 by the artist Olaus Carolus Wassman (1730–1784), commissioned by the then owner of the house, Verner Rosenkrantz, who had had Krabbesholm renovated and modernized. It is highly likely that Christen Dalsgaard's imagination derived nourishment at an early age from the array of these colorful pictures. Despite the primitive quality of their execution they are, according to one Danish art historian, a decoration of great effect containing "a wild profusion in the tracery and vitality and strength of the rococo ornamentation above the resonance of the reddish browns against the blue panels."[1]

Equipped with an understanding of life and a certain artistic experience, Christen Dalsgaard went to Copenhagen in 1841 to train as a painter under a master named Harboe. He was admitted to the Royal Danish Academy of Fine Arts that same year and remained associated with it until January 1848, for a time as a private pupil of Martinus Rørbye.

Dalsgaard was soon inspired by the art historian Niels Lauritz Høyen's appeal to young artists to paint national art, in this case portrayals of the lives of ordinary people in the most outlying areas of Denmark, where the original way's of life had been preserved. Further encouraged by Rørbye, Dalsgaard went home to Krabbesholm every summer to make studies of the landscapes around the Limfjord, of the local farming and fishing population dressed in their local costumes, and of the rooms and workplaces in which they spent their daily lives. Throughout his life he preserved his collection of drawn and painted sketches from the Salling region, making constant use of them for larger compo-

sitions, many of which were executed far later. In time, Dalsgaard bought various of the colorful costumes from the local population of the Limfjord regions, costumes which had gradually gone out of use.

In 1862 Dalsgaard was offered a post as teacher of drawing at Sorø Academy, a highly regarded boarding school in Denmark with a rich tradition behind it. For the next thirty years, the artist made a huge and greatly appreciated contribution there, at the same time continuing to paint his national romantic portrayals of everyday life.

Dalsgaard was not the only artist portraying everyday Denmark life in the second half of the 19th century, but he is perhaps the most important of them. His many detailed depictions of the interiors of ordinary people's homes, executed with the traditional precision and verisimilitude of the Eckersberg School, are of great historical value today. But in addition to this, his portrayals of the lives of farmers and fishers very often have a mournful or tragic undertone not found in the more directly appealing and more anecdotal depictions of rural life painted by the town dweller Julius Exner. Although Dalsgaard was also eminently capable of painting radiant and artfully lighthearted scenes, as the writing girl in the Loeb collection clearly demonstrates, there is often a somber mood to his pictures, possibly stemming from the experiences of his childhood in the beautiful but bleak areas of northern Jutland, with its difficult conditions of life. Snedkeren bringer ligkisten til det døde barn, 1857 (The Carpenter Brings the Coffin for the Dead Child), now in the Statens Museum for Kunst, gives a clear impression of this aspect of Dalsgaard's art.

Christen Dalsgaard made his first appearance at Charlottenborg in 1847, exhibiting there regularly until 1907, the year of his death. The last occasion, however, was postmortem.

Throughout his long life the artist also participated in many other exhibitions. Mention must especially be made of the 1878 World Fair in Paris, in which he showed a version of the Loeb collection's Young Girl Writing, 1871, unless it was this very work that was sent to Paris and to the Raadhusudstilling exhibition held in Copenhagen City Hall in 1901.

Dalsgaard's art is characterized by a gentle sensitivity both in the use of narrative technique and the application of color and light. He was twice awarded the Neuhausen Prize, in 1859 and 1861. Eleven years later he became a member of the Royal Danish Academy. In 1892, the year he resigned his post as teacher of drawing at Sorø Academy, he was appointed titular professor at the Royal Danish Academy. But the old painter remained in Sorø until his death, and it is there he is buried.

S.L.

LITERATURE: Julius Lange, *Nutids-Kunst,* Copenhagen 1873, pp. 235–259; Knud Søeborg, *Christen Dalsgaard og hans Kunst,* Copenhagen 1902; Karl Madsen (ed.), *Kunstens Historie i Danmark,* Copenhagen 1901–07; A. D. Dalsgaard, Christen Dalsgaard, *spredte Træk og Minder* in *Skivebogen,* Skive 1929, pp. 77–99; Arne Bruun Rasmussen in *Kunst i privat Eje,* vol. II, Copenhagen 1945, p. 343; S. Nygård, Krabbesholm in *Danske slotte og herregårde,* vol. 12, Copenhagen 1966, pp. 53–66; Erik Mortensen, in *Weilbach,* vol. 2, Copenhagen 1995; Charlotte Sabroe, Christine Buhl Andersen, Inge Bucka (eds.), *Christen Dalsgaard 1824–1907,* Vestsjællands Kunstmuseum, Skive Kunstmuseum, Den Hirschsprungske Samling, 2001.

[1]Torben Holck Colding in *Dansk Kunsthistorie,* vol. 2, Copenhagen 1973, pp. 446–447.

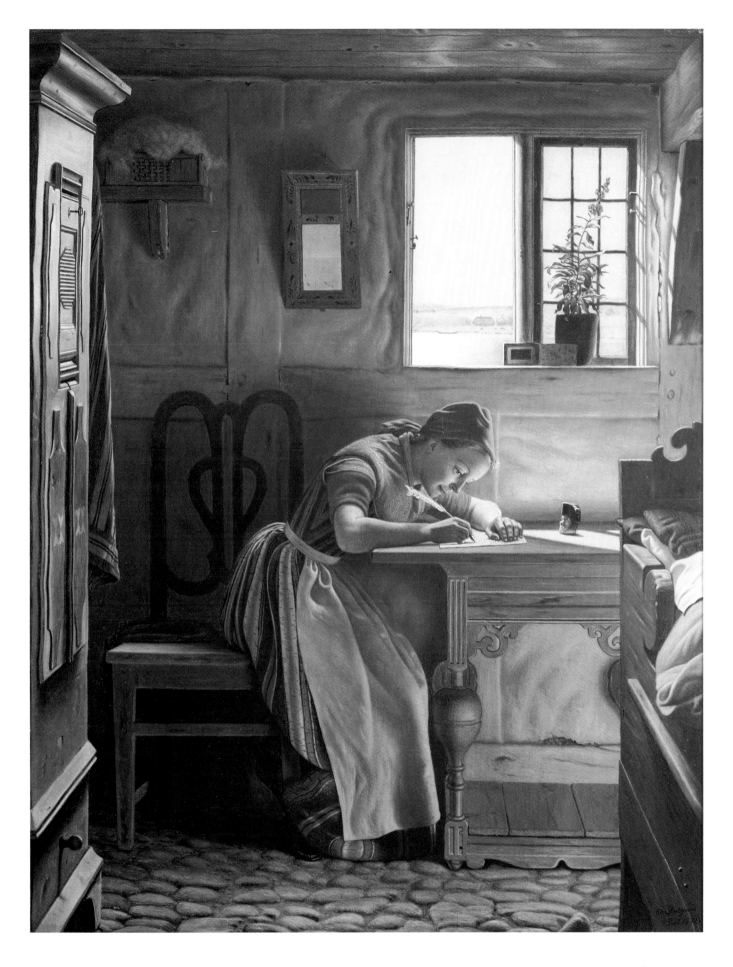

CHRISTEN DALSGAARD
1824–1907

22. *Young Girl Writing*, 1871
(Ung pige, der skriver)

Oil on canvas, 25 x 18¾ in. (64 x 48 cm)

Signed lower right: Chr. Dalsgaard, Sorø 1871

PROVENANCE: Bruun Rasmussen, Auction 548, 1990, lot 42, ill.

EXHIBITED: Paris World Fair, 1878, no. 15; Busch-Reisinger Museum, Harvard University Art Museums, *Danish Paintings of the Nineteenth Century from the Collection of Ambassador John L. Loeb Jr.*, 1994, no. 3; Bruce Museum of Art and Science, Greenwich, Connecticut, and The Frances Lehman Loeb Art Center, Vassar College, New York, *Danish Paintings of the Nineteenth Century from the Collection of Ambassador John L. Loeb Jr.*, 2005, no. 12, ill.; Scandinavia House, New York, *Danish Paintings from the Golden Age to the Modern Breakthrough, Selections from the Collection of Ambassador John L. Loeb Jr.*, 2013, no. 9.

LITERATURE: Julius Lange, *Nutids-Kunst, Skildringer og Karakteristikker*, Copenhagen, 1873, pp. 249–250; Karl Madsen, *Kunstens Historie i Danmark*, Copenhagen, 1901–1907, p. 307–308; Knud Søeborg, *Christen Dalsgaard og hans Kunst*, Copenhagen, 1902, p. 94, ill. p. 96; Patricia G. Berman, *In Another Light, Danish Painting in the Nineteenth Century*, New York, 2007, p. 112, ill. p. 114.

Perhaps the best possible description of this engaging painting comes from art historian and humanist Julius Lange (1838–1896) in one of his best known-works.[1]

> ...in 1871 came the charming painting—in a painterly sense one of Dalsgaard's most beautiful—of the quite young girl sitting by the window, completely engrossed in the important undertaking of writing a letter. We will make no insinuation at all concerning the contents of the letter, which were perhaps not really so important; but in the entire posture, in the way in which she was holding her head to one side to see down the lines and involuntarily twisting her foot round one of the chair legs, the rare and solemn quality of the event were expressed with so much grace and humour.

Altogether, Christen Dalsgaard made four versions of *Young Girl Writing*. Three of them are dated 1871, and the fourth is dated 1875.

In 1878 one was exhibited at the Paris World Fair, establishing the picture's reputation and its significance in the history of Danish art. Since it cannot be determined with certainty which of the versions was sent abroad, the history of all four paintings is considered here.

The artist's nephew, A. S. Dalsgaard, recalls that his uncle was extremely industrious and always had something in preparation, "either a new idea or a repeat of an older motif that had come to life for him anew."[2] The same source provides the information that the Dalsgaards had a single child, a daughter, who died as a baby, but the artist and his wife adopted a little orphan girl on whom they both doted. Whether the model for the girl writing her letter is the artist's adoptive daughter, who in 1871 must have been about 13 years old, is something at which we can only guess.[3]

The features of this young girl are found in other works by Dalsgaard, for instance *En Rekonvalescent (A Convalescent)*, 1870, now in the Hirschsprung Collection. This work was exhibited the following year at Charlottenborg together with others, including *Young Girl Writing*. In the book quoted above, Julius Lange writes of it: "In 1871, Dalsgaard enjoyed a greater success in the exhibition than usually fell to his lot on

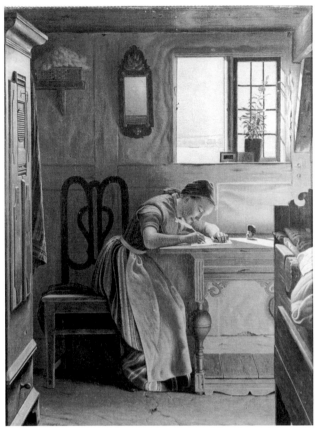

FIG. A: VERSION 2 *Young Girl Writing,* 1871
Oil on canvas, 24¾ x 20 in. (63 x 49 cm)
Signed and dated lower left: Chr. Dalsgaard, Sorø 1871
Ribe Kunstmuseum

FIG. B VERSION 3 *Young Girl Writing,* 1871
Oil on canvas, 24¾ x 20 in. (63 x 49 cm)
Signed and dated lower left: Chr. Dalsgaard, Sorø 1871
Owner unknown

account of some small pictures, in particular the superb little painting of a girl writing a letter."[4] It is no wonder that the artist chose to reproduce his little masterpiece, for there was a market for it.

The three 1871 versions of *Young Girl Writing* are almost identical. They have practically the same dimensions, but slight differences in the execution of each individual work distinguish them from each other. We will consider Version 1 to be in the Loeb collection. Version 2 (Fig. A) belongs to Ribe Kunstmuseum. The current owners of Version 3 (Fig. B) and Version 4 (Fig. C) are not known, but there are photographs and records of their provenance in the Royal Danish Academy of Fine Arts. Version 4 (1875) is a little smaller than the others (21¼ x 17⅓ in., or 54 x 44 cm) and introduces some changes, including a detailed close-up of the girl, though the motif is the same.

In the important *Kunstens Historie i Danmark* published in 1907, edited and written mainly by the art historian Karl Madsen,[5] the author writes about the reception of Danish art in the 1878 World Fair in Paris, when French critics expressed a "unanimous and merciless condemnation of the artistic failings in our national painting."

For more than thirty years, Danish artists had followed the injunctions of the art historian N. L. Høyen to paint mainly Danish landscapes and Danish everyday life, for which reason artists had adapted very little to the new artistic currents from abroad.[6] Karl Madsen writes that although there were French critics who

FIG. C: VERSION 4 *Young Girl Writing,* 1875
Oil on canvas, 21¼ x 17⅓ in. (54 x 44 cm)
Signed and dated lower left: Chr. Dalsgaard, Sorø 1875
Owner unknown

made the effort to acquaint themselves with the language of Danish painting and its positive qualities, and who "emphasised the honesty of Danish art, the intensity of feeling in it and the wealth of talent," most of them nevertheless condemned "its formal incompetence and deplorable predilection for a decorative quality that was devoid of all character."

The criticism of Paul Mantz was typical of this ambivalence. In the newspaper *Le Temps* of November 1878, he drew attention to Christen Dalsgaard's *Letter Writer* as "the most interesting and most significant painting in the Danish section," a work in which "the motif, the will, the thought and the intention deserve the greatest praise." Unfortunately, these gratifying remarks were not allowed to stand without further comment. Mantz goes on to use Dalsgaard's work as an example of his personal assessment of the overall Danish contribution: "But the painter himself, and most Danish painters, are like the young girl. The handwriting is bad, the orthography faulty, the style without art."

Karl Madsen's commentaries on this, twenty-nine years after the catastrophic French reception of the Danish paintings, relativize the event to some extent.

He points out that, in contrast to the art of Eckersberg and especially Købke, the wave of national art had never been able to achieve any particular interest or appreciation on the part of foreign art critics, but also that the national line in art was neither vapid nor without content, and asserts that *Young Girl Writing* was

really a product of Danish national painting (in the form of the girl in her beautiful local costume) and was simply not intended for a French public.

"Despite all the weakness of the form," Madsen writes, "it tells us Danes with understanding and feeling of the special quality and beauty of our countryside and of the joys and sorrows of the people; it tells both of gentle, melancholy dreaming and of a brave striving towards higher goals, and it also tells everyone of the wise and beautiful thoughts of a great and rich artistic soul."[7]

S.L.

[1] *Nutids-Kunst, Skildringer og Karakteristikker*, Copenhagen 1873, pp. 249–250.

[2] Christen Dalsgaard, *spredte Træk og Minder* in *Skivebogen, Historisk Aarbog for Skive og Omegn,* vol. 21, Skive 1929, pp. 77–99.

[3] Christen Dalsgaard was 47 years old in 1871; he married in 1857.

[4] Julius Lange, *Nutids-Kunst, Skildringer og Karakteristikker,* Copenhagen 1873, p. 236.

[5] Karl Madsen (1855–1938), painter, art historian, and subsequently director of Statens Museum for Kunst.

[6] Niels Lauritz Høyen (1798–1870), the first real art historian in Denmark, was a considerable figure on the cultural scene, exercising an almost unique influence on artistic life throughout most of the 19th century. One of his achievements was founding the Art Society of Copenhagen, Kunstforeningen in 1825; together with his colleague, the museologist Christian Jürgensen Thomsen (1788–1856), he became joint head of the Royal Collection of Paintings, which purchased the artists' works, and he was an ardent spokesman for nationalism and the sense of a Scandinavian quality in art. Thanks to his infectious commitment, he persuaded Danish painters and sculptors to give expression exclusively to Danish and Nordic history and attributes in their art and to reject all foreign influence. His ideas continued to affect most Danish portrayals of the countryside and the life of the ordinary people well into the 1880s.

[7] Karl Madsen: *Kunstens Historie i Danmark,* Copenhagen 1901–1907, pp. 307–308.

CHRISTOFFER WILHELM ECKERSBERG

BLAAKROG 1783 – COPENHAGEN 1853

C. W. Eckersberg's father was a carpenter and painter from Blaakrog near Aabenraa in Southern Jutland, at that time part of the Duchy of Schleswig. The son trained as an artisan painter at Aabenraa and Flensburg.

In 1803 Eckersberg was admitted to the Royal Danish Academy of Fine Arts in Copenhagen, where the history painter and architect Nicolai Abildgaard (1743–1809) became his teacher. During his six years at the academy he succeeded in winning a silver and two gold medals. The award of the major gold medal qualified him for the academy's major travel grant. From 1810 to 1813 he studied in Paris, where for rather more than a year there he was a pupil of the neoclassical artist Jacques-Louis David (1748–1825). He spent the next three years in Rome, where he lived in the same building as the Danish sculptor Bertel Thorvaldsen (1770–1844).

Between 1829 and 1841, Eckersberg made a number of short voyages by steamship from Copenhagen to Sweden, Norway, Kiel, and Warnemünde, this latter in the company of Thorvaldsen. He also sailed on the corvette¹ Galathea to Dover (spending half a day in London) and Hamburg, Germany.

The huge range of motifs in C. W. Eckersberg's oeuvre encompassed a certain number of genre pictures and paintings of everyday life, among which were some noteworthy scenes from the 1807 Copenhagen bombardment by the English. He also painted architectural pictures and city views of Paris and especially Rome, as well as portraits, figure pictures, and historical compositions. To all this could be added the decoration of Christiansborg palace and some altarpieces, a few landscapes, and a large number of marine paintings. Eckersberg exhibited at Charlottenborg between 1824 and 1851.

In 1818 C. W. Eckersberg was appointed professor at the Royal Danish Academy, a post he held until his death thirty-five years later. His teaching was of enormous importance for the development of painting during the period that has since come to be known as The Danish Golden Age.

He carried through a series of reforms. For instance, painting from life was modernised. The models were placed in less idealized and more natural postures, and the use of female nudes was introduced into the teaching. (See the Loeb collection for works by his students: Joel Ballin's Young Girl Undressing, *Constantin Hansen's* Study of a Male Model, *and L. A. Smith's* Female Model Before a Mirror, 1841.) *Eckersberg's pupils learned to use local color and to paint bright daylight into their pictures while at the same time avoiding disturbing reflections or dramatic shadow effects. No subject was too ordinary to be turned into a picture, and honest, meticulous reproduction of what was seen was the implacable requirement. In addition, there were several invariable rules, of which the use of the perspective measuring tool was de rigueur. Eckersberg wrote two textbooks on this subject, and his lessons in the use of perspective were epoch-making.*

But what was really new at the time and had never been taught before in any European academy

of fine arts were the lessons in the open air. Eckersberg took his students out on excursions into the countryside around Copenhagen and taught them to paint directly from nature. It was thanks to both classical and radical instruction that Danish art acquired its special quality.

Eckersberg was director of the Royal Danish Academy from 1827 to 1829.

LITERATURE: Christoffer Wilhelm Eckersberg, *Forsög til en Veiledning i Anvendelsen af Perspectivlæren for unge Malere*, Copenhagen 1833, reprint, Copenhagen 1973; Christoffer Wilhelm Eckersberg, *Linearperspectiven, anvendt paa Malerkunsten, En Række af perspectiviske Studier*, Copenhagen 1841. Reprint with preface by Ole Schwalbe, Copenhagen 1978; Inger Hjorth Nielsen, Studier til C. W. Eckersbergs maleri Moses lader det røde hav træde tilbage og Faraos hær oversvømme, *Kunstmuseets Årsskrift* 1975, pp. 103–118; Henrik Bramsen, *Om C. W. Eckersberg og hans mariner*, Copenhagen 1972; Hanne Jönsson (ed.), *C. W. Eckersberg og hans elever*, Statens Museum for Kunst, Copenhagen 1983, containing articles by the editor and Lars Rostrup Bøyesen, Vibeke Petersen, Bente Skovgaard, and Hanne Westergaard. For a fuller discussion in English of Eckersberg and his theories of perspective, see especially Erik Fischer, *C. W. Eckersberg, His Mind and Times,* Copenhagen 1993; Bjarne Jørnæs in *Weilbach,* vol. 2, 1994; Peter Nisbet, *Danish Paintings of the Nineteenth Century from the Collection of Ambassador John L. Loeb Jr.,* Harvard University Art Museums Gallery Series no. 8, Cambridge, Massachusetts 1994, pp. 4–5; Philip Conisbee, Kasper, Monrad, Lene Bøgh Rønberg, *Christoffer Wilhelm Eckersberg 1783–1853,* National Gallery of Art, Washington 2003; Anneli Fuchs and Emma Salling (eds.), *Kunstakademiet 1754–2004,* vol. I–III, Copenhagen 2004; Villads Villadsen (ed.), *C. W. Eckersbergs dagbøger,* vol. 1–2, Copenhagen 2009; Kasper Monrad (ed.), *Christoffer Wilhelm Eckersberg,* Statens Museum for Kunst, Copenhagen 2015.

S.L.

[1]A warship ranking just below a frigate, having usually only one tier of guns.

C. W. ECKERSBERG
1783–1853

23. *Figure Study of Two Women*
(Studie af antikke kvindefigurer)

Graphite and wash on paper, 6⅔ x 9¾ in. (170 x 250 mm)

Signed lower right: *Eckersberg*

PROVENANCE: Private collection, 20 Stenosgade 4A 1616 Kø[benhavn] V (inscription on back); Bruun Rasmussen, Auction 558, 1991, lot 447, ill. p. 175.

EXHIBITED: Busch-Reisinger Museum, Harvard University Art Museums, *Danish Paintings of the Nineteenth Century from the Collection of Ambassador John L. Loeb Jr.,* 1994, no. 4, ill. p. 4.

LITERATURE: Inger Hjorth Nielsen, Studier til C. W. Eckersbergs maleri Moses lader det røde hav træde tilbage og Faraos hær oversvømme, *Kunstmuseets Årsskrift* 1975, pp. 103–118; Peter Nisbet, *Danish Paintings of the Nineteenth Century, from the Collection of Ambassador John Loeb Jr.*, Busch-Reisinger Museum, Harvard University Art Museums, Cambridge, Massachusetts 1994, pp. 4–5.

After the youthful Christoffer Wilhelm Eckersberg received a major gold medal from the Royal Danish Academy, he left on a six-year-long study journey to Paris and Rome. While in Paris, he received an important commission from home. The wealthy Jewish merchant Mendel Nathanson, for whom Eckersberg was later to execute other important works, wanted a painted composition of considerable size with a subject relating to the Israelites' passage through the Red Sea (Exodus 14). Eckersberg executed a considerable number of drawn sketches for this undertaking, including various arrangements of figures clearly inspired by the neoclassical style of his French teacher, Jacques-Louis David.

FIG. A.
C. W. Eckersberg, *Figure Study of Three Young Women and a Young Man (*Paris, 1812*).* Pencil, pen, black ink, brown and gray wash on white paper, 9⅔ x 12¾ in. (245 x 324 mm), Statens Museum for Kunst, Department of Prints and Drawings.

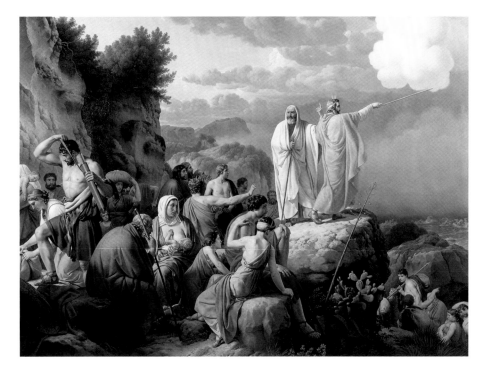

FIG. B
C. W. Eckersberg,
The Crossing of the Red Sea,
Rome 1813–1816
Oil on canvas, 6⅔ x 9⅓ ft.
(203.5 x 283.5 cm),
Statens Museum for Kunst.

In her article in *Kunstmuseets Årsskrift*, 1975, Inger Hjorth Nielsen provides a clear account of the young artist's manner of working, often extending over several years to complete a painting. She refers to a number of hitherto unidentified drawings which appeared in 1971 and were acquired by the Department of Prints and Drawings in Statens Museum for Kunst. One of these drawings was identified as the very first sketch for the commission (Fig. A). All of these drawings must be considered as preparatory works for the final painting *Moses Commands the Red Sea to Retreat and Pharaoh's Army Drowns,* 1816, 6⅔ x 9¼ ft. (204 x 282 cm), Statens Museum for Kunst (Fig. B).

Not all the studies shown in Inger Hjorth Nielsen's article were used for the finished commission, nor was the Loeb collection *Study of Two Women*, which came to public attention only in 1991. But the two women, who appear to be looking out to sea where the remnants of Pharaoh's army are drowning, are unmistakably reminiscent in style and execution of one of the drawings of three young women in ancient dress reproduced in the Nielsen article (Fig. 7) and might, in a slightly reworked form, be related to the central figure at the front of the painting.

S.L.

C. W. ECKERSBERG
1783–1853

24. *Naval Frigate under Sail* (before 1810 or 1820s)
(Orlogsfregat under sejl)

Oil, canvas, 13⅘ x 16½ in. (35 x 42 cm)

PROVENANCE: Commander Sølling (1898); Bruun Rasmussen, Auction 721, 2003, lot 1176, ill.

LITERATURE: Philip Weilbach, *Maleren C. W. Eckersberg, Levned og Værker*, Copenhagen, 1872; Emil Hannover, *C. W. Eckersberg*, Copenhagen, 1898, no. 79, p. 13, ill. p. 12; Henrik Bramsen, *Om C. W. Eckersberg og hans mariner*, Copenhagen 1972; Dorthe Falcon Møller, Jens Lorentzen, Anders Monrad Møller, *Niels Truslew, Skibe i søen 1805*, Copenhagen, 1979; Dorthe Falcon Møller, Skibe i søen in *C. W. Eckersberg*, Aarhus Kunstmuseum, 1983, pp. 67–74; Hanne Poulsen, *Danske skibsportrætmalere*, Copenhagen, 1985; Kasper Monrad, *The Golden Age of Danish Painting*, Los Angeles County Museum of Art, 1993 (pp. 83–115); Philip Conisbee, Kasper Monrad, Lene Bøgh Rønberg, *Christoffer Wilhelm Eckersberg 1783–1853*, National Gallery of Art, Washington, 2003 (on Eckersberg as a marine painter).[1]

The art historian Emil Hannover considered this painting of a naval frigate under full sail in the sound near Kronborg Castle at Helsingør to be one of Eckersberg's earliest marine paintings. It is the first such in the list of works contained in his 1898 monograph, where it stands as number 79. Its counterpart, number 80, shows a naval brig under sail. Both paintings were at that time owned by Commander Sølling of Aarhus.[2] Hannover describes them thus: "It scarcely seems possible to doubt that we are here faced with two of Eckersberg's earliest attempts at marine painting. Coloristically, they reveal such an immature study of nature and then so little assurance in the image of both the ships and the sea that they must be assumed to have been painted in his early years, before his sojourn in Paris." Eckersberg went to Paris in 1810, and as he failed to date either of the paintings, Hannover's suggested dating is based on stylistic criteria.

Hannover's judgment seems unreasonably harsh. The artist's depiction of the huge naval vessel, which, in full sail, is crossing a choppy sea at a good speed, is no beginner's work. There is a fine atmosphere to the painting, the coloring of which is discreet and well balanced, and the artist's portrayal of the sea and the sky seems realistic. So on the basis of stylistic criteria it would surely be natural to place it among Eckersberg's marines from the 1820s, in which the weather plays a special part.

The frigate has been identified as the *Najaden* (*The Naiad*),[3] which was built at Gammel Holm in Copenhagen and launched in 1796. It was intended for a crew of 340 and was known for its seaworthiness. It became famous after a successful action off Tripoli in the Mediterranean in 1797. Like the rest of the Danish fleet, the frigate was confiscated by the British in 1807, a consequence of the Napoleonic wars in which Denmark was allied to France. Other warships were later given the name of *Najaden*. Eckersberg was on occasion able to see the present ship for himself between 1803, when he came to Copenhagen, and 1807 and was thus able to both sketch and paint it before leaving for abroad.

Eckersberg's well-known love of ships and the sea dated back to his childhood. He grew up in Southern Jutland, near the Als Sound, where at an early age his father took him out fishing in his boat. In his reminiscences, he describes with great warmth the experience of the sea, the magnificent sunsets, and the impressions made by the big sailing ships.[4] His interest in maritime life was reinforced when, at the age of 14, he was apprenticed as a painter in the nearby market town of Aabenraa, which at that time was a thriving port. His master, Jes Jessen (1743–1807) was not only a skilled craftsman who could ornament and mar-

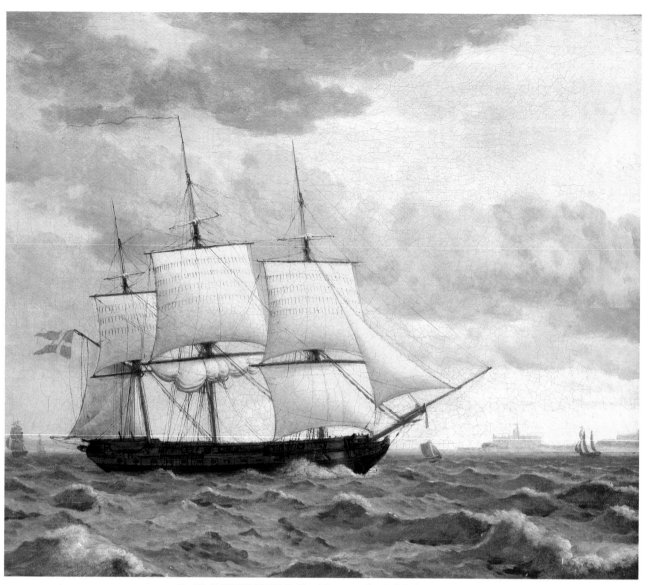

24. C. W. ECKERSBERG *Naval Frigate under Sail (before 1810 or 1820s)*

ble, but he also painted scenes and portraits and was among the first in the province to start painting ships'
portraits, which were a new genre at that time.[5] The demand for an accurate reproduction of the individ-
ual vessel's manifold characteristic details, which was the actual objective in painting a ship's portrait, was
something that Eckersberg had noted at an early age. In 1800, he moved to another port, Flensborg, where
he was employed in Johann Jacob Jessen's (c. 1761–1805) workshop and given the chance to undertake artistic
work by painting views and portraits. So we cannot discount the possibility that Eckersberg already also had
a certain experience of painting maritime motifs when he went to the capital in 1803 in order to train in the
Royal Danish Academy of Fine Arts. Here, too, he could enjoy the movement of ships in the harbor, but
he could also observe the work in the naval dockyard, which was close to the academy at Charlottenborg.

There is little concrete knowledge regarding Eckersberg's early experience as a marine painter and
draftsman, and the subject has been discussed by several generations of scholars. He collaborated to a cer-
tain extent with the copperplate engraver Niels Truslew (1762–1827), who is known for a number of prints
with motifs from the attack on Copenhagen by the British fleet in 1807 and not least the terrible bombard-

ment that set fire to the city. There is no agreement as to how many of the original sketches were the work of Eckersberg, as only a single one bears his name.[6]

Hannover writes that Eckersberg made "several small drawn or watercolor portraits of our warships in 1804."[7] He is here presumably thinking of the drawings in the Collection of Prints and Drawings, which the then head, Jørgen Sthyr, in 1949 related to the series of prints that Truslew published in 1805 under the title *En Samling af Skibe i næsten alle muelige Stillinger i Søen* (*A Collection of Ships in Almost All Possible Circumstances on the Sea*).[8] Most of the 36 prints reproduce a single ship in a way that is very reminiscent of a ship's portrait, but from the accompanying texts it emerges that the object is to show different types of ships. Instead of the name of the ship that always accompanies a ship's portrait, Truslew places a designation of type beneath his picture, for instance *A Russian Naval Brig Blown by a Side Wind*. The portrayal of the ships is very detailed, and at the same time Truslew has given a clear indication of the weather. There is disagreement as to how much Eckersberg contributed to this publication. Dorthe Falcon Møller points out in 1983 that his involvement cannot be documented with the exception of a single watercolor,[9] and so she rejects both Sthyr and Henrik Bramsen 1972.[10] Her view appears not to be shared by Kasper Monrad, who in 1993 talks of it as a fact that Eckersberg was responsible for several of the patterns.[11]

The discussion centers on an evaluation of the stage reached in Eckersberg's development as a marine painter before 1810. Falcon Møller argues that Truslew's portrayals of ships from 1805 were of great significance for Eckersberg's later choice of motifs for his marine painting in that she sees Truslew as Eckersberg's teacher in this field. It is difficult to accept this, for although Truslew's prints are charming enough, they are artistically naïve. And, not least, there are other early drawings by Eckersberg with far more ambitious motifs. For instance there is a drawing in the Collection of Prints and Drawings, signed by the artist on 6 October 1804, depicting the launch of the ship of the Prins Christian Frederik line. We see not only the ship but also the harbor and its surroundings, with the many sightseers watching the event. In the same collection there is a larger drawing of the British destruction of a battleship in dock with the title of *The Last British Outrage 1807*. The artist was proficient in far more than the reproduction of a single ship. The same proficiency is also obvious in the drawings that he produced for another graphic artist, G. L. Lahde (1765–1833).

That Eckersberg also painted marines before 1810 is considered a fact by Philip Weilbach, though this has not so far been brought into the discussion. In addition to this painting in the Loeb collection and to the counterpart referred to above, Hannover lists two other marine paintings which he dates before 1810. No. 81 is described thus: "We are looking from the shore out to sea, on which various ships both large and small are being tossed about. ... It all has the nature of a stormy day." No. 82 represents the view from Kastelsvej over the roads to Copenhagen. No. 81 is also included in Philip Weilbach's list of works from 1872, which is incorporated into Hannover's, though without the addition of the important information that according to Eckersberg's son, the engraver Erling Eckersberg (1808–1889), it was painted before the artist's journey abroad. Weilbach attached great importance to information provided by Erling Eckersberg, for Erling had collaborated with his father and was well acquainted with his work, whereas Hannover, writing more than 25 years later, had to be content with the artist's daughters, who were at least ten years younger than their brother. Hannover had not seen either no. 81 or no. 82, and as they are not known today either, a comparison with the painting in the Loeb collection is unfortunately not possible. But the mere titles suggest quite complex motifs.

In 1816, after six years in Paris and Rome, Eckersberg returned to Copenhagen, where he was in demand for his historical paintings and portraits. He really only embarked on marine painting in the 1820s, when he went to great pains to make himself acquainted with the technical aspects of shipping, naval architecture, rigging, and navigation, making several friends among boat builders, master mariners, and naval officers, who shared their knowledge with him. Among these was Commander Peder Norden Sølling. Eckersberg's activities can be followed via the surviving diaries.

The first marines he painted in the 1820s—and there were many of them—were detailed and accurate portrayals of ships, sometimes named, sometimes anonymous. Philip Weilbach remarked in 1872 that during this period he painted "specifically nature's moods," and that his brushwork was gentler than later. In time, Eckersberg's marines came to bear the stamp of his passion for perspective and meteorological phenomena.

In the painting in the Loeb collection, Eckersberg has placed his emphasis on describing the actual ship and its position in the sea in the given climatic conditions. By way of motif it shows great similarity with several of the dated paintings from 1824, 1825, and 1826, but it seems to be livelier, freer, and executed with greater assurance, although it is still indebted to the tradition of the ship's portrait. At the same time it is an atmospheric nature scene, which might suggest some date in the 1820s. Why, in the 1820s, should Eckersberg paint a ship that had long disappeared from Denmark? It might be because the *Najaden* was of a particularly interesting construction or because the frigate had taken part in famous battles.

As has emerged from this, it is not possible to produce a reliable dating for the painting in the Loeb collection on the basis of present information. A comparison with the now-unknown counterpart, which, as said above, depicts a naval brig, could perhaps provide a different interpretation of the subject and a more reliable date for when it was painted. The painting is nevertheless a fine example of the marine painting in which artistic aspects were crucial, and of Eckersberg's achievement in creating as a new genre in Denmark.

E.F.

[1] I am most grateful to the following marine historians for a discussion on this painting: Hanne Poulsen (formerly curator in the Trade and Shipping Museum, Kronborg in Elsinore), Jakob Seerup (curator in the Royal Danish Naval Museum in Copenhagen), Dr. Phil. Dorthe Falcon Møller, and Dr. Phil. Anders Monrad Møller.

[2] Possibly identical with Ivar Norden Sølling (1841–1925), whose grandfather, Commander Peder Norden Sølling (1758–1827), was a close friend of Eckersberg.

[3] The identification is the work of Jakob Seerup, 2002. Information given to me in 2004.

[4] Quoted from Hannover 1898, pp. 3–4.

[5] Hanne Poulsen, *Danske skibsportrætmalere*, Copenhagen 1985; Hanne Poulsen, Jes Jessen in *Weilbach*, vol. 4, Copenhagen 1996.

[6] H.D. Schepelern, Niels Truslew in *Weilbach*, 3rd edition, vol. 3, Copenhagen 1952, is of the opinion that Eckersberg produced several original sketches, though this view is rejected by Dorthe Falcon Møller in her biography on Niels Truslew, in *Weilbach*, 4th edition, vol. 8, Copenhagen 1998.

[7] Hannover 1898, p. 12.

[8] Jørgen Sthyr, *Dansk grafik 1800–1910*, Copenhagen 1949, pp. 16–18.

[9] *C. W. Eckersberg*, Aarhus 1993, pp. 67–68. Dorthe Falcon Møller told the present writer in 2004 that no complete set of original sketches has been found.

[10] *Om C. W. Eckersberg og hans mariner*, Copenhagen 1972, p. 8.

[11] *The Golden Age of Danish Painting*, Los Angeles 1993, p. 102. There is no reference to documentation.

EDVARD (EDWARD) CHRISTIAN JOHANNES ERIKSEN (ERICHSEN)

COPENHAGEN 1876 – COPENHAGEN 1959

Edvard Eriksen's father was a shoemaker in Copenhagen, and his mother originally came from Iceland. As a young man, he trained as a woodcarver and then entered the Royal Academy of Fine Arts in 1894, advancing to the model class. He left the academy in 1899 without passing the finals. After holding a post with a casting company in the island of Funen, where he married in 1900, he moved to Copenhagen and earned a living as a stucco worker, proceeding with his art in his spare time. However, at the Charlottenborg Exhibition of 1904 he was successful with his first important figure group, Hope, *of a mother holding her child. His model was his beautiful wife. The sculpture won the annual academy medal and was bought by the national gallery, Statens Museum for Kunst. Two years later, he produced a group work called* The Sentence of Adam and Eve, *which he sold to the same museum and years later carved in marble in Italy. A bursary in 1906 enabled him to live with his family in Florence, Rome, and Carrara with a stay in Dresden, Germany, before coming home in the spring of 1908.*

In 1909 he entered an official competition to produce a monument in memory of King Christian IX (1818–1906) and Queen Louise (1817–1898) in the cathedral of Roskilde. Due to a shortness of time, he could not satisfy the conditions of the competition, but even so, he was nominated to finish the monument jointly with the architect Hack Kampmann (1850–1920). From 1913 to 1915, Eriksen produced three marble figures: Sorrow, Remembrance, *and* Love. *The female faces, for which his wife was the model, are very similar to that of* The Little Mermaid *erected in 1913 at the waterfront of Copenhagen. Illustrating Hans Christian Andersen's (1805–1875) fairy tale, this figure is Eriksen's main work, which is now world-famous.*

In spite of his success, Eriksen eventually experienced hard times. His style—naturalism with a touch of symbolism—was outdated by the upcoming modernism, and commissions slowed to a trickle. Though he was forced to sell his villa in Copenhagen with its studio, he made a living creating small-scale tombstone monuments for private families. During the 1940–45 German occupation of Denmark he once again modeled a statue, illustrating a fairy tale by Andersen, Clumsy Hans *(Klodshans), of a young man riding a goat. A cast of this, made in 1958, commemorates the Danish-born actor Jean Hersholt (1887–1956) and can be seen at the Forest Lawn Memorial Park in Los Angeles. Hersholt had known Andersen well. In 1949, Hersholt had published his own English translation of Andersen's fairy tales,* The Complete Andersen, *in New York.*

E.F.

LITERATURE: Dorthe Falcon Møller in *Weilbach*, vol. II, Copenhagen 1993; Egon Eriksen, *Edvard Eriksen og Den lille Havfrue – liv og kunst*, Copenhagen 1998; Christopher Bramsen, *Hans Christian Andersen's the Little Mermaid, from Fairy-Tale to National Monument*, Copenhagen 2010.

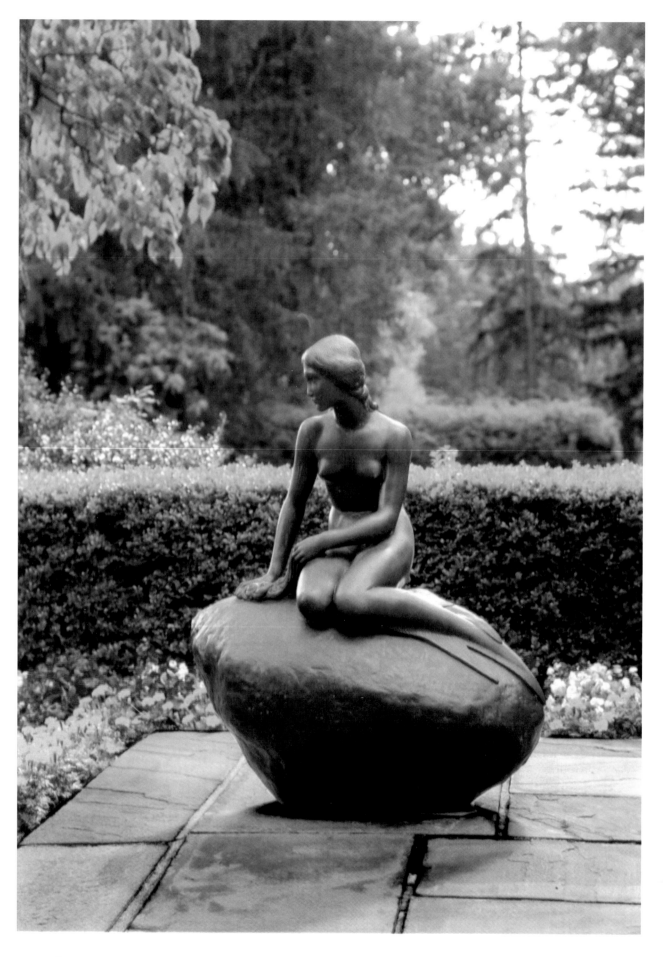

EDVARD ERIKSEN
1876–1959

135. *The Little Mermaid*
(Den lille havfrue)

Replica in half size after the original from 1910–1913

Patinated bronze, H. 96 cm

PROVENANCE: Bruun Rasmussen Auction 786, 2008, lot 24, ill.

LITERATURE: Jens Erik Sørensen (ed.), *Dansk skulptur i 125 år*, Copenhagen, 1996, p. 97; Per Eilstrup, *The Little Mermaid. Her Story, the Writer and the Fairy Tale,* Copenhagen, 1994; Egon Eriksen, *Edvard Eriksen og Den lille Havfrue – liv og kunst,* Copenhagen, 1998; Egon Eriksen, *The Little Mermaid of Copenhagen and Her Family,* Maribo, 2001; Christopher Bramsen, *Hans Christian Andersen's the Little Mermaid, From Fairy Tale to National Monument,* Copenhagen, 2010.

This figure is a smaller and later version of Eriksen's most famous sculpture, *The Little Mermaid,* from 1910–13. The subject is the mermaid from Hans Christian Andersen's well-known fairy tale, first published in 1837. It is about the fate of the youngest daughter of the sea king. At the age of fifteen, she is allowed to rise out of the ocean to admire the world of human beings while sitting on a rock in the moonlight. Here she falls in love with a beautiful young prince, whom she eventually saves from drowning in a shipwreck. Now she is tempted to become human and gain an immortal soul, this being possible only if someone falls deeply in love with her. If not, then she must die, her body dissolving into foam. She carries out her plan with help from a witch (by means of a magical drink), who demands her tongue in return for transforming her fishtail into two legs. The mermaid swims to the prince's palace, swallows the potion, and faints. When waking up with her new legs she is found by the prince, who takes her to his court, eventually spending a lovely time with her. Everyone admires her beauty and extraordinarily graceful dance. Although the prince is engaged to marry a neighboring king's daughter, he takes the mermaid with him on the ship sailing to her country. The princess is beautiful, but he mistakens the princess for the girl who saved his life, and their engagement is announced. The mermaid's heart breaks, and at sunrise the following morning, she hurls herself into the sea, where her body dissolves in foam. However, she does not die but is welcomed by the "daughters of the air." She is invited to join them to eventually gain an immortal soul doing noble deeds.

In the age of Romanticism, imaginative beings—such as mermaids and elfin maidens—inspired poets, painters, and choreographers as symbols of man's temptations. Hans Christian Andersen's mermaid is by far the most famous, and over the years, Eriksen's mermaid has become the symbol of Copenhagen. In 1989 Disney produced a popular animated movie based on Andersen's story, but the studio gave it a happy ending.

On a waterside promenade in Copenhagen, Eriksen's original bronze figure is mounted on a large granite stone amid similar stones. She longs for her sisters in the deep and thinks of the price she paid to become human. The statue was commissioned by Carl Jacobsen (1842–1914), founder of the Ny Carlsberg brewery in Copenhagen, who was famous as an art patron. He turned his vast private collection into a public museum, the Ny Carlsberg Glyptotek, dedicated to modern and ancient sculpture. Since then it has devel-

oped into one of the finest museums in Denmark, housing Danish Golden Age and French Impressionist painting as well.

The idea of the mermaid sculpture came to Jacobsen in 1909 as he attended a ballet at the Royal Theatre based on Andersen's fairy tale, choreographed by Hans Beck (1861–1952), with music by Fini Henriques (1867–1940). With the prima ballerina Ellen Price (1878–1968) in the title role, the ballet was a great success, performed more than 50 times. Jacobsen very much admired female dancers of whom he had commissioned earlier statues. In Elsinore, close to the castle of Kronborg, stands a fountain with several dancers by Rudolf Tegner (1873–1950), and a group statue of dancers by Carl Bonnesen (1868–1933) is at the Carlsberg Brewery in Copenhagen, both also commissioned by Jacobsen.

In the spring of 1910, Eriksen had a model in clay ready for Jacobsen to approve. However, Jacobsen was not content because she had legs, not a mermaid's fishtail. The sculptor did not entirely follow Jacobsen's demand but turned her feet into fins. Originally Eriksen wanted the dancer Ellen Price to be the model, but according to Eriksen's son, she refused to pose in the nude, so once again he chose his wife. By the fall of 1910, the figure was finished and cast in bronze the following year. Finally, it was placed at Langelinie, a walking promenade at the northern end of the old Copenhagen harbor, close to the Citadel. The festive inauguration took place on August 24, 1913, to Jacobsen's delight.

As the popularity of the mermaid statue continued to rise, Eriksen was often asked to make replicas, which he agreed to do, but only smaller than the original. His will stipulates that his heirs and descendants adhere to this decision. There are statuettes of a height of 10 inches in bronze and in porcelain, the latter produced by the Royal Danish Manufactory of Porcelain (Royal Copenhagen). In the 1930s, Eriksen allowed his original foundry, the firm of Lauritz Rasmussen, to produce it half size, which is about 39 inches. There are approximately 70 such casts, all made from the artist's original form, supervised by himself or later by his descendants. In the beginning, this version of the mermaid figure was mounted on a granite stone, but from the 1960s, the "stone" was cast in bronze, as is the case with the figure now in the Loeb collection. When Lauritz closed down in 1966 the casting of the mermaids was taken over by one of the firm's pupils, Holger Rolsted (1915–84), who had his own foundry beginning in 1945. As the Loeb figure bears The Rolsted stamp, it must be dated between 1966 and 1984. Eriksen also made a version in the format 4:5 for Osaka in Japan, which is placed close to the water. Quite small versions are sold as tourist souvenirs.

Today Eriksen's figure is not the only mermaid statue located on the Copenhagen waterfront. In 2006 Bjørn Nørgaard (*1947), known for the series of tapestries on Danish history in the palace of Christiansborg, made a modern, distorted version of the mermaid, placed not far from the original. In 2009, another mermaid appeared at the Copenhagen harbor, a bronze cast after the figure (in Statens Museum for Art) modeled in 1921 by Anne Marie Carl Nielsen (1863–1945), wife of the famous Danish composer Carl Nielsen (1865–1931). More true to Andersen's story, her mermaid is very young and with her big tail appears startled in the moment the transformation begins. Her presence outside the Royal Library's modern building (called "The Black Diamond") is because the library houses the first editions of Andersen's tales and the musical work of Carl Nielsen. According to old legends, mermaids were said to be frequently in the waters leading to Denmark's naval harbor.

E.F.

JOHAN JULIUS EXNER

COPENHAGEN 1825 – COPENHAGEN 1910

Julius Exner was born in Copenhagen and died there after a long and productive life in the service of national Romantic genre painting. His father was a musician, an immigrant from Bohemia. The son was apprenticed as a painter, and at the age of fourteen he was admitted to the Royal Danish Academy of Fine Arts. Here he followed instruction from 1839 to 1845 with the intention of becoming a history painter, training under professors J. L. Lund (1777–1867) and C. W. Eckersberg, among others.

The catalogues of the Charlottenborg exhibitions show that the young Exner started his artistic career as a portraitist and that historical compositions were his special interest. Thyra Danebod forsøger at formilde Gorm den Gamle i sin vrede mod nogle fangne kristne *(Thyra Danebod Attempts to Mollify Gorm the Old in His Anger with Some Captive Christians) was the title of his first major work in this latter genre. The title of the painting reveals that its creator had an early sense of narrative style with anecdotal features. The work was exhibited in 1849 and immediately purchased for the Royal Collection of Paintings.*

It might have been on this occasion that the art historian N. L. Høyen began to take particular interest in the young artist, turning the painter's attention to the special features of the farmers of Amager as a motif for a national genre painting. The fertile flat island of Amager in the Sound lies in continuation of Copenhagen. The island encompasses the districts of Christianshavn and Sundbyerne with Kastrup and Kastrup Airport in the north and the Taarnby, Store Magleby, and Dragør districts farther to the south. In 1521 the Danish king Christian II summoned Dutch farmers to Amager in order to have them cultivate Danish land. It was the naturalized descendants of these immigrants who, even in Exner's day, still dressed for festive occasions in beautiful traditional local dress and whose everyday lives differed little from what had always been known. From 1852 until as late as the 1870s, Exner found most of his motifs on Amager. In contrast to Dalsgaard, it was exclusively the lighter sides of life he portrayed. Often making some narrative point in his paintings, he was fond of picturing affluent farmers in well-furnished interiors or outside their delightful residences, dressed in beautiful, colorful Sunday clothes, engaged in friendly conversation or pursuing innocent pastimes.

In 1857–1858, having been awarded the academy's travel bursary, Julius Exner went via Dresden and Vienna to Italy and Switzerland, returning home via Paris. But apart from an atypical but interesting picture from Venice, 1859, En gondol *(A Gondola), Statens Museum for Kunst, the journey did not bring any decisive changes in his circle of motifs. At the beginning of the 1860s Exner visited Sweden on several occasions and painted a small number of genre scenes. But it continued to be the Amager farmers—and occasionally the population in the central Zealand Hedebo region—in which he was particularly interested. Then toward 1880, he focused on the little fishing community on the small island of Fanø in the North Sea near the German border.*

Compared with the earlier paintings, those from Fanø were often subdued, and the characterization of the figures was more searching. But the reproductions of national costume and of accurate details in original interiors continued unabated. It should be added here that the artists depicting everyday life in Denmark often based their portrayals of the homes and workplaces and the beautiful handmade furniture on many different visual impressions collected in sketchbooks and pieced together according to their intentions in the finished compositions. These were always executed in the painters' studios. Exactly the same was the case with the national Romantic landscape artists who took their most beautiful motifs wherever they were to be found and later placed them side by side in idealized portrayals of the Danish countryside.

Julius Exner was accorded various official distinctions during his long life as an artist. In 1847 he was awarded the Neuhausen Prize for a portrait of his sister, and in 1853 he received the Thorvaldsen Medal. He became a member of the Royal Danish Academy of Fine Arts in 1864 and was on the academy council from 1887. For twenty years Exner was an assistant in the Royal Danish Academy of Fine Arts Life School, and in 1876 he was appointed professor with an official residence in the academy. It is here we find the aging painter in the Loeb collection. In addition to his almost annual participation in the Charlottenborg spring exhibitions from 1844 to 1910, Julius Exner showed works in a multitude of other exhibitions both in Denmark and abroad.

Exner's idyllic scenes of everyday life were very popular far into the 20th century. He was a master of scenes with large numbers of figures, creating a coherence between the figures by means of the anecdote, just as he allowed local color to appear with several recurrent hues in order to create painterly cohesion in his works.

In addition to his many oil paintings, the artist left a large number of graphics and drawings. He also produced the illustrations for the poet Christian Winther's (1796–1876) Billeder og Vers (Pictures and Verses), which appeared in 1862.

S.L.

LITERATURE: Nicolaj Bøgh, Julius Exner, Navnlig Bidrag til hans Ungdomshistorie in Hver 14 Dag, vol. 1, Copenhagen 1895, pp. 385–395; P.V. Ørsted, Julius Exner, Copenhagen 1903; Th. B. (= N. Lützhøft), Hvad Exner fortalte in Julebogen, VII, 1908, pp. 45–68; Julius Exner, Smaa Kunstbøger, Copenhagen 1910; Marianne Zenius, Genremaleri og Virkelighed, Copenhagen 1976; Annette Stabell in Weilbach, vol. 2, Copenhagen 1994; Peter Nisbet, Danish Paintings of the Nineteenth Century from the Collection of Ambassdor John L. Loeb Jr., Harvard University Art Museums Gallery Series no. 8, Cambridge, Massachusetts 1994, p. 10.

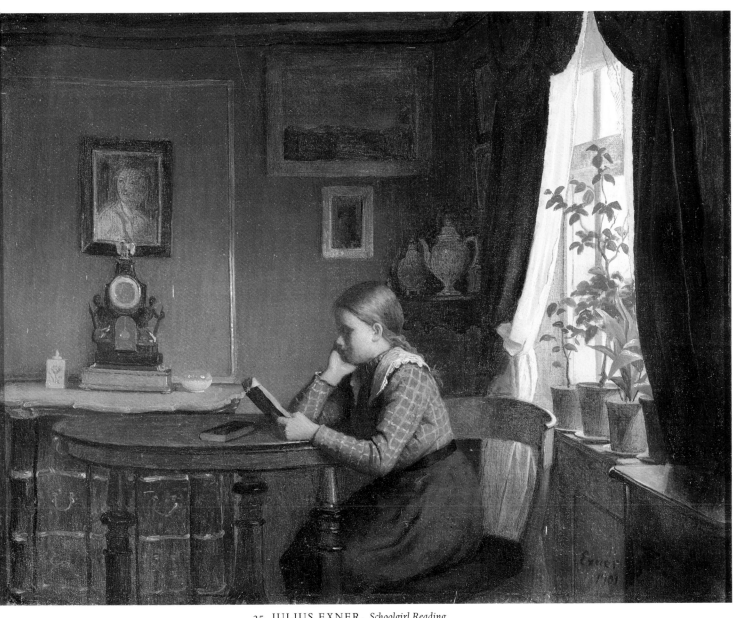

25. JULIUS EXNER, *Schoolgirl Reading*

JULIUS EXNER
1825–1910

25. *Schoolgirl Reading*, 1901
(Læsende skolepige)

Oil on canvas, 15 x 18½ in. (38 x 47 cm)

Signed and dated lower right: Exner 1901

PROVENANCE: The artist's estate auction, Charlottenborg 1911, lot 44; Hansen, Vejle (1911); proprietær (large landowner) Erik Juhl, Dalbygaard (1944–45); Bruun Rasmussen, Auction 552, 1991, lot 410, ill. (described as *Interiør med lille pige der læser med ryggen vendt mod vinduet*).

EXHIBITED: Busch-Reisinger Museum, Harvard University Art Museums, *Danish Paintings of the Nineteenth Century from the Collection of Ambassador John L. Loeb Jr.,* 1994, no. 5.

LITERATURE: Dorde Hansen in *Kunst i Privat Eje III.* 1944–45, p. 345 (discussed without indication of dimensions and without illustration); Peter Nisbet, *Danish Paintings of the Nineteenth Century, from the Collection of Ambassador John Loeb Jr.,* Busch-Reisinger Museum, Harvard University Art Museums, Cambridge, Massachusetts, 1994, p. 10.

Julius Exner is best known for his detailed anecdotal portrayals, often of large numbers of farmers and fishermen in their local costume on the island of Amager to the east of Copenhagen and the small island of Fanø in the North Sea close to the border with Germany. However, as this painting shows, he also mastered delicate studies of individual figures engrossed in their everyday work. The model seems to be the young girl Gudrun, who posed for the portrait from 1905, also in the Loeb collection.

Clear, gentle light from outside the tall window framed with curtains falls on green potted plants, envelops the tiny figure of a girl, caresses her shiny brown hair, and brings out the gilding on the furniture and moldings.

We are looking at a wealthy middle-class home—perhaps the artist's own. The inspiration from Netherlandish genre painting is plain to see.

S.L.

JULIUS EXNER
1825–1910

26. *Portrait of the 13-Year-Old Gudrun Reading*, 1905
(Portræt af den 13-årige Gudrun læsende)

Oil on canvas, 12½ x 9½ in. (32 x 24 cm)

Signed lower right: Exner 1905

PROVENANCE: Bruun Rasmussen, Auction 688, 2000, lot 1436, ill.

In 1882, Julius Exner exhibited a picture at Charlottenborg entitled *En lille pige læser sine lektier (A Little Girl Doing Her Homework)*. The whereabouts of this picture is unknown, nor do we have any information concerning its motif, materials, or measurements, and we do not know whether the child doing her homework in that painting was dressed in national costume.

However, shortly after the turn of the century, Professor Exner took up the motif again. A little girl engrossed in a book or deep in her own thoughts and holding the book in her hand appears repeatedly in the work of his later years. The model seems to be the same in each case, a girl called Gudrun. She figures in the two paintings in the Loeb collection, in which she is nine and thirteen years old respectively.

The figures in Julius Exner's numerous portrayals of everyday life all appeared in colorful local costume, intended to underline the national Romantic idea behind the picture. But Gudrun was painted wearing her own clothes and apparently always in the professor's residence at Charlottenborg, in the artist's own home, not only in his studio.

Who was Gudrun? We do not yet know. Her name has just come to public attention on account of the appearance of the present work. The reverse of the picture carries a penciled inscription: "Gudrun 13 år" (Gudrun 13 years old)—nothing else. Enquiries of the artist's great-grandson, a well-known Danish architect, confirmed the idea that a nine-year-old Gudrun was painted in the professorial residence but at the same time disproved the theory that she was a member of the family, not even a grandchild.[1] According to census returns, Gudrun was not a member of any of the other families then living in the Charlottenborg complex with the Kongens Nytorv 1 address.[2] And yet Gudrun must have been a frequent visitor to Julius Exner and his wife, Inger Henriette Sophie Jensine Ringsted, over a period of four or five years or more. The serious little girl in her warm winter dress and white school apron must have been a familiar and much appreciated model for the artist.

By way of contrast to the 1901 picture in which a great deal has been made of the interior in which she is sitting, Gudrun is here seen alone against a dark maroon background, which allows attention to be concentrated on her dainty figure and gives the viewer the opportunity of taking pleasure in the many carefully blended colors used, from the dust blue, olive green, and black harlequin pattern of the sleeves of her dress to her lustrous brown hair, which corresponds to the leather binding of the book. The shadows from the many folds in the apron and the exquisite work in it point the way to the fair

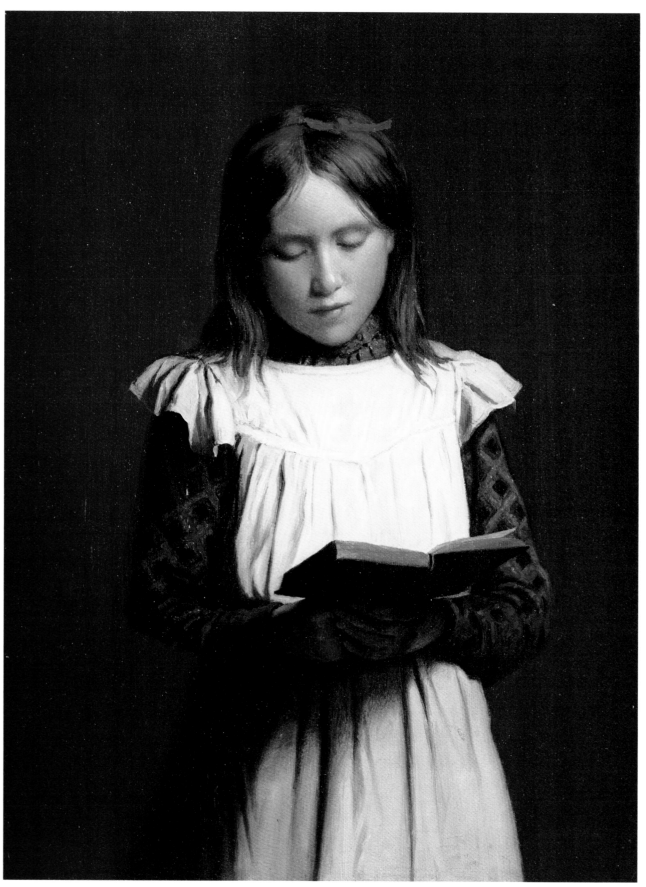

26. JULIUS EXNER *Portrait of the 13-Year-Old Gudrun Reading, 1905*

skin of her round, rosy-cheeked face. Her eyelashes and eyebrows are of the same brown as her hair, which is crowned by a narrow red ribbon tied in a bow at the top of her head. The artist's long experience of portraying figures in the exquisitely made national costume and his innate sense of the narrative quality of color does not fail him even when he is to reproduce the everyday dress of a little girl.

S.L.

[1] I am grateful to Professor Johannes Exner for this information.
[2] National Archives, Copenhagen.

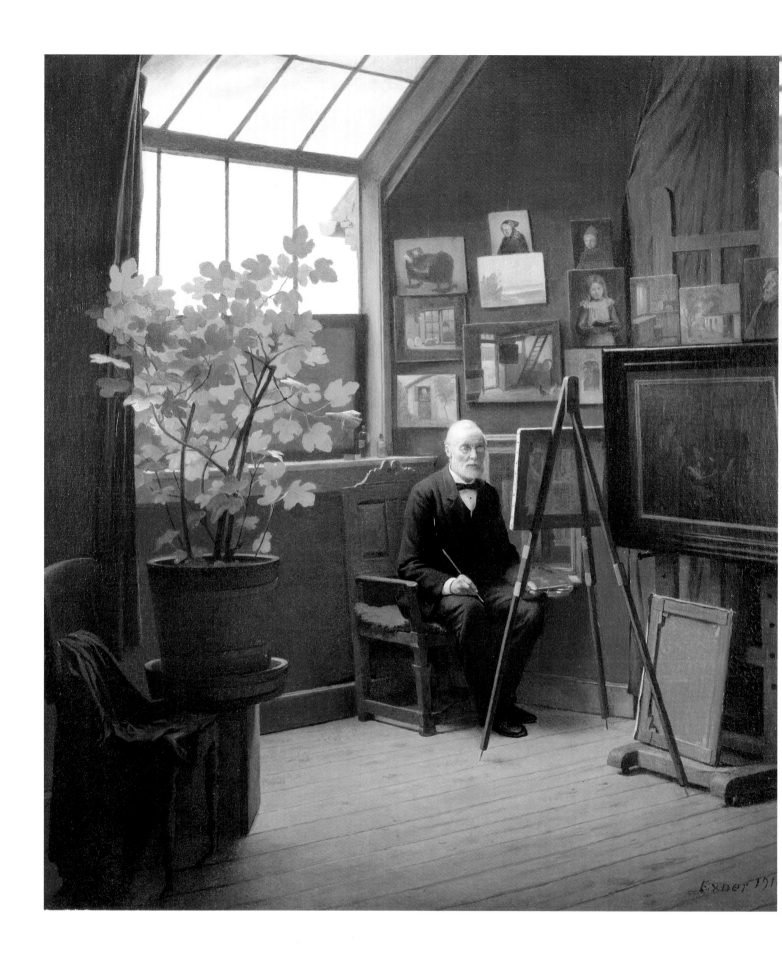

JULIUS EXNER
1825–1910

27. *Self-Portrait, the Artist's Last Work,* 1910
(*Selvportræt. Kunstnerens sidste arbejde*)

Oil on canvas, 26⅓ x 23½ in. (67 x 60 cm)

Signed lower right: Exner 1910

PROVENANCE: Artist's estate auction, Charlottenborg 1911, lot 86; Kunsthallen, Auction 256, 1963, lot 44, ill. p. 31; Bruun Rasmussen, Auction 552, 1991, lot 209, ill. (described as *Kunstneren i sit atelier*).

EXHIBITED: Busch-Reisinger Museum, Harvard University Art Museums, *Danish Paintings of the Nineteenth Century from the Collection of Ambassador John Loeb Jr.,* 1994, no. 6; Bruce Museum of Art and Science, Greenwich, Connecticut, and The Frances Lehman Loeb Art Center, Vassar College, New York, *Danish Paintings of the Nineteenth Century from the Collection of Ambassador John L. Loeb Jr.,* 2005, no. 31, ill.; Scandinavia House, New York, *Danish Paintings from the Golden Age to the Modern Breakthrough, Selections from the Collection of Ambassador John L. Loeb Jr.,* 2013, no. 10; Gargosian Gallery, New York, In the Studio, 2015.

LITERATURE: Annette Stabell in *Weilbach,* vol. 2, 1994, p. 266; Peter Nisbet, *Danish Paintings of the Nineteenth Century from the Collection of Ambassador John Loeb Jr.,* Busch-Reisinger Museum, Harvard University, Cambridge, Massachusetts, 1994, p. 10, ill.; Patricia G. Berman, *In Another Light, Danish Painting in the Nineteenth Century,* New York, 2007, p. 129, ill. p. 139.

When Julius Exner reached the age of eighty, he painted himself in his professorial residence in the Royal Danish Academy of Fine Arts, elegantly dressed in a suit and waistcoat, sitting by his easel in a corner of his studio beneath the large skylight.[1] Entitled *My Studio, the Artist's Self-Portrait,* the work was exhibited at Charlottenborg in 1906 (Fig. A), sufficient to convince everyone that the old artist was still very capable indeed.

This picture is less tall and somewhat wider than the one with the same motif in the Loeb collection. It provides a view of the spacious, high-ceilinged studio and immediately draws attention to a tub containing a luxuriant small fig tree, whose many light-green leaves reflect the clear daylight entering the room. The wall beside him contains an impressive array of his works, some on easels, some hanging side by side. One of them is *Portrait of Gudrun Reading,* in the Loeb collection. Receiving special attention is one of Exner's magnificently framed principal works from his late years, *The Music Lesson, Interior from Fanø School,*[2] which had been exhibited in Munich five years before.

In a dark corner in the left foreground there is a glimpse of some article of clothing, presumably the artist's smock, thrown across a high-backed armchair. The Eckersberg school's demand for minutely veracious reproductions of reality was still very much alive in an artist like Exner; it would not allow him to omit such an important detail as his artist's smock, which would have been part of his attire if he had not chosen to portray himself impeccably dressed in a suit.

Four years later, the year in which he died, Exner copied the self-portrait in the smaller version seen here, making certain alterations: the painter is now sitting with his back to the window so that the work he is painting on the easel can benefit from the best light. His dress is just as impeccable, and the smock is still there, this time on a more modest chair, because Exner himself is sitting in the armchair.

The room does not extend so much to the side as in the earlier picture, and it is more difficult to distinguish the motifs of the paintings on the wall. However, the small paintings at the top and bottom near-

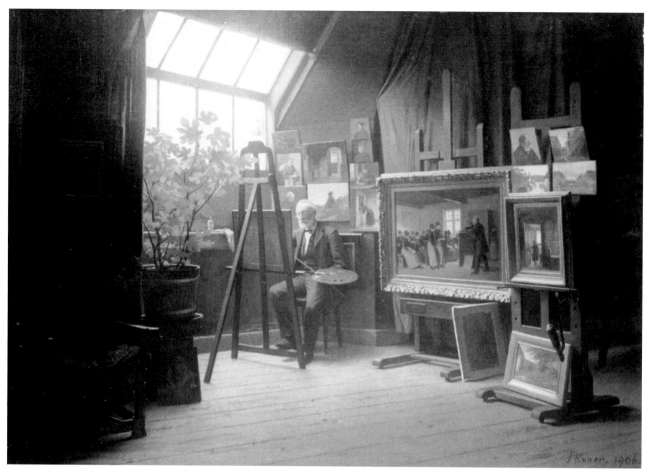

FIG. A *My Studio, the Artist's Self-Portrait*, 1906
Oil on canvas, 22¾ x 32¼ in. (58 x 82 cm), present owner unknown.

est the window are identifiable as *A Child in a Cradle*[3] and *Old Woman by a Half Door*,[4] pictures representing two very different stages in his life, the second of which had perhaps only just been finished. As in the earlier painting, the Loeb collection's *Portrait of the 13-year-old Gudrun Reading* is also identifiable.

This time, the large easel on the right holds a work exhibited in 1901 entitled *Young Lad Returning from the Hunt*.[5] It is an evening scene of a room in a farm in which the mother, grandmother, and younger sister are looking delightedly at the young son showing off his bag for examination and admiration. The fig tree looks bigger, but it has not grown. It still draws the light and retains it in its crown, as does the young hunter's mother as she holds the lighted paraffin lamp out toward her son.

The artist is given a less prominent role than four years previously, as though he is in the process of disappearing into his works.

<div align="right">S.L.</div>

[1]Julius Exner, *Min Malerstue, Kunstnerens Selvportræt*, 1906. Oil on canvas, 22¾ x 32¼ in. (58 x 82 cm), private collection. (Fig. A).

[2]*Musiktimen, Interiør fra Fanø skole*, undated. Oil on canvas, 28⅓ x 40¼ in. (74 x 102 cm), private collection.

[3]*Et barn i en vugge*, 1856. Oil on canvas, 9¾ x 12½ in. (25 x 32 cm), private collection.

[4]*Gammel kone ved en halvdør*, 1905. Oil on canvas, 9 x 11½ in. (23 x 29 cm), private collection.

[5]*Ung knøs vender hjem fra jagten*. Oil on canvas, 27⅓ x 37 in. (69 x 94 cm), private collection.

CARL RUDOLPH FIEBIG

ECKENFÖRDE 1812 – COPENHAGEN 1874

Carl Fiebig grew up in his native town on the Flensborg Fjord in the duchy of Schleswig in the southern part of Jutland in a quite productive artistic environment. His father was a painter, but Carl received his first instruction from his sister's husband, a well-known local portrait painter by the name of Hans Friedrich Baasch (1784–1853). After confirmation he was apprenticed as an artisan painter and continued his training as an artist when he entered the Royal Danish Academy of Fine Arts in Copenhagen in 1832. There he was taught portraiture by Professor J. L. Lund (1777–1867), and he left the academy after being awarded the minor silver medal. In 1837 he exhibited for the first time at Charlottenborg, where he continued to exhibit regularly until a few years before his death.

Fiebig immediately specialized in portraiture and became known and appreciated for the verisimilitude he was able to create on the canvas. On account of his modest prices, he also received many commissions. His style is detailed and meticulous and thus typical of that period, although more cautious in expression than is seen in other popular portraitists of the time, such as David Monies (1812–1894), August Schiøtt (1823–1895), and Andreas Hunæus (1814–1866). In its charm it can be reminiscent of Julius Exner (1825–1910). Fiebig's portraits can be seen in the Museum of National History at Frederiksborg Castle and in Jægerspris Palace, where his portraits of King Frederik VII and his consort, Countess Danner, hang. He also painted several altarpieces.

E.F.

LITERATURE: B.H. Feddersen, *Schleswig-Holsteinisches Künstler-Lexikon*, Bredstedt 1984; Kirsten Nannestad in *Weilbach,* vol. 2, Copenhagen 1994.

CARL FIEBIG
1812–1874

28. *Portrait of a Little Girl with Her Dog,* 1856
(Portræt af pige i blå kjole)

Oil on canvas, 29⅛ x 22 in. (74 x 56 cm)

Signed and dated bottom left: *Fiebig 1856*

PROVENANCE: Bruun Rasmussen Vejle, Auction 85, 2003, lot 12, ill.

We have here a three-quarter figure seen from the front of a little girl with brown eyes and light brown hair with golden highlights. She is smiling innocently and confidently at the beholder, embracing her dog, which is standing on a chair to the right and looking devotedly at her. She wears earrings and is dressed in a very elegant blue dress with a flounced skirt, blue-, white-, and red-striped trim, puff sleeves adorned with open-work white material and the blue, white, and red trim. At the neck, the dress is cut to reveal to the child's shoulders. There is fine lace around the edge, the same as that decorating the sleeves. The dog is a kind of spitz and wears a broad, decorated collar.

The portrait must have been a commissioned work, but the artist has nevertheless succeeded in giving it a universal character. As a result of the philosopher J. J. Rousseau's epoch-making ideas concerning the special nature of children, the portrayal of children had been a popular subject for painters since the end of the 18th century, as is typically seen in the work of Joshua Reynolds (1723–1792) in England. In Denmark, Jens Juel was the first to portray children's games and their spontaneity. The understanding of children continued to develop throughout the 19th century. Fiebig's portrait of this child was painted at the same time that Hans Christian Andersen (1805–1875) was writing fairy tales for children. Also at the same time, the painter and draftsman Lorenz Frølich (1820–1908)—a close friend of J. Thomas Lundbye and P. C. Skovgaard—was enjoying great success in Paris with his illustrated books for children.

We do not know the identity of the little girl in the portrait, but her appearance and dress make it clear that she belongs to the more affluent strata of society, the bourgeoisie or the nobility.

E.F.

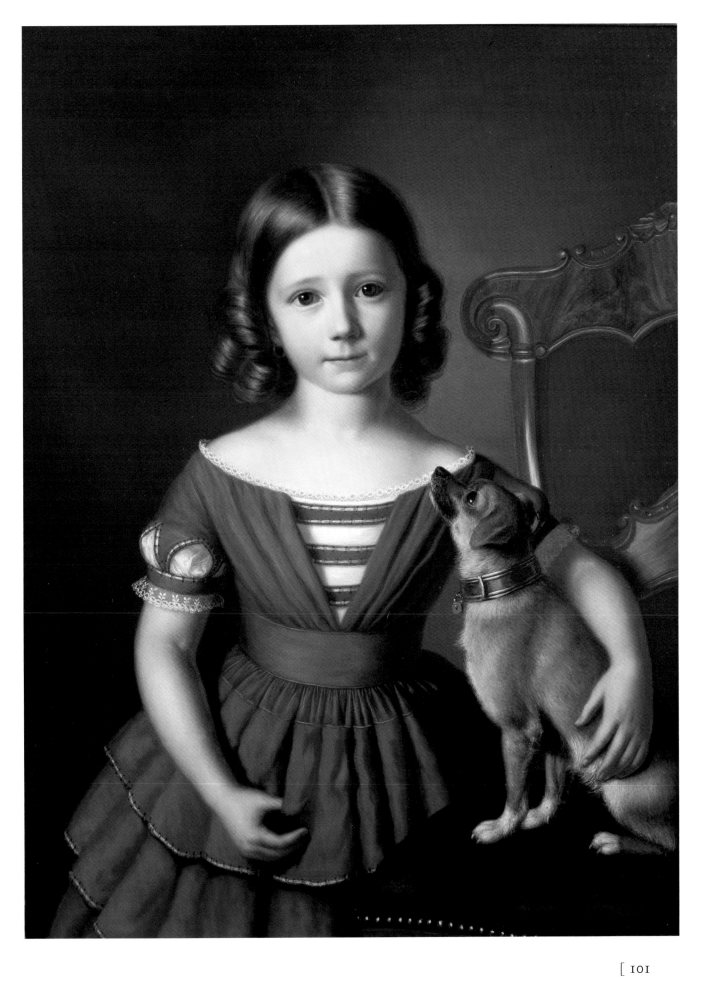

LUDVIG FREDERIK FIND

VAMDRUP 1869 – COPENHAGEN 1945

Ludvig Find hailed from Østerbygård near Vamdrup in the northern part of Southern Jutland. His father was a theologian and later became a parish priest. In the summer of 1885, Ludvig Find was apprenticed to an artisan painter and started at the Technical School that same year. Soon after this, he became a pupil at the Overgaard and Jensen Egeberg School of Drawing with the aim of being admitted to the Royal Danish Academy of Fine Arts in Copenhagen. He achieved this objective in April 1886.

The teaching in the academy, however, was a disappointment to the young Ludvig Find, as it was for so many of his contemporaries. After less than two years he applied to De frie Studieskoler under P. S. Krøyer, who for a time influenced him. However, Find quite soon started to react against Krøyer's naturalistic plein air painting. Nor was a period spent in Zahrtmanns Skole in November–December 1900 any help in fulfilling Ludvig Find's artistic ambitions.

About 1892 he turned his back on naturalistic genre painting once and for all and adopted a decorative Symbolist idiom inspired by the Danish pioneers of this style, Mogens Ballin (1871–1914) and Gad Frederik Clement (1867–1933). Find became enthralled with Paul Gauguin (1848–1903) and the group surrounding him, known as Les Nabis. He had become acquainted with their work through Ballin, who had learned French from Gauguin's Danish wife, Mette Gad, and was a visitor to her home. At the same time he established a close link with the poets associated with the literary period-ical Taarnet *(1893–1894), whose editor, Johannes Jørgensen (1866–1956), would later become a famous author; he was also an inspired and sensitive art critic with a lyrical, colorful flow of language well suited to the symbolist idiom. During the periodical's brief life at the beginning of the 1890s, Find, along with Mogens Ballin and the Dutch painter Jan Verkade (1868–1946), were its main suppliers of vignettes and illustrations.*

A journey to Italy, including visits to Florence and Venice in 1893–1894 undertaken together with the painters Carl Frydensberg (1872–1944) and G.F. Clement, was of great importance to Find. There his interest in Symbolist painting was reinforced, particularly as a result of his encounter with 15th-century Italian art. He was especially fascinated by the works of Piero della Francesca (c. 1420–1492), making copies of some of them. These efforts left their mark on Find's art, especially in the strangely inscrutable monumental portrait, 1897 En ung mand, Den norske maler Thorvald Erichsen (A Young Man, the Norwegian Painter Thorvald Erichsen), *in Den Hirschsprungske Samling.*

The journeys abroad were of crucial significance to Ludvig Find's artistic development, especially the visits to Paris in 1902 and 1904. There his art took a quite different turn as he followed the exam-ple of the former Nabis painters Pierre Bonnard (1867–1947) and Édouard Vuillard (1865–1940) and moved toward a colorful, light-filled neoimpressionist style of painting that he combined with his knowledge of the decorative play of lines and surprising cuts in Japanese woodcuts. With this, Find

had discovered his true form of expression, one of the first examples of which was the Loeb collection's Den ny hat (The New Hat). While continuing in this direction, he gradually discovered his own circle of motifs, which he continued to cultivate for the rest of his life. With his family and home as his preferred models, he painted landscapes, gardens, and children, "usually with great painterly zest and a sweet gracefulness which he retained in his art until late in life," commented Jens Peter Munk. In addition, he painted a considerable number of portraits, many of them children. Ludvig Find visited Paris again in 1907, and he was also in London that same year. In the spring of 1910 he made a short visit to Berlin.

Find made his first appearance at Charlottenborg in 1889 and exhibited there for the next four years and in 1896. From 1897 to 1945, Den Frie Udstilling was his forum. He became a member in 1898 and some years later was appointed to the exhibition committee. The list of the exhibitions in which Ludvig Find participated and the many grants and distinctions he received is long and distinguished. All that will be mentioned here is the award of the Eckersberg Medal, given to him in 1928.

Find was responsible for various works of illustrations. In addition he turned for a time to ceramics with Herman A. Kähler (1846–1917) in Næstved, and he produced designs for works in pewter for Mogens Ballin.

<div align="right">S.L.</div>

LITERATURE: Simon Koch in *Taarnet*, vol. 1, 1893–1894, pp. 22–30; Merete Bodelsen, *Ludvig Find*, Copenhagen 1943; Elof Risebye in *Samleren*, 1943, pp. 148–154; *Kunstnere omkring Taarnet*, Skovgaard Museum, Viborg 1976; Hanne Honnens de Lichtenberg, *Symbolismen i dansk kunst*, Nivaagaard 1993, pp. 35–43, 83; Jens Peter Munk in *Weilbach*, vol. 2, Copenhagen 1994; *Sjælebilleder, symbolisme i dansk og europæisk malerkunst*, Statens Museum for Kunst 2000.

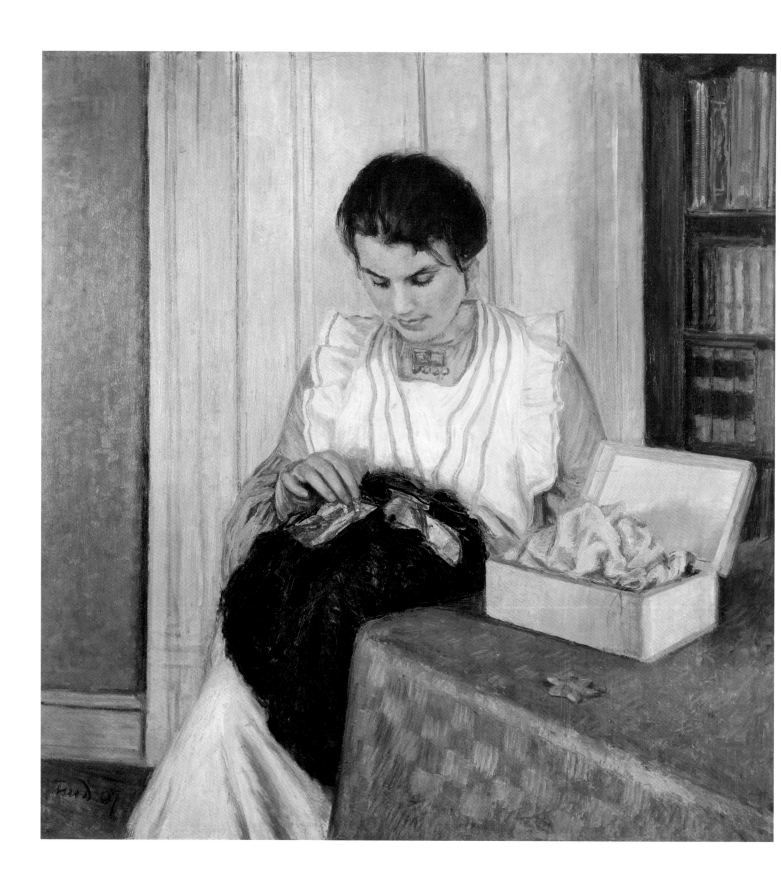

LUDVIG FIND
1869–1945

29. *The New Hat,* 1907
(Den ny hat)

Oil on canvas, 42½ x 41¾ in. (108 x 106 cm)

Signed and dated lower left: Find 07

PROVENANCE: Niels Lindeskov Hansens Kunstsamlinger; Bruun Rasmussen, Vejle, Auction 59, 1998, lot 44, ill. p. 28 (described as *Interiør med syende kvinde*).

EXHIBITED: Den Frie Udstilling, 1907, Tillæg, no. 224; Bruce Museum of Art and Science, Greenwich, Connecticut, and The Frances Lehman Loeb Art Center, Vassar College, New York, *Danish Paintings of the Nineteenth Century from the Collection of Ambassador John L. Loeb Jr.*, 2005, no. 30, ill.; Scandinavia House, New York, *Danish Paintings from the Golden Age to the Modern Breakthrough, Selections from the Collection of Ambassador John L. Loeb Jr.*, 2013, no. 11.

LITERATURE: Ernst Goldschmidt, Finds nye Portræt på Den frie Udstilling, *Politiken* 20.04. 1907; Merete Bodelsen, *Maleren Ludvig Find*, Copenhagen, 1943, p. 49; Elof Riesebye, Ludvig Find in *Samleren*, Copenhagen, 1943, p. 153.

The woman sewing is presumably Ludvig Find's wife, Maren Kirstine (Kirsten), née Clausen, who often sat for him. However, it was not the artist's intention merely to create a portrait. Whereas he had previously worked in a symbolist metaphor in which an involved and decorative play of lines formed part of an integral part of the picture and gave it an extra dimension, here he has been deeply concerned to liberate the color from the other devices and make it shine like a jewel. The motif does not have a serious underlying meaning. There is no action, let alone an anecdote; it is purely and simply a picture. To produce such works, Find almost always used his own relatives as his models and focused on everyday life in the home. In doing so, he had found his true means of expression.

The inspiration came from Paris, first from the French impressionists and then the neoimpressionists like Pierre Bonnard (1867–1947) and Édouard Vuillard (1868–1940) and from the Japanese woodcuts whose expressive lines appealed to the young Danish artist more than impressionism's dissolution of contours. In December 1906, Find held a one-man exhibition at Winkel & Magnussen's in which his colorful, French-inspired paintings occasioned surprise but brought success because their effect was one of "festive intensity," as one critic put it.

When the Loeb collection's woman sewing was exhibited in the Free Exhibition (Den Frie Udstilling) the following spring under the title of *Den ny Hat (The New Hat)*, it was this very painting that was the subject of an independent and very laudatory article in the newspaper *Politiken* by the young artist Ernst Goldschmidt, who had shortly before returned home from a time studying in Paris.

Under the title of "Find's New Portrait," the article began, "For its second hanging, Den Frie Udstilling (The Free Exhibition) has received a new painting by Find, portraying a lady decorating her hat. It is a picture which not only is the best Find has yet painted, but it is in general one of the best things the exhibition has produced this year.... A picture such as Find's latest portrait would attract attention anywhere in a major spring exhibition, in any city, even in Paris.... Find's picture is radiant with the colors of spring. There is a freshness and grace in the coloring, and the drawing is vibrant and poised. There is an air of pure youth about it. It unites graceful French suppleness and Danish sincérité...." (*Politiken*, 20.04.1907).

S.L.

JOHANNES AUGUST FISCHER

COPENHAGEN 1854 – COPENHAGEN 1921

August Fischer trained in the Royal Danish Academy of Fine Arts from 1869–1874 and was later a private pupil of P. S. Krøyer, but he never joined the period's rebels. He first painted a number of genre paintings, but gradually specialized in city views and found a splendid means of gaining an income by satisfying a demand from the public at large for decorative cityscapes from Denmark and abroad. He seems to have had a particular liking for cities with old houses and canals. In Denmark, these included the cathedral city of Ribe out in the far west of the Southern Jutland marshlands; in Germany, especially Hamburg and Nuremberg; in Holland, Dordrecht in the Rhine delta; and of course the most famous of all European canal cities, Venice.

Fischer showed for the first time at Charlottenborg in 1874, exhibiting there regularly until 1905 and then again from 1919 until his death. He took part in the major Scandinavian exhibitions in the 1880s and was represented in the watershed exhibition of Danish art in Copenhagen City Hall (Raadhusudstillingen) in 1901. Stylistically, his painting can be termed naturalistic, but as a painter of views, he represents a tradition in Western European painting aiming at a specific objective whereby reality stands outside the artistic trends of the time.

August Fischer was an older brother of the famous Paul Fischer, but nevertheless little is known of his life. He is represented in two Danish art museums, in Ribe and Århus.

E.F.

LITERATURE: Erik Mortensen, in *Weilbach*, vol. 2, Copenhagen 1994.

AUGUST FISCHER
1854–1921

30. *Canal Scene from Nuremberg, Pegnitzufer Near Spitalbrügge, Looking Toward the Synagogue, 1904*

(Kanalscene fra Nürnberg, Pegnitzufer ved Spitalbrügge, set mod Synagogen)

Oil on canvas, 17⅔ x 23⅓ in. (45 x 59 cm)

Signed and dated lower left: Aug. Fischer 1904

PROVENANCE: Arne Bruun Rasmussen, Auction 525, 1989, lot 87, ill. p. 11.

LITERATURE: Harald Hammer-Schenk, *Synagogen in Deutschland*, Hamburg, 1981; *Die Architektur der Synagoge*, catalogue, Deutsches Architekturmuseum, Frankfurt am Main, 1988.

The motif by the River Pegnitz at the center of old Nuremberg was one of which Fischer painted several variants. An old photograph from the place shows that the many picturesque houses on the right are correctly reproduced topographically. On the other hand, the area on the left, which seems to be situated on the island of Schütt, is different in this and another larger painting of 1891 (25⅖ x 36¼ in., or 64.5 x 92 cm), now in a private collection. Both the riverbank and the trees in the background differ in various respects. The spire on the left, seen in both, is part of the Heilig-Geist-Spital, founded in 1331.

A large building with a dome in the right background forms a contrast to the small burghers' houses with overhangs and external galleries. It is the city's synagogue, built 1864–1870 in German Romanesque style with A. Wolff (1832–1885) as its architect. The far side overlooks one of the central squares of the city, the Hans-Sachs-Platz. In that period, the Jewish communities in Germany manifested themselves with synagogues that in size and style—in this case historicism—could equal Christian churches and thus display the status they represented in the society of the day.

Before World War II, Nuremberg was one of the German cities with the greatest number of houses surviving from the Middle Ages and the Renaissance periods. Its huge significance for German history inevitably led the National Socialists to regard it as archetypically German and thus an important symbol, so in 1938 the synagogue was demolished to great popular jubilation. During the winter of 1945, 90 percent of the Old City of Nuremberg was destroyed in Allied bombing raids. The network of streets has been preserved, and many buildings have been reconstructed, but not this site, where a students' hall of residence now stands. So August Fischer's painting reproduces an idyll that today has been lost.

Aarhus Kunstmuseum owns a smaller, but beautifully finished, picture of Nuremberg by Fischer (inv. no. 289, 11 x 14½ in., 28 x 37 cm), a bequest from the prominent Århus merchant and margarine manufacturer Otto Mønsted (1838–1916). It is dated 1896 and shows a different view of the river, with the characteristic houses and a woman washing clothes in the river water.

E.F.

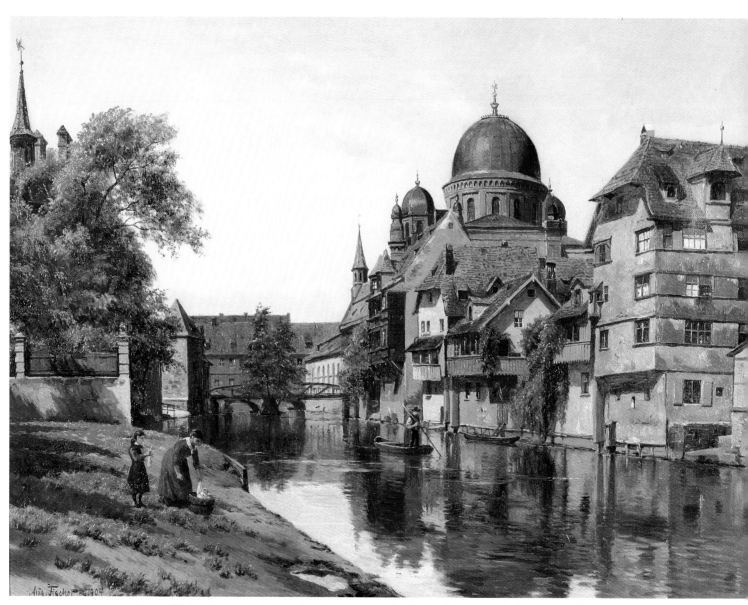

30. AUGUST FISCHER, *Canal Scene from Nuremberg, Pegnitzufer Near Spitalbrügge, Looking Towards the Synagogue*, 1904

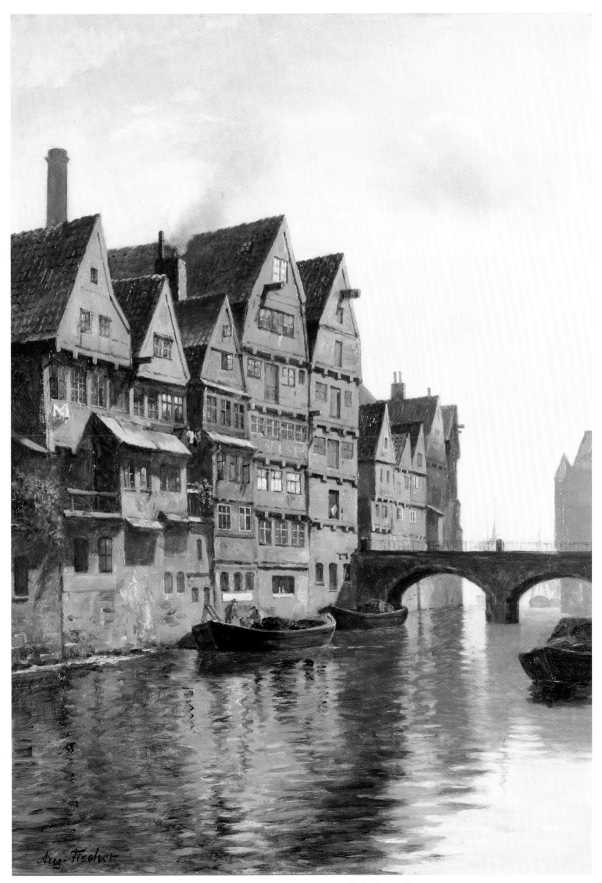

31. AUGUST FISCHER, *Canal View, Küterwallsfleeth, Hamburg*

AUGUST FISCHER
1854–1921

31. *Canal View, Küterwallsfleeth, Hamburg*
(Kanalparti, Küterwallsfleeth, Hamburg)

Oil on canvas, 24¾ x 17⅔ in. (63 x 45 cm)

Signed lower left: Aug. Fischer

PROVENANCE: Arne Bruun Rasmussen, Auction 532, 1989, lot 533, ill. p. 238; Bruun Rasmussen, Auction 538, 1990, lot 611, ill. p. 204.

According to an inscription on the reverse, this idyllic painting represents Küterwallsfleeth at the heart of Hamburg, a canal that continues Admiralitetsfleeth close to the old city wall and the Binnenalster, and is situated about halfway between the old city churches dedicated to St. Nicholas and St. Michael. We are looking toward Alsterfleeth, and the tall building in the background is probably the city hall. In this part of Europe it is the traditional custom to place the houses with their gables facing toward the street. As one of the Hanseatic cities, Hamburg has since the Middle Ages been an important center for trade and transshipment. Later, too, the city was characterized by merchants' houses like these, with space for the storage of goods.

During World War II, Hamburg harbor and the central parts of the city were destroyed by Allied bombing, which was at its worst in 1943. Rebuilding after the war meant a radical replanning of the city, with the establishment of wide streets, the filling of canals, and the construction of huge office blocks. Meanwhile, it seems from older maps that the houses in Küterwallsfleeth were already demolished sometime before this. The name exists today as a street name.

E.F.

PAUL (POUL GUSTAV) FISCHER

COPENHAGEN 1860 – GENTOFTE 1934

Paul Fischer was one of a group of painters who, from the 1880s, started to portray modern life as seen in both town and country. Among the Nordic painters his work especially resembles are P. S. Krøyer, the Finnish Albert Edelfelt (1854–1905), and the Swedish Hugo Birger (1854–1887), in addition to the Henningsen brothers. He learned the painter's craft from his father, who was both an artist and craftsman painter, and he trained for a brief period in the Royal Danish Academy of Fine Arts. In 1882 he experienced success with some illustrations for one of the cultural periodicals of the time, and in 1884 he made his first appearance at Charlottenborg. Among his early major works are Østergade, juletravlhed på Strøget *(Østergade, Christmas Shopping in Strøget), 1886,* I Det Kongelige Teater *(In the Royal Theatre), showing familiar Copenhagen figures in the auditorium, and* Mågerne fodres på Dronning Louises Bro *(Feeding Gulls from the Queen Louise Bridge).*

Paul Fischer became famous as the result of a number of scenes of Copenhagen, which formed the basis of his public success. Although he was admired and used as an illustrator, revealing an original creative talent as a poster artist, he was not in his day reckoned among the true naturalist artists of the Modern Breakthrough. His paintings were not bought by the art museums, which preferred the very similar portrayals of Copenhagen by Erik (1855–1930) and Frants Henningsen (1850–1908). Nevertheless, Fischer's work achieved high prices in his day. Interest declined after his death, but in the mid-1980's, the public again became aware of his work, not only in Denmark but abroad.

Paul Fischer took most of his motifs from the heart of Copenhagen. His pictures of the city are usually populated with a large number of figures, including people buying from the tradespeople in the street, the ladies often being portraits done to order. After 1900, Fischer painted a fair number of pictures of bathers on the north coast of Zealand, which seen in the moral light of the time must be said to be rather daring. Fischer learned photography and left some 5,000 photos (Copenhagen City Museum), which to a considerable extent provided the direct foundation for the street scenes and figures in his pictures. Using photographs in this way was a method that in Denmark was considered too easy a shortcut to achieving a result, so artists did not discuss the matter in public.

Most of Paul Fischer's extensive oeuvre is in private collections. Of his work in public collections, mention should be made of I Glyptoteket på Ny Carlsberg, 1887 *(In The Glyptotek at Ny Carlsberg), painted at about the same time as P. S. Krøyer's interior from the same place (now in the Carlsberg Museum, Copenhagen). In addition, Fischer's painting from 1906 of* Christian IX Announcing to the Deputation from the Norwegian Storting His Agreement to Prince Carl Assuming the Norwegian Throne, *is not much inferior to Laurits Tuxen's work in its solution to a large and complicated undertaking. It is now in the Royal Palace in Oslo. A smaller replica was commissioned for the Museum of National History at Frederiksborg Castle in Hillerød. Copenhagen City Museum has acquired a number of works by Paul Fischer over recent years.* E.F.

LITERATURE: Helge Carlsen, Erik Mortensen, *Billedmageren Paul Fischer*, Copenhagen 1991; Erik Mortensen in *Weilbach*, vol. 2, Copenhagen 1994.

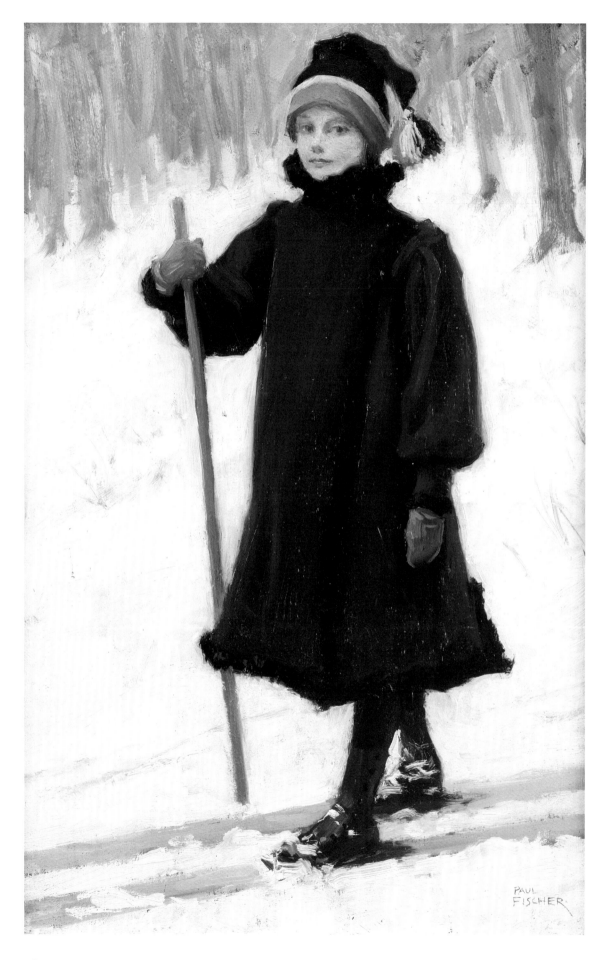

PAUL FISCHER
1860–1934

32. *Harriet Skiing* (early 20th century)
(Harriet på ski)

Oil on panel, 11¾ x 7¾ in. (30 x 20 cm)

Signed lower right: Paul Fischer

PROVENANCE: Presumably identical with *Harriet paa Ski,* Auction, *Paul Fischer* Charlottenborg 1.2.1904, lot 47 (12 x 8 inches or 30.2 x 20.08 cm, purchased by a tailor by the name of Ibsen); Arne Bruun Rasmussen, Auction 452, 1983, lot 60 (described as *Lille skiløbende pige*).

EXHIBITED: Bruce Museum of Art and Science, Greenwich, Connecticut, and The Frances Lehman Loeb Art Center, Vassar College, New York, *Danish Paintings of the Nineteenth Century from the Collection of Ambassador John L. Loeb Jr.*, 2005, no. 27, ill.

When outdoor activities came into fashion at the end of the 19th century, the bourgeoisie went in for sports in both winter and summer. This painting can be viewed as a document of cultural history, illustrating skiing before real sports clothing was developed. The girl is Harriet, the artist's eldest daughter, born of his first marriage to Norwegian-born Dagny, daughter of Oslo art dealer Julius Frederik Grønneberg and Hulda Tegner. Hulda Tegner was the cousin of two idiosyncratic and distinguished Danish artists, the illustrator and porcelain artist Hans Tegner (1853–1932) and the controversial symbolist sculptor Rudolf Tegner (1873–1950).

Harriet's posture and cheerful expression suggest that she was already a skilled skier, but it is not possible to determine whether the picture was painted in Norway, where the opportunity for skiing exists throughout the winter, or in Denmark, where it is impossible to predict when there will be snow. Deer Park at Jægersborg to the north of Copenhagen was at that time the skiing area most frequently used by the people of Copenhagen.

Harriet was born in 1890, which dates this painting to the beginning of the 20th century. Fischer often used her as his model, as he did with the rest of his children. The artistic gifts she inherited from both her parents later led her to a professional career as a painter, first exhibiting in 1911. During the following years, she exhibited together with her father at Båstad in Sweden. From 1915 to 1920 she studied at the Royal Danish Academy of Fine Arts in Copenhagen and also received instruction in Paris and Madrid; this led her away from artistic life in Denmark, where she never really made a name for herself.

E.F.

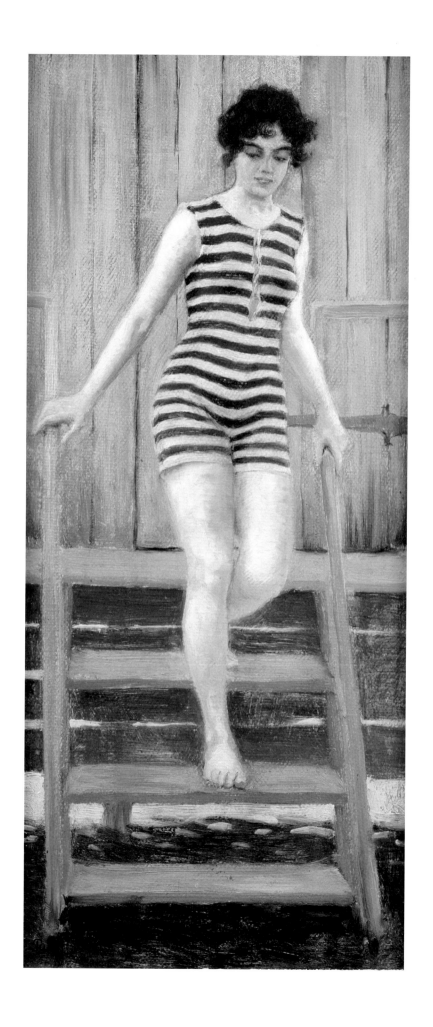

PAUL FISCHER
1860–1934

33. *Woman in Bathing Suit, sketch*, after 1905
(En badepige, skitse)

Oil on canvas, 15¾ x 7 in (40 x 18 cm)

Signed bottom left: Paul Fischer

PROVENANCE: Bruun Rasmussen, Auction 682, 2000, lot 1610, ill.

As a preparatory work for larger paintings, Fischer photographed his models and then often painted a study such as the present one.

At the end of the 19th century, medical science discovered the beneficial effect on health of the sun, fresh air, and seawater, and the middle classes flocked to the countryside in the summer. Concepts such as holiday and open-air life emerged and gave rise to new motifs. Although the strict rules of the day for social behavior, dress, and etiquette could be relaxed out in the country during the summer, morals required bathing costumes that were decorous in the extreme when seen with present-day eyes, and in many places men and women swam separately. Nevertheless, it was to a great extent due to sports and outdoor life that views on morals changed fairly rapidly after 1900 and made it possible for Fischer to paint and enjoy success with pictures of girls both without and, as here, with bathing suits.

The art historian Erik Mortensen has pointed out the connection between this type of picture and the philosophical movement known as vitalism, the best known representatives of which in Denmark are the painter and sculptor J. F. Willumsen (1863–1958), the sculptor Kai Nielsen (1884–1924), and the author and Nobel laureate Johannes V. Jensen (1873–1950).

E.F.

SVEND HAMMERSHØI

FREDERIKSBERG 1873 – FREDERIKSBERG 1948

The artistic reputation of painter, ceramist, and designer Svend Hammershøi has been overshadowed over the years by that of his more famous brother, Vilhelm, nine years his senior. The artistic quality of Svend's work is indisputably fine, but the disparity in fame may be explained—at least in part— because he was even more reclusive than his brother. Like Vilhelm, he was a very private person, having only a few close friends outside his family circle, to which he was deeply attached. Svend never married, never moved from his mother's home, and even after her death in 1914 went on living there with his sister Anna for the rest of his life.

Surprisingly, Svend Hammershøi's work had greater recognition than that of Vilhelm's during his own lifetime, but that recognition was primarily for the younger brother's work as a designer, not for his painting. Until recently, only a small group of connoisseurs have appreciated and collected his paintings. Among those few was C. L. David (1878–1960), founder of The David Collection Museum in Copenhagen.

On the other hand, Hammershøi's achievements as an inventive ceramicist and silver designer have enjoyed flattering attention from museums and have been the subject of several studies, such as the one in Tove Jørgensen's 1990 exhibition catalogue. In recent years, his artistry in these fields has been featured in several exhibitions, bringing increased interest to his work.

Hammershøi's education was diverse and thorough. In 1889, at the age of sixteen, he spent a year at the Technological School, where his teacher, the painter Holger Grønvold (1850–1923), was instrumental in developing his technical skills. Svend then trained as a painter at the Royal Danish Academy of Fine Arts from February 1890 until the winter of 1892, receiving guidance from his brother Vilhelm in the same period. Soon afterward, he was accepted in the circle of author Johannes Jørgensen (1866–1956), who with his journal Taarnet *(The Tower) defined symbolism in Denmark.*

From 1892 to 1896, Svend attended Zahrtmann's School, one of Denmark's independent art schools, where he grew as an artist and participated in student exhibitions. With the idealism typical of the 1890s, he and his comrades at that school formed an artist group called The Hellenes. At Refsnæs, a scenic region in the western part of the island Zeeland, they sought to demonstrate antique Greek ideals by uniting art with improvement of the body through athletics. This artistic fraternity is an early example of the cultural movement that in Denmark is called "vitalism." Among other principles, the followers focused on the healthiness, beauty, and force of natural life liberated from the restrictions of civilization.

In the same period Svend began working with ceramics at (among other places) Kähler's famous factory in Næstved, where he served as an aide to the designer Thorvald Bindesbøll (1846–1908). Svend Hammershøi was among those who propelled the great interest in decorative art and artistic craftsmanship of the 1890s into the twentieth century.

Over the years, Svend Hammershøi exhibited his work in the Den Frie udstilling (The Free Exhibition) side by side with that of his brother Vilhelm. Svend's connection to the most important artists in the avant-garde represented by the Free Exhibition can be seen in his inclusion in his brother's monumental painting Five Portraits (1901, Thielska Galleriet, Stockholm, Sweden). In this picture, he sits with the critic Karl Madsen, the architect and designer Thorvald Bindesbøll, and the painter and sculptor J. F. Willumsen (1863–1958).

Svend Hammershøi's first paintings were strongly influenced by the symbolist movement, for example, a picture of the coast of Refnæs (1904, Nationalmuseum, Oslo). But within a few years he had found his own mode of expression through architectural paintings, where the interaction between the leafless trees, historical buildings, and claire-obscure (use of marked differences in light and dark, providing a dramatic effect) are dominating features. While Vilhelm mainly painted interiors and chose perpendicular perspectives, Svend often used an inclined perspective.

As had Vilhelm, Svend became very fond of England. In the years from 1907 to 1933 he painted intensively there, especially in Oxford and in Wells, interrupted only by World War I. The Gothic buildings appealed to him, and in the paintings, he created in England we see many different, yet related motifs: tight composition, subdued color scale, and blurred outlines. Stairs and sculptural details are often dominating elements, and the atmosphere he evokes clearly shows the influence of symbolism. Svend Hammershøi won recognition in London with exhibitions at the Royal Institute of British Architects in 1929 and at the Royal Academy in 1931.

Svend Hammershøi did architectural painting in Denmark and, primarily in the winter months, painted the castles of Kronborg, Rosenborg, Frederiksborg and the ruins of Koldinghus, Kolding in Jutland. Besides the castles, he also painted several old churches in Copenhagen, Nikolaj, Vor Frue, Trinitatis, and Sankt Petri. (His brother Vilhelm also painted several of these churches.) Svend Hammershøi's paintings are to be found mostly at the Museum at Koldinghus, but he is also represented at the Statens Museum for Kunst in Copenhagen.

An important part of Svend Hammershøi's oeuvre is his decorative art. For a brief period in the 1890s, he was one of the artists prestigious enough to sign his work at the Royal Porcelain Manufactury (today "Royal Copenhagen"). Five of his pots represented the company at the 1900 World Fair in Paris, and one was sold to the Musée National du Céramique in Sèvres. Later on he worked at Bing and Grøndahl's, designing and decorating ceramics, an art form extremely important to him. In 1910 he renewed collaboration with Kähler, creating a series of original works, some of which were displayed in the Danish Museum of Decorative Arts in 1916. These were unglazed red clay pots with very detailed pictures of plants, as well as pots with asymmetrical rims. In the 1930s, part of his work was decorated with Kähler's trademark: black and white speckles and a softened glaze. Svend Hammershøi's ceramic work is well represented at Næstved Museum, located close to the Kähler factory.

Some of Svend Hammershøi's ceramic shapes were rendered in silver by the goldsmith Holger Kyster (1872–1944) in Kolding. A connection between the two was established in 1906, initiated by Thorvald Bindesbøll. The collaboration lasted until the mid-1920s, with Hammershøi creating mod-

*els for silver objects for domestic use, such as jars, and cups. They were much influenced by art nou-
veau, with leaf ornamentation the most characteristic feature. At the 1925 World Exhibition in Paris,
Hammershøi and Kyster were awarded gold medals. Kyster left his collections to the Museum on Kold-
inghus, which included a wide representation of Svend Hammershøi's decorative art.*

E.F.

LITERATURE: Tove Jørgensen, *Svend Hammershøi 1873–1948, maler og formgiver*, Museet på Koldinghus 1990; Hanne Honnens de Lichtenberg, *Hellenerne på Refsnæs* in Svend Eriksen et al. (eds.), *En bog om kunst til Else Kai Sass*, Copenhagen 1978, pp. 399–412; Hanne Honnens de Lichtenberg in *Weilbachs Kunstnerleksikon*, vol. 3, Copenhagen 1995; Anne-Mette Villumsen et al. (eds.), *Svend Hammershøi, en kunstner og hans tid*, Skovgaard Museet, Viborg 2008; Gertrud Hvidberg-Hansen, *Hellas under nordlig himmel* in Gertrud Hvidberg-Hansen and Gertrud Oelsner (eds.), *Livslyst, sundhed, skønhed, styrke i dansk kunst 1890-1940*, Odense 2008, pp. 159, 160, 162.

136. *A View from the Stock Exchange of Copenhagen*, 1944

(Udsigt fra Børsen)

Oil on canvas, 34½ x 28½ in. (90 x 75.5 cm)

Signed bottom right with initials and dated: 44

On the stretcher: Half of the label from the Charlottenborg exhibition signed by the artist followed by "u. c." (not subject to censorship).[1]

PROVENANCE: Bruun Rasmussen and Børge Nielsen, Vejle, Auction 3, 1990, lot 482; Bruun Rasmussen, Vejle, Auction 113, 2008, lot 369, ill.

EXHIBITED: Charlottenborg 1945, no. 129 (described as *Udsigt fra Børsen, 90 x 75, 2500 Kr.*).

It was typical of Svend Hammershøi to choose a motif from central Copenhagen on a dark winter day—and to give dramatic dominance to black leafless trees. This painting is therefore an excellent representative of his work. From his early years, architecture was also a favorite motif, and in Copenhagen he had an abundance of old buildings he could choose to paint. His artistic eye was frequently attracted by towers, spires, and other historical details dating from the Middle Ages, the Renaissance, and the Baroque period. Unlike many artists who like to paint on bright sunny days, Hammershøi preferred the dark Nordic winter months, when daylight is sparse and colors are few.

At the left in this painting we see a row of trees growing alongside the ramp leading to the main hall of the Stock Exchange, a stately Renaissance building that stands behind the painter and is therefore not in the picture. The base of the ramp is seen at the bottom of the painting, and at the lower end is a statue of Mercury. From his position at the top of the ramp, just in front of the Stock Exchange, the painter had a fine view of the main facade of the Palace of Christiansborg, with its tower rising behind the tops of the trees.

This area of the Danish capital is of major importance in its history. The palace stands on the islet opposite the old strand of Copenhagen where a canal bordered with town houses can be glimpsed at the far right in the painting. The fortified castle was built late in the 12th century by Bishop Absalon, considered to be the founder of Copenhagen. In the 15th century the Danish king Erik af Pommern took it over, and during the following centuries it was periodically repaired and/or reconstructed by later Danish kings. In the 1730s, the Copenhagen Castle was torn down to give place for the first Christiansborg Palace, a symmetrical construction in Baroque style, named after the king, Christian VI. This was destroyed by fire in 1794 but rebuilt in the early 19th century in neoclassical style by Christian Frederik Hansen (1756-1845). Unfortunately, in 1884 the second palace also burned down. However, the domed chapel of the second palace survived and was added to the third palace (which is the one Hammershøi painted), built on the same site as the previous two. The salvaged dome is visible in the painting at the lower right of the palace facade.

The Christiansborg Palace once served as the residence of the Danish kings, but after the devastating fire of the first palace in 1794 and the royal family's evacuation to the Amalienborg palaces, the royals have continued to live there from then on. Today's impressive concrete and granite edifice, designed by architect Thorvald Jørgensen (1867-1946) and erected at the beginning of the 20th century, is the seat of the Danish

136. SVEND HAMMERSHØI *A View from the Stock Exchange of Copenhagen*, 1944

government. The sumptuous rooms are beautifully adorned and are used for official occasions and royal receptions.

Svend Hammershøi chose a dark and cloudy day to paint a fine impression in claire-obscure of Denmark's long winter darkness. The electric light visible in the facade windows adds a touch of warmth to the otherwise chilly atmosphere. The color scale is subdued, limited to black, gray, brown, and a bit of clear blue in the sky, where the clouds permit it. Without rendering every detail, his brush convincingly characterizes the trunks and branches of the trees, as well as the sandstone of the ramp and the many-storied palace.

Stylistically the painting belongs to the 1890s more than to the 1940s, and there is a likeness to the art of his brother Vilhelm. Svend Hammershøi confidently pursued this artistic mode, which he found in the beginning of the 19th century and continued painting in for the rest of his life.

<div align="right">E.F.</div>

[1]Censorship of works of art proposed for the annual exhibitions at Charlottenborg was established to guarantee an acceptable artistic quality.

VILHELM HAMMERSHØI

COPENHAGEN 1864 – COPENHAGEN 1916

Vilhelm Hammershøi showed himself from the start to be an independent and distinctive artistic personality. He made his first appearance in 1885 with Portrait of a Young Girl, *a painting of his sister Anna, now in the Hirschsprung Collection. The outline is blurred and the color reduced to shades of gray in which are mixed hints of green, yellow, and red that closer examination shows to be a profusion of color. Seen through the eyes of that time, it was in motif, color, and technique unusually unostentatious in its simplicity, but despite its subdued expression it possessed an unaccustomed assertive force. Hammershøi's originality and talent amazed the modern artists of the time, who caused a stir by sending the Royal Danish Academy of Fine Arts a letter of protest when the portrait was not awarded the Neuhausen Prize.*

The following year, painter and critic N. V. Dorph (1862–1931) described Hammershøi prophetically as consciously representing something new:

> It is typical of both the most recent literature and the most recent art that the moods treated are predominantly gloomy, or perhaps it is the poetry of monotony that is presented. The fine, delicate grayish colors and the subdued, cool tones in a treatment about whose floating, gentle character there is an almost unhealthy wistfulness, a kind of controlled melancholy that stands in the sharpest contrast to the bold, full use of the brush and the jovial, resplendent colors used by the painters of the Breakthrough.[1]

Soon afterward, Hammershøi began painting architecture, and with this his range of motifs, forms of expression, and painterly preferences were fixed in all their essentials.

Hammershøi grew up in the security of a bourgeois Copenhagen family and enjoyed understanding and encouragement from his mother, who at an early stage ensured good art instruction for him. He lived during a time in which the traditions inherited from the Golden Age and C. W. Eckersberg were still very much alive. Hammershøi attended the academy for five years from around 1880, but it was in De frie Studieskoler he received the crucial equipment that enabled him to follow an independent course of development. His work amazed his teacher P. S. Krøyer, who found both him and his art rather odd, but he was wise enough not to try to persuade him to change tack.

It can be seen from Hammershøi's paintings that even at an early stage he was profoundly conversant with older art, especially that of 17th-century Holland. This was well represented in Copenhagen in the Royal Collection of Paintings in Christiansborg Palace (subsequently Statens Museum for Kunst) and the private Moltke Collection, both of which had already been of great significance to the artists of the Danish Golden Age. The Royal Collection of Prints and Drawings was also accessible to the young artist and provided a rich source of inspiration. Hammershøi continued his studies during visits abroad: to Germany in 1885, to Holland and Belgium in 1887, and to Paris in 1889, where he was represented in the World Fair by four of his paintings. They made such an impression

on the far-sighted French critic Théodore Duret (1838–1927) that Duret visited Copenhagen the following year to see more.

Hammershøi's highly developed visual talents allowed him quickly and effortlessly to perceive the essential qualities in both older and more recent art. His preference was work of simplicity in composition and artistic effects, especially ancient Greek art, the Dutch artists Vermeer van Delft (1632–1675) and Pieter de Hooch (1629–1683), and among the moderns James McNeill Whistler (1834–1903), a reproduction of one of whose paintings had attracted his interest in 1883. Sympathetic insight and enthusiasm, however, he was well able himself to exploit for his own purposes.

Two major events took place in 1891. He married Ida (1869–1949), a sister of the painter Peter Ilsted, whom he frequently used as his model. And he became a cofounder of Den Frie Udstilling, with which he remained for the rest of his life. A contributory reason for the establishment of this first alternative periodic exhibition was that his painting Syende ung pige (Young Girl Sewing) had been rejected by the Charlottenborg exhibition in 1885.

Accompanied by Ida, he spent considerable time in Paris, then proceeded to Tuscany, where he became familiar with Florentine art. After this experience, Hammershøi painted three ambitious figure paintings, Artemis, 1893–1894 (Statens Museum for Kunst), Tre unge kvinder (Three Young Women), 1895 (Ribe Kunstmuseum), and Fem portrætter (Five Portraits), 1901–02 (Thielska Galleriet, Stockholm), important works that are still the subject of a great deal of discussion. Though he produced relatively few large-scale compositions, Hammershøi painted a large number of simpler pictures, portraits, landscapes, and interiors before his death in 1916 at the age of only 51. Thanks to his participation in the major Scandinavian and international exhibitions in Berlin 1891, St. Petersburg 1897, the London Guildhall 1907, Brighton 1912, and New York the same year, there was a considerable interest in Hammershøi's work at the time.

It is the interpretation of Hammershøi's work that presents the greatest challenge. What is available in the way of factual information on his life and work provides no answer to the most burning questions raised by his art. The important critic and museologist Karl Madsen (1855–1938), who was one of his early champions, formulated the aim of the painters of the Breakthrough with the dictum "more truth, greater seriousness, profounder honesty." This also fits Hammershøi, but it is not the whole truth, and Madsen is no more informative in an article he wrote about the artist in 1899.[2] Hammershøi was an aesthete; he was exclusive not only in his art but also personally, and he was not ambitious for public honors.

Hammershøi's artistic individualism is typical of the age, and his paintings contain features that are met in the writing of author Jens Peter Jacobsen (1847–1885), who gained significance outside Denmark in the 1880s. Hammershøi is regarded by most people as a symbolist.[3] His paintings are experienced as poetical and emotionally charged. It is typical that, irrespective of motif, he creates an enigmatic atmosphere, an intellectual tension that invites interpretation, such as was provided by the literary historian Henrik Wivel in 1996 when he viewed Hammershøi's art as expressing a new intellectual idealism. Others have pointed to similarities with a painter from Hammershøi's own time, the

Belgian Fernand Khnopff (1858–1921). It would fit well if it were possible to demonstrate that he was interested in the landscapes of Arnold Böcklin (1827–1901), which in the Scandinavia of that day awoke the greatest interest in Sweden. Thereby a palpable link would be created via Friedrich Nietzsche (1844–1900) with the so-called metaphysical painting of Giorgio de Chirico (1888–1978) and the surrealists. This potential interpretation, however, is rejected by Poul Vad (1988). Meanwhile, it remains an open question whether the metaphysical dimension in Hammershøi's work was intentional or unconscious.

In his day, Hammershøi was among the Danish artists known abroad, partly through the efforts of his patron, dentist Alfred Bramsen (1851–1932). It is also well known that the German poet Rainer Maria Rilke (1875–1926) took a great interest in him. Hammershøi was never forgotten by later generations and was included in the 1960 Paris exhibition Les sources du XX siècle. But he was "rediscovered" in the 1980s when Roald Nasgaard and Kirk Varnadoe became interested in Scandinavian symbolism. The result was the mounting of major exhibitions on the subject in Europe and the United States, whereby transatlantic cultural links were reestablished. An enthusiastic international interest arose in Vilhelm Hammershøi, whose work attracted great attention in exhibitions in the United States in 1983 and 1998.

E.F.

LITERATURE: Hanne Finsen, Inge Vibeke Raaschou-Nielsen (eds.), *Vilhelm Hammershøi, Painter of Stillness and Light, A Retrospective Exhibition*, Wildenstein, New York, and the Philips Collection, Washington, 1983 (texts by Thorkild Hansen, Harald Olsen; partly based upon the catalogue published for the exhibition *Vilhelm Hammershøi, En retrospektiv udstilling* at the Ordrupgaard Collection in Copenhagen, 1981); Poul Vad, *Vilhelm Hammershøi, værk og liv*, Copenhagen 1988; Poul Vad, *Hammershøi and Danish Art at the Turn of the Century*, New Haven and London 1992 (English edition of his book from 1988); Erik Brodersen in *Weilbach*, vol. 3, Copenhagen 1995; Susanne Meyer-Abich, *Vilhelm Hammershøi. Das malerische Werk*, Inauguraldissertation, Ruhr-Universität, Bochum 1995; Anne-Birgitte Fonsmark, Mikael Wivel (eds.), *Vilhelm Hammershøi, 1864–1916, Danish Painter of Solitude and Light*, exhibition catalogue, Ordrupgaard, Copenhagen, 1997, Musée d'Orsay, Paris, 1998, Solomon R. Guggenheim Museum, New York 1998 (texts by Poul Vad, Robert Rosenblum); Bente Scavenius and Jens Lindhe, *Hammershøis København*, Copenhagen 2003; Felix Krämer, Kasper Monrad, Barbara Ludwig, *Vilhelm Hammershøi*, Hamburger Kunsthalle 2003 (in German); Patricia G. Berman, *In Another Light, Danish Painting in the Nineteenth Century*, New York 2007, p. 220-241; Felix Krämer et al. (eds.), Hammershøi, Royal Academy of Arts, London 2008; Kasper Monrad (ed.), *Hammershøi and Europe*, Statens Museum for Kunst, Copenhagen 2012; Kasper Monrad (ed.), *Vilhelm Hammershøi, Masterworks from SMK, the National Gallery of Denmark*, Copenhagen 2015.

[1] En Strømændring in *Tilskueren*, pp. 400–406.

[2] Karl Madsen, Vilh. Hammershøi in *Kunst*, vol. I, 1899.

[3] One of a group of writers and artists who concern themselves with general truths instead of actualities, exalt the metaphysical and the mysterious, and aim to unify and blend the arts and the function of the senses.

VILHELM HAMMERSHØI
1864–1916

34. *Study drawing after plaster cast of ancient Greek Aphrodite, torso from c. 500 B.C.* (c. 1880)

(Studietegning efter gipsafstøbning efter antik græsk Afrodite, torso fra ca. 500 F. Kr.)

Charcoal, paper, 29½ x 18⅘ in. (75 x 48 cm)

Signed on right edge: VH

PROVENANCE: Bruun Rasmussen, Auction 698, 2001, lot 1377, ill.

EXHIBITED: Tokyo, Museum of Western Art, Vilhelm Hammershøi, the Poetry of Silence, 2008, no. 1, ill.; Scandinavia House, New York, *Danish Paintings from the Golden Age to the Modern Breakthrough, Selections from the Collection of Ambassador John L. Loeb Jr.*, 2013, no. 12.

LITERATURE: Patricia G. Berman, *In Another Light, Danish Painting in the Nineteenth Century*, New York, 2007, p. 226, ill. p. 224.

Vilhelm Hammershøi received his first professional training between the ages of eight and twelve, when he drew at home twice a week. In recognition of the boy's unusual talent, his mother had engaged the highly esteemed teacher of drawing Niels Christian Kierkegaard (1806–1882), who himself had been trained by C. W. Eckersberg. After this, Hammershøi attended the Technical School, where his teacher Holger Grønvold (1850–1923) was of great importance to him and under whose tutelage this piece was drawn. Grønvold had shortly before this trained in Paris under Henri Lehmann (1814–82), who was a pupil of J.-A.-D. Ingres (1780–1867). In addition to his ability to develop his pupils' drawing abilities, Grønvold had a clear sense of how their artistic abilities could best be stimulated. Several generations of the most important painters of the time have expressed their deep appreciation of the teaching and the understanding they encountered from Grønvold, who personally had no success as a painter.

With support from the Royal Danish Academy of Fine Art, the technical schools were established during the 19th century to improve the training of artisan craftsmen, and they also had courses leading to admission to the academy. Drawing was an essential discipline, and the methods used were the same as in the academy. The students first copied two-dimensional models and then drew elementary spatial objects before advancing to drawing sculpture proper. At the academy the process ended with the students being allowed to work from life.

This tradition goes back to the Renaissance, which cultivated the Greek and Roman art of antiquity as its ideal. The enthusiasm for antiquity was the central pillar in the acquisition of art and an academic education, a tradition that obtained right up to the beginning of the 20th century. Since its establishment in 1754, the Royal Danish Academy has collected casts of ancient sculptures for use in teaching, and the technical schools also had classical casts at their disposal. Such casts were considered to have a general educational value, an idea that toward 1900 resulted in the establishment of large collections of casts open to the public. In the Royal Collection of Casts from 1895—which today forms part of Statens Museum for Kunst—ordinary people could study three-dimensional reproductions of ancient sculpture. Similar collections are known from other major cities in Europe and the United States.

This drawing is the result of a relatively difficult set exercise. Its size and the hatching technique used suggest that it was done about 1880,[1] while Hammershøi was a pupil of Grønvold and at the same time attending the preparatory class in the academy. The figure is well defined also in a spatial sense, although Hammershøi has taken the liberty of omitting the traditional outline, which was considered indispensable by the authorities at the Royal Academy. Hammershøi worked artistically even in a set exercise such as this and actually expresses his own experience of the beautiful classical female figure. It is easily understood that his teachers and fellow students were quick to realize that his talent was an unusual one. This is no conventional practice drawing but rather already a typical piece of Hammershøi, departing from the traditional.

E.F.

[1]Deduced by comparison with other drawings from this period.

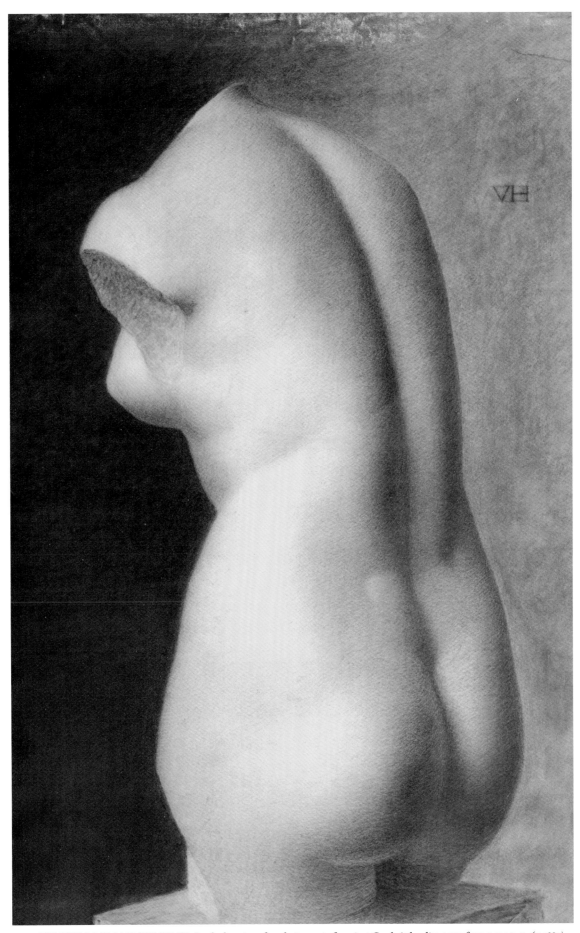

34. VILHELM HAMMERSHØI *Study drawing after plaster cast of ancient Greek Aphrodite, torso from c. 500 B.C. (c. 1880)*

VILHELM HAMMERSHØI
1864–1916

35. *Landscape Study from Haraldskær Paper Mill by the Stream in Vejle* (1883)

(Landskabsstudie. Fra Haraldskær Papirfabrik ved Vejle å)

Oil on mahogany, 7½₀ x 9⅘ in. (18 x 25 cm)

PROVENANCE: The artist's sister, Anna Hammershøi; the insurance company director Mogens Bramsen, whose paternal grandfather was the brother of the art collector Alfred Bramsen; Mogens Bramsen's heirs, Bruun Rasmussen, Auction 712, 2002, lot 1503, ill.

LITERATURE: Sophus Michaëlis and Alfred Bramsen, *Vilhelm Hammershøi, Kunstneren og hans Værk*, Copenhagen, 1918, no. 13 (described as *Landskabs-Studie fra Haraldskær Papir-Fabrik ved Vejle Aa*); Susanne Meyer-Abich, *Vilhelm Hammershøi. Das malerische Werk*, Inauguraldissertation, Ruhr-Universität, Bochum, 1995, no. 19 (described as *Landschaftsskizze*).

When he painted this landscape with factory buildings in 1883, Hammershøi was still a very young man. That spring he was a pupil in the Artists' Free Study Schools, at the same time continuing at the Royal Danish Academy, which he had attended since 1879. He spent the summer of 1883 at Vejle, a beautiful town by a fjord in eastern Jutland, at the home of his uncle William Rentzmann, who was showing interest in his progress. About 1882, his uncle had commissioned the painting *Priam Pleads with Achilles for Hector's Corpse*, in which Hammershøi used a relief by Bertel Thorvaldsen as his model. This is today in the possession of Malmö Kunstmuseum. Hammershøi profited artistically from the visit, which resulted in several landscapes of the area.

It is no random factory Hammershøi has painted. The picture shows the Haraldskær Paper Mill, a little to the west of the town of Vejle, as it looked in 1883. From 1872, the owner had been Hammershøi's Uncle William, an enterprising factory owner who worked extremely energetically not only on behalf of his own factory but the paper industry as a whole. Several steam engines were working behind the facades, while the idyllic lake in the foreground acted as a millpond, the water from which was used for production.[1]

The artist has chosen an overcast day such as is often found during the Danish summer, and he has reproduced the red buildings from a distance, partly covered by large dark green trees and with light green reeds and slender trees on the right. The sky is dominated by large, whitish-gray clouds, reflected in the pond. The painting is done with great skill, although it is a more cautious approach than the Hammershøi we normally encounter because the work dates from such an early period.

E.F.

[1]Jacob B. Jensen, Papirfabrikkerne i Vejledalen, in *Vejle Amts Årbog*, 1984, pp. 7–32.

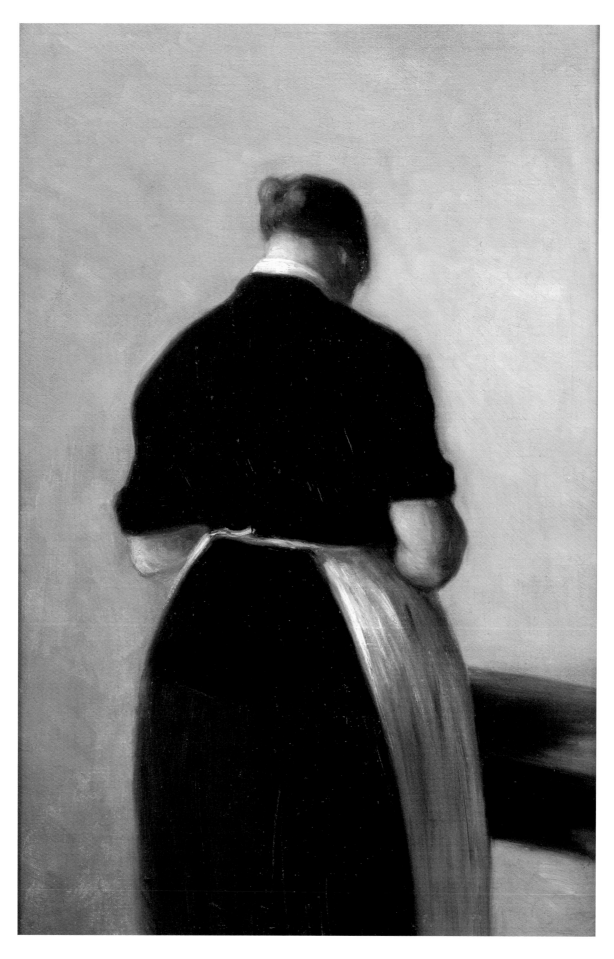

VILHELM HAMMERSHØI
1864–1916

36. *Study of standing woman, seen from behind* (1884 / 1888)
(Studie af stående kvinde, set bagfra)

Oil on canvas, 21 x 13¾ in. (53 x 35 cm)

PROVENANCE: Arne Bruun Rasmussen, Auction 475, 1985, lot 72, ill.; Bruun Rasmussen, Auction 712, 2002, lot 1445, ill.

EXHIBITED: Scandinavia House, New York, *Danish Paintings from the Golden Age to the Modern Breakthrough, Selections from the Collection of Ambassador John L. Loeb Jr.*, 2013, no. 13.

LITERATURE (concerning the motif): Sophus Michaëlis and Alfred Bramsen, *Vilhelm Hammershøi, Kunstneren og hans Værk*, Copenhagen, 1918, no. 24 (described as *En ung Pige som hælder af en Kande*), the present painting is not in the oeuvre catalogue; Poul Vad, *Hammershøi, værk og liv*, Copenhagen 1988 (English edition 1992); Patricia G. Berman, *In Another Light, Danish Painting in the Nineteenth Century*, New York, 2007, p. 226, ill. p. 225.

A woman seen from behind is a motif that Vilhelm Hammershøi painted in his early youth and to which he returned in variations throughout his life. It is a familiar motif in 17th-century Dutch painting and was popular among other Danish artists, such as Anna Ancher and Viggo Johansen (1851–1935) during the 1880s.

This little study shows a fairly robust woman with reddish hair standing with her head bent, wearing a black dress with sleeves rolled up and a white apron, seen indoors obliquely from behind by daylight. To the right of her a wooden table is sketched in, though it is not continued on her left. Her pose suggests she is concentrating on some manual task. The study is fairly monochromatic, but there are shades of blue and brown in the black dress and delicate suggestions of bright daylight on the model's neck and arms and on her apron.

This study is not found in any of the published catalogues of Hammershøi's work, but it is closely related to several well-known paintings. The motif is identical to the central elements in a rather larger study (25 x 22 in., or 63.5 x 55.5 cm). In Alfred Bramsen's catalogue from 1918, this is listed as number 63, and in 1924 it was bought by Statens Museum for Kunst (Fig. A). It appears to be of the same woman, seen from the same angle and in the same light. More is included of the table on the right, in addition to which the top of a light chair in which the daylight is reflected can be seen on the far edge. It also contains more of the room in which the woman is standing, and on the far left there is the hint of a corner.

Bramsen considers study no. 63 to be a preparatory work for the painting *From a Baker's Shop* (Vejen Kunstmuseum; no. 60 in Bramsen's list, Fig. B). Despite the dimensions 44⁹⁄₁₀ x 35⁴⁄₅ in. (114 x 91 cm), Bramsen calls this a study and dates it to 1888. In this painting we see a dark-haired, rather hefty woman in a black dress with long sleeves and a white apron; she is viewed directly from behind, not obliquely. Apart from the color of her hair, the model is similar to the woman used by the artist in the Loeb collection study and in the above-mentioned no. 63.

However, when it comes to composition, the Loeb collection study is rather more like a different and earlier painting, *Living Room, A Young Girl Pouring Tea*, where Hammershøi's mother is sitting on the right; despite its finished state, this painting is quite small, 15 x 12³⁄₅ in., or 38 x 32 cm (Bramsen's catalogue, no. 23, private collection, Fig. C). And also the more unfinished *A Young Girl, Pouring from a Pot*, which Bramsen

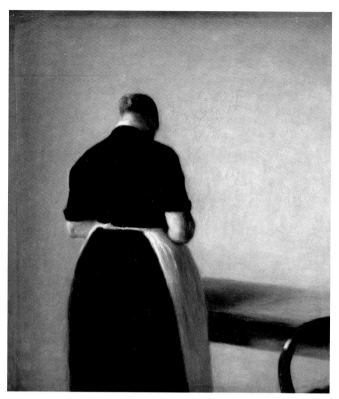

FIG. A *Female Figure*, 1888
Preparatory work for the painting *From A Baker's Shop*
Oil on canvas, 25 x 22 in. (63.5 x 55.5 cm) Not signed or dated.
Statens Museum for Kunst. Bramsen no. 63

FIG. B *From a Baker's Shop*, 1888
Oil on canvas, 44⁹⁄₁₀ x 35⅘ in. (114 x 91 cm)
Vejen Kunstmuseum. Bramsen no. 60

calls a preparatory work for this, although the format is much bigger, 19⁷⁄₁₀ x 16½ in., or 50 x 42 cm (Bramsen no. 24, private collection, Fig. D). This applies in particular to the woman's posture, the daylight, and the chairback in the right of the picture. The woman here is wearing a black dress with long sleeves and a white apron, and the chair is identical to or of the same type as that in the picture belonging to Statens Museum for Kunst. She is pouring tea and there is a cloth on the table in front of her. The model here has dark, not reddish, hair, and she is also slimmer. According to Bramsen, it was the artist's sister, Anna, who posed for the last two of these pictures. It is difficult to believe this, however, for judging from photographs and Hammershøi's pictures of her from 1885 and 1887, Anna was younger, slimmer, and more graceful than this model.

As said above, Alfred Bramsen dates *Sitting Room, A Young Girl Pouring Tea* and *From a Baker's Shop* to 1884 and 1888 respectively. But neither painting has been dated by the artist himself, and there is no other indication of the year in which they were painted. Meanwhile, Bramsen was closely associated with Hammershøi, and so we need weighty reasons indeed before rejecting his assertions concerning dating and the relationship between preparatory works and finished paintings. The explanation must be that Hammershøi was free in his use of his model studies when painting his more finished pictures, a manner of working that is typical of an artist of his generation. As for the dating of the study in the Loeb collection, we can scarcely be more precise than to say sometime between 1884 and 1888.

E.F.

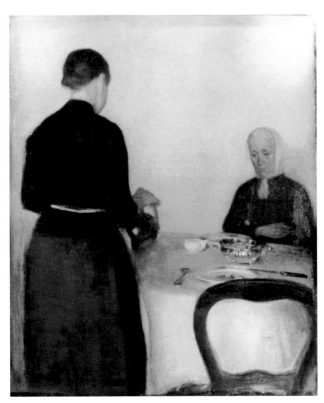

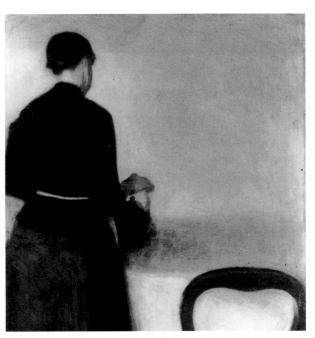

FIG. D *A Young Girl Pouring from a Pot*, 1884
Oil on canvas, 19⁷⁄₁₀ x 16½ in. (50 x 42 cm)
Private collection. Bramsen no. 24

FIG. C *Sitting Room, A Young Girl Pouring Tea*, 1884
Oil on canvas, 15 x 12⅗ in. (38 x 32 cm)
Private collection. Bramsen no. 23

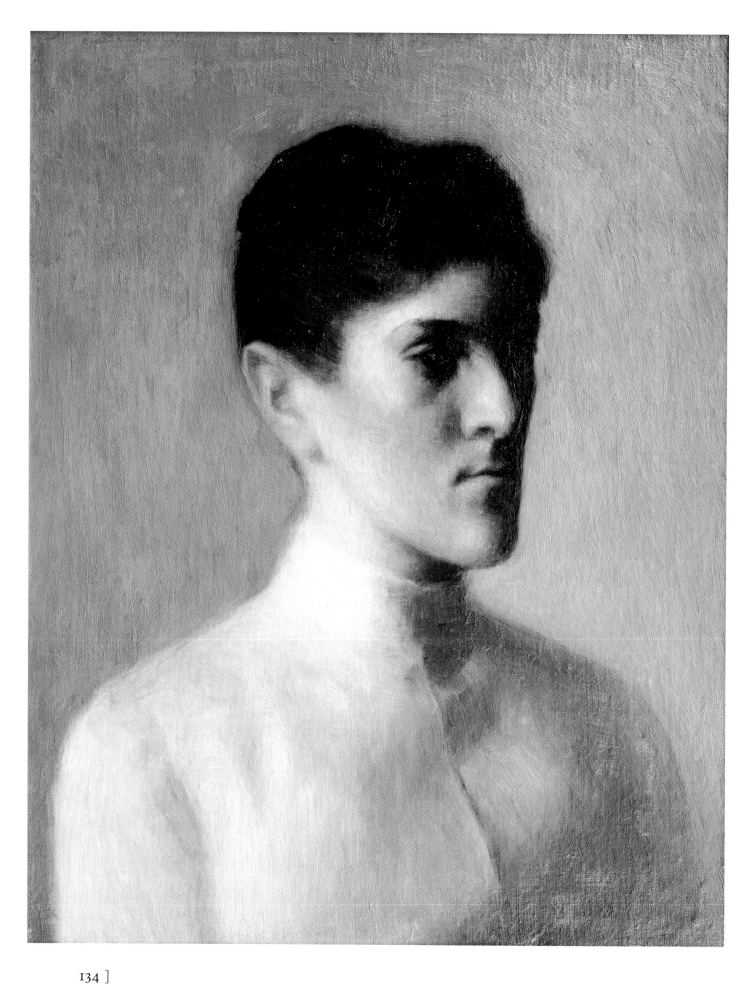

VILHELM HAMMERSHØI
1864–1916

37. *Portrait of Miss Ellen Becker* (1890)
(Portræt af frøken Ellen Becker)

Oil, 21⅖ x 17¾ in. (55 x 45 cm)

PROVENANCE: The painter Kristian Møhl (1876–1962); Arne Bruun Rasmussen, Auction 164, 1964, lot 68; Arne Bruun Rasmussen, Auction 316, 1974, lot 88, ill.; Bruun Rasmussen, Auction 721, 2003, lot 1156, ill.

EXHIBITED: Kunstforeningen, Copenhagen, *Vilhelm Hammershøi*, 1916, no. 67 (belonging to the painter Møhl).

LITERATURE: Sophus Michaëlis and Alfred Bramsen, *Vilhelm Hammershøi, Kunstneren og hans Værk*, Copenhagen 1918, no. 93 (as painted in 1890, described as *Portræt*); Susanne Meyer-Abich, *Vilhelm Hammershøi. Das malerische Werk*, Inauguraldissertation, Ruhr-Universität, Bochum, 1995, no. 87 (described as *Fräulein Becker*).

Hammershøi painted a fair number of portraits around 1890. Among them was one of a young woman, Miss Ellen Becker (1871–1946), whose subsequent married name was Faber. It is a head-and-shoulders portrait in which she is seen in three-quarter profile to the right with her face in shadow. She is wearing a simple white dress, the only ornament on which is a small upright collar; she wears no jewelery. The background is pale, grayish white with an admixture of bluish rose. Together with the shadow falling on the dress, Ellen Becker's dark hair and dark eyes form a contrast to the lighter parts of the painting. The colors of the complexion of the face are pink with a touch of violet. By means of a restrictive color scale, the artist has again created a harmony of color of great artistic beauty. With a shimmering reproduction of the shape, brought about by virtue of quite small differences in nuance in the individual colors, Hammershøi has endowed his painting with depth, atmosphere, and life.

In Bramsen's register of 1918 this painting is listed as number 93 and described as the final version of three in all. The other two are slightly smaller. Number 94 measures 16½ x 12¼ in. (42 x 31 cm), and here the artist has included more of the young woman's figure and arms. Number 95, which measures 16⁹⁄₁₀ x 12¼ in. (43 x 31 cm), is not described in any detail. They were both sold in 1916 in the artist's estate auction, and their present owners are unknown. No photographs of them have been discovered to allow comparison.

Bramsen also states that the painting in the Loeb collection was exhibited in Munich in 1892. He probably refers to the *IV. Internationale Kunstausstellung* in the Glaspalast at Munich that year, in which Hammershøi took part with four paintings, including as number 701 a portrait of a woman, also painted in 1890. However, according to the catalogue it was not that of Miss Becker but a portrait of the painter Elisabeth Wandel (1850–1921) (no. 100 in Bramsen's register).

Ellen Becker was the daughter of the pharmacist Ludvig Becker and belonged to the cultured middle classes. There is nothing to tell us how she came to know Hammershøi or why this portrait was painted. In 1910, at the age of almost 40, she married Dr. Knud Faber (1862–1956), who was the leading figure of the day in clinical science, a professor and consultant in Rigshospitalet, the State University Hospital of Denmark. The marriage was a harmonious and happy one. In his memoirs, Faber gives a beautiful description of her charm and the support she afforded him in all conditions of life. He especially emphasized the understanding she had for his work on behalf of the community and praised her strong character, which found

expression while he was gravely ill in 1914. The couple had an official residence in the hospital until 1932, after which she established a beautiful home at Østerbro near the Øresund coast. In 1911, Ellen Faber gave birth to a son, who became a doctor, as subsequently did a grandson.

The closed, somber quality of the young woman's face in Hammershøi's painting does not seem to have been characteristic of Ellen Becker, if we are to believe accounts of her personality and later photographs of her. Evidently, this is a typical feature of the artist's portraits from this period; it is also seen in those he painted of his friends Karl Madsen (1890, Statens Museum for Kunst) and Kristian Zahrtmann (1899, Statens Museum for Kunst). Both of these men were lively and quick-witted. This could be seen in their behavior and facial expressions and is apparent in photographs and other artists' portraits of them, for instance those by P. S. Krøyer and Viggo Johansen (1851–1935). Hammershøi, by contrast, sought seriousness and introspective qualities and did not re-create those features that superficially might seem to convey his models' personalities. The quiet, expressive grandeur that is a characteristic of Hammershøi's art applies also to his portraits, which, perhaps more than anything else, are pictorial art.

<div align="right">E.F.</div>

VILHELM HAMMERSHØI
1864–1916

38. *Landscape from Virum Near Frederiksdal, Summer,* 1888

(Landskab fra Virum ved Frederiksdal, sommer)

Oil on canvas, 10¼ x 17¾ in. (26 x 45 cm)

Signed bottom left: VH

PROVENANCE: Grosserer Julius Hertz, Frederiksberg; Winkel & Magnussen, Auction 189, 15.2.1936 (Peter Hertz, art historian, son of Julius), lot 12; Overretssagfører Otto Bing; Sotheby's London 6.6.2001, lot 10, ill.

EXHIBITED: Kunstforeningen, Copenhagen, *Vilhelm Hammershøi*, 1916, no. 48; Liljevalchs Konsthal, Stockholm, *Nyere dansk kunst*, 1919, no. 20; Musée du jeu de Paume, Paris, *L'art danois fin XVIIIᵉ siècle jusqu'à 1900*, 1928, no. 56; Bruce Museum of Art and Science, Greenwich, Connecticut, and The Frances Lehman Loeb Art Center, Vassar College, New York, *Danish Paintings of the Nineteenth Century from the Collection of Ambassador John L. Loeb Jr.*, 2005, no. 22, ill.; New York, Scandinavia House, *Luminous Modernism, Scandinavian Art Comes to America. A Centennial Retrospective 1912–2012*, 2011–2012; Scandinavia House, New York, *Danish Paintings from the Golden Age to the Modern Breakthrough, Selections from the Collection of Ambassador John L. Loeb Jr.*, 2013, no. 14.

LITERATURE: Alfred Bramsen, *Vilhelm Hammershøis Arbejder, Fortegnelse*, Copenhagen, 1900, no. 24; Sophus Michaëlis and Alfred Bramsen, *Vilhelm Hammershøi, Kunstneren og hans Værk*, Copenhagen, 1918, no. 70 (described as *Landskab, Sommer, Virum*); Poul Vad, *Vilhelm Hammershøi*, Copenhagen, 1988, p. 62 (English edition 1992); Susanne Meyer-Abich, *Vilhelm Hammershøi. Das malerische Werk*, Inauguraldissertation, Ruhr-Universität, Bochum 1995, no. 58 (described as *Landschaft bei Virum. Skizze*); Patricia G. Berman, *In Another Light, Danish Painting in the Nineteenth Century*, New York, 2007, p. 227–228, ill. p. 226; Patricia G. Berman, *Luminous Modernism*, New York, 2011, P. 38, ill. p. 30 (detail), 39, cover.

Golden brown fields and a clouded, hazy sky separated by a narrow line of white houses surrounded by trees that are so distant that the details are almost entirely obscured—such is the motif of this picture. The simplicity is typical of Hammershøi's early landscapes, where, in addition, he was particularly preoccupied with horizontal lines. The locality is the village of Virum, about seven and a half miles (12 kilometers) north of Copenhagen with a row of farms and, on the left, Blæsenborg Mill, all seen from rather less than three-fifths of a mile (one kilometer) to the south.

The picture was painted in the summer of 1888 while Hammershøi was staying in the nearby village of Lyngby at the home of Karl Madsen (1855–1938), originally a painter and then the leading critic of the time and a warm spokesman for the new art. Madsen was one of Hammershøi's earliest admirers, one of the close friends whom he later portrayed in *Fem portrætter (Five Portraits)* (1905, Thielska Galleriet, Stockholm). Madsen was then living permanently in an 18th-century country house at Lyngby, and it was here Hammershøi painted his first interior with white doors.[1] From the house it was only just over three-fifth's of a mile (one kilometer) to the place where he sat working with the present painting. The road leading there would take him through the forest and past the royal palace of Sorgenfri and also past one of Jens Juel's motifs, the high rise in the forest known as "Dansebakken," which was once a favorite spot for excursions and entertainments.[2]

The extensive meadows near Virum, which dominate Hammershøi's painting, were just to the east of the Furesø lake. The atmosphere can still be experienced today in the large protected area close to the lake, near Frederiksdal, a county seat dating from the 1740s, and the painter N. Abildgaard's country house, Spurveskjul, from 1805, where Hammershøi later rented rooms. The fields adjoin the large area of natural

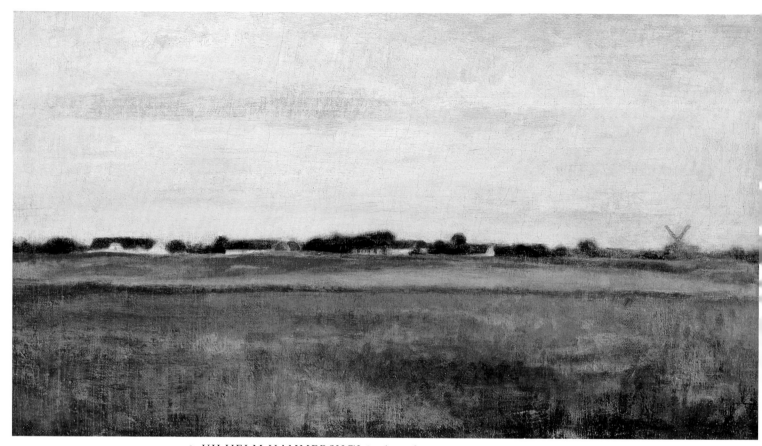

38. VILHELM HAMMERSHØI *Landscape from Virum Near Frederiksdal, Summer, 1888*

beauty around the Mølleå River ("Mill Stream"), which flows from Furesø lake through Bagsværd and Lyngby lakes and out into the Sound, bordered all the way by forest and marsh.

In the 18th and 19th centuries, the water from the stream provided the power for various sizeable industrial undertakings in the area. The Mølleå valley and the forests have been preserved to the present day, while most of the open areas have been parceled out to private housing in areas that are now suburbs of Copenhagen.

Hammershøi also painted a larger version of this landscape with slightly different proportions and with a clearer sky and minus the mill.[3] It was shown in Den Frie Udstilling in 1891 and belonged to the dentist Alfred Bramsen, who became known as the most important collector of Hammershøi's work. During his stay at this place, Hammershøi also made several paintings of Lyngby Lake, of which he had a view when looking south from the very same spot.

A motif with so few elements and such a strictly limited scale of color gave Hammershøi the possibility of concentrating on the fine nuances, and he has thereby created space and atmosphere in the picture. To Hammershøi, simplicity was not a limitation but a choice.

<div align="right">E.F.</div>

[1]*Interiør. Den gamle bilæggerovn (Interior. The Old Stove)*, 1888, oil on canvas, 23⅗ x 20½ in (60 x 52 cm), Statens Museum for Kunst.

[2]Jens Juel, *Dansebakken ved Sorgenfri* (1800) (*A Party at Dansebakken near Sorgenfri*), oil on canvas, 16½ x 24 in. (42 x 61 cm), Statens Museum for Kunst.

[3]*Landskab fra Virum ved Frederiksdal (Landscape from Virum near Frederiksdal)*, 37⅖ x 21½ in. (49.5 x 54.5 cm), private owner.

VILHELM HAMMERSHØI
1864–1916

39. *Interior, Strandgade 30, 1899*

(Interiør, Strandgade 30)

Oil on canvas, 26 x 21¼ in. (66 x 54 cm)

PROVENANCE: Overretssagfører Konrad Levysohn; Arne Bruun Rasmussen, Auction 457, 1984, lot 96 (described as *Interiør med kvinde stående ved bord*).

EXHIBITED: Den Frie Udstilling, 1899, no. 49; Kunstforeningen, *Vilhelm Hammershøi*, Copenhagen, 1916, no. 142; Busch-Reisinger Museum, Harvard University Art Museums, *Danish Paintings of the Nineteenth Century from the Collection of Ambassador L. John Loeb Jr.,* 1994, no. 7; Bruce Museum of Art and Science, Greenwich, Connecticut, and The Frances Lehman Loeb Art Center, Vassar College, New York, *Danish Paintings of the Nineteenth Century from the Collection of Ambassador John L. Loeb Jr.,* 2005, no. 23, ill. p. 77 and cover; London, Royal Academy of Art, *Vilhelm Hammershøi, the Poetry of Silence*, no. 24, ill.; Tokyo, Museum of Western Art, *Vilhelm Hammershøi, the Poetry of Silence*, 2008, no. 53, ill.; Scandinavia House, New York, *Danish Paintings from the Golden Age to the Modern Breakthrough, Selections from the Collection of Ambassador John L. Loeb Jr.,* 2013, no. 15; Ordrupgaard, Copenhagen, *At Home With Hammershøi*, 2016, ill. p. 94.

LITERATURE: Sophus Michaëlis and Alfred Bramsen, *Vilhelm Hammershøi, Kunstneren og hans Værk*, Copenhagen, 1918, no. 198 (described as *Stue* (Sitting Room); Poul Vad, *Hammershøi, værk og liv,* Copenhagen, 1988, ill. p. 186 (English edition 1992); Peter Nisbet, *Danish Paintings of the Nineteenth Century from the Collection of Ambassador John L. Loeb Jr.,* Busch-Reisinger Museum, Harvard University, Cambridge, Massachusetts, 1994, p. 12, ill. on back cover; Susanne Meyer-Abich, *Vilhelm Hammershøi. Das malerische Werk*, Inauguraldissertation, Ruhr-Universität, Bochum, 1995, no. 178 (described as *Interieur. Strandgade 30*); Patricia G. Berman, "Lines of Solitude, Circles of Alliance, Danish Painting in the Nineteenth Century" in *Danish Paintings of the Nineteenth Century from the Collection of Ambassador John L. Loeb Jr.,* Bruce Museum, 2005, p. 25; Patricia G. Berman, *In Another Light, Danish Painting in the Nineteenth Century,* New York, 2007, p. 233, ill. p. 230; Felix Krämer, "Interiors, Strandgade 30" in Anne Birgitte Fonsmark (ed.), *At Home With Hammershøi*, Ordrupgaard, Copenhagen, 2016, pp. 84–134.

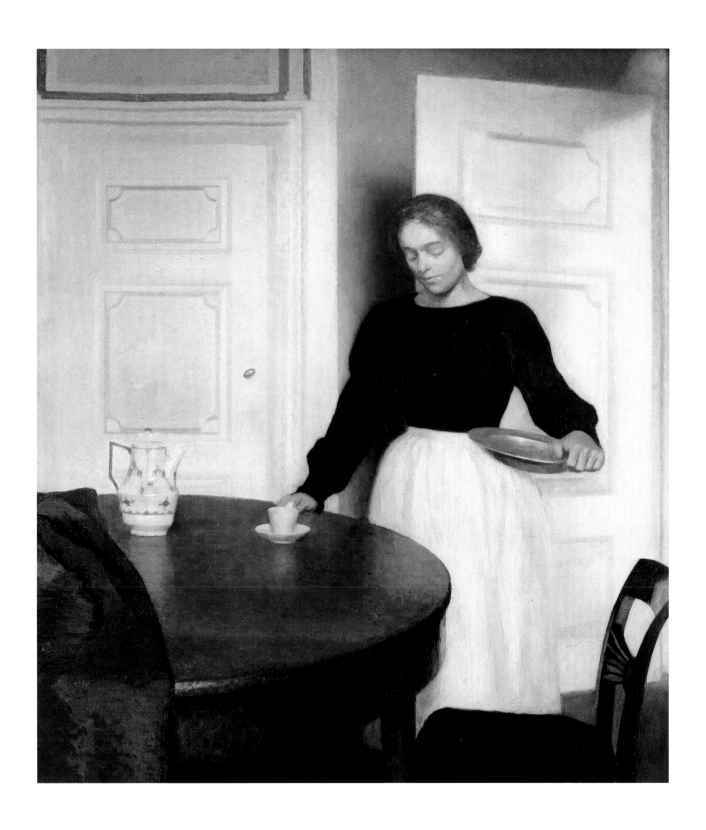

40. *Interior of Woman Placing Branches in Vase on Table,* 1900

(Interiør med kvinde, der stiller grene i et glas, Strandgade 30)

Oil on canvas, 15¾ x 11¾ in. (40 x 39 cm)

Signed with initials lower right: VH

PROVENANCE: The English concert pianist Leonard Borwick, London; Bruun Rasmussen, Auction 465, 1984, lot 164.

EXHIBITED: Busch-Reisinger Museum, Harvard University Art Museums, *Danish Paintings of the Nineteenth Century from the Collection of Ambassador John L. Loeb Jr.,* 1994, no. 8; Bruce Museum of Art and Science, Greenwich, Connecticut, and The Frances Lehman Loeb Art Center, Vassar College, New York, *Danish Paintings of the Nineteenth Century from the Collection of Ambassador John L. Loeb Jr.,* 2005, no. 24, ill.; Tokyo, Museum of Western Art, *Vilhelm Hammershøi,* no. 54, ill.; New York, Scandinavia House, *Luminous Modernism, Scandinavian Art Comes to America. A Centennial Retrospective 1912–2012,* 2011–2012; Scandinavia House, New York, *Danish Paintings from the Golden Age to the Modern Breakthrough, Selections from the Collection of Ambassador John L. Loeb Jr.,* 2013, no. 16; Ordrupgaard, Copenhagen, *At Home With Hammershøi,* 2016, ill. p. 95.

LITERATURE: Sophus Michaëlis and Alfred Bramsen, *Vilhelm Hammershøi, Kunstneren og hans Værk,* Copenhagen, 1918, no. 205 (described as *Stue*); Poul Vad, *Hammershøi, værk og liv,* Copenhagen 1988, p. 264, ill. (English edition 1992); Peter Nisbet, *Danish Paintings of the Nineteenth Century from the Collection of Ambassador John L. Loeb Jr.,* Busch-Reisinger Museum, Harvard University, Cambridge, Massachusetts, 1994, p. 12, ill.; Susanne Meyer-Abich, *Vilhelm Hammershøi. Das malerische Werk,* Inauguraldissertation, Ruhr-Universität, Bochum, 1995, no. 184 (described as *Interieur mit einer Frau, die Zweige in eine Vase stellt. Strandgade 30*); Elisabeth Fabritius, Vejen ud af fotograWets perspektiviske rum, *in* Ingrid Fischer Jonge and Gertrud With (eds.), *Verden set på ny, Fotografi og malerkunst 1840–1900,* Det Nationale Fotomuseum, Det Kongelige Bibliotek, 2002, pp. 75–86; Gertrud Oelsner, "Photographic Strategies, Perceptual Reflections and Introvert Tendencies in Painting around 1900" in *Statens Museum for Kunst Journal 2002,* vol. 6, pp. 25–43; Patricia G. Berman, "Lines of Solitude, Circles of Alliance, Danish Painting in the Nineteenth Century" in *Danish Paintings of the Nineteenth Century from the Collection of Ambassador John L. Loeb Jr.,* Bruce Museum, 2005, p. 25; Anne Rosenvold Hvidt, "The Strange Thing about Hammershøi" in *Hammershøi/Dreyer: The Magic og Images,* Ordrupgaard, Copenhagen, 2006, pp. 43–60; Patricia G. Berman, *In Another Light, Danish Painting in the Nineteenth Century,* New York, 2007, pp. 229–236, ill. p. 231; Patricia G. Berman, *Luminous Modernism,* New York, 2011, p. 42, ill. p. 43; Felix Krämer, "Interiors, Strandgade 30" in Anne Birgitte Fonsmark (ed.), *At Home With Hammershøi,* Ordrupgaard, Copenhagen, 2016, pp. 84–134.

In 1898, Hammershøi moved into a first-floor apartment at no. 30 Strandgade in the Christianshavn area of Copenhagen. It was here that such a significant number of his interiors were created that they are considered the most typical of Hammershøi's works in that genre. The house, built on two tall floors, dates back to the 17th century and is one of the oldest in the district. The living rooms overlook Strandgade and face northwest. Opposite are the splendid 18th-century buildings of the Asiatic Company, which Hammershøi also painted, and which today house parts of the Danish Ministry of Foreign Affairs.

In the apartment, the rooms, proportions, and lighting are from the 17th century while the paneling on the walls, the doors, and the contoured door frames date from the 18th century. It is an exquisite example of Copenhagen architecture, and with the strikingly dominant aesthetic feeling that was characteristic of Hammershøi it is understandable that its simple beauty was sufficient in itself to serve him as a source of inspiration over such a lengthy period. The light in Scandinavia varies enormously over the year: short days in the winter and long days in the summer accompanied by many hours of twilight during the middle of summer. Hammershøi's rooms overlooking the street are in shadow until the afternoon, and only in the summer months does the sun enter directly. Similar lighting conditions were, incidentally, to be found in the house of Dutch painter Vermeer van Delft (1632–1675).

So the apartment provided Hammershøi with the best circumstances for painting a rich variety of inte-

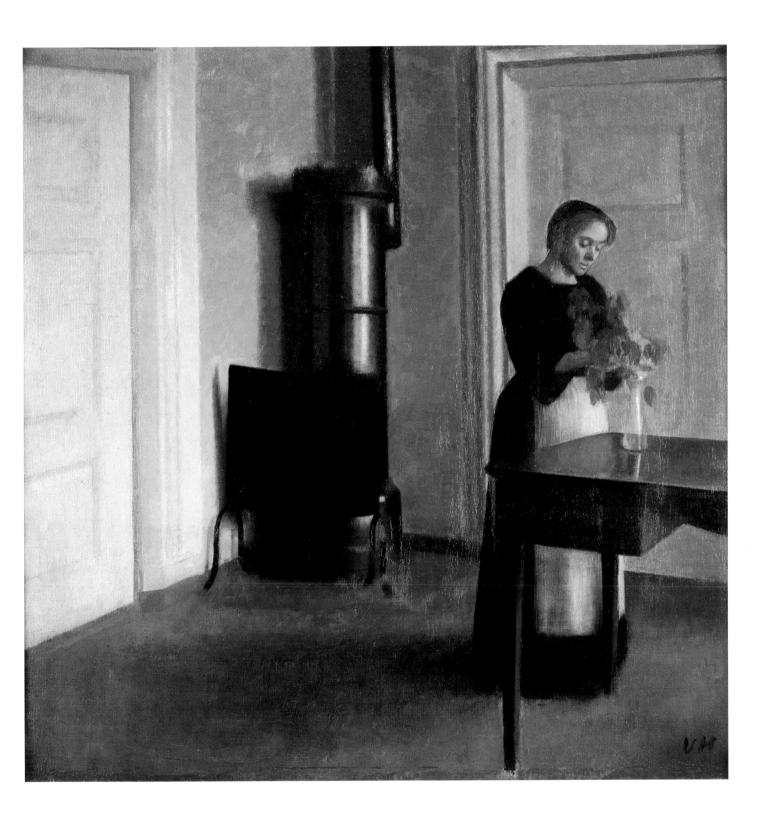

riors. Among the countless motifs are wall surfaces and parts of rooms with diverse amounts of furniture and numbers of paintings and objects. Sometimes the essential motifs are the doors, either open or closed, or the view through several open doors revealing light-filled rooms in the depths of the picture. The half-open door was a much-loved motif in antiquity and was also frequently used by another famous Dutch painter, Pieter de Hooch (1629–1683). When it is a question of composition, Hammershøi chooses to paint either frontally facing a wall, which is then seen parallel to the plane of the picture, or he chooses a corner in the room and employs two-point perspective, alternating between a perspective from a standing and sitting position. His wife, Ida, is shown in some of the pictures, always as a lone figure, always dressed in very few colors, and always sitting or standing motionless.

These two pictures were painted in the same room, the central living room overlooking Strandgade, where we see the corner with the stove from two different angles. In *Interior of Woman Placing Branches in a Vase* the floor represents a significant part of the picture, and here the perspective shows that the painter had been standing. In *Interior, Strandgade 30* Hammershøi had been seated, something that supports the more intimate character of this painting. The tables are different, without doubt chosen on the basis of the respective compositional intentions. Ida Hammershøi, wearing the same black dress and white apron, acted as the model in both paintings: in one, she is putting some sprays in a vase, while in the other, she is putting a china cup on the mahogany table. The bowl supported from the hip is one Hammershøi painted several times; the motif is well known in art history. The color of the walls is different in the two paintings, yellowish in one, bluish in the other, which presumably merely tells us that Hammershøi was fairly free in his treatment of reality. We gain a good sense of the fine light streaming in through the windows from the street, especially in *Interior, Strandgade 30*, where it illuminates the white-painted doors and where the jug (from the Royal Porcelain Manufactory), the cup, and Ida's dress are reflected in the polished surface of the table and give plasticity to the thick material, which was no doubt made of felt, usually placed beneath a tablecloth. An 1899 variant of the motifs was shown in the New York exhibition as no. 18 (Bramsen & Michaëlis no. 196, owner the Tate Gallery, London).

Hammershøi's Strandgade paintings can be viewed as one or several sequences of motifs, all with the same objective—exploring the light and the room. They are pictorial constructions always with their emphasis on the static. This is substantiated by a comment from the artist himself, one of the few he made about his method: "What makes me choose a motif is just as much the lines in what I will call the picture's architectonic posture. And then the light, of course."[1]

Looking at the composition, it is impossible to avoid regarding the Strandgade paintings as related to photography. It is quite obvious that like his contemporaries (Degas is the most famous) Hammershøi had long since acquired what people of the time called "the photographic view," i.e., he worked by applying apparently random cuts to his motif. That he also used photographs as guides for his paintings is confirmed by a few surviving examples, including a scored network on a portrait photograph of Ida, which became the painted portrait from 1890.

If we look at the Strandgade interiors as a whole, it seems more likely that Hammershøi worked with other optical apparatus. On the one hand he might have used the easily transportable camera lucida, which projects the image directly down onto the canvas. Or it might be imagined that he examined his motifs and planned the general arrangement with the help of a camera obscura or the focusing screen of a large cam-

era.[2] A motif such as the Loeb collection painting of the woman putting branches in a vase was scarcely created on the basis of direct observation. It is much more likely to have been found by viewing through the limited field of vision afforded by a lens. The use of optics would also explain why Hammershøi was at times tempted by quite extreme angles and introduced elements such as unfocused objects in the foreground that would have been excluded in a traditional painting. His predilection for an idiosyncratic cropping of his motifs is seen in other interiors from Strandgade more clearly than in the two paintings in the Loeb collection under discussion here, and this is also the case in the later paintings from his Bredgade apartment.

In 2001 painter David Hockney (b. 1937) launched the discussion on artists' use of optics since the Renaissance, originally to the horror of many art historians.[3] After having experimented with the use of a camera lucida to draw portraits, Hockney embarked on a more systematic examination of the use of optics in an earlier age, a use that has not only been forgotten but actually kept secret because the use of such aids has over the years been considered dishonest. Likewise, the direct use by painters of photographs as patterns from which to work has also been viewed with disapproval. In *Secret Knowledge*, Hockney emphasizes time and time again that the use of optics leaves no trace, which could be the explanation for why there appear to be no surviving drawn or photographed preparatory studies for Hammershøi's interiors. In addition, Hockney points out that there is only a very slight depth definition in a camera lucida, and that the artist typically moves his apparatus several times while working. This means—still according to Hockney—that several vanishing points[4] appear in his drawing or painting that are unrelated to each other, whereby the artist in reality abandons classical perspective. On the other hand, a new dynamic emerges that gives the painter fresh possibilities.

It is my theory that Hammershøi used the aid of optics, and that in his late interiors he wanted to explore the artistic potential they offered him. His interiors appear to reproduce reality, but the suggestive atmosphere, which appeals to the viewer and which has invited so many interpretations, can very well be due to the fact that they are not exclusively linear perspective constructions. Hammershøi created his own unique picture universe; he wanted to do more than re-create reality.[5] In actual fact, he was well on his way into an image creation touching on cubism and other radical 20th-century innovations.

E.F.

[1]Stenographic interview with C. C. Clausen in the periodical *Hver 8. Dag,* 1907, p. 438.

[2]These theories were proposed in the catalogue for the exhibition in the National Photo Museum in the Royal Library, Copenhagen, in 2002, where I also wrote on the Skagen artists' relationship to photography and optics. The Ancher family possessed and used a still-existing camera lucida, as did the Norwegian Skagen painters Fritz Thaulow (1847–1906) and Christian Krohg (1852–1925). The surviving parts of P.S. Krøyer's camera lucida are in Skagens Museum.

[3]David Hockney, *Secret Knowledge, Rediscovering the Lost Techniques of the Old Masters*, London 2001. With an unprejudiced eye and with unusual visual sensitivity, Hockney illustrated the subject on the basis of an enormous amount of pictorial material that he brought for discussion to various scientists who were able to confirm and supplement his results. The so-called Hockney-Falco thesis is now the subject of serious discussion in the art world.

[4]When photographing (or constructing a perspective of) a room, face to the back wall, the side walls—normally of the same height—seem to get smaller the farther away they are. If you put a rule on the lines of these walls they will all meet in one point: the vanishing point.

[5]I am continuing my explorations of Hammershøi's methods.

VILHELM HAMMERSHØI
1864–1916

41. *Courtyard Interior at Strandgade 30* (c. 1905)
(Gårdinteriør. Strandgade 30)

Oil on canvas, mounted on panel, 29½ x 24¾ in. (75 x 63 cm)

Signed with initials lower left: VH

PROVENANCE: The collection of Grosserer William Bendix, Copenhagen; Winkel & Magnussen, Auction 224, 1937, lot 25, ill. p. 25; Overlæge G. Espersen, Thisted; Bruun Rasmussen, Auction 465, 1984, lot 163, ill. p. 75.

EXHIBITED: Den Frie Udstilling 1906, nr. 82; Busch-Reisinger Museum, Harvard University Art Museums, *Danish Paintings of the Nineteenth Century from the Collection of Ambassador John L. Loeb Jr.*, 1994, no. 9; Ordrupgaard, Copenhagen, Museé D'Orsay, Paris, Solomon R. Guggenheim Museum, New York, *Vilhelm Hammershøi*, 1997–98, no. 41; Bruce Museum of Art and Science, Greenwich, Connecticut, and The Frances Lehman Loeb Art Center, Vassar College, New York, *Danish Paintings of the Nineteenth Century from the Collection of Ambassador John L. Loeb Jr.*, 2005, no. 25, ill.; New York, Scandinavia House, *Luminous Modernism, Scandinavian Art comes to America. A Centennial Retrospective 1912–2012*, 2011–2012; Scandinavia House, New York, *Danish Paintings from the Golden Age to the Modern Breakthrough, Selections from the Collection of Ambassador John L. Loeb Jr.*, 2013, no. 17; Ordrupgaard, Copenhagen, *At Home With Hammershøi*, 2016, ill. p. 91.

LITERATURE: Winkel & Magnussens (ed.), *Vilhelm Hammershøi*, Copenhagen (1905), no. 8; V. Jastrau (ed.), *Vilhelm Hammershøi*, Smaa Kunstbøger, no. 15, Copenhagen, 1916, ill. p. 49; Sophus Michaëlis and Alfred Bramsen, *Vilhelm Hammershøi, Kunstneren og hans Værk*, Copenhagen, 1918, no. 269. ill. (described as *Gaard-Interiør*); Haavard Rostrup, Om Vilhelm Hammershøis Kunst in *Kunst og Kultur*, Årg. 26, Oslo, 1940, ill. p. 192; Winkel & Magnussen (eds.), *Kunst i Privat Eje*, I-III. Copenhagen 1944–45, vol. III, p. 373, ill. (described as *Et Hjørne af Mikkel Vibes Gaard*); Poul Vad, *Hammershøi, værk og liv*, Copenhagen, 1988, ill. p. 373 (English edition 1992); Peter Nisbet, *Danish Paintings of the Nineteenth Century From the Collection of Ambassador John L. Loeb Jr.*, Busch-Reisinger Museum, Harvard University, Cambridge, Massachusetts, 1994, p. 12, ill p. 13; Susanne Meyer-Abich, *Vilhelm Hammershøi. Das 'malerische Werk*, Inauguraldissertation, Ruhr-Universität, Bochum, 1995, no. 265 (described as *Innenhof. Strandgade 30*); Patricia G. Berman, "Lines of Solitude, Circles of Alliance, Danish Painting in the Nineteenth Century" in *Danish Paintings of the Nineteenth Century from the Collection of Ambassador John L. Loeb Jr.*, Bruce Museum, 2005, p. 25; Anne-Birgitte Fonsmark, Henri Loyrette, and Mikael Wivel, *Vilhelm Hammershøi*, Ordrupgaard, Copenhagen, 1997, p. 166, ill. p. 104 (English edition); Patricia G. Berman, *In Another Light, Danish Painting in the Nineteenth Century*, New York, 2007, p. 240–241, ill. p. 240; Patricia G. Berman, *Luminous Modernism*, New York, 2011, p. 40, ill. p. 41.

This motif with the large number of windows was painted in the artist's apartment in Strandgade 30. Toward the courtyard at the rear, the building has been extended with two wings; these are connected by a closed external gallery with windows covering the original facade and cutting off the view of the floor below. This is seen on the right of the picture, while the windows on the left overlook the south wing, here furnishing the entrance to the apartment. The scene has been painted from the north wing opposite from the window where Hammershøi painted *Dust Motes Dancing in Sunlight* in 1900. The gallery seen from the dark inside room has also served as a motif. Although the picture appears to have been painted only in brown and shades of grayish black, it also contains areas in blue. It provides a splendid statement of the building's architecture, the skewed windows and the half-timbered construction that can be glimpsed behind the layer of plaster beneath the windows.

The woman standing at the open window and wearing a scarf around her head has many predecessors in Dutch painting, and yet the painting provides a striking impression of old Copenhagen. There is yet another version of this motif (Bramsen & Michaëlis no. 268, which in 1944 belonged to Thorsten Laurin in

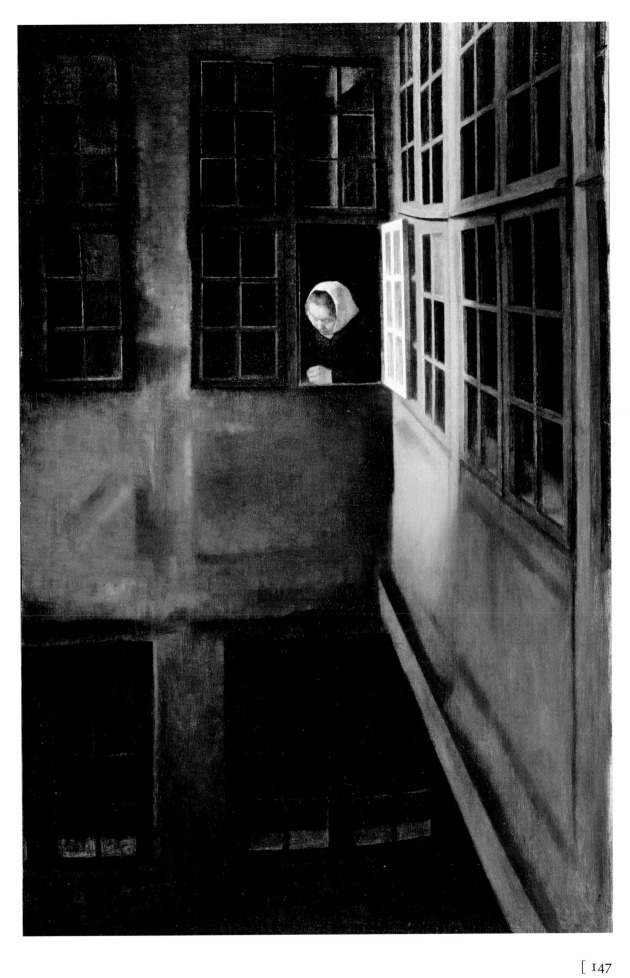

Stockholm; exhibited in New York, 1998, as no. 40), and one without a figure (Bramsen & Michaëlis no. 193, exhibited in New York as no. 17), with a preparatory work as though Hammershøi has painted the same corner of the building diagonally across the courtyard from another of the windows in the apartment.

<div align="right">E.F.</div>

VILHELM HAMMERSHØI
1864–1916

42. *The Church of St. Peter, Copenhagen* (c. 1906)
(Petri Kirke set fra Larslejstræde, København)

Oil on canvas, 30¾ x 20¼ in. (78 x 51.5 cm)

Signed bottom left: VH

PROVENANCE: Dr. Bøcher (Carl Christian or his son Einar); Grosserer Sophus Iversen; Kunstforeningen, Copenhagen, Auction 5.4.1921 (Sophus Iversen), lot 16; O. Dessau prior to 1951; Bruun Rasmussen, Auction 526, 1989, lot 77, ill.; Sotheby's London 6.6.2001, lot 11, ill.

EXHIBITED: Liljevalchs Konsthal, Stockholm, *Nyere dansk kunst*, 1919, no. 454; Bruce Museum of Art and Science, Greenwich, Connecticut, and The Frances Lehman Loeb Art Center, Vassar College, New York, *Danish Paintings of the Nineteenth Century from the Collection of Ambassador John L. Loeb Jr.*, 2005, no. 26, ill.; London, Royal Academy of Art, *Vilhelm Hammershøi, the Poetry of Silence*, 2008, no. 52, ill.; Tokyo, Museum of Western Art, *Vilhelm Hammershøi, the Poetry of Silence*, 2008, no. 17, ill.; New York, Scandinavia House, *Luminous Modernism, Scandinavian Art Comes to America. A Centennial Retrospective 1912–2012*, 2011–2012.

LITERATURE: Sophus Michaëlis and Alfred Bramsen, *Vilhelm Hammershøi, Kunstneren og hans Værk*, Copenhagen, 1918, no. 302 (described as *Petri Kirke, Forstudie til Nr. 301*); William Ritter, *La peinture en (sic!) Danemark, Vilhelm Hammershøi* in *L'art et les artistes*, [pre-1916], ill. p. 268; Poul Vad, *Vilhelm Hammershøi*, Copenhagen 1988, p. 325 (discussion of the motif) (English edition 1992); Susanne Meyer-Abich, *Vilhelm Hammershøi. Das malerische Werk*, Inauguraldissertation, Ruhr-Universität, Bochum, 1995, no. 301 (described as *Petrikirche. Skizze)*; Elisabeth Fabritius, Vejen ud af fotograWets perspektivske rum, in Ingrid Fischer Jonge and Gertrud With (eds.), *Verden set på ny*, Det Nationale Fotomuseum, Det Kongelige Bibliotek 2002, p. 82; Patricia G. Berman, "Lines of Solitude, Circles of Alliance, Danish Painting in the Nineteenth Century" in *Danish Paintings of the Nineteenth Century from the Collection of Ambassador John L. Loeb Jr.*, Bruce Museum, 2005, p. 24; Patricia G. Berman, *In Another Light, Danish Painting in the Nineteenth Century*, New York, 2007, p. 239, ill. p. 237; Patricia G. Berman, *Luminous Modernism, Scandinavian Art Comes to America*, New York, 2011, p. 44, ill. p. 33, 45.

The Danish capital of Copenhagen is famous as the city of towers, and the churches in the oldest central part of the city have since the Middle Ages been adorned with towers of the kinds that were common throughout northwestern Europe. The robust architectonic shapes and the sculptural tower that make up this motif are, together with the narrow scale of color ranging from reddish brown to gray, typical of Hammershøi. He had previously found similar motifs in the 16th- and 17th-century royal castles of North Zealand.

In 1893 he painted a view of Frederiksborg Castle at Hillerød and in 1897 one of Kronborg Castle at Elsinore. Hammershøi was deeply conscious of the inheritance from the Golden Age and in his choice of subjects acknowledges painters such as Christen Købke and P. C. Skovgaard. In the 1830s, they had chosen to concentrate on the characteristic turrets of the castles, while Hammershøi here prefers to emphasize the contrast between the turrets and other structures, in several cases the surrounding walls with their large, flat surfaces. As in the paintings of interiors, it is the lines in the motif that have interested him. Hammershøi was in his day criticized for his immaterial quality, and neither is this picture meticulously painted in a traditional sense. But he chose this technique quite consciously because it allowed him to reproduce the hazy nuances of an overcast day, which are so characteristic of the Danish winter.

The Church of St. Peter dates back to the Middle Ages, but it was extended several times after King Frederik II put it at the disposal of the city's German Lutheran congregation in 1585. The tower is seen in

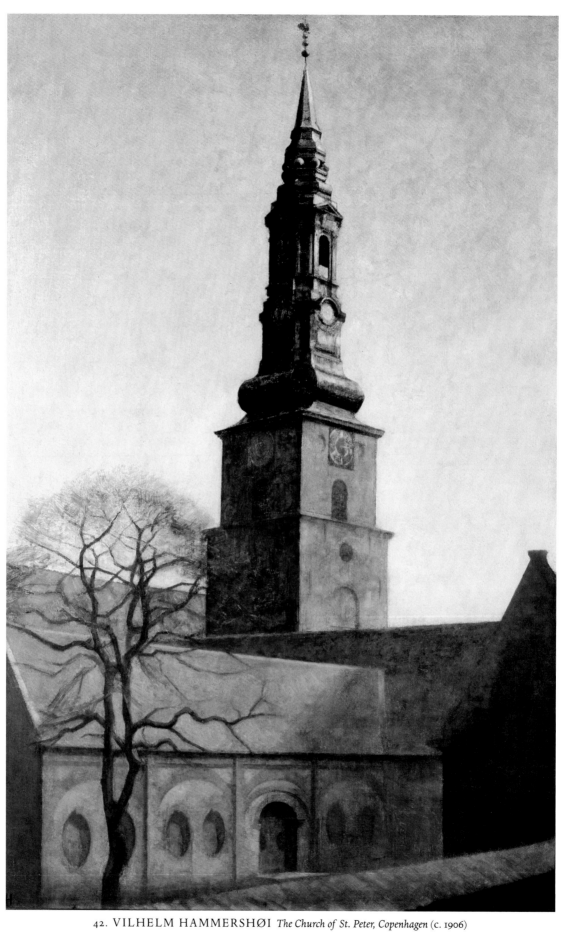

42. VILHELM HAMMERSHØI *The Church of St. Peter, Copenhagen* (c. 1906)

FIG. A *The Church of St. Peter*, 1906
(Petri Kirke)
Oil on canvas, 51⅓ x 46½ in. (133 x 118 cm)
Unsigned
Statens Museum for Kunst
Michaëlis and Bramsen, 1918, no. 301

the shape it was given in the 1750s. The large building on the left is part of the three-winged sepulchral chapel from the second half of the 17th century. With its location in the densely built medieval city just opposite Copenhagen University, there is not much free space around the church buildings and the surrounding walls such as the one seen at the bottom of the picture. The complex has been preserved to the present day and was thoroughly and tastefully restored from 1995 to 2000.

In his Hammershøi monograph, Alfred Bramsen describes the painting in the Loeb collection as a preparatory work for a larger, almost square picture from 1906, now in Statens Museum for Kunst, that includes the end wall of the chapel on the right. This means that the tower is seen on the left in that picture and not centrally as in the present work, in which the upright format and slightly changed viewpoint give it a uniquely dominant position. The leafless tree on the left is thereby given greater compositional significance. The picture in the Loeb collection could therefore with equal justification be considered another, equally valid version of the motif.

E.F.

VILHELM HAMMERSHØI
1864–1916

131. *The Artist's Wife Ida* (1895)
(Portrætstudie af kunstnerens hustru Ida)

Oil on canvas, 16 ³/₂₀ x 13 in. (41 x 33 cm)

Unsigned

PROVENANCE: Art historian Karl Madsen (1918); Winkel & Magnussen, Auction 237, 1938 (Karl Madsen), lot 17, ill. p. 12; Madsen's son-in-law, the painter Arne Lofthus; Lofthus's daughter, the assistant museum curator Else Lofthus; Bruun Rasmussen, Auction 743, 2005, lot 1070, ill. (described as *Portræt. Brystbillede uden Hænder. En face. Forstudie til den midterste af Figurerne, Ida Hammershøi, i "Tre kvinder"* 1895).

EXHIBITED: Den Frie Udstilling, 1908, no. 71 (*Dameportræt*); Kunstforeningen, Copenhagen, *Vilhelm Hammershøi*, 1916, no. 114; Liljevalchs Konsthal, Stockholm, *Nyare dansk konst*, 1919, no. 430; Musée du Jeu de Paume, Paris, *L'art danois*, 1928, no. 65; Forum, Copenhagen, *Det danske Kunststævne*, 1929, no. 122; Prins Eugens Waldemarsudde, Stockholm, *Vilhelm Hammershøi*, 1975, no. 12.

LITERATURE: Sophus Michaëlis and Alfred Bramsen, *Vilhelm Hammershøi, Kunstneren og hans Værk*, Copenhagen, 1918, no. 149 (*Portræt*); Poul Vad, *Hammershøi, værk og liv*, Copenhagen, 1988, p. 142f, ill. p. 142; on portraits of Ida: Harald Olsen in *Vilhelm Hammershøi, en retrospektiv udstilling*, Ordrupgaard, 1981, pp. 26–32 (in English); Poul Vad, "Vilhelm Hammershøi, tre unge kvinder" in William Gelius (ed.), *Ribe Kunstmuseum 100 år*, Ribe, 1991, pp. 52–55; Susanne Meyer-Abich, *Vilhelm Hammershøi. Das malerische Werk*, Inauguraldissertation, Ruhr-Universität, Bochum, 1995, no. 131.

The portrait of the artist's wife Ida was painted as a preparatory work for a larger commissioned painting, *Three Young Women* from 1895, which was shown in Den Frie Udstilling that year and is today owned by Ribe Kunstmuseum. Ida (1869–1949) was the sister of the artist's friend, the painter Peter Ilsted, and it was during the summer of 1890 during Hammershøi's visit to Stubbekøbing on the island of Lolland in southern Denmark that she and Hammershøi became engaged. In the large painting, we see Ida flanked by her two sisters-in-law: on the left Ingeborg Ilsted, the wife of Peter Ilsted, and on the right Anna Hammershøi, the artist's sister. The three young women are seen full-length, sitting in a room, which is merely suggested with great simplicity, behind them. As was typical in the 1890s, the design is in the nature of a frieze, with virtually no perspective effect, so that it reminds one both of paintings by James McNeill Whistler (1834–1903), an artist whom Hammershøi admired and subsequently sought to contact, and of the Florentine Renaissance painting that he had studied so intensively during the preceding years. After their wedding in 1891, the Hammershøis went to Holland and spent the winter in Paris. In 1893 they visited a number of northern Italian cities including Verona, Venice, Bologna, Siena, and Florence.

There was a strong bond between the artist and his mother and sister, but it was Ida who shared his everyday life, and she appears as a model in many of his later paintings. Hammershøi painted several portraits of her, the first in 1890, where she is sitting indoors, dressed ready to go out (private collection). The double portrait from 1892 of Ida and Hammershøi himself (Davids Samling/The David Collection, Copenhagen) says little about their relationship. Things are different in the enigmatic portrayal of the couple from 1898, *Two Figures* (Aros, Aarhus Kunstmuseum), which contains both drama and melancholy.

In this portrait study, which is quite like the finished picture but seems to be more lush in its coloring, we see that Ida has just the hint of a smile. The artist generally abstained from sweetness and personality

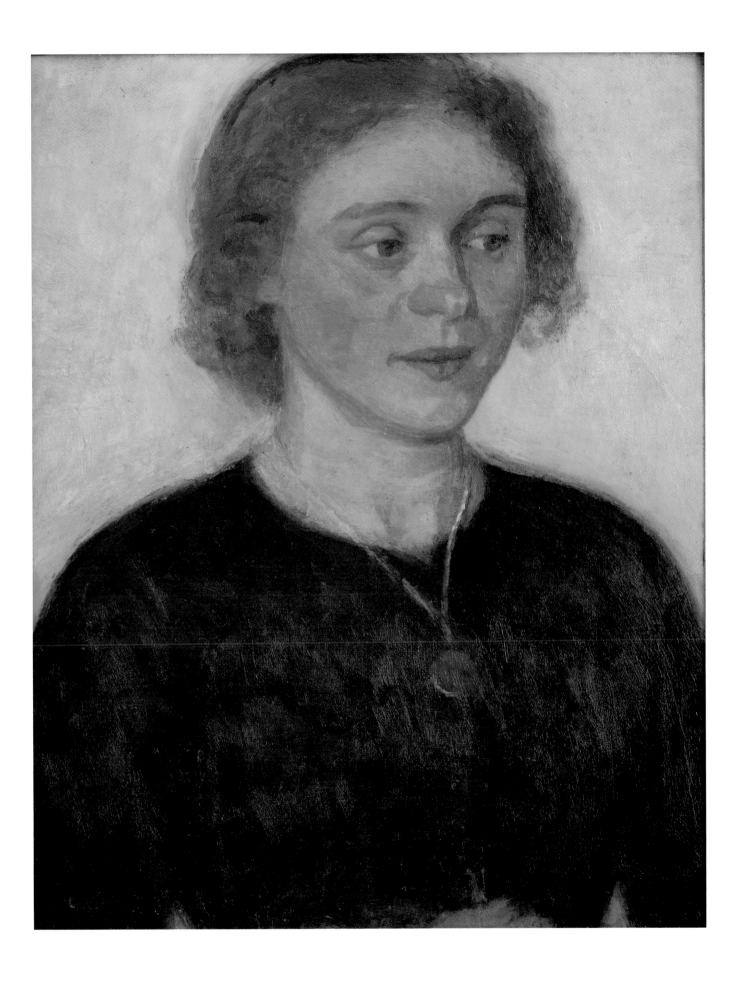

in portraits, not only in those of Ida. Hammershøi's biographer Poul Vad points out how the artist has hinted at a flower in her hand, so that the painting relates to *The Girl with the Carnation* (Statens Museum for Kunst), which until 2006 was thought to be a work by Rembrandt and after which Hammershøi made a drawing. Vad also suggests another possible inspiration for this portrait of Ida: Paul Gauguin's *Vahine no te Tiare* (Ny Carlsberg Glyptotek), the portrait of a woman from Tahiti, which was included in the Free Exhibition in 1893.

The Loeb portrait study originally belonged to Karl Madsen (1855–1938), who was the spokesman for the painters of the Modern Breakthrough in the 1880s and who praised Hammershøi. Madsen was included in Hammershøi's great *Five Portraits* (Thielska Galleriet, Stockholm). A close friendship between the Madsen and Hammershøi families continued for several generations. Hammershøi was godfather to Madsen's granddaughter Else Lofthus (1909–2004), who owned this picture until her death. Karl Madsen rated it so highly that he included it in the prestigious exhibition in Paris in 1928, where he presented a French public a choice of fine art with what he considered the best of Danish painting.

E.F.

VILHELM HAMMERSHØI
1864–1916

132. *Interior with a Woman Standing*
(Interiør med stående kvinde)

Oil on canvas, 26½ x 21½ in. (67.5 x 54.3 cm)

PROVENANCE: Winkel & Magnussen 1918; Bukowski's, Stockholm, Auction 383, 1969, lot 164; Christie's, London 29.3.1990, lot 83; Codan Insurance; Sotheby's London, The Scandinavian Sale, June 2005, lot 167, ill.

EXHIBITED: Scandinavia House, New York, *Danish Paintings from the Golden Age to the Modern Breakthrough, Selections from the Collection of Ambassador John L. Loeb Jr.*, 2013, no. 18.

LITERATURE: Sophus Michaëlis and Alfred Bramsen: *Vilhelm Hammershøi, Kunstneren og hans Værk*, Copenhagen, 1918, no. 358 (described as *Stue*); Robert Egevang (ed.), *Historiske huse på Christianshavn*, Copenhagen, 1993; Susanne Meyer-Abich, *Vilhelm Hammershøi. Das malerische Werk,* Inauguraldissertation, Ruhr-Universität, Bochum, 1995, no. 362; on the motif: Lena Boëthius, Görel Cavalli-Björkman (eds.), *Vilhelm Hammershøi*, Göteborgs konstmuseum, 1999, no. 52; Bente Scavenius and Jens Lindhe: *Hammerhøis København*, Copenhagen, 2003, p. 94.

After living for some years in Bredgade, the Hammershøi family moved back to Strandgade in the Christianshavn district of Copenhagen, this time to no. 25 on the west side of the street, opposite his former apartment at no. 30. This big house was built in 1738–39 as offices and meeting rooms for Asiatisk Kompagni (a trading company doing business with Asia, mostly India and China), and at the end of the 1970s it was restored for the use of the Danish Ministry of Foreign Affairs. Its late baroque facade with dark red bricks and sandstone ornamentation, and its huge mansard roof, are well known from several paintings by Hammershøi from about 1902 (e.g., in Statens Museum for Kunst). The tall windows in the bel étage (main floor) where Hammershøi and Ida lived, are characteristically divided in the same way as those on the courtyard side in the old apartment at no. 30. This is seen in the painting *The Four Rooms* from 1914 (Ordrupgaard Collection). In the new apartment the height of the rooms from floor to ceiling was higher, and the light effects thus produced inspired the artist.

During the few years Hammershøi still had left, he painted a series of interiors from this beautiful apartment. This painting shows two rooms linked by a jib door.[1] In the farthest room we can see a closed door, which is beautifully molded, as are the doorframe and the low dadoes in the rooms. In the window niche in the next room, Ida is standing close to a small table, with her back to us. The walls are gray and are adorned with just one small framed picture in each of the rooms. We see only the edge of the jib door, which takes up as little room as possible in this painting.

We know from other Strandgade 25 paintings that there were in reality four rooms opening one upon the other when viewed from where the artist had placed his easel. An example is the Ordrupgaard Collection's *The Four Rooms* from 1914, in which all the doors are open and the old floors, with the broad floorboards, fill much of the painting. Here in the nearest room we see a washstand and mirror, and in the next one a Windsor chair, also familiar from other paintings.

The painting in the Loeb collection is thus a typical example of Hammershøi's interiors, where he varies his simple motifs by changing the furnishings, including the pictures hanging there, and by showing us a sometimes narrow and sometimes broad section of the reality of his home. In the exhibition catalogue

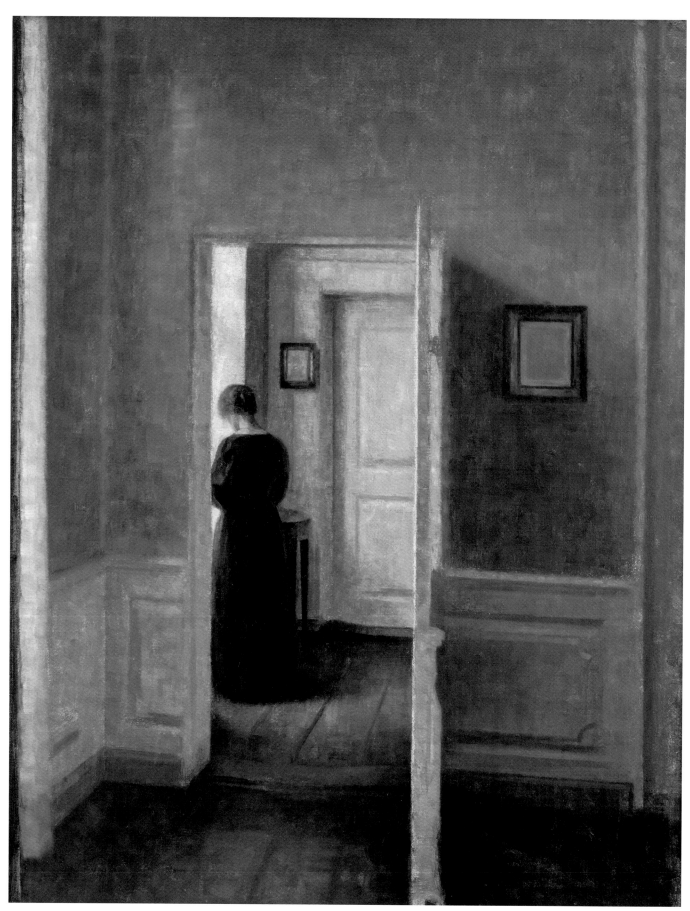

132. VILHELM HAMMERSHØI *Interior with a Woman Standing*

from Gothenburg 1999, Görel Cavalli-Björkman describes how, during his final years, Hammershøi used a drier color so that the white appears more chalklike than formerly, giving the grayscale "a new resonance" (p. 146).

<div align="right">E.F.</div>

[1] A door made flush with the wall, without moldings.

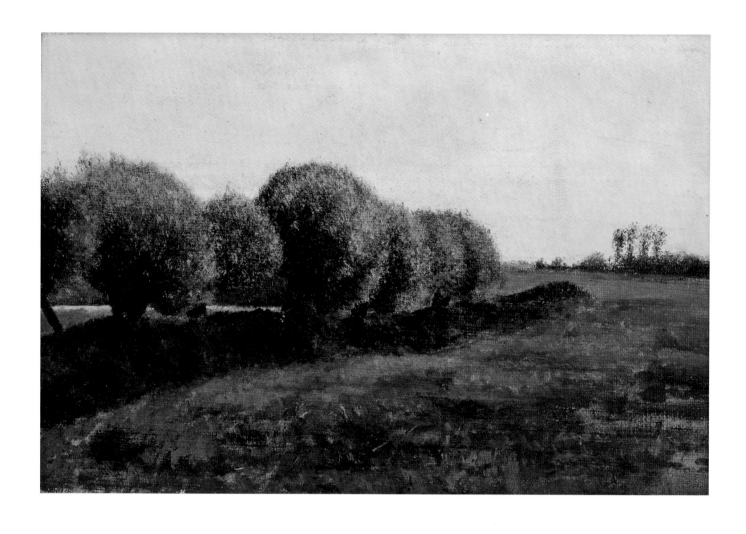

VILHELM HAMMERSHØI
1864–1916

134. *Landscape with a Row of Trees* (probably 1880s)
(Landskab med en række træer)

Oil on canvas, 7¾ x 11¾ in. (20 x 30 cm)

Not signed or inscribed

PROVENANCE: The sculptor Helen Schou, Copenhagen; Bruun Rasmussen, Auction 770, 2007, lot 428, ill.

This small sketch of a landscape was probably painted when Hammershøi was still a young man. As was so often the case, he chose a clouded day when the sky was almost white. We look at a wide green field, bordered at the left by a row of dome-shaped trees. The grayish-green color of the foliage suggests they are willows. They grow in an embankment and form a strong diagonal to the left of the picture. Beyond the trees there is a stream, but how large it is we cannot tell. Beyond the water more green appears. To the right on the horizon behind the field are some bushes and four tall trees, probably poplars, all painted very dimly.

The paint is in part very thin, the brown ground being visible in the embankment. Apparently Hammershøi scraped off some of the paint, a well-known technique of his seen in other sketched landscapes by the artist, such as *Landscape from Virum Near Frederiksdal, Summer*, 1888, no. 38 (in the Loeb collection).

This little sketch was formerly part of the collection of sculptor Helen Schou (1905–2006), who had a fine eye for the qualities of Danish painting. Her major work is the equestrian statue of King Christian X, finished and erected in 1955 in Aarhus, Jutland's largest town. Her stately home and large studio in Ordrup, north of Copenhagen, overlooked Øresund Sound. It was the neighboring house of the private residence of the American ambassador to Denmark. Ms. Schou and Ambassador Loeb became friends during his Danish tenure.

The history of the painting is otherwise unknown, left unrecorded by Alfred Bramsen in his Hammershøi oeuvre catalogue, published in 1918, nor was it noted by Susanne Meyer-Abich 1995.[1] However, the authenticity is ensured by Ida Hammershøi, widow of the painter, who wrote the following words in ink on the back of the canvas: "malet af Hammershøi attesteres Ida Hammershøi" (painted by Vilhelm Hammershøi certified by Ida Hammershøi).

E.F.

[1]Susanne Meyer-Abich, *Vilhelm Hammershøi. Das malerische werk*, Inauguraldissertation, Ruhr-Universität, Bochum, 1995.

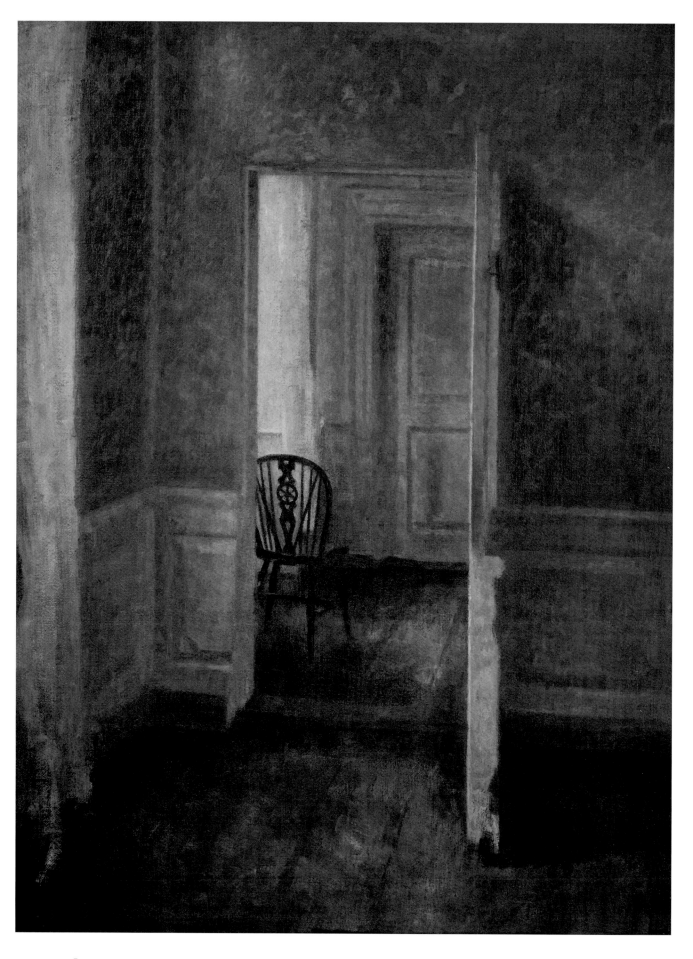

VILHELM HAMMERSHØI
1864–1916

146. *Interior with Windsor Chair* (1913)
(*Interiør med windsorstol. Strandgade 25*)

Oil on canvas, 29 x 21¼ in. (73.5 x 54 cm)

Not signed, nor inscribed

PROVENANCE: Ida Hammershøi, the artist's wife; Anna Hammershøi, the artist's sister; engineer Peter Olufsen and Kamma Ilsted, niece of Ida Hammershøi (a gift from Anna Hammershøi); Ambassador Henning Halck; Ms. Franciska Halck; Sotheby's, London, December 10, 2014, lot 40, ill.

EXHIBITED: Copenhagen, Ordrupgaard, *Vilhelm Hammershøi*, 1981, no. 128, ill. p. 156; New York, Wildenstein, Washington, The Philips Collection, 10 pt, 1983, no. 73.

LITERATURE: Alfred Bramsen and Sophus Michaëlis, *Vilhelm Hammershøi. Kunstneren og hans Værk*, Copenhagen 1918, p. 112, no. 366 (described as *Stue*); Poul Vad, *Hammershøi, værk og liv*, Copenhagen, 1988, p. 343, ill. (described as *Interiør med windsorstol. Strandgade 25*); Poul Vad, *Vilhelm Hammershøi and Danish Art at the Turn of the Century*, New Haven, London, 1992, ill. p. 343; Susanne Meyer-Abich, *Vilhelm Hammershøi. Das malerische Werk*, 1995, no. 377; Poul Vad, *Hammershøi, værk og liv*, Copenhagen, 2003, p. 364 (mentioned), ill. p. 388; Tom Okke in *Børsen*, December 5, 2014; Camilla Stockmann in *Politiken*, December 10, 2014.

Vilhelm Hammershøi usually worked on a series of paintings. In the beautiful apartments that he lived in, he explored the individual rooms from different angles and in different lightings. Often, he would paint a parlor from the same angle with varying pieces of furniture, people, or pieces of art. In other words, the interior paintings from his apartments represent only selected parts of all that was in the artist's home; they have been composed for purely artistic reasons. According to contemporary eyewitnesses, Hammershøi's rooms were not as empty as he painted them but furnished normally, with pictures on the walls.

The rooms we see in this painting were in Strandgade 25, a building typical of late baroque architecture. It originally held the Asiatic Company's offices. Four consecutive parlors, of which we see two, were connected by doors all equally distant from a wall with windows. Two were panel doors, while the one we see at the front is a "jib" door (without molding at the bottom). It intrigued Hammershøi to look through this succession of doors, and this is one of a total of four he painted at this place in the apartment. The Loeb collection includes two of the four (no. 132). The artist must have loved living in a building with such marvelous architectural details for him to paint. The house of the Asiatic Company was designed by the Dutch architect Philip de Lange (c. 1705–1766) and erected just before 1740.

In *Interior with Windsor Chair*, we see the corner of the front room with the wall panel that continues in the door, which we see in a sharp profile. Light streams at the left from a window that is not in the picture, but its presence is indicated by the bevel of the window and the light curtain. In the next parlor, where the light is also coming from a similar window at the left, a Windsor chair stands at the left, with its back toward the viewer. The next door is shut. This is exactly the same view of two parlors that Hammershøi reproduces in *Interior with Woman Standing* (Loeb collection no. 132; Fig. A). The open jib door stands in the same position, but in *Interior with Windsor Chair*, its bottom edge is also seen, as well as more of the floor. Here the chair replaces the figure of Ida Hammershøi, and the framed pieces of art on the walls have been omitted.

The same chair reappears in the painting *The Four Rooms (De fire rum)*, owned by the Ordrupgaard Col-

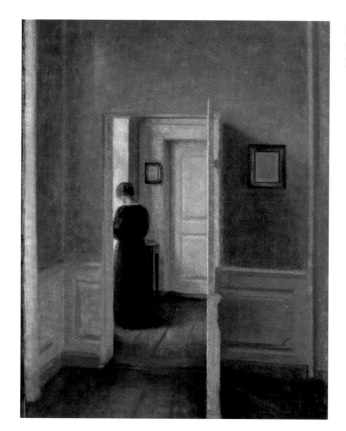

FIG. A *Interior with a Woman Standing* (1913)
Oil on canvas, 26½ x 21½ in. (67.5 x 54.3 cm)
Loeb Collection no. 132. Bramsen 1916 no. 358.

lection (Fig. B), in which all three doors are open. It was painted the year after (1914) from a position farther to the left, so that we see the right side of door frames in the three consecutive parlors. The Windsor chair is still situated in parlor number two, but this time to the right of the door into parlor number three, seen from the front. The same angle is also found in Hammershøi's final painting of 1915, where Ida is seen sitting in the first parlor with a needlework (Fig. C). She sits by a table on which a coffee cup and a coffee pot are standing. Without altering his position as seen in *The Four Rooms (De fire rum)*, the painter has simply added a table, the figure of Ida, and in the front on the left, a chair. Farthest back in the parlor, one can see the Empire-style sofa appearing in other paintings by Hammershøi.

The light is brighter in *Interior with Windsor Chair* than in the other paintings. It comes from the tall windows found in the sequence of parlors. They cannot be seen in the paintings, but the long, bright curtains are softly lit. The perspective is similar in all four interior pictures, and the vanishing point is so high that the painter must have been standing when choosing the angle on the section of the interior that he wanted to paint. According to Alfred Bramsen (1916), this painting was not completed.

E. F.

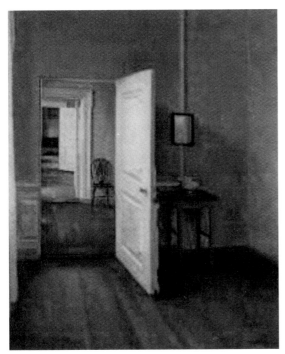

FIG. B *The Four Rooms* (1914)
Oil on canvas, 33½ x 27¾ in. (85 x 70.5 cm)
Ordrupgaard Collection, Copenhagen. Bramsen 1916
no. 368.

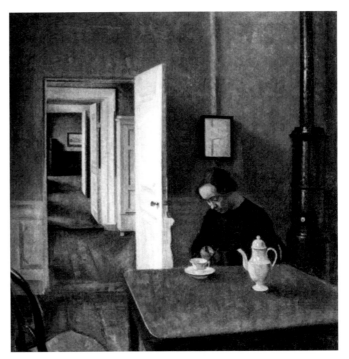

FIG. C *A room (Stue)* (1915)
Oil on canvas, 28⅓ x 25½ in. (72 x 65 cm)
Marin Karmitz Collection, France. Bramsen 1916 no. 377.

CARL CHRISTIAN CONSTANTIN HANSEN

ROME 1804 – FREDERIKSBERG 1880

Constantin Hansen grew up in Copenhagen, but he was born in Rome and baptized in Vienna. His godmother was Mozart's widow, Constance, after whom he received his Christian name. He received his first instruction in art from his father, the portraitist Hans Hansen (1769–1828). At age twelve he started in the Royal Academy with the intention of becoming an architect, but he later changed to painting. After the death of his immediate family, he became closely attached to Professor C. W. Eckersberg. Constantin Hansen was awarded both silver medals, but in 1831 and 1835 he competed in vain for the major gold medal. In 1835, thanks to funds from the Fonden ad Usus Publicos, he was able to go to Italy for further training. He lived there for nine years, mainly studying architectural and decorative painting. Together with a friend, the decorative painter Georg Hilker (1807–1875), he also studied antique painting in Italy with a view to the later decoration of the entrance hall to Copenhagen University. But during his stay he also executed several portraits and pictures of everyday life, as well as what is perhaps his best-known work, A Company of Danish Artists in Rome, *1837, Statens Museum for Kunst. Seven figures—Constantin Hansen, the architect Gottlieb Bindesbøll (1800–1856), Martinus Rørbye, Wilhelm Marstrand, Ditlev Blunck (1798–1854), Jørgen Sonne (1801–1890), and Albert Küchler (1803–1886) (plus the dog on a chair) are congregated in the Roman apartment of Bindesbøll. On a table can be seen one of Bindesbøll's drafts for the planned museum for the sculptor Bertel Thorvaldsen (1770–1844) in Copenhagen.*

Constantin Hansen's earliest works were mostly portraits inspired by his father's great exemplar Jens Juel; he often used his sisters as models. In time he specialized in architectural painting, presumably on the recommendation of Eckersberg, but he is best known for his pictures of ancient buildings. Like Eckersberg twenty years earlier, Hansen sometimes painted colossal but not immediately recognizable fragments of these historical structures, occasionally viewed from very close up and drastically foreshortened.

After returning home from his first extended visit abroad, Constantin Hansen joined Hilker in decorating the entrance hall to Copenhagen University, using a fresco technique that he had recently learned in Munich (1844–1853). In 1846 Constantin Hansen's painting Orpheus Ascending from Tartarus *(Hannover 1901, cat. no. 242, ill. p. 117), which was intended to gain him membership in the Academy, was unfortunately rejected. The same thing happened two months later to Christen Købke. Both events were unjust and led to a scandal, giving rise to much discussion.*

Hansen was in France, Holland, and Belgium in 1858, and in 1873 he visited Italy for the last time. In his later years he again painted a number of portraits, including group portraits. The best known is the mighty The Constituent National Assembly, *1861–1865 (Frederiksborg).*

Constantin Hansen exhibited at Charlottenborg between 1824 and 1878, though he did not do so every year, and received various marks of honor and distinctions over the years. In 1854 he was appointed a titular professor at the academy, where he was the director from 1873 to 1879. S.L.

LITERATURE: Emil Hannover, *Constantin Hansen,* Copenhagen, 1901 (with oeuvre catalogue); Hannemarie Ragn Jensen, Constantin Hansen, "A 19th-Century Danish Classicist" in *Hafnia, Copenhagen Papers in the History of Art,* no. 10, Copenhagen, 1985; Stig Miss and Jens Erik Sørensen (eds.), *Constantin Hansen 1804–1880,* Thorvaldsens Museum, Aarhus Kunstmuseum 1991; Hannemarie Ragn Jensen in *Weilbach,* vol. 3, Copenhagen, 1995.

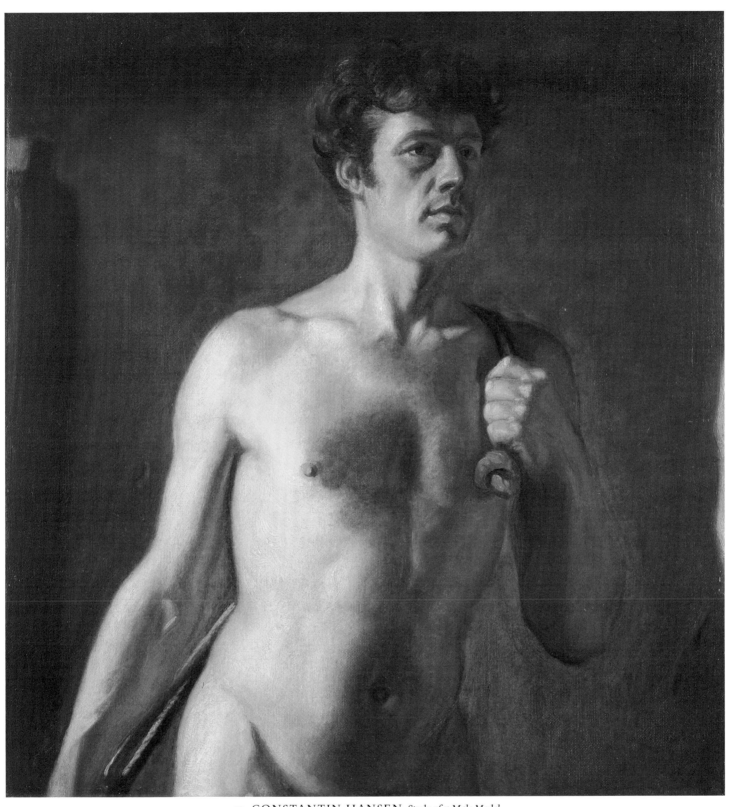

43. CONSTANTIN HANSEN *Study of a Male Model*

CONSTANTIN HANSEN
1804–1880

43. *Study of a Male Model*
(Mandlig modelstudie)

Oil on canvas, 17¼ x 16⅔ in. (43,5 x 41,5 cm)

PROVENANCE: Editor Svend Kragh-Jacobsen; Arne Bruun Rasmussen, Auction 465, 1984, lot 19.

EXHIBITED: Busch-Reisinger Museum, Harvard University Art Museums, *Danish Paintings of the Nineteenth Century from the Collection of Ambassador John L. Loeb Jr.,* 1994, no. 10.

LITERATURE: Peter Nisbet, *Danish Paintings of the Nineteenth Century, from the Collection of Ambassador John Loeb Jr.,* Busch-Reisinger Museum, Harvard University Art Museums, Cambridge, Massachusetts, 1994, discussed and ill. pp. 4–5.

The attribution of this painting to Constantin Hansen has not been documented, but derives from Arne Bruun Rasmussen, who had a profound knowledge of Danish Golden Age painting.

While Constantin Hansen was a pupil, the teaching in the Royal Danish Academy of Fine Arts in Copenhagen was divided into junior and senior classes. In the latter, students were allowed first to draw and later to paint live models. In the life class, work was mostly carried out in the evening in artificial light, and the professors took turns, a month at a time, during which they arranged the model's pose.

Constantin Hansen attended the academy's life class from 1825 to 1833, when he was taught by such diverse professors as J. F. Clemens (1741–1838), C. A. Lorentzen, (1746–1825), J. L. Lund (1777–1867), and C. W. Eckersberg.

Eckersberg's teaching differed markedly from that of the other teachers in that he placed his models in natural, almost everyday poses, and did so in bright daylight when they were to be painted in oils. Eckersberg's aim was to expand the traditional life studies which had always had history painting as their objective, i.e., the ability to produce famous historical, mythological, or religious scenes.

Professor Eckersberg's pupils learned especially to see the figure in relation to light and shade, to the laws of perspective, and to the immediate physical surroundings.

This work is traditional in arrangement for historical painting. The model is supporting himself on the obligatory rope, necessary for the model to be able to stay in the pose. He has been placed in artificial light so as to allow training in the dramatic effect of strong shadows deriving from historical painting's demands for such things as a heroic and masculine appearance. (The public of the time interpreted strong shadows as heroic and masculine.)

This life study shows the influence of Eckersberg's radical teaching in its realism and its harmonious and artless arrangement. Eckersberg exerted a great influence on Constantin Hansen, who became one of the pupils by whom he set the greatest store.

S.L.

HEINRICH HANSEN

HADERSLEV 1821 – FREDERIKSBERG 1890

Hansen first trained as a painter's assistant in Flensborg in what was then Danish Southern Jutland. In 1842 he entered the Royal Danish Academy of Fine Arts in Copenhagen as a decorative artist, and during his studies he worked alongside many other young students who were decorating Thorvaldsens Museum. Here he became good friends with Ferdinand Meldahl (1827–1908), who subsequently qualified as an architect and later became the energetic director of the academy. Not only did Hansen win the major silver medal for decorative art but in 1846 he was also awarded the silver medal in the academy's life class, where he spent his final student years.

Architectural and decorative shapes of the past had been the accepted basis for contemporary decorative art, but more and more in the 1840s, decorative artists drew inspiration not only from classical antiquity and the Renaissance but from later eras. The drawings Hansen brought home from his first study trip to Germany in 1847 containing examples of Gothic, Renaissance, and Baroque work were so good that he was appointed to the academy to teach perspective and ornamentation in 1848. In 1850, he was awarded a bursary by the academy in recognition of his painting Frederiksborg Castle in the Time of King Frederik III *(i.e., from the period of that king's reign, 1648–1670). In early May of that year, he and Meldahl left on a major study trip. Between then and 1852 he visited Spain, France, Scotland, England, and the Netherlands, completing such thorough studies of historical monuments that he had material for paintings to last him the rest of his life.*

Hansen was the first in Denmark to do what is known as "architectural paintings." As distinct from a view or a vedute reproducing reality, an architectural painting is typically a reconstruction of the outside of a building and its surroundings, or an interior. The reproduction is a piece of art and thus essentially different from the architect's surveys or perspective reproductions. The architectural painter brings a vanished age to life, reproducing the chosen motif as though it were reality, often including figures wearing historical dress. Hansen won great popularity for his technical and perspective skills, his sure sense of the special quality of the styles of architecture and of decoration styles, and his ability to reproduce the details in a clear and pleasing form.

In the Denmark of the 1840s, when nationalist sentiments were running high, there was an intense focus on the Danish cultural heritage. This was true for instance in France, when a start was made on "restoring" older buildings, which in those days meant they were reconstructed in what was believed to be their original form. This was done with great medieval cathedrals and several buildings from the reign of Christian IV, 1588–1648, including Frederiksborg Castle. This popular king was particularly active in commissioning fine buildings, and people once believed that he was an architect himself. The style was named after the king, but in fact it is Dutch Renaissance and is the work of Dutch architects brought in by the king. The "Christian IV style" was Heinrich Hansen's favorite. His many detailed drawings of Frederiksborg turned out to be invaluable when the castle was recon-

structed after the great fire of 1859. As Meldahl's closest associate he produced new drawings for decorations, including a set for the ceiling in the great hall.

Hansen's talents went beyond decoration and architectural paintings. He became one of historicism's finest and most productive designers of furniture and ornaments. From 1868 to his death he was artistic director of the Bing & Grøndahl porcelain factory; he held several honorary offices, was decorated, and enjoyed great general recognition. Both as a painter and a designer, Heinrich Hansen belonged to the school of historicism, which was the dominant style in the second half of the 19th century. Throughout most of the 20th century, this style was seriously undervalued, and only in recent years have people again begun to appreciate its qualities.

E.F.

LITERATURE: H. Stemann, *Meldahl og hans venner*, vol. 1-6, Copenhagen 1926–1932; Birgit Jenvold, *Heinrich Hansen, kunstner i tid og rum*, Haderslev 1992.

HEINRICH HANSEN
1821–1890

130. *Tycho Brahe's Uraniborg*, 1882
(Uranienborg)

Oil, 23½ x 22⁴/₅ in. (60 x 58 cm)

Signed: H.H. 82.

PROVENANCE: Bruun Rasmussen, Auction 743, 2005, lot 1076, ill.

EXHIBITED: Charlottenborg, Foreningen for National Kunst, Kunstforeningen, *Mindeudstilling for Heinrich Hansen*, 1944, no. 44.

LITERATURE: Birgit Jenvold, *Heinrich Hansen, kunstner i tid og rum*, Haderslev, 1992 (the finished painting is reproduced p. 26); Poul Grinder-Hansen (ed.): *Tycho Brahes verden. Danmark i Europa 1500–1650*, Nationalmuseet, Copenhagen, 2006.

The name of Heinrich Hansen is linked to Frederiksborg Castle in several ways. This painting presents part of the decorations that were started after the decision was made to rebuild the castle after the 1859 fire and turn it into a museum of national history. The room where the motif was to be painted was intended to tell the story of the world-famous Danish astronomer Tycho Brahe (1546–1601).

An undated letter from Heinrich Hansen to his friend Ferdinand Meldahl (1827–1908), professor of architecture, director of the Royal Danish Academy of Fine Arts, and the man responsible for the rebuilding of Frederiksborg, reads: *As agreed I herewith send the 2 sketches or preliminary works for the 2 paintings that it is intended should be placed above the fireplace and above the door in the Tycho Brahe Room, representing Uranienborg (the figures are those of Tycho introducing Queen Sophie to Anders Sørensen Vedel, who is handing the queen a collection of medieval ballads) and Stjerneborg with some of the nocturnal life there in the service of astronomy. The buildings are represented according to Tycho's drawings and plans. I offer to paint these pictures ...*

The painting in the Loeb collection must be identical to one of the submitted pictures to which Hansen refers in his letter, which is presumably from 1881 or 1882. In any event, it is a completely finished work in itself and thus more than a preliminary study. The board of the Frederiksborg Museum approved it and its companion piece. The works for the actual decoration, which are rather larger—the painting of Uraniborg measures 5²/₃ ft. x 5³/₅ ft. (165 x 173 cm)—were signed by Heinrich Hansen that same year, 1882, and exhibited in Charlottenborg in 1883. They still hang in the Frederiksborg Museum.

This example is typical of Hansen's architectural painting. The big, idiosyncratic building no longer existed in his day, so he painted a visualization. We see Uraniborg, or Uranienborg, the original name of which was Uraniburgum, created by the astronomer Tycho Brahe. His fame and dramatic life story were never forgotten, and still awoke keen interest in later ages, especially in the historians, poets, composers, and painters of the 19th century, and not only those in Denmark.

As was customary for young noblemen, Tycho Brahe had had a lengthy training, especially in Germany, when he discovered a supernova in 1572 and published a description of his observations the following year. From 1576 he was given generous financial support by the Danish king Frederik II, who also awarded him an "enfeoff——"[1] (a freehold property). It was the small island of Hven, situated in the sound between Denmark, Sweden, and Danish territory, until ceded in 1660 to Sweden as part of the peace process between the two. Between 1576 and 1580, Uraniborg was built according to Brahe's designs, square with a semicir-

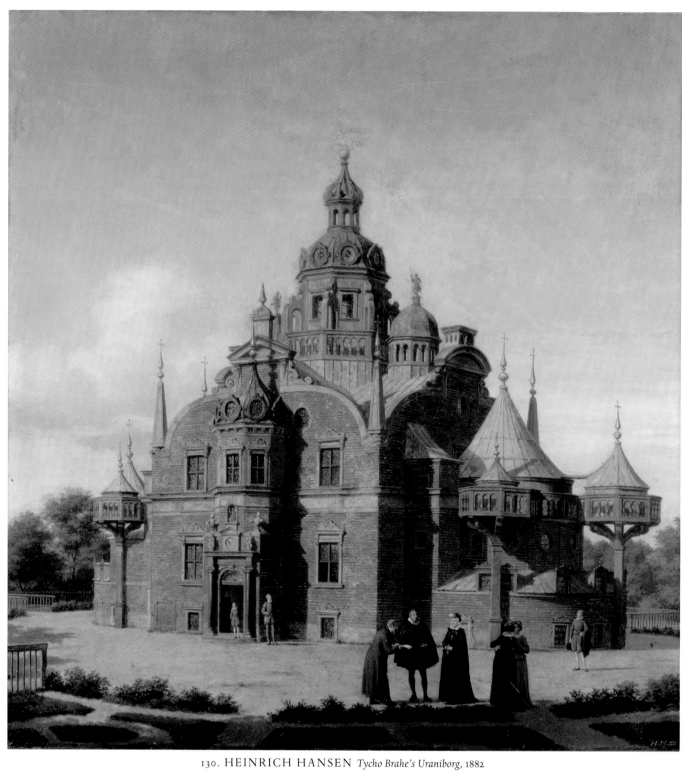

130. HEINRICH HANSEN *Tycho Brahe's Uraniborg,* 1882

cular outbuilding at either end. It stood cornerwise at the center of another square, an enclosed garden with gates and service buildings, including a printing press and a paper mill. A short distance from this, Brahe built the partly subterranean observatory Stjerneborg (Stellaeburgum) for his many instruments. In this research center he worked with his pupils and assistants in constant contact with foreign scientists. On several occasions he received visits from royalty. In 1590 James VI of Scotland (later painted by Wilhelm Marstrand among others) came there, and in 1596 the new young king, Christian IV.

Meanwhile, Brahe fell into disgrace, allegedly for mistreating his peasants and for disrespecting the new king, and he left Denmark in 1597. The buildings on Hven started to disintegrate and by about 1650 had virtually disappeared. Brahe went to Prague, where Emperor Rudolf II supported his activities from 1599 until Brahe's death in 1601. In Prague, he collaborated with the astronomer Johannes Kepler (1571–1630), who preserved Brahe's instruments and written observations, materials that represented a crucial contribution to the younger scientist's epoch-making scientific discoveries. Brahe died when he was only 54, and it was demonstrated a few years ago that his death was caused by mercury poisoning. On the basis of this, in 2004 two authors put forward the theory that he was murdered by Kepler.

Although Brahe still believed that Earth was the center of the universe, his observations and publications had lasting value and ensured him a prominent place in the history of science, so there was every reason to memorialize him in Denmark's new museum of national history. This Heinrich Hansen did with the painting of Brahe's splendid house, where we see Frederik II's queen, Sophie, visiting him in 1586 in the company of the historian Anders Sørensen Vedel. Tycho Brahe's buildings on Hven are today marked out on the ground, and part of the garden has been reconstructed.

E.F.

[1]Brahe was given a freehold estate in land.

ERNESTINE SOPHIE HENCK

SORØ 1822 – NÆSBY 1893

Sophie Henck was a member of the Copenhagen bourgeoisie, the daughter of the regimental surgeon and hospital consultant Carl Ludvig Henck. She studied first under J. L. Jensen and subsequently O. D. Ottesen (1816–1892).

Her oeuvre is not large. She took part in the annual Charlottenborg exhibitions, but only at irregular intervals, showing between one and four flower paintings at a time. The first occasion was in 1858, when she exhibited Markblomster (Meadow Flowers), En ribsgren (A Redcurrant Branch), Frugtstykke (Fruit Piece), *and finally a copy of a flower piece by the Netherlandish artist Jan van Huysum (1682–1749). Van Huysum's flower piece was acquired for the Royal Collection of Paintings in 1842 from a Norwegian collector, Prefect Thygeson. Ottesen painted a work in homage to that same piece that was purchased by the architect J. D. Herholdt (1818–1902).*

Sophie Henck's copy of the van Huysum piece was sold to Aarhus Museum (now Aros, Aarhus Kunstmuseum). Between 1867 and 1870 she exhibited each year at Charlottenborg: Voksende jordbær (Growing Strawberries), Et glas med forårsblomster *(A Vase of Spring Flowers),* Rød og hvidtjørn (Red and White Hawthorn), *and* En æblegren i blomst (A Branch of Apple Blossom). *This last was shown in the Women Artists' Retrospective Exhibition, Charlottenborg, 1920, now in the possession of Storstrøms Kunstmuseum, Maribo.*

In 1869, the sole work she exhibited was a copy of another Netherlandish flower piece by Joris van Son (1623–1667) entitled En udhugget stenramme omgivet af frugter (A Carved Stone Frame Surrounded by Fruit). *The original, a large picture measuring 67 x 47⅔ in. (170 x 121 cm), dates from 1665. In 1875 and 1876, she exhibited strawberry pictures, one each year.*

Sophie Henck went abroad twice, once to Dresden in 1848 (a violent year to travel, as it was the year of revolutions in Europe) and once to Paris, where she stayed between 1857 and 1858. She probably copied in the famous art collections in both cities. Paris offered special possibilities, as there were art schools there for women.

Unmarried, she lived with her parents; when her mother died in 1871, she moved to Kristiansdals Kloster near Sorø in Southern Zealand, where there was an establishment for unmarried women.

M.T.

LITERATURE: Laura Bjerrum in *Weilbachs Kunstnerleksikon*, vol. 3, Copenhagen 1995.

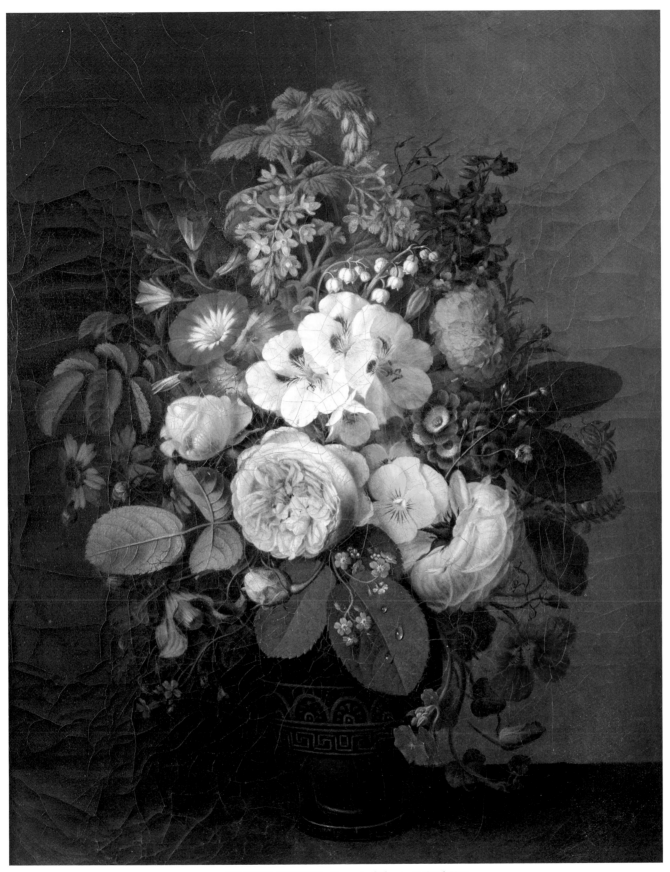

44. SOPHIE HENCK, *Bouquet of Flowers in Greek Vase*

SOPHIE HENCK
1822–1893

44. *Bouquet of Flowers in Greek Vase*
(Brogede blomster i græsk vase)

Oil on canvas, 16¼ x 12½ in. (41 x 32 cm)

PROVENANCE: Kunsthallen, Auction 398, 1991, lot 66, ill. p. 3.

EXHIBITED: Bruce Museum of Art and Science, Greenwich, Connecticut, and The Frances Lehman Loeb Art Center, Vassar College, New York, *Danish Paintings of the Nineteenth Century from the Collection of Ambassador John L. Loeb Jr.*, 2005, no. 11, ill.

LITERATURE: Patricia G. Berman, *In Another Light, Danish Painting in the Nineteenth Century*, New York, 2007, ill. p. 129.

In 1868, Sophie Henck exhibited a painting in the Charlottenborg exhibition entitled *En Vase med Blomster* (no. 80), *(A Vase of Flowers)*. As her oeuvre was small, it may well be that this is the same picture. It depicts a bouquet in a classical vase, with a compact and strict pyramidal, indeed even conical, composition. It is reminiscent of the bouquets painted in the 1840s by Sophie Henck's teacher, J. L. Jensen, but is even more compact and more round than his and quite obviously the creation of a different temperament. The pyramidal shape harks back to Dutch flower painting, but in all its diversity it radiates peace rather than splendor.

M.T.

The following flowers are seen in the painting:

FROM TOP TO BOTTOM: Ribes sanguineum (flowering currant); Delphinium hybrida (Delphinium); Convallaria majalis (Lily-of-the-valley); Convolvulus tricolor (Bindweed); Rosa (Rose); Coreopsis sepc. (Tickseed); Primula hybrida (Auricula); Viola hybrida (Violet); (Pansy); Myosotis palustris (Forget-me-not); Tropaeolum majus (Nasturtium).

T.T.

174]

CARL VILHELM HOLSØE

ÅRHUS 1863 – ASSERBO 1935

Carl Holsøe was born in Jutland, moving to Copenhagen in 1882 to study at the Technological School and then at the Academy of Fine Arts. After three semesters at the academy, Holsøe joined P. S. Krøyer's drawing school in Copenhagen, where he met his lifelong friends Peter Ilsted and Vilhelm Hammershøi.

This friendly triumvirate might be designated "The Danish Interior School of the Nineteenth Century," for each painted scenes from his own household, sharing a view of domestic tranquility not seen in Danish art before, though preceded by, and evocative of, the 17th century interiors of the Dutch masters Jan Vermeer (1632–1675), Pieter de Hooch (1629–1683), and Gerrit ter Borch (1617–1681). It was Hammershøi, however, who has been credited with being the true inspiration for Holsøe's focus on interior settings; the influence of Hammershøi is evident throughout his work.

A significantly successful artist in his day, Holsøe's work has enjoyed a recent resurgence of interest among art connoisseurs. Over his career he exhibited 116 paintings, chiefly in Charlottenborg but also in Europe and England. In Paris he received an honorable mention in 1889 from The Salon, and in Denmark he was awarded the Royal Academy's highest award, the Eckersberg Medal.

B.H.

LITERATURE: Karl Madsen in *Nordisk Tidskrift*, 1888, p. 104; Peter Michael Hornung and Kasper Monrad, *Dengang i 80'erne*, Kunstforeningen, Copenhagen, 1983; *Danish Paintings*, Bury Street Gallery, London, 1986; Bente Scavenius, *Den Frie Udstilling i 100 år*, Copenhagen 1991; Vera Rasmussen in *Weilbach*, vol. 3, Copenhagen 1995.

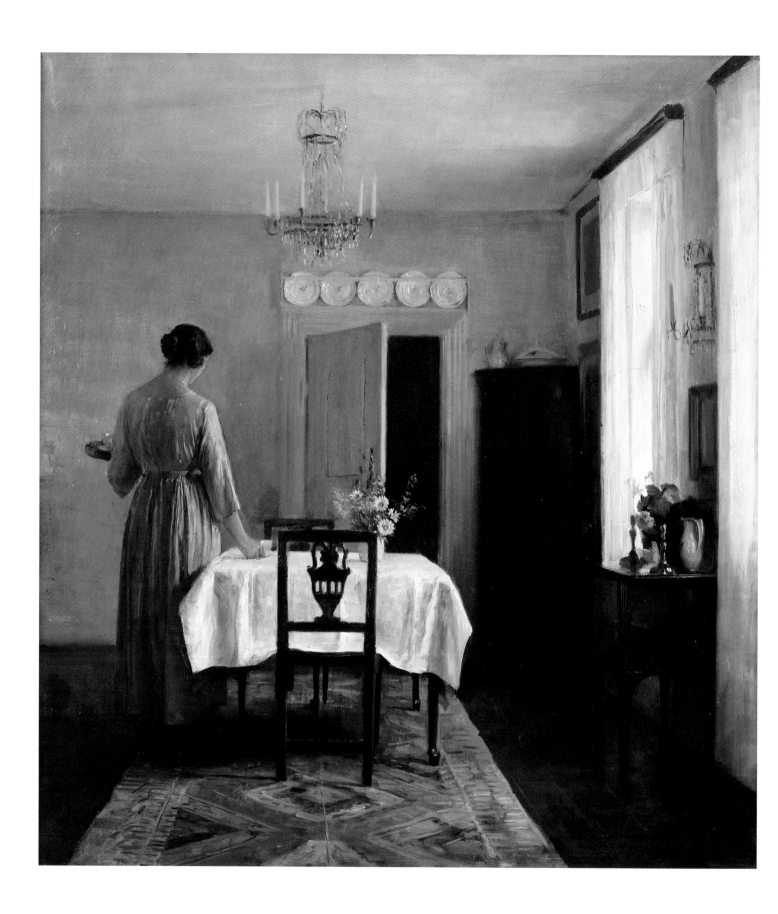

CARL HOLSØE
1863–1935

45. *Artist's Wife Setting Table*
(Kunstnerens hustru dækker bordet)

Oil on canvas, 28¾ x 25½ in. (73 x 65 cm)

Signed lower right: C. Holsøe

PROVENANCE: Bruun Rasmussen, Auction 682, 2000, lot 1449, ill. p. 49 and cover.

EXHIBITED: Scandinavia House, New York, *Danish Paintings from the Golden Age to the Modern Breakthrough, Selections from the Collection of Ambassador John L. Loeb Jr.*, 2013, no. 19.

EXHIBITED: Bruce Museum of Art and Science, Greenwich, Connecticut, and The Frances Lehman Loeb Art Center, Vassar College, New York, *Danish Paintings of the Nineteenth Century from the Collection of Ambassador John L. Loeb Jr.*, 2005, no. 16, ill.

LITERATURE: Patricia G. Berman, *In Another Light, Danish Painting in the Nineteenth Century*, New York, 2007, p. 244, ill. p. 248.

The charm of soft indirect light in an interior household setting never failed to intrigue Carl Holsøe throughout his long career of depicting domestic tranquility. Here we have an example of his ability to capture the play of light and use it to illuminate indirectly the subject of his painting, Mrs. Holsøe.

We see Holsøe's wife, Emily Heise, his favorite and most frequent model, setting the table sometime after 1886 in their minimally furnished dining room in Lyngby, Copenhagen. "Less is more" was a decorating choice typical of well-to-do homeowners at the turn of the century in Denmark. That choice is epitomized here by the couple's two handsome mahogany chairs, corner cupboard and side table, a softly sparkling Swedish crystal chandelier, glowing white porcelain plates above the doorway, and a woven pastel rug, the colors of which echo the pinks and muted greens in the flower vase. Though few in number, the objects in the room are tasteful and placed with an artist's eye for composition.

The linen tablecloth, illuminated by summer light filtered through white muslin curtains, is the focal point of the painting; nevertheless, though she is more dimly lit, Holsøe has made sure we are mindful of how important the woman is to the composition.

The Artist's Wife Setting the Table gives evidence that Holsøe was a master of the interior setting, as do his many studies of women such as *Reading by Window, Standing by Window, Sewing by Chair,* and *Woman Standing near Cello,* which hang in national collections throughout Scandinavia.

B.H.

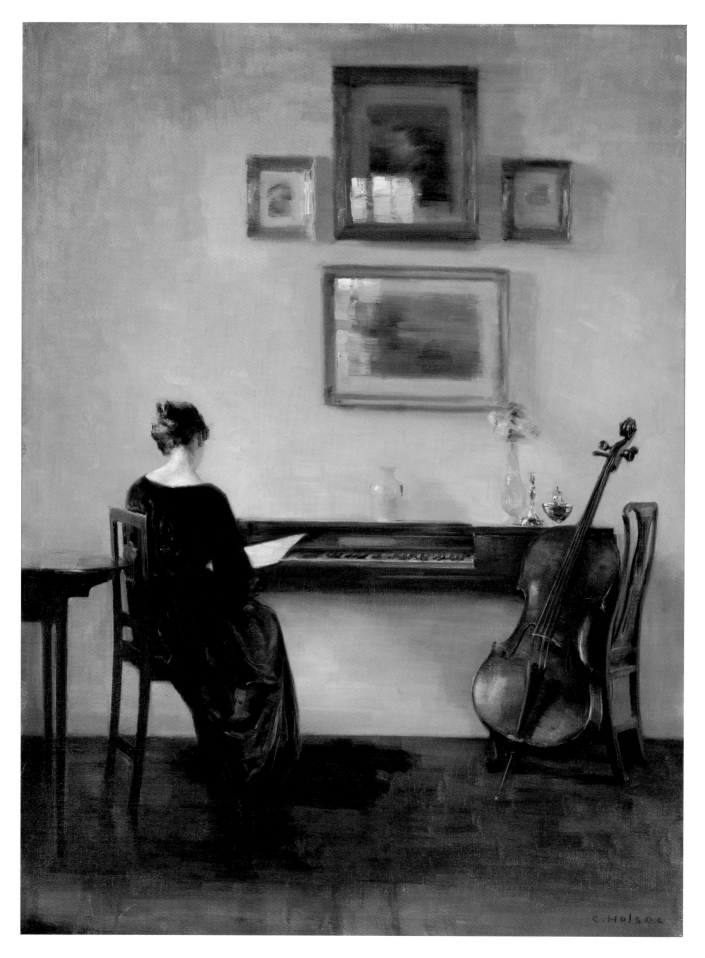

CARL HOLSØE
1863–1935

138. *Interior with Woman Seen from Behind (after 1900)*
(Interiør med kvinde set bagfra)

Oil on canvas, 37 x 28⅓ in. (94 x 72 cm)

Signed bottom right: C. Holsøe

PROVENANCE: Arne Bruun Rasmussen, Auction 291, 1973, lot 103, ill. p. 21; Bruun Rasmussen, Auction 822, 2011, lot 33, ill.

We see a living room with ivory-colored walls, where a young woman sits by a rectangular spinet. She is seen aslant from the back, with her head gracefully bent over a white paper, perhaps a piece of music she is studying. The painter commands immediate attention to her beautiful white neck, which dominates the picture, accentuated by her dark hair and boat-necked black dress. At her right, a cello leans against the spinet in a position that almost makes it resemble another person.

The room is bright and airy and has an extremely high ceiling. Behind the painter, there is a small, paned window, reflected in the glass above two pictures in gold frames that hang at the rear wall. They are flanked by two smaller ones, also in gold frames. Outside the frame, to the left, there is another window, from which the sun shines on the women's figure and on the edge of the gold frames. The white rear wall is parallel to the plane of the picture, which gives it a sense of tranquility and at the same time highlights the individual figures and pieces of furniture.

Holsøe was a good friend of Vilhelm Hammershøi, and like him focused especially on interior painting, inspired by Dutch 16th-century art. They both preferred to paint bright rooms, furnished with fine, well-kept, bourgeois furniture. In their work method, the two artists are alike as well. When comparing Holsøe's paintings, one can see how the rectangular piano and other mahogany furniture, along with other pictures and decorations, reappear in ever-new arrangements. A woman's figure with her back turned, also inspired by the golden century of the Netherlands, was Holsøe's preferred motif; his oeuvre has many more examples of this than that of Hammershøi.

Carl Holsøe did not date his pictures, which makes it hard to establish the time of their creation. In other interior paintings where the window type in this painting occurs, there is a view of green areas. *Interior with Woman Seen from Behind* must therefore have been painted after Holsøe moved from Copenhagen, shortly after 1900, to more rural surroundings north of the capital, first Charlottenlund, and after that Bondebyen ("the Peasants' Town" quarter) in Lyngby.

E.F.

PETER VILHELM ILSTED

SAKSKØBING 1861 – COPENHAGEN 1933

Peter Ilsted was apprenticed to an artisan painter in 1877; in 1878 he began training at the technological school and later went on to study at the Academy of Fine Arts in Copenhagen. He served at the academy from 1893 to 1915 as an assistant teacher. While still quite young, he traveled throughout Europe visiting other art schools and museums and in the late 1880s visited the Middle East; in 1913 he visited England.

His earliest works were oil paintings of the domestic genre and portraiture, but after 1909, he focused intensely on etchings and hand-colored mezzotints, returning often to his favorite theme of domestic interiors.

Ilsted's work was in demand for exhibitions throughout Denmark and Europe for most of his life. He first exhibited at Charlottenborg in 1883 and regularly thereafter. Americans were exposed to his painting at the Chicago World's Fair in 1893. Among his professional recognitions were an honorable mention from the Paris salon in 1889 and the Eckersberg Medal at the academy in 1890 for a painting called Cupid and Psyche.

LITERATURE: S. Clod Svensson in *Samleren*, 1933, pp. 49–56; Aksel Jørgensen (foreword), *Peter Ilsted, Maleren, Grafikeren, Mennesket*, Copenhagen 1945; Theodore B. Donson, *Peter Ilsted, Sunshine and Silent Rooms*, New York 1990; Jens Peter Munk in *Weilbach*, vol. 3, Copenhagen 1995; Joan Abdy, *Peter Ilsted, Exhibition at Lumely Cazalet*, London 1999.

B.H.

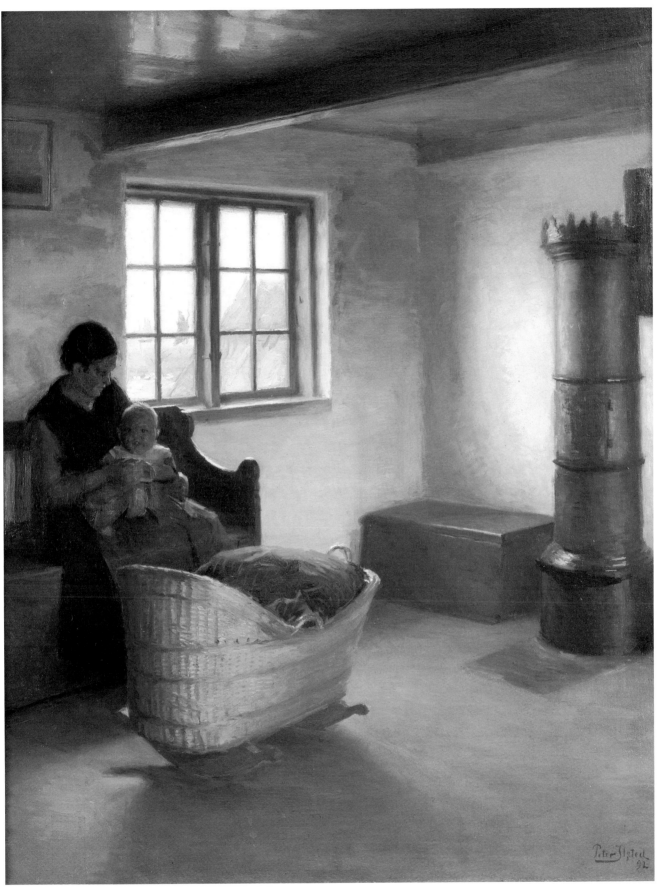

46. PETER ILSTED, *Mother and Child, 1892*

PETER ILSTED
1861–1933

46. *Mother and Child*, 1892
(Interiør fra et fiskerhjem i Hornbæk)

Oil on canvas, 22½ x 17⅔ in. (57 x 45 cm)

Signed and dated lower right: Peter Ilsted 92

PROVENANCE: The collection of Prince Georg and Princess Anne of Denmark; Bruun Rasmussen, Auction 500, Part 1, 1987, lot 29, ill. p. 26 (described as *Interiør med moder*).

EXHIBITED: Charlottenborg 1893, no. 200; Bruce Museum of Art and Science, Greenwich, Connecticut, and The Frances Lehman Loeb Art Center, Vassar College, New York, *Danish Paintings of the Nineteenth Century from the Collection of Ambassador John L. Loeb Jr.*, 2005, no. 20, ill.; Scandinavia House, New York, *Danish Paintings from the Golden Age to the Modern Breakthrough, Selections from the Collection of Ambassador John L. Loeb Jr.*, 2013, no. 20.

LITERATURE: S. Clod. Svensson, Peter Ilsted og Sortekunsten, in *Samleren*, 1933, pp. 48–56, *En Fiskerstue i Hornbæk*, 1932 (mezzotint black-and-white after the motif); Theodore B. Donson, *Peter Ilsted, Sunshine and Silent Rooms*, New York, 1990, no. 40, *Fisherman's Room in Hornbæk*, mezzotint in colors, 1932 (O/S 72), 19⅓ x 45¾ in. (49.2 x 45 cm); 19⅜ x 17¾ in. signed in pencil, ill.; Patricia G. Berman, *In Another Light, Danish Painting in the Nineteenth Century*, New York, 2007, p. 244, ill. p. 246.

Over the span of his long career, Peter Ilsted returned most frequently to his favorite subject: interior domestic scenes with tranquil women framed by walls, windows, and sparse furnishings such as the stove, wooden dowry chest, and woven baby basket we see here.

Ilsted draws us into this modest home of a fisherman and his wife with tenderness as he captures a mother gazing serenely at her plump, contented baby. We are aware that it is summertime, with greenery visible just outside the window, as well as a sailboat and the ocean on the horizon, but ultimately it is the simplicity of the interior composition, the wonderful texture of the family's humble furnishings, and the play of light in the room that keep us returning for yet another infusion of Danish quietude.

This piece in the Loeb collection is unusual, for it is one of only a very few oil versions compared to the many etchings and mezzotints of domestic interiors for which Ilsted is best known. Not too surprisingly, this particularly gentle scene was painted the very year (1892) that Ilsted married Ingeborg Petersen.

It is worth noting that he was one of three contemporaneous Nordic artists who consistently chose interior scenes as favorite subjects, the other two being Carl Holsøe and Ilsted's brother-in-law, Vilhelm Hammershøi, who married his sister Ida in 1891, the year before Ilsted's own marriage.

The Ilsted and Holsøe styles of painting interiors, however, are markedly different from that of Hammershøi. Whereas Ilsted and Holsøe works are warm and inviting, Hammershøi's are formal and austere. Though differences exist in their styles, art scholars observe that Ilsted's artistry was influenced by his brother-in-law, Hammershøi, and that the interior studies produced by all three are reminiscent of work done by Dutch painters in the 17th century.

These three artists are all represented in the Loeb collection; all three enjoy a revitalized interest among today's collectors.

B.H.

PETER ILSTED
1861–1933

47. *Portrait of Vilhelm Hammershøi* (1900)

(Portræt af Vilhelm Hammershøi)

Etching, print dimensions 5⅒ x 5½ in. (130 x 140 mm)

LITERATURE: *Fortegnelse over Peter Ilsteds grafiske Arbejder*, Copenhagen, 1924, no. 44; Aksel Jørgensen, *Peter Ilsted* Copenhagen 1945, ill. p. 9; Jørgen Sthyr, *Dansk grafik 1800–1910*, Copenhagen, 1949, p. 214, ill. p. 215.

"In a splendid little etching, Ilsted has provided a portrait of the young Vilhelm Hammershøi dressed in a frock-coat, but bearded and with his hair long in the style of an artist," wrote Aksel Jørgensen[1] in 1945. Hammershøi is described as a quiet personality, introspective and exclusive, but seriously committed to his art. This informal Ilsted portrait shows him as a private individual deep in thought. The portrait was probably created on the basis of a photograph. The Royal Library in Copenhagen possesses two portrait photographs of Hammershøi in which his dress, hair, and beard correspond closely to Ilsted's print. One of them is taken full face and shows Hammershøi together with his wife Ida and the painter Karl Madsen's (1855–1938) son Henry.[2] In the other, he is seen almost in profile, leaning back in just the same way as in Ilsted's portrait and with a similar expression on his face. A photograph of him in three-quarter profile, corresponding completely to Ilsted's engraving, might very well have existed without its being known today.

Peter Ilsted and Vilhelm Hammershøi made each other's acquaintance during their early years while training under P. S. Krøyer in the 1880s. Together with their mutual friend Carl Holsøe (1863–1935), they were preoccupied with the same range of motifs, interiors with figures and trees in the landscape. In 1890, Hammershøi became engaged to Ilsted's sister Ida, and with the resultant marriage in 1891 the friendship between the two artists became even deeper.

Ilsted is known for his extensive oeuvre as a painter, but at the same time he was a remarkable graphic artist. Starting in 1882, he executed a large number of etchings before turning to the demanding colored mezzotint in 1909. As a reproductive graphic artist, Ilsted executed a number of prints after older European paintings, for instance Frans Hals and Rubens. But he also worked independently as a *peintre-graveur*. As in his painting, he found inspiration and exemplars in 17th-century Netherlandish art, which was being studied with renewed interest in the 1880s by the modern artists of the time. Ilsted himself was a keen collector and possessed many fine graphic prints, even some by Rembrandt. Most of Ilsted's graphic oeuvre, however, consists of independent works.

This portrait is certainly closely related to a photograph, but the convincing depiction of personality would scarcely be possible without Ilsted's close relationship to his brother-in-law. The etching is one of the last by Ilsted, one of the prints from about the turn of the 20th century in which, according to Aksel Jørgensen, the artist reached his peak as an etcher. "Such beautiful prints with such a masterful exploitation of the potentials of etching have rarely been executed in Denmark. Now Ilsted had mastered the art—and so it no longer interested him."

This print of the portrait of Hammershøi, with its deep black and huge wealth of nuances, is a fine early example. There are others in the Royal Collection of Prints and Drawings in Statens Museum for Kunst in Copenhagen. The Royal Library possesses Ilsted's mezzotint from 1920 after the self-portrait by Hammershøi from 1913, since 1920 in the Uffizzi Gallery of artists' self-portraits in Florence.

E.F.

[1] The painter and graphic artist Aksel Jørgensen (1883–1957) was himself an outstanding technician and art connoisseur. From 1920 he was professor in the Royal Danish Academy of Fine Arts and was of particular importance as head of the academy's department of graphic art.

[2] The photograph was the work of a professional photographer with an address in the Christianshavn area of Copenhagen, close to Hammershøi's apartment in Strandgade.

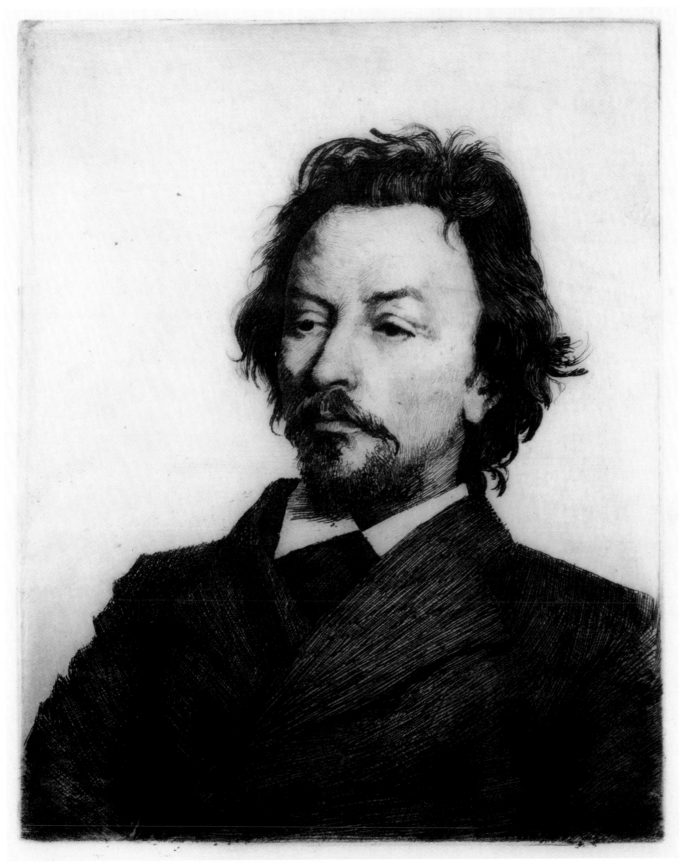

47. PETER ILSTED *Portrait of Vilhelm Hammershøi (1900)*

EGILL JACOBSEN

COPENHAGEN 1910 – 1998

Egill Jacobsen was one of the pioneers of a form of Danish abstract expressionism that was later to result in the international artists' movement known as Cobra, founded in Paris in 1948. The name is derived from the first letters of the three capital cities, Copenhagen, Brussels, and Amsterdam. The Cobra painters expressed themselves in a spontaneous and violent idiom adorned with monsters, masks, and birdlike creatures inspired by children's drawings, folk art, and the art of the South Seas. One of the main figures in the association was another Danish painter, Asger Jorn (1914–1973).

Jacobsen makes use of an artistic mask idiom that is clear, logical, lyrical, and often pervaded by a strangely gentle tone that is entirely his own.

His father, who occupied a modest position as a copyist, spent much of his free time painting copies from reproductions. His pictures were fairly inept, but they embodied an unconditional respect for art that made its mark on his son.

This son became apprenticed as a tailor, but he abandoned the trade and after a period at Carl Schwenn's school of painting was admitted to the Royal Danish Academy of Fine Arts. He stayed there for only about a year, as he felt that the institution could not teach him anything. Egill Jacobsen's work first appeared in the Kunstnernes Efterårsudstilling in 1932, and in countless exhibitions throughout his life, the most important of which were artists' associations: Linien 1937, Corner & Høst 1938–1941, Grønningen, from 1944 with a few breaks until 1958, then again from 1985 to 1995. His work also appeared in a large number of both group and solo exhibitions in museums and galleries at home and abroad. These include the Venice Biennale in 1956 and 1964 and the São Paulo Biennale in 1985.

Egill Jacobsen's early pictures were small, naturalistic motifs from the outer districts of Copenhagen, painted with broad strokes in dark colors. Jacobsen himself relates that the Danish Golden Age painters played an important part in his artistic career.

Of lasting importance to Egill Jacobsen's development toward an abstract idiom was a visit to Paris in 1934 and, after his return, contact with such artists as Ejler Bille (1910–2004), who was then mainly a sculptor, the painter Richard Mortensen (1910–1993), who later became taken by concrete abstract art, and the surrealist Vilhelm Bjerke Petersen (1909–1957).

Among the works Jacobsen saw in Paris were pictures by Picasso (1881–1973), Matisse (1869–1954), Braque (1882–1963), Max Ernst (1891–1976), and Miró (1893–1983), and he also visited the ethnographic collections in the Musée de l'Homme, where the obvious connection between modern art and primitive non-European art fascinated him.

Egill Jacobsen and his friends subsequently made the acquaintance of the psychologist Dr. Sigurd Næsgaard (1883–1956), and for a time Jacobsen attended his lectures on psychology, psychoanalysis, and the importance of the subconscious in relation to the abstract idiom in art.

In 1938 Egill Jacobsen painted Ophobning (Accumulation), *now in Statens Museum for Kunst,*

which was to be of great importance to the group of artists of which he was one—Bille, Mortensen, and Petersen. The background of the work was Hitler's expansion into Czechoslovakia, a clear forewarning of the coming world war. The picture is executed in a nonfigurative, spontaneous manner of painting. Strong, aggressive colors and shapes and powerful black figurations in strange disharmonious rhythms overwhelm the viewer with waves of despondency and desperation. The work became a precursor of the postwar Cobra movement.

Soon afterward, Egill Jacobsen's paintings reflected completely different moods. They could still be characterized by forceful utterances of temperament, but gradually a lyrical element, often inspired by experiences in nature, came to constitute the fundamental tone in his painting. From 1941 to 1944, Jacobsen collaborated with the other spontaneous-abstract artists in publishing the periodical Helhesten, *the major inspiration for which came especially from Asger Jorn. The mask form combined with all kinds of floating triangles, leaning verticals, graceful curves, and an array of indefinable squiggle-like dots and lines gradually came to represent the dominant structure in Egill Jacobsen's idiom, where color became the principal player and the invisible world of the mind the actual motif. As time passed, Egill Jacobsen's art adopted brighter colors and a lighter, more sketchlike form, as is exemplified by the two works in the Loeb collection.*

He became a professor in the Royal Danish Academy of Fine Arts in 1958, the first abstract painter ever to be appointed, where he taught until 1973; he then became an honorary member of the academy. He received various marks of distinction, such as the Eckersberg Medal in 1959, the Thorvaldsen Medal in 1969, and the Prince Eugen Medal in 1984. In addition, he executed several large-scale paintings to decorate public buildings such as Hvidovre Town Hall and Aarhus University.

S.L.

LITERATURE: Harald Leth, Egill Jacobsen, *Vor Tids Kunst* 54, Copenhagen 1956; Gunnar Jespersen, *De Abstrakte*, Copenhagen 1967 (2nd ed. 1991); *Smilet bag masken*, Galerie Asbæk, Copenhagen 1980; Per Hovdenakk, *Egill Jacobsen, I, Malerier 1928–65*, Copenhagen 1980; Pierre Lübecker, *Om maleren Egill Jacobsen og hans maskekunst*, Copenhagen 1982; Per Hovdenakk, *Egill Jacobsen, II, Malerier 1955–80*, Copenhagen 1985; Peter Michael Hornung, *Rejsen til friheden*, Galerie Asbæk, Copenhagen 1985; Peter Michael Hornung in *Fogtdals Kunstleksikon*, vol. 6, Copenhagen 1990; Gunnar Jespersen, *Farvens klang*, Copenhagen 1990; Troels Andersen in *Weilbach*, vol. 4, 1996.

EGILL JACOBSEN
1910–1998

48. *Green Mask,* 1977
(Grøn maske)

Oil on canvas, 45⅔ x 35 in. (116 x 89 cm)

PROVENANCE: Galerie Asbæk, Copenhagen, 1983.

EXHIBITED: The American Scandinavian Society of New York at Privatbanken Gallery, *Selections of Contemporary Danish Art,* 1989, no. 6.

LITERATURE: Per Hovdenakk, *Egill Jacobsen, II,* 1985, p. 179, no. 1977/23. (described as *Uden titel*).

In various articles and interviews, Egill Jacobsen has recalled how he started painting and how he progressed to using the mask as the essential structure in a painting in which color became his most important tool—feelings, presentiments, and experiences, the actual motif.

His earliest pictures of masks were created as early as the spring and winter of 1934–1935, shortly after his first visit to Paris. He was living at the time in an attic in Købmagergade in Copenhagen. This room contained a stove and some extremely modest furniture and measured only 2 x 3 metres (6½ x 10 feet). But there was space enough to paint self-portraits. So he looked at himself in the mirror and produced one expressive portrait after another.

As time went on, the pictures changed... "and became more summary and abstract, because color came to play a greater part, and as though in a long, slow transition, the self-portraits developed into pictures of masks."[1]

The two works in the Loeb collection, painted more than forty years later, are still composed on the basis of the physiognomy of the mask. But Jacobsen's mask pictures are never repeats; they are variants of a single motif, explored again and again in the form of silent questions to the subconscious.

The mask, which was taken from the arts of Africa and the South Seas, is not to be associated with a specific physiognomy. "It is the face of all faces, and its function is not to hide, but to express and make visible."[2]

S.L.

[1] From Gunnar Jespersen's conversations with Egill Jacobsen reproduced in Jespersen's book *De abstrakte,* Copenhagen 1967.

[2] *Fogtdals Kunstleksikon,* vol. 6, Copenhagen 1990.

EGILL JACOBSEN
1910–1998

49. *Braun Symphony,* 1980
(Braun Symphony)

Oil on canvas, 39⅓ x 26⅓ in. (100 x 67 cm)

Signed on reverse: E.J. 80

PROVENANCE: Galerie Asbæk, Copenhagen, 1983.

EXHIBITED: Galerie Asbæk, Copenhagen, *Egill Jacobsen,* 1983, no. 2; The American Scandinavian Society of New York at Privatbanken Gallery, *Selections of Contemporary Danish Art,* 1989, no. 7.

LITERATURE: Per Hovdenakk, *Egill Jacobsen, II,* 1985, p. 185, no. 1980/3 (described as *Uden titel*).

In an article entitled *"Samtidighedens princip"* ("The Principle of Contemporaneity"), the artist Per Kirkeby[1] maintains that there are pictures about which it is very difficult to say anything, because they possess an unusual degree of presence. By this he means that all the elements in the work are present on the surface the very moment they encounter the eye of the viewer. Therefore, the picture cannot be interpreted according to current analytical principles. The viewer cannot allow his gaze to wander around in the picture in search of some kind of action or some overriding composition. And this means that it will never be possible to understand the picture's statement by following the course of specific lines, let alone have an idea as to which points are far and which are near on the basis, for instance, of the degrees of lightness and weight contained in the colors.

Egill Jacobsen's pictures are like this, continues Kirkeby, and it has nothing to do with the fact that they are abstract or that their essence is distant and ethereal, "for of course the pictures represent what they are and not some historical idea—but [the question here] is the principle of contemporaneity." Or put another way, we are faced with "the absolute development-free presence of the pictures."

For this reason, so many abstract works have no title. If a title is affixed to a picture like this, the viewer's eyes are led into the painting's universe under false pretenses.

This work has no action and no development. It is not a piece of pictorial music of a specific genre; it does not even express a specifically defined feeling, although it has been created on the basis of an inner experience. It gives no reply. It merely asks.

It is therefore impossible ever to finish looking at a picture like this. We will ceaselessly be attracted by its enigmatic quality, enriched by its strange beauty and strengthened by its presence.

S.L.

[1]Per Kirkeby, *Samtidighedens princip* in *Smilet bag masken en bog til Egill Jacobsen.* Galerie Asbæk, 1980, pp. 46–49.

ROBERT JULIUS TOMMY JACOBSEN

COPENHAGEN 1912 – TÅGELUND NEAR EGTVED 1993

Robert Jacobsen was self-taught. In his youth he earned his living by such different jobs as bartender, badminton player, sailor (traveling as far as America), warehouseman, and banjo player in an orchestra. In the years during and immediately after World War II he also took part in three different films created by the gifted avant-garde artist Albert Mertz (1920–1990) and the highly regarded film director Jørgen Roos (1922–1998). He derived his earliest impressions of the world of art when, as an errand boy, he came across Henning Larsen's Kunsthandel in Copenhagen, where he met various artists such as the naturalist painters John Christensen (1896–1940) and Søren Hjorth Nielsen (1901–1983) and the surrealist Wilhelm Freddie (1909–1995).

Jacobsen fashioned his first sculptures in wood around 1930. In 1932, Den Frie Udstilling in Copenhagen put on a display of the German Expressionists along with the works of the Swiss artist Paul Klee (1879–1940). Klee's work especially made a deep impression on the young Robert Jacobsen.

Jacobsen made his first appearance in the Kunstnernes Efterårsudstilling in 1941, and four years later, in the year marking the end of the war and the conclusion of the German occupation of Denmark, he showed a number of heavy stone sculptures with the common title of "Fabulous Monsters." During the war he had worked with painters including Asger Jorn (1914–1973), Carl Henning Pedersen (b. 1913), Egill Jacobsen (1910–1998), and Ejler Bille (1910–2004), who gathered at the periodical Helhesten and at the Høstudstillingen exhibition. The "Fabulous Monsters" were related to the mythical creatures found in these abstract works by these painters, and if Jacobsen had continued developing this fantasy universe, he would have ended at the center of the Cobra movement. However, he chose a different path.

In 1947 he was awarded a grant which would cover a temporary stay in Paris, where he went with his family, accompanied by Richard Mortensen (1910–1993). The two Danish artists quickly became accepted in the circle around Denise René and her gallery. Artists exhibiting there, among others, included Jean Arp (1887–1966), Jean Dewasne (b. 1921), Alberto Magnelli (1888–1971), and Serge Poliakoff (1900–1969).

Jacobsen settled in France for the next twenty-two years. For a year or so, he shared a flat and studio with Asger Jorn in Paris, but then he acquired his own workshop and began to develop a type of constructive black-painted iron sculptures in which the interspace acquired greater and greater significance. It was as if it were framed by the metal so that the air was transformed into the weightless mass of the work. The sculptures possessed a hitherto unseen rhythmical lightness and almost appeared to be movable. Standing against a white wall, they resembled calligraphic signs, but they were purged of any narrative expression, exclusively animated by clear and pure artistic language.

To earn a living, Jacobsen worked for a long time together with mechanics in the Paris suburb of Suresnes. There he gained practical training in the use of tools and the theory of materials at the

same time learning to weld and use iron in all conceivable ways. In the piles of scrap in the workshops he found free iron for his concrete sculptures, which were exhibited in the Galerie Denise René and where they were very well received. After a few years, the artist changed his mode of expression so as not to repeat himself and lose his sensitivity. He turned to sculptures that were more dense in structure and more stable. The black paint disappeared and was replaced by various means of treating the metal with acids, resulting in a range of subtle colors.

The 1960s brought a radically different mode of expression with the series of "dolls" that gradually developed into "personages," inspired partly by African cult figures, made of all kinds of random rubbish welded together with visible traces of ornamentation and magic. The first "dolls" were humorous, graceful, and mainly friendly. The "personages" were awkward, often aggressive, and suffused with traces of malice.

In 1969, Robert Jacobsen moved back to Denmark and bought a farm near Egtved in central Jutland. There he executed various small surrealist-inspired scenes with figures. In addition to iron sculptures, he made a series of fascinating graphic works using a variety of techniques, often syntheses of earlier works, for example, the Loeb collection's Opus Egtved. *He also executed many large-scale works intended for public places. The clear, concrete form continued in Robert Jacobsen's work, at times in interplay with more expressive forms and in later years quite often painted red or blue.*

Especially during the last twenty years of Jacobsen's life, various monumentally large sculptures, constructions mainly cerebral in form, left the master's workshop in Tågelund to be erected in many places throughout the world. He exhibited in countless places in Denmark and abroad, including many important international museums and biennials.

He was a member of Høstudstillingen 1941–1943 and of the Groupe Denise René, Paris, from 1947. He took part in the exhibitions arranged by Linien on several occasions and was also a member of Den Frie Udstilling from 1959 and of Grønningen from 1976. From 1962 to 1981 he was a professor at the Academy of Fine Arts in Munich and from 1976 through 1985 was professor of wall and space art in the Royal Danish Academy of Fine Arts Schools of Visual Art. He was also an honorary professor in the Academies of Florence and Munich. Honors awarded to him include the Venice Biennale International Prize for Sculpture in 1966, the Thorvaldsen Medal in 1967, and the Swedish Prince Eugen Medal in 1974.

Throughout his life, Robert Jacobsen was a member of the Copenhagen Artisans' Association (Håndværkerforening) and was the recipient of distinguished decorations from France such as the "Arts et Lettres" (Knight) and The Legion of Honour (Officer).

S.L.

LITERATURE: Jean Dewasne, *Le gros Robert*, Paris 1950; Ernst Mentze, *Robert Jacobsen*, Copenhagen 1961; Gunnar Jespersen, *De abstrakte*, Copenhagen 1967; Gunnar Jespersen, *Robert Jacobsen*, Oslo 1978; Jens Christian Jensen in *Robert Jacobsen*, Musée Rodin. Paris 1985; Mette Thelle, *Omkring en skulptur af Robert Jacobsen* in *Linien II*, Statens Museum for Kunst, Copenhagen 1989, pp. 38–39; Karsten Orth and Lise Seisbøll (eds.), *Robert Jacobsens univers*, Kunsthallen Brandts Klædefabrik, Odense 1992 (text by the editors and Gunnar Jespersen, Poul Borum, Ejnar Johansson); Marianne Barbusse Mariager in *Weilbach*, vol. 4, Copenhagen 1996; Mette Højsgaard, *Robert Jacobsen and Paris*, Statens Museum for Kunst, Copenhagen 2001 (full text in English).

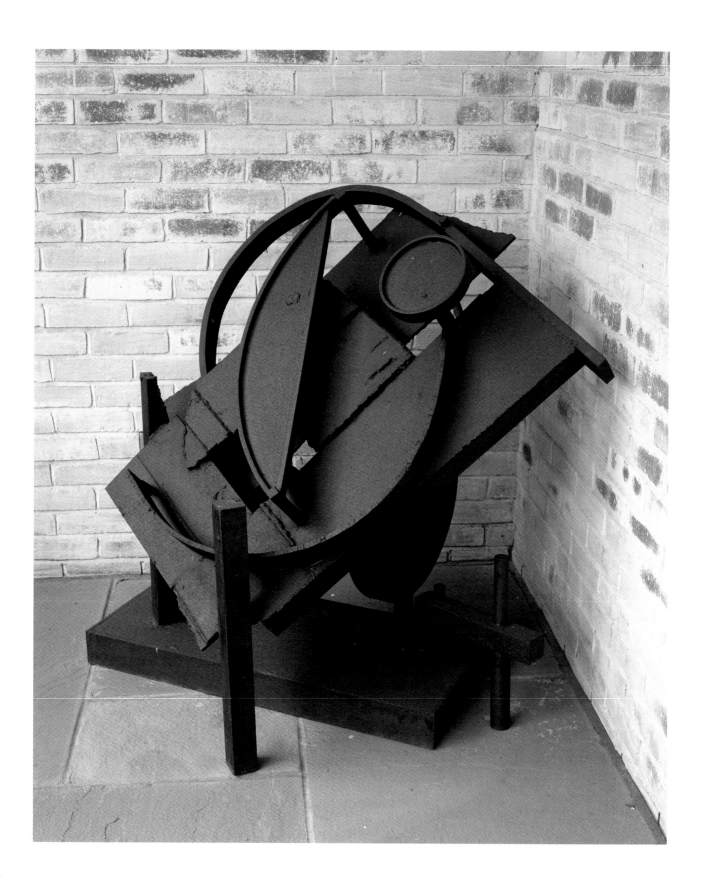

ROBERT JACOBSEN
1912–1993

50. *Opus Egtved,* 1973
(Opus Egtved)

Iron sculpture on base, 41⅓ x 43⅔ in. (105 x 110 cm)

PROVENANCE: Galerie Asbæk, Copenhagen (1976); bought from Jacob Asbæk, June 2, 1983.

EXHIBITED: Galleriet Kulturhuset, Stockholm, 1976, no. 46, ill.; Galerie Asbæk, *Robert Jacobsen,* Copenhagen, 1976; The American Scandinavian Society of New York at Privatbanken Gallery, *Selections of Contemporary Danish Art,* 1989, no. 5.

"When, as a child in Christianshavn, I went past F. C. Mogensen's iron foundry in Sofiegade, I caught the smell of the rusty iron and the moulding sand in my nose," recalled Robert Jacobsen. "There was to me something strange and improbable about this smell that had an inspiring effect. The smell formed part of my everyday surroundings during my childhood, and so I felt that I already had some kind of association with iron when I started using it."[1] Throughout his life, Robert Jacobsen's art moved between two poles: the strictly constructive, introspective idiom and the spontaneous expressive creation. In his later years he worked with a kind of synthesis of all his earlier sculptural forms.

The Loeb collection *Opus Egtved* from 1973 emerges as such, a summary of earlier works: concrete in structure, balanced and immovable, but by virtue of its massive weight strangely expressive, fragile and strong at the same time.

Egtved is the name of a small village in Jutland, not far from Vejle. The sculptor spent the last twenty-four years of his life living close to it.

S.L.

[1] Gunnar Jespersen, *Robert Jacobsen,* Sophienholm, Copenhagen 1982, p. 7.

CHRISTIAN ALBRECHT JENSEN

BREDSTED NEAR HUSUM 1792 – COPENHAGEN 1870

The artist C. A. Jensen was born in the small town of Bredsted north of Husum in Southern Schleswig, the son of a glover. He trained in the Royal Academy of Fine Arts in Copenhagen 1811–1816 where he was taught by Professor C. A. Lorentzen (1777–1867) along with (among others) the German painter Ferdinand Flachner. Jensen left the Academy in 1816 after having won only the minor silver medal, the lowest-ranking of the official tokens of ability awarded. He spent 1817–1818 in Dresden, Germany, where he registered at the city's Academy of Fine Arts. From there he proceeded to Italy and Rome with financial support from the Fonden ad Usus Publicos.

During his three years in Rome, C. A. Jensen studied the latest developments in portraiture, which tended to be intimate portrayals of the facial features executed in a small format. Having joined the circle around Bertel Thorvaldsen (1770–1844) in Rome, he painted a number of small portraits of his Danish acquaintances there, including the poet B.S. Ingemann (1789–1862), the historian Hector F. Janson Estrup (1794–1846), whom he had met in Dresden, and the sculptor H. E. Freund (1786–1840). During the same period, he copied a number of the works of older masters.

Once back home, Jensen acquired a reputation as a portraitist for the affluent Copenhagen bourgeoisie. He produced one sparkling portrait after another, straightforward in manner and with little in the way of staging. For a time he even outdid Eckersberg, whose cool neo-classical style lacked the sensitive psychological insight characteristic of Jensen's works. The years 1825–1830 saw the execution of many of C. A. Jensen's best paintings, including portraits of a colonial civil servant, Johannes Søbøtker Hohlenberg, 1826, now in Statens Museum for Kunst, the artist's own wife c. 1826, now in Den Hirschsprungske Samling, and one of his friends in Rome at the time, Professor, dr. theol. Henrik Nicolai Clausen, 1827, now in the Museum at Frederiksborg Castle.

However, his success did not continue, for he had difficulty in gaining official appreciation of his work. Though he was recognised by the Royal Danish Academy of Fine Arts in 1823 and made a member the following year, five years later he was passed over when a new chair was to be filled after the death of C. A. Lorentzen. Throughout his life C. A. Jensen had to suffer from the art critics' rancorous opposition to his free use of the paint brush and his occasional broad strokes. It was the influential Professor Høyen (1798–1870) who was at the forefront of the disparagement and at times ridicule of the portraitist and his "blotchy" style of painting, which was described as "messy" and "unacademic." In time, Høyen managed to denigrate Jensen to such an extent that many of his earlier clients began to look down on him and reduced the number of their commissions.

Jensen ran into financial difficulties after 1830. A growing family increased the need for rapid productivity, and his works began to vary in quality. Nevertheless, Prince Christian Frederik, later King Christian VIII, who had been an admirer of the artist ever since his time at the Academy, supported him when he applied for a post as a replica artist for the collection of portraits at Frederiksborg Cas-

tle, then being organized as a museum of portraits and national history. For a number of years Jensen was thus occupied with painting replicas of historical portraits and duplicates of his own portraits of important and famous persons.

N. L. Høyen, who at this time was engaged in what was a highly necessary reorganisation of the art collections in Frederiksborg Castle, was very much against this arrangement. Naturally enough, he preferred original, contemporary works of art as the basis for the collection. C. A. Jensen's time as a replica artist was thus not a happy one, and his financial situation did not improve sufficiently even though, thanks to the support of the Crown Prince, he continued to produce portraits for Frederiksborg Castle for a period lasting until 1847, and despite the fact that in 1835 he was made a titular professor and given an official residence at Charlottenborg.

Then he had the idea of going abroad to seek commissions. From 1837 he traveled abroad regularly, especially to Britain, but also working in France, Germany, Holland and even Russia, where, between 1839 and 1843, he painted eleven portraits of famous astronomers for the observatory at Pulkovo near St. Petersburg. Meanwhile, at the death of Christian VIII in 1848, C. A. Jensen's financial situation deteriorated to such an extent that he was no longer able to support his wife and their eight children. He was also meeting political opposition because during the war between Denmark and Prussia he was unable to refrain from expressing his sympathy for the cause of the Schleswig-Holsteiners.

At the suggestion of a friend from his youth, H. N. Clausen, the artist was given an appointment with a fixed annual salary as an assistant in the Royal Collection of Prints and Drawings. C. A. Jensen remained in this inferior position for the rest of his life. In the middle of the 1850's he was also given permission to restore paintings for Frederiksborg Castle Chapel. But apart from a few replicas of Raphael and Perugino and a few portraits, he ceased painting entirely. His last effort was to accommodate a request to paint Dr. theol. Andreas Gottlob Rudelbach, *1858, now in Statens Museum for Kunst. With this undertaking, Jensen surpassed himself and created a portrait which, in its characterisation of a personality and in its painting technique, at the same time harked back to the great Dutch portraitist Frans Hals. It proclaimed a new and different artistic vision.*

C. A. Jensen exhibited at Charlottenborg between 1813 and 1857 and in other venues such as the Royal Academy in London and the world fairs in Paris and London. His oeuvre consists of more than 400 portraits of which the best stand comparison with the work of international artists. Nevertheless, he was totally forgotten by art critics until more than thirty years after his death, people learned to appreciate the scintillating style of Impressionism.

S.L.

LITERATURE: Sigurd Schultz, *C.A. Jensen*, I–II, with a list of the portraits, Copenhagen 1932; Thomas la Brie Sloane, *Neoclassical and Romantic Painting in Denmark 1754–1848*, Evanston, Illinois, 1972; Claus M. Smidt, *Portrætmaleren C.A. Jensen*, Copenhagen 1986; Hannemarie Ragn Jensen in *Weilbach*, vol. 4, Copenhagen 1996.

C. A. JENSEN
1792–1870

51. *Portrait of History and Genre Painter Ferdinand Flachner,* c. 1815
(Ferdinand Wolfgang Flachner)

Oil on canvas, 17½ x 13⅔ in. (44,5 x 35 cm)

PROVENANCE: Charlottenborg, 1815, no. 38 (described as *En herværende Kunstners Portræt*); Konservator P. H. Rasmussen's Auction, 19.3.1889, lot 34; H. H. I. Lynge's Auction, 20.4.1898, lot 62; Winkel & Magnussen, auction 114 (M. Grosell), 1932, lot 59, ill. p. 13; Kunsthallen, Auction 462, 1996, lot 11, ill. p. 9.

LITERATURE: Sigurd Schultz, *C. A. Jensen*, I–II, Copenhagen, 1932, no. 3. ill. p. 119.

The German painter Ferdinand Wolfgang Flachner (1792-after 1847) was born in the town of Zirndorff in Bavaria and was admitted to the Royal Danish Academy of Fine Arts in Copenhagen in 1809. In 1813 he won both the minor and the major silver medals; three years later he won the minor gold medal. During the seven years he spent in Copenhagen, Flachner worked in the office of a wealthy merchant, Johann Friedrich Zinn (1779–1838). In 1818, after exhibiting at Charlottenborg for five years in a row, he gained a considerable reputation, especially as a history painter, Ferdinand Flachner left Copenhagen. He settled in Munich under his baptismal name of Flachenecker and made a living mainly as a lithographer. During his time at the Academy in Copenhagen, Flachner established a friendship with, among others, the Norwegian-born landscape artist Johan Christian Dahl (1788–1857), who was later to become a professor in Dresden, the sculptor Herman Ernst Freund (1786–1840) and the portraitist C. A. Jensen. Jensen's portrait of his friend stems from the time spent by the two artists at the Academy. Jensen's work here shows clear traces of the teaching he received from the ageing Professor C. A. Lorentzen (1746–1828), who had assumed Jens Juel's professorship after Juel's death in 1802. Though far from being as good an artist as his eminent predecessor, Lorentzen was probably as knowledgeable and meticulous a teacher.

In his extensive monograph on C. A. Jensen, Sigurd Schultz provides a very instructive description of 19th-century portrait painting as it was still taught in the Academy until Eckersberg's neo-classical teaching took the lead. One example used by Schultz is the Flachner portrait, which might possibly have been executed in Lorentzen's studio as a practice piece. We are told that a lively and attentive facial expression plus a certain out-turned and mobile physical posture in the figure portrayed were taught as factors necessary for attracting the attention of the viewer. These elements are both present in this portrait of Flachner, in which the eyes express openness while the impression of a quick turn of the head is achieved by placing the model's right shoulder at right angles to the front surface of the picture. A very important ingredient in Lorentzen's instruction in portraiture was the significance of shade and color in creating shape.

The basis of the composition was constituted by the artificial source of light falling obliquely from high up on the left and dividing the oval of the face into gradually alternating areas of strong light and deep shade. A more subdued light is shining on the background to the right of Flachner; the area behind and to the left of him is unlit. In this way an effect of enclosed space is achieved, giving depth to the painting and adding a sense of air behind the model. Through the use of chiaroscuro, further heightened by reflections

in the shadows, the facial features are endowed with an appearance of movement, resulting in a certain psychological effect.

Jensen chose colors determined on the basis of the model's complexion for his portraits; here the colors appear in more or less concentrated form dispersed across the picture in many nuances of brown and beige. He used color to model the figure and give it plasticity. This was done with contrasting hues and cold and warm colors.

The 17th-century school of portraiture set great store by a decorative pictorial effect linked to an artistic tradition emphasising dignity and decorum and the happy lives of the upper classes. Such stylistic features were still to be found at the time when C. A. Jensen was an art student, as was an appreciation of domestic life. Both can be seen in the characterisation of Ferdinand Flachner. He is portrayed as elegant in appearance but with carelessly tousled hair and a loosely fitting stock in a portrait genre described by Schultz as "the dressing gown style."

S.L.

C. A. JENSEN
1792–1870

52. *Portrait of Joseph Hambro*, 1828
(*Portræt af Joseph Hambro*)

Oil on canvas, 9 x 7½ in. (23 x 19 cm)

Signed and dated on lower left: C A Jensen 1828

PROVENANCE: Bruun Rasmussen, Auction 663, 1999, lot 334, ill. p. 132.

EXHIBITED: Bruce Museum of Art and Science, Greenwich, Connecticut, and The Frances Lehman Loeb Art Center, Vassar College, New York, *Danish Paintings of the Nineteenth Century from the Collection of Ambassador John L. Loeb Jr.*, 2005, no. 3, ill.

LITERATURE: Sigurd Schultz, *C.A. Jensen*, I–II, Copenhagen, 1932, no. 230; Bo Bramsen and Kathleen Wain, *The Hambros 1779–1979*, London, 1979; Else Martensen Larsen and Hasse Neerbek, *Slægter omkring Øregaard*, Øregaard Museum, 1990 (on Joseph Hambro and his family).

A commanding presence was captured by the artist C. A. Jensen in this portrait of Copenhagen industrialist and "virtual" banker Joseph Hambro, arguably the forerunner of the world-renowned Hambro banking family. This depiction of Joseph Hambro at the age of forty-eight was painted at the height of his brilliant business career by the foremost portrait painter of the time.

Another quite similar portrait of Joseph Hambro, commissioned by friends to commemorate his fiftieth birthday, can be viewed at the Copenhagen Stock Exchange (Det Danske Handelskammer) where his visage joins those of the greatest leaders in the history of Danish Commerce, (Fig. A). A third portrait, very similar to that in the Loeb collection, but smaller, is also dated 1831; here Hambro's face appears more narrow and his hair has become gray (Fig. B).

Joseph Hambro's ingenious innovation of extending foreign loans to his trading clients ultimately yielded large economic boosts for the Danish State and Court, and for which he received many honors, including that of the prized title of Privy Counselor by King Frederik VI for successfully negotiating loan agreements between England and Denmark. (The English government lent a large amount of money to the bankrupt Danish government.)

Born in Copenhagen, Joseph Hambro had the right temperament and talent for furthering his German father's ambitions. Entrepreneur Calmer Joachim Hambro had emigrated from Hamburg in 1778 to Copenhagen, setting up a trading company called simply "C. J. Hambro." Calmer's young son Joseph, at the age of seventeen, traveled back to Hamburg for an apprenticeship with the trading firm of Furst, Haller & Co., but soon returned to Copenhagen to work in his father's business, eventually taking it over in 1806. Securing a coveted wholesaler's license, he rapidly built up a reputation as Copenhagen's leading general clothier, only one aspect of his multi-faceted and far-reaching interests, including speculation in currency, spices and sugar from the Danish Virgin Islands and wool from England.

Joseph married Marjam von Halle in 1807. It remained for their sole offspring, Carl Joachim, to really establish the Hambro family as world class bankers. Because of Marjam's prolonged mental instability, (she died in a mental institution in 1838) Joseph arranged for young Carl to be reared in the Christian home of zoologist Johannes Reinhardt. Under the care of the Reinhardts as surrogate parents, the child was baptized

a Christian. Nevertheless, it was his Jewish father's footsteps in which Carl Joachim followed, ultimately establishing an even greater name in the world of commerce and government than had his father Joseph and grandfather Calmer Hambro. Though Joseph had certainly laid the groundwork for the Hambro banking fame, it was son Carl Joachim who established himself as a more traditional banker at London's Old Broad Street Number 70, the true beginning of the Hambro banking business in England.

Joseph would probably note with approval that the Øregaard estate, which he bought for Carl Joachim, his wife, Caroline (née Gostenhofer), and their four sons, is now the Øregaard Museum in Copenhagen's suburb, Hellerup, for Joseph had a great interest in art. In his latter years he traveled extensively, making visits to artists he admired such as Bertel Thorvaldsen in Rome, and contributing significantly toward the building of Thorvaldsen's Museum in Copenhagen. Joseph Hambro died in Copenhagen at the age of sixty-eight.

Coincidentally, the Hambro family is distantly related to the John L. Loeb Jr. family through the Levy family of Hamburg, Germany. The family name of John Loeb's great-grandfather, Adolph Lewisohn, was originally Levy in Hamburg. One branch of the Levys changed the Levy name to Lewisohn and another branch changed the name from Levy to Hambro (after Hamburg). Much of the famous Lewisohn art collection is in the Metropolitan Museum of Art in New York City.

B.H.

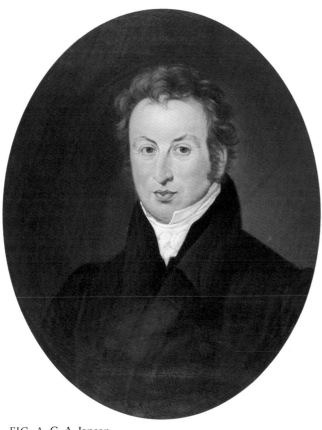

FIG. A C. A. Jensen
Portrait of Joseph Hambro (1780–1848), 1831
Oil on canvas, 25 x 19⅔ in. (63 x 50 cm). The Copenhagen Stock Exchange.

FIG. B C. A. Jensen
Portrait of Joseph Hambro, 1831
Oil on canvas, 9⅕ x 7⅓ in. (23.3 x 18.7 cm), Schultz no. 230, present owner unknown.

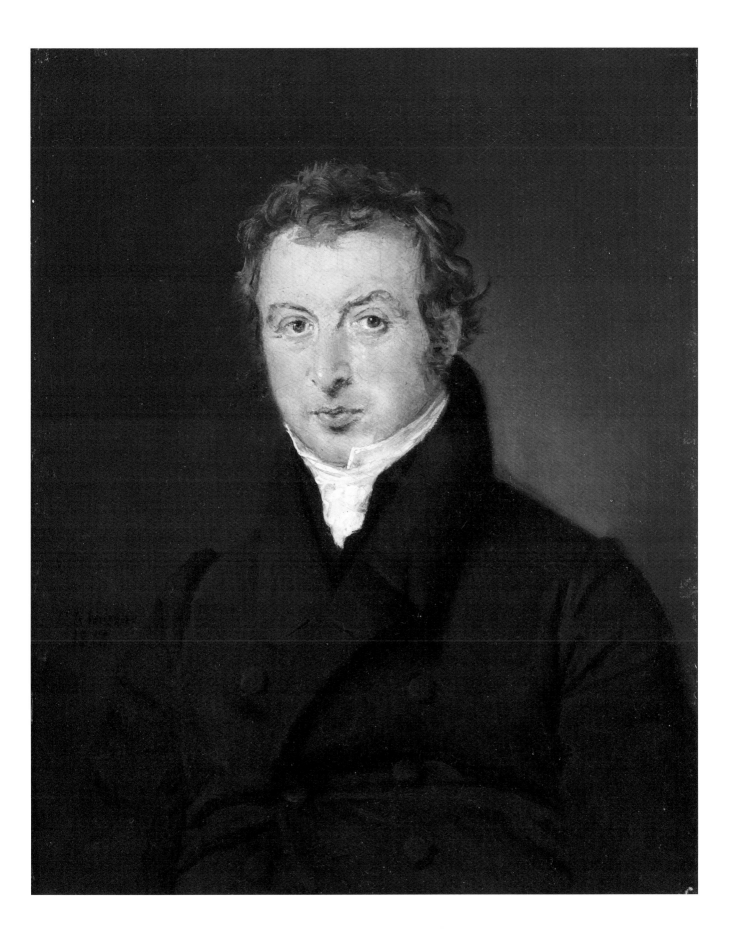

C. A. JENSEN
1792–1870

144. *Portrait of the Flower Painter J. L. Jensen*, 1828
(Portræt af blomstermaler J. L. Jensen)

Oil on canvas, 25 x 19¾ in. (63.5 x 50 cm)

Signed and dated to the right by the shoulder: C.A. Jensen 1828

PROVENANCE: Royal Chamber Singer Emilie Ulrich, Copenhagen; Bruun Rasmussen, Auction 846, 2014, lot 32, ill.

EXHIBITED: Holmegaards Glasgalleri, *Udstilling af danske blomstermalere på H. C. Andersens tid*, 1983.

LITERATURE: Sigurd Schultz, *C.A. Jensen*, I–II, Copenhagen, 1932, no. 154, vol. I, pp. 230, 232, ill. p. 219.[1]

This portrait of flower painter J. L. (or I. L.) Jensen was painted by C. A. Jensen. Having the same last name, these two Golden Age painters were sometimes confused with each other.

Flower painter J. L. Jensen looks elegant in his black coat and bright white cravat. He has thick, curly dark hair and fashionable sideburns. The subject seems a bit self-satisfied, perhaps having pleasant thoughts about his early success. Only 28 years old, he is already well established in the art world of Copenhagen. Two years earlier, he was appointed painter-in-chief at the Royal Porcelain Factory of Copenhagen, and, at about the same time, unanimously elected as a member of The Royal Danish Academy of Fine Arts. Jensen's flower paintings were already in great demand. As fast as he painted a picture, a buyer was waiting. A beautiful selection of his work can be seen in the Loeb collection.

The year is 1828, and the young J. L. Jensen is working on two prestigious commissions, both in connection with the forthcoming marriage of young Crown Prince Frederik (later Frederik VII). The flower painter is creating a magnificent wall decoration for the dining room of their future residence (now called the Frederik VIII Palace). At the same time, he is painting fruits and flowers on a set of dessert china that the king is giving the bride for her trousseau.

C. A. Jensen also painted J. L. Jensen's wife, Signe, and both portraits are in the Loeb collection. During the years following 1828 the masterful portraitist's reputation declined, primarily because of the malicious criticism of art historian, Professor N. L. Hoyen. The truth is that C. A. Jensen was a masterful painter who could not only faithfully reproduce the faces of his clients, but also convey their inner selves.

The biographer of C. A. Jensen, Sigurd Schultz, describes the latter talent by comparing the Loeb collection's vivid portrait of the young J. L. Jensen with a slightly less spirited rendering of the same man painted six years later, where the flower painter is seen sitting by his work with palette, brush and maul stick (Fig. A). The unique artistic characteristics of portrait painter C. A. Jensen can be seen clearly in his Loeb collection paintings.

These include: *Portrait of History and Genre Painter Ferdinand Flachner* (no. 51) (Fig. B) and *Portrait of Joseph Hambro* (no. 52) (Fig. C) *Portrait of Flower Painter J. L. Jensen* and *Portrait of Flower Painter J. L. Jensen's Wife*. When comparing these paintings, Jensen's artistic devlopment can be followed, and the relationship between the artist and his model can be detected.

When C. A. Jensen portrayed his friend Ferdinand Flachner, both artists were still students at the Royal Academy of Fine Arts, and only twenty-three years old. They were inexperienced, and trusted the guidance

of an instructor, and they trusted each other. Jensen's finished portrait demonstrates that he followed professorial instructions. Ferdinand Flachner, no doubt posed as instructed, half-turned outward, facing the artist. He wears a pleasant, but slightly quizzical expression (cf. no. 51). The young C. A. Jensen completed this portrait of his Academy comrade quite beautifully for this stage of his artistic development. It is conceivable that the two students shared a feeling of secret amusement. Do we not see the hint of amusement in Flachner's expressive eyes?

Far different is his portrait of financier, trader and banker Joseph Hambro. After lengthy study trips to Dresden and Rome, where C. A. Jensen progressed in portrait painting, developing a personal painting style that, for a while, made him the portrait painter in highest demand in Copenhagen. This new technique can be observed in the Loeb collection's portrait of Joseph Hambro, as well as in the portraits of flower painter J. L. Jensen and his wife: Occasional quick, sensitive brush strokes without clear contours have been placed on the canvas in repetitive, transparent layers of paint. They catch the light and make the painting sparkle in numerous subtle nuances of color. It is an intuitive method of painting.

Jensen has shown us Joseph Hambro's somber and speculative eyes under handsomely arched eyebrows, his wide forehead bespeaking intelligence. He seems unapproachable, with a certain arrogance that does not invite conversation with the painter. Where there plainly existed humor and trust between Ferdinand Flachner and C. A. Jensen, here the portrait painter seems to feel respect but not warmth toward the prominent Joseph Hambro. Though there was a cool distance between model and painter, Jensen has certainly conveyed much of Hambro's character and personality. Three years later, C. A. Jensen was commissioned to paint another portrait of Joseph Hambro, this time perhaps with instructions to carry out a more academically defined portrayal, where no revealing brush strokes are visible. Somewhat larger, this oval painting now hangs at the Copenhagen Stock Exchange (no. 52, Fig. A).

With regard to the portraits of the flower painter and his wife, C. A. Jensen seems to have been completely in his element, without any kind of restrictive reverence. It probably particularly delighted him to paint Signe Marie Jensen. He was never immune to feminine allure, which is clearly felt here, where the sweetness and pride of the young Mrs. Jensen seems to have flooded out onto the canvas in joyful company with each of the painter's brush strokes. As for her husband's portrait, that also seems free of restrictions.

Almost all of the portrait painter C. A. Jensen's work conveys his deep understanding of the human soul. Because of this ability, combined with an extraordinary artistic talent, his paintings stand the test of time beautifully.

S.L.

[1]After the publication of *The Ambassador John L. Loeb Jr. Danish Art Collection*, New York 2005, Marie-Louise Berner and Mette Thelle have collaborated on an upcoming literary work about J. L. Jensen. Suzanne Ludvigsen would like to thank the two researchers for their many new pieces of information about the flower painter, who, until now, has rarely been included in Danish art history.

[2]The palace of Frederik VIII (originally Brockdorff's palace, built 1750–60) is one of four rococo palaces that together form the complex Amalienborg in Copenhagen. It was designed by the Danish rococo architect in royal service, Nicolai Eigtved (1701–1754). In 2010, the palace of Frederik VIII was furnished as a residence for Crown Prince Frederik and Crown Princess Mary with their children; Marie-Louise Berner, *J. L. Jensen - En dansk Guldaldermaler*, pp. 10–31, and Mette Thelle, *J. L. Jensens rum til Prinsesse Vilhelmine og Prins Frederik på Amalienborg*, pp. 32–45 in Jane Sandberg (ed.), *Dansk Blomstermaleri. J. L. Jensen og hans kvindelige efterfølgere*, Øregaard Museum, Copenhagen 2006; Lin Rosa Spaabæk and Mette Thelle, *Den naturlige påmindelse*, in Mads Falbe-Hansen (ed.), *Frederik VIII's palæ. Restaurering. Ombygning. Kunstnerisk udsmykning*, Copenhagen 2010, pp. 176–183.

FIG. A C. A. Jensen
The flower painter J. L. Jensen, 1835
Oil on canvas, 9⁴/₅ x 8 in.
(25.1 x 20.6 cm)
Signed and dated bottom right:
C.A. Jensen 1835
Present owner unknown
Sigurd Schultz 1932, no. 267

FIG. B C. A. Jensen
*Portrait of History and Genre
Painter Ferdinand Flachner,* c. 1815
Oil on canvas, 17½ x 13⅔ in. (44.5 x 35 cm)
Loeb collection no. 51

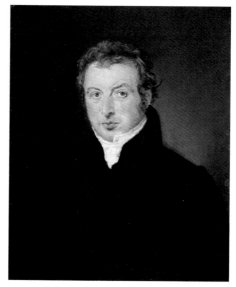

FIG. C C. A. Jensen
Portrait of Joseph Hambro, 1828
Oil on canvas, 9 x 7½ in. (23 x 19 cm)
Loeb collection no. 52

C. A. JENSEN
1792–1870

145. *Portrait of the Flower Painter J. L. Jensen's Wife, 1827*

(Portræt af blomstermaler J. L. Jensens hustru)

Oil on canvas, 25 x 19½ in. (63.5 x 50 cm)

Signed and dated top right: C.A. Jensen 1828

PROVENANCE: Kgl. kammersangerinde Emilie Ulrich, Copenhagen; Bruun Rasmussen, Auction 846, 2014, lot 32, ill.

EXHIBITED: Holmegaards Glasgalleri, *Udstilling af danske blomstermalere på H.C. Andersens tid*, 1983.

LITERATURE: Sigurd Schultz, *C.A. Jensen*, I–II, Copenhagen, 1932, no. 153, vol. I, pp. 230, 232, ill. p. 219.

Flower painter J. L. Jensen's handsome wife Signe Marie Vilhelmine, (née Visby), is barely twenty-three years old in this portrait. She married her artist husband on May 27, 1825 in the village of Gentofte, north of Copenhagen. The wedding took place only a few months after the groom's appointment as Painter-in-chief at the Royal Porcelain Factory of Copenhagen, an honorable and steady position that made it possible for him to marry, as well as two years later letting his wife, and later himself, be painted by the city's most prominent portrait painter.

It is not unlikely that the flower painter carefully decided how his young wife should present herself in her portrait. Signe's beautiful gown appears to be made of mauve tulip leaves, making one think of the magnificent flower arrangements that would be the motif throughout the life of J. L. Jensen. Here we see that the fabric of his wife's iridescent atitre is made of expensive silk taffeta, appropriate for her regal mien. Her neck and shoulders are bare, while her arms are hidden by plump puffed sleeves, so long they fall below her wrist. The voluptuous bosom of Signe Marie appears both proper and daring, concealed and contained beneath the heart-shaped dress seams that point towards her small waist. The bottom oft her broad waist-band leads to the skirt of her gown, which continues on to the bottom of the picture. Imagination suggests that her skirt ends in an extravagant width.

The cheeks of this lovely young woman are as brightly pink as a freshly opening rose. Her simple jewelry pieces are minimal: only a small multi-strand bead necklace with a gold clasp, and slender gold earrings. A handsome comb, strudded with turtle shells, stands back of her tightly-curled coiffure. Signe Marie Jensen has been painted by a masterful artist who captured not only the pride and dignity but the joy and glow of a happily married young woman.

In the late 1820s, the portrait painter C. A. Jensen was at the height of his career. His insightful, but flattering, represtations of his clients made him in much demand among the bourgeoisie of Copenhagen. With their warm humanity and buoyant character portrayals, they even outshone the much admired and popular marble-like and flawless portraits by his colleaque, Professer C. W. Eckersberg. Later on, the works of C. A. Jensen were to be criticized and even ridiculed by the most influential art historian of his day, N. L. Høyen, to the degree that the portrait painter became ignored, and ultimately forgotton.

In his mention of Signe's portrait, the biographer of C. A. Jensen, Sigurd Schultz, praises the exact aspects of the painter's impressionistic painting technique that are valued highly today, but that Høyen regarded with the deepest disdain: *Jensen painted away, straight forward without hesitance and without mistakes.*

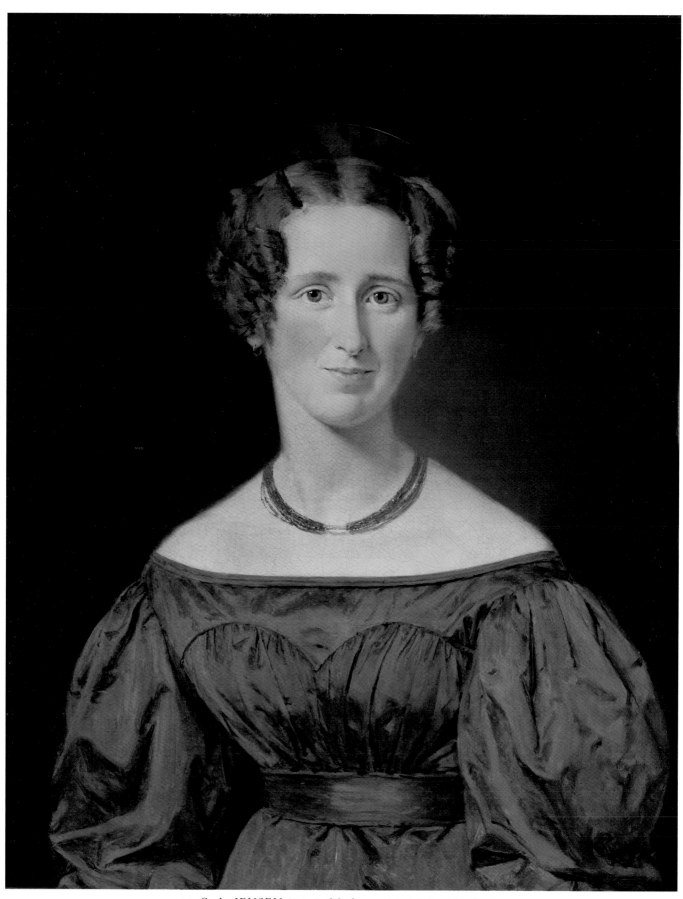

145. C. A. JENSEN *Portrait of the flower painter J. L. Jensen's wife, 1827*

Where the brush stroke is allowed to stand, specifically in attire and hair, it is both forceful and rhythmic, of an equality that gives a splendid beauty of craftsmanship (...). It is scholastic to see how a painter in that time could fall in love with the effects of the materials of contemporary fashion, here in the case of Jensen, when he painted the iridescence of the dress between red violet and olive and thoroughly basked in it, and it is always a pleasure to observe how beautifully he could characterize the fall of the hair in women's hairstyles. Obviously, it gave him a special pleasure to take on with the wet, heavily oily color mass he here used and with amusing details such as the small shadows on the forehead from the curls in the hair, or the incursion of light in the edges of the curls in the hair.

Signe Marie was the daughter of Hans Jensen Visby, a teacher in Aagerup by Frederiksborg in the north of Zeeland. Visby was a colleague and a friend from youth of Jensen's father. The young couple had a residence in Copenhagen, and in the summer, a little house with a flower garden in Gentofte. In 1833, six years after this portrait in the Loeb collection was painted, Signe fell ill. Because the doctors thought that a southern climate would help her recover, J. L. Jensen and his wife left Denmark and went out on an extended journey to France and Italy. They were away for two years and Signe came home well. Her painter husband enriched by many impressions of beauty. Their marriage was to be childless, but they took in a little niece, Sara Henriette, born around. 1845. Johan Laurentz Jensen had an exceedingly industrious, but short life that to the sorrow of his wife and his many friends, ended in 1856.[1] Signe Marie Vilhelmine Jensen died in 1885.

S.L.

[1] *Mindeblade om Professor, Blomstermaler Johan Laurentz Jensen. Medlem af det kongelige Academi for de skjønne Kunster i Kjøbenhavn, Ridder af Dannebroge. Manuscript for Venner,* Copenhagen 1856.

JOHAN LAURENTZ JENSEN[1]

GENTOFTE 1800 – COPENHAGEN 1856

"Blomster-Jensen" ("Flower Jensen") is the popular nickname given to Johan Laurentz Jensen. He made several thousand flower paintings and decided on the genre as his specialty while still studying at the Royal Danish Academy of Fine Arts in Copenhagen. He was admitted to the Academy at the age of fourteen, as was quite typical. The son of the parish clerk in Gentofte, then a village north of Copenhagen, he had such an obvious talent that he encountered no opposition from his parents when he chose to become an artist. His basic training in the life class culminated with the minor and then the major silver medals after three years of study. He learned flower painting with C. D. Fritzsch (1765–1841), who in his youth was a friend of the great Danish sculptor Thorvaldsen (1770–1844). Fritzsch's scenes of Copenhagen street life were the models for C. W. Eckersberg's youthful works in that genre. As a flower painter, Fritzsch worked in the classical Dutch tradition with tightly composed bouquets in vases such as are seen, for instance, in the work of Jan van Huysum (1682–1749).

We know only flower and fruit pieces by Jensen. An unsigned painting from the Botanical Gardens then situated behind the Royal Danish Academy of Fine Arts at Charlottenborg in Copenhagen has been attributed to him, but the attribution has subsequently been disputed, and a portrait, (sold by Arne Bruun Rasmussen auction 481, no. 78) is probably not a self-portrait, but a portrait painted in 1852 by his namesake Johannes Jensen (1818–1873).

Jensen made his first appearance in the Academy's annual exhibition at Charlottenborg in 1818, and with a traveling bursary he was able to make a trip to Paris.

Since the Empress Joséphine had acquired the palace of Malmaison in 1798, France had been experiencing a great fashion for flowers. She had all kinds of flowers, especially roses, imported and cultivated, and she created a scientific milieu in which botanists and artists worked together, one achievement of which was the publication of some splendid botanical works illustrated by Pierre-Joseph Redouté (1759–1840), including one devoted to the rose.

In 1822 Redouté succeeded his teacher Gerard van Spaendonck (1746–1822), who was a pupil of van Huysum, the Maître des Dessins in the Jardin des Plantes in Paris. It is possible to imagine Jensen participating in these courses in drawing and painting, which were open to the public. We know that he sent a copy of a flower painting by van Spaendonck along with drawings of live flowers to the crown prince of Denmark. It is tempting to imagine that it was in this fascinating milieu that he chose the rose as the flower around which his entire production is grouped.

While in France, Jensen spent some time in Sèvres, where he learned porcelain painting, which later resulted in an appointment to the Royal Porcelain Manufactory in Copenhagen (1825–1840). That year he became a member of the Academy, and ten years later he was given the title of professor. He retained his connection with his native town, where he owned a small summer residence. There he taught his numerous pupils, among whom was the subsequent Queen Louise, married to Christian IX,

and her sister Augusta (one of whose paintings is represented in the Loeb collection.) He counted a large number of women among his pupils.

In 1833–1835, he was in the south of France and Italy. He sold to, and exhibited with, the painter and art collector François-Xavier Fabre (1766–1837) at Montpellier.

In Rome he formed part of the Danish colony of artists centered around Bertel Thorvaldsen (1770–1844), who lent him some of his antique vases so that he could paint them, and who also bought from him. Hans Christian Andersen (1805–1875) tells in his diary for 1834 how, while out walking, he plucked purple anemones for Jensen, who incorporated them into a painting.

With the pink cabbage rose as his focal point, Jensen created his virtuoso compositions in which he juggled flowers rather like modules fitted together. The result is paintings of a uniquely decorative power. Through his treatment of light (in which he selected flowers to illuminate especially, but with the entire bouquet standing out against a dark background), he establishes a link with Dutch flower painting from the 17th century. The light is not the fleeting light of nature, but an idealised light. Strawberries, beech leaves, elder and cornflowers lend a National Romantic tone to some of the works. Even when he worked with the classical international repertoire, his paintings have the same unmistakable quality of a slightly naive sweetness such as one found in Auguste Bournonville's (1805–1879) ballets.

Jensen's oeuvre consists of several types of motif: flowers in clear drinking glasses, flowers in simple earthenware pots, flowers laid out on a table. Each type allows a large amount of space around the bouquets. It was possibly during his later years that he introduced a new motif in which he painted the flowers seen from close quarters without a vase or table, as in classical flower painting. Unfortunately, there is still only scant research on this important Danish Golden Age painter. There are no drawn preparatory works from his hand in Danish collections. Perhaps he simply did not draw, but knew his flowers so well that he could freely combine them on the canvas.

At the age of fifty, Jensen's sight began to fail. With great effort he executed an extensive decoration of garlands of flowers for the Royal Theatre in Copenhagen as part of Gottlieb Bindesbøll's restoration. He traveled south to see the World Fair in Paris in 1855, in which he took part and was awarded a prize. After this he went into decline.

M.T.

LITERATURE: Bernard Nollen, *A Posy of Flowers Painted by Scandinavian Artists in the Time of Hans Christian Andersen*, Liechtenstein 1982; Hanne Westergaard, *H.C. Andersens blomster*, Copenhagen 1985; Barbara Scott, Johan Laurentz Jensen, the Father of Danish Flower Painting in *Apollo*, vol. CXXVII, no. 309, November 1987, pp. 337–342; Ingvar Bergström, *Johan Laurentz Jensen (1800–1865); Father of Danish Flower Painting*, Hirsch & Adler Galleries Inc., New York 1988–89; Elisabeth Fabritius in *Weilbach*, vol. 4, Copenhagen 1995; Inger Nørballe, *Romantikkens blomster blomsternes sprog*, Bakkehusmuseet, Copenhagen 1998.

[1] Though J. L. Jensen signed his paintings "I.L." Jensen, we have used the name J. L. Jensen throughout this catalogue, as it is listed in the biographies of the *Weilbach Dictionary of Danish Artists*.

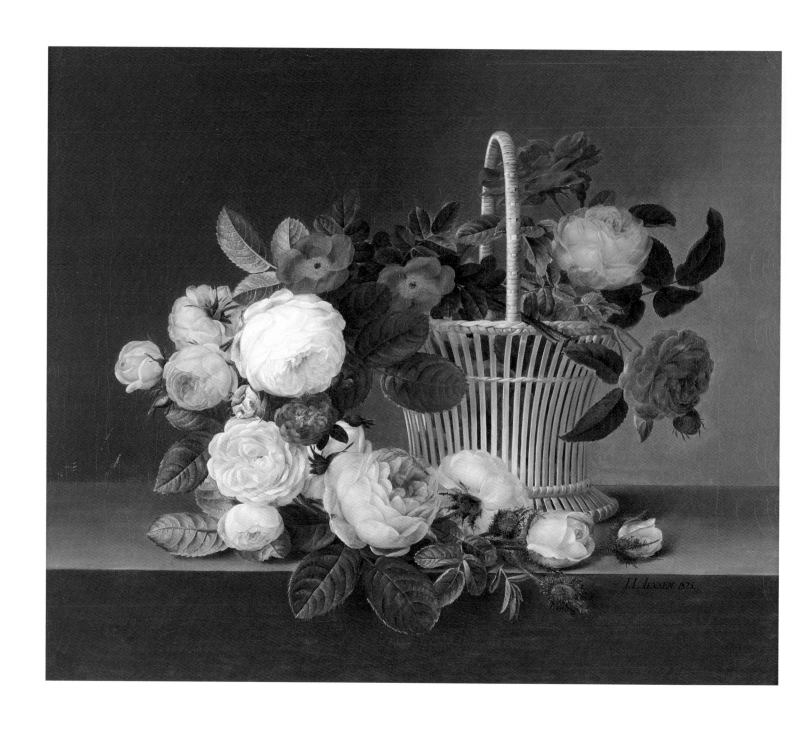

J. L. JENSEN
1800–1856

53. *Basket with Roses on a Sill, 1825*
(Kurv med roser på en karm)

Oil on canvas, 15 x 17⅔ in. (38 x 45 cm)

Signed and dated lower right: I.L. Jensen 1825

PROVENANCE: Nellemann & Thomsen, Auction 592, 1990, lot 1223, ill. p. 84 (described as *Opstilling med sammenflettede rosengrene i en kurv på en træplade)*; Bruun Rasmussen, Auction 558, 1991, lot 4, ill. p. 13.

The basket, like the vase, is an accessory seen in classical Dutch flower painting. Here it is placed asymmetrically in the picture to allow room for a garland of roses winding round the basket and ending in a bud. A single yellow rose forms an important contrasting splash of color amidst the red and white.

The picture was painted the year in which Jensen became a member of the Royal Danish Academy of Fine Arts. In another piece he painted in that year, a similar garland is seen in an arrangement made up of seasonal flowers brought together in a single composition.

The rose was Jensen's preferred flower. Another painting entitled *A Basket of Roses (En Kurv med Roser, 1829)* was sold at the auction of the Dowager Queen Caroline Amalie's estate at Amalienborg Palace on 24 April 1882, lot no. 77. It has the same measurements as the painting in the Loeb collection, 15¼ x 17¾ inches, but changed in pencil in one of the catalogues to 14⁷⁄₁₂ x 17⅓ inches. But the painting thus sold was dated 1829. So unless there is a printing error in the catalogue, this cannot be the painting now in the Loeb collection. *A Basket of Roses,* no. 77, was sold to the bookseller Philipsen.

Queen Caroline Amalie was widowed on the death of Christian VIII in 1848. She was born at Augustenborg Castle in the Southern Jutland duchies in 1798.

M.T.

The following flowers are seen in the picture, clockwise from the yellow rose:
Rosa hemispherica pre-1625, "sulphur rose," *Rosa gallica* "Assemblages de Beautés" 1823; syn "Rouge Éblouissante"; *Rosa centifolia* "Muscrosa" pre-1563, "common moss"; *Rosa centifolia* "Major" L. pre-1563, "cabbage rose," *Rosa centifolia pomponiana,* "Pompon de Bourgogne," pre-1664, "Burgundian Rose" (the small flower immediately below the large white one); *Rosa Centifolia* "Alba" 1775; syn. "Unique Blanche," "White Province," *Rosa?* (centifolia variants); *Rose foetida* "bicolor," pre-1600, "Austrian copper"; *Rosa gallica* again, above the yellow "sulphur rose."

T.T.

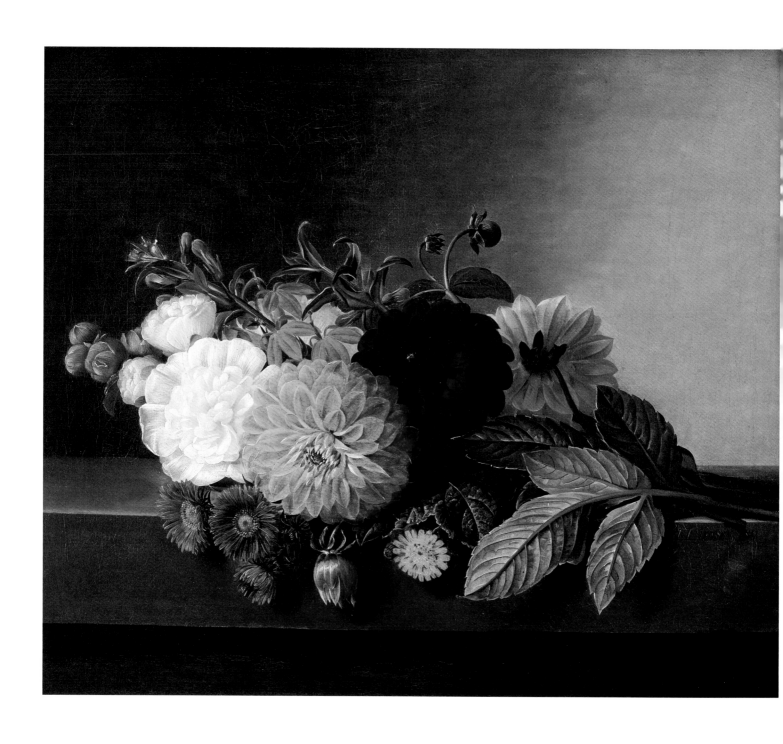

J. L. JENSEN
1800–1856

54. *Dahlias, Asters, and Hollyhock on a Sill,* 1831
(Georginer, asters og stokroser på en karm)

Oil on canvas, 13 x 15⅓ in. (33 x 39 cm)

Signed and dated lower right: I.L. Jensen 1831

PROVENANCE: Bruun Rasmussen, Auction 454, 1983, lot 363, ill. p. 199.

Jensen was fond of this type of flower painting presenting a bouquet lying on a table; indeed, it might be said that he himself developed it. It creates a horizontal, quietly restful composition. The heads of the dahlias lie like circles of color intersecting each other, with radiant white against the dark area; there are fine complementary contrasts in the small flowers overhanging the edge of the table.

The dahlia, which derives from Mexico, was new in Europe in the 1840's and became a very popular late summer flower in Danish gardens. The hollyhock was a favorite in rustic gardens.

In 1831 Jensen exhibited eleven flower pieces in the Charlottenborg exhibition, but as they appear only under the general designation of "flower pieces," without further specification, it cannot be determined whether this painting was among them.

Between 1830 and 1855, Jensen sold forty-three paintings by lottery in Kunstforeningen (The Copenhagen Art Society) and was thus among those most frequently purchased. Unfortunately, the titles are imprecise and the measurements not indicated, so it is difficult to identify the works concerned.

M.T.

The following species are seen in this painting:
FROM ABOVE: *Lobelia fulgens Willd,* "lobelia"; *Dahlia hybrida,* "lahlia"; *Aster hybrida* (?), "Michaelmas daisy"; *Calendula officinalis L.,* "marigold"; *Alcea rosea,* peony-shaped double flowers, "hollyhock."

T.T.

J. L. JENSEN
1800–1856

55. *Basket of Flowers and Fruits, 1833*

(Opstilling med druer, ferskner, figner, vindruer og granatæbler i en kurv på marmorplade,
hvorpå georginer, liljer og snerler)

Oil on canvas, 28⅔ x 36¼ in. (73 x 92 cm)

Signed and dated lower right: I.L. Jensen 1833

PROVENANCE: Arne Bruun Rasmussen, Auction 483, 1986, lot 50, ill. p. 25.

EXHIBITED: Busch-Reisinger Museum, Harvard University Art Museums, *Danish Paintings of the Nineteenth Century from the Collection of Ambassador John Loeb Jr.,* 1994, no. 11; Bruce Museum of Art and Science, Greenwich, Connecticut, and The Frances Lehman Loeb Art Center, Vassar College, New York, *Danish Paintings of the Nineteenth Century from the Collection of Ambassador John L. Loeb Jr.,* 2005, no. 4, ill.

LITERATURE: Peter Nisbet, *Danish Paintings of the Nineteenth Century from the Collection of Ambassador John Loeb Jr.,* Busch-Reisinger Museum, Harvard University, Cambridge, Massachusetts, 1994, p.6.

The full and compact arrangement consists of a basket of fruit on a marble plinth on which there is a pumpkin and a bunch of flowers: lilies, dahlias and a succulent-like blue flower. The cracked pomegranate is reminiscent of a Dutch still-life painting, where it often symbolises immortality or fertility. Grapes, fig leaves and peaches betoken exotic fruits, so the picture could have been painted during the artist's visit to the south of France and Italy, which he started in 1833. He may have seen Caravaggio's *Basket of Fruit* (now in Ambrosiana, Milano) or perhaps, like every other Scandinavian, he was merely fascinated with the glorious sweetness of the fruit.

It is difficult to know whether any message lies hidden in the images, couched in the flower language of the time, i.e. the symbolical language implicit especially in bouquets presented to the chosen one. Care has to be taken, however, not to force works of art into a fixed pattern in the nature of a picture puzzle.

Cheeks as soft as peaches is still a phrase used today. In the 19th century, the peach also symbolised full lips. The apricot asks: Were you always as content as you are now? The pumpkin symbolises determination. The white lily, the Virgin's flower from the annunciation symbolises purity, humility and a woman's dignity.

Jensen exhibited sixteen different flower and fruit pieces at Charlottenborg in 1833.

M.T.

The following flowers and fruits are seen in the picture:
IN THE BASKET, FROM THE LEFT: Lily buds, grapes, malus baccata (L.) Moench. (?), "Siberian crab"; *Ficus carica,* "fig"; *Prunus persica Batsch,* "peach"; *Punica granatum L.,* "pomegranate." On the plinth, from the left: *Lilium candidum L.,* "madonna lily"; *Dahlia hybrida* (?), "dahlia"; *Sedum telephium L.* (ssp. maximum?), "Stonecrop"; ipomea tricolor Cav. Syn.: *Ipomea rubrocaerula* (?) "waterlily"; *Cucurbita pep L.,* "pumpkin."

T.T.

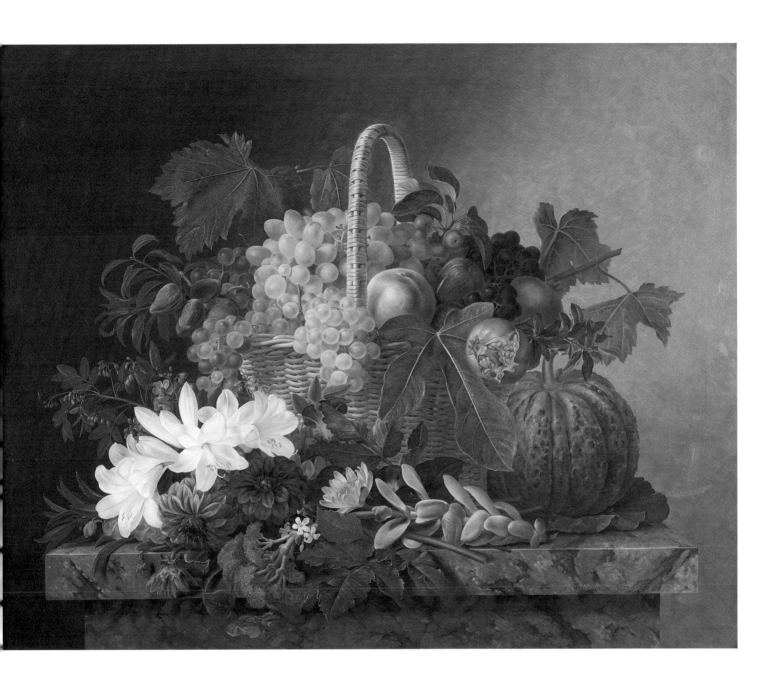

J. L. JENSEN
1800–1856

56. *Still Life of Fruits with Pineapple, 1833*

(Frugstykke, opstilling med ananas, blå og grønne druer i en kurv og ferskener på en stenkarm)

Oil on canvas, 27½ x 21½ in. (70 x 55 cm)

Signed and dated lower right: I.L. Jensen 1833

PROVENANCE: Professor C. Barnekow; Bruun Rasmussen, Auction 517, 1988, lot 10, ill. p. 15.

EXHIBITED: Busch-Reisinger Museum, Harvard University Art Museums, *Danish Paintings of the Nineteenth Century from the Collection of Ambassador John Loeb Jr.*, 1994, no. 12; Bruce Museum of Art and Science, Greenwich, Connecticut, and The Frances Lehman Loeb Art Center, Vassar College, New York, *Danish Paintings of the Nineteenth Century from the Collection of Ambassador John L. Loeb Jr.*, 2005, no. 5, ill.; Scandinavia House, New York, *Danish Paintings from the Golden Age to the Modern Breakthrough, Selections from the Collection of Ambassador John L. Loeb Jr.*, 2013, no. 21.

LITERATURE: Peter Nisbet, *Danish Paintings of the Nineteenth Century from the Collection of Ambassador John Loeb Jr.*, Busch-Reisinger Museum, Harvard University, Cambridge, Massachusetts, 1994, discussed and ill. p. 6: Patricia G. Berman, "Lines of Solitude, Circles of Alliance, Danish Painting in the Nineteenth Century" in *Danish Paintings of the Nineteenth Century from the Collection of Ambassador John L. Loeb Jr.*, Bruce Museum, 2005, p. 25; Patricia G. Berman, *In Another Light, Danish Painting in the Nineteenth Century*, New York, 2007, p. 128, ill. p. 128.

The fruit piece makes use of a simple and contrasting application of green and orange. At the same time there is a strong contrast in shapes between the conical fruits and the radially extending leaves. The dominant pineapple might be inspired by Gerard van Spaendonck (1746–1822) or Jensen's teacher, C. D. Fritzsch (1765–1841). The immediate impression, however, is that the arrangement is the result of the artist's own enthusiasm for the abundance of fresh fruits in a southern clime. It could be a work executed during the artist's visit to Italy.

Pineapples symbolise "the duration of true love" in the flower language of the time. A possible symbolical meaning would depend on whether the painting was a commissioned work, intended as a gift. It may be that this impressive work once formed part of Christian Fenger's collection. Fenger was King Frederik VI's personal physician. Martinus Rørbye painted a portrait of Fenger (Ribe Kunstmuseum) in which two flower paintings can be seen hanging on the wall. It is not known whether there were any paintings by J. L. Jensen among those he owned. (Kasper Monrad, *Hverdagsbilleder*, Copenhagen, 1989, p. 67). The Barnekow family, to whom this fruit piece once belonged, were descendants of Fenger.

M.T.

The following fruits can be seen in the painting:

Ananas, "pineapple"; *Prunus persica*, "peach"; *Corylus avellana*, "hazel"; *Rubus spec.* (?), "Berries"; *Vitis vinjifera*, "grape vine."

T.T.

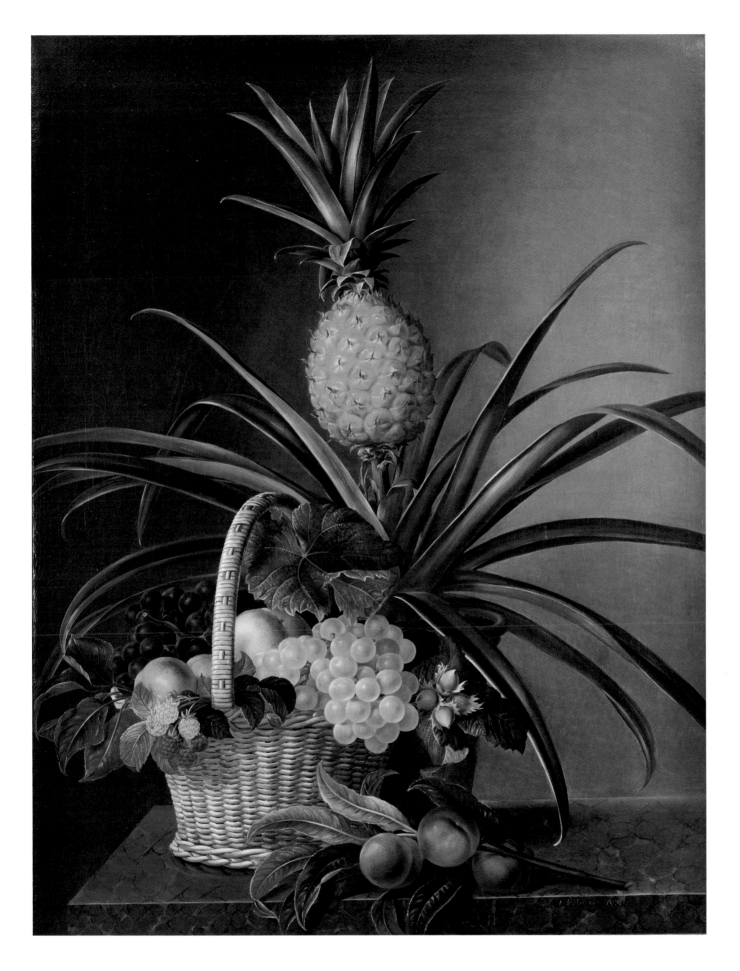

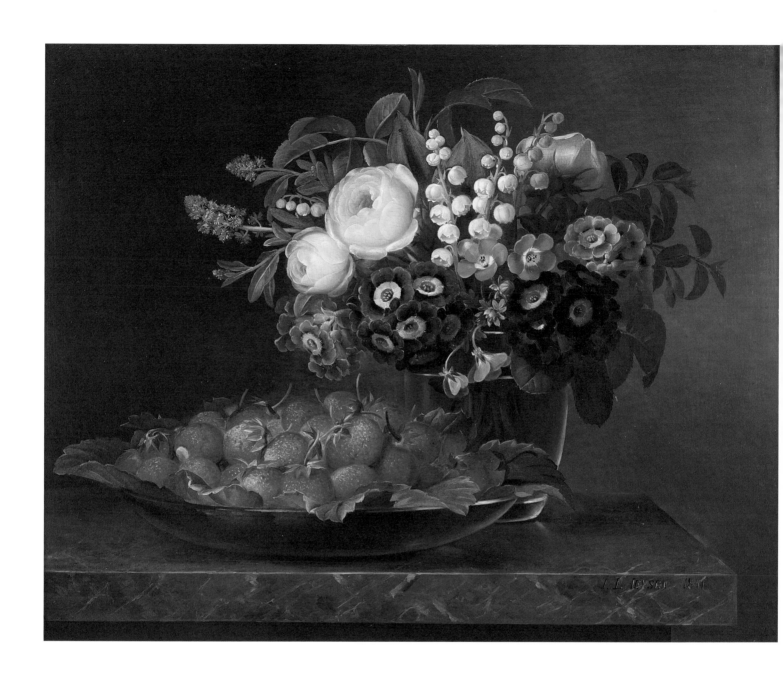

J. L. JENSEN
1800–1856

57. *Strawberries and Flowers,* 1841

(Jordbær og roser)

Oil on panel, 12 x 15 in. (30.4 x 38 cm)

Signed lower right: I.L. Jensen 1841

PROVENANCE: Queen Caroline Amalie; the queen's estate auction in Amalienborg, 24 April 1882, lot 84 (described as *En Skaal med Jordbær og en Bouket Roser*); Miss. F. Treschow (1882); Viola Hedemann; Helge Harth.

It might be imagined that this quite small picture was commissioned as a present from a suitor. There is in a glass vase a bouquet combining pink cabbage roses, lilies of the valley, and auriculas, radiating the gentleness that is so characteristic of Jensen. The flat dish of strawberries on fresh leaves provides a fine dissonance in color. The strawberries, like the rose, represent the desire for love, whereas the lily of the valley and the auricula both symbolize childish innocence and a receptive mind.

A painting of the same nature, bearing the same date, and similarly painted on board, was also sold in the auction of the dowager Queen Caroline Amalie's effects. It bore the title *A Bowl of Strawberries and a Bouquet of Roses,* 1841. The measurements, however, are not the same (8¾ x 12 inches or c. 22,3 x 30 cm). The picture similar to that in the Loeb collection was also sold to Miss F. Treschow. Jensen exhibited four fruit and flower pieces at Charlottenborg in 1841. In 1842, in a somewhat larger picture, Jensen painted strawberries alone, placed in a Greek kylix.

In 1846, one of the most important Copenhagen daily newspapers, *Flyve Posten,* contained the following comment on Jensen: "This artist excels in verisimilitude and brilliance in his colors, an elegant and skilled use of the brush, and taste in combining and arranging the objects portrayed; indeed Jensen even knows how to introduce poetry into this realm."

<div align="right">M.T.</div>

The following flowers and fruits can be seen in the painting:
Rosa centifolia, "Major" L. pre-1563, "cabbage rose"; *Convallaria majalis,* "Lily of the valley"; blue, five-petaled flowers (myosotis?) (forget-me-not?); *Primula hybrida,* "auricula"; *Fragaria hybrida,* "Strawberry."

<div align="right">T.T.</div>

J. L. JENSEN
1800–1856

58. *Bouquet of Field Flowers with Butterflies*, 1841
(Markbuket med aks og sommerfugle)

Oil on canvas, 22 x 17⅓ in. (56 x 44 cm)

Signed and dated lower right: I.L. Jensen 1841

PROVENANCE: Bruun Rasmussen, Auction 454, 1983, lot 361, ill. p. 195.

EXHIBITED: Bruce Museum of Art and Science, Greenwich, Connecticut, and The Frances Lehman Loeb Art Center, Vassar College, New York, *Danish Paintings of the Nineteenth Century from the Collection of Ambassador John L. Loeb Jr.*, 2005, no. 7, ill.

It frequently happens that Jensen places his subjects in a natural setting, portraying his flowers on the root, but usually linked to beech trunks and against a landscape background. Here, he is content to allow a branch to sway in the background, and he goes quite close up to the flowers of the field. He thereby creates a very Danish June bouquet consisting of blue cornflowers, red poppies, and white oxeye daisies. The barley at the back is a little too ripe to correspond to the time of year when the other flowers would be blooming, but they could presumably appear at the same time. In any event the artist has chosen to show both. The narrow grassy foreground is unusual. The lighting seems to be one commonly employed by Jensen, an indoor rather than outdoor light source.

Jensen had already shown an interest in this motif the previous year, for on 2 January 1840 Kunstforeningen (the Copenhagen Art Society) sold a painting by lottery entitled *Markblomster og Insecter* (*Field Flowers and Insects*), and in 1853 another one was disposed of in the same way, this time simply called *Markblomster* (*Flowers of the Field*)—owners unknown.

M.T.

The following flowers are seen in the painting:
FROM ABOVE: Malt; *Leuchantemum vulgare*, "oxeye daisy"; *Papaver rhoeas L.* (?), "corn poppy"; *Centaurea cyanus*, "cornflower" or "bluebottle."

T.T.

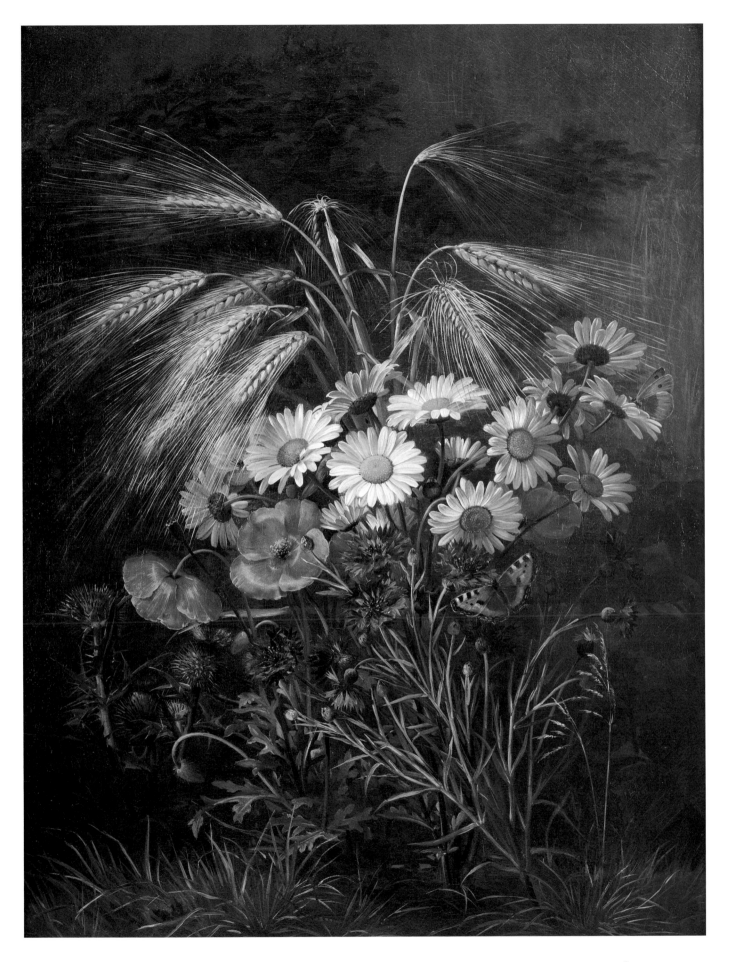

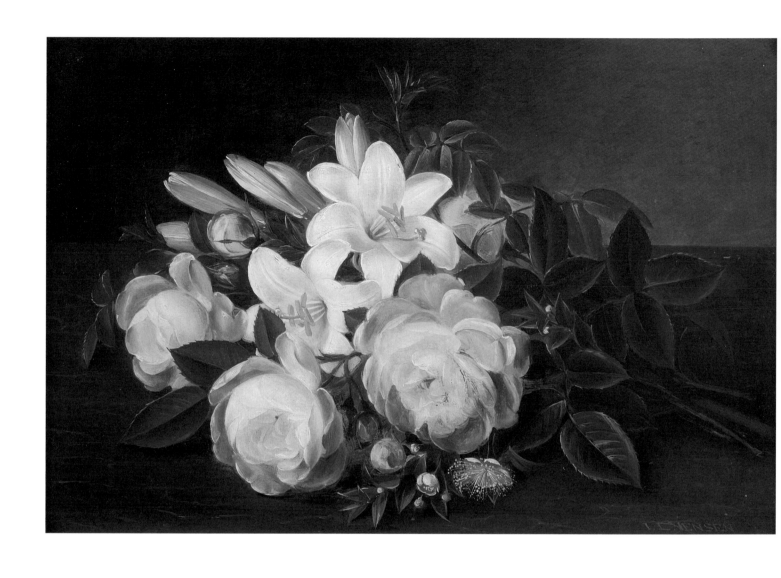

J. L. JENSEN
1800–1856

59. *Pink Roses and Lilies*

(Lyserøde roser og liljer)

Oil on panel, 10 x 15⅖ in. (25.5 x 39.1 cm)

Signed lower right: I.L. Jensen

PROVENANCE: Arne Bruun Rasmussen, Auction 454, 1983, lot 364 (described as *Lyserøde roser og liljer*).

Roses and lilies are often included in Jensen's works. Here they appear on their own, though with a single myrtle protruding at the bottom in this horizontally placed bouquet, the central feature of which is the lilies in full flower. Could it be a bridal bouquet? The lily represents innocence, chastity, and a woman's dignity. The rose is for love, and when in bud it represents a presentiment of love. The myrtle is the pledge of tender, domestic affection. We come very close to the flowers in all their sweetness, and the bouquet is so radiant that it almost bursts out of the picture.

An almost identical picture was sold in Kunsthallen, Auction 27.3.1985, lot 80, measuring 11 ⅘ x 16½ in. (or 30 x 42 cm). Which of the two is the replica cannot be determined.

M.T.

The following flowers are seen in the painting:
Lilium candidum L., "madonna lily"; *Myrtus communis L.*, "lyrtle"; *Rosa?*

T.T.

J. L. JENSEN
1800–1856

60. *Pink Roses, White Lilies, Honeysuckle, and Ivy Branches*

(Hvide liljer, lyserøde roser, kaprifolier og efeuranker)

Oil on canvas, 22 x 28 in. (56 x 71 cm)

Signed lower right: I.L. Jensen

PROVENANCE: Arne Bruun Rasmussen, Auction 454, 1983, lot 360, ill. p. 193.

On a stone slab or table edged with ivy leaves, there are cut lilies, roses, and myrtles. Behind them can be seen a display of roses, presumably a bouquet, but almost in the nature of a bush. A couple of honeysuckles can be glimpsed appearing from among the profusion of rose leaves. There is very little space around the flowers. This is a "flowers in flowers" motif, and we are entirely in the flowers' own world.

M.T.

The following species can be seen in the painting:

FROM THE TOP LEFT, TOWARD THE RIGHT: *Rosa centifolia* "Major" L. pre-1563, "cabbage rose"; *Caprifolium L.*, "honeysuckle"; *Lilium candidum L.*, "madonna lily"; Red rose bud and open flower: *Rosa gallica*, "Tuscany Superb" (?) 1848 (if it is "Tuscany Superb," the painting must be dated after 1848); *Rosa centifolia* "Muscosa," pre-1700, "common moss"; *Myosotos*, "forget-me-not"; *Mytus communis L.*, "myrtle"; *Hedera hybrida*, "ivy branches."

T.T.

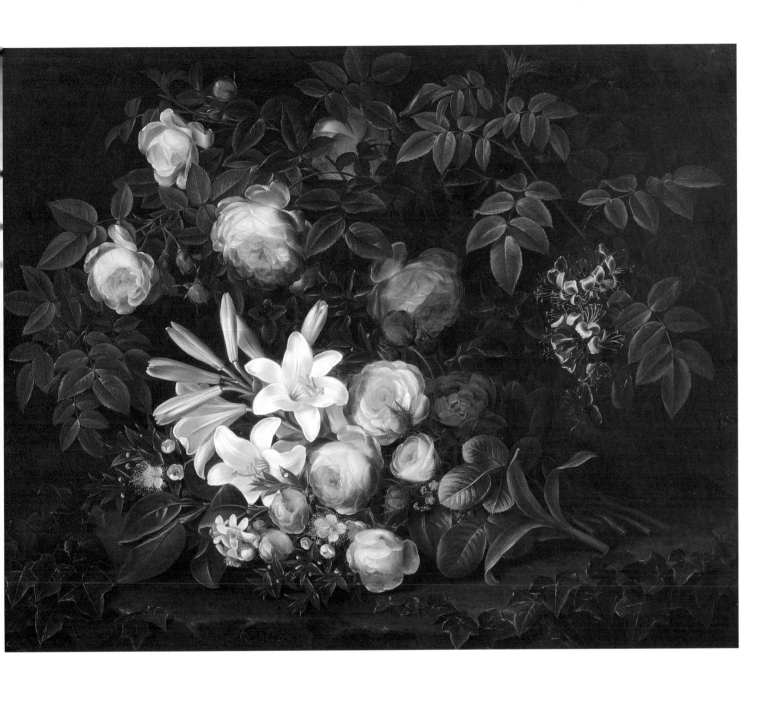

J. L. JENSEN
1800–1856

61. *Basket with Roses, Pink Carnations, Lilacs, and Fuchsia Surrounded by Elder Branches*
(Kurv med roser, fuchsia og nelliker omgivet af hyldegrene)

Oil on canvas, 27¾ x 35¾ in. (71 x 91 cm)

Signed lower right: I. L. Jensen

PROVENANCE: Arne Bruun Rasmussen, Auction 465, 1984, lot 187, ill. p. 87.

Standing on a wooden board or table, the pictured basket here contains roses, carnations, fuchsia and other flowers with the basket appearing to have been pushed beneath an elder bush in flower. In ancient popular belief, the elder provides protection from evil, and it has guarded the corner of many a house. It is associated with the light summer nights, when its perfume is released and its bunches of flowers hold the light. This combination of cultivated and wild plants is sometimes seen in Jensen's work, possibly painted in his own garden in Gentofte. As a type, it is reminiscent of another Jensen picture in the Loeb collection, *Pink Roses, White Lilies, Honeysuckles, and Ivory Branches,* which also mixes the wild and the cultivated, the cut and the still growing.

If the picture is admired for the flower language of the time, the elder refers to frugality and limited means, and the carnation teasingly asks: "Do you really seriously mean what you are telling me?" The *Rosa centifolia* symbolizes a rich emotional life, love, and delight but also silence.

A small replica (or a copy of the painting), 7 x 9¼ in. (18 x 25 cm), painted on board, was sold in the Arne Bruun Rasmussen Auctions, no. 629, 4 March 1997, no. 98; the present owner is unknown.

M.T.

The following flowers are seen in the painting:

FROM ABOVE: *Sambucus nigra L.*, "elder." In the basket: *Rosa centifolia* "Major" L. pre-1563, "cabbage rose"; *Rosa gallica*, "Tuscany" (?); *Fuchsia hybrida*, "fuchsia"; *Syringa vulgaris*, "lilac"; *Dianthus*, "carnation"; *Calceolaria hybrida* (?), "lady's purse" or "slipper flower"; *Rosa?*

T.T.

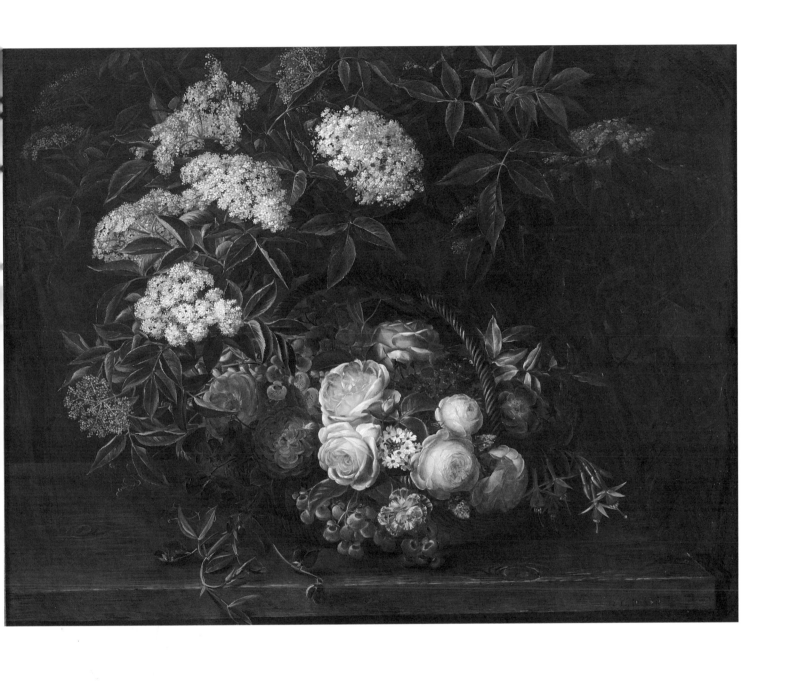

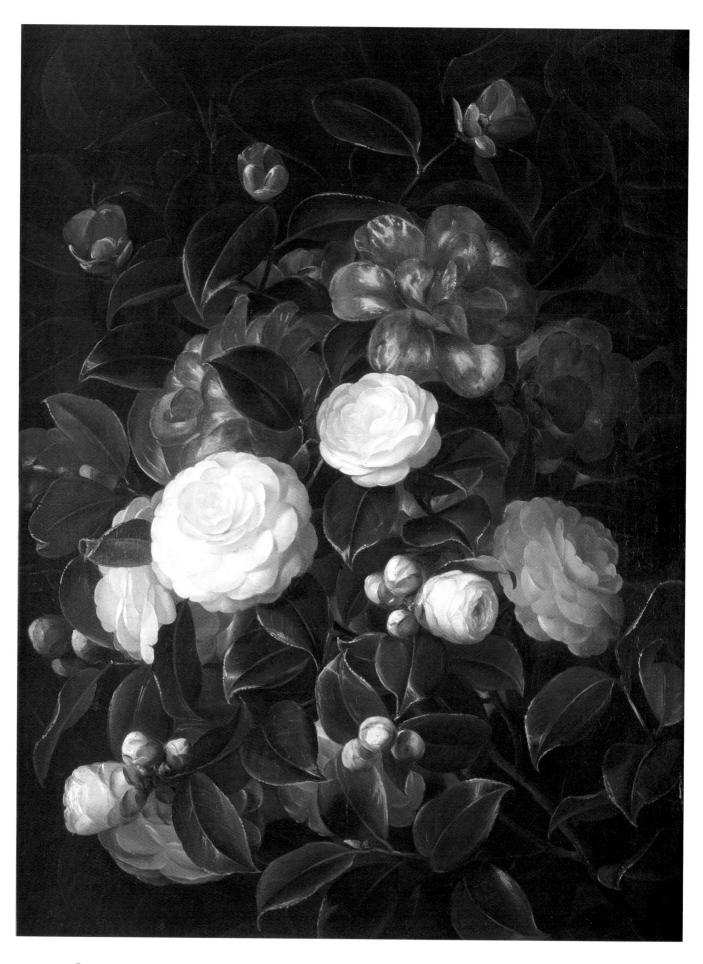

J. L. JENSEN
1800–1856

62. *Red and White Camellias*
(Røde og hvide kameliaer)

Oil on canvas, 20½ x 15⅓ in. (52 x 39 cm)

Signed lower left: I.L. Jensen

PROVENANCE: Arne Bruun Rasmussen, Auction 452, 1983, lot 102, ill. p. 45.

Camellias were usually cultivated in pots, but Jensen approaches so closely here that we can see only the uppermost part of the plants (which generally flower in the wintertime). We are confronted with a white camellia in front of a red one, both flowering very profusely. It is scarcely possible to imagine any flower opening more than a camellia, but it takes some time before the tight buds open to full blossom. Jensen has portrayed all these stages in a color composition dramatized with contrasts.

In symbolic language, the camellia signifies transitoriness and pride.

In 1831, Jensen painted a red camellia in a pot together with hyacinths and auriculas; the present owner is unknown.

M.T.

The following species is seen in the painting:
Camellia japonica L., "camellia."

T.T.

J. L. JENSEN
1800–1856

63. *Poppies and Lilacs*
(Valmuer og Syrener)

Oil on panel, 27½ x 22 in. (70 x 56 cm)

Signed lower right: I.L. Jensen

PROVENANCE: Sotheby's, Auction "Elisabeth," London, November 2, 1988, lot 7 (described as *Poppies and Lilacs*).

EXHIBITED: Bruce Museum of Art and Science, Greenwich, Connecticut, and The Frances Lehman Loeb Art Center, Vassar College, New York, *Danish Paintings of the Nineteenth Century from the Collection of Ambassador John L. Loeb Jr.*, 2005, no. 6, ill.

In this picture, which is filled to overflowing, we see spring in all its profusion—not exotic plants, but spring in a Danish country garden, concentrated in a sophisticated, slightly garish display of color. The pale purple lilac, known from every hedge, is combined with the delicate, simple red poppy and branches bearing white blossoms. Perhaps the painter was also interested in the contrast in size between the three flowers he combined in a single composition.

Because it is a herald of spring, the lilac symbolizes the first stirrings of love. The poppy expresses doubt.

M.T.

The following flowers are seen in the painting:
FROM THE TOP: *Syringa vulgaris L.*, "lilac"; *Papaver somniferum*, "opium poppy" and "opium poppy peony-flowered series"; *Philadelphus coronarius L.*, "mock orange."

T.T.

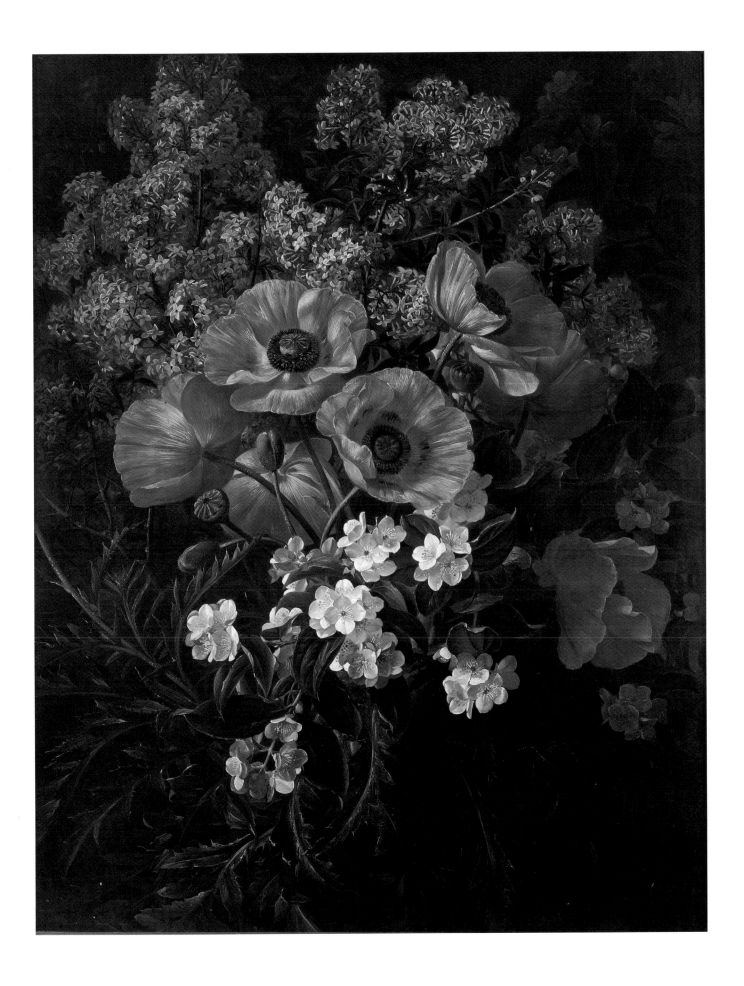

J. L. JENSEN
1800–1856

64. *Bouquet of Poppies, Peonies, and Bindweeds*
(Buket af valmuer, pæoner og snerler)

Oil on canvas, 24⅘ x 19¾ in. (63 x 50 cm)

Signed lower right: I.L. Jensen

PROVENANCE: Presumably identical with lot 86 (described as *Blomsterstykke*) at the estate auction of the dowager Queen Caroline Amalie, Amalienborg 24.4.1882; acquired by Michelsen (1882); Arne Bruun Rasmussen Auction 483, 1986, lot 48, ill. p. 24.

Like three others in the Loeb collection, this picture belongs to the type which does not show the flowers in vases, nor standing or lying on a tabletop with space around them, but the artist paints them using a close-up technique. Until research has gone further, it will not be possible to decide whether this type belongs to a specific period in Jensen's enormous oeuvre. I might tentatively suggest that it is a late type, i.e., from the end of the 1840s. Here we see single and double poppies (not peonies, as the title suggests), bright red and pink, with a few blue convolvulus as a contrasting color, the exuberant as opposed to the delicate. The poppies are represented in three stages, from seed pods to buds to fully flowering blossoms, and they are seen from the front, in profile, and turned away. Perhaps it is a bouquet to show the rapid passage of time. The poppy very often appears in classical Dutch flower painting.

An undated painting entitled *Flower Piece* sold in the auction of the dowager Queen Caroline Amalie's effects at Amalienborg Palace on 24 June 1882, lot no. 86, corresponds in dimensions (25 x 20½ inches, 65 x 52 cm) to the painting in the Loeb collection. However, the title is too imprecise to allow an assured identification.

M.T.

The following flowers are seen in the painting:
Papaver somniferum, "opium poppy"; *Papaver somniferum,* "opium poppy peony flowered series"; *Ipomoea tricolor,* "bindweed."

T.T.

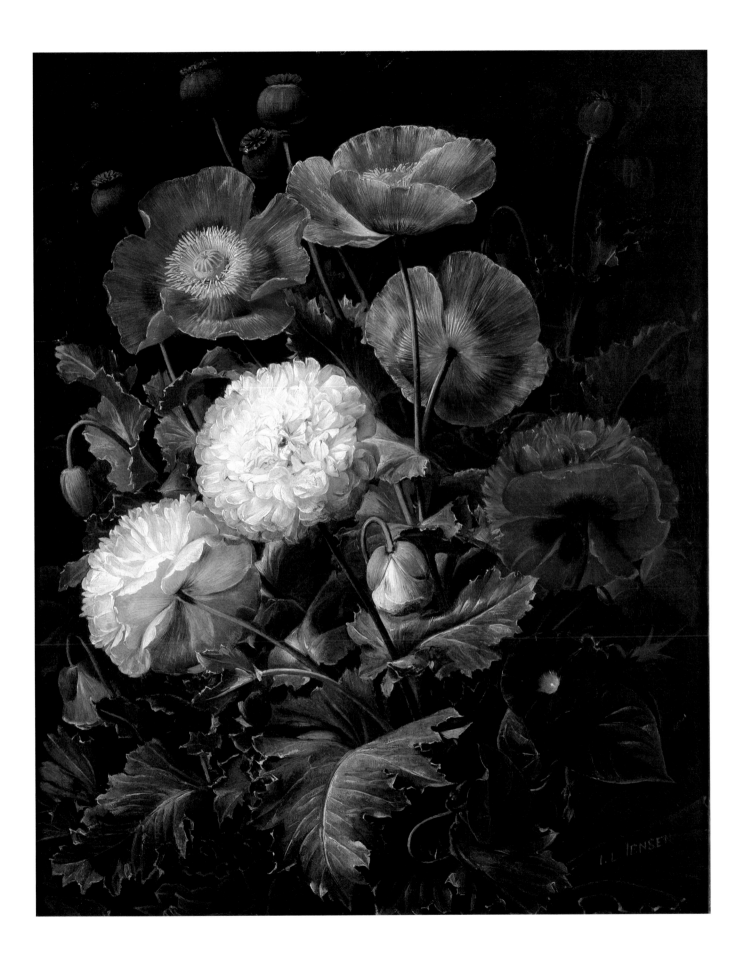

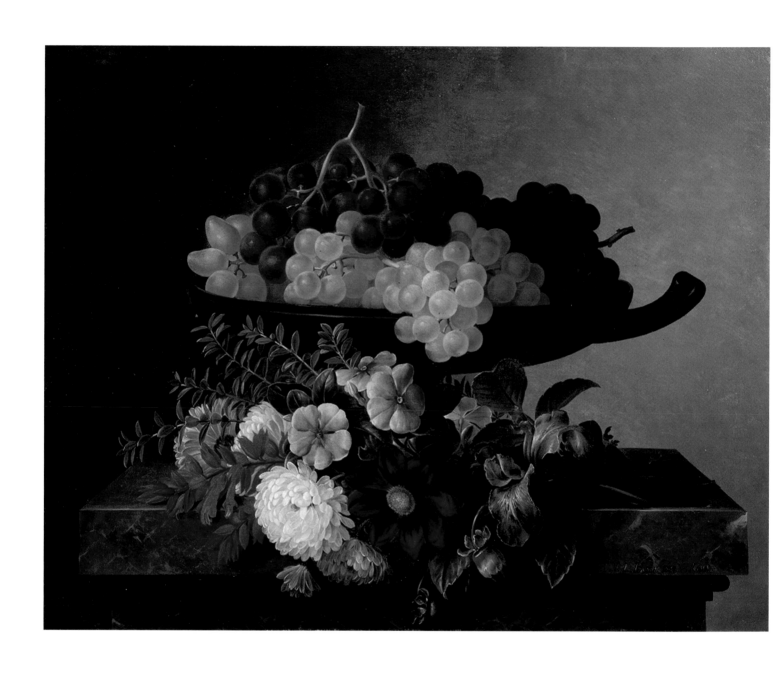

J. L. JENSEN
1800–1856

139. *Flowers and Grapes on a Stone Sill, 1834*
(*Blomster og vindruer på en marmorkarm*)

Oil on canvas, 14¼ x 18½ in. (36 x 47 cm)

Signed and dated: I. L. Jensen, 1834 Roma

PROVENANCE: Bruun Rasmussen, Auction 841, 2013, lot 18, ill.[1]

When J. L. Jensen left Copenhagen in 1833 for a two-year journey to Italy through Montpellier in southern France, it was first and foremost for the sake of his wife's health. For a flower painter, Rome and southern Italy were not a "must" in the way it was for his contemporary landscape and figure painters. Jensen had finished his room decorations, and thus the Pompeian wave that the excavations in Herculaneum and Pompeii initiated was no more useful to his art.

The hub of the Danish colony in Rome was the elderly sculptor Bertel Thorvaldsen (1770–1844). Many of Jensen's peers from the Academy, among them the painters Jørgen Sonne (1801–1980), Ditlev Blunck (1798–1854), Albert Küchler (1803–1886), and the sculptor H. V. Bissen (1798–1868), as well as the poet and author Hans Christian Andersen (1805–1875), were delighted to visit the Jensen couple's home in Rome. The two had a real home, whereas all their friends had gone to Rome alone, and it would be a long time before they could start their own homes there.

No one should think that the stay in Italy did not leave its mark in the art of J. L. Jensen. His sense of shape sharpened, his arrangements became more assertive, the result bolder. The fruits and flowers of southern Italy have a unique color and shape that Jensen was able to capture in his paintings. An earlier visitor to the area also greatly admired the fruit there: Prince Christian Frederik (1786–1839, later King Christian VIII) noted in his diary from his great Italy tour of 1818 to 1820 that in Strasbourg "We passed a fruit shop close to the cathedral. I have never seen the like of it, and for travelers from the Nordic countries, it brings great pleasure to see so many plucked fruits. As it proved, we could not withstand the temptation either, and a quantity of grapes and peaches were purchased."[2]

Grapes, oranges, pomegranates, peaches, and apricots were no longer what Jensen could study only in Dutch paintings. Now he lived among these magnificently colorful fruits, and not only painted but ate them with delight. A painting that Bertel Thorvaldsen bought from Jensen, an arrangement with an orange, walnuts, and grapes,[3] conveys his sensuous tasting experience. This picture, along with five others acquired by the sculptor, can today be seen at Thorvaldsens Museum in Copenhagen.

On November 10, 1833, Jensen was visited by Hans Christian Andersen. "I saw his Italian flower painting," he wrote in his diary.[4] There is reason to believe that this refers to a very large painting, the largest Jensen ever produced apart from the room decorations for the royal family. The picture depicts oranges, agave, roses, dahlias, and a laperga on a very large marble stand, adorned with Thorvaldsen's relief and placed in an Italian landscape. This work was purchased by Senator Martin Johan von Jenisch (1790–1864) for his newly built country house close to Altona, outside of Hamburg. There it still hangs on public display.[5]

In 1844 Jensen painted the Loeb collection's *Flower and Grapes on a Stone Sill*. The picture has two com-

ponents: The first is a flat Grecian kylix (drinking bowl) on a foot with large, angular handles, black with a narrow, red line at the top, filled with blue and yellow grapes. Both color and shape indicate that there are two kinds of blue and two kinds of yellow grapes. Illuminated yellow ones are in the foreground while shaded blue ones are at the back.

We do not see the foot of the kylix. In front of it is the other component of the picture: a freshly picked flower bouquet, unbound, chosen for contrast in color and shape, with a single crimson dahlia as the focal point. This flower radiates energy in its outlines and unifies all picture elements with its color. Around it are blue iris, yellow and white dahlias, rosa primula, and red sage. Green boxwood branches stretch up against the black clay vessel.[6]

As the grapes hang over the curved edge of the kylix, so the flowers fall over the hard edge of the marble sill. This painting can be understood geometrically as circle over square, but it can also be conceived as an exchange between inorganic, man-made shapes and nature's inventions.

Most often, Jensen places the arrangements he paints on a cast stone sill or a marble table. Here, the sill has additional classical profiling. The space above the arrangement is bare. The monochrome of the background, the two-colored grapes, and the polychrome of the flowers give a compelling falling cadence, springing from the stem of the upper blue cluster of grapes.

The Etruscan vessels (as the Grecian vases were then called because they were first found in Etruria) originated in ancient Greece. In the 1800s, they practically toppled out of the ground there, and also in southern Italy, and became important collectors' items. Most famous were the collections of the diplomat Lord William Hamilton (1731–1803) from his time in Naples. Some of these are now at the British Museum in London.

Prince Christian Frederik was also an avid collector. The vase collection in the palace of Amalienborg (his favorite dwelling) is now the core of the antique collection at the National Museum in Copenhagen. Bertel Thorvaldsen also collected, and J. L. Jensen painted a magnificent bouquet in a Grecian vase that Thorvaldsen bought.[7] In 1834, while in Sorrento, Jensen produced a compelling study of a bouquet in a Grecian vase that was bought by Prince Christian Frederik.[8]

The Greek fascination of artists, scientists, and collectors of the 1800s was the atmosphere from which many of Jensen's Italian pictures emerged. The Loeb collection's *Flower and Grapes on a Stone Sill* is an eminent example of this.

M.T.

[1]According to Bruun Rasmussen, the painting is mounted in a period bobinet frame (decorated with lace) with corner ornamentation.

[2]September 30, 1818. The diary is written in French (my translation). Albert Fabritius et al. (eds.), *Christian VIII. Dagbøger og optegnelser*, Copenhagen 1973, vol. II, 1, p. 111.

[3]*Nature morte med frugter på en marmor-bordplade*, 1833, oil on canvas, 9½ x 12 in. (24.1 x 32.7 cm), Thorvaldsens Museum, inv. no. B 237.

[4]K. Olsen, H. Topsøe-Jensen (eds.), *H.C. Andersens dagbøger 1825–1875*, Copenhagen 1971–1977, vol. 1, p. 228.

[5]*Marble Vase with Laperga, Oranges, and Agaves*, 1833, oil on canvas, 68½ x 49¼ (174 x 125 cm). Jenisch Haus was the country seat of the Hamburg merchant Senator Martin Johan von Jenisch the Younger. It was built between 1831 and 1834 to designs by Franz Gustav Forsmann and Karl Friedrich Schinkel. It is now part of Norddeutsches Museum, Altona. See also Barbara Scott, "Johan Laurentz Jensen, the Father of Danish Flower Painting," in *Apollo*, vol. XII, Nov. 1987, pp. 337–342.

[6]Mette Thelle would like to thank professor emeritus, dr. scient. Ole Jørgen Hamann and the florist Lise Kramhøft for their help in identifying the plants in the painting.

[7] *Still Life with Flowers in an Antique Vase (Nature morte med blomster i en antik vase på en marmorplade)*, 1834, oil on canvas, 24¼ x 19¾ in. (61.5 x 50.3 cm), Thorvaldsens Museum, inv. no. B 232. See also Torben Melander, *Thorvaldsens Antikker*, Copenhagen 1993.

[8] *Flowers in a Vase (En vase med blomster)*, oil on canvas, 40½ x 35½ in. (102.8 x 90 cm), Statens Museum for Kunst, inv. no. KMS 265. See also Bodil Bundgaard-Rasmussen et al. (eds.), *Christian VIII og Nationalmuseet*, Copenhagen 1999.

J. L. JENSEN
1800–1856

140. *Dahlias in a Basket*, 1840

(Kurv med georginer)

Oil on canvas, 17 x 22¾ in. (43 x 58 cm)

Signed and dated: I. L Jensen 1840

PROVENANCE: Bruun Rasmussen, Auction 841, 2013, lot 19, ill.

LITERATURE: Heidrun Ludwig, "Still Life Painting in the Eighteenth Century," in Jochen Sander (ed.), *The Magic of Things*, Städel Museum Frankfurt and Kunstmuseum Basel, 2008.

With very small variations, the wicker basket in this picture is similar to the one used by Jensen in *Still Life with Pineapple* from 1833 (cat. no. 56), a decorative but also useful basket that he used many times in his paintings. Here it is filled with a magnificent selection of pom-pom dahlias. Once in a while, Jensen chose to paint a single species, e.g. the blushing moss rose, poppy, camellia, rare orchids, or just a delicate violet. To work with just one or two colors, apart from the green foliage, was for Jensen an important alternative to diverse displays of splendor. In this painting Jensen demonstrates how rich a color scale a single species of dahlia can exhibit.

Nature sets a magnificent palette, and the artist brings us the beauty of these colors. He shows us how each petal in the almost-circular flower has its own shape and refracts the light in its own way, depending on where the light shines in the bouquet: in the orange one, slightly offset from the center, just by the handle of the basket, the white one, the pink, the shaded yellow and the illuminated yellow, or the crimson, almost black. They are all twisted and turned so that we see the flower in all its aspects and in all stages, from bud to fully opened flower. Just there, Jensen stops the cycle of nature. The portrayal of decay does not interest him.

Jensen likes to counterpose various colors in his arrangements, and with his discerning eye, always avoids the trite. The other Jensen paintings in the Loeb collection are either displays of plucked flowers and harvested fruit, placed on a sill indoors, or plants and flowers that are still situated in their site of growth.

The dahlia came to Europe from the highlands of Central America through Spain in 1789, and at the time it was believed to have edible roots. The wild dahlia is a single flower, but by 1817 gardeners had bred the double-flowered dahlia. In 1809, a dahlia landed in the garden of the famous German author and scientist Johann Wolfgang von Goethe (1749–1832). His gardener, August Friedrich Dreyssig (1766–1822), used it for breeding, and in 1820 he had 42 variations in his assortment, 17 of which were double-flowered. The dahlia became *en vogue*, not only in the gardens of scholars but laymen as well.

In 1817, Goethe wrote a short text on flower painting.[1] According to him, a classical Dutch flower painting was intended to appeal to the senses. The new flower painting, that is, one from the 1800s, shows the subject as it looks in real life. The flower painter must accurately portray the structure of the foliage and petals. The stamen and anthers (the reproductive system) must be correctly portrayed botanically, so that the art lover and the botanist are both satisfied. In other words, the flower painting should transcend the

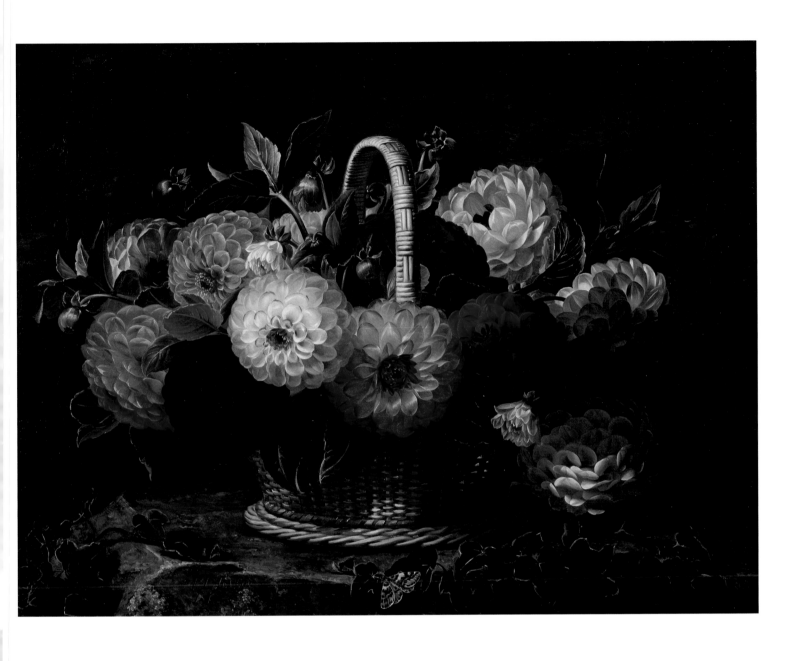

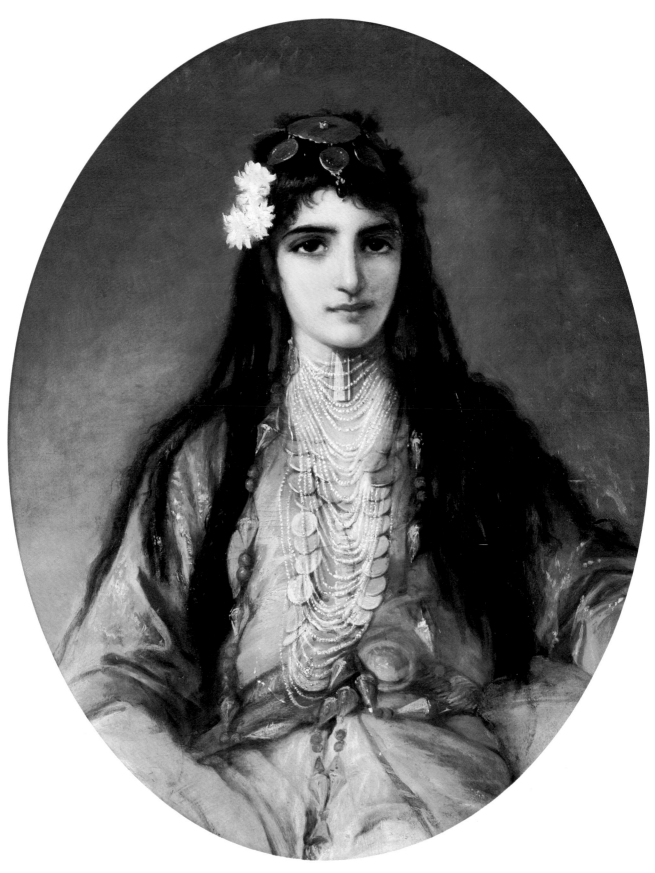

65. ELISABETH JERICHAU BAUMANN *Zarina, a Jewish Girl from Smyrna, 1874*

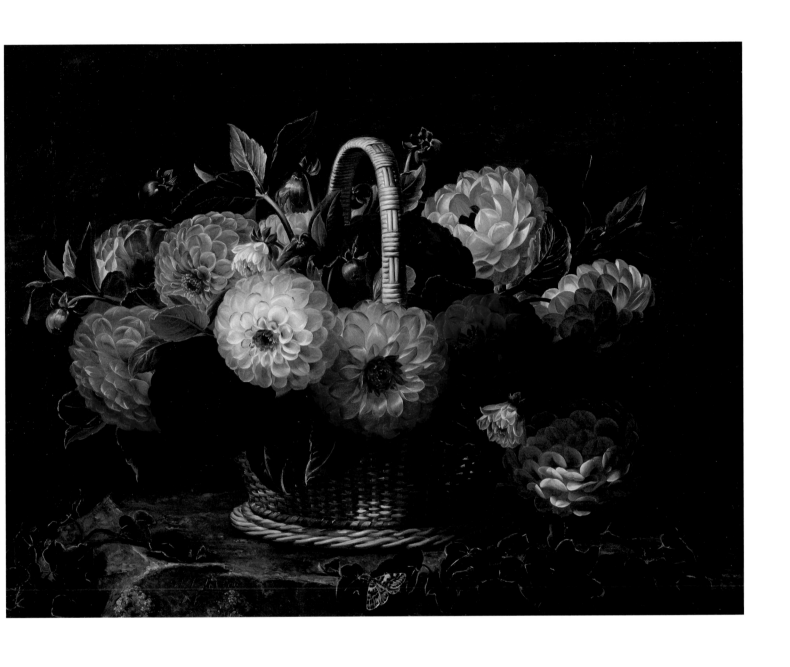

baroque "See how rare and magnificent but transient I am!" to an expression typical of the age of enlightenment: "See how I was created."

J. L. Jensen is a keen observer of both a flower's species and its individual characteristics. The heavy, nodding head of the dahlia provides the composition of the picture. The energy and novelty he developed in his Italian paintings between 1833 and 1835 had by 1840 become very strong artistic statements.

<div align="right">M.T.</div>

[1]Johann Wolfgang von Goethe, "Blumenmalerei," in *Über Kunst und Altertum,* vol. I, no. 3 (1817). Münchenausgabe, vol. II, 2, 1995.

ELISABETH MARIA ANNA (LISINSKA) JERICHAU BAUMANN

JOLIBORD (NEAR WARSAW) POLAND, 1819 – COPENHAGEN 1881

Elisabeth Jerichau Baumann was a talented, enterprising, and determined woman whose life was unusual for her time. At the age of nineteen she began her training at Düsseldorf, which at that time was one of the most important art centers in Europe, especially in the study of genre and history painting. She also began exhibiting there and in 1844 experienced her artistic breakthrough. She was thus well advanced in her career when, during a visit to Rome the following year, she met the Danish sculptor Jens Adolf Jerichau (1816–1883). He was one of the outstanding talents of the period and for a short time had worked with the world-famous Bertel Thorvaldsen (1770–1844) before Thorvaldsen left Rome in 1838. The couple married and moved to Copenhagen in 1849, where Jens Adolf became a professor in the Royal Danish Academy of Fine Arts.

To her amazement, Elisabeth Jerichau Baumann discovered that she was not given a positive reception by her fellow artists there. These were the most intense years of national patriotism during the first Schleswig war, and she encountered a powerful and concerted opposition in the art world, whose purpose was to protect the ideals of the Danish Golden Age and the heritage from C. W. Eckersberg. Even as late as about 1880, the most important subject of discussion in Danish artistic life was the relationship to other countries, i.e., the fear of influence, especially from Germany and France. However, Elisabeth Jerichau Baumann refused to be intimidated and tried to find subjects that she believed would speak to the Danish public. The allegorical Danmark, 1851 *(Denmark),* Ny Carlsberg Glyptotek, *did not bring her the recognition she deserved, although the painting quickly became known and reproduced. She had greater success with portraits of important personalities of the time. Here her portrayals of the politician Orla Lehmann, 1848 (The Museum of National History at Frederiksborg Castle) and Hans Christian Andersen must be given special mention. She also repeatedly painted portraits of Christian IX's Queen Louise (1817–1898), herself a painter, and her daughters (The Amalienborg Museum). It is interesting to note that these ladies corresponded with her.*

Because of the "European" quality of her work, Elisabeth Jerichau Baumann remained a controversial figure in Danish art. Not until 1865 was one of her paintings, En såret dansk kriger (A Wounded Danish Warrior), *purchased by Statens Museum for Kunst. It remained the only one. Her painting continued to be seen as alien and her personal behavior did not conform to the strict norms of bourgeois society as to what was fitting for a woman. She was not reserved, patient, or humble but keen to continue her career—although she gave birth to nine children! Several developed into talented painters, while others turned out to be mentally unstable. She has several descendants alive today who are artists. A grandson, J. A. Jerichau (1891–1916), was among the most talented of Danish modernist painters.*

Even while Jens Adolf was director of the Royal Danish Academy from 1857–1863, she chose to pursue her own career and retained her connections with artists and intellectuals abroad, where she continued to exhibit and have success in selling her pictures. Baumann was captivated by an interest in Asia that had originated at the beginning of the 19th century and was especially pursued by French artists. Accompanied by her sons, she traveled abroad, the first time in the 1860s. As a woman, she could gain access to harems and the private lives of the Asian women she visited and could therefore exhibit authentic portrayals of this exotic world; she also brought costumes and other paraphernalia home. These motifs often betray a sensualism that may well have been one of the 19th century's taboo subjects but which can also be seen in her husband's sculpture, which frequently has an erotic subject. The leading circles in Danish artistic life tried to keep her out of sight, and indeed her paintings have until recently been kept in museum storerooms.

She has herself given an account of her difficulties and experiences in the books Ungdomserindringer (Youthful Memories) *and* Brogede rejsebilleder, *Copenhagen 1881* (Motley Travel Pictures).

E.F.

LITERATURE: Sigurd Müller, *Nyere dansk Malerkunst,* Copenhagen 1884; N. Bøgh, *E. Jerichau Baumann,* Copenhagen 1886; Peter Nørgaard Larsen, *Elisabeth Jerichau Baumann,* Øregaard Museum 1996; Peter Nørgaard Larsen in *Weilbach,* vol. 4, Copenhagen 1996.

ELISABETH JERICHAU BAUMANN
1819–1881

65. *Zarina, a Jewish Girl from Smyrna,* 1874

(Zarina, jødisk pige fra Smyrna)

Oil on canvas, 32⅔ x 24¾ in. (83 x 63 cm) (Oval)

PROVENANCE: Bruun Rasmussen, Auction 682, 2000, lot 1439, ill. p. 41.

LITERATURE: Elisabeth Jerichau, *Brogede Rejsebilleder (Motley Travel Impressions),* Copenhagen 1881, pp. 88–89, ill. as a xylograph[1] executed by the author herself from her own painting.

This scintillating portrait, which almost seems as though it were painted with tar and fire, has a well-documented provenance provided by the artist herself in a retrospective glimpse of her colorful life in the books *Ungdomserindringer (Memories of Youth),* 1874, and *Brogede Rejsebilleder (Motley Travel Impressions),* published in 1881, the year she died.

This latter work relates a variety of curious experiences from two long visits to the Middle East and the eastern and southern Mediterranean countries in 1869–1870 and again in 1874–1875. Mrs. Jerichau visited Turkey on each of these journeys; on the first occasion she went alone and on the second in the company of her son Harald.[2] The book is illustrated with beautiful black and white xylographs executed after sketches and paintings by the author herself or Harald Jerichau. (Fig. A.)

In *Brogede Rejsebilleder* she describes the meeting in Smyrna (present-day Izmir) with the young Zarina and her family and provides an account of how the portrait of her came into being. The book also contains a finely executed woodcut of the same motif as the painting. (Fig. A.) After a spirited account of the arrival and the first part of her sojourn in the hot, vibrant, alien city, Elisabeth Jerichau tells of her efforts to achieve permission to paint in a Jewish home.

In this respect, the dominant experience is that of her meeting Zarina's parents, Madame P., her husband (a wholesale carpet dealer), and the couple's countless family members, who made up a very active household. In intense, graphic language, she presents the astonished reader with pictures of the family's life, whether in their everyday activities or on festive occasions. The following passage is taken from the account of how the Loeb collection portrait came into being. (Her writing is as lively and colorful as her painting style):

> It was a great favour thus to be accepted in this Jewish home; it was an even greater indulgence that they allowed me to paint the family's eldest daughter, a delightful fifteen-year-old girl. I have never yet seen a more charming woman than this little friend of mine. It is scarcely possible to describe her; but come and see her portrait—it enthrals everyone—I am almost jealous of it; for it is as though the picture of this young Oriental girl with the tightly closed, fine lips, the dark eyes shining like stars and wearing a tuberose in her dark hair, on which the bridal jewels have been placed, eclipses all my other works. I could have sold it time and time again for an exorbitant price; but I promised to make a replica for the mother, the only condition on which she would allow her daughter to be painted by me, and I have still not found time to copy it; indeed part of the bottom section of the picture is still missing. I cling to it as though by magic, the same magic as it works on the

[247

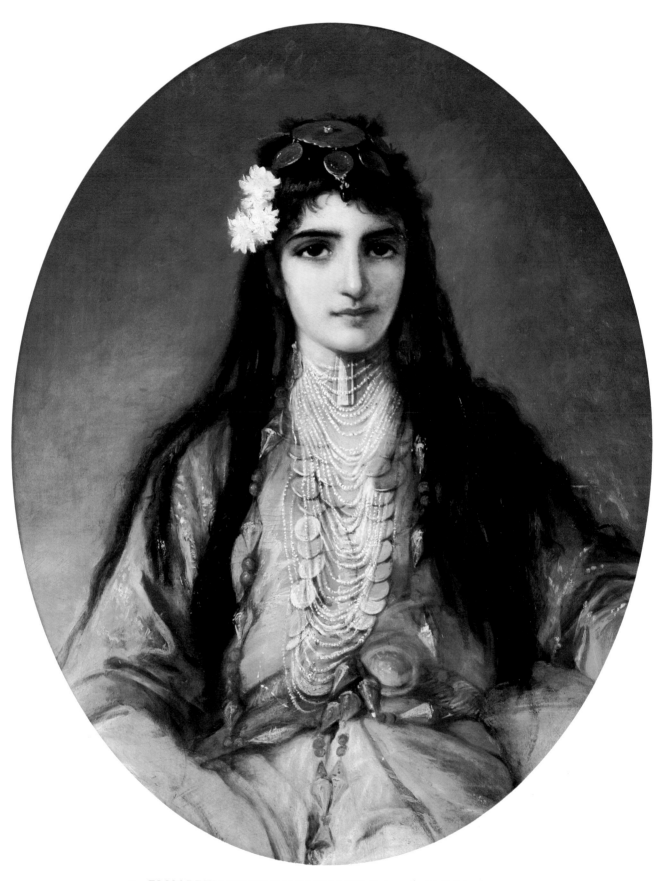

65. ELISABETH JERICHAU BAUMANN *Zarina, a Jewish Girl from Smyrna,* 1874

viewer. When the fifteen-year-old girl becomes a girl of twenty, the magic that resides in her picture will perhaps be gone—it will be gone when the passion slumbering in the tightly closed bud breaks out as with flaming rose petals, and the chaste modesty that subdues the fire of her eye and tightly encloses the golden dress over the maidenly breast falls like the veil that gives a special charm to a half-fancy. This is the characteristic feature in my little Oriental Jewish girl with the eyes of a gazelle and the tuberose in her black plaits.

But her toilette! Each time it took between an hour and a half and two hours to arrange it. I presented myself at my fair young lady's home at eight o'clock. She was not ready until ten o'clock, as all the tiny plaits had to be arranged, and then the runner[3] had to be sent to Mr. Taranto to fetch the grandmother's ducats; they were kept back because she was envious, and so the runner had to go to another relative, and once everything was finally in order, with a truly beating heart I set about my task, which had to be finished by a specific time; it was as though I were competing for a prize.

But then all the members of the family—and it was big—great and small, young and old, Jews and Jewesses, were like flies savouring sweetness. One after the other they all came, often seven or eight at a time, including the doctor, indeed even the preserving woman, the lace dealer, the washerwoman, the runner, the sons, the school friends, the girls and God knows who they all were, indeed even the grandmother from Rhodes had come, and there they sat and exasperated me by nudging my arm, standing in the light, knocking against the easel, chattering to each other and addressing the most incredible questions to me. At last, I exclaimed, "I can't go on—I need to be alone." But freedom was not to be mine; . . .

But at last the portrait was finished. It was evening when I left after having granted the entire family a solemn audience, whereupon I went off with it standing upright in the coach. When I drove past the illuminated cafes, the men crowded together while the coach carrying me and the portrait swayed to and fro on the uneven cobblestones. "Look! Look!" came the cries. The boys ran alongside hooting; but the darkness of the night protected this journey, so that the portrait came to no harm.

The book's xylographed version of Zarina's portrait might well have been made on the basis of the painting before it was replicated for Madame P, as the woodcut lacks "part of the bottom section of the picture." If the illustrations to *Brogede Rejsebilleder* were made in the same year as the book was published, it must be assumed that the painted portrait of the beautiful Jewish girl was only completed in 1881—and it is to be hoped for Zarina's mother that she managed to obtain her replica. However, it is also possible that in the black and white picture in the

FIG. A Elisabeth Jerichau Baumann
Zarina, a Jewish Girl from Smyrna
A woodcut book illustration, 5 x 6¼ in. (130 x 160 mm).

[249

book the artist has consciously chosen to reproduce part of the portrait of the young girl, seen from a lesser distance in order thereby to heighten the effect of the work.

S.L.

[1] A print made on wood; a special sort of woodcut made for illustrations.

[2] Harald Jerichau (1851–1878), an artist, as was his younger brother Holger (1861–1900). Harald died in Rome from typhoid and malaria only four years after this trip.

[3] A runner was a male member of the household staff whose work consisted in being a messenger for all manner of purposes. Mr. Taranto, who belonged to a prominent Jewish family to which Elisabeth Jerichau had a letter of recommendation, was the person who introduced the artist to Jewish circles in Smyrna and helped her to find both models and possibly special accoutrements for their dress.

AUGUST ANDREAS JERNDORFF

OLDENBURG 1846 – COPENHAGEN 1906

August Jerndorff's father was a restaurateur and court painter in the grand duchy of Oldenburg in Germany. He died there only a year after the birth of his son, after which the mother and child moved back to Copenhagen, from where the family hailed.

Jerndorff received his first training from his uncle, the painter Just Holm (1815–1907) and then became a pupil and assistant to the painter Christian Hetsch (1830–1903), who was the son of the German architect and professor G. F. Hetsch (1788–1864) of the Royal Danish Academy of Fine Arts in Copenhagen. Even while training, Jerndorff attended classes in the Technical School. He qualified there in 1863 and was that same year admitted to the Royal Danish Academy of Fine Arts, where he qualified in 1868. Of further importance to Jerndorff's development was the fact that he was a pupil of the landscape artist P. C. Skovgaard.

Jerndorff belongs to the generation of Danish artists who were trained before the establishment of French-influenced naturalism and who throughout their lives dissociated themselves from this movement, in contrast to his contemporaries P. S. Krøyer and Theodor Philipsen (1840–1920), both of whom enthusiastically endorsed the new currents from Paris.

However, Jerndorff was not without an eye to the future. In 1880, together with the painters Laurits Tuxen and Frans Schwartz (1850–1917) he helped to establish an alternative life school in Søkvæsthuset in Christianshavn. This initiative later led to the creation of De frie Studieskoler (The Free Study Schools).

The artist's earliest works included biblical compositions; small, bright landscapes showing the influence of Skovgaard; and portraits. It was this latter genre that in time was to become August Jerndorff's hallmark as an artist.

In his commissioned portraits he usually presented his models in characteristic situations to which he added details of the milieu of the persons concerned. The year after painting Theodora Jacobsen (1886), Jerndorff executed a portrait—very grand in style—of the old brewer J. C. Jacobsen in his winter garden (Museum of National History at Frederiksborg Castle). In 1893 the brewer's son Carl had his portrait painted by Jerndorff. Carl Jacobsen is pictured standing in front of his desk, on top of which are shown a microscope, chemical containers, a plan of the brewery, and various drawing instruments. A door in the background opens into the hall of his art collection with dark red walls decorated with a classical frieze. Jerndorff produced a large number of such stately portraits.

Apart from a few interruptions, August Jerndorff spent the period from 1875 to 1878 in Italy, returning home via Paris. It is believed that it was impressions gained during this visit of 17th-century and Italian Renaissance portraiture that were of special importance for the artist and left their traces on his work. In 1882, Jerndorff was in Vienna and again in Italy; the following year he visited Munich.

During his not particularly long life as an artist, Jerndorff was made the recipient of various dis-

tinctions. However, he did not become a professor in the Academy until 1901. August Jerndorff exhibited at Charlottenborg from 1866 to 1893, interrupted by a brief period in Den Frie Udstilling, and then again from 1896 to his death. He also showed works in a large number of exhibitions both in Denmark and abroad, such as the world fairs in Paris in 1878, 1889, and 1900, exhibitions in Vienna 1882, Berlin 1891, and Chicago 1893.

Important elements in August Jerndorff's work were his interest in decorative art and design and his gifted and imaginative work as a book illustrator. The principal work in this latter genre was the illustration of Holger Drachmann's Troldtøj (Trolls), created 1889–1890. Jerndorff was responsible for various fine-quality ceramic works in the 1880s, together with others including the architect Thorvald Bindesbøll (1846–1908), the son of the designer of Thorvaldsens Museum, and the Skovgaard brothers, whose father was the landscape artist P. C. Skovgaard. Jerndorff's death in 1906 prevented him from carrying out his last commission, the restoration of Jørgen Sonne's (1801–1890) frieze on the Thorvaldsens Museum.[1]

S.L.

LITERATURE: H. Chr. Christensen, *August Jerndorff 1846–1906, Fortegnelse over hans Arbejder*, Copenhagen 1906; *Fortegnelse over en Samling Malerier, Studier og Tegninger af afdøde Professor August Jerndorff*, V. Winkel & Magnussen, Copenhagen 1907; Bente Scavenius, *Fremsyn-Snæversyn*, Copenhagen 1983; Mette Bligaard, Portræt af en konseilspræsident in *Carlsbergfondets årsskrift*, 1986, pp. 99–106; Mette Bligaard in *Weilbach*, vol. 4, 1996.

[1]Between 1846 and 1850, Sonne executed the still existing frieze decorating the walls of the recently built Thorvaldsens Museum in Copenhagen. In stylized images, the frieze portrays the sculptor's return from Rome and the unloading of his sculptures from the ship that had brought them back.

AUGUST JERNDORFF
1846–1906

66. *Portrait of Theodora Jacobsen, Seated in the Ny Carlsberg Glyptotek*, 1885

(Portræt af Theodora Jacobsen, siddende i Ny Carlsberg Glyptotek)

Oil on canvas, 22 x 16½ in. (56 x 42 cm)

Signed and dated lower left with monogram: Juli 1885

PROVENANCE: Commissioned by the brewer, director, dr. phil. Carl Jacobsen; Bruun Rasmussen, Auction 679, 2000, lot 286, ill. p. 141.

EXHIBITED: Charlottenborg 1886, no. 202; Paris World Exhibition 1889, no. 77; Bruce Museum of Art and Science, Greenwich, Connecticut, and The Frances Lehman Loeb Art Center, Vassar College, New York, *Danish Paintings of the Nineteenth Century from the Collection of Ambassador John L. Loeb Jr.*, 2005, no. 15, ill.

LITERATURE: H. Chr. Christensen, *August Jerndorff 1846–1906, Fortegnelse over hans Arbejder*, Copenhagen 1906, no. 180.

On 5 November 1882, Carl Jacobsen (1842–1914), brewer, art collector, patron of the arts, and from 1899 the holder of the honorary degree of dr. phil., opened his first public art collection, and the following year he published a catalogue compiled himself of *Glyptoteket paa Ny Carlsberg* (The Glyptotek[1] at Ny Carlsberg).

This predecessor of the Ny Carlsberg Glyptotek in Dantes Plads in Copenhagen (opened fifteen years later) was housed in an extension to Bakkegården, Carl and Ottilia Jacobsen's home at that time; this was the roughly 200-year-old principal building of the Valby farm on the land where the Ny Carlsberg brewery had been built. Following the example of his father, the founder of the Carlsberg breweries, J. C. Jacobsen (1811–1887), Carl Jacobsen had extended the house by building a winter garden with the intention of creating a decorative interplay between plants and sculptures. However, before this conservatory was completed, art had triumphed over nature, for Carl Jacobsen acquired a number of original plaster models by sculptors including H. W. Bissen (1798–1868), who after the death of Bertel Thorvaldsen in 1844 was considered to be the leading Danish sculptor. As time passed, more works of art were added, among these antique sculptures, and room after room had to be built to create space for the collection.

Theodora, Carl and Ottilia Jacobsen's eldest child, was eight years of age when she was placed on a stool in the middle of her father's first glyptotek in front of the jewel in the collection, the Casali sarcophagus.

The little girl with the black-stockinged legs that fail to reach the floor is dressed in a demure dark velvet dress trimmed with white lace, enhanced by a modest amethyst brooch and a gold heart hanging around her neck. Her clasped hands correspond to a serious, somewhat dispirited face framed by shoulder-length straight hair carefully brushed behind her ears and kept in place by a yellow ribbon.

The contrast between Carl Jacobsen's daughter and his valuable collection of art is striking and strangely captivating. The main figure in the painting is a living child, but it is as though the lonely little figure has withdrawn into herself, oblivious to the works of art surrounding her. Placing the girl in the foreground of the painting interrupts most of the view of the late Antonine masterpiece in front of which she is sitting, but it does not reduce the viewer's awareness of the sumptuous decoration of the sarcophagus

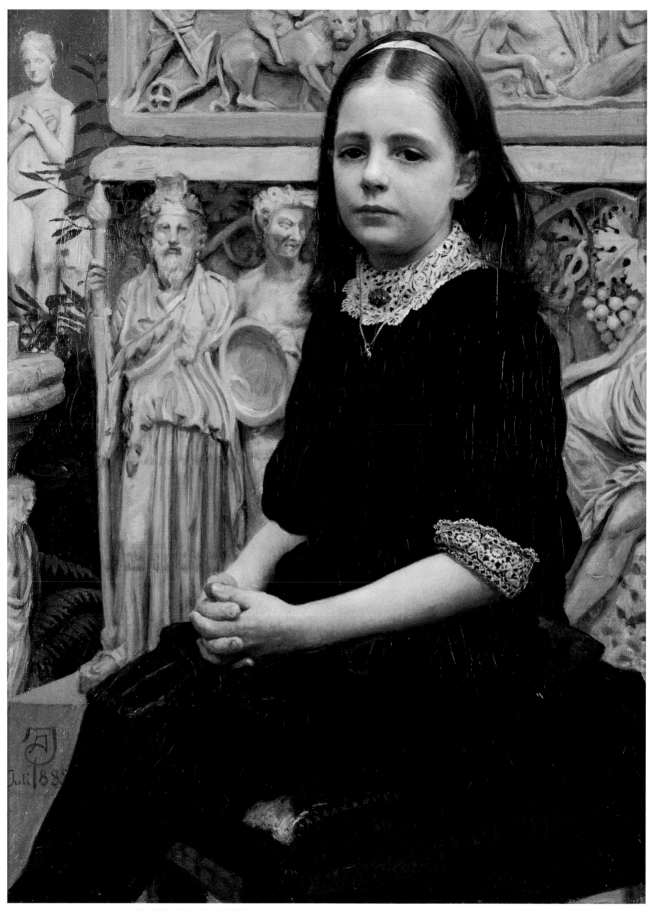

66. AUGUST JERNDORFF *Portrait of Theodora Jacobsen, Seated in the Ny Carlsberg Glyptotek, 1885*

which is very far removed from the world of Theodora's childhood. Voluptuous episodes from the wedding feast of the god of fertility Dionysus and the beautiful Ariadne decorate the heathen obsequies from a distant past.

The massive marble sarcophagus, created in the last quarter of the second century A.D., had been acquired two years previously by Carl Jacobsen from the Villa Casali in Rome. On the front we see Dionysus and Ariadne, seated on a rocky promontory flanked by naked satyrs and maenads in order to watch a wrestling match between Pan and a cupid. This many-figured scene has a host of symbol-laden cult accessories, including various musical instruments, several goats, and a dog. There are vines growing in the depths of this lifelike, action-packed scene, decoratively twining in and out among the figures.

Behind Theodora on the left side of the sarcophagus can be seen part of a bearded Dionysus holding a staff and a timpano, his hair entwined with ivy and bunches of grapes and a goatskin thrown over his long, flowing robe; the head of a satyr is seen to the left of the little girl's shoulder. Behind her we can glimpse the god Hermes' *kerykeion* (herald's staff) alongside a bunch of ripe grapes in addition to part of the bridegroom's half visible leg.

On the relief on the lid of the sarcophagus above the actual coffin, Dionysus can be seen standing on a chariot drawn by two panthers. On one side of the animals rides a lyre-playing cupid. The little group is moving toward the two main figures and constitutes part of the wedding festivities taking place in a rocky landscape dotted with trees. The painter has cut his picture at the top in such a way that the heads of the figures cannot be seen.

In a compositional sense, the heavy sarcophagus acts as a set piece added from the right in the middle distance of the painting, but the mammoth, relief-decorated marble creation does not quite reach the opposite edge. An ingenious perspective line allows us to see a little more of the winter garden with the displaced green plants, a smaller section of yet another antique fragment, and, at the very back and raised high up on an invisible plinth, we see H. W. Bissen's graceful plaster figure *Bathing Girl* against the background of an ochre wall.

At the age of twenty-three, Theodora Jacobsen (1877–1956) married the brewer Edgar Frederik Madsen, who later became a director of the Wibroe Breweries in Elsinore.

<div align="right">S.L.</div>

[1]*Glyptotek*: a collection of sculpture.

JENS JØRGENSEN JUEL

BALSLEV 1745 – COPENHAGEN 1802

Jens Juel is considered one of the most outstanding of Danish artists. The painter Hans Hansen (1769–1828), the father of Constantin Hansen, wrote of him in his diary, "If angels could paint, I scarcely think they could do it much better." Juel's portraiture stands comparison with the best in its age, but he is nevertheless still almost unknown outside Denmark, and little is known of his personality or his life.

Juel grew up in a modest home on the island of Funen, where his father was a schoolteacher. He was first taught to paint portraits with a master in Hamburg, where the dominant ideal was a sound and modest portrayal inspired by Dutch art. At the age of twenty, he continued in the Royal Danish Academy of Fine Arts in Copenhagen, where he became one of the talented young men who lived up to the expectations of an artistic training in Denmark.

The Academy was founded by the absolute monarch Frederik V in 1754, and French artists brought in for the purpose occupied posts as professors until the beginning of the 1770s. The demands made on composition by history painting did not come easily to Juel, and only in 1771 did he succeed in winning the final gold medal. During his time at the Academy, Juel received numerous commissions for portraits, the results of which reflect his development toward an ever greater sophistication in the use of materials and colors as well as composition. He learned chiaroscuro painting (which was still rococo) from the Swedish-born professor and court painter C. G. Pilos (1711–1793), but he learned more especially from the new French portrait art of his time, which he could study in the magnificent works resulting from the time Louis Tocqué (1696–1772) spent in Denmark in 1758–1759. Juel's most important work from this period is the portrait of the very young Queen Caroline Mathilde (1769), in Statens Museum for Kunst. She is dressed in a fur-edged turquoise silk dress, the color matching her eyes and forming a contrast to her skin, with its white porcelain quality.

On the basis of several years' support by a number of private patrons, Juel was given the opportunity to travel abroad to visit the major artistic centers of the time with their local masters and rich collections of art. He left Denmark in 1772, going first to Hamburg, then Dresden, and finally reaching Rome in 1774, where Pompeo Batoni's (1708–1787) full-length portraits were of great importance to him. In the autumn of 1776 he reached Paris, where he could see modern neoclassical portrait painting. Spring 1777 found him in Switzerland, where his art was so admired that for the next three years he was busily engaged in painting the portraits of the leading families in Geneva. In the best English manner, several of them show figures sitting in a park, for instance Mathilde de Prangin (1778–1779) and the envoy to the French court, Jean-Armand Tronchin (1779), both in Statens Museum for Kunst. By chance, he also here met the poet J. W. Goethe (1749–1832), whose face he drew.

After returning home in 1780, Juel became, in quick succession, court painter, a member of the Academy, and a professor there, and he now revealed his talent and his ability as Denmark's leading

portraitist. It is thanks to him that we today are so familiar with the appearance of so many members of the royal family, the aristocracy, and the middle class of the time.

Juel's production of paintings and pastels has been reckoned to total more than 800, and he employed several assistants in his studio. His paintings are nevertheless constantly characterized by their great variety and exuberance. In his time he was highly praised for his skill in creating a true likeness in his portraits. His attitude toward his models is always undemanding and is distinguished by a sympathetic approach without any desire to achieve a more profound psychological interpretation. This has given a later age the impression that Juel himself was unreflective, but the latest research has established that he was particularly interested in the Enlightenment philosophy of his time.

Even before his travels abroad, Juel had heard about J. J. Rousseau's (1712–1778) epoch-making thoughts on nature and his belief that children should be treated on the basis of their own abilities and aptitudes, ideas that around 1770 had been tested at the Danish court in the upbringing of the crown prince Frederik. Children begin to turn up in Juel's portraits from his time in Switzerland, where he also had his eyes opened to the landscape. Children are later pictured behaving in a natural manner more and more often in his art, quite often as the center of a conversation piece, the type of group portrait so popular in the 18th century. He himself had a large family with his wife Rosine. She was twenty-five years his junior, and in 1791 he produced a charming portrait of her sitting beside him in front of the easel (Statens Museum for Kunst).

Juel painted landscapes not only as backgrounds for his portraits but he also laid the foundation for true landscape art in Denmark. The area around Jægerspris (Egnen om Jægerspris (1782), *Statens Museum for Kunst, has recently been interpreted as expressing the spiritual aims of the order of Freemasons. Juel was himself a Mason, which in an absolutist society was not entirely without its problems in the period after the French Revolution. Perhaps this is the reason why Rosine burned all his letters and papers after his death.*

Jens Juel was in any case not particularly communicative, either in letters or in his teaching. This was a complaint of his students, including his two most famous ones, Casper David Friedrich (1774–1840), who attended the Royal Danish Academy 1794–1798, and Philipp Otto Runge (1777–1810), who studied there 1799–1801. Juel expressed himself elegantly and straightforwardly through his art, which became "the foundation for the flowering of Danish-Norwegian art that occurred in the 19th century with artists including C. W. Eckersberg and I.C. Dahl."[1]

E.F.

LITERATURE: Ellen Poulsen, *Jens Juels tegninger*, Den Kongelige Kobberstiksamling, 1975; Kasper Monrad, Jens Juel in *Danish Painting, The Golden Age*, National Gallery, London, 1984, pp. 74–85; Barbara Scott, The Danish Reynolds, Jens Juel (1745–1802) in *Apollo* no. 125, June 1987, pp. 411–415; Ellen Poulsen, *Jens Juel, Katalog*, I–II, Copenhagen 1991 (partly translated into English); Charlotte Christensen (ed.), *Hvis engle kunne male*, Det nationalhistoriske Museum på Frederiksborg Slot 1996 (containing texts by Charlotte Christensen, Hanne Lopdrup, Erik Westengaard, Jens Heinet Knudsen); Torben Holck Colding in *Weilbach*, vol. 4, Copenhagen 1996.

[1]Colding, 1996.

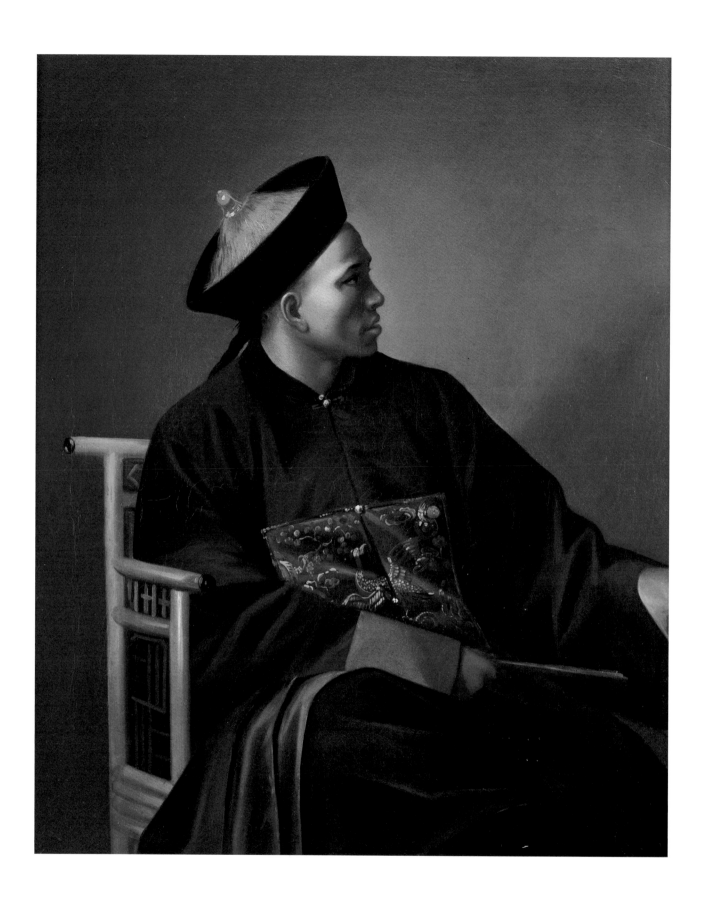

JENS JUEL
1745–1802

67. *Seated Chinese Man in Mandarin Dress,* c. 1780s
(En siddende kineser i mandarindragt)

Oil on canvas, 16½ x 13½ in. (42 x 34,5 cm)

PROVENANCE: Gift from artist to *materialforvalter* (storehouse manager) Jonas Eschemoës and wife, Louise Ulrike, friends of Juel; hofkirurg, etatsråd O.C.E. Schwartzkopf and wife (neé Hostrup-Schultz) Estate Auction 1893, no. 749, bought by cand. Larsen; Winkel & Magnussen, Auction 130 (Professor Karl Larsen), 1933, lot 245, ill. p. 41; Grosserer Aage Backhaus; Ms. Ellen Krøyer Christensen; Editor Svend Kragh-Jacobsen; Bruun Rasmussen, Auction 465, 1984, lot 1, ill. p. 10.

EXHIBITED: Kunstforeningen, *Jens Juel,* 1909, no. 228; Københavns Bymuseum, *Københavnsk kultur i det 18. århundrede,* 1966, no. 215, ill. plate XII; Kunstforeningen, *Jens Juel i privat eje,* 1982, no. 37; Busch-Reisinger Museum, Harvard University Art Museums, *Danish Paintings of the Nineteenth Century from the Collection of Ambassador John L. Loeb Jr.,* 1994, no. 13. 1994, no. 13; Bruce Museum of Art and Science, Greenwich, Connecticut, and The Frances Lehman Loeb Art Center, Vassar College, New York, *Danish Paintings of the Nineteenth Century from the Collection of Ambassador John L. Loeb Jr.,* 2005, no. 1, ill.; Scandinavia House, New York, *Danish Paintings from the Golden Age to the Modern Breakthrough, Selections from the Collection of Ambassador John L. Loeb Jr.,* 2013, no. 22.

LITERATURE: Herman Madsen, *Kunst i privat Eje,* I–III, Copenhagen, 1944–45, vol. II, p. 205, ill.; Herman Madsen, *200 Danske Malere og deres Værker,* I–II, Copenhagen, 1946, vol. 1, p. 40, ill.; Ellen Poulsen, *Jens Juel Katalog, Malerier og pasteller* (Catalogue, Paintings and Pastels), 1–2, Copenhagen, 1991, vol. 1, no. 263, ill., vol. 2, p. 198; Peter Nisbet, *Danish Paintings of the Nineteenth Century from the Collection of Ambassador John Loeb Jr.,* Busch-Reisinger Museum, Harvard University, Cambridge, Massachusetts, 1994, discussed and ill. p. 3; Patricia G. Berman, "Lines of Solitude, Circles of Alliance, Danish Painting in the Nineteenth Century" in *Danish Paintings of the Nineteenth Century from the Collection of Ambassador John L. Loeb Jr.,* Bruce Museum, 2005, p. 14; Patricia G. Berman, *In Another Light, Danish Painting in the Nineteenth Century,* New York, 2007, p. 27, ill. p. 26.

The Loeb picture has the elegant yet matter-of-fact realism for which Juel is renowned. Although not a commissioned portrait of an identifiable individual, it treats the exotic subject, a seated Chinese man in Mandarin dress, with dignified respect. Juel painted at least three versions of this subject. This version depicts the Chinese man in profile in a mandarin jacket with a blue lining, decorated with a blue silk embroidered front; he wears a black hat with a red point and holds a brown pipe. Even though the clothes and chair did not belong to the sitter, they were probably part of the export goods onboard the ships in the China trade in which Denmark was involved. Porcelain, dolls, decorated paper, and furniture were some of the most traded items in the Asiatic Company. Years later, in 1792, Juel made a drawing for P. A. Heiberg's play *The Chinatrader* which depicts a man giving such objects to his lover.[1]

The Loeb painting was given by the artist to a friend, an official of the Royal Asiatic Company active in China trade. This appropriate association is reinforced by an early inscription on the back of a larger version of this picture (now at the Georg-August University of Göttingen), which can be translated "A Chinese second helmsman on a Danish China clipper, which was partly crewed by Chinese. Painted from the life (but in Mandarin clothes) by the great portrait painter Jens Juel of Copenhagen." The picture thus attests both to Juel's skill and sensitivity, and also to the expanding horizons of the Danish commercial classes. It surely speaks also of an enlightened respect for human beings of other cultures.

B.H.

assisted by P.N.

[1]This drawing can be found in The Royal Danish Print Collection. Charlotte Christensen (ed.), *Hvis engle kunne male,* Det Nationalhistoriske Museum på Frederiksborg Slot 1996, p.158.

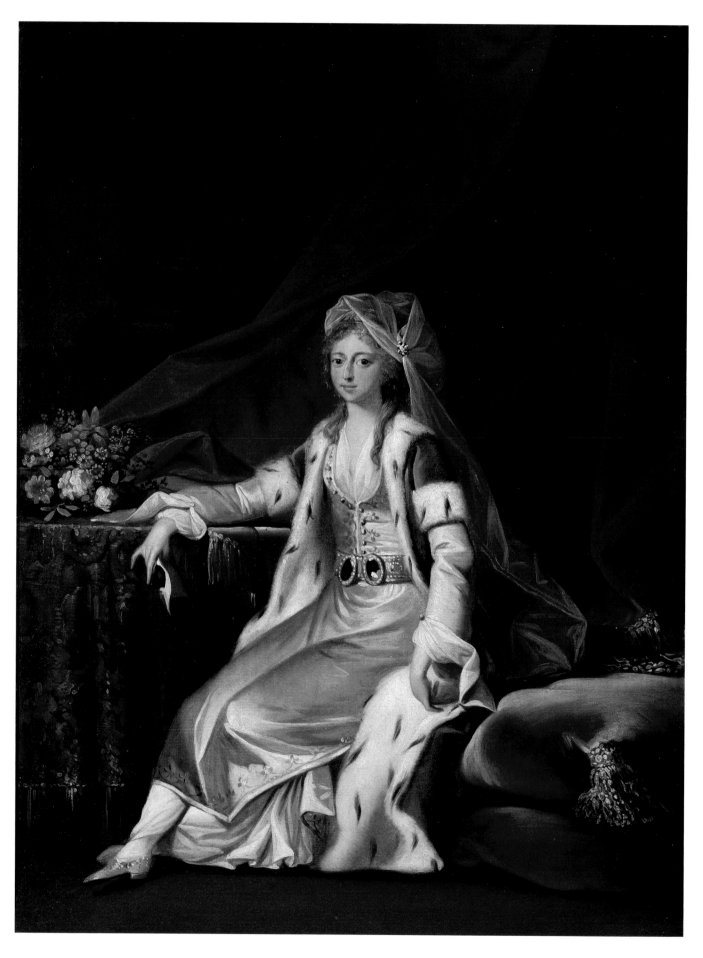

JENS JUEL
1745–1802

141. *Portrait of Princess Louise Augusta of Denmark in Turkish Dress* (1785–86)

(Portræt af prinsesse Louise Augusta i tyrkisk dragt)

Oil on canvas, 17¾ x 13⅓ in. (45 x 34 cm)

Not signed or inscribed

PROVENANCE: A Jutland manor house; Bruun Rasmussen, Auction 846, 2014, lot 12, ill.

LITERATURE: Ellen Poulsen, *Jens Juel. Katalog*, 1–2, Copenhagen 1991, no. 383, ill. in *Katalog*, vol. 2, p. 234; *Den store danske encyklopædi*.

During her lifetime, it was already known that Louise Augusta (1771–1843) was not the daughter of the King of Denmark, Christian VII (1749–1808), but a fruit of the liaison between the queen, the English-born Caroline Mathilde (1751–1775), and Johann Friedrich Struensee (1737–1772), personal physician to the king. Nevertheless, she was officially considered a Danish princess from birth. The king's power was absolute, but he was neither interested in nor able to rule the country because he suffered from schizophrenia. He was surrounded by courtiers, advisors, and ministers, all of whom vied for his power. The insecure king behaved erratically, even out in town. Hoping to mitigate these spectacles, his handlers expedited a marriage, which took place in 1766. Well more than a year later, Caroline Mathilde bore a successor, Frederik (1768–1839), who would become King Frederik VI.

In 1768, a physician named Struensee was engaged to escort the king on a several-month journey abroad, including visits to the French and English courts. By listening to the fantasies of the king and seeking to understand him, Struensee won his trust and was appointed to a modest position at the Danish court after their return. In 1770, the king invited Struensee to meet the queen, and the two speedily began a love affair. Contrary to previous court practice, Struensee became a part of the family. Among others, he dined with the king and queen in the evening, and the king began to function better in ruling the country. Struensee realized he could lose his power and position, so in 1771 he instituted a "cabinet rule," where decisions on matters of state no longer required the king's signature. With inspiration from French Enlightenment philosophers, he hastily initiated a radical reformation, during which the introduction of freedom of the press was the most controversial. After a masked ball in January 1772, Struensee was arrested, and in April convicted and executed for lèse-majesté (treason). The miserable queen was exiled and never again saw her children. Princess Augusta grew up without her mother and became closely attached to her brother Frederik. She was both painted and drawn, right from birth. Juel's first portrait of her is from 1784 (Royal Collection, London), and he painted her frequently after that.

This full-length portrait of the princess in Turkish attire is from 1785–1786 according to biographer, Ellen Poulsen. It is one of a number of almost identical paintings in the same size. At masquerades in the European royal houses and on the theater stage, "the Turk" had become a recurrent character from the beginning of the 1700s, easily recognized by moustaches, turbans, and balloon pants.[1] A masquerade participant with turban can be seen in a grand ceiling painting at Frederiksberg Castle, just outside of

Copenhagen. The remarkable painting is an expression of the Western fascination with the exotic. It also characterizes the work of the Danish artist Melchior Lorck (1526/27–1583), who traveled in Turkey (1555–1559) with an ambassadorial group from the Holy Roman Empire and brought home a great many drawings of Turkish architecture, military, attires, and tombs that would provide designs for graphic prints. At that time the expanding Muslim Ottoman Empire, with its capital in Istanbul, was a force feared in Europe, where Muslims were considered a threat to Christianity. In 1529, Sultan Suleiman the Magnificent (1494/95–1566) lay siege to Vienna, and in 1683, the city was again in danger of being conquered. Wars with Turkey continued in the 1700s, but gradually the threat to Europe weakened, and the Turkish influence became safe and considered merely an exotic element.

Portraits of Europeans in Turkish costumes are seen in the 1600s, and especially in the 1700s, in several European countries. Around 1700, the Turk appears in plays performed by the Italian troupes in France, among other places, e.g., *Harlequin grand vizier* (1688). An embassy from the Ottoman Empire to France (1720–1721) gave new inspiration to the theater, which is reflected in paintings by Antoine Watteau (1684–1721). In 1733, Voltaire (1694–1778) wrote his Eastern tragedy *Zaïre*, which was performed in Copenhagen in 1767 on the king's order and ran for several seasons. Christian VII himself played the main character at several performances at the Court Theatre of Christiansborg Castle. He also performed in Turkish attire in a carrousel, a tournament held during his brother-in-law Prince William's visit to Copenhagen in 1769.

Turkish music in Western Europe also inspired the great composers of the time, among them C. W. Gluck (1714–1787) and W. A. Mozart (1756–1791). It was music of the Turkish elite soldiers, the Janissaries, and their use of timpani, drums, and wind instruments that made up the era's new music, which became known as "alla turca." Several operas with Turkish themes were performed in Copenhagen, some at the Court Theatre, some at the Royal Theatre. The mother of Christian VII, the English-born Queen Louise, had been a student of G. F. Händel (1685–1759) and became fond of operas; she promoted this art form in Copenhagen, and her interest was passed on to her son. In the 1770s and the 1780s, the play *Suleyman II* was performed, from which there exist drawings by Peter Cramer (1726–1782) showing the actors in Turkish costumes. There is also a portrait by Jens Juel depicting Marie Cathrine Preisler (1761–1797) playing the part of Roxelane (Ellen Poulsen no. 241). Additionally, in 1776, Willibald Gluck's *La rencontre imprévue*, from 1764, which also has elements of Turkish music, was performed. It was in the same period that the Danish explorer Carsten Niebuhr (1733–1815) published accounts from his travels in Arabia and surrounding countries. Turkey was in vogue.

It is in this context that the portrait of the princess in Turkish attire should be seen. She is painted in full figure, wearing a yellow silk dress that is open at the sides, with a close-fitting buttoned bodice and a thin white petticoat. At her waist she wears a belt adorned with two blue medallions on the buckle. Over all is a short-sleeved blue velvet coat with an ermine lining. Below her ankles, which are crossed, she wears flat, pointed gold shoes. She wears a tiara, and over this, a gauzy turbanlike veil fastened with a brooch that may be set with diamonds. In her right hand she holds a mask. She sits by a table holding an exquisite bouquet of flowers—a decorative touch typical of Juel.

In the rest of Europe, it had long been common to paint the noble ladies of the time in this kind of apparel, though most often wearing balloon pants. According to the Danish costume researcher Ellen

Andersen, the style was called circassienne, which is a traditional folk costume from Circassia in Caucasus.[2] Among the most well-known are Carle van Loo's (1705–1765) two paintings of the mistress of the French king Louis XV, Marquise de Pompadour (1721–1764), in Turkish apparel from 1754. We do not know if Jens Juel was familiar with them, but copper-engraved replicas of them circulated under the titles "La Sultane" ("The Sultana") and "La Confidente" ("The Confidante"). They were painted as overdoors in her bedroom, decorated in Turkish style at Château de Bellevue, which the king had built for her just outside of Paris, and the interior is depicted in the paintings. One of them shows Pompadour taking a cup of coffee, brought to her by a black female slave. The other shows her sitting on a low divan by her embroidery, conversing with a friend who is likewise in Turkish attire.[3] It was more comfortable than the laced corsets of the rococo era and was featured in the fashion journals of the time.

During his studying trip, Jens Juel copied a painting of a lady in Turkish attire (Ellen Poulsen no. 156) by the Italian Pietro Longhi (1701–1785). During his stay in Geneva late in the 1770s, he painted portraits of ladies in similar costumes: *Jeanny Françoise Turrettini, née Boissier* (1777, Ellen Poulsen, no. 177), *Suzanne de la Rive, née Tronchin* (1777, Ellen Poulsen no. 166 and 167), and *Jacqueline H.E. Sénebier, née Morsler* (1778, Ellen Poulsen no. 177). In Geneva, the Turkish was especially topical, as Jean-Étienne Liotard (1702–1789), called "the Turkish painter," in 1776 had returned to his hometown after a career with several European princely houses. He had lived in Constantinople (Istanbul, 1738–42), painting and drawing the unfamiliar apparel and interiors. When he returned to Europe, he continued to wear Turkish attire and even grew a long beard, quite unfashionable at the time. Liotard was known for his portraits of Europeans in Turkish costumes; in 1753, while a French court painter, he painted Madame Adelaïde de France (1732–1800), daughter of Louis XV. In Geneva, Jens Juel had the opportunity of seeing Liotard's works.

Princess Louise Augusta sits beside large red velvet pillows at her left, and on her right, a European-height table with a heavy Asian covering. The fur-adorned coat, the belt with medallions, and the mask echo portraits of many of European ladies. Despite being small, the painting is a typical royal portrait, with traditional set pieces, heavy drapery, and a background of impressive columns.

However, the composition was not originated by Jens Juel. There exist an aquarelle drawing (National Gallery of Denmark, inv.no. 12753) (Fig. B) and a similar miniature (Rosenborg Castle, inv.no. 19-161) by Cornelius Høyer (1741–1804) that both depict the sister of Christian VII, Princess Louise of Denmark (1750–1831), married to Carl, Landgrave of Hessen-Kassel (1744–1836) in Turkish attire with balloon pants. She too sits with a mask in her hand by a table with a flower bouquet, and in the background a drapery is seen. Jens Juel most likely did not know the works of Cornelius Høyer, which were painted in 1772 at Gottorp Castle in Schleswig, where the princess lived with her consort. Juel was still abroad when the miniature was displayed at the Salon at Charlottenborg in 1778. One must therefore conclude that the compositions of Jens Juel and Cornelius Høyer must have come from an older design.

The portrait of Louise Augusta in Turkish attire is known in two versions:

I. The painting described by Ellen Poulsen (no. 383, fig. A).

II. The painting in the Loeb collection that exists in more replicas, as is common for the work of portrait painters such as Jens Juel. They are listed below.

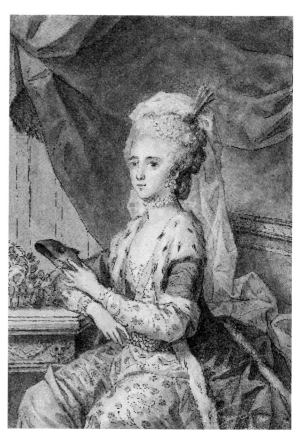

FIG. A *Princess Louise Augusta of Denmark
in a Turkish Dress* (1785–86)
Oil on canvas, 17½ x 13 in. (44.5 x 33 cm)
Not signed
Private collection
Ellen Poulsen no. 383

FIG. B Cornelius Høyer (1741–1804)
Princess Louise of Denmark in a Turkish Dress, 1772
Indian ink and watercolor, 5¼ x 3¾ in. (134 x 94 mm)
Statens Museum for Kunst, Department of Prints
and Drawings

Ellen Poulsen, however, does not account for the difference between the two. In her catalogue (no. 383), the composition is identical to the Loeb collection picture, apart from the fact that the princess sits on European furniture, a gilded neoclassical bench on which a small red pillow with a golden tassel lies. Her silk dress has a high waist with a draped bodice, and the belt with red and blue decoration on the buckle is placed just below her bosom. Her shoes are red, and the thin, white veil over her hair is fastened with a golden ribbon.

The Loeb collection's painting (II. 1) is very similar to another (II. 2), except that the position of the head and the expression of the face are a bit different. None of these is identical with no. II. 3, II. 4, II. 5, or II. 6. Ellen Poulsen refers to no. II. 4 and mentions several other replicas, but as her pieces of information are fragmentary and no photographs exist, it cannot be determined whether or not they are identical to any of the remaining in the listing below:

I. 1. Ellen Poulsen, 1991, no. 383 (Fig. A). Oil on canvas, 17½ x 13 in. (44.5 x 33 cm). Not signed. In 1991 owned by a member of the Wolffhagen family, Denmark.

264]

II. 1. Oil on canvas, 17¾ x 13 in. (45 x 34 cm). Not signed. Bruun Rasmussen, Auction 846, 2014, lot 12, ill. Provenance: a Jutland manor house. Loeb collection no. 141.

II. 2. Oil on canvas, 17¾ x 13 in. (45 x 34 cm). Not signed. Bruun Rasmussen, Auction 850, 2014, lot 26, ill. Provenance: a Danish estate since the 1850s. Unknown private owner.

II. 3. Oil on canvas, 17¼ x 13¾ in. (44 x 35 cm). Not signed. Arne Bruun Rasmussen, Auction 208, 1967, lot 148, ill. p. 25. Unknown private owner.

II. 4. Oil on canvas, 17½ x 13¼ in. (44.5 x 33.5 cm). Not signed. Provenance: Henrik Valdemar Nørgaard (1869–1931), owner of the estate Rye Nørskov; Auction Henrik Nørgaard, II, 1931, lot 1836 (no measurements); 1944 industrialist Knud Neye (1885–1945); Arne Bruun Rasmussen, Auction 409, 1980, lot 4, ill.; purchased by Schleswig-Holsteinisches Landesmuseum, Gottorp (inv. no. 1980-349).

II. 5. Oil on canvas, 17¾ x 13¾ in. (45 x 35 cm). Kunsthallen, Auction 307, 1974, lot 96 (ill. p. 13). In the auction catalogue, the provenance is mistakenly registered as Knud Neye, whose painting (II. 4) was not sold until 1980.

II. 6. Oil on canvas, 16½ x 13½ in. (41.8 x 34.6 cm). Not signed. Provenance: antique dealer Albert Petersen, Copenhagen. Purchased from him in 1904 by the Museum of National History Frederiksborg (inv.no. A 1725). Not in Ellen Poulsen 1991. It seems to be a copy rather than a work by Jens Juel.

E. F.

[1]Maria Elisabeth Pape, *Die Turquerie in der bildenden Kunst des 18. Jahrhunderts,* Köln 1987; Nicholas Tromans, *The Lure of the East,* London 2008; Bent Holm, *The Taming of the Turk. Ottomans in the Danish Stage,* Copenhagen 2011 (Danish edition Copenhagen 2010), upon which our information concerning European fascination with anything Turkish is based.

[2]Ellen Andersen, *Moden i 1700-årene,* Copenhagen 1977, pp. 196–197. Circassia, which in the 1700s was a part of the Osman Empire, is today a part of Russia.

[3]Most of the palace is torn down, and the aforementioned paintings were purchased by Empress Catherine the Great of Russia at the end of the 1700s and exist today in The State Hermitage Museum, St. Petersburg.

FREDERIK CHRISTIAN JACOBSEN KIÆRSKOU (KIÆRSCHOU)

COPENHAGEN 1805 – COPENHAGEN 1891

F. C. Kiærskou, whose father was a police court copy clerk, lost his parents at an early age, after which he became a pupil in the Royal Orphanage School, an institution founded by Frederik IV in 1727 to support children whose fathers had died. Because young Frederik Christian showed a talent for drawing even as a child, the principal of the orphanage ensured that he was given a place in the Royal Danish Academy of Fine Arts School of Drawing in 1820. Here, J. P. Møller advised that the boy should learn decorative painting before thinking of becoming a landscape artist.

Kiærskou's training thus took more than ten years in the traditional classes in the Academy. At the same time, he was apprenticed for three years to a master painter by the name of Rasmussen, after which he worked for five years as a decorative painter in a firm called Hambros Enke.

In 1832, F. C. Kiærskou won the Academy's proxime accessit *in landscape art, and the following year he was awarded the money prize for* Et parti træer i Classens have (A Group of Trees in Classens Have). *In time he also received travel grants from sources including Fonden ad Usus Publicos, which enabled him to undertake an extended study visit to Germany and Switzerland at the beginning of the 1840s. He also visited Sweden several times.*

Kiærskou was accorded recognition by the Royal Danish Academy of Fine Arts in Copenhagen in 1843 and became a member in 1845. Three years later he was appointed a member of the Academy of Fine Arts in Stockholm. In 1859 he became a titular professor in the Danish Academy, and eight years later he was given an official residence at Charlottenborg.

Kiærskou left a very large oeuvre (mainly of landscape motifs), equally distributed among Denmark and the mountainous regions of southern Germany, Austria, and Switzerland as well as a number of Swedish localities. He made his debut at Charlottenborg in 1826 and exhibited there almost every year, often showing large numbers of works until 1882.

F. C. Kiærskou worked in the same landscape tradition as the trio of J. Th. Lundbye, P. C. Skovgaard, and D. Dreyer (1816–1852), as well as the contemporary but rather later developed Vilhelm Kyhn. In contrast to these, however, Kiærskou was so firmly anchored in the classic international painting metaphor based on older copperplate engravings rather than outdoor studies that he never managed to acquire the vibrant view of nature that characterized the works of his younger colleagues. Nor can Kiærskou's works be said to be typically national romantic, although many of the motifs were Danish.

With his predilection for lighting in the manner of Claude Lorrain (c. 1600–1682), he was closely related to J. P. Møller's landscape art. But there is nothing to suggest that he was ever a pupil of Møller, who, like Kiærskou, occupied an important post as conservator.

S.L.

LITERATURE: Henrik Bramsen, *Landskabsmaleriet i Danmark 1750–1875*, Copenhagen 1935, pp. 89–90; Laura Jacobsen, *Søllerød, set med malerøje*, Copenhagen 1983; Peter Nørgaard Larsen in *Weilbach*, vol. 4, Copenhagen 1996.

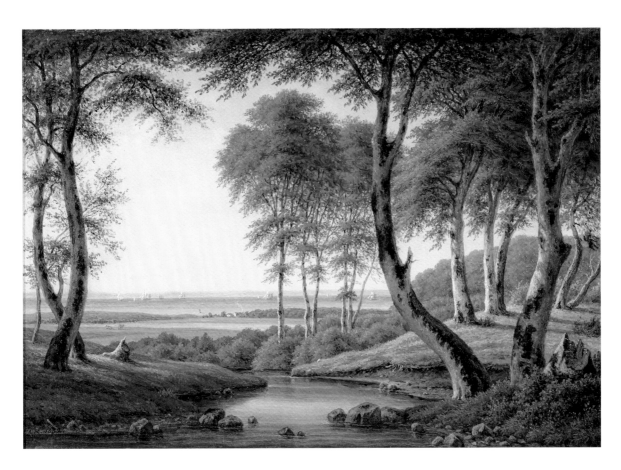

F. C. KIÆRSKOU
1805–1891

68. *View from Dyrehaven over the Sound to the Outflow of Mølleåen, 1882*

(Udsigt fra Dyrehaven over Sundet ved Mølleåens udløb)

Oil on canvas, 11¾ x 16½ in. (30 x 42 cm)

Signed with initials and dated lower left: FCK 1882

PROVENANCE: Direktør Carljohan Stæhr; Bruun Rasmussen, Auction 526, 1989, lot 276.

Although Frederik Christian Jacobsen Kiærskou was a pupil of both C. W. Eckersberg and J. L. Lund (1777–1867), there is no trace of Eckersberg's teaching in his pictures. This artist's motifs consist in the main of Danish and Swiss landscapes. According to Bramsen, in the first of these categories we most frequently find broad views combining forest and flat countryside, composed according to specific patterns left by Claude Lorrain.

"Among them there is especially one that shows an oblique view into the space between two groups of trees at an unequal distance from the foreground, which is usually formed by sloping terrain formations."[1]

This description applies not least to the painting in the Loeb collection, where the direction of the view and the depth of space are further underlined by the meandering course of the Mølleå stream and the bluish appearance of the Sound. S.L.

[1] Henrik Bramsen, *Landskabsmaleriet i Danmark 1750–1875,* Copenhagen 1935, p. 89.

PEDER SEVERIN KRØYER

STAVANGER 1851 – SKAGEN 1909

P. S. Krøyer was the most successful painter of his generation. As a child he demonstrated such a convincing talent that when he was fourteen he started at the Royal Danish Academy of Fine Arts and took the final examination there five years later. For some years he successfully painted portraits and pictures of everyday life in Arild, Sweden, and Hornbæk at the north coast of Zealand; he then decided to undertake training abroad.

Among the young artists of the day there was a growing sense of dissatisfaction. The Royal Danish Academy of Fine Arts still taught along the lines laid down many years before by C. W. Eckersberg, who refused to allow young artists contact with modern German or French art. While nationalism was at its height, the crucial aim was to protect Danish art against foreign influences, which were considered harmful. But the desire for fresh approaches persuaded the young artists to make for France. Krøyer became a pupil of Léon Bonnat (1833–1922) and learned to work in a completely new way with regard to the total concept of motif; he absorbed the modern French art of the day, both the academic Salon art and the naturalism soberly portraying the countryside, the city, or the working population.

Awarded the bronze medal from the Paris Salon in 1881, Krøyer experienced his international breakthrough with Italienske landsbyhattemagere (Italian Village Hatters). *In Copenhagen, the painting created a storm of indignation on account of its uninhibited realism. Krøyer was regarded as revolutionary, and he confirmed that reputation while teaching in De frie Studieskoler. But neither his skill nor his charm could be denied, and it was not long before the artists of the Breakthrough triumphed over the outdated Academy of Fine Arts. On the basis of a number of large and splendidly executed commissions, Krøyer went from success to success, given demanding commissions that brought great honor to him. In 1888, together with Laurits Tuxen, he arranged an exhibition of French art in Copenhagen for the brewer Carl Jacobsen (1842–1914) of the Carlsberg Breweries.*

Krøyer discovered Skagen in 1882, after which he devoted his summers to motifs that Michael Ancher had hitherto had to himself. In contrast to Ancher, Krøyer was an extrovert, a painter who sought company and who liked painting in the company of others. Many other Scandinavian plein air painters flocked to Skagen, which changed the character of the area completely, now being characterized by parties and discussions at Brøndum's Hotel. For Krøyer, the important feature was the painterly aspect, and so there were no social attitudes behind his choice of motifs. During the 1880's, he discovered a field that was to occupy him constantly, the portrayal of the light on Nordic summer evenings and nights, done in shades of blue. He painted Fiskere på Skagens Strand, 1883 (Fishermen on Skagen Beach, *Statens Museum for Kunst) and* Fiskere går ud på nattefiskeri, 1884 (Fishing by Night, *Musée d'Orsay, Paris). In the 1890s, he produced a series of atmospheric romantic paintings in which his wife Marie was his central motif; these are his most charming and today*

his most popular group of motifs. They include Sommeraften ved Skagens Sønderstrand, 1893 (Summer Evening on Skagen Sønderstrand, *Skagens Museum*) portraying Marie and Anna Ancher walking along the shore. These paintings can be seen as a typical manifestation of the decade of symbolism but were probably especially due to inspiration from James McNeill Whistler (1834–1903).

Krøyer reached the pinnacle of happiness in 1889 when he married Marie Triepcke, a much-feted beauty sixteen years his junior, who was herself training to be a painter. In 1891 they set up their first summer residence in Skagen Vesterby, well away from the artists' colony. The rose garden, which Krøyer painted, and their second house, which they themselves arranged and decorated under the influence of the English arts and crafts movement and the periodical The Studio, are known from the beautiful photographs Krøyer took with a large-format French camera he had bought in 1885. Krøyer was receptive to everything new and, like many of the artists of the day, made use of the photograph as an alternative to the sketchbook. Meanwhile, his photographs show that he was also able to use photography as an independent creative medium.

While Krøyer continued to enjoy success with large commissions in Copenhagen, Marie never managed an artistic career and preferred to live in isolation in Skagen. Within a few years of their marriage, her difficult nature made for complications in Krøyer's life. Also, he began to suffer attacks of illness, the source and nature of which have still not been fully explained but which are traditionally attributed to some venereal disease. In 1905, Marie left him and their daughter.

In 1906 he completed Skt. Hansblus på Skagens Strand (Midsummer Bonfire on the Beach at Skagen, *Skagens Museum*) showing the group of artists gathered around watching. Ill and broken, Krøyer died in Skagen in 1909 at the age of only fifty-eight, surrounded by loyal friends, including Michael and Anna Ancher. The romantic and tragic story of Krøyer's marriage has in recent years led to biographies, films, and a stage play.

E.F.

LITERATURE: Elisabeth Fabritius, P.S. Krøyer's Photographs in M. Saabye (ed.): *P.S. Krøyer's Photographs*, Den Hirschsprungske Samling, Copenhagen 1990, pp. 141–170; Peter Nisbet, *Danish Painting of the Nineteenth Century from the Collection of Ambassador John L. Loeb Jr., Harvard University Art Museums Gallery Series, No. 8*, Cambridge, Massachusetts, 1994, pp. 11–12; Elisabeth Fabritius in *Weilbach*, vol. 4, Copenhagen 1996; B. Scavenius (ed.): *Krøyer and the Artists' Colony at Skagen*, National Gallery of Ireland, Dublin 1997 (including texts by Claus Olsen, Bente Scavenius, Marianne Saabye, Annette Johansen, Elisabeth Fabritius); Annette Johansen (ed.), *Harmony in Blue*, Skagens Museum 2001 (including texts by Annette Johansen, Mette Bøgh Jensen, Claus Olsen, Gertrud Oelsner Hansen, Guénola Stork, Håkon Wettre); Peter Michael Hornung, *P.S. Krøyer*, Copenhagen 2002; Marianne Saabye, Katrine Halkier (eds.), *Krøyer i internationalt lys*, Den Hirschsprungske Samling, Copenhagen 2011 (texts by the editors and Jan Gorm Madsen, Mette Bøgh Jensen, Anna Schram Veilby, Lisette Vind Ebbesen, Jesper Svenningsen).

P. S. KRØYER
1851–1909

70. *Study of a Woman from Arildsläge in Sweden in Festive Dress,* 1872

(Studie af en kvinde fra Arildsläge i højtidsdragt)

Oil on canvas, 10¼ x 7¾ in. (26 x 20 cm)

PROVENANCE: Bruun Rasmussen, Auction 465, 1984, lot 60 (described as *Svensk bondekone i kirkedragt*).

EXHIBITED: Busch-Reisinger Museum, Harvard University Art Museums, *Danish Paintings of the Nineteenth Century from the Collection of Ambassador John Loeb Jr.*, 1994, no. 15.

LITERATURE: Probably H. Chr. Christensen, *Fortegnelse over P.S. Krøyers Oliemalerier*, Copenhagen 1923, no. 61 (27 x 23 cm/10½ x 9 in.); Margareta Ramsay (ed.): *Konstnärerna hos Mor Cilla. Nordiska målare i Arildsläge 1856–1913*, Hälsingborg 1987, Krapperup Museums skriftserie no. 4 (on the artists' colony at Arild); Peter Nisbet, *Danish Paintings of the Nineteenth Century from the Collection of Ambassador John Loeb Jr.*, Busch-Reisinger Museum, Harvard University, Cambridge, Massachusetts, 1994, pp. 10–12.

The young Danish figure painters of the 1870s spent summers studying in the open and hunting for motifs, and ever since the Golden Age the preferred subjects of artists had been the ordinary people of the country districts. The painters took lodgings in country villages and fishing villages, filling their portfolios with detailed studies of the local models, dresses, articles of everyday use, houses, and surroundings. On the basis of these, the artists then spent the winter in their studios painting one or more large compositions intended for exhibition and sale. The painters who could exhibit motifs from regions unfamiliar to their public could be sure of attracting attention.

In the summer of 1872, a couple of years after completing his studies in the Royal Danish Academy of Fine Arts, Krøyer settled for a time at Arildsläge on Kullen, the mountainous peninsula in Sweden located at the northern extremity of the Sound. It was a spot that had attracted both Danish and Swedish artists since about 1830; for instance, F. C. Kiærskou had painted Kullen as seen from the sea, and in 1860 and over the following years, the marine artist Carl Bille (1833–1895) worked in Mölle and C. F. Sørensen (1818–1879) in Arild, a place known for shipbuilding and shipping. The artists appreciated both the picturesque mixture of buildings and scenery and the untouched countryside. It was especially the Kullen massif,[1] with its dramatic differences in height, that tempted the Danish artists, who at home had to look hard for anything but gentle hills and flat, cultivated fields. It is not far from the Danish capital to Kullen via Elsinore and Helsingborg.

In Arildsläge, Krøyer painted a series of somewhat similar pictures of men and women from the local population, one of which was the present work, which is not registered by H. Chr. Christensen in his catalogue of Krøyer's oil paintings. The characteristic headgear forms part of the local costume from Lugguda on Kullen, a festive dress that was, and still is, worn on Sundays and holy days and at parties. However, no major finished figure pictures by Krøyer are known from Arild. He did not complete paintings of this kind until he visited Hornbæk, where he worked during the following summers.

Arild was an artists' colony, and it is quite undeserved that it should not be known in the same way as Skagen and other colonies from the same time in Scandinavia, Britain, and France. As in Skagen, there was a hospitable inn at Arild, run since 1856 by "Mor Cilla" (Cecilia Andersson), in which painters and authors

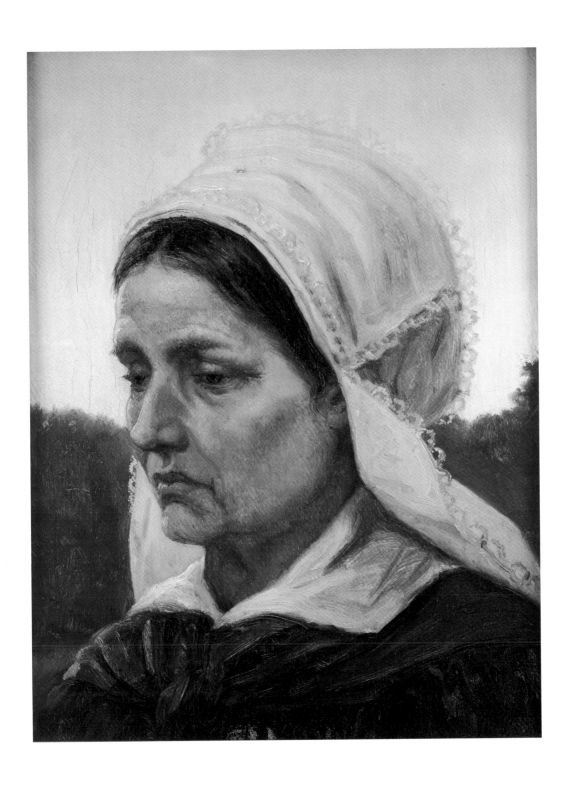

congregated and inspired each other. In the 1890s there was even art instruction arranged in conjunction with the inn. At the end of the 19th century the place was visited by important Swedish painters such as Carl Skånberg (1850–1883), Richard Bergh (1858–1919), and Gustaf Rydberg (1835–1933). Krøyer visited Arild again in 1881 and 1895, when he was a guest of Bernhard Middelboe (1850–1931), who, like August Jerndorff, had his own house there and thus was permanently associated with Kullen.

E.F.

[1] A principal mountain mass.

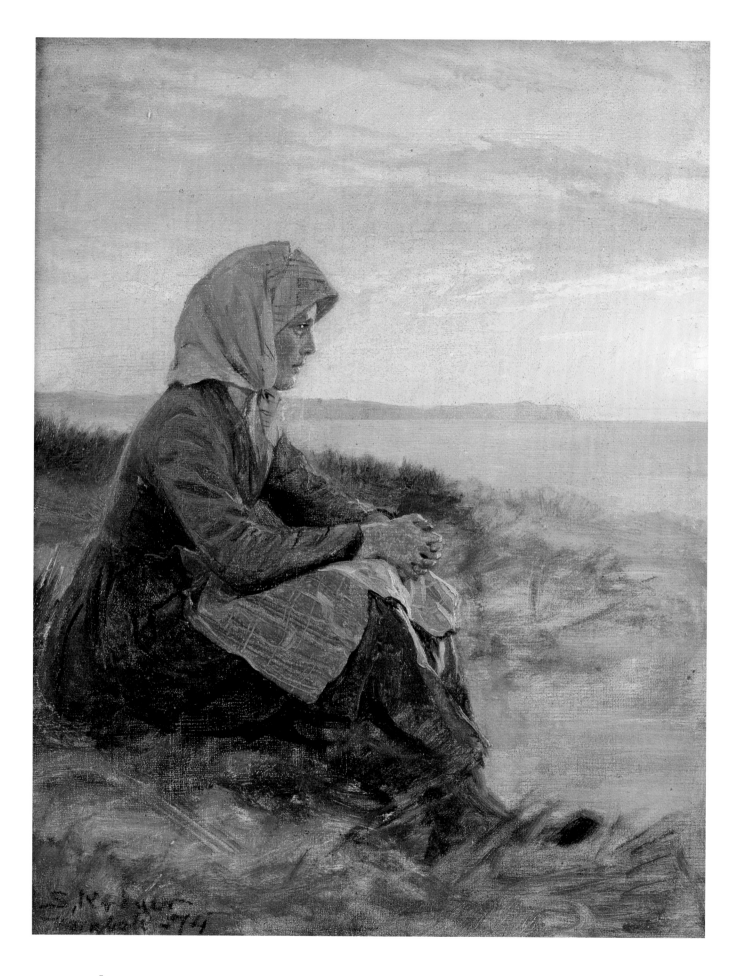

272]

P. S. KRØYER
1851–1909

71. *Seated Fisherman's Daughter*, Hornbæk 1874
(Siddende fiskerpige, Hornbæk)

Oil on canvas, 11¾ x 9¾ in. (30 x 25 cm)

Signed bottom left: S. Krøyer Hornbæk –74

PROVENANCE: Overretssagfører L. Zeuthen, Copenhagen; Bruun Rasmussen, Auction 688, 2000, lot 1467, ill.

EXHIBITED: Charlottenborg, *P.S. Krøyer*, 1910, no. 47 (owner: overretssagfører L. Zeuthen).

LITERATURE: H. Chr. Christensen, *Fortegnelse over P.S. Krøyers Oliebilleder*, Copenhagen 1923, no. 110 (described as *Siddende Fiskerpige, 1874*, L. Zeuthen).

In the 1870s, Hornbæk on the north coast of Zealand attracted a number of young painters, not only marine artists such as Holger Drachmann (1846–1908) and Carl Locher but also Academy students from the life school, who at this time still came to study the local population with a view to painting large genre paintings and paintings of everyday life. They congregated there during the summer and formed an artists' colony in which they inspired each other as they painted the countryside and the people at work or busy at home.

P. S. Krøyer had worked at Kullen in Sweden in 1872, but in 1873 he chose Hornbæk, where he returned during the ensuing summers and painted a number of studies of the fishermen and their families, young and old. In 1873, he started on the preparatory work for an interior of the local smithy; this led to a finished composition that he exhibited at Charlottenborg in 1875, which now belongs to the Hirschsprung collection. That summer he finished a larger, ambitious composition, *Morgen i Hornbæk, fiskerne kommer i land (Morning in Hornbæk, the Fisherman Come Ashore)*,[1] which was exhibited in 1876 and is also part of the Hirschsprung collection. There are several other large-scale works resulting from Krøyer's visits to Hornbæk, painted before he defied those determining the art policy of the time and before leaving for France to continue his training.

This little study of a fisherman's daughter sitting in one of the dunes near the shore gives an excellent impression of the beautiful landscape that attracted the artists. She is enjoying the late light of a summer evening, the Danish sky sometimes being lit up by the setting sun in shades of pale blue turquoise, lilac, or rose as far into the night as 10:00 p.m. In the background, we can see the coast stretching west toward Gilleleje. The study is more carefully finished than normal, though this does not apply to every part of it. The entire foreground, with the light tufts of lyme grass, is still only at a rudimentary stage, painted in cold, quite dark colors. In a coloristic sense it also forms a contrast to the choice of warm colors characteristic of the rest of the picture and creates a splendid impression of the special light of the north. On the other hand, the girl herself, the surface of the water, the sky with its clouds, and the coastline are elegantly finished, with fine clear patches of light. The study gives a good impression of Krøyer's talent at this early stage of his life.

E.F.

LITERATURE (on the artists' colony at Hornbæk): Kai Flor, *Hornbæk*, Copenhagen 1940; Mona Faye, *Hornbæk i kunsten*, Marienlyst, Elsinore 1997.

[1] Illustrated no. 82, Fig. A.

72. *Portrait of the Artist's Wife Marie* (presumably 1889)

(Kunstnerens hustru Marie)

Oil on canvas, 16 x 13 in. (41 x 33 cm)

PROVENANCE: Auction, the artist's estate, Charlottenborg 1910, lot 116 (described as *1890, Dameportræt, Brystbillede en face*), purchased by Henriksen, Brolæggerstræde 8, Copenhagen (700 kroner); purchased by Ny Carlsberg Glyptotek, inventoried 16.9.1910 [possibly erroneously for 1911] (900 kr), inventory no. 1768; loaned 1930 to Skagens Museum, returned to Ny Carlsberg Glyptotek 13.5.1943; Winkel & Magnussen, Auction 301, 1943, lot 113, ill. p. 45; Hjalmar Bruhn, shipbroker; according to E. Brünniche, owned by Finn Brodersen, presumably after 1952; Arne Bruun Rasmussen, Auction 71, 1956, lot 129, ill. p. 82; Bruun Rasmussen, Auction 679, 2000, lot 262, ill. p. 123; Bruun Rasmussen, Auction 688, 2000, lot 1474, ill. p. 145.

EXHIBITED: Den Frie Udstilling 1891, no. 27 (described as *Portræt)*; Charlottenborg, *P.S. Krøyer*, 1910, no. 187 (the artist's estate, described as *1890. Fru Maria Krøyer, Brystbillede en face*); Charlottenborg, *P.S. Krøyer*, 1951, no. 152 (described as *Portræt af kunstnerens hustru, brystbillede en face, leende)*, owner Hjalmar Bruhn; Kunstforeningen, Copenhagen, *P.S. Krøyer*, 1980, no. 40, ill. on cover; Modum Blaafarveværk, Norway, *P.S. Krøyer*, 1992, no. 55, ill. p. 59; Aarhus Kunstmuseum, *Tradition, modernitet, P.S. Krøyer*, 1992–93, no. 60, ill. p. 85; Gammel Holtegaard and Skagens Museum, *Portrætter fra et ægteskab, Marie og P.S. Krøyer*, 1997, no. 37, ill. p. 45; Den Hirschsprungske Samling, Copenhagen, *Krøyer i internationalt lys*, 2011, no. 90, ill.; Scandinavia House, New York, *Danish Paintings from the Golden Age to the Modern Breakthrough, Selections from the Collection of Ambassador John L. Loeb Jr.*, 2013, no. 24.

LITERATURE: Ny Carlsberg Glyptotek, *Katalog moderne Samling* 1916, no. 837; 1927, no. 807; 1936, no. 807; H. Chr. Christensen, *Fortegnelse over P.S. Krøyers Oliebilleder*, Copenhagen 1923, no. 428 (described as *1890, Kunstnerens Hustru, Fru Maria Krøyer. Brystbillede en face. D.f.U. 1891. A 116 for 700 Kr. til Ny Carlsberg Glyptotek)*; Kirstine og Hjalmar Bruhn, *Malerier, Tegninger, Kunstindustri*, I-III, Copenhagen 1934–54; Elisabeth Fabritius, P.S. Krøyer's Photographs in M. Saabye (ed.), *P.S. Krøyer's Photographs*, Den Hirschsprungske Samling 1990, pp. 92, 165; Jytte Nielsen, Maleren P.S. Krøyer i Stenbjerg in *Aarbog for Thy og Hanherred*, 1994, pp. 7–8; Knud Voss, *Skagensmalerne*, Tølløse 1994, pp. 181–182; Charlotte Christensen, Träumerei in Jacob Thage (ed.), *Portrætter fra et ægteskab, Marie og P.S. Krøyer*, Gammel Holtegaard and Skagens Museum 1997, p. 27; Tonni Arnold, *Balladen om Marie*, Copenhagen 1999, ill. p. 112; Peter Michael Hornung, *Peder Severin Krøyer*, Copenhagen 2002, ill. p. 232; Patricia G. Berman, *In Another Light, Danish Painting in the Nineteenth Century*, New York 2007, ill. p. 172.

The portrait of Marie (as of July 1889, the artist's wife) was apparently painted while the couple were on their honeymoon by the North Sea. An inspired situation painting of a trusting, tenderly smiling young woman who, in the artist's sensuous interpretation, seems to be in love, loved, and desired, which all in all makes it a very private portrait. It is thereby inevitable that it should be brought into the interpretation of the artist couple's tragic love story, which today has achieved almost mythical status.

Marie is sitting in a room with windows on two sides. A mild, warm light comes from the left, while a stronger light coming in from behind catches the hair at the back of her head and the loose locks. Around the outline of her chignon we can distinguish a deep bluish-purple shade, which, as a complementary color to the sunlight entering from the window, creates a coloristic tension that reveals Krøyer's interest in Impressionism at this time. Marie is wearing a blue dress with white collar, decorated with a brooch. The face and coiffure have been painted in stages, partly with a palette knife, and this section has been beautifully finished with fine clear light in her eyes and on her teeth. In contrast to this, the dress at the front of the picture appears to be more sketchlike, due to the fact that Krøyer has scraped the first layer of paint away leaving only a slight remainder, though the neck has been repainted. The background is painted *alla prima*, with broad, assured strokes in shades of greenish gray; the window is a radiant gold; all this exem-

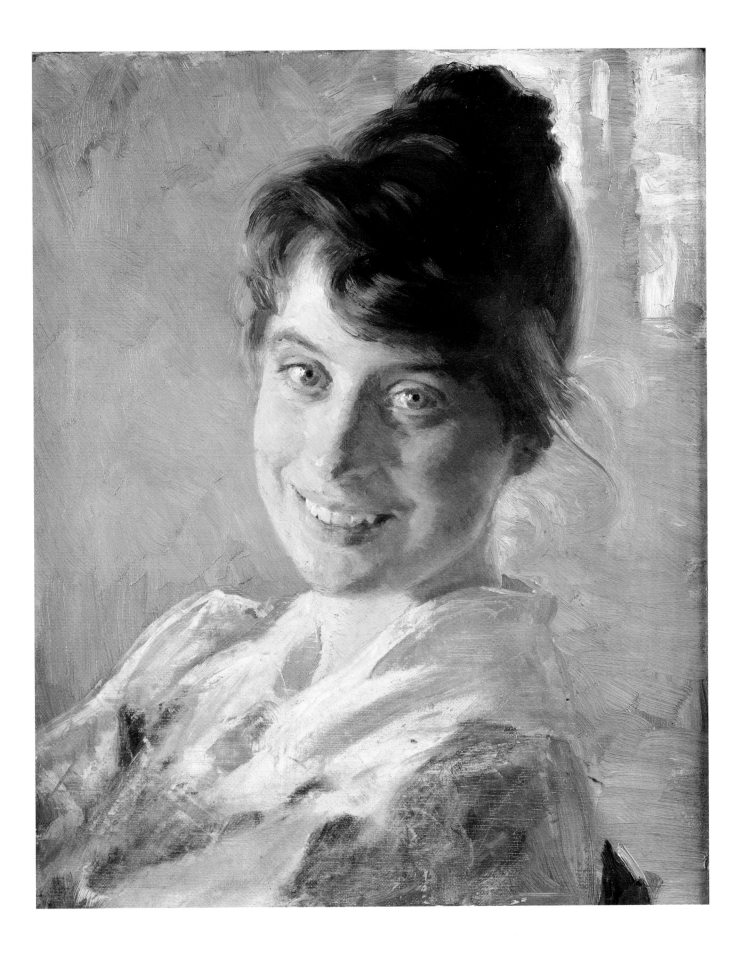

plifies the artist's consummate ability to re-create space and atmosphere. Krøyer must have picked the picture up while the paint was still wet, for there are thumbprints on either side.

Interest in the purely private aspects of the two artists' lives burgeoned after the publication in 1990 of Krøyer's photographic oeuvre, which had been unknown until then. This showed him not only as a great artist in this field, too, but by virtue of their documentary quality, the photographs gave the public an insight into the way the couple liked to present themselves and how Krøyer idealized his motifs in the paintings and drawings.

When Krøyer married at the age of thirty-eight, he was an advocate of "free love," with no societal responsibilities. His experience with women was quite considerable, although the widespread discretion in Protestant northern Europe of the day means that we do not know the names of very many of his liaisons. As one of the radical artists of the time, he pursued the ideas that had been launched by the pioneering Danish critic Georg Brandes (1842–1927), whose principles were free thinking, godlessness and respect for a woman's right to an erotic life.

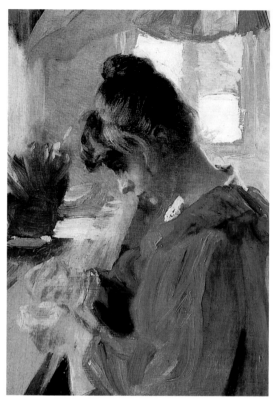

FIG. A *Marie Krøyer at Her Handwork,* 1889
Oil on wood, 13¾ x 9⅘ in. (35 x 25 cm)
Private collection
H. Chr. Christensen no. 449 (as 1890)[2]

Marie Triepcke was only twenty-one years old and well advanced in her training as a painter when she met Krøyer among the Scandinavian artists flocking to Paris in the winter of 1888–1889 for the World Fair. Although she had sat for him, and he had been her teacher, he had not really noticed her before. In 1889 she was a much-feted beauty who easily charmed both younger and older men and, according to the strict judgment of her contemporaries, also knew how to exploit this ability. The feminist Norwegian painter Kitty Kielland (1843–1914), who formed part of her circle in Paris, wrote of Marie in a private letter that she was "very beautiful, too beautiful, and so fully convinced of her beauty that she is always referring to it."[1] But at the same time, according to the author Sophus Schandorph, she was "splendidly free from prejudice."

The Krøyer engagement was announced in Paris in May 1889, and Copenhagen thereafter rang with inquisitive commentaries on the match between the famous and successful artist who, according to contemporary witnesses, wanted to have a beautiful wife, and the young art student's conquest of the much older and influential man, the leader of the artists' opposition in society. Several suitors, including the promising young painter J. F. Willumsen (1863–1958), had difficulty in hiding their disappointment. In the case of Robert Hirschsprung (1865–1889), the son of Krøyer's patron Heinrich Hirschsprung (1836–1908), the news is said to have exacerbated the tuberculosis from which he died within a few months thereafter, an event that provided Krøyer with certain problems.

After the wedding on 23 July 1889 at the home of the bride's parents in Augsburg in southern Germany, Mr. and Mrs. Krøyer went to Stenbjerg in Thy in northwestern Denmark. They stayed at Stenbjerg Kro,

where they surrounded themselves with Japanese textiles and objects they had bought in Paris, where Japonism had taken serious hold. Here Krøyer painted *Interiør* (*Interior*), portraying Marie at her evening toilet (Den Hirschsprungske Samling). In addition there was a portrait of her standing, a gift to her parents (Skagen Museum). In this and in other accurately dated paintings, drawings, and photographs from 1889, Marie's face is still very youthful, her hair cut short at the side and forehead, long in back, with a highly placed chignon. In portraits from Italy the following winter, where she fell seriously ill, she wears a more classical coiffure.

In a letter quoted by Knud Voss, Krøyer says that he repeatedly painted Marie in Stenbjerg, and there is reason to believe that the picture in the Loeb collection is one of those paintings. If we compare it with another sketched portrait in which Marie is sitting in a red cloak, bent over a piece of handwork, it is obvious that they were painted in the same room. The coiffure is again that from 1889 and presumably it is even the same dress, of which we see the white collar. Here, the window can be seen more plainly and is exactly the type seen in older photographs of Stenbjerg Kro. Despite the traditional date of 1890, which first appeared in 1910 in the catalogues of the private exhibition in September and sale of the artist's estate in November, the portrait of the smiling Marie must therefore be considered as having been painted in Stenbjerg in the late summer of 1889.

E.F.

[1] Kitty Kielland 6.2.1889 to Eilif Peterssen, Nasjonalbiblioteket, Oslo.

[2] Here I am referring to Christensen's catalogue on the painted oeuvre by Krøyer, the full title of which is cited in LITERATURE. Like the painting in the Loeb collection, this additional portrait is also dated 1890 by Christensen, whereas I believe they are both from 1889.

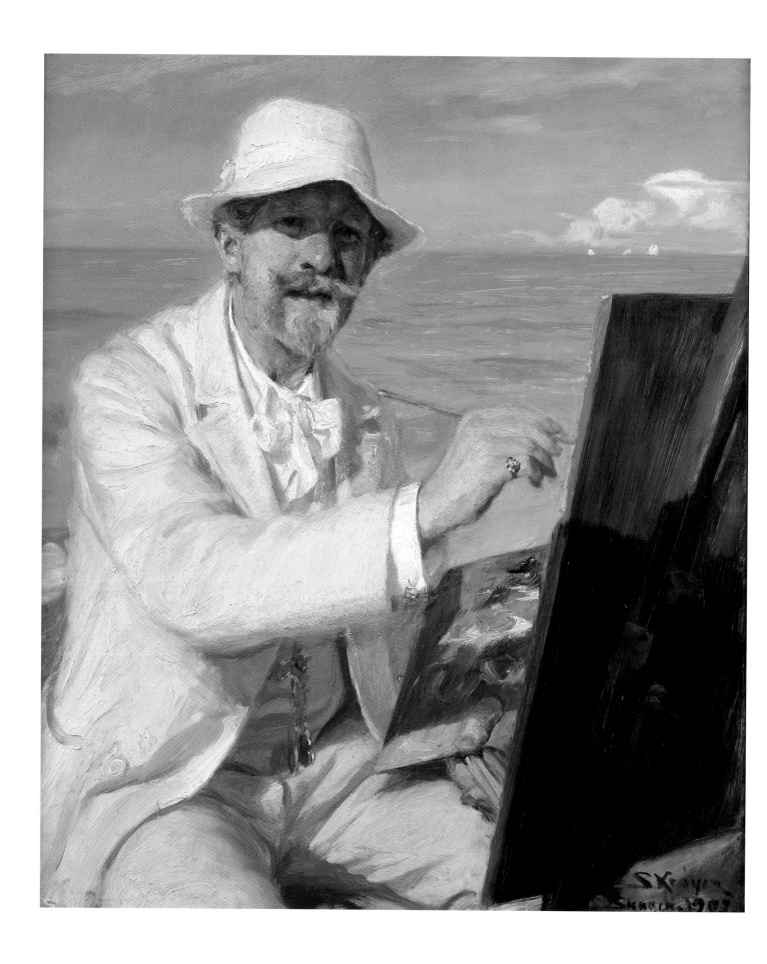

278]

73. *Self-Portrait, Sitting by His Easel at Skagen Beach,* 1902

(Selvportræt, siddende ved staffeliet på Skagens strand)

Oil on panel, 21¼ x 17¾ in. (54 x 45 cm)

Signed with initials and dated lower right: SKrøyer Skagen 1902.

PROVENANCE: Winkel & Magnussen, Auction 115, 1932, lot 99, ill. p. 6 (described as *Selvportræt. Ved Staffeliet paa Skagens Strand, 1902*); Bruun Rasmussen, Auction 465, 1984, lot 206, ill. p. 71.

EXHIBITED: Ed. Schultes Kunstsalon, Berlin, *P.S. Krøyer,* 1903; Busch-Reisinger Museum, Harvard University Art Museums, *Danish Paintings of the Nineteenth Century from the Collection of Ambassador John Loeb Jr.,* 1994, no. 16; Bruce Museum of Art and Science, Greenwich, Connecticut, and The Frances Lehman Loeb Art Center, Vassar College, New York, *Danish Paintings of the Nineteenth Century from the Collection of Ambassador John L. Loeb Jr.,* 2005, no. 29, ill.; New York, Scandinavia House, *Luminous Modernism, Scandinavian Art Comes to America. A Centennial Retrospective 1912–2012,* 2011–2012; Scandinavia House, New York, *Danish Paintings from the Golden Age to the Modern Breakthrough, Selections from the Collection of Ambassador John L. Loeb Jr.,* 2013, no. 25.

LITERATURE: *Die Kunst, Monatshefte für freie und angewandte Kunst,* XVIII, 10, 15.2.1903, ill.; *Kunstbladet,* December 1909, p. 303 (as 1907); Charlottenborg, *P.S. Krøyer,* Kunstforeningens Udstilling, 1910, ill. p. 1; H. Chr. Christensen, *Fortegnelse over P.S. Krøyers Oliebilleder,* Copenhagen, 1923, no. 756 (as 1907); Peter Michael Hornung, *P.S. Krøyer,* Skagen Monografier, no. 3, Copenhagen 1987, ill. p. 139 (as 1907); Elisabeth Fabritius in Marianne Saabye (ed.), *P.S. Krøyer's Photographs,* Den Hirschsprungske Samling, Copenhagen 1990, p. 170 (on the artist's clothing); Jens Erik Sørensen and Erik Nørager (ed.), *Tradition, modernitet, P.S. Krøyer,* Aarhus Kunstmuseum 1992, ill. p. 185 (designated 1907 and incorrectly assigned to Skagens Museum); Peter Nisbet, *Danish Paintings of the Nineteenth Century from the Collection of Ambassador John Loeb Jr.,* Busch-Reisinger Museum, Harvard University, Cambridge, Massachusetts, 1994, ill. p. 1, pp. 10–12; Knud Voss, *Skagensmalerne,* 1994, ill., p. 176; Patricia G. Berman, "Lines of Solitude, Circles of Alliance, Danish Painting in the Nineteenth Century" in *Danish Paintings of the Nineteenth Century from the Collection of Ambassador John L. Loeb Jr.,* Bruce Museum, 2005, p. 20; Patricia G. Berman, *In Another Light, Danish Painting in the Nineteenth Century,* New York, 2007, p. 156, ill. p. 158.

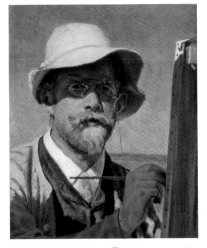

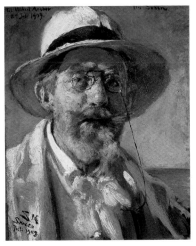

FIG. A *Self-Portrait,* 1897
Oil on canvas, 34½ x 27½ in. (87.5 x 70 cm)
Signed bottom left: S Krøyer. SKAGEN. 1897.
The Museum of National History at Frederiksborg Castle, Hillerød. (There is also a sketch for this painting in the Hirschsprung Collection.)
H. Chr. Christensen no. 592

FIG. B G. Bertoncelli (1850–1920)
Copy after: P. S. Krøyer
Self-Portrait, 1888
Oil on canvas, 19¼ x 16 in. Signed bottom right: S.K. 1888, in the Galleria degli Uffizi, Florence, H. Chr. Christensen no. 397
Oil on canvas, 19⅕ x 15⅝ in. (48.7 x 40.2 cm)
Skagens Museum

FIG. C *The Artist's Last Self-Portrait,* 1909
Oil on panel, 16 x 12¾ in. (40.8 x 32.4 cm)
Signed bottom left: SK SKAGEN Juli 1909; top left: til Michael Ancher 8de Juli 1909; top right: fra Søren Michael and Anna Ancher's House, Skagen
H. Chr. Christensen no. 793

This Krøyer self-portrait from 1902 is a laterally reversed variant of the one he painted in 1897, which had been commissioned by the committee in charge of the Charlottenborg exhibition (Fig. A). The dating of the painting in the Loeb collection was incorrectly read as 1907 as early as 1909, when the picture was reproduced in *Kunstbladet*, and this incorrect dating has accompanied it ever since. The correct year is 1902, as the signature indeed indicates, as does the fact that the painting was reproduced in a German periodical of 1903, in a review of the artist's private exhibition in Berlin.

There are two other self-portraits which very closely resemble that in the Loeb collection, but both are head and shoulder portraits. One of them was painted for the Uffizi in Florence in 1888, when Krøyer was at the height of his career (Fig. B). The other is the artist's last, in 1909, a gift to Michael Ancher, in which a particularly striking feature is the drastic change in the artist's face since 1902, resulting from his illness (Fig. C).

South Beach at Skagen was the setting for a very considerable portion of Krøyer's paintings, the most famous being *Summer Evening on the South Beach at Skagen* (Fig. D). So it is natural that he should have chosen to paint himself there with the water as his background. The artist's off-white suits were made from thin, uncolored wool woven on local farms. The choice is typical of Krøyer. He and his wife were deeply fascinated by the English arts and crafts movement, whose ideas and ideals of beauty were reflected in the arrangement of his home at Skagen, shown in photographs he took. The eggshell-white suit, which Krøyer was the first to think of and have made, started a fashion in artistic circles at Skagen about 1900.

E.F.

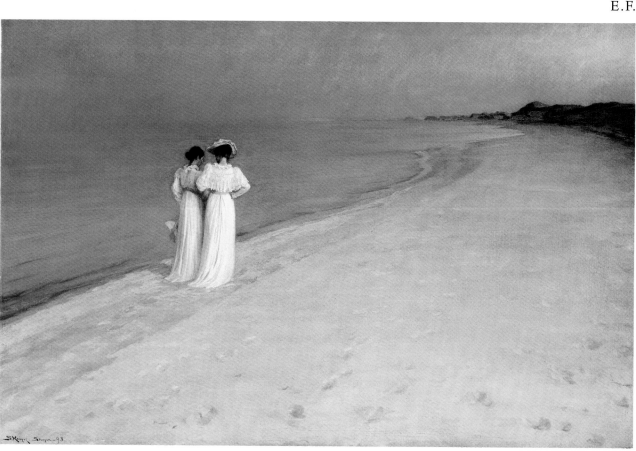

FIG. D P. S. Krøyer
Summer Evening on the South Beach at Skagen, 1893
Oil on canvas, 39⅖ x 59 in. (100 x 150 cm). Signed and dated bottom left: S. Krøyer. Skagen 93.
Skagens Museum

CHRISTEN SCHIELLERUP KØBKE

COPENHAGEN 1810 – COPENHAGEN 1848

Christen Købke was admitted to the Royal Danish Academy of Fine Arts in 1822 at the age of twelve. In time he was to win both the minor and major silver medals, but he never competed for a gold medal. At first he had C. A. Lorentzen (1749–1828) as his teacher, and after Lorentzen's death he became a private pupil of C. W. Eckersberg.

Eckersberg exercised a crucial influence on Købke, evidenced in the restrained manner in which he recorded what he saw, the crystal-clear treatment of light, and the classical structure of his pictures, but Købke also learned from other artists' works, such as C. A. Jensen's portraits and J. C. Dahl's landscapes. For a time at the end of the 1830s, the sculptor Hermann Ernst Freund (1786–1840), Eckersberg's professorial colleague in the Academy, exercised a somewhat problematic influence on Christen Købke. He sought to guide his artistic course of development away from natural, scintillating everyday scenes in the direction of a more intellectual idiom, taking works of classical antiquity for models.

For fifteen years, Købke's father was employed as a master baker in the Citadel in Copenhagen. This defense complex was situated then, as now, at the northern approach to Copenhagen harbor, separated from the city and the Sound by a moat. Most of the motifs in Købke's paintings derive either from the Citadel and its immediate surroundings or from the area around the Sortedam Lake at Østerbro, at that time a northern suburb of Copenhagen.

Købke was very closely tied to his family and so continued living in his childhood home as long as possible. When the elder Købke retired from the Citadel in 1833 and bought an impressive country house in Blegdammen overlooking the Sortedam Lake, Christen also went to live there. Four years later, when he married a cousin of his own age (twenty-seven), a home was set up for the young couple at the north end of the ample parental home.

At the urging of art historian N. L. Høyen, who felt that young Danish artists should devote a portion of their time portraying national monuments in their works,[1] Købke painted an austere, light-filled interior, taking its motif from one of the oldest churches in Jutland, The Transept of Aarhus Cathedral *(1830), now in Statens Museum for Kunst. Some five years later he produced a number of pictures of Frederiksborg Castle in Northern Zealand, equally demonstrating his talent.*

At the start of his artistic career, for other motifs Købke chose to paint small, undemanding scenes from his immediate surroundings. But as time passed, he set about executing much larger works, all of which were meticulously finished after preparatory sketches and painstaking perspective calculations had been made. View Outside the North Gate of the Citadel *(1834), Ny Carlsberg Glyptotek, and* Morning View of Østerbro *(1836), Statens Museum for Kunst, are some of the most important works from this phase.*

Købke's portraits were mainly of his closest relatives and people in his circle of acquaintances whom he knew well, for instance his fellow artists. Among the latter, special mention should be made

of the portrait The Landscape Artist Frederik Sødring *(1832), Den Hirschsprungske Samling.
(Frederik Hansen Sødring's* Rønneby Waterfall at Blekinge, Sweden, *is included in the Loeb
collection.)*

*Around the middle of the 1830s, Christen Købke was gripped by a short-lived feeling of artistic
insufficiency; at the same time he became prone to brooding over religious questions. The hitherto
tranquil spontaneity of his art was replaced by a more ponderous, somber, and less detailed idiom.
This is seen in several huge portraits such as* The Decorative Artist C.G. Hilker *(c. 1837), Statens
Museum for Kunst, and* The Sculptor H.E. Freund *(1838), Royal Danish Academy of Fine Arts.
Købke's periodic melancholy is also sensed in some of his autumn landscapes, for instance* Autumn
Morning by the Sortedam Lake *(1838), Ny Carlsberg Glyptotek, Copenhagen.*

*A two-year travel grant from the Fonden ad Usus Publicos enabled him in 1838 to embark on a pro-
longed visit to Italy, most of the time in the company of his friend Georg Christian Hilker (1807–1875).
His travels took him via Berlin to Dresden, Munich, Venice, Florence, and Rome. But the main goal
of the journey was Naples, where the young artists, inspired by Professor Freund, made copies of
ancient wall paintings from Pompeii.*

*As a young man, Herman Ernst Freund had spent more than ten years in Italy, for part of the
time as Bertel Thorvaldsen's (1770–1844) closest colleague in Rome. During a visit to southern Italy,
his discovery of the interior and decorative art of Pompeii and Herculaneum had had a decisive influ-
ence on Freund's view of art. After returning to Copenhagen in 1828, he never ceased wishing he were
back in Italy. His official residence in Frederiksholms Kanal was testimony to this, and he persuaded
young artists, including Købke, Hilker, and Constantin Hansen, to decorate the rooms throughout the
house in a sophisticated Pompeian style, with the furniture and household utensils also patterned on
ancient models.*

*An excursion by sea to the Sorrento peninsula with Constantin Hansen, who had arrived from
Rome, developed into a three-month-long stay on the island of Capri, while Hilker remained in
Naples. While in Capri, despite frequent rain, Købke made a series of drawings and painted sketches
for larger-scale paintings he planned to work on after his return home.*

*Unfortunately, Købke came home to sorrows and problems that would drain his energy and for a
time partly deprive him of his ability to work. Freund, his artistic guide and mentor, had died shortly
before. One of Købke's brothers had also died, and soon another brother died. His wife Sanne gave
birth to the couple's first child, but after a second birth she fell seriously ill and suffered a long and
painful period of illness. In 1843, the elder Købke died, and two years later the house in Blegdammen
had to be sold. Severely depressed by all this, Købke now found himself compelled to move with his lit-
tle family to a dark apartment in Copenhagen. Poor financial prospects made him consider becoming
a decorative painter, for which reason in 1844–1845 he took part in the decoration of the rooms in the
newly built Thorvaldsens Museum.*

*The studies he had made in Italy did not lead to success for Christen Købke. He did not feel
inspired to paint, and a major work,* View of the Marina Piccola on Capri *(1846), Gottorp,*

Schleswig, intended to gain him membership in the Academy, was rejected. Købke was deeply distressed by this, and it was no consolation to him that his friend Constantin Hansen also had a painting rejected, a painting for which he also had hoped to become a member. Nevertheless, Købke completed a small number of sunny landscapes, mostly with motifs from the Sortedam Lake and all executed after the return from Italy, which demonstrate that Købke was well on his way to regaining his delight in painting. But in February 1848 he died of pneumonia at the age of thirty-eight.

With the exception of 1846, Christen Købke exhibited annually at Charlottenborg between 1831 and 1847. During his lifetime his pictures attracted little attention outside his circle of relatives and friends, and it was really only at the end of the century that he received the recognition he deserved. Since then, increasing numbers have come to appreciate his unassuming, limpid works, the best of which, by virtue of their assured brush strokes and impeccable treatment of color and light, show Danish art at its best. Today there are works by Christen Købke in most major Danish museums as well as some of the most famous foreign collections in Europe and the United States.

In his own day he was of particular importance to the artistic development of J. Th. Lundbye (1818–1848), Dankvart Dreyer (1816–1852) and Thorald Læssøe (1816–1878).

S.L.

LITERATURE: Emil Hannover, *Maleren Christen Købke*, Copenhagen 1893; Mario Krohn, *Maleren Christen Købkes arbejder*, Copenhagen 1915; *Tegninger af Christen Købke* with introduction by Karl Madsen, Copenhagen 1929; Hans Edvard Nørregård-Nielsen, Lyricism of Christen Købke in *Apollo*, June 1981; Hans Edvard Nørregård-Nielsen, *Undervejs med Christen Købke*, Copenhagen 1991; Sanford Schwartz, *Christen Købke*, New York 1992; H.P. Rohde, *Kun en maler, Christen Købke, Breve og optegnelser*, Copenhagen 1993; Hans Edvard Nørregård-Nielsen and Kasper Monrad (eds.), *Christen Købke 1810–1848*, exhibition catalogue from Statens Museum for Kunst, Copenhagen 1996 (containing essays by Philip Conisbee, Torsten Gunnarsson, Hans Edvard Nørregård-Nielsen, Kasper Monrad, and Mikael Wivel); Hans Edvard Nørregård-Nielsen, in *Weilbach*, vol. 4, Copenhagen 1995; Hans Edvard Nørregård-Nielsen in *Christen Købke*, 1–3, Copenhagen 1996.

[1] On Høyen, see note 6 on Christen Dalsgaard, *Young Girl Writing*.

CHRISTEN KØBKE
1810–1848

69. *The Sculptor Bertel Thorvaldsen*, c. 1828
(Copy of the upper section of C. W. Eckersberg's painting of 1814, presented to the Royal Danish Academy of Fine Arts)

(*Portræt af billedhuggeren Bertel Thorvaldsen.*
[*Kopi efter den øverste del af C. W. Eckersbergs maleri fra 1814, skænket Det danske Kunstakademi*])

Oil on canvas, 21¼ x 17⅔ in. (54 x 45 cm)

PROVENANCE: Medaljør F. C. Krohn's Auction, 1883, no. 20; Konferensraad T. Petersen (1884, 1893); Overretsassessor A. Petersen (1912); painter Carlo Madsen; Grosserer Carl-Eilert Wivel (1953); Karen Margrethe Wivel (1981); Arne Bruun Rasmussen, Auction 465, 1984, lot 58, ill.

EXHIBITED: Kunstforeningen, Copenhagen, *Christen Købke*, 1884, no. 4; Kunstforeningen, Copenhagen, *Christen Købke*, 1912, no. 9; Kunstforeningen, Copenhagen, *Christen Købke*, 1953, no. 8; Ny Carlsberg Glyptotek, Copenhagen *Købke og Kastellet, Et dansk Guldaldermotiv*, 1981, no. 1; Busch-Reisinger Museum, Harvard University Art Museums, Cambridge, Massachusetts, *Danish Paintings of the Nineteenth Century from the Collection of Ambassador John L. Loeb Jr.*, 1994, no. 14; Statens Museum for Kunst, *Christen Købke 1810–1848*, 1996, no. 9, ill. p. 30; Scandinavia House, New York, *Danish Paintings from the Golden Age to the Modern Breakthrough, Selections from the Collection of Ambassador John L. Loeb Jr.*, 2013, no. 23.

LITERATURE: Emil Hannover, *Maleren Christen Købke*, Copenhagen, 1893, no. 10, mentioned p. 6; Mario Krohn, *Maleren Christen Købkes Arbejder*, Copenhagen, 1915, no. 9; Knud Voss, *Guldaldermalerne og deres billeder på Statens Museum for Kunst*, Copenhagen 1976, mentioned p. 91; Peter Nisbet, *Danish Paintings of the Nineteenth Century from the Collection of Ambassador John Loeb Jr.*, Harvard University, Cambridge, Massachusetts, 1994, discussed and ill. pp. 4–5; Hans Edvard Nørregård-Nielsen and Kasper Monrad, *Christen Købke 1810–1848*, Statens Museum for Kunst, 1996, mentioned pp. 34, 39, ill. p. 30 (in English); Hans Edvard Nørregård-Nielsen, *Christen Købke, 1–3*, Copenhagen, 1996, no. 9, mentioned and ill., vol. 1, pp. 70–72.

This piece is Købke's copy of a section of C. W. Eckersberg's portrait of Bertel Thorvaldsen (1770–1844),[1] which was painted in Rome in 1814, when the forty-four-year-old sculptor had been living there for seventeen years. The young Eckersberg had come from Paris, where he had been taught the previous year by Jacques Louis David (1748–1825). Thorvaldsen is portrayed in the robes of the S. Lucca Academy, wearing two decorations on his chest and sitting in a reddish-brown chair in front of a green curtain, above which a section of the Alexander frieze can be seen. (This was the frieze the Danish sculptor had modeled for the Quirinal Palace on the occasion of Napoleon's expected visit to Rome.) In Købke's copy he shows only Thorvaldsen's head and shoulders against a neutral brownish background instead of Eckersberg's fragmentary reproduction of the *Entry of Alexander the Great into Babylon*.

Købke was eighteen in 1828. Shortly before this he had been admitted to Professor Eckersberg's studio, where he was immediately given the task of copying some of his teacher's works. Købke had come from the studio of the recently deceased professor C. A. Lorentzen (1746–1828), whose works he had also been given the task of reproducing. The difference between the two teachers reflects a change of generation and a radical new view of art.

This is clearly seen by comparing the following three works: (1) the portrait of Ferdinand Flachner (in the Loeb collection) executed by the young C. A. Jensen when he was a pupil of Lorentzen around 1815; (2) Eckersberg's 1814 portrait of Thorvaldsen; and (3) Købke's copy of this work executed some fourteen years later. C. A. Jensen's portrait of Flachner is thus almost contemporary with Eckersberg's portrait of Thor-

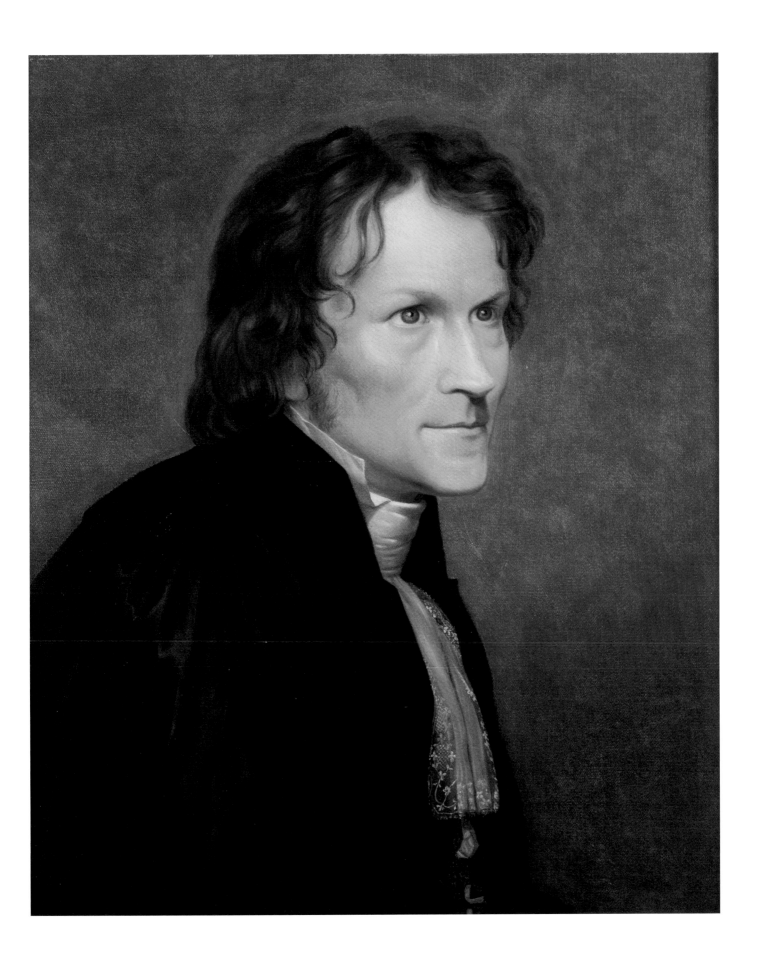

FIG. A C. W. Eckersberg
Portrait of Bertel Thorvaldsen in the Robes of the S. Lucca Academy, 1814
Oil on canvas, 36 x 29 in. (91 x 74 cm),
Royal Academy of Fine Arts

FIG. B C. A. Jensen
Portrait of History and Genre Painter Ferdinand Flachner (c. 1815)
Oil on canvas, 17½ x 13⅔ in. (44.5 x 35 cm), Loeb collection

valdsen. But while Jensen had aimed at a lively, vibrant style derived from the artistic rococo idiom, the clear, harmonious ideal world of neoclassicism had already made its mark on Eckersberg's approach.

The biggest difference between these first two portraits is the use made of the light source. The Flachner portrait is illuminated from some invisible point from the top left above the frame, directed toward only part of the surface, whereas all the pictorial elements in the Thorvaldsen painting, including the background, are shown in a full uniform light.

It has been said of Eckersberg's incomparable work that its almost surrealist honesty in relation to reality endows his figure of Thorvaldsen with a curious lack of physical presence, like a cardboard figure in a puppet theater pushed into the narrow airless space between relief and picture surface.[2]

Perhaps Christen Købke had similar thoughts when he started copying the portrait. So how has he accomplished his task? If we compare the teacher's portrait of Thorvaldsen with the pupil's copy, we will see a difference between the two solutions to the portrait (besides the smaller format and the changed background): Købke has retained the clear uniform lighting on the figure itself, except for one minor point where he has been unable or unwilling to free himself from Lorentzen's teaching. To create depth and air behind the figure, the young Academy pupil has introduced a shaded area in the lower right-hand corner of the painting in exactly the same way as C. A. Jensen did in his portrait of Ferdinand Flachner. However, a comparison between the Flachner portrait and Købke's painting shows that Købke's is primarily neoclassical in approach.

Whereas C. A. Jensen was aiming at vibrancy and presence in what can be called a momentary psychological impression, Købke's whole objective is to produce the exact opposite; his portrait subject looks introspective, almost timeless. The play of Ferdinand Flachner's facial features and his posture radiate impulsiveness, and the flickering quality of the light gives the viewer a feeling of volatility and capriciousness. Bertel Thorvaldsen's contemplative gaze, directed at some invisible object, harmonizes well with the homogeneous composition, the entire idea of which is reflection, balance, and spirit.

In time, the difference between Jensen's expressive artistry and Eckersberg's classical detachment should become even clearer. Throughout his life, Christen Købke was affected by his professor's sense of form and his outstanding ability to re-create reality, but C. A. Jensen's coloristic brilliance and sparkling portrait style also proved a source of great inspiration to him.　　　　　　　　　　　　　　　　S.L.

[1]See Fig. A.

[2]Eva Henschen, *Menneskeskildringer i Eckersbergs romerske kunst* in *C. W. Eckersberg i Rom 1813–16,* Thorvaldsens Museum, Copenhagen 1983.

PETER VILHELM CARL KYHN

COPENHAGEN 1819 – FREDERIKSBERG 1903

The son of a Royal Greenland trade department supervisor by the name of Carl Gotlieb Kyhn, Vilhelm Kyhn first embarked on a training in commerce and then became apprenticed to a copperplate engraver and architect. Between 1836 and 1844 he was a student at the Royal Academy of Fine Arts, where he received instruction from both C. W. Eckersberg, by whom he set great store, and J. L. Lund (1777–1867). He won the minor silver medal in 1843.

Kyhn made his first appearance at Charlottenborg that year, exhibiting there annually for the following sixty years. He also participated in the 1878 and 1900 world fairs in Paris; in 1845 he won the Neuhausen Prize. He spent 1850–51 traveling in France and Italy with funds from a two-year grant from the Academy, but the trip had to be curtailed on account of illness. He later visited Sweden and Norway several times and was in Paris again in 1878.

Vilhelm Kyhn was principally a landscape artist. His very extensive oeuvre varied in quality, especially in his early years, perhaps because he was torn between Eckersberg's teaching, with its emphasis on precise, balanced observations of nature, and the desire on the part of Lund's pupils to find freer, more emotional means of expression. In addition, like all landscape artists, he found it difficult to translate the immediate experience of the countryside into carefully finished works suitable for exhibition. Under the influence of the art historian N. L. Høyen (1798–1870), Kyhn gradually created his own version of national romanticism.

From the 1850s, Kyhn ran his own private school of drawing and painting, and from c. 1870, a school for women artists. (Anna Ancher spent three years as one of his pupils there, as female artists did not have access to teaching in the Academy.)

Kyhn was a driving force behind the setting up in 1853 of Den danske Radeerforening (The Danish Society for Etching). Between 1871 and 1879 his garden studio, under the name of Huleakademiet (The Cave Academy), became the meeting place for a group of young artists who were dissatisfied with teaching in the Academy. Although Kyhn was an implacable opponent of the new international influence on Danish art, especially French, he nevertheless appears in time to have been inspired by French plein air painting. (See Loeb collection, Summer Meadows.)

From 1873 he worked near Himmelbjerget in Central Jutland. In the 1880s, Kyhn appears to have alternated between purely studio works and large plein air paintings. However, in many of his works he continued throughout his life in the full-hearted Romantic mood he had aimed at since early youth.

S.L.

LITERATURE: Karl Madsen, Vilhelm Kyhn in *Tilskueren*, Copenhagen 1884, pp. 429–439; Hanne Westergaard, Landskabsmaleri, original graWk og billeder i bøger, Om Vilhelm Kyhn, 1819–1903 in *Bogvennen* 1978, Copenhagen 1978; Finn Terman Frederiksen, *Kunst og natur, Omkring et landskabsbillede af Vilhelm Kyhn*, Randers Kunstmuseum 1982; *Vilhelm Kyhn*, Kunstforeningen, Copenhagen 1993 (with essays by Holger Reenberg and Jørn Guldberg); Holger Reenberg in *Weilbach*, vol. 4, Copenhagen 1996; Jørn Guldberg, Stedsans (eds. Lene Burkard, Jørn Guldberg and Karsten Ohrt), in *Stedsans—om tid, sted og rum i dansk landskabsmaleri*, Kunsthallen Brandts Klædefabrik, Odense 1998.

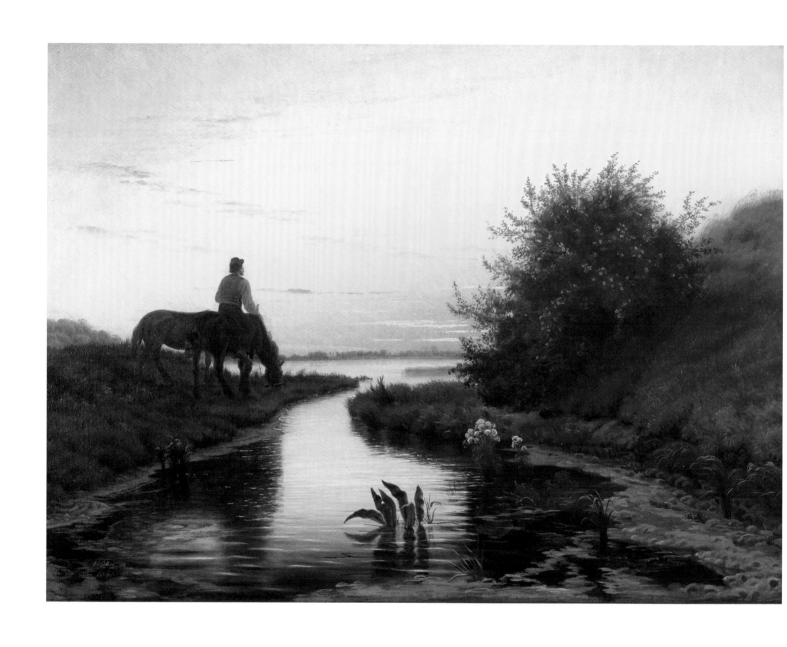

74. *Evening Atmosphere,* 1861
(Aftenstemning)

Oil on canvas, 27¼ x 37 in. (69 x 94 cm)

Signed and dated lower left: V. Kyhn 1861

PROVENANCE: Arne Bruun Rasmussen, Auction 465, 1984, lot 211 (described as *Aftenstemning. Hestene vandes*).

EXHIBITED: Charlottenborg, 1861, no. 105; Busch-Reisinger Museum, Harvard University Art Museums, *Danish Paintings of the Nineteenth Century from the Collection of Ambassador John Loeb Jr.,* 1994, no. 17; Scandinavia House, New York, *Danish Paintings from the Golden Age to the Modern Breakthrough, Selections from the Collection of Ambassador John L. Loeb Jr.,* 2013, no. 26.

LITERATURE: Peter Nisbet, *Danish Paintings of the Nineteenth Century from the Collection of Ambassador John Loeb Jr.,* Busch-Reisinger Museum, Harvard University, Cambridge, Massachusetts, 1994, ill. p. 8; Patricia G. Berman, *In Another Light, Danish Painting in the Nineteenth Century,* New York 2007, p. 186, ill. p. 186–187.

> Peace now rests o'er land and town, no sound the earth doth make;
> The moon smiles blissful to the clouds, the stars smile to each other.
> And radiant and calm the lake embraces the heavens...
>
> *(Fred hviler over land og by, ej verden larmer mer;*
> *Fro smiler månen til sin sky, til stjerne stjerne ser.*
> *Og søen blank og rolig står med himlen i sin favn, ...)*

Such are the first lines of one of the evening hymns by the great Danish Golden Age poet Bernhard Severin Ingemann (1789–1862), a text that quickly became known to every child in Denmark. Perhaps Vilhelm Kyhn had these lines in mind when he painted his picture of evening, and perhaps he imagined that the farm worker riding on the foremost of the horses on the banks of the stream is repeating the words to himself, while his eyes survey the infinite expanse of the evening sky.

It is quite certain that, far from reproducing a specific topographical locality, this work has the sole intention of awakening in the mind of the viewer a feeling of rest and peace, perhaps with a touch of melancholy along with a profound sense of the artist's gratitude for the beauty of his native land. To Kyhn, the Danish landscape was the most beautiful in the world, and almost all his works are concerned with defining and praising the special national character of nature's many phenomena.

It may be that Vilhelm Kyhn borrowed an occasional stylistic feature from the famous German Romantic Caspar David Friedrich (1774–1840), a figure by whom few of the Danish landscape artists of the time failed to be influenced; here it is the figure shown with his back to us, intended to represent the viewer of the picture.

Kyhn was otherwise a determined opponent of all foreign influence, especially of German and French art. With all his heart he belonged to the circle of "blond" artists. This term related to a conflict between the nationalist painters loyal to Høyen's principles and those who were more European in their outlook. The two groups were known as the "blonds" and the "brunettes," and the latter had gradually come to dominate both the Royal Danish Academy of Fine Arts and the Copenhagen Art Society, Kunstforeningen.

Vilhelm Kyhn's irreconcilable attitude to the brunettes, whom he attacked publicly, was the reason he was unable to sell a single painting to the Copenhagen Art Society between 1847 and 1856. S.L.

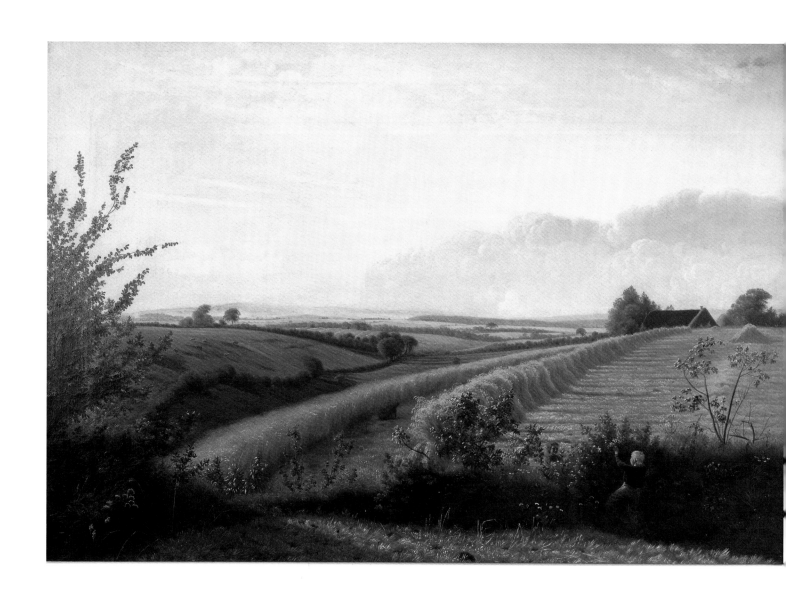

VILHELM KYHN
1819–1903

75. *Late Autumn Afternoon. Motif from Horneland Near Faaborg,*
1863

(Sildig eftermiddag i efterhøsten. Motiv fra Horneland i nærheden af Faaborg)

Oil on canvas, 34⅔ x 51¼ in. (88 x 130 cm)

Signed and dated lower left: V Kyhn 1863

PROVENANCE: Probably Dr. med. L. J. Mygge (1864); Frøken Ida Pouline Holst; Winkel & Magnussen, Auction 300, (Ida Pouline Holst) 1943, lot 13, p. 6 (incorrectly described as *Høstlandskab ved herregaarden Palsgaard*); Arne Bruun Rasmussen, Auction 236, 1969, lot 19, ill. p. 11; Fabrikant Hother Neckelmann (1969); Bruun Rasmussen, Auction 688, 2000, lot 1458, ill. (described as *Stille sommeraften i høstens tid; i forgrunden legende børn*).

EXHIBITED: Charlottenborg 1864, no. 70 (described as *Sildig Eftermiddag i Efterhøsten. Motivet taget paa Horneland i Nærheden af Faaborg. I Baggrunden sees Horne Kirke*); Charlottenborg, *Vilhelm Kyhn 1819–1903, Hundredaarsudstilling*, 1919, no. 138 (measurements given, 47 x 68 cm, are incorrect). However, on the basis of subsequent information in the catalogue for the Centenary Exhibition, the landscape from Horneland exhibited there must be considered identical with the painting in the Loeb collection. The wording in the catalogue is *"Sildig Eftermiddag i Efterhøsten. Horneland ved Faaborg. Sign.: V. Kyhn 1863. Udstillet 1864. Tilh. Dr. med Mygge"* (Late Autumn Afternoon. Horneland near Faaborg. Sign.: V. Kyhn 1863. Exhibited 1864. Belonging to Dr. Mygge, M.D.). Scandinavia House, New York, *Danish Paintings from the Golden Age to the Modern Breakthrough, Selections from the Collection of Ambassador John L. Loeb Jr.*, 2013, no. 27.

In 1836, the year in which Kyhn was admitted to the Royal Danish Academy of Fine Arts, one of the leading figures of the Danish Golden Age, scientist Hans Christian Ørsted, gave a lecture on the Danish spirit, which he believed derived from the Danish countryside. In the distant past, he said, our forefathers settled in this gentle and kindly landscape "from which everything terrible is almost completely excluded.... Surrounded by this countryside, the people have now lived and developed over many centuries, so should it not be possible to find some consonance between the two?"

Late Autumn Afternoon is precisely such a "gentle and kindly landscape," with no suggestion at all of anything "terrible." It creates an image of the spirit of the people of Funen Island as many still think of it, and it is even more clearly defined by the presence of a pair of children playing peacefully in the wall of flowers in the foreground.

Horneland is a peninsula projecting out into the southern Funen archipelago to the west of the town of Faaborg. It is a fertile, area surrounded by peaceful waters teeming with fish and dotted with a large number of islands and islets, of which we here glimpse the small Illumø in the center and the larger Helnæs in the far distance on the horizon.

For the landscape artists of the Golden Age, the year had a regular rhythm. Their summers were spent in various parts of Denmark, drawing and painting outdoors, producing sketches and studies for use in the winter's work, which was about creating large, well-composed landscapes for the spring exhibitions at Charlottenborg.

In the Royal Danish Academy of Fine Arts, Kyhn had been the pupil of two contrasting teachers. On the one hand there was the sober Professor Eckersberg, who had taught him to paint studies out in the open and to reproduce what was there to be reproduced, neither more nor less. On the other hand there was the

Romantic J. L. Lund (1777–1867), who had studied at the Copenhagen Academy together with Caspar David Friedrich (1774–1840) and at that time was still in contact with the German Romantic currents emanating from Dresden, where both Friedrich and the Norwegian J. C. Dahl (1788–1857) were professors.

Throughout his life Vilhelm Kyhn struggled in his art to unite the disparate teaching to which he had been exposed in his youth. In contrast to increasing numbers of his colleagues, even late in the century he remained loyal to the art historian N. L. Høyen's vision of a national Romantic painting that could reveal their country to the Danes and sing the praises of its special qualities. In 1844, Høyen had summed up his thoughts on this in a famous lecture titled *On the Conditions for the Development of a Scandinavian National Art (Om Betingelserne for en skandinavisk Nationalkunsts Udvikling)*.

Although this scene from Horneland in Funen is apparently an example of a predominantly topographical presentation of a specific locality as it looked in reality, there is not much of Eckersberg about this painting. It is a typical Romantic work. With the diagonal line across a rolling landscape and its tall foreground vegetation—which both emphasizes the depth and brings our gaze back from its journey out into the picture's space—it reminds us of the source of the Romantics' inspiration: Dutch landscape painting of the 17th century.

S.L.

VILHELM KYHN
1819–1903

76. The Parsonage in Greve, 1877
(Præstegården i Greve)

Oil on canvas, 37 x 29½ in. (94 x 75 cm)

Signed and dated lower right: V Kyhn 77

PROVENANCE: Winkel & Magnussen, Auction 160, 1934, lot 92, ill. p. 11 (described as *Greve Præstegaard*); Bruun Rasmussen, Auction 538, 1990, lot 36 (described as *Fra præstegårdshaven i Greve med kirketårnet i baggrunden*).

EXHIBITED: Charlottenborg 1878, no. 142; Busch-Reisinger Museum, Harvard University Art Museum, *Danish Paintings of the Nineteenth Century from the Collection of Ambassador John Loeb Jr.,* 1994, no. 18; Bruce Museum of Art and Science, Greenwich, Connecticut, and The Frances Lehman Loeb Art Center, Vassar College, New York, *Danish Paintings of the Nineteenth Century from the Collection of Ambassador John L. Loeb Jr.,* 2005, no. 13, ill.

LITERATURE: Peter Nisbet, *Danish Paintings of the Nineteenth Century from the Collection of Ambassador John Loeb Jr.,* Busch-Reisinger Museum, Harvard University, Cambridge, Massachusetts, 1994, ill. p. 8; Patricia G. Berman, "Lines of Solitude, Circles of Alliance, Danish Painting in the Nineteenth Century" in *Danish Paintings of the Nineteenth Century from the Collection of Ambassador John L. Loeb Jr.,* Bruce Museum 2005, p. 17; Patricia G. Berman, *In Another Light, Danish Painting in the Nineteenth Century,* New York 2007, p. 117, ill. p. 115.

Peter William van Wylich (1803–1881) was a fine, wise, and much-loved minister in the parishes of Greve and Kildebrønde who retired on 30 January 1877 after thirty years of devoted service. It may be that Vilhelm Kyhn's superb picture of the parsonage that had formed the framework for van Wylich's personal and professional life for so many years was a presentation made to him by his grateful parishioners to mark his retirement.

The parsonage in Greve has a very special history. Under the pseudonym of "Nicolai, 18 Aar gammel" ("Nicolai, aged 18"), the theologian and author Henrik Scharling (1836–1920) published a novel entitled *Ved Nytaarstid i Nøddebo Præstegaard (New Year at Nøddebo Parsonage)*. It was a tender, humorous portrayal of the idyllic life in a Danish parsonage, but at the same time contributed to the debate on social problems. The author used himself and his brothers as models for the novel's three students, who were spending their holidays in the parsonage. They bring up the social questions of the time for discussion with the gentle, understanding old pastor and his two daughters. Van Wylich is said to have served as the model for the pastor, and Nøddebo parsonage was the family's own home in Greve, where the young Scharling had been a visitor since childhood.

The book was an immediate success. Its reputation lives on in Danish popular culture, not least because it was dramatized and turned into a comic vaudeville at the end of the 1880s. *Nøddebo Præstegaard* is still performed every year at Christmas by both amateurs and professionals throughout the country.

Vilhelm Kyhn has chosen to show the lovely thatched parsonage on a beautiful day in midsummer as seen from the garden in the lee of the whitewashed medieval Greve church. One of the characteristic corbie-stepped[1] gables of the church tower stands out grandly against a magnificent clouded sky. At the top of the gable a stork is standing on one leg, while its mate is floating in from the blue sky. Farther down, a pair of pigeons are preening themselves.

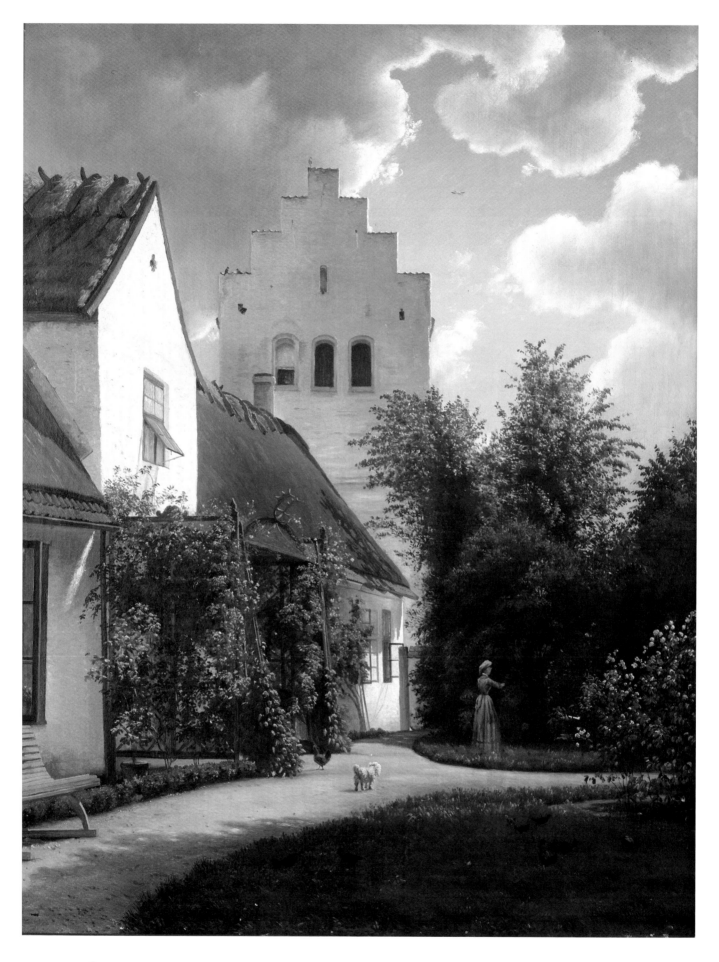

We understand that the garden is spacious. A huge tree outside the area covered by the picture casts a shadow across the lawn, where some hens are walking about; the shadow just about reaches the bench in front of the white wall of the house. We glimpse flowering plants inside the window, and flowers grow outside everywhere. A profusion of pink roses are climbing up an ingenious pergola, and there are even pots on the ground containing flowering plants. The entrance, flanked by hops[2] on oblique frames, is crowned with a deer's formidable antlers. (Pastor Van Wylich was obviously a hunter.) He was also a paterfamilias with a large and lively family. As for the parson's wife, she "was the dearest little person."[3]

The painting was executed on the basis of a meticulous and almost identical preparatory study about half the size of the finished work (see Fig. A), presumably made on the spot. If we compare the two, we find only very small differences, such as slight variations in the foliage and in the distribution of the clouds.

The small town of Greve is situated about 18 miles (30 km) south of Copenhagen. The parsonage and church still exist.

S.L.

FIG. A *A Summer's Day at Greve Parsonage, preparatory study for The Parsonage in Greve*, 1877
Oil on canvas, 17⅓ x 14½ (44 x 37 cm), private collection

[1] A series of steps that rise toward the ridgepole of a building and terminate at the upper part of a gable wall.

[2] A twining Eurasian vine.

[3] The words of the author Axel Valentiner, quoted from Wilhelm von Antoniewitz in *Greve og Kildebrønde Sognes Historie*, 1967, pp. 60–63. I am grateful to the Rev. Kjeld-Ole Munk for information on the history of Greve parsonage.

VILHELM KYHN
1819–1903

77. *Summer Meadow,* 1880

(Sommerdag ved en sø, i forgrunden børn, der plukker blomster)

Oil on canvas, 31½ x 46 in. (80 x 117 cm)

Signed and dated lower left: V Kyhn 1880

PROVENANCE: Arne Bruun Rasmussen, Auction 300, 1973, lot 117, ill. p. 37; Arne Bruun Rasmussen, Auction 383, 1978, lot 94, ill. p.15; Sotheby's, London, March 14–15, 1989, lot 19, ill. (described as *Summer Meadows*).

EXHIBITED: Possibly Charlottenborg 1880, no. 142; Busch-Reisinger Museum, Harvard University Art Museums, *Danish Paintings of the Nineteenth Century from the Collection of Ambassador John Loeb Jr.,* 1994, no. 19.

In May 1878, Vilhelm Kyhn went to Paris to see the World Fair for himself. He had been a member of the exhibition committee and had thus helped decide which Danish paintings were to be sent to Paris. He himself participated with two works, *Jour d'été (Summer Day)* and *Au coucher du soleil (hiver) (Winter Sunset).*

The Danish artists did not fare particularly well in Paris. In most cases they were totally ignored by the French critics; the leading French art periodical, *Gazette des Beaux-Arts,* did not devote a single word to the Danish section. In other newspapers, works by Danish artists were scathingly and trenchantly criticized for their lack of skill, their stylistic deficiencies, and catastrophic lack of artistic content. Only a very small number of works was accorded any praise; these included a genre painting by Christen Dalsgaard, a historical composition by Carl Bloch, and Vilhelm Kyhn's landscapes.

During the winter of 1879, the art historian Julius Lange (1838–1896) delivered a series of lectures to Kunstforeningen (the Copenhagen Art Society) in which he considered the World Fair and concluded by comparing the Danish works with those from other countries. Not without reason Lange maintained that Danish art was at a low ebb. The question then was how this period of stagnation could be brought to an end. Should the path to be followed go via Paris in order to acquire a new painterly technique and "by boldly breaking into the secrets of the French studios learn the art of painting a sky so that it shimmers and glows, and discard our own dreary way of reproducing a sky as though it were a matter of painting a wall blue?" Or was there a realistic possibility of renewing Danish art on a national basis?[1]

Lange urged the latter course, but he was given no backing by the younger generation of artists nor, strangely enough, did he receive very much support from the now almost sixty-year-old Vilhelm Kyhn. Despite his legendary resistance to all foreign influence, Kyhn appeared to have adopted plein air painting in the manner of the French landscape artists. He was no longer content to capture the weather and the ever-changing daylight in his small oil studies, as Eckersberg had taught his pupils to do. In more and more cases he started to paint his major exhibition works outdoors. In this respect, Kyhn had suddenly become modern. The portrayal of the children picking flowers in the middle of a Danish summer gives the impression of having been executed on the spot and so anticipates early works by painters such as Hans Brendekilde and L. A. Ring.

The landscape does not appear to be from either Funen or Zealand. It is more likely that we are in the area around Himmelbjerget in central Jutland, which makes it possible to assume that the Loeb collection's

Summer Meadows is actually identical with the painting *Sommerdag, Emnet i nærheden af Ry Station (Summer's Day, a Subject Close to Ry Station),* exhibited at Charlottenborg in 1880.

S.L.

[1] Julius Lange, *Vor kunst og Udlandets,* Copenhagen 1879, p. 31.

VILHELM KYHN
1819–1903

78. *Gathering Storm Near Ry,* 1896
(Optrækkende uvejr ved Ry)

Oil on canvas, 37⅔ x 50 in. (96 x 127 cm)

Signed and dated lower right: Vil Kyhn 1896

PROVENANCE: Grosserer J. L. Dupont (1919); Winkel & Magnussen, Auction 73, 1929, lot 7 (described as *Optrækkende uvejr ved Ry,* the dimensions erroneously given as 24 x 126 cm); Arne Bruun Rasmussen, Auction 453, 1983, lot 108, ill. p. 25.

EXHIBITED: Charlottenborg 1896, no. 227 (described as *Eftermiddag, Himmelbiærgaasen set fra Rye Station*); Charlottenborg, *Vilhelm Kyhn 1819–1903, Hundredeaarsudstilling,* 1919, no. 337.

Vilhelm Kyhn's close association with the landscape was legendary. Of his profound admiration and his humility in the face of the ever-changing light and profusion of color in nature there is ample evidence, for instance in letters from the aging artist to his young pupils, who looked up to him and considered him radical and modern.

Kyhn's main aim was to re-create the atmosphere in a landscape; he wanted, so to speak, to express the soul of nature, and to emphasize this he would sometimes put into his painting some detail that was out of proportion. Here we have an example with a dazzlingly white, tousled poodle in the left foreground; it seems far too big in comparison with a woman farther away in the picture, who is wearing a light-colored headscarf, and standing with another dog outside a small house with smoke rising from its chimney.

The viewer's eye is immediately caught by the poodle's radiance and then led on in a rapid diagonal movement across to the point where the rainbow starts. The unsettled, leaden sky and the flock of fluttering gulls underline the nervous quality of the weather and compel the viewer to look down as though to seek shelter among the undulating, heather-clad hills and the lush, green, low-lying land cutting through them.

It is impossible to say whether the disproportionate size of the dog was merely happenstance or whether Kyhn was working consciously, but with the animal's presence as a fixed point from which the viewer is forced to begin a peregrination through the picture's universe, the painter's apparent clumsiness achieves a telling effect. The sense of a gathering storm and of rapidly vanishing daylight makes all white features in the landscape shine as though floodlit, further intensifying the magnificent effect of the picture and adding a disturbing monumentality to it.

In the view of some scholars, Vilhelm Kyhn developed into an out-and-out naturalist in his later years. He painted his motifs as they were and as they can still be recognized to some extent. In this respect, his works differed markedly from the idealized national Romantic portrayals of the 1830s and 1840s, which were often pieced together from fragments of landscape from several different regions.[1]

S.L.

[1] Finn Terman Frederiksen, *Kunst og natur, Omkring et landskabsbillede af Vilhelm Kyhn,* Randers Kunstmuseum 1982.

HANS HENRIK LERFELDT

ÅRHUS 1946 – COPENHAGEN 1989

"My special area is: the fear that steals in as laughter."

Hans Henrik Lerfeldt had the above epigraph printed at the bottom of his visiting card, which he gave to the artist Jens Jørgen Thorsen (1932–2000) when they met for the first time. The whole text on the card, and a tenderly surrealistic prose poem from Thorsen to Lerfeldt, can be read in a small pamphlet on the artist published by the Galerie Asbæk.

Hans Henrik Lerfeldt's childhood was dreadful. He lived part of it in devastated postwar Berlin, was adopted into a strict religious home, and was passed on to various children's homes by his adoptive father, a clergyman. Moral prejudices and suppressions, guilt, and defiance, together with the impressions from a series of periods subsequently spent as a psychiatric patient lay like heavy clouds over Lerfeldt's short life and left their mark on his art.

From 1965 to 1970, Hans Henrik Lerfeldt attended classes in the Royal Danish Academy of Fine Art, where one of his teachers was the architect and graphic designer Gunnar Biilmann Petersen (1897–1968); he also took classes at the School of Graphic Art with the great Danish graphic artist Palle Nielsen (1920–2000). At the beginning of the 1970s, Lerfeldt became deeply preoccupied with surrealism and was especially inspired by the controversial painter Wilhelm Freddie (1909–1995), who had introduced the figurative aspect of this artistic movement into Denmark.

Lerfeldt went in for the provocative and the repulsive, placing great emphasis on the sexual. Woman as a fetish object was a recurrent theme in the artist's suggestive, dreamlike art of the subconscious. His motif universe included accurate details of various parts of the body—sexual organs, hair, women's legs with garters and high-heeled shoes, whips, and oversized insects, all executed with a photographic precision that both created an illusion of reality and established a cool distance. In order to achieve the greatest realism in his surreal arrangements, the artist introduced details from his considerable collection of pornographic pictures.

A rather different range of motifs emerged in a number of paintings executed in Berlin in the 1980s, which Lerfeldt based on old photographs of people, including himself as a child. A profound interest in jazz played a great part in Lerfeldt's life and inspired him to paint a series of portraits of musicians, such as Duke Jordan (1922–2006), Bill Evans (1929–1980), and his favorite, Chet Baker (1929–1988). He even drew up a complete discography of the latter's music. In 1985 he made a demonic portrait poster of Karen Blixen (Isak Dinesen, 1885–1962) for a commission from Dansk Bogtjeneste.

Hans Henrik Lerfeldt exhibited in many different venues, though mainly in Denmark, for instance at Charlottenborg 1968–1970, in Kunstnernes Efterårsudstilling 1968–1969, and Corner 1970–1975, in addition to various other group exhibitions. He has had solo exhibitions in various galleries, including the Galerie Asbæk in 1978, 1980–1981, and 1985 and in museums such as Ribe Kunstmuseum in 1981 and Sønderjyllands Kunstmuseum in 1985.

A photograph in Jens Jørgen Thorsen's book showing Hans Henrik Lerfeldt in a pub in the center of Copenhagen provides the impression of an intelligent, disturbingly obese, and not particularly happy man.

S.L.

LITERATURE: Virtus Schade in *Kunst*, 2, 1970, pp. 42–44, 46ff; Jens Jørgen Thorsen, *Hans Henrik Lerfeldt*, Copenhagen 1981; Ove Mogensen (ed.), *Hans Henrik Lerfeldt Erotisk symbolisme i Danmark,* Sønderjyllands Kunstmuseum, Tønder 1985 (with an essay by Maria Marcus); Marianne Barbusse Mariager in *Weilbach,* vol. 5, Copenhagen 1996.

HANS HENRIK LERFELDT
1946–1989

79. *Sleepwalker*

Watercolor, 11¾ x 7¾ in. (30 x 20 cm)

Signed and dated: 83

PROVENANCE: Galerie Asbæk, Copenhagen (1983).

EXHIBITED: The American Scandinavian Society of New York at Privatbanken Gallery, *Selections of Contemporary Danish Art*, 1989, no. 11.

A quite young woman stares at us, but she is actually looking into herself, and we are drawn along with her into an enigmatic universe through her wide-open, porcelain-blue eyes. On the other side, a small transparent girl is walks toward us with her eyes closed. A gigantic bluebottle fly has affixed itself to the child's skirt in the middle of her stomach.

It is left to spectators to interpret this vision, just as the artist himself presumably developed his own ideas only as his strange picture took shape.

As often happens in Lerfeldt's pictorial universe, we are confronted with a perfect female fixed in a glamorous attitude such as is seen in advertisements. In the Loeb collection work, she is Lolita-like, with skin that looks glazed; her shiny brown hair fits like a silk bonnet around a serious, doll-like face.

We are disturbed in this work by the presence of an intruding insect that is bigger than it should be, found where it does not belong. The intruding insect is not an innocent memory of childhood anymore because the girl is approaching adult life, and then such memories of childhood will not remain innocent; they will be transformed into nightmares.

Lerfeldt's stories within the stories take place behind brilliantly executed facades and are played out both in the artist's subconscious and in the ideas he is able to awaken in the mind of the viewer. In this case they are disturbing presentiments of an irrevocable and fateful confrontation between innocence and corruption.

S.L.

CARL LUDVIG THILSON LOCHER

FLENSBURG 1851 – SKAGEN 1915

Carl Locher was born in the maritime city of Flensburg, where his father, J. T. Locher (1825–1869), enjoyed some success as a sea painter. In the mid-1850s, the family moved to Copenhagen. Carl's interest in ships thus derives from his childhood home, where he also received his first artistic instruction. He was only seventeen when his father died, but his training was so advanced that he continued to run the sea painting business for some years. In 1870–71, he became familiar with the sea in earnest when he embarked on his first long voyage to the West Indies, traveling home via London.

The desire for further training of a more artistic nature led him to become a pupil of the marine artist Carl Baagøe (1829–1902) and then of Holger Drachmann (1846–1908), who was also one of the most famous poets of the day. After this, Carl applied to the Royal Academy of Fine Arts in Copenhagen, where he was a pupil until 1874. He aimed for an academic career, and from 1870 he exhibited at Charlottenborg, the Academy's official annual exhibition, and several times competed for the Neuhausen Prize, never winning it. Now he alternated further instruction with voyages asea and brief visits abroad.

Like other young Scandinavian painters, Locher settled for a time in France in order to acquaint himself with new artistic forms of expression. During the years 1876–78 he was a pupil of Léon Bonnat (1833–1922) in Paris, for a time studying together with Laurits Tuxen and P. S. Krøyer. He also learned a great deal by copying earlier sea paintings. While in Paris he painted Redningsbåden går ud, forrygende storm, *1877 (The Lifeboat Goes Out, Raging Storm, replica at Handels- og Søfartsmuseet, Kronborg), on the basis of studies made in Skagen, a work which he exhibited at home in 1878. That same year he painted* Ageposten (The Post Wagon), *portraying the horse-drawn wagon carrying the mail on its way to Skagen along the South Beach. This painting was bought by the landowner O. Rosenørn-Lehn, who was foreign minister and director of the National Gallery (now Statens Museum for Kunst) and was also building up a considerable private collection.*

With his background in marine painting, Locher found it relatively easy to free himself from the traditional academic manner of painting. Sketches from Normandy from 1876 in the Michael and Anna Ancher's House Museum at Skagen and in Skagens Museum show that by this time Locher had acquired the sketchlike style of plein air painting, which was the way of the future. In 1879 he stayed at Skagen, where the artists' colony was taking shape with the participation of such figures as Drachmann, Karl Madsen (1855–1938), the Norwegians F. Thaulow (1847–1906) and Christian Krohg (1852–1925), Michael Ancher, and his future wife, Anna. That summer, during a visit to the Faroe Islands and Iceland, Locher painted some magnificent sketches of the mountainous islands in the North Atlantic.

Locher was something of a loner, and a free life was a prerequisite for his painting. Although he married early and had children, he was often away from home. However, from 1880 to 1889 he lived at

Hornbæk on the north coast of Zealand in a house almost on the shore. From a glass-covered veranda that protected him from wind and rough weather, he could paint the coast, the sea, and the weather in all seasons. The family then moved to Copenhagen, where they lived until 1910. During this period, Locher's interest in graphic art increased, and he received instruction from Hans Meyer (1846–1919) at the Berlin Academy of Fine Arts with a view to starting a school of graphics in Copenhagen. His own works using the vernis-mou[1] technique were greatly admired in their day and were awarded a bronze medal in the World Fair in Paris in 1900. The last five years before his death in 1915 were spent entirely in Skagen. He built a house with a large studio that still stands, with a view across the famous South Beach, so often portrayed by Locher and countless other painters. A younger painter and critic, Walter Schwartz (1889–1958), who grew up at Skagen, described him as impulsive and stubborn but with a vivacious painter's temperament.

Locher exhibited regularly and, as was then the custom, also put his paintings up for sale in auctions. He took part in the major general Scandinavian exhibitions that were held particularly frequently in the 1880s, while his work was often used to represent Denmark abroad.

Danish marine painting was founded by C. W. Eckersberg, but the genre was not taught at the Academy of Fine Arts. So it went its own way, influenced by trends outside Denmark. The quality of sentiment and drama that gave greater freedom to its exponents was viewed as alien at the time of Locher's youth. So, as in the case of his exemplars, C. F. Sørensen and Drachmann, even from Locher's early years there exist numerous inspired sketches which he alternated with large-scale, carefully accomplished compositions on historical subjects. Thus in 1889 he painted Kong Frederik VII's ligfærd, 1863 (The Funeral of King Frederik VII 1863) and Slaget på Kolberger Heide 1644 (The Battle of Kolberg Roads 1644) for the Museum of National History at Frederiksborg Castle. After the Modern Breakthrough in the 1880s, most of Locher's work consisted of inspired studies of color and atmosphere, usually with the sea and the coast as motifs.

E.F.

LITERATURE: Karl Madsen, *Skagens Malere og Skagens Museum*, Copenhagen 1929; Walter Schwartz in *Politiken* 4.9.1942; Hanne Poulsen, *Danske skibsportrætmalere*, Handels-og Søfartsmuseet på Kronborg, 1985; Claus Olsen in *Weilbach*, vol. 5, Copenhagen 1996.

[1] "Soft-ground etching." Instead of covering the surface with the usual resin, the artist spreads a composition of warmed resin and tallow, using a brush roller, creating a softer ground. He then places a thin sheet of paper on the plate and draws on it with a sharp pencil. The technique dates to the 18th century.

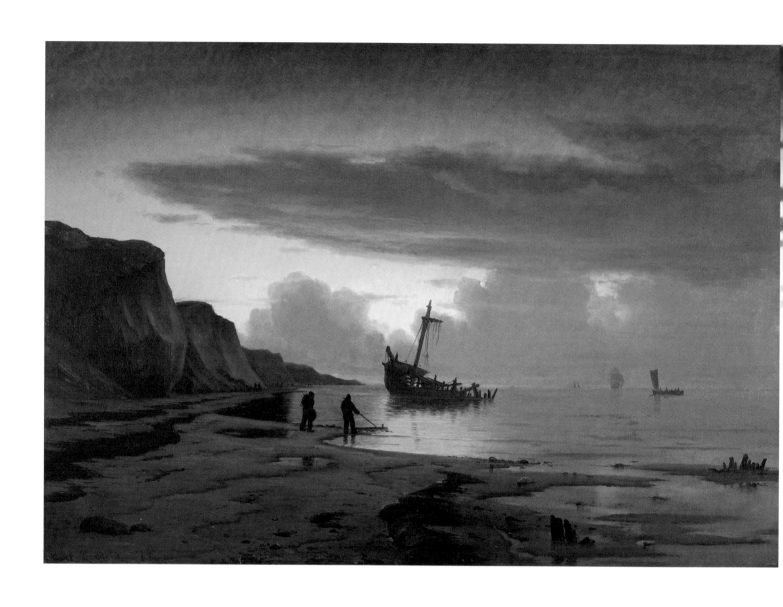

CARL LOCHER
1851–1915

80. *Fishermen by a Wreck Near Kandestederne, 1872*
(Fiskere ved vrag ud for Kandestederne)

Oil on canvas, 34⅔ x 49¼ in. (88 x 125 cm)

Signed and dated lower left: Carl Locher 72

PROVENANCE: Arne Bruun Rasmussen, Auction 453, 1983, lot 121, ill. p. 51.

While Locher was a pupil of Holger Drachmann (1846–1908), the two together visited the northern-most point of Denmark, Skagen, which was very popular among marine artists even before it became a real artists' colony. Christian Blache (1838–1920) and Fritz Thaulow (1847–1906) painted there, and in 1870 Carl Neumann (1833–1891) enjoyed success with a painting of fishermen hauling a seine on the north shore at Skagen (Statens Museum for Kunst). A number of small pictures Locher painted there in 1872 have been preserved, demonstrating his passionate interest in things maritime. This large painting, on the other hand, is a carefully composed work demonstrating that Locher was progressing toward a more academic mode of expression. He often returned to Skagen.

The easiest way of reaching Skagen at that time was by sea. There was no railway from Frederikshavn and the road only went halfway, as far as Aalbæk. From there, visitors had to proceed in an open wagon car-rying the mail, which went along the eastern shore in all kinds of weather. Locher painted this coast on repeated occasions. There were no cobbled streets in the village of Skagen in those days, and the village consisted of a modest number of houses in Vesterby and Østerby, where Brøndum's hostelry was situated. After an 18th-century catastrophe caused by sand drift, houses were built down among the dunes, where further drifting had been stopped by planting galea and lyme grass. Skagen Point, which divides the North Sea from the Kattegat, consists of sand and dunes with low vegetation, and the climate is far harsher than farther south in Denmark. Shipwrecks off the shores around the point were inevitable in former times despite charts and the lighthouses (which are still in existence today). Grenen, the extreme east-pointing tip, constitutes an especially dangerous reef that over the years has claimed the lives of many a seaman.

At Skagen, the marine artists found a host of motifs in the sea, the shore, and the weather, which is at its roughest on the north-facing coast and gentler on the south. In addition, there were many ships that could be seen sailing past, as well as numerous wrecks, providing the artists with suitable subjects for paint-ing. In 1850, the frequent shipwrecks led to a rescue service being established. It was the duty of the local population to assist shipwrecked crews and, if possible, to save the cargoes. Some wrecks were sold and cut up; there was a lack of wood at Skagen, and the houses were usually built of timber from stranded ships. Other wrecks were left on the shore as somber monuments.

In this picture, Locher has chosen to paint two wrecks on the stormy north coast near Kandestederne, a lonely stretch of shore some ten kilometres (6¼ miles) to the west along the North Shore. The serious nature of the motif is underlined by the dramatic dark cloud formations and the sinking sun and thus cor-responds closely to the ideals of marine painting at the time.

E.F.

[307

CARL LOCHER

1851–1915

81. *The Frigate* Jylland *off the Coast of Madeira*, 1877

(Fregatten Jylland ud for Madeiras kyst)

Oil on canvas, 34⅔ x 49½ in. (88 x 126 cm)

Signed and dated lower right: Carl Locher 77

PROVENANCE: Arne Bruun Rasmussen, Auction 453, 1983, lot 120, ill. p. 41.

LITERATURE ON THE HISTORY OF THE FRIGATE JYLLAND: Frits Hammer Kjølsen, *Fregatten fortæller,* Copenhagen 1962; Bent Kure, *Historien om fregatten Jylland,* Copenhagen 1995; Finn Askgaard (ed.), *Fregatten Jylland, fra Orlogsværft til Museumsdok,* Næstved 1996.

The Danish man-of-war *Jylland*, this picture's motif, is seen at a distance, viewed obliquely from the front, all sails set, in the green, foam-topped rollers off Madeira. The artist catches the atmosphere of a beautiful daybreak in which the red morning light tinges the rocky shore and the great sails. The sinking moon is reflected in the water.

In 1875 Carl Locher took part in the frigate *Jylland*'s summer cruise to Madeira, which took him also to northern France, London, Antwerp, and Hamburg. He used this time to make a thorough study of the large ship and often used it as his motif. For instance, in 1877 he exhibited *Quiet Evening on the North Sea, the Frigate* Jylland *Alongside Fishing Vessels*. In 1881 he signed a painting of the *Jylland* in a strong breeze in the Atlantic, which he exhibited in 1884. Many years later, in a large-scale painting from 1898, he included the frigate in compositions in no way related to actual events, as was the general practice among marine artists. He also painted it moored in Copenhagen with a house in the background, which serves as a frame of reference to show the vessel's enormous proportions.

The *Jylland*, built during the years 1860–1862, was the last frigate in the Danish navy to be built in the traditional manner, constructed of oak and full-rigged, although it also had a steam-driven auxiliary motor. The funnel can be seen behind the sails in Locher's picture. The *Jylland* has the classic man-of-war high stern and long, straight sheers[1] and is notable for its white-painted gun deck with black gun ports. During the Second Schleswig War of 1864 the *Jylland*, armed with forty-four cannons, took part in the Battle of Heligoland in which it was badly damaged, with many of its crew killed or injured. In 1874, it was rebuilt as the royal yacht but was occasionally used as a drill ship. The *Jylland* was in service until 1887. Stripped in 1892, it was decommissioned in 1908 and sold for salvage but was immediately bought by a group of private individuals with a view to preservation. Funds were collected on several occasions, but several attempts at restoration failed; the frigate was hogged[2] and was in danger of being abandoned. After a long struggle, the *Jylland* was turned over to a private foundation. A plan was devised for using modern techniques to preserve the ship; the work, which demanded a good deal of reconstruction, was begun in 1984. The frigate was placed in an exhibition dock at Ebeltoft in Jutland and opened as a museum in 1994, as one of the few 19th-century men-of-war to be preserved. The crucial support for the undertaking came from the A.P. Møller og Hustru Chastine Mc-Kinney Møller Foundation. E.F.

[1] The fore-and-aft curvature from bow to stern of a ship's deck as shown in side elevation.

[2] A term meaning that the keel of the ship is broken, usually causing the end of the life of the vessel.

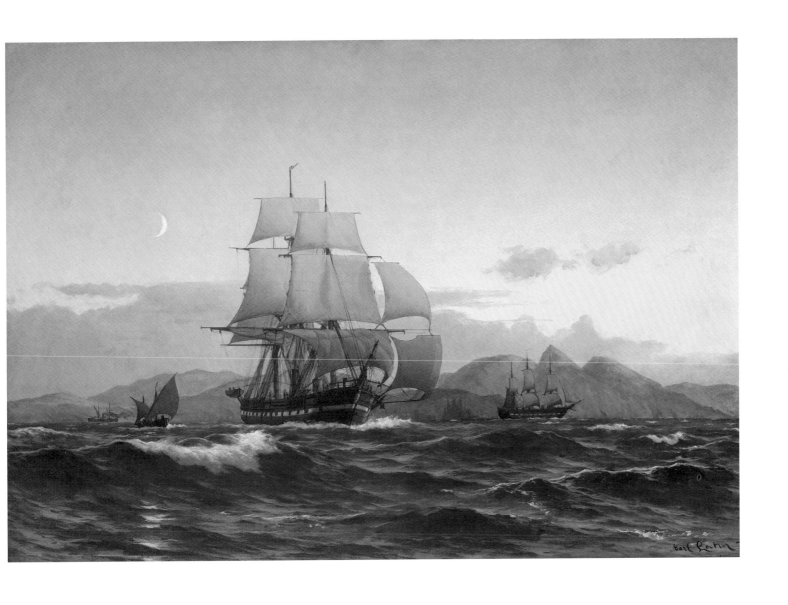

CARL LOCHER
1851–1915

82. *Fishermen Coming Ashore, Hornbæk,*
a preparatory work for an unknown composition
(Fiskerne kommer i land, forarbejde til en ukendt komposition)

Oil on canvas, 16¼ x 25¼ in. (41 x 64 cm)

PROVENANCE: Kunsthallen, Auction 421, 1991, lot 93, ill. (described as *Fiskerne vender hjem*).

LITERATURE: (On the artists' colony in Hornbæk): Kai Flor, *Hornbæk*, Copenhagen 1940; *Mona Faye, Hornbæk i kunsten*, Marienlyst Slot, Elsinore 1997.

Although Carl Locher mainly painted the sea, he also took an interest in figure painting at times. This compositional sketch was clearly painted at Hornbæk, a small fishing village on the north coast of Zealand, just over 10 kilometres (6¼ miles) from Elsinore and Kronborg, today a popular and fashionable holiday resort. From the broad, white sandy beach there is a view of Kullen in Sweden, an interesting sight to Danish eyes as this peninsula is distinguished by cliffs, which in Denmark are found only in Bornholm.

Hornbæk was discovered by artists about 1830, when the Golden Age painters were gradually beginning to take an interest in the fishing population, though they never devoted the same interest to them as to the rural population. In the 1870s, Hornbæk was visited by so many painters that people began to talk of an artists' colony. It became a meeting place for marine painters such as C.F. Sørensen (1818–1879), Holger Drachmann (1846–1908), and Carl Locher and the figure painters Kristian Zahrtmann (1843–1917), Viggo Johansen (1851–1935), P. S. Krøyer, the brothers Frants Henningsen (1850–1908) and Erik Henningsen (1855–1930), as well as two who today are virtually unknown, Bernhard Middelboe (1850–1931) and Holger Roed (1846–1874), the son of Professor Jørgen Roed (1808–1888). It was during this period that Johansen painted his first major genre pictures, including *Mother and Son,* which ensured him success at Charlottenborg. In 1875, before going to France, Krøyer painted the ambitious figure composition *Morning at Hornbæk, The Fishermen Coming Ashore* (Den Hirschsprungske Samling, Copenhagen).

Locher's sketch appears to have been painted on the same stretch of coast but in the afternoon light. The profile of Kullen forms the background, and the wooden constructions jutting out into the water from the shore are seen in many other pictures from Hornbæk. Holger Roed also drew this place. A large group of fishermen are coming ashore, dragging boats up onto the beach, as was necessary

FIG. A P. S. KRØYER
Morning at Hornbæk, The Fishermen Coming Ashore, 1875
(Morgen ved Hornbæk, fiskerne kommer i land)
Oil on canvas, 40⅖ x 63⅗ in. (102.7 x 161.5 cm)
Den Hirschsprungske Samling, Copenhagen

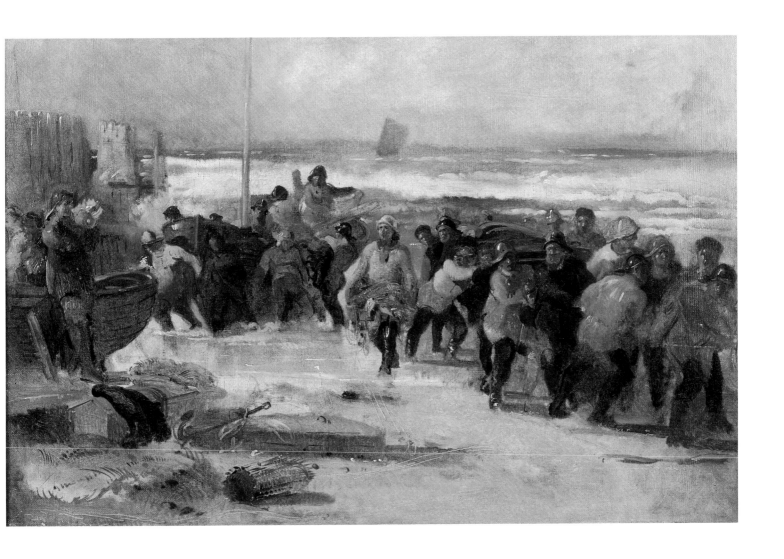

before the harbor was built. If we look at the lighting and the dynamics between the groups of fishermen, Locher's work is of a quite different and more dramatic character than Krøyer's (see Figure A). In terms of time, it could coincide with the days when Locher's impressions from Bonnat's school in Paris were fresh in his memory and reflect his experience of seeing Delacroix's and Géricault's grandiose figure compositions in the Louvre. That would date the sketch to the 1880s, when Locher was a permanent resident in Hornbæk.

We do not know the finished composition that resulted from this sketch, but the sketch invites a broader interpretation. Is the aim to portray seamen who have been saved and are being carried ashore? Among other things, Locher was familiar from Skagen with rescues and shipping disasters, and he knew Michael Ancher's work. Hornbæk was famous for one rescue that C. W. Eckersberg had used as a motif in 1806. In 1774, a group of five fishermen and laborers rescued the skipper from an English ship, the last surviving member of the crew. This deed was remembered in Ove Malling's *Store og gode Handlinger (Great and Good Deeds),* published in 1777 and later translated into several languages including English; the book inspired poet Johannes Ewald to write his play *Fiskerne (The Fisherfolk)* in 1779.

<div style="text-align:right">E.F.</div>

ANDERS CHRISTIAN LUNDE

COPENHAGEN 1809 – COPENHAGEN 1886

There is very little information available on Anders Lunde, although he left a large oeuvre, mainly of landscapes. The occupation of his father, Svend Svendsen Lunde, is referred to as that of a "tea pourer."[1] The son was apprenticed to a painter after his confirmation and he continued to work as an artisan after finishing his apprenticeship. At the same time he was training at the Royal Danish Academy of Fine Arts.

At the Academy we meet Lunde's name as early as 1823, when he was attending the second-year class in freehand drawing. From the Academy papers it emerges that Anders Christian Lunde was following the established path through the plaster class and the life school and that he was awarded the minor silver medal in 1833 and the major medal in 1835. He was also awarded the money prize for "painting after a live model," which it was possible to win before the major silver medal. In 1833, the desire to become an artist seems to have persuaded him to leave the guild of painters, and the following year he exhibited for the first time at Charlottenborg with a "study head from nature."[2]

With a few exceptions, Anders Lunde then exhibited at Charlottenborg every year until 1887, the last occasion being post mortem. In addition, he took part in exhibitions in the Academy of Fine Arts in Stockholm in 1850 and 1870 and in the Nordisk Kunstudstilling in Copenhagen in 1872 and 1883. During his early years, Lunde painted a number of portraits, including one of his father that is now in Statens Museum for Kunst. Later, he produced many landscapes, both Danish and Italian.

After several unsuccessful attempts, Anders Lunde managed to gain support from the Academy for a visit to Italy, which lasted from 1842 to 1847. He is said to have left at his own expense, after which he was given funding for a two-year stay and then managed on his own for the remainder of the time. In 1857 he was accorded recognition at the Royal Danish Academy of Fine Arts in Copenhagen.

During his day, it was pointed out that there was a certain similarity between Lunde and the Holstein painter Louis Gurlitt (1812–1897), especially with regard to the Italian motifs. The two artists were in Italy during the same period.

S.L.

LITERATURE: Philip Weilbach, *Dansk Konstnerlexikon,* Copenhagen 1877–78; Peter Nørgaard Larsen in *Weilbach,* vol. 5, Copenhagen 1996.

[1]An old-fashioned word, used by Weilbach and Peter Nørgaard Larsen about Lunde's father's occupation. Lunde senior probably worked in a restaurant.

[2]A head study of a live model.

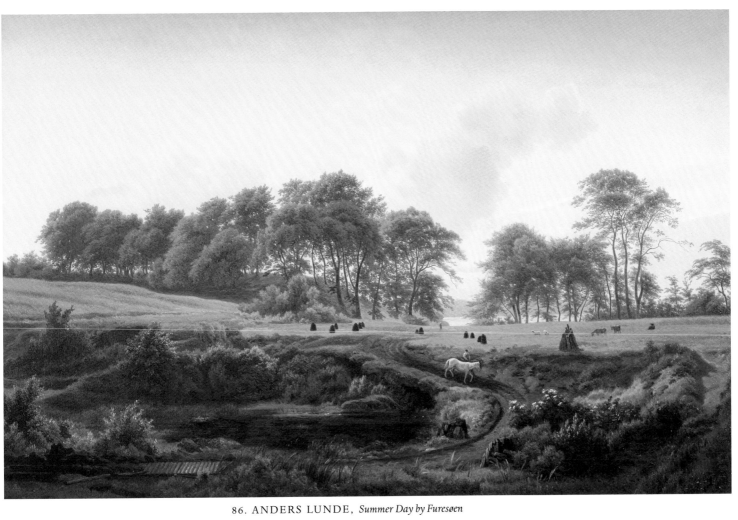

86. ANDERS LUNDE, *Summer Day by Furesøen*

ANDERS LUNDE
1809–1886

86. *Summer Day by Furesøen*
(Sommerdag ved Furesøen)

Oil on canvas, 24¾ x 40½ in. (63 x 103 cm)

Signed lower left with monogram

PROVENANCE: Frederiksberg Ovenlyssal, Auction 282, 1957, lot 22, ill. (described as *Sommerdag ved Furesøen 1875*); Arne Bruun Rasmussen, Auction 483, 1986, lot 33 (described as *Sjællandsk landskab ved en sø, på engen står tørv til tørre*).

EXHIBITED: Presumably Charlottenborg 1873, no. 126 (described as *Ved Furesøen*).

Anders Lunde is one of the lesser-known artists of the Danish Golden Age, and information available about him is sparse and often contradictory. We do know that he has a large oeuvre to his name, consisting mainly of landscapes. An examination of references to him in the Charlottenborg exhibition catalogues reveals especially the names of the most beautiful areas of northern Zealand, such as Ermelund, Hellebæk, Gurre Lake, Rudersdal, Raadvad, and Jægersborg Dyrehave.

For the first edition of Philip Weilbach's *Dansk Kunstnerleksicon*, Anders Lunde provided the information that the Royal Collection of Paintings purchased a landscape from him titled *Strandparti i Nærheden af Taarbæk* (*The Shore near Taarbæk*) which was exhibited in 1841. He also said that he painted *Fredensborg Slot* (*Fredensborg Palace*) for Frederik VII in 1850, a work "that was presented by the King to the Russian Grand Duke."

The extensive, beautiful Furesø Lake is just over 6¼ miles (10 kilometres) northwest of the center of Copenhagen. Lunde exhibited at Charlottenborg a work based on a motif from there in 1873. Although an auction catalogue from 1957 erroneously lists the painting as having been executed in 1875, it seems likely that this work was in fact the Loeb collection's *Summer Day by Furesø Lake*. Indications are that the picture was probably intended for exhibition at Charlottenborg. The meticulous finish is impressive, and it is impossible not to delight in the many descriptive details as we move about in the picture's universe.

S.L.

314]

HOLGER PETER SVANE LÜBBERS

COPENHAGEN 1850 – COPENHAGEN 1931

Holger Lübbers was a grocer's son from Århus, where he started his training. However, he went to Copenhagen to study at the Royal Danish Academy of Fine Arts and was a student there from 1879 to 1882. At the same time he trained on his own as a marine painter. He exhibited at Charlottenborg from 1878 and in 1881 won the Neuhausen Prize. His marine paintings are often detailed, with large numbers of ships off familiar shore localities. He often portrayed the northern part of the Sound off Humlebæk and Hellebæk, frequently with Kronborg Castle as the background to paintings of the heavily used waters between Elsinore and Helsingborg. The busy harbor and roads of Copenhagen were likewise among his favorite motifs. In addition, Lübbers painted ship portraits, for instance one of the frigate Jylland. He also painted in western Jutland and southern Italy and in a few paintings introduced a shore with figures. Lübbers particularly distinguished himself with a number of vivid portrayals of the sea in which the weather plays a crucial role. As marine painters have the primary task of depicting ships and the sea, they have the privilege of being able to paint independently of general developments and fashions in painting.

E.F.

LITERATURE: Hanne Poulsen in *Weilbach*, vol. 5, Copenhagen 1996.

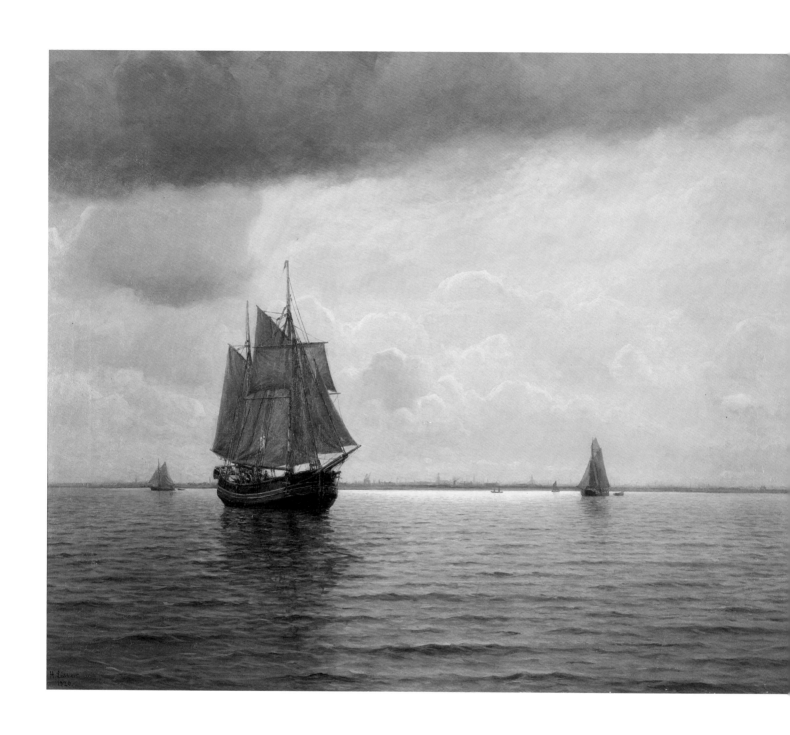

HOLGER LÜBBERS
1850–1931

83. *Freighters in the Sound Outside Copenhagen Harbor,* 1920
(Fragtskibe i Øresund ud for Københavns Havn)

Oil on canvas, 40½ x 49¼ in. (103 x 125 cm)

Signed and dated lower left: H. Lübbers 1920

PROVENANCE: Arne Bruun Rasmussen, Auction 525, 1989, lot 212, ill. p. 27.

The changeable weather in Denmark has always been a welcome challenge to marine artists, and in the course of time has given rise to very different motifs within the relatively narrow range of subjects available to marine painting. The weather plays a crucial role in Lübbers's work, and he often chooses a cloudy day. It is also typical of him that he should portray very early or very late times of day.

Here we are in the Sound at some distance from Copenhagen; the profile of the city forms the background of the picture. A storm cloud is gathering over the artist, and close to the coast the surface of the water is dramatically illuminated by sunbeams falling through a gap in the clouds. Lübbers has taken great care in his portrayal of the foremost ship, a schooner-rigged ketch with flying foresail, while the two in the background are a ketch and probably a yacht respectively. This painting may well have been a work commissioned by a shipowner.

In former times, the sea was the most frequently used means of transport in Denmark, and freighters lay tightly packed in harbors and fjords. Even after the establishment of the railway network small craft continued to be used by the shipping trade, and freighters of the size seen in the picture were common until about 1960, though in time they were driven by machinery. About 1920, when the present picture was painted, this kind of shipping was experiencing difficulties as a result of World War I.

E.F.

JOHAN THOMAS LUNDBYE

KALUNDBORG 1818 – BEDSTED 1848

Alongside Købke with his classical training, J. Th. Lundbye, a Romantic, stands as the artist who perhaps most clearly and wholeheartedly represents the younger generation of the Danish Golden Age.

The son of an army officer, Johan Thomas chose at an early age to follow an artistic career. Despite his father's disapproval, he took private lessons from the animal painter Christian Holm (1803–1846) and was then admitted to the Royal Danish Academy of Fine Arts in 1832 to work under J. L. Lund (1777–1867). Lundbye was registered in the Academy for ten years, though he never won any of the medals.

The museologist and archaeologist Christian Jürgensen Thomsen (1788–1856) gave Lundbye support and advice during his early years. Thomsen had also been a source of help to this young Romantic landscape artist's exemplar, Johan Christian Dahl (1788–1857),¹ when he was studying at the Academy in Copenhagen twenty years earlier.

Lundbye first showed a painting in Charlottenborg in 1835, exhibiting there regularly until the year prior to his death. A landscape from the Sabine Mountains in Italy was also exhibited there posthumously in 1850.

Lundbye's great and only visit abroad, lasting from June 1845 to July 1846, took him through Germany, Switzerland, and the south of France to Rome, where he stayed for seven months. He then went on through Pæstum and Naples and proceeded to northern Italy, where he spent some time in Florence. There he started writing his autobiographical work Trolddom og Huletanker *(Magic and Cave Thoughts). The journey home was through Belgium and Holland, where the collections in the museum in The Hague filled him with intense enthusiasm.*

J. T. Lundbye was a landscape artist, and like his friend and colleague P. C. Skovgaard he was closely associated with the art historian N. L. Høyen (1798–1870), by whose national Romantic ideas he was deeply inspired—as he was also enthralled with the religious ideas of the poet and Lutheran pastor N. F. S. Grundtvig (1783–1872). (Grundtvig's ideas are briefly explained in a footnote in the article about Skovgaaard's Forest with a Herd of Fallow Deer and Two Girls *in the Loeb collection.)*

Lundbye produced pictures of the Danish countryside that were pure eulogies to his native land. With his gigantic principal work, En dansk kyst *1842–43 (A Danish Coastline, Statens Museum for Kunst), which cost him much effort, Lundbye wanted to prove to the world outside that the Danish countryside was in grandeur and beauty in no way inferior to foreign landscapes.*

The artist gradually moved away from spontaneous observations of nature, intending now to bring out typical Romantic and Danish features. His paintings often contained reminders of the glories of former times in the form of burial mounds, churches and medieval castles—and were frequently pieced together from fragments of landscape taken from various localities.

J. Th. Lundbye was perhaps the most widely read and most eager-to-write artist of the Golden Age. His numerous diary entries, letters, and descriptions of works not only throw light on his personal struggles and his artistic self-understanding but they also contain important comments on cultural and political currents of the day.

In 1848 he volunteered for military service and was killed by a stray shot at Bedsted in southern Jutland at the age of only twenty-nine.

S.L.

LITERATURE: Karl Madsen, *Johan Thomas Lundbye 1818–1848*, Copenhagen 1895; F. Hendriksen, *Lorenz Frölich, Egne Optegnelser og Breve til og fra Hans Slægt og Ungdomsvenner*, Copenhagen 1920–21; Johan Thomas Lundbye, *Et Aar af mit Liv*, Copenhagen 1967; Johan Thomas Lundbye, *Rejsedagbøger 1845–1846*, Statens Museum for Kunst, 1976; *Johan Thomas Lundbye 1818–1848 . . . at male det kjære Danmark*, Thorvaldsens Museum 1994 (with English summaries); Hans Edvard Nørregård-Nielsen in *Weilbach*, vol. 5, 1996; Marianne Saabye (ed.), *Tegninger & Huletanker, Johan Thomas Lundbye 1818–1848*, Den Hirschsprungske Samling 1998 (containing articles by Marianne Saabye, Jette Baagøe, Iver Kjær, Bente Skovgaard, and Ejner Johansson).

[1] Johan Christian Dahl (1788–1857), Norwegian landscape artist, was born in Norway while it still belonged to Denmark. He was trained in Copenhagen and lived most of his life in Dresden, Germany, where, like his friend, the famous German painter Caspar David Friedrich (1774–1840), he was a professor in the city's Academy of Fine Arts. Dahl's sense for the Romantic manner of painting and his dramatic, passionate art, which was inspired partly by 17th-century Dutch landscape artists, became an example for the Danish national Romantic painters of the 1830s and 1840s.

J. TH. LUNDBYE
1818–1848

84. *Landscape Near Lake Arresø, Frederiksværk,* 1838

(Landskab ved Arresø, Frederiksværk)

Oil on cardboard or on paper laid down on canvas, 8⅓ x 14½ in. (21.2 x 31.5 cm)

Signed lower right with monogram and dated: May 38

On reverse: J. Th. Lundbye. Studie fra Frederiksværk. Mai 1838

PROVENANCE: Oberstinde E. C. Lundbye; Jernstøber K. Brandt; Winkel & Magnussen, Auction 77 (K. Brandt's estate), 1930, no. 109, ill. p. 23; Mrs. Theodora Vøgg, née Jacobsen (her portrait as a child was painted by A. Jerndorff, now in the Loeb collection); Kunsthallen, Auction 256, 1963, lot 96, ill. p. 13; Arne Bruun Rasmussen, Auction 465, 1984, lot 51, ill. p. 38.

EXHIBITED: Kunstforeningen, Copenhagen, *Arbejder af Johan Thomas Lundbye*, 1893, no. 27; Town Hall, Copenhagen, *Raadhusudstillingen*, 1901, no. 1153; Busch-Reisinger Museum, Harvard University Art Museums, *Danish Paintings of the Nineteenth Century from the Collection of Ambassador John Loeb Jr.*, 1994, no. 13; Artemis Fine Arts, Inc., New York, *Danish Paintings of the Golden Age*, 1999, no. 29, ill.; Scandinavia House, New York, *Danish Paintings from the Golden Age to the Modern Breakthrough, Selections from the Collection of Ambassador John L. Loeb Jr.*, 2013, no. 28.

LITERATURE: Karl Madsen, *Johan Thomas Lundbye*, Copenhagen, 1895, no. 49 (described as *Landskabsstudie*); Karl Madsen, *Johan Thomas Lundbye, 1818–1848*, Copenhagen, 1949 (2nd. ed., revised by Viggo Madsen and Risse See, no. 49, described as *Landskab med store Træer ved Arresø*); Peter Nisbet, *Danish Paintings of the Nineteenth Century from the Collection of Ambassador John Loeb Jr.*, Harvard University, Cambridge, Massachusetts, 1994, discussed and ill. pp. 6–7; to be included in the forthcoming catalogue raisonné and biography on the artists by Hans Edvard Nørregård-Nielsen; Patricia G. Berman, *In Another Light, Danish Painting in the Nineteenth Century*, New York 2007, pp. 114–116, ill. p. 108.

Lundbye's father was an army captain, later colonel. The artist's earliest childhood home was at Kalundborg in northwest Zealand. For ten years from 1826 the family lived in the Citadel in Copenhagen, where the master baker was Christen Købke's father, a fact that is of significance for Danish art history as it explains why Lundbye and his friends who visited him there were early influenced by the slightly older Christen Købke.

In 1836, Lundbye senior was appointed head of the Rocket Corps in Frederiksværk. His artist son, who was now a pupil of Professor J. L. Lund (1777–1867) in the Royal Danish Academy of Fine Arts, remained in Copenhagen, but he often visited his parents in their official residence to the north of the little town lying amidst beautiful countryside, with the northern end of Roskilde Fjord on one side and the huge Arresø Lake on the other. A few kilometers to the north there is Tisvilde, Skovgaard's childhood region—and then the open sea.

This fine little landscape, which derives from one of Lundbye's visits to Frederiksværk, could be an illustration to his oft-quoted diary entries from four years later: *What I have set myself as the aim of my life as a painter is to paint my beloved Denmark, but with all the simplicity and modesty which are so characteristic of it. What beauty there is in these fine lines in our hills, which are so charmingly fashioned like so many waves that they look as though they had appeared from the sea, the mighty sea by whose shores the steep, yellow dunes stand in our forests, fields and moorlands? But only a Dane can paint it . . .* [1]

S.L.

[1] Diary entry, Maundy Thursday 1842, J. Th. Lundbye, *Et Aar af mit Liv*, Copenhagen 1967, p. 47.

J. TH. LUNDBYE
1818–1848

85. *Landscape Study, Sørups Vang, 1840*

(Landskabsstudie, Sørups Vang)

Oil on canvas, 9½ x 12½ in. (24 x 32 cm)

Signed lower left: Sørups Vang 7 Aug 1840

PROVENANCE: Xylograf Fr. Hendriksen (1895); Skibsmægler Hjalmar Bruhn (1945); Arne Bruun Rasmussen, Auction 96, 1958, lot 144, ill. p. 19; Arne Bruun Rasmussen, Auction 243, 1970, lot 15, ill. p. 27; Arne Bruun Rasmussen, Auction 467, 1984, lot 82, ill. p. 65; Bruun Rasmussen, Auction 558, 1991, lot 9, ill. p. 17.

EXHIBITED: Kunstforeningen Copenhagen, *Arbejder af Johan Thomas Lundbye*, 1893, no. 43; Kunstforeningen, Copenhagen, *Malerier af Johan Thomas Lundbye*, 1931, no. 35; Busch-Reisinger Museum, Harvard University Art Museums, *Danish Paintings of the Nineteenth Century from the Collection of Ambassador John Loeb Jr.*, 1994, no. 21.

LITERATURE: Karl Madsen, *Johan Thomas Lundbye, 1818–1848*, Copenhagen 1895, no. 85; Karl Madsen, *Malerier af Johan Thomas Lundbye*, Kunst i Danmark, Ny Række, III, Copenhagen 1931, no. 15, ill.; Karl Madsen, *Johan Thomas Lundbye 1818–1848*, Copenhagen 1949 (2nd ed., revised by Viggo Madsen and Risse See, no. 85, described as *Studie fra Sørups Vang ved Frederiksværk*), mentioned p. 119; Peter Nisbet, *Danish Paintings of the Nineteenth Century from the Collection of Ambassador John Loeb Jr.*, Busch-Reisinger Museum, Harvard University, Cambridge, Massachusetts, 1994, pp. 6–7. To be included in the forthcoming catalogue raisonné and biography on the artist by Hans Edvard Nørregård-Nielsen.

Sørup Vang is situated at the southern end of the big Esrum Lake midway between Hillerød and Fredensborg. When visiting his parents at Frederiksværk, Johan Thomas Lundbye also sought his motifs in the far east of the engaging North Zealand landscape just about equally distant from Frederiksborg Castle and Fredensborg Palace. We see green, sunlit meadows and a field of ripe corn disappearing across spits of land beyond the lake. In the far distance the silhouette of Grib Forest can just be distinguished against a mighty sky filled with drifting clouds into which it merges. The importance of cloud formations in pictures of the Danish countryside, something with which the Golden Age artists were deeply preoccupied, can be seen from the many painted cloud studies from the period.

However, the subject was also examined in literature. The English meteorologist Luke Howard published his *Essay on the Modifications of Clouds* in 1802. In 1820, Goethe made this work widely known in Germany with his *Wolkengestalt nach Howard*. Six years later saw the publication in Copenhagen of the botanist J. F. Schouw's *Skildringer af Vejrligets Tilstand i Danmark* (*Portrayals of Weather Conditions in Denmark*), and in 1840, the same year as that in which Lundbye painted Sørup Vang, the poet B. S. Ingemann published a paper entitled *Den Luke Howardske Skyformationslære betragtet som Billedform for Naturpoesien* (*The Luke Howard Theory of Cloud Formation as an Image for Nature Poetry*). Lundbye was deeply interested in literature and probably knew these works.

The beautiful cloud formations in both the works by Lundbye contained in the Loeb collection may well bear the stamp of these scientific considerations, but they are nevertheless principally the product of the painter's poetical mind and artistic talent.

S.L.

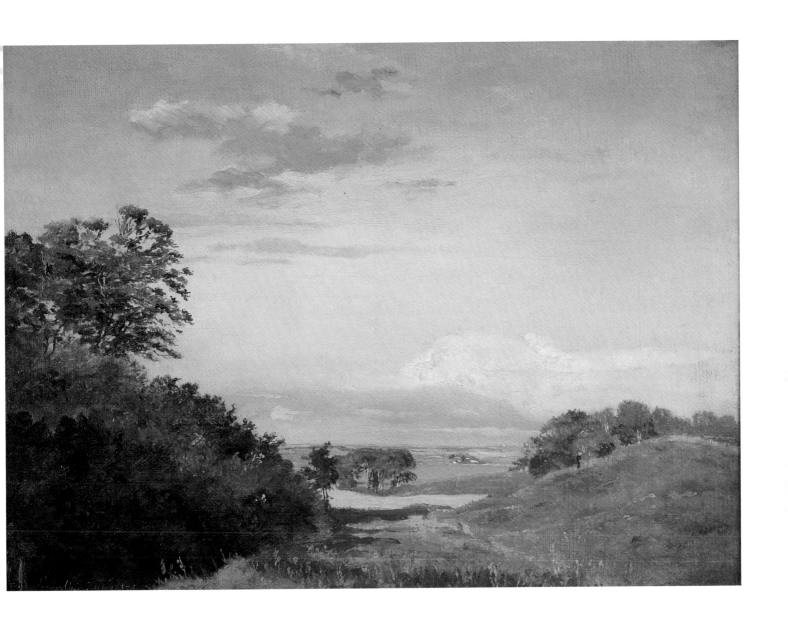

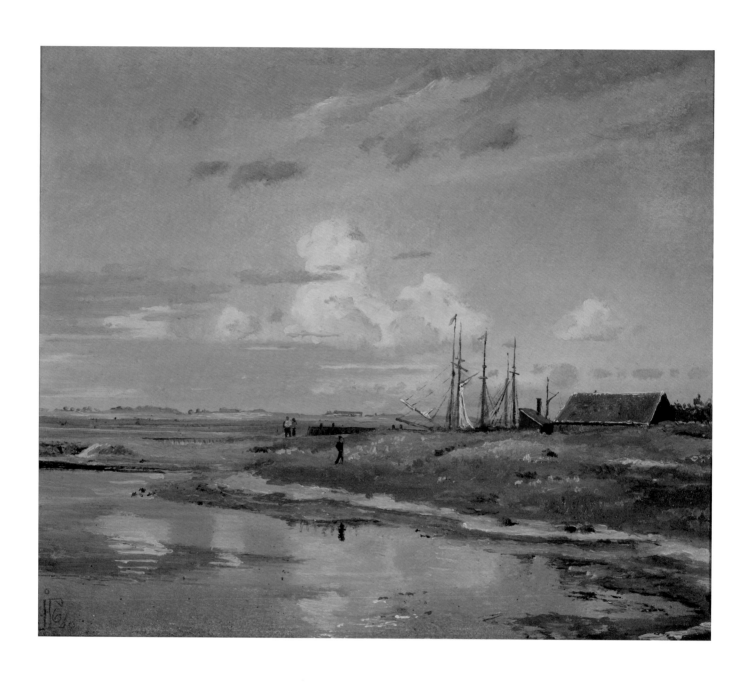

J. TH. LUNDBYE
1818–1848

142. *Ships in a Harbor at Kalundborg Fjord*, 1846
(Skibe i havn ved Kalundborg Fjord)

Oil on paper laid on canvas, 51 x 61 in. (20 x 24 cm)

Signed lower left with monogram and dated: 46

Signed on the back: J. Th. Lundbye. Fjordparti. 1846.

PROVENANCE: Given as a gift from the artist to Inspector of Customs Johan Thomsen in Kalundborg; Physician Christian Myrdahl; Winkel & Magnussen, Auction 243 (Chr. Myrdahl's estate), 1939, lot 100, ill. p. 7 (described as *Parti fra Refsnæs*);[1] Danish private collection (2014).

EXHIBITED: Fyns Kunstmuseum and Storstrøms Kunstmuseum, *Himlens spejl, Skyer og vejrlig i dansk maleri 1770-1880*, 2002–2003, no. 52, ill. p. 193, pl. 36 (described as *Fjordparti*).

LITERATURE: Karl Madsen (Viggo Madsen and Risse See eds.), *Johan Thomas Lundbye 1818 – 1848*, Copenhagen 1949, no. 226 A, mentioned p. 253, ill. p. 251 (described as *Skibe i Havn ved Kallundborg Fjord*); to be included in the forthcoming catalogue raisonné and biography of the artist by Hans Edvard Nørregård-Nielsen.

A sunny late summer day. A wide, blue sky with drifting clouds, mirrored in the sea. A scrap of grassy isthmus, separated from a bit more distant coastline by a narrow strip of deep blue water. A figure of a frail man clad in black, wandering along the nearest shore, his reflection following him in the water as a dog would his master. Two people with their backs turned, lingering farther away, are seen as cheerful dollops of color against the rippling waves of the fjord and the yellow cornfields on the other shore. Next our eyes reach ships with masts as tall as the trees from which they are made, rocking on the water side by side, close to a pair of buildings with red roofs. The many withered-green, yellowish, cream white, red-brown, and gray nuances of color in the land, figures, and ships are met by the tile colors of the roofs and matched by the blue notes in the sky and the sea.

This charming little oil sketch was painted in Kalundborg Harbor and could have been made on a boat close to the shore. This is documented by a later watercolor with the same motif, seen from the city and from a greater distance.[2] However, the artist could possibly have been situated on land. Kalundborg city in the northwest of Zealand is built within a natural fjord on the southern side of the Røsnæs (Refnæs) peninsula that, along with the smaller and somewhat more southerly located Asnæs peninsula, defines the fjord. At the seaside entry to Kalundborg, one passes a small, narrow spit of land, Gisseløre, which points in a southeastern direction and forms a small cove toward the mainland. Lundbye could have been standing with his paint box somewhere here, from where there was a view of the anchored ships by the outer rim of the isthmus and the peninsula of Asnæs.

We are in the late summer of 1846. Lundbye has just returned home after his long journey abroad (cf. biography) and is now back in his beloved Denmark, which he continually longed for and had defined as his life goal to paint.

Kalundborg was the artist's birthplace, where he spent the first eight years of his childhood, and where his mother had returned as a widow to take care of her elderly parents. Just prior to leaving for a trip

abroad, Lundbye drew a picture of his maternal grandfather, customs inspector Emanuel Bonnevie (1763–1846), sitting in his dressing gown by the window in his house at Skibbroegade 129.[3]

Lundbye was deeply attached to his mother, and after his return to Copenhagen July 18, 1846 on the steamboat *The Lion* from Kiel, he traveled as fast as possible to the Kalundborg region, where letters from him to P. C. Skovgaard (among others) tell how happy he now was and how well he was working. Among other studies, he created one for *The Mill Hill at Kalundborg (Møllebakken ved Kalundborg).*[4]

However, he does not mention *Ships in a Harbor at Kalundborg Fjord*—nor the other, slightly smaller oil sketch that he gave to inspector of customs Johan Thomsen: *View of the Seaside of Kalundborg (Udsigt over Kalundborg, set fra søsiden)* (cf. note 1).

All that is known about Johan Thomsen comes from an 1845 census, where it was noted that he was the local customs cashier, was 34 years old, was born in Copenhagen, and resided in Skibbroegade in Kalundborg. The street number is not stated. According to the same census lists, Johan Thomsen did not live on the premises of no. 129, where the Bonnevie family resided. However, there can hardly be any doubt that the young customs officer knew the old Bonnevie and may have been appointed as his successor. Thus Lundbye could have met Johan Thomsen through his grandfather, and either of the two customs officers might have inspired this painting by explaining to the young artist the importance of Kalundborg as a port and the maritime duties of the anchored ships.[5]

The small painting is a sketch, not meant as a study for an exhibition piece. The fast, lively brushstrokes add life and nerve to the picture, which makes the human figures appear as thickly applied lines without contours. Professor N. L. Høyen would consider such a work a "smear painting" and would not have approved it as a legitimate work of art. Here, one should think fifty years forward to the French Impressionists who, under great resistance, paved the way for sketch to be considered legitimate art.

Even though J. Th. Lundbye enjoyed recognition for his outstanding animal and landscape portrayals throughout his short life, he often doubted his own worth as an artist. For long periods he suffered from depression, and he was depressed during his tour abroad. On the last page in his travel diary, he wrote from Altona on June 16, 1846, that his friends had said a loving good-bye to a "sickling" but that they hoped to see him again as "strong and healthy."[6] And so it was to be.

Lundbye's pictures from the Kalundborg region are characterized by overconfidence and something close to rapture over his return to Denmark and his hometown. Maritime paintings like this one are not the usual subjects of Lundbye's work, but this painting of the harbor entrance fully lives up to his own and his friends' expectations of the journey.

A diary paragraph from December 9, 1846, ends as follows: "… as a lovely fairy tale now the whole journey lies before me, as one of the most wonderful fables we never tire of hearing over and over again—I am so happy in this and thank God for this happiness, for a great happiness I can only consider that which tore me out of my despair and gave me back my joy."[7]

<div style="text-align: right">S. L.</div>

[1]The physician Chr. Myrdahl also owned *View of the Seaside of Kalundborg (Udsigt over Kalundborg, set fra søsiden)*. Sign. monogram. 5½ x 9½ in. (14 x 24 cm). This little picture was also given by the artist to inspector of customs Johan Thomsen in Kalundborg. Present owner unknown.

[2]Wholesaler, painter Axel Peter Ditmar (1833-1899), *The Harbor of Kalundborg (Havnen i Kalundborg)* (around 1859), watercolor. Present owner unknown. Many thanks to Ulla Hærslev, Kalundborg Local Archive.

3 *Justice of the Supreme Court, Inspector of Customs E. Bonnevie, the maternal grandfather of the artist*, May 1845. Pen, brush, ink and watercolor, 8¾ x 7 in. (221 x 178 mm). National Gallery of Denmark, Department of Prints and Drawings. Shortly after the old man's death in November 1846, the drawing was used as a model for an etching entitled *Christmas present for family and friends from JTL 49*.

4 *Study for the Mill Hill at Kalundborg (Studie til Møllebakken ved Kalundborg)*, 1846. Oil on canvas, 9¼ x 12¾ in. (23.5 x 32.5 cm). Ny Carlsberg Glyptotek. Lundbye's mother was at Fyn at the time of the return of her son and consequently did not see her son before the end of August. He remained in the home with his mother and his elderly, weak grandparents for fourteen days.

5 In the picture you see two larger vessels, a schooner and a ketch, along with three one-masted cargo ships (called yachts) a bit farther away. All three are typical cargo ships that conducted domestic trade between the Danish regions, carrying agricultural and other goods, while the schooner and the ketch were used in nearby European shipping to the Baltic Sea, England, and the Canal coast. Here, the outgoing cargo was most typically grain for England, returning with coal for the emerging Danish industrialism. Back then, Kalundborg was a typical grain export harbor, thanks to large estates and other significant farmsteads in the fertile hinterlands of the city. Many thanks to Asger Nørlund Christensen, The Maritime Museum of Denmark.

6 Johan Thomas Lundbye, *Rejsedagbøger 1845–1846*, The National Gallery of Denmark, Department of Prints and Drawings, Copenhagen 1976.

7 Ibid. Introduction by Bjarne Jørnæs, quoted from Karl Madsen's selection of Lundbye's diary entries, p. 21, p. 274.

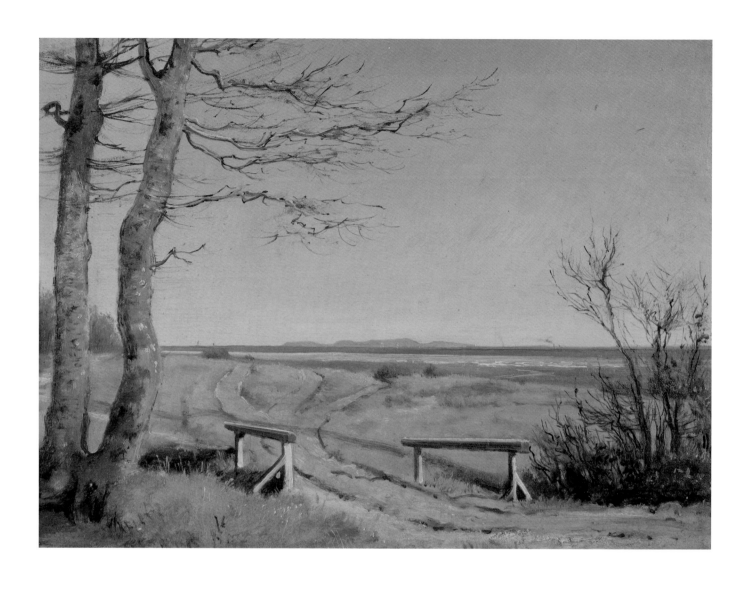

J. TH. LUNDBYE
1818–1848

147. *View toward Kullen, Sweden, from Julebæksbroen (the Julebæk Bridge)*, 1848

(Udsigt mod Kullen fra Julebæksbroen)

Oil on paper laid on canvas, 11 x 14½ in. (28 x 37 cm)

Signed lower left with monogram and dated: februari 48 Godt-Haab

Inscribed on the stretcher with black ink: J. Th. Lundbye, Julebæksbroen ved Hellebæk 1848 ¹⁰⁄₂

PROVENANCE: The artist's mother, widow Cathrine Lundbye; Professor J. L. Ussing, acquired directly from the artist's mother; M. E. Ussing (1931); descendants of J. L. Ussing; Bruun Rasmussen Auction 857, 2015, lot 8, ill. p. 19 (described as *Udsigt mod Kullen fra Julebæksbroen*).

EXHIBITED: Kunstforeningen, Copenhagen, *Arbejder af Johan Thomas Lundbye udstillede i Kunstforeningen i København*, 1893, no. 150; Town Hall, Copenhagen, *Raadhusudstillingen af Dansk Kunst*, 1901, no. 1188; Kunstforeningen, Copenhagen, *Malerier af Johan Thomas Lundbye (1818–1848)*, 1931, no. 108.

LITERATURE: Karl Madsen: *Johan Thomas Lundbye 1818–1848*, Copenhagen 1895, no. 260, ill. (drawing by Karl Madsen) p. 264; Karl Madsen, *Malerier af Johan Thomas Lundbye*, Copenhagen 1931, no. 43, ill.; Viggo Madsen, Risse See (eds.), Karl Madsen, *Johan Thomas Lundbye 1818–1848*, Copenhagen 1949, no. 260, ill. p. 21818–184895; Marianne Saabye (ed.), *Tegninger & Huletanker, Johan Thomas Lundbye 1818–1848*, Den Hirschsprungske Samling, Copenhagen 1998 (containing articles by Marianne Saabye, Jette Baagøe, Iver Kjær, Bente Skovgaard and Ejner Johansson); Bente Bramming, *Længsel hos Lundbye* in Bente Bramming, Hans Edvard Nørregård-Nielsen, Ettore Rocca (eds.), *Længsel, Lundbye og Kierkegaard*, Aarhus 2013, pp. 99–153; to be included in the forthcoming catalogue raisonné and biography on the artist by Hans Edvard Nørregård-Nielsen.

H ere we have a sun bright winter's day, with two beech trees grown together and a primitive wooden bridge spanning a partially overgrown creek. Deep wheel tracks start in parallel courses in the matted soil between the railings of the bridge, then point in diverging directions across a flat landscape covered by withered grass, glowing with an unusual pale gold hue. A horizontal coastal line lies under a wide, clear blue sky. White waves splash in a bright blue sea that darkens as it reaches the Swedish shore, above which the Kullen headland appears.[1]

This Luncbye oil study in the Loeb collection is a small piece that at first glance seems just a simple landscape. Looking closer, it captivates with its wonderful clarity and richness of color. The picture was a preliminary study for a larger exhibition painting. Along with six other works, this was the last piece the painter produced for the annual exhibition at the Royal Danish Academy of Art in the spring of 1848.

A short character study of J. Th. Lundbye and his art, including the last years of the artists's life, were written by one of his many good friends, archaeologist Johan Louis Ussing (1820–1905), who had met with the painter in Rome a few years before.[2] Among the comments he made about Lundbye were that though he had been reluctant to leave Denmark, Lundbye had wanted for a long time to see Italy's great art. The talented painter worked tirelessly depicting what he saw in Rome, but he longed to return to Denmark.

By mid-July 1846, Lundbye had come home from his time studying abroad, happy and grateful to see his beloved Denmark again and relieved because he felt freed from his recurrent depression and low selfesteem. During his stay abroad, he had begun the strange sketchbook *Trolddom og Hule-Tanker* (*Sorcery and Cave Thoughts*), in which he drew himself as a gnome or *tomte* (a mischievous creature). Under the

FIG. A *On High Stilts,* 1846
Pencil, black ink, watercolor, 5¼ x 7½ in. (133 x 190 mm)
Signed lower right: Florenz 14. April
The sketchbook *Trolddom og Hule-Tanker (Sorcery and Cave Thoughts),* 1846–48, leaf no. 3
The Hirschsprung Collection

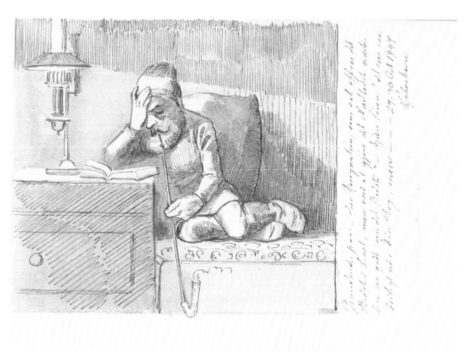

FIG. B *Rooted In Resignation,* 1847
Pencil, brown ink, and wash, 5¼ x 7½ in. (133 x 190 mm)
The sketchbook *Trolddom og Hule-Tanker (Sorcery and Cave Thoughts),* 1846–48, leaf no. 27
The Hirschsprung Collection

330]

name "Bakketrolden Sindre" ("the hill troll Sindre"), Lundbye portrayed his alter ego in a long series of imaginary situations which were actually expressions of his frequent angst, shown with a unique mix of humor and melancholy.[3]

After his return in 1846, Lundbye had a productive and happy late summer in the region around the town of Kalundborg, where he was born,[4] followed by an industrious winter in Copenhagen that resulted in, among other pieces, four large paintings for the spring exhibition at Charlottenborg in 1847, one of which was purchased by the Royal Collection of Paintings.[5]

However, after another good summer filled with drawn and painted studies from his favorite areas in northern Zealand, depression and self-reproach once again began tormenting Lundbye.

He had returned to Copenhagen in September 1847. Here he had, as so often before, been struck by infatuation, this time falling deeply in love with Georgia Schouw,[6] ten years his junior, and his love was reciprocated. Lundbye, however, did not think himself deserving of this love-induced bliss. He had again begun to doubt his worth, both as a human being and as an artist. He felt unbearably torn between his longing for a woman's love and his pursuit of heavenly joy: two strong feelings that could not be reconciled in his mind. Regarding this, for him a hopeless dilemma, he found some sort of comfort and encouragement in reading the writings of theologist and philosopher Søren Kierkegaard. They seemed to command him to cease relationships with women (currently Georgia) and focus on what he called the "next best"—his art and his profound belief in God. Again, Lundbye drew himself in the Sindre's image, "on the ground of resolving to sacrifice the best thing in life by making the next best as good as the best—dear Soren! It looks so right in your book, but—29–30 Oct 1847 Copenhagen" (Fig. B).[7]

J. Th. Lundbye's artistic need to communicate was not expressed solely in drawings and paintings. Throughout his life, he kept a journal about all that moved him, as well as many reflective, often joyful but also melancholy and much troubled, letters to friends and acquaintances, most especially to his mother, whom he treasured over anyone else. Lundbye was intellectually gifted and from his boyhood had avidly studied classical poetry and prose. Søren Kierkegaard's thoughts on existence and belief consumed the young Lundbye with increasing intensity in the last years of his short life.

On January 20, 1848, King Christian VIII died suddenly and was succeeded by his son, Frederik VII.[8] The violent political turmoil that immediately ensued would develop into the abolition of absolute monarchy and war with the duchies of Schleswig-Holstein, but none of this distracted Lundbye. Unlike his comrades, he did not take any interest in politics but the noise and agitated mood of the city disturbed his peace. He wanted to get away from Copenhagen.

On February 9, Lundbye traveled to northern Zealand and took a fortnight's lodging in the town of Godt-Håb (Good Hope), not far from the coastal town Hellebæk. While there, he produced a good number of exquisite drawings and oil studies, including this one in the Loeb collection, *View toward Kullen, Sweden, from Julebækbroen (Julebæk Bridge)*.

On the northern shore of Zealand, between Hornbæk and Elsinore, the small creek Julebækken runs out into Øresund. It was this view that Lundbye chose for his new painting. We can see how he delighted in the clear, cold air, the sea, the sky, and the lonely, sunlit landscape.

Lundbye returned from Godt-Haab with a large number of successful works that to his great joy were praised by both Professor Høyen and his painter friend P. C. Skovgaard. Subsequently, the two artists must

have been busy finishing their pictures for the Charlottenborg Exhibition, which as usual was to open on March 31. Lundbye's last great painting, *Winter landscape—the Julebæk bridge with view of Kullen and Höganäs*,[9] was based primarily on his preliminary study, which is now in the Loeb collection. The larger painting, with some changes, is now in the Skovgaard Museum, Viborg, Denmark.

It was most likely without their usual excitement that the young painters showed up at Kongens Nytorv with their exhibition pieces that year; their thoughts were quite certainly with the war down in Schleswig-Holstein. Copenhagen had become a political hotbed; everyone was seized by national furor, including, by now, Lundbye. During February 1848, the turmoil of the French Revolution had spread to most of Europe, including the duchies of Holstein and Schleswig, where there was a push for a free constitution, independence from Denmark, and the merging of both dukedoms into the German Confederation without taking into consideration that the northern half of Schleswig was Danish-minded and Danish-speaking. In Copenhagen, agitated citizens went to the king, demanding the end of absolutism. With no resistance from Frederik VII, his old cabinet dissolved, and the new, popularly elected March Ministry was formed. However, more troubles loomed. An armed rebellion for secession had broken out in the duchies, whose allies, because of misleading rumors, considered the change in the constitution in Copenhagen to be a coup against King Frederik VII and the legitimate government.

Along with a large number of young volunteers—over a thousand, including the young archaeologist J. L. Ussing—Lundbye and Skovgaard enlisted for training in military service at the Central-Exercerskolen af 27. Marts for Studenter, Kunstnere og Polyteknikere (The Central Drill School of March 27 for Students, Artists, and Polytechnicians) in Copenhagen. After no more than about fourteen days of intense training, Lundbye could write in his journal on April 15 that he had enlisted in the army and would be speedily sent to the war scene. The entry in his diary ended that day with the prescient sentence, often quoted: "If a stray bullet—then it will only bring a heart to rest, that suffers from more painful wounds. God bless Denmark! And my mother!"[10] Indeed, it was a stray bullet that killed him.

P. C. Skovgaard was rejected for active service and had to remain in Copenhagen. J. L. Ussing did not go either. As a royal official, he received an intractable rejection to his application by Monrad, Minister of Culture. Ussing recounts that episode in his previously mentioned memories, where he also described his last meeting with Lundbye: "My neighbor during the exercises was my dear friend, the painter J. T. Lundbye. It was the last time I saw him. At the end of April he departed for the army in Sundeved[11] along with Svend Grundtvig and Carlos Dalgas, and a few days later he was killed, a victim of the unhappy shooting accident at Bedsted Field." Wrapped in the flag of Denmark, J. Th. Lundbye was buried at the nearby Bedsted Cemetery.

In January 1863—not many months before the outbreak of the Second Schleswig War, so fateful for Denmark—Lundbye's mother died. Despite all warnings, she had traveled to Southern Jutland in the hard winter to see her son's grave this one time. She was buried by his side. Presumably, several years earlier, J. L. Ussing had acquired Lundbye's beautiful little oil study from her, with the tracks in the road veering in divergent directions, as if they were the painter's questions about life choices.

S.L.

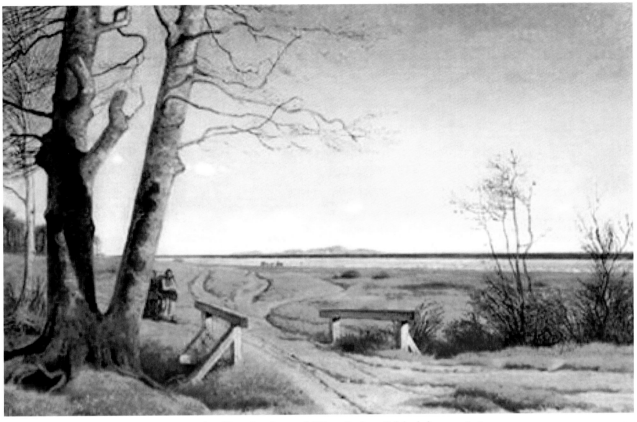

FIG. C *Winter Landscape. View toward Kullen, Sweden and Höganäs from Julebæksbroen,* 1848
Oil on canvas, 23½ x 36½ in. (60 x 93 cm)
Skovgaard Museet, Viborg

[1]Kullen is the name of the long headland that lies by the entrance to Øresund in Höganäs municipality, in the northwestern Skåne, Sweden. The Kullen peninsula is situated across from the upper coast of northern Zeeland.

[2]Johan Louis Ussing (1820–1905) was a Danish philologist and archaeologist who later became known for promoting Danish knowledge of ancient Roman and ancient Greek culture. J. L. Ussing, *Af mit Levned,* published by his sons, Copenhagen 1906.

[3]J. Th. Lundbye, *Trolddom & Huletanker, 1846–48,* Den Hirschsprungske Samling 1998. Sketchbook with a series of drawings with Lundbye himself in the shape of the hill troll Sindre as the recurring motif. Comprised of leaves produced mostly during the last part of Lundbye's travel abroad, and ended on April 15, 1848, eleven days before his death. On the last drawing, dated 30 March 48, the *tomte.* Sindre is featured as a volunteer soldier.

[4]Cf. *Ships in a Harbor at Kalundborg Fjord,* 1846. Loeb collection no. 142.

[5]*A Milking-Place near the Manor og Vognserup (Malkeplads ved Herregaarden Vognserup).* Exhibited at the Charlottenborg Exhibition 1847, no. 120.

[6]Georgia Schouw (1828–1868). After the death of Lundbye, Georgia and P. C. Skovgaard got together, sharing their grief over the death of their mutual friend. The following year they were engaged, and in 1851 they were married. Cf. Loeb collection no. 143. *Driveway near Vejle, in the background the town.*

[7]Søren Kierkegaard (1813–1855), theologist and philosopher, father of Christian Existentialism.

[8]Christian VIII (1786–1848), king of Denmark from 1839, followed by his son, Frederik VII (1808–1863).

[9]*Winter Landscape with a View toward Kullen, Sweden and Höganäs from Julebæksbroen (Vinterlandskab. Julebæksbroen med Udsigt mod Kullen og Höganäs),* 1848. Oil on canvas, 23½ x 36½ in. (60 x 93 cm). Signed lower right with monogram and "48 Mrtz."

[10]See further Ejner Johansson, "Den sidste måned i Lundbyes liv. Maleren i krig 1848" ("The last month in Lundbye's life. The painter at war 1848") in Marianne Saabye (ed.), *Tegninger & Huletanker, Johan Thomas Lundbye 1818–1848,* Den Hirschsprungske Samling 1998, pp. 91–120.

[11]Sundeved is a peninsula between Aabenraa Fjord and Flensborg Fjord. Svend Grundtvig (1824–1883), son of N. F. S. Grundtvig. Carlo Dalgas (1821–1851) died after being critically wounded in the last battle of the war at Møllhorst in Schleswig-Holstein.

NICOLAI WILHELM MARSTRAND

COPENHAGEN 1810 – COPENHAGEN 1873

Wilhelm Marstrand started at the Royal Danish Academy of Fine Arts in 1825 and the following year was accepted as a pupil in C. W. Eckersberg's private studio, together with others including Martinus Rørbye. (Eckersberg had known Wilhelm Marstrand since he was a boy and was aware of his excellent abilities. Wilhelm's father, N. J. Marstrand, was an instrument maker and later a commercial counselor—an honorary title given by the king to people connected with commerce; he and Professor Eckersberg were close friends and often made music together.)

In the course of his approximately ten years in the Academy, Marstrand won the silver medals but twice competed in vain for the gold medal. He showed his first painting at Charlottenborg in 1829 and then exhibited there almost every year until 1873. Two grants from the Fonden ad Usus Publicos enabled Marstrand to travel abroad. He was in Norway in 1835, the following year going to Rome via Berlin, Dresden, and Munich. He stayed in Rome for almost four years, returning to Denmark via Paris. In the mid-1840s and early 1850s he was again in Italy. He also visited Amsterdam, southern Italy, Sweden, Vienna, and in 1862 was in London together with N. L. Høyen (1798–1870) and P. C. Skovgaard. During the spring and summer of 1869 he visited Rome for the last time—on this occasion with the lithographer Adolf Kittendorff (1820–1902) and P. C. Skovgaard. Before going abroad, the young Wilhelm Marstrand painted several Copenhagen genre scenes, sometimes verging on caricature and making some subtle point. In Italy he continued painting scenes of everyday life, often in an ambiguous, humorous idiom. But he also threw himself into large-scale compositions containing numerous figures and vivid, colorful pictures of Italians dancing and making merry. Even before his visits, he had familiarized himself with everyday life in Rome through the etchings of the Italian artist Bartolomeo Pinelli (1781–1835). Once home in Copenhagen, Marstrand continued with his narrative and illustrative works. The social comedies of Ludvig Holberg (1684–1754), which since their appearance in the 1720s had enjoyed widespread popularity in Denmark, provided a series of choice motifs for Marstrand, and a few years later, episodes from Cervantes's Don Quixote *(published 1605–1615) also found their way into his repertoire.*

Marstrand could not identify with the burgeoning nationalism of the 1840s. In a letter home, he wrote, "What have all these politics, nationality and corn taxes to do with artistic effect and the beauty of line? What is meant by saying that art should be national?"[1] In his later years he developed an interest in history painting, helping restore this genre to favor. Wilhelm Marstrand became a professor in the Academy in 1848; he was the director from 1853 to 1857 and again from 1863 to 1873.

S.L.

LITERATURE: Karl Madsen, *Wilhelm Marstrand 1810–1873*, Copenhagen 1905; *Nivaagaard viser Marstrand*, Nivaagaard 1992 (containing articles by Gitte Valentiner, Elizabeth Cederstrøm, Kirsten Nørregaard Pedersen, Bent Holm, Claus M. Smidt, and Erik Fischer); Gitte Valentiner, *Wilhelm Marstrand Scenebilleder*, Copenhagen 1992; Stig Miss in *Weilbach*, vol. 5, 1996; Otto Marstrand, *Maleren Wilhelm Marstrand*, Copenhagen 2003.

[1]Gitte Valentiner, 1992, p. 72 and note 38.

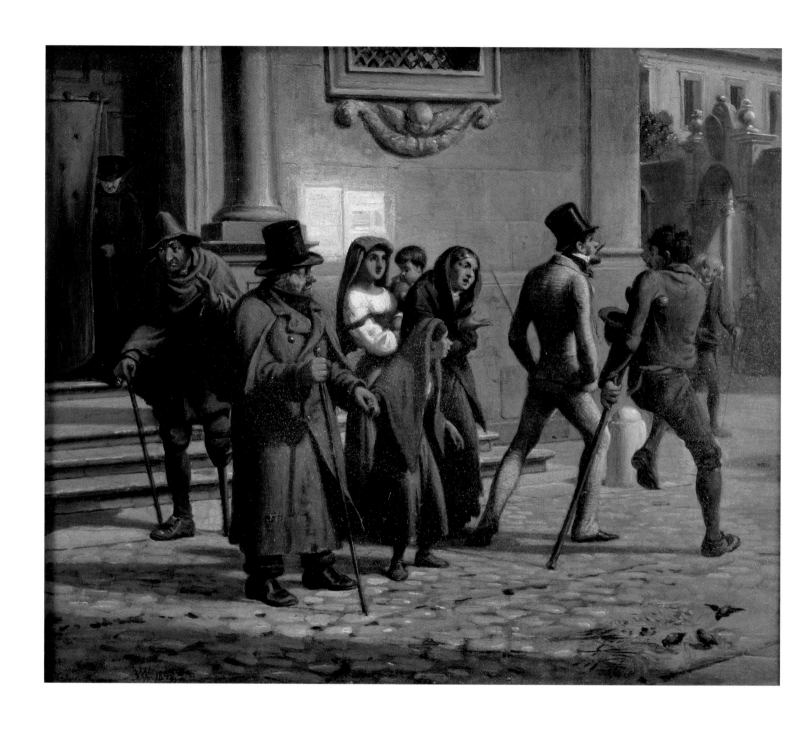

WILHELM MARSTRAND
1810–1873

87. *An Englishman Pursued by Beggars in Rome*, 1848
(En englænder forfulgt af tiggere i Rom)

Oil on canvas, 11 x 12½ in. (28 x 32 cm)

Signed and dated lower left with monogram, dated 1848

PROVENANCE: Professor E. Holm (1898); Director Max Lester; Winkel & Magnussen, Auction 26 (Max Lester, Part 2), 1924, no. 68, ill. p. 9; Director Gorm Rasmussen; Winkel & Magnussen, Auction 206 (Gorm Rasmussen), 1936, no. 19, ill. p. 28; Grosserer Jul. Tafdrup, Vedbæk (1945); Bruun Rasmussen, Auction 465, 1984, lot 56, ill. p. 44.

EXHIBITED: Charlottenborg 1850, Tillæg no. 234 (described as *Tiggere i Rom*); Charlottenborg, Kunstforeningen, *Wilhelm Marstrand*, Charlottenborg 1898, no. 226 (incorrect measurements); Busch-Reisinger Museum, Harvard University Art Museums, *Danish Paintings of the Nineteenth Century from the Collection of Ambassador John Loeb Jr.*, 1994, no. 22.

LITERATURE: Karl Madsen, *Wilhelm Marstrand, 1810–1873*, Copenhagen 1905, p. 125, ill.; Kai Grunth, Max-Lester Auktionen in *Samleren* 1924, p. 176; Herman Madsen, *Kunst i Privat Eje*, I–III, Copenhagen, 1944–45, vol. III, p. 179, ill.; Peter Nisbet, *Danish Paintings of the Nineteenth Century from the Collection of Ambassador John Loeb Jr.*, Busch-Reisinger Museum, Harvard University, Cambridge, Massachusetts, 1994, discussed and ill. p. 9.

In 1898 Wilhelm Marstrand's first biographer, the painter and art historian Karl Madsen, assembled and arranged the Copenhagen Art Society (Kunstforeningen) Marstrand Exhibition, which he provided with appropriate details of the measurements and materials used by Marstrand. He then wrote a detailed monograph on the artist, published by the Society in 1905. The material was so extensive and apparently so difficult to encompass that in consultation with the Art Society administrators he abandoned the idea of furnishing his book with a complete list of Marstrand's works.

This might explain why the measurements of *An Englishman Pursued by Beggars on the Streets of Rome* were erroneously given in the 1898 exhibition catalogue as 47 x 37 cm (18½ x 14½ in.). Another explanation might be that it was reduced in height on a later occasion, before being reproduced in the monograph. The whereabouts of a drawing with the same motif, said to have belonged to the Henriques family (relatives of the painter Salomon [Sally] Henriques), are today unknown.[1]

Marstrand's main aim, following instruction in the Royal Danish Academy of Fine Arts, had been to become a history painter, but as was the case with most of Eckersberg's gifted pupils, he soon began drawing and painting genre scenes from everyday life in Copenhagen.

Instead of executing unmarketable works with historical, religious, or mythological motifs set in an ideal, divine universe, the young artists selected as their motifs situations from everyday life, portraying the ways in which ordinary human beings related to each other. Marstrand's genre pictures often had a humorous or satirical content, sometimes bordering on pessimism, but never showed signs of social indignation.

His inspiration came from the English artist William Hogarth (1697–1764) and probably from the etchings titled *Scenes from Popular Life in Rome*, 1820–1821, by the Italian painter and graphic artist Bartolomeo Pinelli (1781–1835), works that enjoyed great popularity among the Copenhagen artists.

In Rome Marstrand continued largely in the same vein, though with a difference: in contrast to his painting in Copenhagen, he was no longer at home but was depicting as an observant tourist.

A quite different kind of tourist was the "English fop" in the Loeb collection painting, whom Karl Madsen characterises as "... wearing a tight-Wtting light blue suit, his cigar stuck in the air, his top hat at the back of his head and his hands in his pockets, strutting past the entrance to a church unaVected by the beggars' attempts to awaken his sympathy. And in addition they are almost speechless at his appearance. A little girl with a red shawl over her head and leading a blind beggar by the hand, stops in amazement and stares after the apparition with her mouth wide open—she can scarcely believe her own eyes."[2]

S.L.

[1] I am grateful to Gitte Valentiner for her information regarding this painting.
[2] Karl Madsen, *Wilhelm Marstrand*, 1905, p. 125.

WILHELM MARSTRAND
1810–1873

88. *The Goose Girl, Rome*

(Gåsepigen, italiensk pige med en gås i romersk park)

Oil on canvas, 20 x 14½ in. (51 x 37 cm)

Signed with initials lower left: W.M.

PROVENANCE: Kunsthallen, Auction 440, 1994, lot 93, ill. p. 25.

Wilhelm Marstrand visited Rome three times. The first two stays were the longest: from 1836 to 1840 and again from 1845 to 1848, though this latter was interrupted with an excursion during the summer to Ischia and Sicily. During the summer and autumn of 1869, Marstrand was again in Rome, this time accompanied by the painter P. C. Skovgaard and the lithographer Adolph Kittendorff (1820–1902).

This charming portrayal of a pretty young girl, who has apparently been collecting eggs in her apron and is anxiously drawing back from a goose of rather belligerent aspect, is thought to be set in a Roman park. Marstrand had perhaps captured the situation in his sketchpad with a view to later developing the painting, but it is not possible to say exactly when he did so.

S.L.

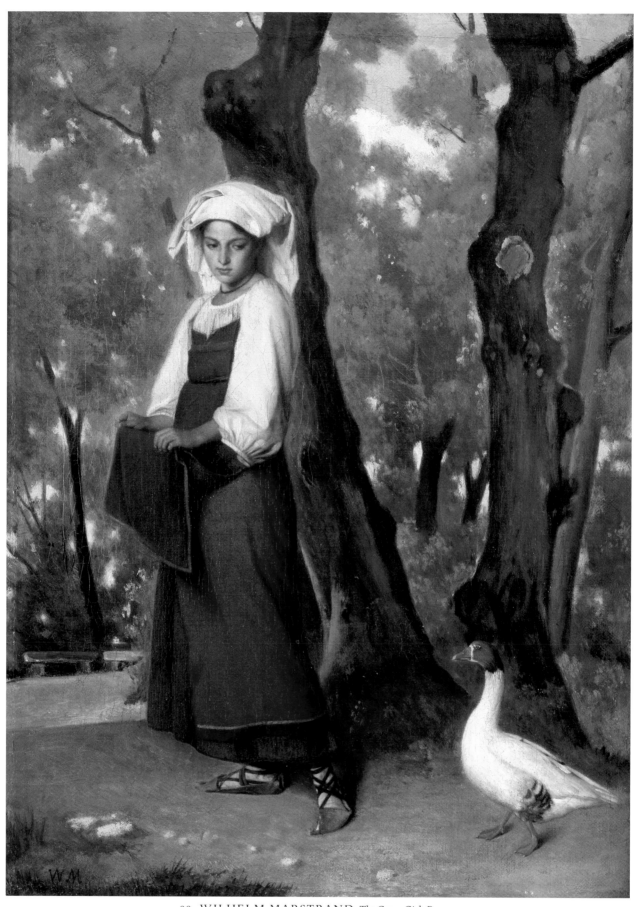

88. WILHELM MARSTRAND *The Goose Girl, Rome*

WILHELM MARSTRAND
1810–1873

133. *A Lady Going Ashore from a Gondola*
(probably begun 1854, completed c. 1870)
(En dame stiger i land fra en gondol)

Oil on canvas, 58 x 80 cm

Unsigned

PROVENANCE: Anna Lund, née Marstrand (1898); Winkel & Magnussen, Auction 9, 1923 (Consul General V. Glückstadt), lot 57, bought by Consul General C.F. Glad; Winkel & Magnussen, Auction 100 (C.F. Glad's estate), 1931, lot 426, ill. p. 41; Bruun Rasmussen, Auction 743, 2005, lot 1045, ill. pp. 40, 41 and cover.

EXHIBITED: Charlottenborg, *Kunstforeningens Marstrand Udstilling*, 1898, no. 512; Voss Kunsthandel, Copenhagen 1919, no. 28, ill.; Nivaagaard, *Nivaagaard viser Marstrand*, 1992, no. 67, ill.

LITERATURE: Karl Madsen, *Wilhelm Marstrand*, Copenhagen 1905; Gitte Valentiner, *Wilhelm Marstrand, Scenebilleder*, Copenhagen 1992 (on the Venetian motifs, pp. 107–115; the drawing from the balcony to which reference is made in the text is reproduced p. 113); Gitte Valentiner: *Nivaagaard viser Marstrand*, Nivaagaard Malerisamling, 1992 (with texts by Gitte Valentiner, Elisabeth Cederstrøm, Kirsten Nørregaard Pedersen, Bent Holm, Claus M. Smidt, Erik Fischer), no. 67, ill.

This charming scene from everyday life in Venice is one of several similar paintings by Marstrand. When the artist arrived in the city late in 1853, he had applied for leave of absence from the Royal Danish Academy of Fine Arts in order to recuperate. He made a great effort that year to complete a very large painting containing numerous figures from Dalarna in northern Sweden in which churchgoers come sailing in large boats on Lake Siljan. As expected, this commissioned work, intended for the National Gallery (Statens Museum for Kunst), became a major undertaking. Marstrand really intended to go to Rome but decided on a longer stay in Venice, which he had visited only briefly on his earlier travels. In February 1854 he went home to fetch his wife and little son, who stayed with him until the late summer. (Marstrand had not married until 1850, when he was forty.)

Despite the winter, Marstrand had been captivated by the enchanting character of the city, the colors, the light, and the everyday life that assumes a different aspect in Venice from that of all other cities because so much movement to and fro every day takes place on the water. He discovered Venice through the eyes of a painter and made a careful study of classical Venetian painting, especially Titian and Veronese, of whom the latter was of special importance to his later historical painting. In addition, it was his idea to work intensively with the "alla prima" technique.[1]

The painting shows a beautiful young woman going ashore from a gondola one lovely summer afternoon on the Grand Canal, the southern buildings of which we can see on the left. The steps in the foreground lead to the Palazzo Loredan, the facade of which is visible at the left. The tall, handsome Renaissance palace farther back, partly obscured by the woman's figure, is the Palazzo Rezzonico. At the back, just behind the bend in the canal, the Ca' Foscari ends the view.

The motif was taken from quite close to the painter's residence in the city. On June 19, he made a drawing of his family, with the painter P. C. Skovgaard and his wife, on a balcony with roughly the same view. Thus it can be determined that Marstrand lived in the bel étage of the Case Mainella, next door to the

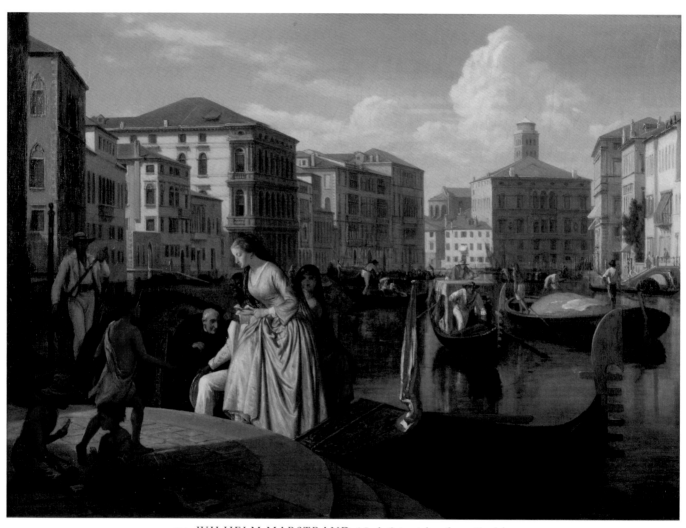

133. WILHELM MARSTRAND *A Lady Going Ashore from a Gondola*

Palazzo Loredan. From here, Skovgaard also painted the view toward the east with the church of Santa Maria delle Salute, though not making it topographically correct (Statens Museum for Kunst). The writer Hans Christian Andersen also visited Marstrand here.

Marstrand's painting was considered by Karl Madsen in 1898 to have been finished in Copenhagen toward 1870 on the basis of the sketches he made in Venice. ARoS, Aarhus Kunstmuseum owns a preparatory work of the canal without figures (inv.no. 471). An oil sketch of a variation of the motif shows a different woman giving alms to a beggar in a boat immediately behind her boat (Statens Museum for Kunst, inv.no. 1558). The beggar's boat is found in another oil sketch in Statens Museum for Kunst, where the motif is placed on the other side of the Grand Canal and with the Salute church in the background (inv.no. 2045) (all reproduced in Gitte Valentiner 1992).

Having spent some of his youth studying in Rome and Naples, Marstrand had been fond of portraying the exotic everyday life in brief anecdotal pictures, usually of a humorous nature. But the Italy he had come to know, and which he showed us in his paintings, was undergoing a huge transformation. He did not find so many, nor such picturesque, costumes and headdresses in Venice as farther south; the city was characterized, rather, by the large number of tourists—especially English tourists. It was the contrast between the rich tourist and the poor Italian that occupied his attention.

Apart from the many charming studies of the city, Marstrand also benefited from his long sojourn in other ways. He read Alexander von Humboldt's (1769–1859) scientific works, *Kosmos* and *Ansichten der Natur*, which assumed great importance for him. From Venice he also brought back a number of photographs, which today are rare treasures in the library of the Royal Danish Library, the Danish National Art Library.

E.F.

[1] "Alla prima" is direct painting, completed all in one session.

DANIEL HERMAN ANTON MELBYE

COPENHAGEN 1818 – PARIS 1875

Anton Melbye's life was adventurous and rich in experiences. He originally wanted to be a sailor but had to give up this idea because he was nearsighted. Instead he was apprenticed in the shipbuilding trade, breaking off this training to become a musician. But in 1838 he found his right place when he started training in the Royal Danish Academy of Fine Arts to become a marine artist. He did this after consulting C. W. Eckersberg and immediately thereafter became his private pupil. The actual training took only about a year, but Eckersberg's favor and occasional influence left their traces on Melbye throughout his life.

Early in the 1840s the young artist began to embark on long voyages to see for himself how ships and the sea behaved in varying conditions, with a view to painting them. This was at first on the recommendation of the Holstein draftsman and art historian Baron C. F. von Rumohr (1785–1843), who enjoyed great respect in the artistic life of the period, partly because he had played an important role in establishing the Royal Collection of Prints and Drawings. Later it was King Christian VIII who ensured that Anton Melbye could take part in various naval excursions to foreign parts. These were at first voyages in the Baltic on the corvette Flora[1] *and in the North Sea on the ship* Christian VIII, *and then as far away as Morocco onboard the paddle-driven warship* Hekla. *On this latter journey, Melbye is said to have found the motif for his famous dramatic picture* Eddystone Fyrtaarn, 1846 (The Eddystone Lighthouse), *Statens Museum for Kunst, which brought him the Charlottenborg exhibition medal. Anton Melbye had exhibited his works there since 1840, and this he continued to do throughout his life, though with a number of interruptions as a result of his constant traveling. Anton taught marine painting to his two younger brothers, Vilhelm (1824–1882) and Fritz (1826–1869). They also became marine artists, and all three spent a large part of their professional lives abroad. Through Fritz, Anton Melbye met the young Camille Pissarro (1831–1903) and for a time was his teacher; in 1859 Pissarro exhibited in the Salon as a pupil of Melbye.*

From 1847 to 1858 Melbye had his center in Paris, though in 1853 he took part in a ten-month-long French expedition to Constantinople, where among other work he is said to have been asked to make two paintings for the sultan. On returning to Paris, he was presented to Napoleon III and obtained a commission for a large painting for the emperor and for an album of drawings with Asian motifs for the empress. His many distinguished clients reinforced his standing and led to still more commissions. Also in Paris, Melbye became a friend of the landscape painter Jean-Baptiste-Camille Corot (1796–1875), who for a time exerted an appreciable influence on the Danish artist.

Anton Melbye's pictures were dramatic and full of action, with a gripping emotional content that could occasionally verge on the melancholy. In this he was not at all like his teacher Eckersberg, whose art was classical, clear, and sober. For the Romantic Melbye, as for another marine artist and pupil of Eckersberg, Carl Frederik Sørensen (represented in the Loeb collection with Coast with Steep Cliffs

344]

and View of the Sound), *the actual reproduction of the ships gradually acquired less importance than natural phenomena such as the behavior of the sea and the sky in varying weather conditions. Reproductions of storms and tempestuous seas, calm waters, sunset, moonlight, or incipient dawn became the mainstays in the paintings, delighting an ever-growing public both in Denmark and far beyond. Melbye's oeuvre is extremely extensive, and yet his pictures never became superficial or simply routine products. Anton Melbye was also one of the first Danish artists to take an interest in the daguerreotype, a technique which he learned toward the end of the 1840s from Louis Daguerre in Paris.*

Anton Melbye, who had been awarded neither silver nor gold medals during his brief time at the Academy, nevertheless won the Neuhausen Prize in 1843 and the exhibition medal three years later. In 1846 he was also awarded the Thorvaldsen Medal, and he was given the Academy travel grant for the period 1846–1848. In Constantinople he was honored with the distinguished Turkish Order of Chivalry; in Paris he was made a Knight of the Legion of Honour, and in 1858, when he had returned to Denmark after his long sojourn in France, he was appointed a Knight of the Order of Dannebrog.

After 1858, Anton Melbye lived sometimes in Copenhagen as a member of the Academy with the title of professor, sometimes in Hamburg, where he had many clients among the rich merchants and shipowners of the city, and sometimes in Paris, where he died. In Philip Weilbach's contemporary, and far from uncritical, consideration of Melbye it can be seen that Denmark did not always appreciate the celebrated painter, who was felt to have neglected his talent during the long periods he spent abroad because he had too soon been pampered with major commissions.

S.L.

LITERATURE: Philip Weilbach, *Dansk Konstnerlexikon*, Copenhagen 1877–78; Henrik Bramsen, *Danske marinemalere*, Copenhagen 1962, pp. 36ff, 101, 113ff; *H.C. Andersen's dagbøger*, VII, 1866–67, Copenhagen 1972; Hanne Westergaard in *C. W. Eckersberg og hans elever*, Statens Museum for Kunst, 1983, pp. 123–124; Annette Stabell in *Weilbach*, vol. 5. Copenhagen 1996.

[1] A corvette is a warship ranking in the old navies next below a frigate and having usually only one tier of guns.

ANTON MELBYE
1818–1875

89. *Fishing Boat Reefing Its Sails*
(Marine med fiskekutter der reber sejlene)

Oil on panel, 6 x 9⅔ in. (15 x 24,5 cm)

Signed lower left: Anton Melbye

PROVENANCE: Arne Bruun Rasmussen, Auction 453, 1983, lot 134.

The customs officer Lieutenant Jacob Buntzen Melbye and Anna Marie Christina Løehts had three sons, Anton, Vilhelm, and Fritz; all became recognized marine artists. The boys' affinity for and love of life at sea derived from their home, for Jacob Melbye is known to have painted ships' portraits.[1] The Loeb collection has two works by the eldest and most famous of the brothers, Anton Melbye.

Anton was a private pupil of C. W. Eckersberg for a year or so (the artist's father Jacob was a friend of Eckersberg),[2] but the young artist was not much influenced by his teacher's art. Eckersberg's manner of working was far more closely related to the accurate reproduction of motifs by ship portraitists.

For a marine artist, depicting light, weather, and the ever-changing waves was often of greater importance than the actual presentation of the ships at sea. The marine artist's paintings were considered to be works of art. They were usually exhibited, their success subject to the view of art at the time, and the demand for them did not necessarily emanate from maritime environments.

This fairly small oil sketch painted on wood contains no information as to either date or place. Consequently, it cannot be said whether the portrayal of the fishermen at work is a study for a larger work or whether it was merely intended to remind the artist later of a morning at sea just before dawn. With its diagonal composition and its richly varied coloring of the light, the work in the Loeb collection is fully in accordance with the Romantic style of painting that was in vogue with many of the young Academy pupils at the end of the 1830s and beginning of the 1840s.

S.L.

[1] A ship's portrait is a painting of a specific, named vessel in which the main emphasis is placed on presenting the ship as exactly as possible. A ship portraitist produced his paintings on commission for shipowners or skippers. The occupation was a recognized expertise that was much in demand and should not be confused with marine painting.

[2] On 22 December 1851, Eckersberg noted in his diary: "Visit from Melbye's father, who brought a drawing by Anton of a North American brig." Quoted from Hanne Westergaard in *C. W. Eckersberg og hans elever,* Statens Museum for Kunst 1983, p. 123.

ANTON MELBYE
1818–1875

90. *Sailing Ships and Steamship,* 1864
(Marine med flere sejlskibe og en damper)

Oil on canvas, 17⅔ x 26⅔ in. (45 x 68 cm)

Signed and dated lower left: Anton Melbye 1864

PROVENANCE: Friis (Fritz?) Warb(u?)rg Altona 3 (according to partly illegible slip of paper on the reverse); Arne Bruun Rasmussen, Auction 452, 1983, lot 158, ill. p. 53.

Although he only needs to smell seaweed for a new painting to emerge from his imagination, it is gratifying to see that even in the midst of this redoubtable productivity Melbye never repeats himself; the lyrical atmosphere is ever different: sometimes it is heavy clouds gathering over a tempestuous Atlantic Ocean, sometimes an early daybreak as if it were being cradled on cheerful, recently awakened waves, sometimes the cold, golden light of evening against a clear sky while a biting cold strong breeze furrows the dark waves.

So wrote one of the leading art critics, Karsten Wiborg, on Melbye's paintings at the 1844 Charlottenborg exhibition.[1]

That year, Anton Melbye exhibited seven sea pieces, for the first time including a picture of a steamship in a gale. (Among Melbye's patrons were such distinguished names as King Christian VIII, Thorvaldsen's Museum, Count Scheel, Count Trampe, a certain Etatsraad Mansa, and an agent by the name of G. Carstensen, who bought the 1844 painting of the steamship.)

Also in 1844 Melbye began some long voyages. He was given permission to sail to Morocco on the very recently acquired naval paddle steamer "Hekla,"[2] and later that year sailed on the frigate "Gefion" when it went to Livorno in Italy to fetch Thorvaldsen's last works back to Copenhagen.

The year 1864 was fateful for the Danes. Prussia and Austria declared war on Denmark and were victorious. At the Peace of Vienna on October 30 that year, Denmark had to surrender the duchies of Schleswig, Holstein, and Lauenburg to Prussia and Austria. Though the country was not materially destroyed by the war, the economic balance was undisturbed, and shipping remained unaffected, Anton Melbye did not send any paintings to Charlottenborg. No sea pieces by him are to be found in the exhibition until 1866, when he showed two. This Loeb collection marine painting (in which the vessel in the background was perhaps one of the 43 steamships that Denmark owned as early as 1862), might have been one of these.

S.L.

[1] K.F. Wiborg, *Konstudstillingen i 1844,* Copenhagen 1844, p. 47.

[2] The *Hekla,* named after the famous Icelandic volcano, was built in England in 1842; it was 50 metres long (164 ft.), 8.5 metres wide (28 ft.), had 637 tons displacement, and was armed with seven guns. The ship played a decisive role on several occasions in the war against the duchies of Schleswig and Holstein 1848–1850. It sailed for the last time in 1875 and was broken up in 1882.

CHRISTIAN VILHELM MOURIER-PETERSEN

HOLBÆKGAARD NR. RANDERS 1858 – COPENHAGEN 1945

Both Christian Mourier-Petersen and his father were born at the mansion of Holbækgaard near Randers in eastern Jutland. The son completed his schooling in 1878 and embarked on the study of medicine at Copenhagen, possibly inspired by Johan Rohde (1856–1935), a friend from Randers, two years older than Christian, who had chosen that career path. Rohde practiced as a naval doctor during his military service, after which he took private instruction in drawing and painting until 1881, when he was admitted to the Royal Danish Academy of Fine Arts. Mourier-Petersen broke off his medical studies to become a painter and as early as April 1880 became a student at the Academy.

In reaction to the rigid and antiquated form of teaching, both these young artists soon left the Academy. Rohde remained there for only a year, after which, together with others including Christian Mourier-Petersen, he became one of the pioneers in establishing first Kunstnernes Studieskoler (1882) and then Den frie Udstilling (1891). In various ways Rohde played a decisive role in the renewal of the stagnated artistic life of Copenhagen at the end of the century. It was also Rohde who made sure that a considerable number of paintings by Vincent van Gogh (1853–1890) were shown in Den frie Udstilling in 1893. The person who had told Johan Rohde about the Dutch artist was Christian Mourier-Petersen, who knew him well.

Mourier-Petersen's studies at the Royal Danish Academy of Fine Arts lasted until spring 1883, when he became a pupil of Laurits Tuxen in Kunstnernes Studieskoler, with whom he studied for the next three years. Tuxen taught the principles he had learned from Léon Bonnat in Paris, but it was the journeys abroad that matured Mourier-Petersen as an artist. He spent the period from about 1887 to 1889 abroad, especially in France. In the early spring of 1888 he was in Arles, where he met Vincent van Gogh (1853–1890), who had settled there shortly before. The two artists saw a good deal of each other, and van Gogh mentioned Mourier-Petersen in several of his letters to his brother Theo, who was in Paris:

> I have made the acquaintance of a Danish artist who talks about Heyerdahl and other northerners, Kroyer etc. His work is dry, but very conscientious, and he is still young. Some time ago he saw the exhibition of the Impressionists in the Rue Lafitte. He is probably going to Paris for the Salon, and wants to make a tour in Holland to see the museums. (Letter no. 468, 10.3.1888.)[1]

The many comments Van Gogh makes in his letters about Mourier-Petersen, whose company he appreciates, draw the picture of a likable young man who wishes to be an artist although he has not much experience as yet and who has come to the south of France both on account of his health and in order to paint:

> He has studied medicine, but I suppose he was discouraged by the student's life, and by the other fellows and the professors as well. He never said anything to me about it though, except

once when he stated, *"It's the doctors that kill people."* When he came here, he was suffering from a nervous disorder, which had been brought on by the strain of examinations. I do not know how long he has been painting—he certain hasn't gone very far as a painter—but he's a good fellow to knock around with, and he observes people and often sums them up very accurately. (Letter no. 490.)

On his return to Paris at the beginning of June 1888 Mourier-Petersen followed van Gogh's recommendation and rented a room from his brother Theo at 54 rue Lépic in Montmartre. From here he wrote on June 15 to his friend Johan Rohde:

...Am still living at the home of the Dutch art dealer, where I pay for my stay with studies and can make use of a small studio that is quite charming and well-suited although terribly overcrowded with paintings etc., as a result of which I can hardly move without putting my legs or arms through priceless Impressionist works of art.[2]

The two brothers do not appear to have been very impressed by Mourier-Petersen's paintings, although before the Danish artist's departure from Arles, Vincent wrote:

His last three studies were better and more full of color than what he had done before... (Letter no. 488.)

The Hirschsprung collection owns a Mourier-Petersen painting of a flowering peach tree from Arles. Both this and the Loeb collection French Landscape can be seen in relation to the famous series of flowering fruit trees that van Gogh executed in the same place and at the same time.

Back home in Denmark, Christian Mourier-Petersen painted some atmospheric naturalist landscapes from places such as the area around Randers and the Jutlandic heath in addition to portraits and interiors, for instance the Loeb collection's beautiful painting showing the ironing room at his childhood home (The Ironing Room in an Old Country Mansion). In 1895 he lived and worked for a time together with Hans Smidth at Karup in central Jutland. He was employed in the Royal Porcelain manufactory as an underglaze painter with an artist's signature from 1894 to 1895.

In 1925–1926 he visited Estonia and then went on a further visit to France. Here, too, it was the landscapes that were of special interest to him. In the 1930s Mourier-Petersen painted a good many landscapes in the Hornbæk Plantation near the north coast of Zealand.

He exhibited a few works at Charlottenborg 1889–90 but was otherwise a loyal member of Den frie Udstilling from the start of the association in 1891 until 1931.

<div align="right">S.L.</div>

LITERATURE: Johan Rohde, *Journal fra en rejse i 1892*, published by H.P. Rohde with an introduction by N.G. Sandblad, Copenhagen 1955, pp. 12, 33, 73, 89; H.P. Rohde, *Van Goghs verden*, Copenhagen 1964, pp. 252–253; Vincent van Gogh (ed.), *The Complete Letters of Vincent van Gogh*, Boston 1988 (First edition, 1958); Jens Peter Munk in *Weilbach*, vol. 5, Copenhagen 1997.

[1]This and the following quotations are taken from Vincent van Gogh (ed.), *The Complete Letters of Vincent van Gogh*, Boston 1988. Heyerdahl is probably the Norwegian painter Hans Heyerdahl (1857–1913).

[2]H.P. Rohde 1964.

CHRISTIAN MOURIER-PETERSEN
1858–1945

95. *French Landscape, Provence* (1888)

(Fransk landskab, Provence)

Oil on canvas, 20½ x 26⅔ in. (52 x 68 cm)

PROVENANCE: Civilingeniør Vagn Mourier-Petersen (1950); collection belonging to Christian Mourier-Petersen's family (1988); Arne Bruun Rasmussen, Auction 510, 1988, lot 329, ill. p. 135 (described as *Å med træer, Provence, Sydfrankrig*); Bruun Rasmussen, Auction 593, 1993, lot 93, ill. p. 55.

EXHIBITED: Kunstforeningen, Copenhagen, *Christian Mourier-Petersen 1858–1945, Malerier*, 1950, no. 5 (described as *Aa med Træer. Sydfrankrig*).

At the end of the 1880s, Christian Mourier-Petersen visited the south of France, including Arles, where he struck up a friendship with Vincent van Gogh (1853–1890), and the two artists met regularly in van Gogh's favorite café. In May 1888, Mourier-Petersen went to Paris and lodged with Theo van Gogh (1857–1891). Contact between the two Danish and Dutch artists was maintained in an exchange of letters.

Among the subjects painted in Arles by Mourier-Petersen were some flowering fruit trees, presumably inspired by van Gogh's example. The Danish artist met many of the French Impressionists in Paris, and he was influenced by their art, but he was also taken by the somewhat older Barbizon artists.

The landscape in the Loeb collection shows evidence of both sources of inspiration. The strong light and the glaringly beautiful play of color surrounding the calligraphically distributed fruit trees in the background, resplendent in their profusion of flowers, is reminiscent of the passion and genius of the Dutch painter. However, the stream in the foreground, in which everything—including the melancholy of the solitary girl—is reflected awakens memories of works by a painter like Corot (1796–1876).

French Landscape, Provence is an interesting and strangely divided work that in several ways heralds the radical expression of the coming century, though without being able to renounce the tradition of the past. It stands both as a record of a journey and a reminiscence of the way he saw the scene with his artistic soul.

S.L.

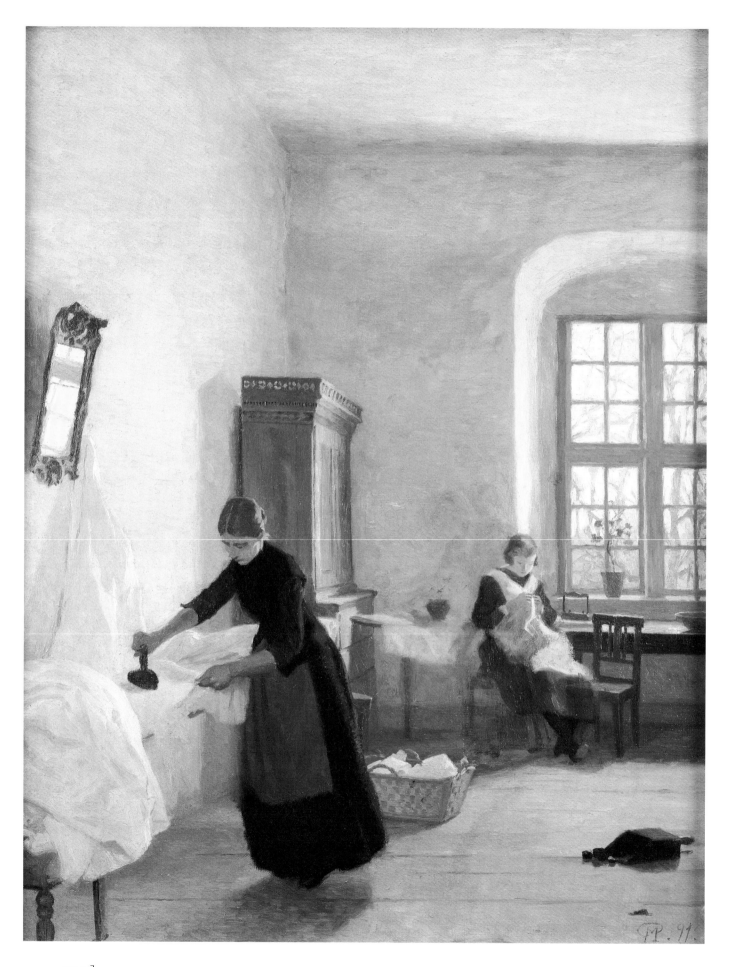

354]

CHRISTIAN MOURIER-PETERSEN
1858–1945

96. *Ironing Room in an Old Country Mansion,* 1891
(Strygestue i en gammel gård på landet)

Oil on canvas, 25½ x 19½ in. (65 x 50 cm)

Signed lower right with monogram and dated: 91

PROVENANCE: Arne Bruun Rasmussen, Auction 497, 1987, lot 75, ill.; Jane Abdy, London (2000); Bruun Rasmussen, Auction 688, 2000, lot 1486, ill. (described as *Strygestuen på Holbækgård. Interiør med ung pige, der stryger, i baggrunden sidder en pige ved vinduet og syr*).

EXHIBITED: Den Frie Udstilling, 1891, no. 34; Kunstforeningen, Copenhagen, *Christian Mourier-Petersen 1958–1945, Malerier,* 1950, no. 13; Scandinavia House, New York, *Danish Paintings from the Golden Age to the Modern Breakthrough, Selections from the Collection of Ambassador John L. Loeb Jr.,* 2013, no. 30.

The motif derives from the mansion of Holbækgaard, which stands with a view across Randers Fjord on the border of the eastern Jutlandic peninsula of Djursland. The building has a history going back more than eight hundred years. In the second half of the 19th century, the place was in the possession of the artist's father, Adolph Tobias Herbst Mourier-Petersen.

On various occasions, the first being as early as 1880 while he was still at the Academy, Christian Mourier-Petersen used the rooms in his childhood home as subjects for his paintings. However, most of the interior portrayals from Holbækgaard were made at the beginning of the 1890s, when the impressions from the artist's extended visit to France were still fresh in mind.

The inspiration from Impressionism is clearly seen. Women ironing and sewing were a much-loved motif, especially by Edgar Degas (1834–1917). This influence is also seen in the numerous light reflections, the asymmetrical composition, and the daring, almost photographic way in which the picture is cut,[1] which Degas and those of like mind learned from Japanese woodcuts. Even during his stay in Arles, Mourier-Petersen was already acquainted with the works of the Impressionists, as van Gogh made plain in a letter to his brother Theo:

> ...I talked to him a lot about the Impressionists; he knew them all by name or from having seen their pictures, and he is very much interested.[2]

In Paris, Christian Mourier-Petersen associated regularly with the Impressionist artists. He lived at the home of the art dealer Theo van Gogh in Montmartre and bought his paints from the renowned art dealer Père Tanguy.

In a letter written from Holbækgaard to his friend Johan Rohde 12 March 1889, he makes the following comment:

> ...In the "Café des nouvelles Athènes" in Paris I sometimes met a group of artists, some young and some old, among whom there were several famous figures, for instance Degas and Pissarro. The latter was born under a Danish flag, that is to say on St. Thomas. Van Gogh had introduced me, and they were very courteous, sometimes even convivial...[3]

Edgar Degas normally stayed outside the circle of Impressionists, and he consorted with only a small number of people, but Mourier-Petersen was fortunate enough to make his acquaintance. Perhaps the Holbækgaard interior in the Loeb collection is the result of his remembering the master's sharpness of observation and his talent to sum life up "in its essential aspects," as he himself[4] put it.

The Danish artist has perhaps tried to live up to this in his portrayal of two young women busy ironing and repairing the laundered clothes in the mansion. We see a simple whitewashed room with a lofty ceiling, the only decoration being the gilt rococo mirror on the wall, reflecting the tall window and the winter landscape outside. The ironing hangs from a hook beside the mirror to avoid creasing and becoming dirty from falling on the floor. For the same reason, the black coal scuttle has been left at a safe distance from all the white linen. Every object in the bare room has a practical use, from the clothes basket between the girls to tables and chairs and the cupboard in the corner. Only the mirror stands out like the princess in a fairy tale, presumably placed in this position by the painter as a space-expanding accessory used in an age-old European painting tradition.

The exquisite portrayal is underlined by a gentle, soft light and a limited but dense and rich use of color running through a gamut of whites mixed with gray, gray-blue, ice blue, violet, and the most delicate pink shades set against olive, ochre, brown, and gold.

On 18 February 1891, about the time when Christian Mourier-Petersen was working on this picture, he wrote in a letter to Johan Rohde:

> Incidentally, I have had sad news. My Parisian patron, the art dealer van Gogh has died scarcely six months after his brother, the painter. I have just received a message from his wife, whom, incidentally, I do not know at all. It will be a great loss to me and surely to many other painters in the future . . . [5]

S.L.

[1] Here an American might use such photographers' words as "framed" or "cropped." At that time (1891) the methods and aesthetics of photography had made their impact on the painters, who now chose a section of nature as a motif, walking out in nature with an imaginary camera in their hands. They didn't any more compose the picture, they *cut* it, so to speak, out of reality, deciding freely where the "cuts" should be made.

[2] *The Complete Letters of Vincent van Gogh,* third printing, 1988. Letter no. 488.

[3] H.P. Rohde, *Van Goghs Verden,* Copenhagen 1964, p. 253.

[4] Michael Levey, *Malerkunstens Historie. Fra Renæssance til Impressionisme.* Copenhagen 1963, p. 296. Original English edition: *The Concise History of Painting from Giotto to Cézanne,* London 1963.

[5] H.P. Rohde. *Ibid.*

JENS PETER MØLLER

FAABORG 1783 – COPENHAGEN 1854

J. P. Møller was born in Faaborg, the son of a potter. The boy was no more than eight years old when his father died, and he was then fostered with a family relative, a customs inspector by the name of Hansen living in Eckenförde in Schleswig, where Møller's future wife was also fostered.

The young Møller spent four years apprenticed as an artisan painter in the town of Schleswig from 1799 until 1803, when he was admitted to the Royal Danish Academy of Fine Arts in Copenhagen. After training in the Academy, where he had both N. A. Abildgaard and subsequently C. A. Lorentzen (1746–1828) as his teachers, he left for Brussels in 1810, later going on to Paris to train as a conservator. In Paris he shared lodgings with his good friend from Academy days, C. W. Eckersberg, with whom he pursued the study of works including those of Nicolas Poussin (1594–1665) and especially the classical landscapes of Claude Lorrain (c. 1600–1682). J. P. Møller's Parisian teachers in conservation were Lavaltier, Thomas Henry and Jean-Louis Anselin, the latter a conservator in the Musée Napoléon.

For most of his life as an artist, J. P. Møller enjoyed the favour of Prince Christian, the later King Christian VIII, (who once owned The Castle of Pløen *now in the Loeb collection). The prince was deeply interested in art, and in his capacity as president of the Academy, supported Møller's journey abroad to further his training, though it was the Fonden ad Usus Publicos that financed his three years abroad. On the artist's return the prince made sure he was given a commission for four landscapes to decorate the re-built Christiansborg palace, and he was given recognition by the Royal Danish Academy of Fine Arts, becoming a member two years later, in 1815. He was accorded a titular professorship in 1824. (Møller had already gained the post of conservator in the Royal Collection of Paintings in 1814, the same year as that in which he was appointed teacher of drawing in the Naval College. However, he only occupied this latter post for four years.) From 1834 he was a curator in the private art collection Den Moltkeske Malerisamling in Copenhagen. In 1842 he was awarded the distinction of* Ingenio et Arti, *and three years later he was given the title of* Justitsråd. *Thus it was an honourable and distinguished career that the artist enjoyed.*

Møller originally went to Copenhagen to become a landscape artist and exhibited at Charlottenborg for the first time in 1807 with a view from Charlottenlund. He subsequently showed there almost every year until the year of his death with an enormous number of landscape paintings of Danish and foreign motifs. Before going abroad, Møller was influenced in part by Jens Juel's landscape art, but impressions from the French landscape artists encouraged him to idealise his portrayals of the countryside and to reinforce the affective elements in his pictures, partly by re-creating the various times of day. In time, Møller succumbed to the influence of the younger generation, and he is said to have been particularly interested in Købke's landscapes.

In 1835 he requested that the Academy establish a prize for the best study of "a characteristic group of trees painted on the spot."

S.L.

LITERATURE: Henrik Bramsen, *Landskabsmaleriet i Danmark 1750–1875*, Copenhagen 1935, pp. 28, 32, 48, 60, 61, 67, 89, 90; Hannemarie Ragn Jensen in *Weilbach,* vol. 6, Copenhagen 1997.

J. P. MØLLER
1783–1854

91. *The Castle of Pløen, Seen from the Park. Mild Autumn Day*, 1842

(Slottet Plön set fra parken, mild efterårsdag)

Oil on canvas, 15½ x 21 in. (39.5 x 53.5 cm)

Signed and dated with initials lower right: IPM 1842 (On the reverse, a mark burnt into the stretcher: C VIII)

PROVENANCE: Commissioned by King Christian VIII, 1841 (61 Rd[1]), possibly identical to painting entitled *Landskab (Landscape)* owned by Queen Caroline Amalie; the Dowager Queen's Estate Auction, 24.4.1882, Amalienborg, lot 134; Fabrikant J. Adler (1882); Arne Bruun Rasmussen, Auction 522, 1989, lot 22, ill. p. 25.

EXHIBITED: Charlottenborg, 1842, no. 15 (ownership described as His Majesty the King).

LITERATURE: Fortegnelse over Hans Kongelige Höihed Prinds Christian Frederiks Malerisamling. Förste Deel. Arbeider af danske Kunstnere og Kunst Academiets Elever samt af Fremmede som have lært eller övet Kunsten i Danmark, no. 539 (Manuscript, The Royal Library, NKS 1811).

The Castle of Pløen (Plöen[2]), standing in the town of the same name, is situated in the province of Schleswig-Holstein, which when this picture was painted in 1842 was still Danish. Since 1761, both the town and the county had belonged to the Danish royal family by inheritance. J. P. Møller executed this portrayal of the castle and the park at the request of King Christian VIII, who was also president of the Royal Danish Academy of Fine Arts. His Majesty was very interested in art, especially topographical portrayals of regions of Denmark, and he owned a large collection of paintings with motifs of this kind.

Most of these pictures left the possession of the royal family in three auctions of the estates of, respectively, his son and successor Frederik VII (1864), Countess Danner (1874), who was born Louise Rasmussen and accorded the title of countess on becoming in 1850 King Frederik VII's morganatic wife, and finally Queen Caroline Amalie, the widow of Christian VIII (1882).[3]

It is probable that the Loeb collection painting of the Castle of Pløen came onto the open market as a result of one of these sales. However, the original title of the painting does not coincide with any in the printed catalogues for these auctions. The explanation for this might be that the motif was not recognised when the lists of the estates were drawn up, or perhaps there was a reluctance to print the correct title in the catalogue because, as a result of the 1864 war, the town and its castle were no longer in the hands of the Danish royal family.

The Castle of Pløen, Seen from the Park. Mild Autumn Day was exhibited at Charlottenborg in 1842. The following year another painting with a motif from Pløen, also owned by Christian VIII, was exhibited by Møller. The name Pløen is not encountered in any of the above catalogues, but it does emerge from a handwritten note in the 1882 inventory of Queen Caroline Amalie's effects that a manufacturer by the name of J. Adler bought two works from J. P. Møller painted in 1842, one of them titled *Parti af en By med et Slot (View of a Town with a Castle)*, the other *Landskab (Landscape)*. The same hand has added "Pløen" beside the word "town" in the first of these.

From Reitzel's register of the Charlottenborg exhibitions published in 1883, we know that at an auction in 1882 J. Adler bought a painting entitled *Pløen med dets Omgivelser; set fra Landevejen i Nærheden af Riksdorf.*

91. J.P. MØLLER *The Castle of Pløen, Seen from the Park. Mild Autumn Day, 1842*

Formiddagsbelysning (Pløen and its Surroundings; Seen from the Highway near Riksdorf. Late Morning Light) for 440 kroner, and that the original owner of the work was Christian VIII. The auction concerned was undoubtedly that of Queen Caroline Amalie's effects.

In contrast to the Charlottenborg records, the catalogue of the Dowager Queen's effects is furnished with measurements, while the sale prices are listed in both. From this, we gain the information that *Parti af en By* (i.e., Pløen) *med et Slot* cost 440 kroner and that the work's dimensions were not the same as those in the painting in the Loeb collection. But the measurements of the second purchase made by Adler, *Landskab,* were close to those of *Slottet Pløen, set fra Parken; mild efteraarsdag.*

So the possibility cannot be discounted that *Slottet Pløen, set fra Parken; mild efteraarsdag* was sold and left the possession of the royal family in 1882 under the title of *Landskab* at the auction of Caroline Amalie's effects, where it was acquired by J. Adler. *Landskab,* which was the lesser of Adler's two purchases, cost him 105 kroner. According to the catalogue of the estate auction of J. P. Møller,[4] the artist made a number of drawn studies of Pløen Castle and its surroundings in 1840, 1841, and 1842. These include a pencil drawing entitled *Pløen set fra Slotshaven (Pløen Seen from the Castle Park),* dated September 17, but with no indication of the year.

S.L.

[1]The price in old Danish currency.

[2]Both spellings for this locality can be found.

[3]I am grateful to Charlotte Christensen for this information.

[4]*J.P. Møller 1783–1854, Deceased Landscape Painter, Justitsraad, Charlottenborg 30 October 1855.* Both the present catalogue of effects and the lists of the effects of the three royal personages are in Statens Museum for Kunst.

J. P. MØLLER
1783–1854

92. *Landscape with Horse-Drawn Cart on a Bridge, Farm in Background,* 1850

(Landskab med hestekøretøj på en bro. I baggrunden en bondegård)

Oil on canvas, 16¼ x 20½ in. (41 x 52 cm)

Signed with initials and dated lower left: IPM 1850

PROVENANCE: Arne Bruun Rasmussen, Auction 465, 1984, lot 241, ill. p. 109.

This pleasing work is immediately reminiscent of a painting by another artist, I. C. Dahl (1788–1857): *The Bridge across the Tryggevælde River with a View of Køge,* c. 1815, which is in Statens Museum for Kunst. Both works have as their principal motif a horse-drawn cart on a humpbacked bridge across a river. The especially intense light and transparent shadows characteristic of Dahl's pictures are not unlike the play of color in Møller. However, the bridges in each picture turn in different directions, and while Dahl has placed major emphasis on the depiction of the rush of the water in the stream, and a magnificent stark vault of sky against which the bridge bearing the cart is silhouetted, Møller has filled his painting with more trees and staffage[1] figures.

Dahl and Møller knew each other, mostly through C. W. Eckersberg, with whom they shared a friendship. Eckersberg and Møller had been friends from their youth, studying together in the Academy; they subsequently shared lodgings when studying in Paris. There, Eckersberg was taught in the studio of Jacques-Louis David (1748–1825), while Møller prepared himself for a career as a landscape artist and conservator.

These three artists developed in very different directions, but they all shared one model from their youth, the great French painter and graphic artist Claude Lorrain (1600–1682). The stagelike compositional principle in Lorrain's light-pervaded, poetical landscapes has been studied by artists at all times and copied by many. In this painting we see how J. P. Møller has remembered Claude Lorrain's famous trees, which so often act as living set pieces in the scenic space of the painting. A large tree in the foreground on one side is balanced by smaller trees on the other, and through this the viewer's eyes are led along a road across, for instance, an Arcadian landscape to a distant horizon that merges with the sky. The trees are set like dark silhouettes against a light background, whereby a *repoussoir*[2] effect is created to give depth to the painting.

The delicately graduated color transitions typical of that French master can also be seen to a certain extent in Møller, who has furthermore aimed at a classical color scheme such as that of the 17th-century Dutch landscape painters: a brownish or reddish foreground moves into a green middle distance, ending in the far distance with light blue. These painterly effects create a sense of perspective cohesion and, when successful, make the picture stand like some pulsating organism.

S.L.

[1]Human or animal figures added as subordinate elements to the painting of a landscape.

[2]*Repoussage* in a painting is an object in the fore- or middle ground, emphasizing the depth of the perspective.

PEDER MØRK MØNSTED

GRENAA 1859 – FREDENSBORG 1941

Peder Mønsted was born in Jutland. His father was a boatbuilder and miller but decided to earn his living as a photographer. The family moved to Århus, the biggest city in Jutland when Peder Mønsted was a boy. His father also painted.

Young Peder revealed signs of his skill at an early age (even as a child he ground his own colors and kept them in a pig's bladder) and achieved some amazing feats. As as an old man he said in an interview that he had always painted for pleasure and had only undertaken tasks to which he had immediately felt drawn.

He attended the Royal Danish Academy of Fine Arts in Copenhagen for four years, from 1875 to 1879. This was during the time when young artists were rebelling against the dyed-in-the-wool conservative teaching of the Academy, and Mønsted's fellow students were the painters L. A. Ring and H. A. Brendekilde, both of whom in their youth were fervent realists with a social purpose. Mønsted did not himself go through such a phase, and the time spent at the Academy was not a fertile period for him. He attended P. S. Krøyer's alternative study school for a time, commenting in an interview in the newspaper Berlingske Tidende *on October 17, 1929 that "It is a piece of good fortune for life to have met a personality like Krøyer."*

Mønsted went to Rome at his own expense in 1882, traveling on to Capri, where he remained for several months, partly because he fell ill. A fortunate sale enabled him to continue his travels, so he went on to Paris where he received training from A. W. Bouguereau (1825–1905), learning from him his sweeping, sketchlike use of the brush.

The Charlottenborg Christmas exhibition in 1874 saw Mønsted's first appearance in public. He showed a forest scene, and it was in fact the forest that was to be his preferred motif, portrayed at all seasons of the year, with spring and winter his favorites. This was perhaps because he spent the summers of his youth at home in Århus, which is surrounded by forests. His oeuvre is predominantly made up of landscapes, village scenes and small-size portraits.

Mønsted traveled widely, and over several years he visited Capri, Switzerland, Algiers, Greece, and Cairo, where he painted pictures of caravans and the pyramids. But he also traveled throughout Denmark, from Bornholm to Northern Jutland. As a young man he visited the home of a merchant by the name of Sommer, and there he met the author Gustav Wied (1858–1914). He painted a portrait of Sommer's daughter, whom he later married. Together they visited Gustav Wied at the mansion of Bangsbo near Sæby, where they were regular visitors for several years, meeting many other artists.

Mønsted sold a large part of his work abroad, and he sold well. He was on close terms with the royal family and sold paintings to all Christian IX's large European family. Thus King Georg of Greece was surrounded by Mønsted's paintings of his native country. Mønsted lived a princely life as

an artist and owned a large studio; in his last years this was at Fredensborg, where the royal family had — and still has — a summer residence.

Mønsted was a painter in search of "the world of yesterday," not with a sense of bitterness but with an honest, straightforward conception of and search for beauty as his guiding force.

M.T.

LITERATURE: P. Juul Madsen, *Danske genremalere*, Copenhagen 1988; P. Nørgaard Larsen in *Weilbach*, vol. 6, Copenhagen 1997.

PEDER MØNSTED
1859–1941

93. *Summer's Day Opposite Hammeren, Bornholm,* 1882

(Sommerdag ud for Hammeren. Bornholm)

Oil on canvas, 24½ x 37½ in. (62 x 95 cm)

Signed with initials and dated lower right: PM 1882

PROVENANCE: Kunsthallen, Auction 311, 1975, lot 36, ill. p. 51; Arne Bruun Rasmussen, Auction 452, 1983, lot 167, ill. p. 67 (described as *Bornholmsk landskab med Hammershus ruiner og blomstrende lyng*).

LITERATURE: Patricia G. Berman, *In Another Light, Danish Painting in the Nineteenth Century*, New York 2007, ill. p. 116.

We do not know all of the reasons Mønsted was attracted to Bornholm, but from the titles of his exhibitions we can see that he was painting there in 1882 and 1883, returning to the island in 1887, 1917, and 1921, and perhaps on still more occasions. Other artists also found it a rich source of motifs somewhat earlier. In the 1860s Kristian Zahrtmann (1843–1917), who was born in Bornholm, traveled around the island with artist Otto Haslund (1842–1917), painting landscapes and scenes of everyday life, though Michael Ancher, who was born on the island, did not often paint there.

The ruined castle of Hammershus, at the northern tip of Bornholm, fascinated to the artist because account of the bright light resulting from its being surrounded by water on all sides. Mønsted has portrayed a quiet, late summer's day in the light of afternoon with a clear blue sky. The ruins of the castle provide a calm, romantic interruption to the horizon; a mother carrying a child in her arms comes toward the artist along a path leading to him, and we see a ship with its sails set, a glimpse of a lighthouse in the distance. We note that a huge bank of heather is in full flower.

Mønsted perhaps liked the island because it gave him the possibility of portraying the broad sweep of a landscape in undisturbed peace. He gives Janus la Cour (1837–1909), who also painted around Aarhus, and Godfred Christensen (1845–1928) as the sources of his inspiration. Together with Vilhelm Kyhn, Thorvald Niss (1842–1905), and Harald Foss (1843–1922), the four artists created a late Romantic landscape painting in Denmark, a kind of Danish Barbizon school. Unlike the others, Mønsted was not a member of Kyhn's so-called "cave academy," an informal gathering of modern young painters studying together in Kyhn's garden. Mønsted insisted on nature, and explored parts of the cultural landscape, as well as the village environment as the basis for his art. He never became a modernist.

A painting described as *Hammershus Ruiner (Hammershus Ruins)* was sold as lot no. 12 in an auction held in the artist's studio on 7 February 1887. The dimensions of the painting (23⅗ x 6 in. or 60 x 14 cm) do not correspond to those in this Loeb collection work. Mønsted writes in the catalogue that the auction was held in order to finance his next journey abroad.[1]

In the Bruun Rasmussen auction no. 613, 1995, a picture entitled *Parti fra Hammershus* (View of Hammershus), signed "P.M. 1882," was sold as lot no. 351; this is a smaller replica of the version in the Loeb collection measuring 8⅔ x 13 in. (22 x 33 cm). As early as 1881, Mønsted had painted the *Parti fra Hammershus* in an almost identical version measuring 18⅘ x 27½ in. (48 x 70 cm). This was sold in the Bruun Rasmussen auction no. 500, 1987, as lot no. 108, ill. p. 151, and was sold again in the Bruun Rasmussen auction 505, 1988, lot no. 102, ill. p. 59.

M.T.

[1]Peder Mønsted auction catalogue February 7, 1887, Copenhagen.

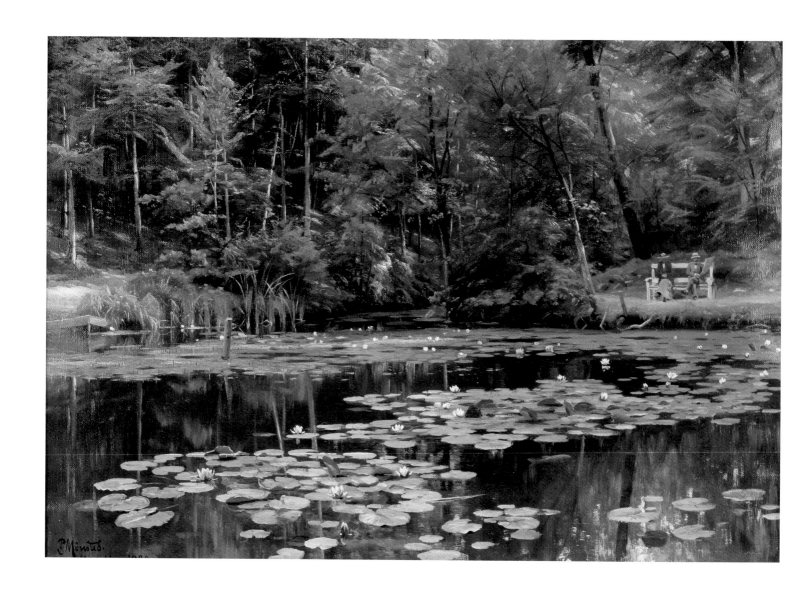

PEDER MØNSTED
1859–1941

94. *Woodland Scene with Pond Near Vejle, 1920*
(Skovparti med sø fra egnen omkring Vejle)

Oil on canvas, 19⅔ x 27½ in. (50 x 70 cm)

Signed and dated lower left: P. Mønsted, Munkebjerg 1920

PROVENANCE: Arne Bruun Rasmussen, Auction 452, 1983, lot 166, ill. p. 65.

EXHIBITED: Bruce Museum of Art and Science, Greenwich, Connecticut, and The Frances Lehman Loeb Art Center, Vassar College, New York, *Danish Paintings of the Nineteenth Century from the Collection of Ambassador John L. Loeb Jr.*, 2005, no. 33, ill.; Scandinavia House, New York, *Danish Paintings from the Golden Age to the Modern Breakthrough, Selections from the Collection of Ambassador John L. Loeb Jr.*, 2013, no. 29.

Reflections in water and contrasts in the forest are a fundamental motif in Mønsted's work. The still water with the white (and a few pink) flowering water lilies with sunbeams falling across them and through the beech foliage has led to this charming picture, entirely enclosed within itself. Mønsted treats the famous water lily motif with a quite different kind of photographic realism from the French Impressionist Claude Monet (1840–1926), for whom color was everything. The white bench on which two excursionists are resting underlines an atmosphere of pleasure and enjoyment.

The area around Vejle is a hilly, east Jutland moraine[1] landscape containing a great deal of beech forest. The picture was painted in Munkebjerg, a favorite destination for excursions, situated quite close to the town.

M.T.

[1]An accumulation of earth and stones carried and finally deposited by a glacier.

OTTO DIDRIK OTTESEN

BROAGER 1816 – FREDERIKSBERG 1892

O. D. Ottesen came from a poor country home just outside Broager in Southern Jutland, an area that formed part of what were known as the Duchies. Until he was eighteen years old he worked on the land, and it is said that even as a shepherd boy he would be found drawing and painting with sticks, feathers, and the juice of berries. He trained as a painter's assistant and at the same time became a pupil at the Royal Danish Academy of Fine Arts in Copenhagen. He copied the Dutch flower and fruit painters in the Royal Collection of Paintings (Statens Museum for Kunst). In his late twenties he specialized in flower painting, self-taught in this regard.

He exhibited for the first time in 1842 in the annual Charlottenborg exhibition, and the following year he sold a fruit piece for King Christian VIII's private collection. He early enjoyed royal favour, being granted dispensation from the military service to which his peasant birth made him liable. He had painted a small fruit piece of the winter's poorest fruits, but he had placed all his energy and skill in it. Later he sold paintings both to Thorvaldsen's Museum and the Royal Collection of Paintings, and he had many private purchasers. Between 1844 and 1876 he sold sixteen paintings to the Copenhagen Art Society (Kunstforeningen). Like J. L. Jensen, he had many pupils, a number of them were women.

When one of the flower pieces by Jan van Huysum (1682–1749) was purchased for the Royal Collection of Paintings in 1843, the event had great significance for Ottesen, who painted an expression of homage to this picture in 1869. Ottesen's first journey abroad was in 1855, taking him to Holland and Paris. He became a member of the Royal Danish Academy of Fine Arts in 1866 and was made a professor in 1874. In his letters he expresses a great interest in and knowledge of flowers, which he studied in gardens and parks just as intensely as he studied the paintings of them in the museums.

After J. L. Jensen, Ottesen became the leading Danish flower painter. His works are executed with great accuracy and precise detail; they are painted with meticulous care and often in clear local colors. "He is an interesting flower painter because he feels a personality in the plants he depicts and isolates every single flower so that the surface of his picture is sometimes refracted," wrote Hanne Westergaard.

In addition to the major flower compositions, Ottesen also painted smaller pictures of plants on the forest floor, a bird's nest, a rose against a wall, and a tiny symbolic picture from his own garden of a laurel-wreathed beehive, a rose, fruit trees, hops, and grapes. Another meticulous picture of a dog rose in red, painted for his two daughters, bears the title The Andante to Beethoven's Pastoral Symphony. The title was painted as an inscription on a stone beneath a bird.

M.T.

LITERATURE: Hanne Westergaard, *Blomstermaleren O.D. Ottesen, Arbejdsbog og Optegnelser,* Copenhagen 1979; Hanne Westergaard, *H.C. Andersens Blomster,* Copenhagen 1985; Jørgen Slettebo, *O.D. Ottesen og andre danske blomstermalere på H.C. Andersens tid,* Museet på Sønderborg Slot 1986; Laura Bjerrum in *Weilbach,* vol. 6, Copenhagen 1997.

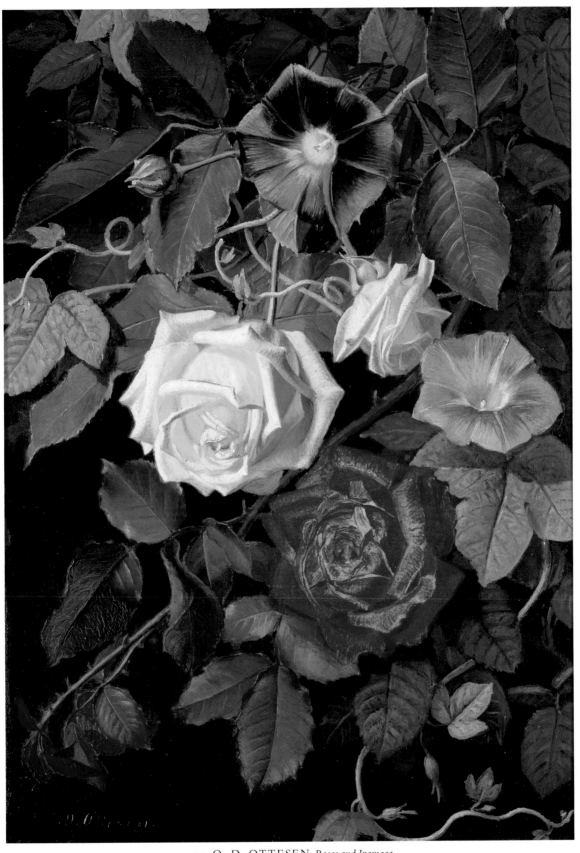

97. O. D. OTTESEN *Roses and Ipomoea*

O. D. OTTESEN
1816–1892

97. *Roses and Ipomoea*
(Rose og Ipomeao, Roserne Marskal Niel og Monsieur Bonsenne)

Oil on panel, 13⅔ x 9¾ in. (35 x 25 cm)

Signed lower left: O.D. Ottesen

PROVENANCE: The auction of the artist's estate, Charlottenborg 1893, lot 7; Bruun Rasmussen, Auction 526, 1989, lot 24, ill. p. 23.

Together with the blue bindweed, these two quite new species of rose stand as a clear and brilliant trio of colors, while at the same time providing a very accurate description of just these roses—for it is especially they that have been given an individuality of their own. The bindweed is just an accompaniment. We see a detail that allows us to follow the rose not only from the top but also from the side, an unusual feature.

In 1844, the Royal Gallery of Pictures in Christiansborg and the Copenhagen Art Society, Kunstforeningen, each bought a picture by Ottesen. A friend gave him a small notebook as a New Year's present. In this, Ottesen carefully listed his most important pictures. He exhibited a Maréchal Niel rose for the first time in 1879 in a larger composition in the Charlottenborg exhibition; in 1881 he exhibited a Monsieur Bonsenne. This might give some slight indication of a date for this painting.

M.T.

The following species of flower are seen in this painting:

From above: *Impomoea* tricolor. Syn.: *Impomoea rubrocaerulea*, "bindweed"; *Rosa noisettiana* "Maréchal Niel," Pradel 1864 (Yellow); *Rosa hybrida bifera*, "Monsieur Boncenne," Liabaud 1864, Syn.: "Baron de Bonstetten."

T.T.

JOHAN ERIK CHRISTIAN PETERSEN

COPENHAGEN 1839 – BOSTON 1874

The master shoemaker Peter Erik Petersen's son Johan had a short but apparently intense life. From the scant information available on this unusual young man, we can derive the following: he graduated from the Borgerdyd School in Christianshavn in Copenhagen in 1857, two years later taking the preliminary degree of cand. phil. However, instead of continuing an academic career, he decided to fulfill a long-cherished desire to become a painter. (In 1855, Johan Petersen, then only a sixteen-year-old school pupil, surprisingly had a painting accepted for Charlottenborg entitled En dansk fregat under sejl [A Danish Frigate under Sail], *a work purchased by King Frederik VII.)*

So in 1860 Johan Petersen was admitted to the Royal Danish Academy of Fine Arts, at the same time becoming a pupil of the marine artist Carl Dahl (1812–1865). Dahl had been a teacher of drawing in the Naval College and a teacher of perspective in the Royal Danish Academy of Fine Arts. As a young man Dahl had been tutored in marine painting by C. W. Eckersberg, and during the professor's old age his pupil, with younger eyes, had skillfully helped his teacher draw rigging and tackle on his paintings of ships.

Not until 1861, six years after his first Charlottenborg success, did Petersen exhibit his next work, also in Charlottenborg. This was Et fuldrigget amerikansk skib, der har kastet bak i stille vejr *(A Full-Rigged American Ship Reversed in Calm Weather), which might possibly be the painting in the Loeb collection. (Petersen showed seven works at Charlottenborg between 1855 and 1865.)*

In 1864 Petersen participated in the second Schleswig war against Prussia and Austria as a cadet and was that year appointed a second lieutenant in the reserve. The following year he emigrated to America and settled in Boston as an artist where his paintings were given a positive reception, resulting in several major commissions. Den atlantiske kapsejlads's afgang fra Sandy Hook (The Start of the Atlantic Race from Sandy Hook) *from 1865 and* Sørøverens erobring; Den flyvende Hollænder (The Pirate's Conquest; The Flying Dutchman) *from 1869 are the titles of two of Petersen's American works.*

Johan Petersen is known to have spent 1867–1868 in the West Indies but died in a Boston hospital six years later in 1874, at only thirty-five years of age.

S.L.

LITERATURE: Philip Weilbach, *Dansk Konstnerlexikon,* Copenhagen 1877–78; J. Revell Carr and Gerhard Kaufmann, *Amerikanische Schiffsbilder und Aquarelle des 18. bis 20. Jahrhunderts aus amerikanischen Sammlungen,* Altonaer Museum, Norddeutsches Landesmuseum, Hamburg 1976; Aase Bak, *Dansk-amerikanske kunstnere 1850–1914,* master's dissertation 1979 (Statens Museum for Kunst); Hannemarie Ragn Jensen in *Weilbach,* vol. 6, Copenhagen 1997.

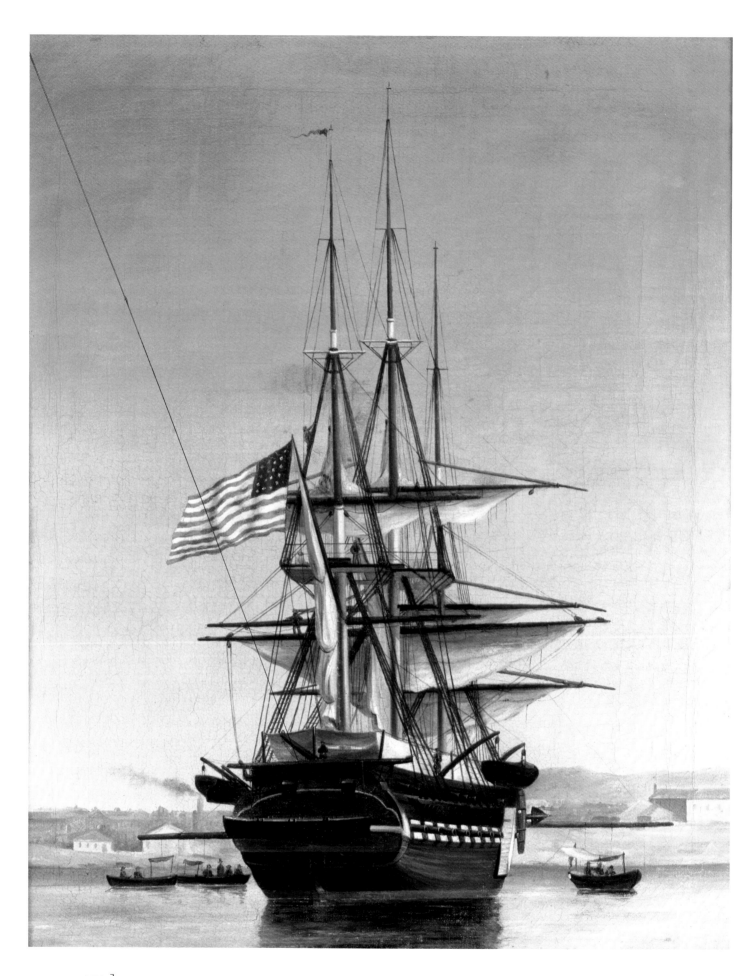

374]

98. *American Frigate at Anchor*

(Amerikansk fregat for anker)

Oil on canvas, 16½ x 13¾ in. (42 x 35 cm)

PROVENANCE: Nellemann & Thomsen, Aarhus, Auction 579, 1988, lot 1798, ill. on front page of catalogue; Connaught Brown, 2 Albemarle, London (1988).

EXHIBITED: Possibly Charlottenborg 1861, no. 152 (described as *Et fuldrigget amerikansk Skib, der har kastet bak i stille Vejr*).

Hanne Poulsen, curator in the Trade and Shipping Museum in Kronborg Castle at Elsinore, suggests that this painting is the work of the artist Johan Petersen, who emigrated to America in 1865, making his home in Boston from 1865 until his death nine years later, though spending the years 1867–1868 in the West Indies.

According to the catalogue from the Århus auctioneers Nellemann & Thomsen, this fine marine painting has been in the possession of one family since it was acquired in the middle of the nineteenth century. According to oral tradition, it was purchased by the then governor of the Danish West Indies.

But when and where was this American frigate painted? There are two possible answers. Because of the provenance indicated above, coupled with the fact of Petersen's visit to the West Indies, the answer to the question of who was governor in the Danish West Indies during the period spent there by Johan Petersen might give a clue. It was Vilhelm Ludvig Birch (1817–1871), one of those remembered for having conducted the negotiations of the sale of the islands of St. Thomas and St. John to the United States, a transaction finalized much later (1917), and who was governor from 1860 until his death eleven years later. A case could be made that Governor Birch requested the Danish artist to depict an American naval visit to Christiansted or Charlotte Amalie on the occasion of the negotiations. The impressive vessel is portrayed in minute detail as though it were some kind of ship's portrait executed to commission.[1] The background scenery, with its cubist buildings and mountains, could represent a West Indian harbor. The climate could also be that of the West Indies; the awnings over the broad deck of the frigate and over the small boats approaching the colossal ship suggest a very warm clime.

But various factors militate against the work having come into being in the way suggested above. If the portrayal of the frigate had been a commissioned work in a traditional sense, it would have contained an indication of the name of the ship, and if the painting had been executed on the spot, which ships' portraits actually rarely are, the identity of the harbor would probably have been clearly shown. Governor Birch would hardly have been content with such an indeterminate portrayal of his residence, and the painter would therefore conscientiously have portrayed what was to be seen, perhaps from a sheltered position in a third boat outside the sphere of the painting.

An alternative possibility is that if the American frigate was not painted in the West Indies, it would likely have been executed in Copenhagen. A stylistic evaluation of the Loeb collection marine painting suggests that we have here a work from a relatively early period in Johan Petersen's life as an artist. Also, the paintings he made in America have a more complicated and action-packed staging than this simple, calm,

almost dozy depiction containing various characteristic features deriving from the artist's classical training. We recognise the Eckersberg tradition's wealth of detail, the precisely determined position of the vessel—in this case in the central axis of the painting—and the careful perspective construction. These are all features suggesting that the huge American vessel, whose monumental appearance is intensified by the low line of the horizon in the background, is the work of a quite young man who was perhaps still under the influence of his teacher and adviser, the marine artist Carl Dahl (1812–1865).

In 1861, six years before his arrival in the West Indies, the then twenty-two-year-old Johan Petersen exhibited a painting entitled *Et fuldrigget amerikansk skib, der har kastet bak i stille vejr (A Full-Rigged American Ship Reversed in Calm Weather)* at Charlottenborg. The Loeb collection painting could well be that very painting. At that time, Petersen had never been outside Denmark, which explains the diffuse portrayal of the background in this work. The artist could have observed and drawn sketches of the foreign frigate in the Copenhagen Roads. The staffage and setting were presumably added later while he was working on the finished composition, perhaps with the help of prints from older travel accounts.

Governor Vilhelm Ludvig Birch's successor, Janus August Garde (1823–1893), took up the gubernatorial post several years after Johan Petersen's visit to the Danish possessions, but the two could well have met before this. Janus Garde, a naval lieutenant, had sailed most of the oceans in the world; in 1860, after his return from his latest excursion to Australia and China, he left the navy to take up an important position as harbor master in Copenhagen. It is possible that Lieutenant Garde saw Johan Petersen's painting at Charlottenborg during the spring of 1861 and purchased it. *American Frigate at Anchor* could thus very well be identical with *A Full-Rigged American Ship Reversed in Calm Weather*, and the first owner of the work could have been the naval officer and later governor of the Danish West Indies, Janus August Garde.[2] This would mean that the oral history of the painting having been owned by a governor of the Danish West Indies is indeed fact.

S.L.

[1] On the difference between ships, portraits and marine paintings, see Anton Melbye's *Fishing Boat Reefing Its Sails* in the Loeb collection.

[2] Information on Vilhelm Ludvig Birch and Janus August Garde are taken from *Dansk Biografisk Leksikon*, Copenhagen 1979–1984.

JOACHIM FERDINAND RICHARDT

BREDE, NORTH OF COPENHAGEN, 1819 – OAKLAND, CALIFORNIA 1895

Ferdinand Richardt trained as a carpenter before enrolling at the Royal Danish Academy of Fine Arts at the age of sixteen. He was admitted to the life class in 1837 and in 1839 began to make topographical paintings of his native area north of Copenhagen. That same year he exhibited for the first time in Charlottenborg. In 1842 he made his first sale to the art-loving King Christian VIII. Richardt was awarded the Academy's major silver medal in 1840 and continued in the life class under J. L. Lund until 1846. He was also given guidance by the sculptor Bertel Thorvaldsen, whose studio in Charlottenborg Richardt portrayed in a painting (Thorvaldsens Museum). Throughout all his artistic studies, he was well trained in perspective.

In 1843, Richardt found a subject that was to become a major preoccupation for him: views of country mansions and churches. Drawing and painting while traveling all over Denmark, he produced work that appeared in printed booklets he published from 1844 to 1868 under the title of "Prospecter af danske Herregaarde (Views of Danish Country Mansions)." These 20 volumes of 12 views each became very popular. In 1845, Christian VIII commissioned him to paint a series of views of selected castles, and then in 1847 he gave Richardt the title of Painter to the Royal Court along with a travel bursary. Between 1852 and 1863 Richardt published another series of lithographs, this time of country mansions from the southwestern part of Scania, which had been Danish territory until 1660.

In 1855, Richardt traveled to the United States, a trip said to be taken at the suggestion of the Vanderbilt family. He landed in New York City, where he set up and maintained a studio from 1856 to 1859. He later visited Niagara Falls, which he had long wanted to see. In the summers of 1855 and 1856 he painted a large number of pictures of the magnificent waterfall and enjoyed a warm reception when he exhibited thirty-two of them in the Stuyvesant Institute in New York the following year. After a prolonged tour of the eastern and midwestern states and Quebec, Canada, he increased his popularity in the United States with a solo exhibition in the National Academy of Design in New York. Several of the exhibited paintings are owned by American public institutions. For instance, one painting of the Niagara Falls hangs in the Department of State in Washington, DC, and there are two views of the Mississippi River painted around 1857 at the White House, which also owns an 1858 view of Philadelphia's Independence House. Richardt planned to publish a book in New York containing 60 American views but it never appeared, though three prints made in 1859 are known to exist.

That summer of 1859, Richardt sailed back to Denmark, where he held an exhibition of his American views in 1860. At the same time he returned to his Danish motifs. However, his days of traveling were not past. In 1862 he married Arnadine Linnemann and went with her to Italy and England, where he also exhibited.

After holding several auctions in Copenhagen, Richardt emigrated with his wife and daughter to the United States, where they first lived in New York City and Niagara Falls. In 1875 the family moved to San Francisco, where he taught in the Arts Association School of Design, finally settling in Oakland, California, where he had his own workshop and teaching facilities. Richardt was among the first to have a painterly eye for the idiosyncratic nature of Yosemite Park, where he painted numerous pictures. Dying in 1895, he was buried in Mountain View Cemetery in Oakland. His works are to be found in many Danish and American museums and in private collections. In 2002, the artist's descendant Justine Hemmert Van Keller, of New Orleans, Louisiana, presented a large collection of Richardt's drawings and watercolors to the National Museum in Copenhagen.

E.F.

LITERATURE: Aase Bak in *Weilbachs Kunstnerleksikon*, vol. 7, 1988; Melinda Stuart and Niels Peter Stilling, *Danske herregårde og Amerika*, Søllerød Museum, 2003 (partly in English).

FERDINAND RICHARDT
1819–1895

129. *Frederiksborg Castle by Moonlight*, 1861
(Frederiksborg Slot i måneskin)

Oil, 13²/₅ x 20½ in. (34 x 52 cm)

PROVENANCE: Bruun Rasmussen, Auction 743, 2005, lot 1075, ill. (described as *Frederiksborg Slot i måneskin*).

LITERATURE: Melinda Young Stuart and Niels Peter Stilling, *Danske herregårde og Amerika. Rejser i guldalderens Danmark og pionertidens Amerika med maleren Ferdinand Richardt*, Søllerød Museum 2003 (partly in English).

The old royal castle of Frederiksborg in the town of Hillerød to the north of Copenhagen has, over the years, earned a special place in the history of Denmark due to its ambitious architecture and its dramatic fate.

Frederiksborg has the character of both a fortress and a country seat. It stands idyllically at the center of a lake and consists of several large buildings, walls, towers, and courtyards linked by bridges. Its location in this beautiful area of northern Zealand, close to large forests and an attractive hunting ground, appealed to King Frederik II. He acquired the property in an exchange of real estate with the nobleman Herluf Trolle in 1560, christened the old mansion with his own name, and maintained the building as it existed at that time.

The castle was given its current appearance when Frederik's son and heir, Christian IV, became king. He razed most of it to replace it with a much larger building. At the beginning of the 17th century he had the castle itself constructed of red brick, with three wings on four floors above a cellar. It was decorated with sandstone ornamentations and boasted numerous garrets and turrets in the copper-covered roof. The interior was also richly and splendidly decorated. The design was by Netherland architects working in close collaboration with the king, who was well versed in architecture. From the inner courtyard, a bridge leads to the outer courtyard, where a fountain containing many figures by Adrian de Vries (1560–1626) has been replaced with a copy. The original was removed by the Swedish conquerors as the spoils of war in 1660 and is now located at Drottningholm Castle near Stockholm. Farther to the south, an S-shaped bridge flanked by circular towers leads to a street lined with houses. Like the towers, they were replicated from the building's older period. Another bridge links the complex to the mainland.

The castle was occupied by the Swedish army in 1658 during the Swedish wars and was the setting for the Danish royal banquet marking the 1660 peace treaty, a major humiliation for Denmark. Succeeding monarchs preferred to use castles other than Frederiksborg, which in the eyes of the royal family became a "castle of sad memories." In 1812, King Frederik VI decided to turn it into a pantheon and moved a great many portraits from the royal collections to the castle. It was then opened to the public, and thus a museum of national history became a reality.

However, the castle and museum we see today is another reconstruction. One night in December 1859, the main building burned down, except for the west wing containing the chapel, the Great Hall above the chapel, and the Audience House. Denmark suffered a painful loss when the north and east wings, containing the portrait collection, fell to the flames.

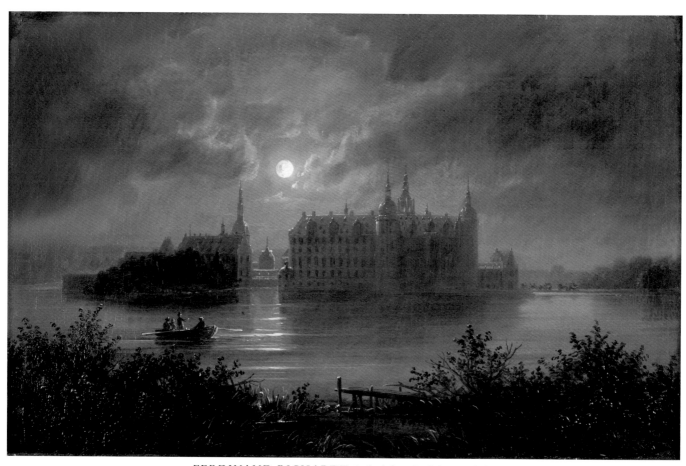

129. FERDINAND RICHARDT *Frederiksborg Castle by Moonlight*, 1861

Fortunately, a large number of pictures of both the interior and exterior of the castle had been painted before the fire. When Danish artists started to paint views of the country around 1800, Frederiksborg Castle was included in their work, and it is probably the Danish castle of which the largest number of paintings exist. In 1815, the Norwegian painter J. C. Dahl (1788–1857) exhibited a view of the castle complex as seen from the market square in Hillerød, and in 1817 he painted the famous picture of the castle by moonlight, a work that is brought to mind by this small picture in the Loeb collection. Of the painters of the Golden Age it was especially Christen Købke who was interested in portraying the castle, particularly the north side in the dramatic light of various evenings. In 1850, Heinrich Hansen exhibited a painting of the castle as it had been at the time of Frederik III (1648–1670). That painting belonged to King Frederik VII (reigning 1848–1863).

Frederiksborg was naturally one of the many castles that Ferdinand Richardt drew during his youth. In 1847 he also exhibited a very large painting of the castle as seen from the northeast, 69 x 100 in. (175 x 255 cm). This was owned by the crown prince, later King Frederik VII.

In 1850, Richardt exhibited several drawings of the castle as seen from other angles, so the artist had plenty of material from which to make paintings of the castle even after the fire.

The destruction by fire of Frederiksborg Castle in 1859 was a devastating loss in the age of nationalism, sadly followed in 1864 by Denmark's being obliged to surrender the duchies of Schleswig and Holstein to Germany after the Second Schleswig War. Then in 1877 the founder of the Carlsberg Breweries, I. C. Jacobsen, offered to finance the rebuilding of the castle and to reestablish the museum with the ambitious intention of illustrating the course of national history for the people. The enormous project was realized in the reconstructed castle, where the history of Denmark was told in original paintings along with new ones, all presented in chronological order.

In 1861, two years after the fire, Ferdinand Richardt painted the castle as it once was, partly from memory and partly based on his earlier sketches. With the castle veiled by moonlight, the picture is a beautiful vision and at the same time an expression of sadness at the loss.

E.F.

LAURITS ANDERSEN RING

While still a young man, L. A. Ring took his name after the place of his birth, the village of Ring in Zealand between Næstved and Præstø. His father was a smallholder[1] who earned a living both as a carpenter and a wheelwright,[2] and the family lived in very modest circumstances.

Ring was apprenticed as an artisan painter in Præstø. He then became a pupil in the Technical School in Copenhagen and in 1874 was admitted to the Royal Danish Academy of Fine Arts. He sought instruction there (although interspersed with considerable gaps) from professors F. Vermehren (1823–1910), N. Simonsen (1807–1885), and J. Exner until 1885. In 1886 he was taught by P. S. Krøyer in Kunstnernes Studieskoler. However, none of these teachers had any profound influence on Ring's artistic development, which came rather from colleagues he met while studying, such as the painter and art historian Karl Madsen (1855–1938), the much older Vilhelm Kyhn, whose landscapes he admired, and the young H. A. Brendekilde. The sense of affinity with Brendekilde diminished later as the two artists developed in different directions. During these years, Ring earned his living by working as a journeyman painter while studying.

In 1889, he embarked with Karl Madsen on his first important visit abroad, traveling via Holland and Belgium to Paris. He spent most of the period 1893–1895 in Italy, where one of his associates was the painter Vilhelm Hammershøi. He visited Italy again in 1899–1900, went there once more eleven years later, and traveled to Berlin in 1930. Various grants and distinctions from the Academy enabled the impecunious young painter to undertake these visits abroad.

L. A. Ring exhibited at Charlottenborg from 1882 to 1928. There were interruptions, some brief and some longer, partly occasioned by a short period during which he was a member of Den frie Udstilling (1902–1904). As the years passed he participated in several world fairs and many similar prominent events in Copenhagen and other European capitals. In time he won several gold medals and other marks of distinction both in Denmark and abroad. Ring gradually became a highly respected artist, with good contacts in the international intellectual movements, but he never forgot that he came from a rural area.

At first, critics often mentioned him in connection with Hans Smidth, painted Jutlandic moorland farmers, while Ring showed solidarity with the poor Zealand rural community. Both artists have sometimes been seen as the heirs to Christen Dalsgaard, who was probably the most important artist to portray the lives of the ordinary people on the basis of Høyen's national Romantic principles.

However, neither Smidth's nor Ring's works had any national objective; they were never, as was the case with Dalsgaard, governed by an overarching narrative element. It is important to emphasize this difference between the style of the more old-fashioned Dalsgaard, with his somewhat idyllic and predictable anecdotes of the life of ordinary people, and Smidth and Ring, who were both on their way to modernism, where the language of art is simple and without additional embellished narrative

elements. Ring's personal views were revolutionary and atheistic, influenced in part by the most important cultural figure of the day, critic and writer Georg Brandes (1842–1927), and authors such as Jens Peter Jacobsen (1847–85) and Henrik Pontoppidan (1857–1943).

Ring's first important painting, Tiggerbørn uden for en bondegård i landsbyen Ring (Children Begging Outside a Farm in the Village of Ring), from 1883 reflects his sense of solidarity with the impoverished environment from which he came and shows the special form of illusion-free realism that characterized many of his future works. The grays in the picture underline its melancholy mood, and the children's awkward and ungainly figures and their pale appearance tell plainly of hard work and undernourishment.

Works like this made critics of the time see Ring's style as naïve and clumsy and to talk of his "curiously rough brush, a brush lacking in color" and his apparently deficient drawing ability. It was also felt that the figures in his paintings seem to have been superimposed, an impression no doubt fueled by Ring's technique of painting the surroundings first and then adding the figures. The Loeb collection's Bondedrengen på vej mod hjemmet, Landsbyen (Road with a Boy) might have been executed this way.

The social commitment in L. A. Ring's work coincided with international trends. The painting I høst (Harvest) and later pastels with the same motif are closely related to works by the French realist Jean-François Millet (1814–1875). Millet's works also came to inspire Ring later, for instance in Den gamle kone og døden (The Old Woman and Death), painted two years later than Loeb's Harvest.

The motif of death appears quite frequently in works by Ring and many of his contemporaries. An expressive and dreamlike, sometimes sinister element was part and parcel of the ingredients of the symbolist art that came to dominate in the 1880s and 1890s, and it marks large areas of Ring's work.

In 1896, a happy turn of events occurred in L. A. Ring's life. At forty-six, the painter married young Sigrid Kähler, the daughter of a faience[3] manufacturer and ceramist, Herman A. Kähler (1846–1917), whose home and workshop in Næstved in southern Zealand had been the painter's constant abode. The newly married couple settled in the fishing village of Karrebæksminde south of Næstved, and it is from here we have Ring's striking, sensitively colored, and symbolist-inspired 1897 portrait Kunstnerens hustru (The Artist's Wife), showing his wife standing in the doorway opening on the garden of their home. The artist often used his wife and growing family as models, not least in a number of paintings executed on the beach outside Karrebæksminde, where in time he erected a caravan.[4]

In 1902, the Ring family moved to the anonymous little central Zealand village of Baldersbrønde, from which many of the artist's best works stem. These pictures, from an area that could not boast of a beautiful landscape in a traditional sense, can be seen in relation to the period's great interest in depictions of reality and plein air painting. Ring's numerous, usually grayish, paintings from Baldersbrønde and nearby, equally modest villages and their surroundings can quite reasonably be

interpreted as veritable sindbillede *(pictures of the mind). The motifs from this painter assuredly come from his own incorruptible and honest mind and soul.*

In January 1914, Ring and his family installed themselves in their own house, Bjerget, at Sankt Jørgensbjerg near Roskilde, designed by their friend, the architect A. L. Clemmensen (1852–1928). Ring remained there until his death nineteen years later.

S.L.

LITERATURE: H. C. Christensen, *Fortegnelse over Malerier og Studier af L. A. Ring, 1880–1910,* 1910 (supplement 1922); Karl Madsen, Maleren L. A. Ring in *Samleren,* 1927, pp. 161–184; Peter Hertz, *Maleren L. A. Ring,* Copenhagen 1934; Inge Vibeke Raaschou-Nielsen and Jens Peter Munk, *L. A. Ring,* Ordrupgaard, Copenhagen 1984; Peter Michael Hornung, Realismen in *Ny dansk kunsthistorie,* vol. 4, Copenhagen 1993, pp. 85–97; Henrik Wivel, Den store stil in *Ny dansk kunsthistorie,* vol. 5, Copenhagen 1995, pp. 203–209; Henrik Wivel, *L. A. Ring,* Copenhagen 1997; Mikael Wivel in *Weilbach,* vol. 7, Copenhagen 1998; Peter Nørgaard Larsen in *Symbolism in Danish and European Painting 1870–1910,* Statens Museum for Kunst 2000.

[1]Chiefly British. A small holding is a piece of land detached from a cottage, hired or owned by a laboring man and cultivated to supplement his main income.

[2]A man whose occupation is to repair wheels and wheeled vehicles.

[3]Earthenware decorated with opaque glazes.

[4]A covered wagon with living quarters where Ring could live as well as paint.

L. A. RING
1854–1933

100. *Harvest*, 1886
(I høst)

Pastel, 24½ x 18¾ in. (62 x 48 cm)

PROVENANCE: Inspektør ved Købmandsskolen Emil B. S. Sachs (1910); Overretssagfører Henrik Sachs (1933); Bruun Rasmussen, Auction 682, 2000, lot 1470, ill. p. 67.

EXHIBITED: Charlottenborg, *Mindeudstillingen for L.A. Ring*, 1933, no. 44; New York, Scandinavia House, *Luminous Modernism, Scandinavian Art Comes to America. A Centennial Retrospective 1912–2012*; 2011–2012; Scandinavia House, New York, *Danish Paintings from the Golden Age to the Modern Breakthrough, Selections from the Collection of Ambassador John L. Loeb Jr.*, 2013, no. 32.

LITERATURE: H. Chr. Christensen, *Fortegnelse over Malerier og Studier af L.A. Ring, 1880–1910*, København 1910, pasteller, p. 97, no. 7; Inge Vibeke Raaschou-Nielsen og Jens Peter Munk, *L.A. Ring*, exhibition catalogue, Ordrupgaard, Copenhagen, 1984, pp. 114–115, kat. no. 14 (on the painting *Harvest* and the replicas of this work); Patricia G. Berman, *In Another Light, Danish Painting in the Nineteenth Century*, New York, 2007, p. 184 , ill. p. 184; Charlotte Lindvald in Patricia G. Berman, *Luminous Modernism*; New York, 2012, p. 50, ill. p. 51.

During the late summer of 1885, L. A. Ring painted a very large picture of a farm worker cutting corn.[1] As his model he used his brother, Ole Peter Andersen, who had settled down as a farmer at Tehusene not far from Fakse on Zealand. Ring had long been considering the picture and the form he would give it. According to his biographer Peter Hertz, it was to be an expression of homage to the simple, hard life in the country, to his family, and to this brother of his who had chosen to follow that life. Before embarking on the actual painting process, Ring made a careful study of Ole Peter's body language by following him back and forth in the field and drawing him. There are two of these drawn sketches in the Royal Collection of Prints and Drawings in Statens Museum for Kunst.

The harvest motif had already attracted L. A. Ring's attention the previous year when, together with a friend of his youth, H. A. Brendekilde, he spent time on the farm of Raagelunde near Odense on Funen, there painting a picture of three farm workers cutting corn. The inspiration for works of this kind came partly from studying reproductions of works by such artists as Pieter Bruegel the Elder (1528/30–1569) and Jean-François Millet (1814–1875). The young Ring also had the opportunity to see an original painting by Millet at Charlottenborg in 1879.[2]

The result was fascinating, as is seen in this Loeb collection pastel. The harvester has been caught in the midst of a great, dynamic backward swing of his body and arms at the very moment when the movement is about to ebb and just before it is to be repeated with a rising motion to sink again toward the ripe corn in a mighty sweep. Like a huge silhouette resembling a cut-out pattern, the brother's figure stands out rhythmically and grandly against the golden field, which fills the greater part of the picture as a result of the high position of the horizon.

His somewhat ragged appearance and coarse figure are evidence of the farmer's hard life. But at the same time, the presentation of his unvarnished, almost brutal shape is an unmistakable symbol of the primal force of nature and mankind's battle with the soil. (The Dutch artist Vincent van Gogh [1853–1890] was working along the same lines at the same time, but the two painters were ignorant of each other's exis-

tence. Only in 1893 could works by van Gogh be seen in den Frie Udstilling [the Free Exhibition] in Copenhagen.)

It was impossible to sell the large picture of his brother, so in order to hold body and soul together, L. A. Ring made several smaller, and therefore more easily sold r,eplicas in oil or pastel, though without reducing the artistic quality. The beautiful, almost supernaturally radiant pastel in the Loeb collection is one of five works made after the monumental work of the same title. Although the pastel is a replica, it has an identity of its own thanks to Ring's technique and the introduction of certain changes. The format has been reduced to a third of the original; the horizon has been lowered, and Ole Peter's house has virtually disappeared in a haze that seems to enfold the entire painting. The light has become stronger but at the same time paler and more unreal, and the figure seems to have come closer to the viewer, like a vision you reach out for but can never grasp.

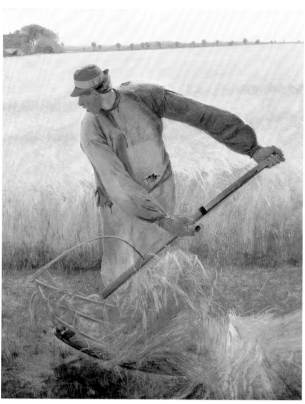

FIG. A L. A. Ring, *Harvest*, 1885
Oil on canvas, 6¼ x 5 ft. (190.2 x 154.2 cm), Statens Museum for Kunst.

Altogether Ring made two smaller oil paintings, two pastels, and a drawing for an illustrated catalogue for the 1886 Charlottenborg exhibition after his huge painting, which had to stand unsold for several years in a corner of his studio in Knabrostræde in Copenhagen. The year following its completion his brother and model, Ole Peter Ring, died after a brief illness.

S.L.

[1] *I høst,* 1885. Oil on canvas, 6¼ x 5 ft. (190.2 x 154.2 cm), Statens Museum for Kunst (Fig. A).

[2] In 1884, Karl Madsen wrote a long, illustrated article on Jean-François Millet, printed in the periodical *Ude og Hjemme,* VII, 20.07.1884, pp. 513–516; 27.07.1884, pp. 527–531.

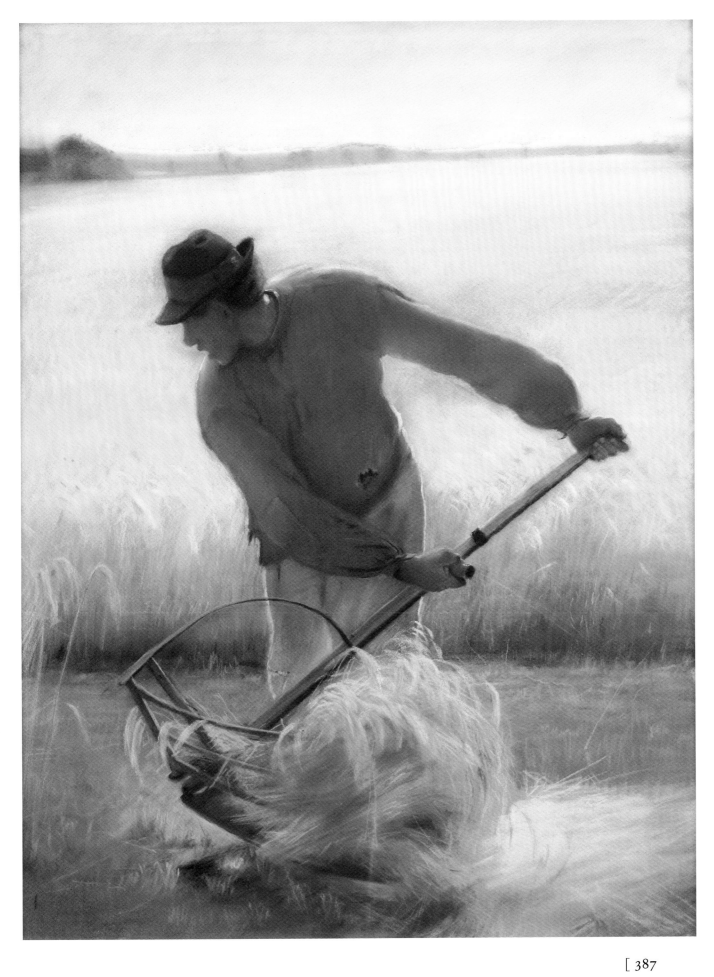

101. *Road with Boy,* 1887

(Bondedrengen på vej mod hjemmet. Landsbyen Ring)

Oil on canvas, 17⅔ x 25½ in. (45 x 65 cm)

Signed and dated lower left: L A Ring 87

PROVENANCE: The art dealers Winkel & Magnussen; the art historian Karl Madsen; Winkel & Magnussen, Auction 237 (Karl Madsen), 1938, lot 64, ill.p. 27 (with additions to the text); Chauffør Harry Pedersen (1953); Kunsthallen, Auction 247, 1961, lot 111, ill. p. 4; Bruun Rasmussen, Auction 581, 1992, lot 458, ill. (described as *Landskab*).

EXHIBITED: Charlottenborg, 1887, no. 331 (described as *Landsbygade*); Guildhall, London, *A Selection of Works by Danish Painters,* 1907, no. 11 (described as *The Village of Ring, Sealand*); Liljevalchs Konsthal, Stockholm, *Nyare Dansk Konst,* 1919, no. 170; Kunstforeningen, Copenhagen, 1924, no. 44; Forum, Copenhagen, *Det danske Kunststævne,* 1929, no. 367; Charlottenborg, *Mindeudstillingen for L.A. Ring,* 1933, no. 52; Kunstforeningen, Copenhagen, *L.A. Ring,* 1953, no. 14.

LITERATURE: H. Chr. Christensen, *Fortegnelse over Malerier og Studier af L.A. Ring i Aarene 1880–1910 (Tillæg 1922),* Copenhagen 1910, no. 92; Karl Madsen, *Maleren L. A. Ring* in *Samleren,* 1927, pp. 161–184, ill. p. 161 (described as *Landsbyen Ring, Tidligt Foraar*); Peter Hertz, *Maleren L.A. Ring,* Copenhagen, 1934, pp. 192–93 and p. 58 ill. (described as *Bondedrengen paa Vej mod Hjemmet. Landsbyen Ring*); Eske K. Mathiesen in *L.A. Ring,* Ordrupgaard, Copenhagen, 1984, p. 12 (and again in English translation p. 17).

The art historian and painter Karl Madsen wrote in the periodical *Samleren* in 1927: "Summer is less attractive to Ring's landscape art than winter, autumn and early spring. The clear, cool air of spring is reproduced with great sensitivity in a picture painted in 1887 in which the road with ramps lining a ploughed field leads through a brief avenue of willow trees to his native village. A farmer's boy, shown walking along the road and looking at the farms with their white, sunlit gable ends, was removed at the request of an art dealer, but has later been resurrected."

According to the artist's first biographer, Peter Hertz, in 1887—the year after painting *Harvest*—the young L. A. Ring was in a state of desperate poverty and melancholy. His figure pictures were not selling at all; there was a market only for landscapes, and among them, pictures portraying sunshine were the most easily sold. This circumstance must have been the reason—much against his will—Ring humored the first owners of the picture, Winkel & Magnussen's Kunsthandel, in their demand that the boy be removed. "Only by constantly forcing his way through the overpainting has the figure again asserted his position in the composition..." writes Hertz. Even with the help of the many different titles assigned to the work it is impossible to determine with any certainty when Ring painted over the figure of the boy and when it reappeared.

Ring and Karl Madsen, who once owned the painting, were good friends. Perhaps these two together brought about the reinstatement of the lonely walking boy who could now without interference continue his walk into the depth of the picture, heading toward the village of Ring, where his world starts.

S.L.

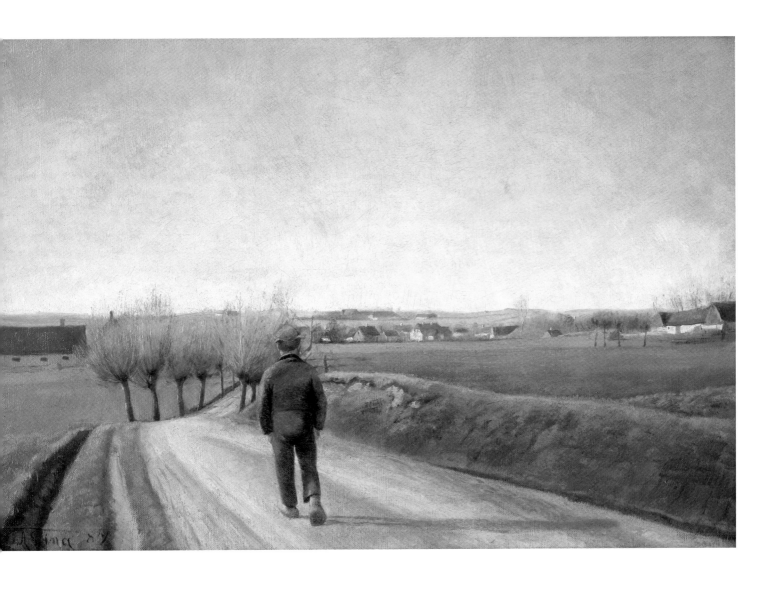

L. A. RING
1854–1933

102. *Johanne Wilde at Her Loom,* 1889
(Johanne Wilde ved væven i en stue i Hornbæk)

Oil on canvas, 15¾ x 14¾ ins. (40 x 37.5 cm)

Signed and dated lower right: 89 L A Ring.

Inscribed on back: *Naar du begynder at glemme din gamle Ven, lad dette Billede minde dig lidt om ham igen. Til Ellen Wilde den 31/12 1892 fra L.A. Ring (When you begin to forget your old friend, let this picture remind you a little of him again. To Ellen Wilde 31/12 1892 from L.A. Ring).*

PROVENANCE: Ellen Wilde, Johanne Wilde's small daughter (gift from the artist, 31 December 1892); Amtsforvalter A. Wilde (1910); Arne Bruun Rasmussen, Auction 491, 1987, lot 244, ill. on the front page of the catalogue; Connaught Brown, London; Sotheby's, *The Scandinavian Sale,* Sale LO1132A, London, 6 June 2001, lot 23, ill.

EXHIBITED: Charlottenborg, Decemberudstillingen 1889 (no catalogue); Connaught Brown, London, *Northern Spirit II,* 5 November–12 December, 1987, no. 7, ill.

LITERATURE: H. Chr. Christensen, *Fortegnelse over Malerier og Studier af L.A. Ring 1889–1910,* Copenhagen, 1910, no. 166 (described as *Dame ved Væven i en Stue i Hornbæk,* owned by Amtsforvalter A. Wilde); Finn Terman Frederiksen, *Før solopgang,* Randers 1995, p. 15.

Johanne Wilde's husband, Alexander Wilde (1855–1929), was employed by the Ministry of Finance, but he was also a productive and talented amateur painter. For that reason, he had for a time rented a studio in Knabrostræde in the center of Copenhagen next door to L. A. Ring. There the two artists got to know each other and became friends. The friendship led to the Wildes hospitably opening their home at Frederiksberg to Ring. He dined there regularly, celebrated Christmas and the New Year with Alexander and Johanne Wilde and their three children, and even accompanied the family when they moved to the country for the summer.

Young Mrs. Wilde looked after the painter and encouraged him during his frequently recurring bouts of depression. Ring's biographer, Peter Hertz, tells how the company of Johanne Wilde and the children—the two boys and little Ellen, their youngest, who became L. A. Ring's special favorite—gave him a sense of "tranquillity and happiness such as he had rarely known before in his life. But at the same time a restless yearning for something still more perfect that was beyond his reach."[1] Hertz more than hints that Ring was in love with Alexander Wilde's wife, but at the same time he makes plain that this love was one-sided and could never be fulfilled. Instead, the painter had ongoing conversations with Johanne Wilde on subjects relating to the meaning of life and the expression and practice of art. In his longing for the unattainable, Ring even visited areas of Jutland where Mrs. Wilde had lived as a child and a girl, and about which she had told him.

In letters he wrote to her while traveling around the country, Ring often returns to an endless discussion between them about "sunshine pictures" and "gray-weather pictures." Mrs. Wilde maintained that there was too little sunshine in Ring's pictures, while he defended himself by maintaining that overcast weather presented him with a much greater array of more painterly possibilities. The following is a passage from a letter to Johanne Wilde from Ring during an excursion into the countryside: "Today, I only managed

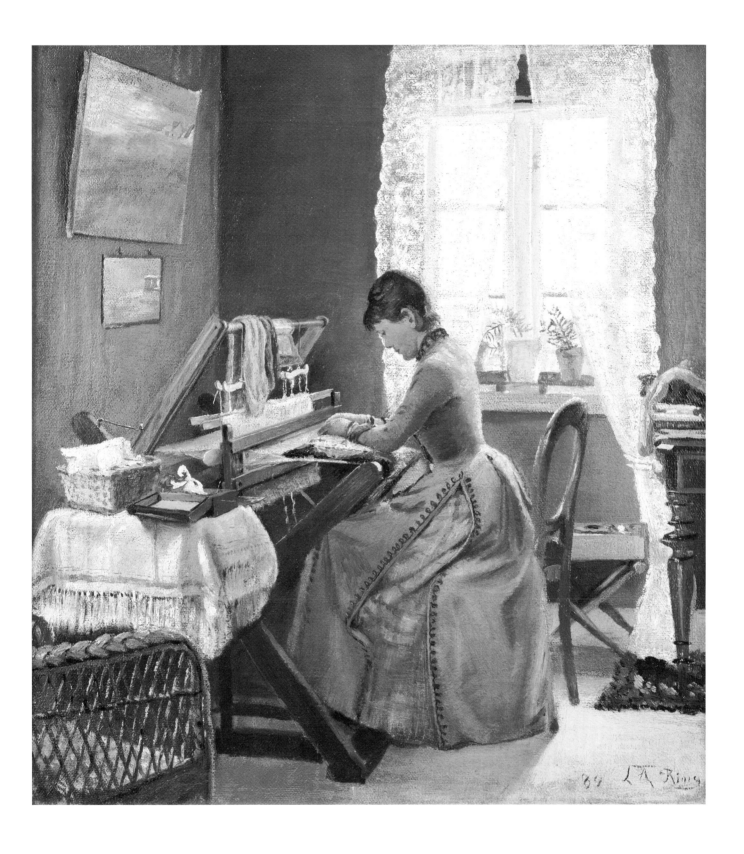

to smear a few colors on and to draw a little. Then the sun came out and I had to stop, but I hope that the weather will be better tomorrow, that is to say that it will be overcast so that I can paint again. You must forgive me, I know that you want sunshine, but neither am I myself keen on overcast weather throughout the day, only a little during the morning, and so our wishes can coincide after all."[2] This must be said to have happened in the present sunny work, executed in 1889 in the Wildes' summer residence at Hornbæk on the north coast of Zealand.

During March of that year, L. A. Ring and painter N. P. Mols (1859–1921) held a retrospective exhibition in the Copenhagen Art Society, Kunstforeningen. After that, with his friend Karl Madsen, Ring took his first journey abroad via Holland and Belgium to Paris, partly in order to visit the World Fair. (Ring exhibited in the Danish pavilion, as did Alexander Wilde, despite his being a self-taught painter.)

There are many diligent women busy with domestic duties in Danish art. The tradition for interiors is long and varied and derives from the 17th-century genre paintings in the bourgeois Netherlands, so much admired by Ring and his contemporaries. L. A. Ring had seen such pictures on his travels, but his portrayal of the beautiful woman in the summery room, where the solemn dark red of the walls is contrasted with the smiling late morning light streaming in through light lace curtains, is different. Nor is it quite like the other two interiors in the Loeb collection: Carl Bloch's portrayal of his parents in the living room from 1855 (Fig. A) and Christian Mourier-Petersen's interior from the ironing room at Holbækgaard (Fig. B), made only a few years after Ring's work. The depiction of the elegant clothier Bloch and his wife, dressed in a bonnet and busy knitting in their well-furnished, middle-class home, is a typical genre painting composed with a focus on the figures and with an implied meaning entirely in the tradition of Marstrand (Carl Bloch's teacher) and the old Dutch masters.

Christian Mourier-Petersen's ascetic work, on the other hand, has no anecdotal content. Everything there is about the play of the light and the shape of the room. The women ironing and sewing are not essential to what the painting has to say but are simply pictorial accessories in line with the mirror on the wall, the basket of washing, the coal scuttle, and the sparse furnishing in the unembellished ironing room. Nor is L. A. Ring's work anecdotal, but in contrast to the other two interiors there seem to be suggestions of ill-defined emotional undercurrents in his picture.

The young woman appears to be alone in her universe—and yet not quite. Her husband is invisibly but unavoidably present on the wall in front of her in two of his canvases, respectfully reproduced by his friend and colleague. Two sea-blue, grayish-green poetical coastal landscapes, still on their stretchers, are here imbued with an infinitely greater significance than the gold-framed paintings in the Blochs' living room and the small rococo mirror reflecting the light at Holbækgaard.

Johanne Wilde is dressed in a light brown dress of a sophisticated cut, made in a soft, glossy material that attracts the sunshine and reluctantly lets it go again. The elegant dress both hides and emphasizes her beautiful figure and endows her entire feminine presence with an unmistakable erotic aura. In addition, there is about her person and the room in which she is sitting a striking feeling of intense presence that is not found in the other two works. She is sitting sideways on her chair, bending over the warp and the colorful linen or woolen yarn as though in the processes of making up her mind on the final composition of her work. Her expression is one of reflection. Prior to this, she has clearly made a series of rapid movements to gather the materials and place them at a convenient distance for her work. A drawer with its contents has

been taken out of a cabinet behind her and placed on a small stool under the window, and she seems to have spun around to the loom in such haste that the chair has only partly come with her.

L. A. Ring's portrait of Johanne Wilde in the family's North Zealand summer residence emerges as a vision exquisite in its colors and apparently rapidly committed to canvas, at once static and living. There are various features in the work that suggest the influence both of traditional Dutch interior painting and the new, light-filled French painting, but the actual story and conception of the work are Ring's entirely. He has painted a picture that can be seen exclusively as the delightful portrait it is, of a beautiful woman at her loom. But it can probably also be seen as a pictorial representation of the balance between two so imponderable concepts: distance and intimacy.

In 1892, the painter's regular visits to the Wilde family came to an end when the family moved to the island of Møn off the south coast of Zealand, where Alexander Wilde had been appointed acting district revenue officer. Perhaps L. A. Ring celebrated a last New Year's Eve together with his faithful friends, on which occasion he wistfully presented this work to their little daughter Ellen.

When you begin to forget your old friend, let this picture remind you a little of him again. To Ellen Wilde 31/12 1892 from L. A. Ring).[3]

S.L.

[1]Peter Hertz 1934, p. 220.

[2]Peter Hertz 1934, p. 228.

[3]Inscription on the reverse of the painting.

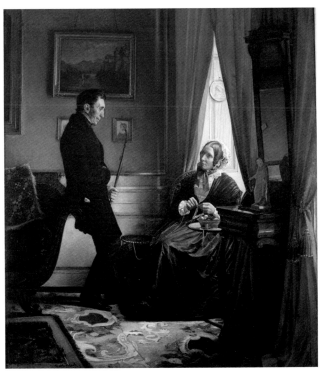

FIG. A Carl Bloch
The Artist's Parents, Mr. and Mrs. Bloch in Their Sitting Room
Loeb Collection

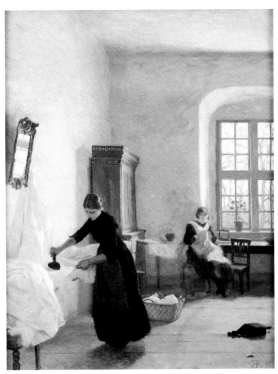

FIG. B Christian Mourier-Petersen
Ironing Room in an Old Country Mansion
Loeb Collection

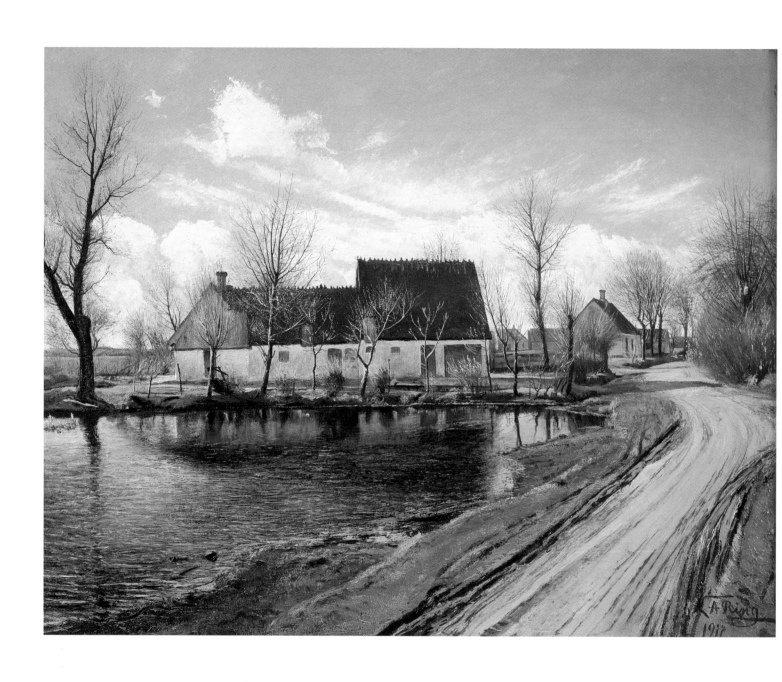

L. A. RING
1854–1933

103. *By the Village Pond at Baldersbrønde, 1911*
(Ved gadekæret i Baldersbrønde)

Oil on canvas, 19⅔ x 24¾ in. (50 x 63 cm)

Signed and dated lower right: L.A. Ring 1911

PROVENANCE: Provst J. S. Therchilsen (1911); Bruun Rasmussen, Auction 558, 1991, lot 75, ill. p. 76.

EXHIBITED: Charlottenborg, 1911, no. 410; Malmø, Sweden, *The Baltic Exhibition*, 1914, no. 2533; Busch-Reisinger Museum, Harvard University Art Museums, *Danish Paintings of the Nineteenth Century from the Collection of Ambassador John L. Loeb Jr.*, 1994, no. 23; Bruce Museum of Art and Science, Greenwich, Connecticut, and The Frances Lehman Loeb Art Center, Vassar College, New York, *Danish Paintings of the Nineteenth Century from the Collection of Ambassador John L. Loeb Jr.*, 2005, no. 32, ill.; Scandinavia House, New York, *Danish Paintings from the Golden Age to the Modern Breakthrough, Selections from the Collection of Ambassador John L. Loeb Jr.*, 2013, no. 31.

LITERATURE: H. Chr. Christensen, *Fortegnelse over Malerier og Studier af L.A. Ring 1880–1910*, 1910 (Tillæg 1922) no. 678; Peter Hertz, *Maleren L.A. Ring*, Copenhagen, 1934, p. 349, ill. (described as *Ved Gadekæret, Husene spejler sig, Baldersbrønde*); Peter Nisbet, *Danish Paintings of the Nineteenth Century from the Collection of Ambassador John L. Loeb Jr.*, Busch-Reisinger Museum, Harvard University, Cambridge, Massachusetts, 1994.

Twenty-four years have passed since the artist painted what must be assumed to be a symbol of himself as a boy on his way toward his roots in the village of Ring (Loeb collection, *Road with Boy*). Now his brother and mother are both dead, his paintings are selling, he has traveled in France and Italy, and since 1896 he has been happily married and become the father of three children.

But restlessness and melancholy still mark him and often make an impression on his work. He sees and paints the world around him with photographic precision and almost corrosive clarity, along with an idiosyncratic, apparently clumsy compositional technique that almost always turns out to add an extra enigmatic dimension to his works.

An example is this street scene from the village of Baldersbrønde near Hedehusene to the west of Copenhagen, where he moved with his family in 1902. It is an icy cold day in early spring. There is no sign of any living being. The viewer's gaze is drawn centrifugally into the picture via the muddy road, straight behind the thatched, whitewashed farm building, and is then taken diagonally upward toward the clouds. The light is glaring; a sapphire sky is reflected in the village pond and takes the farm with it.

S.L.

L. A. RING
1854–1933

104. *Road by the Village Pond in Baldersbrønde, 1913*

(Vej ved gadekæret i Baldersbrønde)

Oil on canvas, 25¼ x 43⅓ in. (64 x 110 cm)

Signed and dated lower left: L A Ring 1913

PROVENANCE: Varemægler A.W. Simmelhag's collection; Arne Bruun Rasmussen, Auction 76 (A. W. Simmelhag's estate), 1956, lot 54, ill p. 35; Kunsthallen, Auction 247, 1961, lot 112, ill. p. 9; Bruun Rasmussen, Auction 576, 1992, lot 80, ill. p. 73; Bruun Rasmussen, Auction 581, 1992, lot 73, ill. p. 73.

EXHIBITED: Glaspalast, Munich, XI *Internationale Kunstausstellung,* 1913; Kunstforeningen, Copenhagen, *Arbejder 1901–1914 af L.A. Ring,* 1914, no. 151; Charlottenborg, *Mindeudstillingen for L.A. Ring,* 1933, no. 191.

LITERATURE: H. Chr. Christensen, *Fortegnelse over Malerier og Studier af L.A. Ring 1880–1910,* Copenhagen, 1910 (Tillæg 1922), no. 747; Peter Hertz, *Maleren L.A. Ring,* Copenhagen, 1934, ill. p. 372.

Peter Hertz writes: "In his pictures of the village pond in Baldersbrønde, Ring has created a series of landscapes, carefully composed, skilfully and sensitively realized with an accurate re-creation of the special quality of the area and of the constantly changing weather which, with the alternating seasons, affected the place and changed its appearance."

Modern interpretations of L. A. Ring's works also take into account the spiritual qualities they contain. In the most recent edition of Weilbach's *Kunstnerleksikon,* the art historian Mikael Wivel says of the present work that Ring is one of the most important Danish landscapists and that he builds on a tradition from painters such as Lundbye and Kyhn (both represented in the Loeb collection).

But L. A. Ring had different aims from the national Romantic artists. He was an atheist, and times had changed radically from the days of the Romantics. As a young man he was a revolutionary, and throughout his life he felt solidarity with the poor in society, not least with the rural population whence he himself came. This can be seen in Ring's art, though there are no signs that he was using it for propaganda purposes.

Wivel writes of this: "The social indignation resided rather in the very precision with which he registered things. His depictions of the village and the cultivated land around it are insistent and precise.... But they are more than that. By means of the surprising manner in which he cuts his motifs, his sophisticated compositional technique and his idiosyncratic way of pointing to the individual elements, Ring is able to endow his pictures with an extra dimension, beyond what is actually portrayed. One of the principal recurrent motifs in his art is the road.... The roads lead us into the pictures and out of them again, and this is not only to be understood literally, but also symbolically as emblems of human life.... He was able to mobilise a colossal precision of detail without for a moment losing sight of his overall intention. He extracted the essence of the Danish landscape and weather, and by letting the roads cut through it as signs of human activity, he made the landscapes emerge as emblems of existence itself."

The three landscapes in the Loeb collection are perfect examples of this.

S.L.

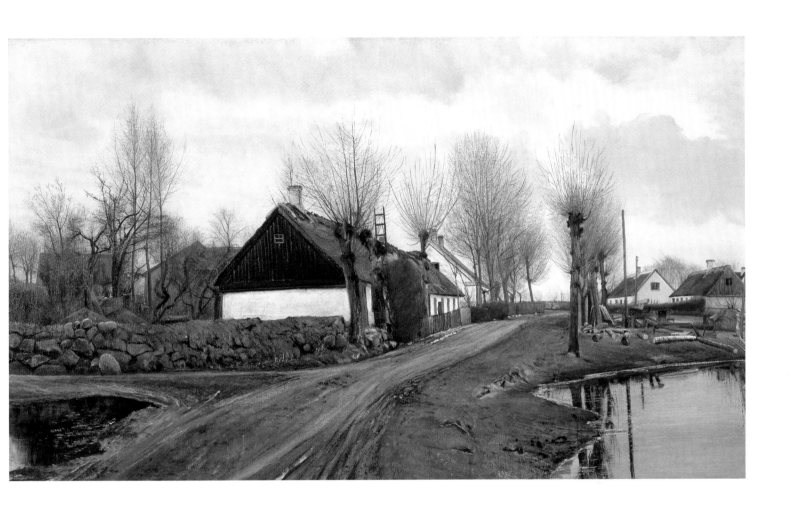

CHRISTIAN EMIL ROSENSTAND

AUSUMGÅRD 1859 – DRESDEN 1932

Emil Rosenstand was a younger relative of Vilhelm Rosenstand, who is also represented in the Loeb collection. He lost his father at an early age and after his confirmation was apprenticed as a wood carver. In 1875 he continued at the Royal Danish Academy of Fine Arts in Copenhagen. In 1878 he moved up into the Life School but broke off his studies to work as a stuccoer for some years during the rebuilding of Frederiksborg Castle. When he returned to Copenhagen in 1881, he resumed his training in the Royal Danish Academy of Fine Arts School of Painting until 1885, though he did not take the final examination. Alongside this, he was already earning his living as an illustrator, still with the ambition of making his name as a painter. In 1883, he made his first appearance at Charlottenborg, exhibiting a genre painting in oil, and he continued to exhibit similar motifs over the next few years.

In 1887 Rosenstand moved to Berlin, where he pursued a successful career as an illustrator. He produced drawings for several magazines, including Moderne Kunst, *and illustrated a fair number of works of light literature. From here, he embarked on a journey lasting several years to Corsica, the Riviera, and Italy, marrying a German woman in 1892. In 1893 he took up painting again and in 1895 once more settled in Berlin. Rosenstand was particularly interested in portraying modern life, and after a visit to Hungary in 1896 he made a series of nine large drawings depicting the life of a young girl. They were exhibited at Charlottenborg in Copenhagen the following year. His situation pictures have been described as superficial, but they nevertheless provide an accurate picture of imperial Germany. As a painter, his preferred medium was gouache, but he was also very active as an etcher, making many portraits using this technique. Rosenberg exhibited for the last time in Copenhagen in 1913 and died in Dresden in 1932. He is represented in the museum at Reykjavik in Iceland.*

E.F.

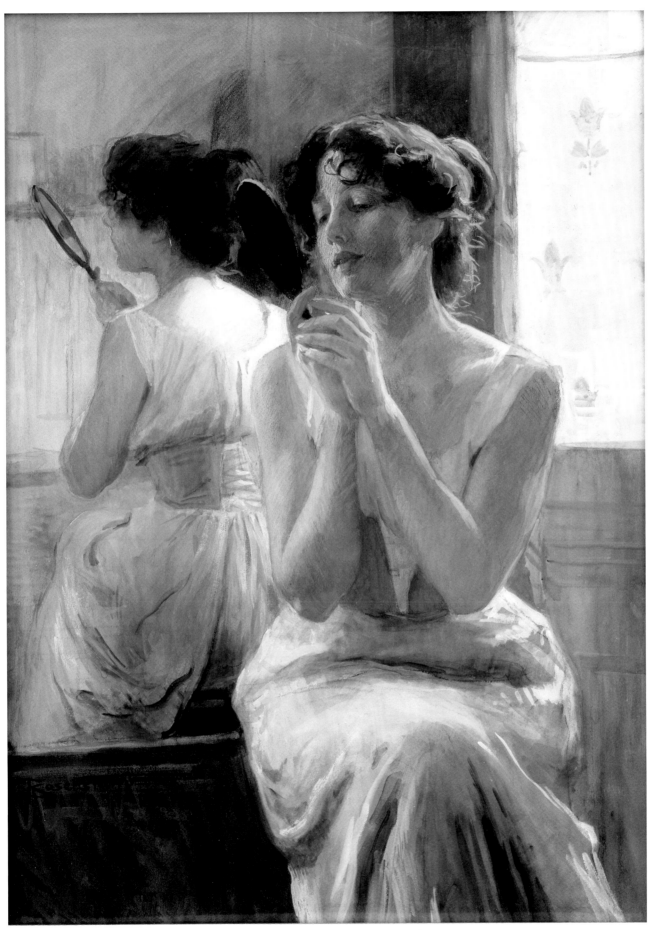

106. EMIL ROSENSTAND *Young Girl in Front of a Mirror, 1901*

EMIL ROSENSTAND
1859–1932

106. *Young Girl in Front of a Mirror,* 1901
(Ung pige foran spejlet)

Watercolor and pastel, 19⁷⁄₁₀ x 14½ in. (50 x 37 cm)

Inscribed bottom left: E. Rosenstand 1901

PROVENANCE: Bruun Rasmussen, Auction 721, 2003, lot 1157, ill.

EXHIBITED: Grosse Berliner Kunstausstellung 1902; Charlottenborg, 1904, no. 451 (described as *Ung pige foran spejlet*); Bruce Museum of Art and Science, Greenwich, Connecticut, and The Frances Lehman Loeb Art Center, Vassar College, New York, *Danish Paintings of the Nineteenth Century from the Collection of Ambassador John L. Loeb Jr.*, 2005, no. 28, ill.

A charming young girl at her morning toilette is the motif in this graceful situation portrait. Her hair is taken up and her corset is tightened, but she is still without the dress that will complete her toilette. The young woman sits in her bedroom, taking a close look at her beautiful face in the hand mirror, which she holds in both hands. The painter is in a position that allows him to paint the view from behind her as well, with her figure revealed in the large wall mirror. The viewer is thus drawn into the young woman's intimate sphere.

The picture forms part of the series of idealized portraits of women that have been a familiar genre in painting since the 18th century. The genre was revived in the 1870s by painters portraying the modern age, whose works were given an enthusiastic reception in the Paris Salon and in the major international art exhibitions of the time. The best known of these artists are probably the French artist Albert Besnard (1848–1934), the Belgian Alfred Stevens (1823–1906), and the American John Singer Sargent (1856–1925), all of whom enjoyed great success in their day. The elegant pictures they created of women were sometimes actual portraits, and sometimes anonymous representations of women in which the emphasis was on decorative qualities.

The period from 1890 to 1910, when the decorative element was integrated into the idiom, is particularly rich in paintings of women. The French artist Edmond Aman-Jean (1858–1936) emphasized color, poetry, and eroticism as in the 18th century. In the art of the Czech artist Alphonse Mucha (1860–1939), woman and ornamentation constitute an indissoluble whole. His view of woman as a beautiful and compelling being is evidence of the successful liberation of women at that time. The symbolists of the period, on the other hand, saw woman as at once mysterious, unapproachable, and demonic.

Rosenstand's charming portrait of a woman is uncomplicated, a momentary impression that reflects the ideal of a vanished age.

E.F.

VILHELM JACOB ROSENSTAND

COPENHAGEN 1838 – COPENHAGEN 1915

Vilhelm Rosenstand's father was a bookkeeper in the Greenland Trade Department and bore the title of Kammerraad. *The son was apprenticed as an artisan painter before being admitted to the Royal Danish Academy of Fine Arts in the autumn of 1856, where he was awarded both the minor and major silver medals. For two winters Rosenstand was a private pupil of Wilhelm Marstrand and was later regarded by many as his successor, as throughout their lives both artists showed a predilection for painting genre and historical pictures.*

During his long life as an artist, Vilhelm Rosenstand was awarded various distinctions such as the Neuhausen Prize, which he won in both 1865 and 1867, and his appointment as titular professor in the Royal Danish Academy of Fine Arts in 1892. He was a member of the Academy Council from 1887 until three years before his death. From 1869 to 1881 he spent almost twelve years in Italy. He was in Vienna to participate in the World Fair in 1873, and he visited Paris in 1878 for a similar reason. What was of special significance for Rosenstand's genre painting was his 1881–1882 visit to the French capital.

In addition to participating in many prestigious exhibitions both in Copenhagen and abroad, Rosenstand exhibited at Charlottenborg almost every year, with very few exceptions, from 1861 to 1910. Although in his time he was considered inferior to artists such as Otto Bache and Carl Bloch, Vilhelm Rosenstand was together with them a typical representative of the many narrative and illustrative painters in the second half of the 19th century. He also achieved a reputation as a respected book illustrator.

In 1864 he served as a lieutenant in the Second Schleswig War against Prussia and Austria. After 1864 he came to stand as one of those rekindling a national awareness, and during the 1890s he painted several very large works with motifs from the war. Vilhelm Rosenstand achieved his greatest personal artistic triumph when he won the competition for two murals to decorate the Great Hall of Copenhagen University, executed 1889–1890.

S.L.

LITERATURE: Sigurd Müller, *Nyere Dansk Malerkunst*, Copenhagen 1884; Sigurd Schultz in *Dansk Biografisk Leksikon*, vol. 12, Copenhagen 1982; Erik Mortensen in *Weilbach*, vol. 7, Copenhagen 1998.

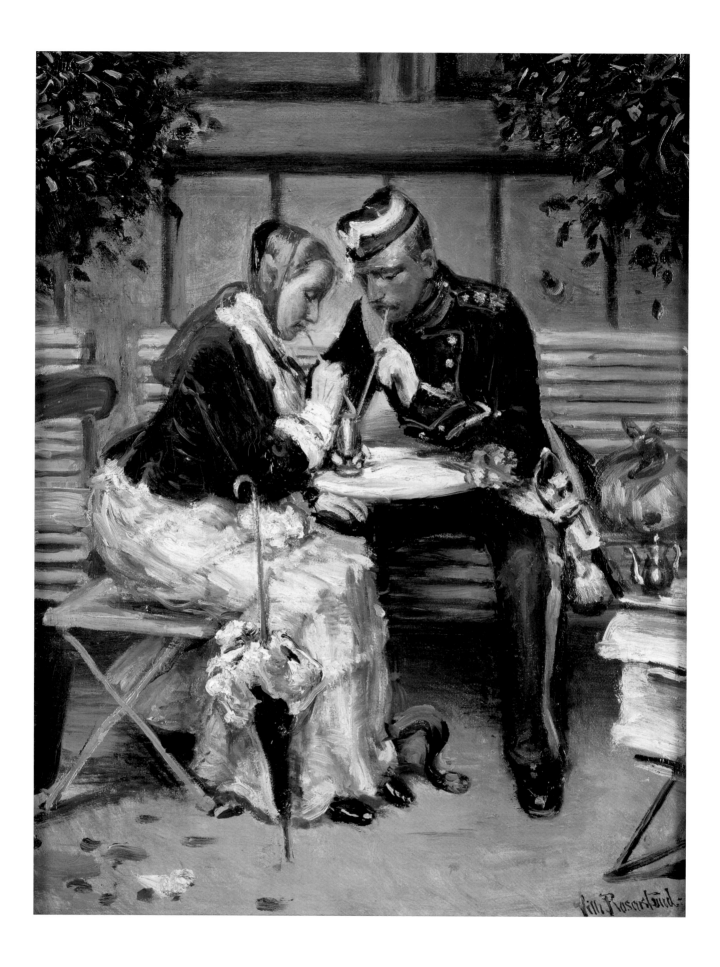

VILHELM ROSENSTAND
1838–1915

107. *Outside the Café à Porta*
(Uden for à Porta's café)

Oil on canvas, 15⅔ x 12¼ in. (40 x 31 cm)

Signed lower right: Vilh. Rosenstand

PROVENANCE: Bruun Rasmussen, Vejle, Auction 27, 1993, lot 979, ill. p. 17 (described as *En soldat og hans pige på café à Porta*).

This picture of the dashing guardsman and his bashful lady friend drinking from the same glass exists in no fewer than nine variants of different sizes. Most of them, including that in the Loeb collection, were presumably preparatory studies for a more methodically executed painting of 1882 also entitled *Outside the Café à Porta*, which was exhibited in the Nordic exhibition in Copenhagen the following year and purchased by the Nationalmuseum in Stockholm (Fig. A).

Vilhelm Rosenstand spent 1881 and part of 1882 in Paris. Like many other Danish artists, he attended Léon Bonnat's school of painting for a time but was not particularly interested in the instruction there. Instead, he continued producing his genre paintings with anecdotal scenes of everyday life—"now with the addition of a touch of Parisian chic" (Sigurd Schultz). His new French-influenced works charmed people of his day, and one of them even secured him the exhibition medal awarded by the Royal Danish Academy of Fine Arts. Once back in Denmark, he continued with Parisian-style subjects such as this good-humored portrayal of life in the famous Café à Porta, which still stands on Kongens Nytorv in Copenhagen.

By comparing the many replicas of the motif it is possible to see how the painter has experimented with different visual narrative elements to illustrate the innocent love scene. In some versions, the guardsman and his pretty companion seem to be drinking lemonade or perhaps a light wine as refreshment. In this version a small chocolate pot on a low table beside the couple and the color of the glass suggests that they are drinking chocolate. On the table in some versions there is a half-open newspaper on a tray along with an array of objects such as a bottle with a tempting label or a *plat de ménage*—but nowhere is there a sign of the other glass. All nine paintings have in common the psychological factor revealed in the facial expressions and postures of the two figures, which has also been reached through other descriptive details. For instance, the soldier's discreetly amorous intention is reinforced by his masculine boots and an echoing interest on the girl's part hinted by the shining little toes of her very feminine coal-black shoes and by the slightly erotic curve of the café table's cast-iron foot.

The bouquet on the table is unmistakably the bearer of the same message.

FIG. A Vilhelm Rosenstand, *Outside the Café à Porta*, 1882, Oil on canvas, 35⅔ x 26½ in. (89 x 70 cm), Nationalmuseum, Stockholm

S.L.

MARTINUS CHRISTIAN WEDSELTOFT RØRBYE

DRAMMEN 1803 – COPENHAGEN 1848

Rørbye grew up as a member of a Danish civil servant family in Drammen in Norway. The family moved to Denmark after Norway was ceded to Sweden in 1814.

By 1820 Martinus Rørbye was a student in the Royal Danish Academy of Fine Arts, where in time he was awarded both the minor and major silver medals and then, after several attempts, the minor gold medal. However, he unsuccessfully competed for the major gold medal. Rørbye was originally one of C. A. Lorentzen's (1746–1828) students, but from 1825 he became a private pupil of Eckersberg, with whom he established a close relationship—so close, in fact, that in 1832 Eckersberg introduced his pupil to the Order of Freemasons, of which he was already a member.

Rørbye exhibited works at Charlottenborg almost every year from 1824 to 1848. Twelve works, mainly with Italian motifs, were shown posthumously by his widow in 1849. Throughout his life Rørbye was extremely fond of traveling, and he ventured farther afield than any other Danish Golden Age artist. He explored Norway in 1830 and 1832. In 1834, financed by a grant from the Fonden ad Usus Publicos, he went first to Paris, where he admired especially the work of Horace Vernet (1789–1863) but was also taken by Théodore Géricault's (1791–1824) The Raft of the Medusa, *while emphatically expressing disapproval of the works of Delacroix (1798–1863) and viewing Ingres (1780–1867) with great skepticism.[1] After Paris, he went to Rome, where he joined the architect Gottlieb Bindesbøll (1800–1856) and traveled on to Athens and Constantinople. He was back in Copenhagen at the end of 1837. The following years offered more opportunities for travel, which in 1839–1840 included another journey to Italy, this time including Sicily. He also took many journeys within Denmark, and he was presumably the first Danish artist to work at Skagen, which he visited as early as 1833.*

Rørbye was appointed professor in the Royal Danish Academy Life School in 1844. Christen Dalsgaard was one of those for whom he played a significant role during his short career as a teacher. Throughout his life Rørbye's preferred motifs were genre paintings and pictures of everyday life in addition to architectural pieces, all in the manner of Eckersberg. His paintings were factual, almost in the nature of reportage, but his portrayals of people revealed tenderness and sensitivity. He also executed a few portraits and a number of landscapes, these latter frequently inspired by J. C. Dahl (1788–1857) and to a certain extent Casper David Friedrich (1774–1840).

S.L.

LITERATURE: Georg Nygaard, *Martinus Rørbyes Rejsedagbog 1830*, Copenhagen 1930; Dyveke Helsted, Eva Henschen, Bjarne Jørnæs, and Torben Melander (eds.), *Martinus Rørbye 1803–1848*, Thorvaldsens Museum, Copenhagen 1981; Jens Peter Munk in *Weilbach*, vol. 7, Copenhagen 1998.

[1]Kasper Monrad (ed.), *Danish Painting, The Golden Age*, National Gallery, London 1984, p. 179.

MARTINUS RØRBYE
1803–1848

105. *Cloister at Palermo with a Dominican Friar*, 1840
(Klostergang i Palermo med en dominikanermunk)

Oil on canvas, 14½ x 11¼ in. (37 x 28 cm)

Signed with initials and dated lower left: MR 1840

PROVENANCE: Auction of the artist's estate, 1849, no. 50; Winkel & Magnussen Private Collection; Winkel & Magnussen, Auction 31, 1925, lot 105, ill. p. 22; Bruun Rasmussen, Auction 552, 1991, lot 120, ill. p. 36.[1]

EXHIBITED: Kunstforeningen, Copenhagen, *Martinus Rørbye*, 1905, no. 186 (according to the chronologically revised catalogue of paintings made by Thorvaldsen's Museum in 1981 on the basis of Mario Krohn's catalogue); Busch-Reisinger Museum, Harvard University Art Museums, *Danish Paintings of the Nineteenth Century from the Collection of Ambassador John Loeb Jr.*, 1994, no. 24.

LITERATURE: Mario Krohn, *Fortegnelse over Martinus Rørbyes Arbejder som Vejledning ved Udstillingen i Kunstforeningen Marts–April 1905*, Copenhagen, 1905; V. Jastrau (ed.), *Martinus Rørbye*, Smaa Kunstbøger nr. 22, Copenhagen, 1933, p. 30 (described as *Klostergaarden San Giovanni in Laterano, Rom 1834*, no measurements); Knud Voss, *Guldalderens Malerkunst, Dansk Arkitekturmaleri 1800–1850*, Copenhagen 1968, fig. 70 (described as *Klostergaard i Fossanuova, 1846*); Dyveke Helsted, Eva Henschen, Bjarne Jørnæs og Torben Melander, *Martinus Rørbye 1803–1848*, Thorvaldsens Museum, Copenhagen, 1981, nr. 186 (List of paintings on the basis of Mario Krohn's catalogue for the Rørbye exhibition in Kunstforeningen, 1905; the Loeb collection Rørbye study was not exhibited, but was included in the updated register from 1981); Peter Nisbet, *Danish Paintings of the Nineteenth Century from the Collection of Ambassador John Loeb Jr.*, Busch-Reisinger Museum, Harvard University, Cambridge, Massachusetts 1994, discussed and ill. p. 9.

In this scene set in a Palermo monastery, we see a monk reading at the corner of a pergola supported on pillars, near a sun-drenched herb garden where a pair of snake like cucumbers lie below a fountain. Judging by his brown habit, the barefooted monk in this picture is not really a Dominican at all but instead belongs to the order of St. Francis.

The motif derives from the artist's second visit to Italy, in 1839–1841, which was also his honeymoon. The artist and his new wife settled in Rome, where their little daughter Athalia was subsequently born. Before that, they had stayed for a time at the Bay of Naples and, from June 25 to the beginning of October 1840, in Sicily. During his first visit to Italy, Rørbye had wanted to visit this island but had not had the opportunity, because instead he had gone to Greece and Turkey in the company of the architect Gottlieb Bindesbøll.[2]

According to a picture in the photographic library of the Royal Danish Academy of Fine Arts, there is in some private collection (the location of which is unknown) a very exact replica after the Loeb collection's little picture, bearing the date of 1846. The Kunstforeningen catalogue register for 1905 also provides the information that Rørbye was working on the same motif in a rather larger picture titled *Klostergang i Palermo med en franciscanermunk (Cloisters in Palermo with a Franciscan Friar)* inscribed *Palermo 1840. M.R.* This work is also in a private collection in someplace unknown.

An aspect of this painting not to be overlooked but difficult to explain is the presence of two cucumbers below the stone fountain. Have they been placed inside the pergola merely for technical reasons, to establish in the picture the relationship between indoors and outdoors? Did Rørbye note the contrast between the green vitality of the vegetables (which look as though they have just jumped over the edge of the foun-

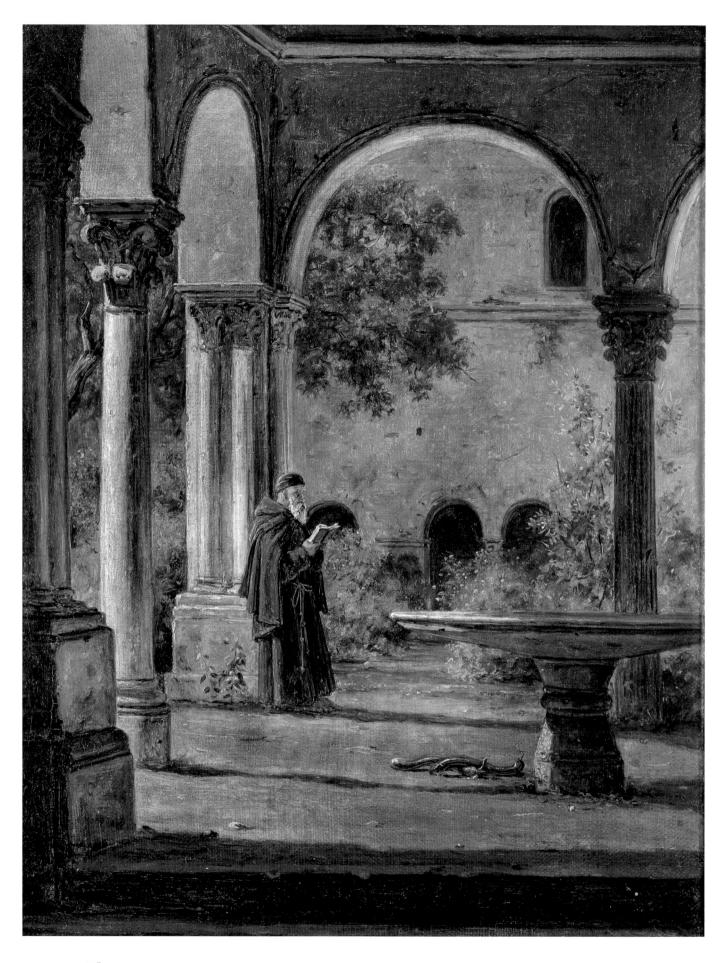

tain) and the other-worldly monk? Or has the artist, in according the cucumbers a prominent position, put into his picture some anecdotal or even allegorical significance that is inexplicable to a modern viewer?

Martinus Rørbye was undoubtedly fascinated by these exotic vegetables, with their long stalks and resemblance to live snakes. There are several instances of the so-called snake cucumber (*Cucumis flexuosus*) in Rørbye's oeuvre, for instance in the work he painted to mark his membership in the Academy, *Scene from Public Life in the Orient* (Fig. A), and in *Harbor Scene in Palermo*,[3] which Thorvaldsen had commissioned. In both of these works we see a basketful of the long cucumbers twisting like reptiles with aggressively flickering tongues. They represent an independent story within the actual motif of the work but nevertheless are only a single element in the totality, accorded the same weight as all the other pictorial elements.

Nearly all of Rørbye's motifs are done objectively, almost as a report, without any action as such, something that in his best works endows the presentation with an overall sense of peace and an almost unreal feeling of timelessness. We find this atmosphere in the picture of the monk reading in the monastery. Peace and reflection dominate here; no troublesome forewarnings disturb that peace. The presence of the two cucumbers is, after all, subordinated to the laws of pictorial expression. If they had had the status of a serpent, relating to one of the many symbolic values of that creature, their presence would have disturbed the totality and shattered the work's message.

S.L.

FIG. A Martinus Rørbye
Scene from Public Life in the Orient, 1838
(Scene af det offentlige liv i Orienten)
Oil on canvas, 36⅖ x 51 in. (92.5 x 129.5 cm), The Royal Academy of Fine Arts

[1] According to the photograph archives in the Academy there is a replica from 1846 of this painting. The provenance of the two works has been confused and cannot be resolved with any certainty. In addition, older literature ascribes two other titles to the same motif; see the Literature list.

[2] Gottlieb Bindesbøll (1800–1856) is best known as the creator of Thorvaldsens Museum in Copenhagen.

[3] Martinus Rørbye, *Havnescene i Palermo,* 1844 *(Harbor Scene at Palermo),* oil on canvas, 33 x 49⅖ in. (84 x 125.5 cm), Thorvaldsens Museum.

JOHAN PETER RAADSIG

COPENHAGEN 1806 – COPENHAGEN 1882

Because the artist's father, Captain Søren Christian Raadsig, died in a shipwreck when his son was only six months old, his mother later remarried, her new husband being the land agent at the mansion of Skjoldenæsholm in central Zealand. Thus the boy experienced four or five years of growing up in beautiful rural surroundings, which would mark him for life and leave its traces in his artistic work.

Peter Raadsig was sent to school in Copenhagen, where he became an apprentice painter; at the same time he was admitted to the Royal Danish Academy of Fine Arts. However, according to his statement for Philip Weilbach's Konstnerlexikon, *it was only after successfully completing his apprenticeship as an artisan painter that he was able to devote himself properly to training as an artist. In 1827 Raadsig progressed to the life school; three years later, he was awarded the minor silver medal, and in 1831 came the major silver medal, but like so many other Academy pupils, he competed in vain for the minor gold medal. That was in 1839.*

Nor did his efforts to gain financial support for a journey to Italy from the Fonden ad Usus Publicos bear fruit, and he was obliged to finance it himself. On the recommendation of others, including C. W. Eckersberg and Bertel Thorvaldsen (1770–1844), he spent 1841–1845 in Rome, after which he extended his visit abroad with a year in Munich. Throughout this period he lived in very difficult financial circumstances.

In 1857, Raadsig won the Neuhausen Prize for Vildttyve i forhør hos en birkedommer (Poachers Being Questioned by a District Judge), *which was bought by Heinrich Hirschsprung (1836–1908).*

Johan Peter Raadsig first exhibited at Charlottenborg in the spring of 1831 with a painting of an old woman reading the Bible. After this, year by year until 1883, there followed an enormous flow of works for the Charlottenborg exhibitions. In addition, he participated in exhibitions in the Academy of Fine Arts in Stockholm in 1850, 1860, 1866, 1868, and 1870 and in the Nordisk Kunstudstilling in Copenhagen in 1872.

For a time in the middle of the 1830's, Raadsig, like many of his fellow artists, was deeply engrossed in subjects from Danish history, not least as portrayed in the literature of the time. It was especially the novels of B. S. Ingemann[1] (1789–1862) that inspired him to paint but also the poems of Christian Winther (1796–1876). The book Store og gode Handlinger af Danske, Norske og Holstenere (Great and Good Deeds by Danes, Norwegians and Holsteiners) *from 1777, written by the historian Ove Malling (1747–1829), also appealed to the national feelings so dominant at the time.*

Raadsig also painted landscapes, including many hunting scenes inspired by his links with Skjoldenæsholm, as well as various genre-like figure pictures. In Rome he produced a number of depictions of everyday life. Like Marstrand, he found his inspiration for this in the etchings of the

Roman painter Bartolomeo Pinelli. (See Marstrand's An Englishman Pursued by Beggars in Rome *in the Loeb collection.)*

It has been said of Peter Raadsig's oeuvre that he set about painting everything with a great narrative enthusiasm, which his artistic abilities were not always able to live up to. However, this does not apply to the lyrical hunting scene in the Loeb collection, with its sensitive coloring.

Raadsig was one of the first Danish artists to make his way to Hornbæk in northern Zealand and Skagen at the northernmost tip of Jutland in order to paint pictures of the life of the fisherfolk. There is a work painted by him in 1852 in Hornbæk in Vejle Kunstmuseum. The Loeb collection contains several examples of works from the same localities by such famed artists as Michael Ancher and Carl Locher.

<div align="right">

S.L.

</div>

LITERATURE: Philip Weilbach, *Dansk Konstnerlexikon,* Copenhagen 1877–78; Karl Madsen, *Skagens Malere og Skagens Museum,* 1929, pp. 10, 16; Jens Peter Munk in *Weilbach,* vol. 7, Copenhagen 1998.

[1]Vilhelm Kyhn was also inspired by the novels of B. S. Ingemann. (See *Evening Atmosphere* in the Loeb collection.)

PETER RAADSIG
1806–1882

99. *Hunter with His Hounds by the Edge of a Lake, Presumably Skjoldenæsholm,* 1881

(Jæger med sine hunde ved bredden af en sø, måske Skjoldenæsholm)

Oil on canvas, 16½ x 25½ in. (42 x 65 cm)

Signed and dated lower right: R Raadsig 1881

PROVENANCE: Bruun Rasmussen, Auction 525, 1989, lot 297.

EXHIBITED: Presumably Charlottenborg, 1881, no. 209 (described as *Udsigt mod Valsølille sø ved Skjoldenæsholm*).

Peter Raadsig's father, a ship captain, was lost at sea while on his way home from Holland when his son was only six months old. Some years later Peter Raadsig's mother married the bailiff of the mansion of Skjoldenæsholm, which is situated in a forested Zealand landscape a good 10 kilometres (6¼ miles) northeast of Ringsted. In this beautiful and varied area, characterized by deep forests and clear lakes, the boy spent his early childhood, and as a grown artist he often returned there to paint. He is buried in Valsølille churchyard, not far from Skjoldenæsholm. The motif of the hunter and his hounds on a duck shoot is not Raadsig's first hunting picture. Even as a young pupil at the Academy, he exhibited a picture of a battue[1] at Charlottenborg, bought by the president of the Academy, the later King Christian VIII.

Among Peter Raadsig's last four works to be exhibited at Charlottenborg in 1881, two took their motifs from the area near Skjoldenæsholm. One of them, *Udsigt mod Hvalsølille sø ved Skjoldenæsholm (View toward Hvalsølille Lake near Skjoldenæsholm)*, could very well be the atmospheric hunting scene in the Loeb collection.

S.L.

[1]The driving, or drawing out, of game from cover by beating woods and bushes.

PETER CHRISTIAN THAMSEN SKOVGAARD

HAMMERSHUS NEAR RINGSTED 1817 – COPENHAGEN 1875

P. C. Skovgaard was born to parents living in modest circumstances on the copyhold farm of Hammers-hus near Ringsted in Zealand. His father subsequently took over another farm, though he soon had to give it up, after which the family moved to Vejby near Tisvilde, where Skovgaard's mother managed a small grocer's shop and his father sought work in Copenhagen. The boy was thus brought up solely by his mother, who herself had some artistic gifts. As a young woman she had even received a little instruction from the flower painter C. D. Fritzsch (1765–1841), J. L. Jensen's first teacher.

Skovgaard was admitted to the Royal Danish Academy of Fine Arts in 1831 where he, along with Dankvart Dreyer (1816–1852) and J. Th. Lundbye, became pupils of Professor J. L. Lund (1777–1867). The three artists became lifelong friends. While studying in the Academy, Skovgaard was also appren-ticed as an artisan painter. He became a journeyman in 1835 and qualified in the Academy in 1845. Skovgaard won no medals, but from 1836 to 1875 he exhibited at Charlottenborg almost every year.

The commitment of N. L. Høyen (1798–1870) and the pastor and poet N. F. S. Grundtvig (1783–1872) to causes Nordic and national were of great importance to the young landscape artists. Skovgaard moreover came into contact with many of the leading national liberal politicians, includ-ing Orla Lehmann (1810–1870), who commissioned paintings from him and backed him throughout his life.

In 1851 P. C. Skovgaard married Georgia Marie Louise Schouw, the daughter of one of the well-known figures of the day, botanist and politician Joachim Frederik (Friedrich) Schouw (1789–1852). Three years later the couple went to Italy, Skovgaard's first journey abroad. Some years after that he also visited London and Paris, and in 1869 he was again in Italy.

In 1860 Skovgaard was made a titular professor in the Royal Danish Academy of Fine Arts but otherwise never made any effort to follow an academic career, preferring his personal freedom. Together with especially J. Th. Lundbye and Dankvart Dreyer, he is considered one of the main cre-ators of Romantic Danish landscape painting. But while Lundbye—and to a certain extent also Dreyer—preferred painting open landscapes, Skovgaard's pictures evolved more and more into grandiose, atmospheric depictions of forests, which he portrayed as great columned halls in a solemn and lofty universe.

The aim of the new national painting was to emphasize the history of Denmark and praise the beauties of the countryside. So it was of great importance to the painters to seek out features in the landscape that possessed peculiarly Danish qualities that could awaken recognition and pride on the part of the Danish viewer. To Lund's pupils there was nothing wrong in piecing together motifs selected from various localities in order to achieve this "typical" quality. However, such an approach ran completely counter to the convictions of J. L. Lund's colleague, Professor Eckersberg. It is said that

Skovgaard once showed one of his landscapes to Eckersberg, who then asked him what area it repre-sented. When Skovgaard replied that his painting was a free composition, he received the following testy reply: "Well, there we are. You people want to do things better than God can do them; if you could only do them as well, you would have reason to be happy."

<div align="right">S.L.</div>

LITERATURE: Henrik Bramsen, *Malerier af P. C. Skovgaard,* Copenhagen 1938; H.G. Skovgaard, *P. C. Skovgaard udstilling i 150 året for kunst-nerens fødsel, Om P. C. Skovgaards landskaber,* Skovgaard Museum, Viborg, 1967, pp. 7–14; Henrik Bramsen in *Dansk Biografisk Leksikon,* vol. 13, Copenhagen 1983; Nina Dahlmann Olsen in *Weilbach,* vol. 7, 1998.

P. C. SKOVGAARD
1817–1875

108. *Forest with a Herd of Fallow Deer and Two Girls,* 1854

(Skov med rudel dådyr og to piger)

Oil on canvas, 48 x 72¾ in. (122 x 185 cm)

Signed and dated lower right: P. C. Skovgaard 1854

PROVENANCE: Biskop D. G. Monrad (1855); Vinhandler J. B. Sandberg (1864); Godsejer C. Scavenius til Klintholm (1871); Kammerherre C. C. Scavenius. Klintholm;[1] Fabrikant Bøie Dorph, Tåstrup (1967); Arne Bruun Rasmussen, Auction 454, 1983, lot 497 (described as *Hjorte i en lysning i en skov, sensommer*).

EXHIBITED: Possibly Charlottenborg, 1855, no. 149 (described as *Sildig Sommeraften*); Skovgaard Museum, Viborg, *P. C. Skovgaard Udstilling i 150 året for kunstnerens fødsel,* 1967, no. 85; Busch-Reisinger Museum, Harvard University Art Museums, *Danish Paintings of the Nineteenth Century from the Collection of Ambassador John Loeb Jr.,* 1994, no. 25.

LITERATURE: Peter Nisbet, *Danish Paintings of the Nineteenth Century from the Collection of Ambassador John Loeb Jr.,* Busch-Reisinger Museum, Harvard University, Cambridge, Massachusetts, 1994, p. 7.

For the national Romantic painters the object was not to achieve the highest degree of naturalism; their aims were more concerned with the ideal. Writing about this, the art critic K. F. Wiborg[2] argued that the aim of art was not to copy nature but that the artistic content of a picture was solely determined by the extent to which "the ideal was reproduced."[3] The background to this far-reaching change in painting style was of a political nature. Intellectual trends at the time, deriving from literary Romanticism, found a religious outlet especially in the Grundtvigian movement[4] as well as a political statement in national liberalism.[5]

Skovgaard was in close contact with both these environments, and over the years their ideas found a common expression in his pictures. This was seen — especially in his carefully worked-out compositions — in the balance he gradually achieved between an ideal grandeur and an elementary delight in nature.

This applies also to this solemn late summer portrayal of a Danish beech forest seen in the light of a setting sun, a painting intended to fill the viewer with reverence. The height and majesty of the beech trees are emphasized partly through the positioning of the staffage figures and the many animals below the horizon, aided by a backlight in the style of Claude Lorrain, which makes the treetops stand out like gigantic, darkgreen silhouettes against the pink and golden cloud formations in the sky.

The artist's delight in nature is seen in the meticulous reproduction of foliage and grass and not least in the rendering of the radiant forest flowers in the foreground, perhaps placed there in special acknowledgement of the artist's father-in-law, the famous botanist J. F. Schouw. The inspiration for all this splendor presumably came primarily from Deer Park, Dyrehaven (north of Copenhagen), where Skovgaard found so many of his motifs, but it is probably based on a number of observations from various other places as well, cobbled together to form an idealized whole.

S.L.

[1]It is not yet documented that this painting, *Skov med rudel dådyr og to piger,* is identical to *Sildig Sommeraften* exhibited at Charlottenborg 1855, nr. 149, which was inherited by Bishop Monrad, and later became part of the Sandberg collection and finally the Scavenius collection. If, as is believed, the two titles are indeed the same painting, the provenance attributed to the hereby cited owners is accurate as well as the Charlottenborg exhibition listed.

[2]The two leading art critics in Golden Age Copenhagen were the art historian Niels Lauritz Høyen (1799–1870), who was by far the more important, and the somewhat younger Karsten Wiborg (1813–1885). In 1838, 1841, 1843, and 1844, Wiborg published a series of papers on art criticism relating to the Charlottenborg exhibitions.

[3]Henrik Bramsen, *Malerier af P. C. Skovgaard,* Copenhagen 1938, pp. 8–9.

[4]Nikolaj Frederik Severin Grundtvig (1783–1872), poet and cleric, was one of the great cultural personalities of the Golden Age who by lecturing and writing brought about a truly national and religious revival. From 1839 until his death, he was the pastor at Vartov Church in Copenhagen. Grundtvigianism was a church movement based on Grundtvig's conviction that the crucial element in the understanding of Christianity was not the interpretation of the Scriptures but of the living Word proclaimed through baptism, the Eucharist, and the Creed. Most of the national Romantic landscape artists, including Skovgaard and Lundbye, were deeply inspired by his ideas.

[5]National liberalism consisted of liberal but profoundly nationalistic parties in the Europe of the 19th century. In Denmark, the 1840s saw the formation of the party *De Nationalliberale,* demanding a free constitution applying as far south as the River Ejder, which marks the border between the duchies of Schleswig and Holstein in present-day Germany. It was a party with a profound sense of Scandinavian unity. Niels Lauritz Høyen was a national liberal, as were Grundtvig, Skovgaard's father-in-law, the politician and botanist J. F. Schouw, and the politician Orla Lehmann (1810–1870). Lehmann commissioned paintings by both Vilhelm Kyhn and P. C. Skovgaard and supported them throughout their lives.

P. C. SKOVGAARD

1817–1875

109. *A Street in Italy, 1854*

(En italiensk gade)

Oil on canvas, 12 x 11½ in. (30.5 x 29 cm)

Inscribed lower right: Corvara 29 Aug. 1854

PROVENANCE: The auction of the artist's estate, 1876, no. 54; Editor Svend Kragh-Jacobsen; Arne Bruun Rasmussen, Auction 465, 1984, lot 4, ill.

EXHIBITED: Kunstforeningen, Copenhagen, *P. C. Skovgaard*, 1917, no. 201; Busch-Reisinger Museum, Harvard University Art Museums, *Danish Paintings of the Nineteenth Century from the Collection of Ambassador John Loeb Jr.*, 1994, no. 26; Artemis Fine Arts, Inc., New York, *Danish Paintings of The Golden Age*, 1999, no. 27, ill.

LITERATURE: Peter Nisbet, *Danish Paintings of the Nineteenth Century from the Collection of Ambassador John Loeb Jr.*, Busch-Reisinger Museum, Harvard University, Cambridge, Massachusetts 1994, ill. and discussed p. 7.

Professor Niels Lauritz Høyen's ideas of a national art reflecting the original character of the Danish people made a powerful impression on P. C. Skovgaard, not least because he himself came from genuine Danish peasant stock. He became one of Høyen's most loyal adherents. But Høyen's national romantic program demanded that the painters should remain at home and work in Denmark, and it was only when they were out of the danger of being seduced by the landscapes and life of foreign nations that they could be trusted to go abroad. Thus, when P. C. Skovgaard was thirty-seven years old and in Høyen's opinion could not be "corrupted," the painter and his wife, together with Høyen and his wife, spent the end of summer 1854 and well into the winter of 1855 in Italy. Halfway through they were joined by Wilhelm Marstrand. (The object of Skovgaard's first journey abroad was to study the old masters, including both the Venetians and Rubens and, not least, Claude Lorrain.)

Skovgaard did not fall under the spell of Italy but on the contrary became even more Danish as a consequence of the journey. On his return he produced what is perhaps his best-known work, *Bøgeskov i maj*, 1857 (*Beech Forest in May*, Statens Museum for Kunst).

A Street in Italy does not immediately attract attention. However, on closer examination it is impossible to avoid taking delight in the subtle play of light and shade and the many exquisite painterly details, such as the dense volume of foliage, the little group of figures in the background characterized by their motley dress, and the washing laid out to dry. A straight gable end blocks the space on the left and sends its greetings to Skovgaard's upright Danish beech trees, such as are seen in the Loeb collection's *Forest with a Herd of Fallow Deer and Two Girls*, painted shortly before his departure for Italy.

S.L.

P. C. SKOVGAARD
1817–1875

110. *Portrait of Elisabeth Wedell-Wedellsborg, née Scavenius, 1862*

(Portræt af Elisabeth Wedell-Wedellsborg, f. Scavenius)

Oil on canvas, 31½ x 24¾ in. (80 x 63 cm)

Signed lower right with monogram and dated: 1862

PROVENANCE: Always in possession of the family; Bruun Rasmussen, Auction 688, 2000, lot 1437, ill.

With her first two names, Karine Lucie Elisabeth Wedell-Wedellsborg was called after her paternal grandmother, Karine Lucie Scavenius, née Debes, whose husband Jacob Brønnum Scavenius (1749–1820) had earned a fortune in India. On his return to Denmark he invested his fortune in the purchase of various estates in Zealand, including Gjorslev, near Stevns Klint on the Baltic shore. He later bought the estate of Klintholm and Møns Klint on the island of Møn east of the southernmost point of Zealand. Jacob Brønnum Scavenius was a keen book collector, especially in the fields of mathematics, history, and language, and over the years he assembled a sizable library.

Jacob Brønnum Scavenius's son Peder (1795–1868) was a gifted jurist, a major landowner, and a very active politician who throughout his life occupied a large number of positions of responsibility in which he unswervingly defended the privileges of the far right wing. In 1840 he was given the title of *Kammerherre,* and three years later he was ennobled. He was appointed by the king as a member of the 1848–1849 constitutional assembly, in which he stood alone in proposing (unsuccessfully) that the 1660 Royal Constitution continue to be observed and absolutism retained with minor changes.[1]

In his youth Peder Brønnum Scavenius had become acquainted with European art during a grand tour of Paris and Rome. Throughout his life he retained a profound interest in art and architecture, and he was a knowledgable and adept collector of the finest examples of Danish Golden Age painting and provided his many residences with modern furnishings and fittings made by the best artists and artisans of the time. Like his father, he was also a great book lover—in his case with a particular interest in astronomy (he even built an observatory at Gjorslev). He had three sons and two daughters by his wife Charlotte Sophie, née Meincke. The oldest son, Jacob Frederik, inherited Gjorslev and became a highly respected minister of culture. The children are said to have had a tolerant and dedicated upbringing, and their parents were on first-name terms with each other, unusual for the time.[2]

That Elisabeth (1840–1920), who was Peder and Charlotte Sophie Brønnum Scavenius's third child, was also a gifted and unusual personality is clearly proclaimed by Skovgaard's portrait of her. Presumably inspired by Gjorslev's extensive library, she became a writer, though originally not publishing under her own name.

In 1861, then twenty-two years old, Elisabeth married a man fifteen years her senior—Captain of the Horse[3] Baron Hans Rudolph Wedell-Wedellsborg (1825–1871). His parents were Lieutenant General (*Kammerherre*) Baron Joachim Wedell-Wedellsborg (1785–1860) and Gregersine Juel. Elisabeth's father-in-law had a long and honorable military career. He came from the estate of Wedellsborg in northwestern Funen and was the third son of the highly esteemed landowner and county prefect *Kammerherre* Count Ludvig Wedell of Wedellsborg (1780–1828).[4]

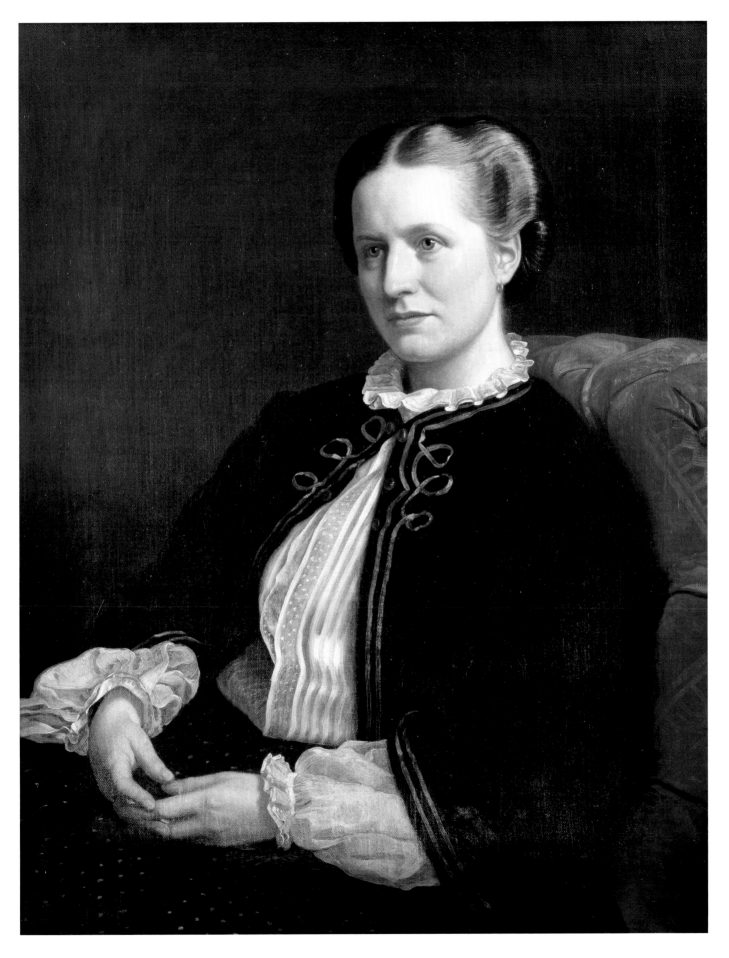

Elisabeth and Hans Rudolph Wedell-Wedellsborg had five children, but they enjoyed only ten years of marriage, as the baron died in 1871 at the age of forty-six, the same year his young widow published her first poems. Three years after her husband's death she moved with the children to the area south of Holstebro in Jutland, where she had bought the estate of Krogsdal, which remained in her possession until 1897. During the following ten years Elisabeth Wedell-Wedellsborg published several collections of poems and dramatizations of sagas, mainly under the pseudonym of Johan Sandel. In 1896, under her own name, she published a poetical version of the Revelations of St. John the Divine, followed in the years 1904–1912 by an exposition and paraphrasing of the Gospels.

So it was no ordinary young woman P. C. Skovgaard had the task of painting. It might seem surprising that he was given the commission at all. He was a national liberal and a follower of Grundtvigian populism, and he was not a dedicated portraitist. His model came from an ultra-conservative milieu and had just married into a family of the same persuasion. Also, why choose a landscape artist to paint a portrait?

Peder Brønnum Scavenius, with his strong will and his well-known insight into the art of the time, probably had something to do with the choice. Artistic qualifications without doubt weighed more heavily with him than opposing political convictions, and Skovgaard was a talented and respected painter. The Scavenius family undoubtedly knew his landscapes from both Stevns and Møns Klint as well as from various localities in the south of Zealand. Perhaps, too, they knew some of his motifs from the mansion of Nysø, Bertel Thorvaldsen's favorite place of residence after his return from Rome—and these motifs included several group portraits of the ladies of the house. In addition, in an exhibition at Charlottenborg, P. C. Skovgaard had recently shown a beautifully finished portrait of Amalie Elisabeth Freund, the widow of the sculptor H. E. Freund.[5]

Karine Lucie Elisabeth was painted the year after her marriage, about the time the couple's first child was born. Perhaps the expected birth is the reason for Elisabeth's absent and secretly happy facial expression. The cool, limited but very beautiful use of colors and the decorative lines suggest inspiration from a ‚great foreign exemplar, such as the French artist Jean-Auguste-Dominique Ingres.

The choice of P. C. Skovgaard turned out to be a wise one. Despite lacking experience in figure painting, the artist succeeded in making his portrait of the young Baroness Wedell-Wedellsborg stand as a noble statement about a gifted and distinctive woman. S.L.

[1] The wave of bloody revolutions that swept over Europe in 1848, starting in Paris with the February Revolution and the fall of the French monarchy, and reaching Copenhagen about a month later. But absolutism in Denmark was ended by means of a peaceful revolution on March 20. A new government, the March Ministry, was formed, with Count A. W. Moltke at its head. Leading national liberal politicians, such as Orla Lehmann, D. G. Monrad and L. N. Hvidt, participated in it. Christian VIII had just died, and his son and successor Frederik VII had been proclaimed king. He accepted without objection that he should no longer reign absolutely and even welcomed the formation of the ministry with relief.

[2] This information on the Scavenius family derives from Bente, Peter and Alette Scavenius, *Klintholm Gods, 200 år i slægten Scavenius' eje,* Copenhagen 1998.

[3] A Danish military title, in former days called *"Ritmester."*

[4] Danmarks Adels Aarbog, Jesper Thomassen, ed., Odense 2000, pp. 568–69, p. 573.

[5] *Amalie Elisabeth Freund, née von Würden. Billedhuggeren, H.E. Freunds hustru (Amalie Elisabeth Freund, née von Würden, the Wife of Sculptor H.E. Freund),* 1860. Oil on canvas, 31$\frac{1}{20}$ x 24$\frac{2}{5}$ in. (79 x 62.5 cm), Statens Museum for Kunst, exhibited Charlottenborg 1861. Hermann Ernst Freund (1786–1840), Amalie Elisabeth Freund (1807–1866).

P. C. SKOVGAARD
1817–1875

143. *Driveway Near Vejle, in the Background the Town* (1852 or 1854)

(Opkørsel til Lille Grundet ved Vejle)[1]

Oil on canvas, 39⅜ x 40 in. (100 x 102 cm)

Signed and dated: P. C. Skovgaard (1852 or 1854, signature unclear)

PROVENANCE: Purchased directly from the painter P. C. Skovgaard by Wholesaler, Honorary Counselor of the King, Hans Puggaard (1788–1866); his son, Rudolph Puggaard (1818–1885); his daughter, Bolette Hartmann (1844–1929), married to the composer Wilhelm Emilius Zinn Hartmann (1836–1898); Bruun Rasmussen, Auction 846, 2014, lot 28, ill.

EXHIBITED: Charlottenborg, *Kunstforeningens Udstilling af P. C. Skovgaards Arbejder i 100 Aaret for hans Fødsel*, 1917, no. 186 (described as *Udsigt over Vejle* 1852).

LITERATURE: H. Ditzel, *Brunshaabprospekter,* Viborg 1975; Nina Damsgaard, "P. C. Skovgaard i Vejle," in *Vejle Amts Årbog 1982,* pp. 41–46; Nina Damsgaard, *Orla Lehmann – og den nationale kunst,* Vejle Kulturhistoriske Museum og Vejle Kunstmuseum 1986 (hereafter referred to as Nina Damsgaard, 1986); Gertrud Oelsner and Karina Lykke Grand (eds.), *P. C. Skovgaard. Dansk guldalder revurderet,* Aarhus 2010.[2]

*D*riveway near Vejle, in the Background the Town is one of two versions of the same motif painted at one of the many beautiful hillsides in East Jutland near the town of Vejle. Both paintings are presumed to have been acquired directly from the artist. Both the paintings in the Loeb collection and *Udsigt aver Vejle* (*A view toward Vejle,* Fig. A) were commissioned by Puggaard's widowed son-in-law, Orla Lehmann (1810–1870), who was one of Denmark's most prominent Liberalists. He served as the Vejle County amtmann (chief administrative officer) from 1848–1861. Both Lehmann and Puggaard were active in the Liberalist movement of the 1840s and 1850s, which pushed for replacing the Danish monarchy with a democratic form of government. This painting was intended to boost interest and support of their controversial cause.

During a journey to Rome in 1842, Orla Lehmann met the Puggaard family, who came from Copenhagen. Mrs. Puggaard (Bolette), née Hage (1798–1847), had a deep interest in and understanding of art, which is why she and her husband often traveled in Italy. In 1842, they were accompanied by their young daughter Annette Marie Bolette, called Maria (1821–1849), who, like her mother, drew and painted the many sights there. The year after they met, Orla and Maria became engaged, and in 1844 they married.

Hans and Bolette Puggaard belonged to the first generation of patrons from the bourgeoisie who collected Danish art almost exclusively. Many of the most prominent artists of the time frequently visited their Copenhagen home as well as their country home in Ordrup north of the city. Among them were the sculptor Bertel Thorvaldsen and the painters C. W. Eckersberg and Wilhelm Marstrand. In this environment, Orla Lehmann gained an insight into art that he developed with guidance from his wife, whose love and study of art equaled that of her mother. Presumably influenced by his son-in-law, Hans Puggaard offered his home as a meeting place for the national Liberalists. Among these were not only politicians but also painters such as P. C. Skovgaard and J. Th. Lundbye, along with prominent cultural figures including the art historian N. L. Høyen. Orla Lehmann would soon collaborate with Høyen regarding the use of art portrayng the beauty of their Danish homeland. It was to be a means of spreading national Liberalist ideas.[3]

On December 8, 1848, Orla Lehmann was appointed *amtmann* in Vejle County, and he reported there

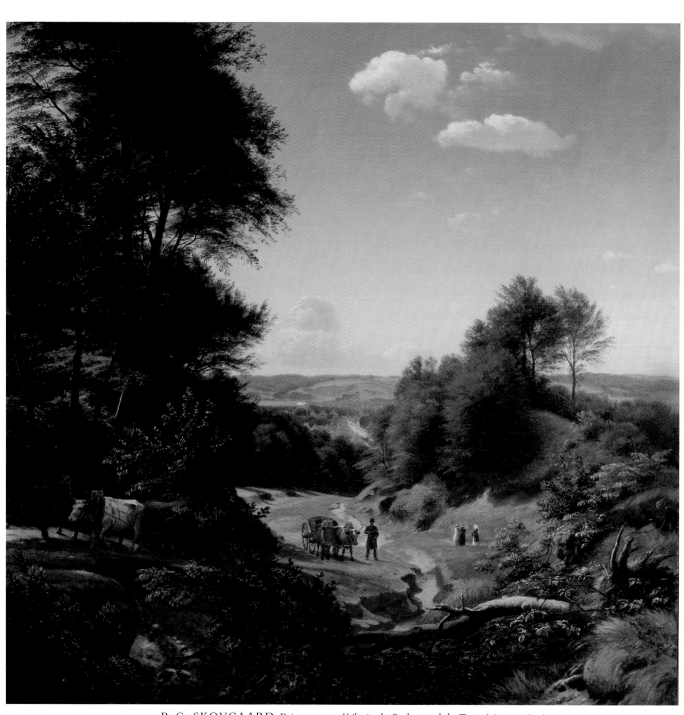

143. P. C. SKOVGAARD *Driveway near Vejle, in the Background the Town (1852 or 1854)*

in the beginning of January 1849. His pregnant wife was far too ill to accompany him to Jutland, and in the spring of 1849, she and a newborn baby died. Late that summer, Orla Lehmann brought their four-year-old daughter Margrethe (1846–1918) to Vejle, along with her godmother, who would care for her and the Lehmann household.

On July 1, 1852, artist and fellow Liberalist P. C. Skovgaard and his young wife Georgia (1828–1868) arrived at Lehmann's *amtmann* residence, staying there until August 30 (about two months). Skovgaard was to produce an idealistic painting of a beautiful area outside the town of Vejle. This was his first visit to Jutland, and he explored more than a few sites for this assignment before settling on the place for this painting.

View toward Vejle (Fig. A), owned by Orla Lehmann, was shown at the annual spring exhibition at Charlottenborg in 1853. *Driveway near Vejle* was not exhibited until February 1917, when the Copenhagen Art Society celebrated the centennial of Skovgaard's birth with an exhibition of some of his work, including the two Vejle paintings. It was then possible to compare their similarities and differences.

Puggaard's painting (in the Loeb collection) is slightly larger than Lehmann's, but both were painted at the same rural location outside Vejle. Among others painted while the artist was in Vejle, they were meant to help boost the Liberalist drive to abolish the monarchy.

The viewer's eyes are first drawn to a brightly lit scene near the front of the picture. A man in a black suit (probably the driver) stands waiting in front of a carriage pulled by two steers. We can imagine that two of the three women pictured at his right came with him from the town in the background and have crossed a small stream, where they have been welcomed by the third woman.

Also dominant is the bright blue sky with a scattering of cumulus clouds, beneath which is the town of Vejle. Just above a tiny speck of red is the towering 600-year-old Church of St. Nikolaj. Next we turn to the darker areas of the picture, composed primarily of wind-blown beech trees. (The beech tree might well be a national symbol of Denmark, just as the maple tree is considered representative of Canada.) Just to the left of the trees we see another steer-drawn cart struggling up a hill, with people in the front and back of the cart. At the very bottom of the picture, we see a fallen tree with a twisted gray-white trunk, its clawlike roots visible.

After viewing it closely, we conclude that, as commissioned by Lehmann/Puggaard, Skovgaard has perfectly rendered an idealistically beautiful rural scene of their beloved homeland. Hans Puggaard, the first owner of this painting, was an ardent collector of Danish art. He would be delighted that *Driveway near Vejle* found a home with Ambassador John L. Loeb Jr., an equally ardent Danish art collector.

<div align="right">S.L.</div>

A lithographed version of Hans Puggaard's painting was made some years after the completion of the work itself (Fig. C).

FIG. A *A View toward Vejle,* 1852 *(Udsigt over Vejle)*
Oil on canvas, 39⅜ x 39¼ in. (98 x 100 cm)
Vejle Kunstmuseum

FIG. B *A View of Vejle, Study* (1852) *(Parti ned over Vejle.
Studie)*
Oil on canvas, 13⅓ x 12½ in. (34 x 32 cm)
Vejle Kunstmuseum

424]

FIG. C Julius Hellesen (1823–1877)
The Old Road Leading to the Farm, Lille Grundet.
From a painting by P. C. Skovgaard (ca. 1860)
Lithography (Emilius Bærentzen & Co. Lithographiske
Anstalt), 9⅓ x 9½ in. (238 x 243 mm)

[1] Lille Grundet was a farm with adjacent lands in the hills by Vejle. It was owned by Orla Lehmann's neighbor and good friend, Dankvard Neergaard, who like Lehmann took an interest in art and invited contemporary artists to live with him and work.

[2] Suzanne Ludvigsen would like to thank Nina Damsgaard for useful information about the Puggaard and Lehmann families. She also wants to thank Gertrud Oelsner and Anne Højer Petersen, Fuglsang Kunstmuseum, for information useful to this article.

[3] N. L. Høyen believed that art should function educationally on the general national character. Portrayals of typical Danish landscapes painted in the most beautiful way possible should inspire pride in the Danish viewer, love of homeland, and commitment to ongoing Danish ethnicity. With regard to national Liberalism see Loeb collection no. 108, including note 5. See also *The Ambassador John L. Loeb Danish Art Collection* Appendix B, pp. 419–425. The Skovgaard couple belonged to the circle around the art historian N. L. Høyen and the poet priest N. S. Grundtvig. All of them were national Liberalists.

GEORG HARALD SLOTT-MØLLER

COPENHAGEN 1864 – COPENHAGEN 1937

Harald Slott-Møller was one of the most talented young painters of the 1880s and belonged to the generation of radical artists who, with Georg Brandes (1842–1927) as their idol, transformed society. Inspired by international currents, especially from England, he revealed himself in the 1890s to be one of the country's most original decorative artists while at the same time continuing to work as a painter. After 1900 he and his wife, the artist Agnes Slott-Møller (1862–1937), née Rambusch, who was an unusually strong personality, gradually found themselves in opposition to the leading modern artists and the general direction being taken by society, and his paintings gradually became more conventional. In this he was subjected to a tragic fate, which has been sealed by the fact that in the judgment of a later age he has often been overshadowed by his wife.

Harald Slott-Møller lost his parents at an early age, but he was given the opportunity to train as an artist first as a student at the Technical School and then as a pupil of the naturalist artist Karl Jensen (1851–1933). In 1881 he was admitted to the Royal Danish Academy of Fine Arts, which he left in 1883 in search of better teaching. In Kunstnernes Frie Studieskoler, which had recently been established with P. S. Krøyer and L. Tuxen as teachers, he found the path to pursuing a fruitful artistic course and became an example of the speed with which this alternative teaching produced results. Fattigfolk (Poor Folk) *or* I dødens venteværelse (In Death's Waiting Room) *(Statens Museum for Kunst), which in motif had already moved away from naturalism, attracted great attention in Charlottenborg in 1888.*

A visit to Italy in 1888–1889 was of crucial importance for the direction taken by his and Agnes's work. The intensive study of early Florentine art from the 14th and 15th centuries, which was an interest new and typical of the age—though not yet in Denmark—led to a predilection for the pre-Raphaelites and other British art, especially the arts and crafts movement. Enthusiasm for the Middle Ages inspired Agnes, who made the range of motifs of Danish medieval ballads into the dominant features of her paintings. A knowledge of kindred spirits in England was of importance to Harald as the designer of artifacts, such as carved and painted furniture, sumptuous jewelry, and articles for everyday use for the Aluminia Faience Manufactory in Copenhagen, of which he was artistic head from 1902 to 1905.

The Slott-Møllers worked zealously to break the monopoly of the Charlottenborg exhibition by establishing an alternative exhibition. Together with Johan Rohde (1856–1935) and J. F. Willumsen (1836–1958) they were in the forefront in establishing Den Frie Udstilling, *which opened for the first time in 1891. Here Harald Slott-Møller exhibited a portrait of Anne Marie Brodersen, better known as the sculptor Anne Marie Carl Nielsen (1865–1945), wife of the famous composer Carl Nielsen, in which for the first time he combined painting, gilding, and wood carving. This is something that is also found in later works such as* Tre kvinder, sommeraften (The Women, Summer Evening)

from 1895, and Foråret (Spring) *1896 (both in Den Hirschsprungske Samling), in which the carved and painted frames are also incorporated as part of the overall work. The couple exhibited in London in the 1890s, finding a greater sympathy for their art there than in Denmark. In 1905 Harald Slott-Møller painted* Paolo og Francesca i Helvede (Paolo and Francesca in Hell), *which is indistinguishable from British art.*

In time, Agnes's production became more extensive but at the same time technically weaker and artistically less and less interesting, something that perhaps played its part in impairing Harald's creativity. Apart from an interesting portrait of the poet Helge Rode (1907, The Museum of National History at Frederiksborg Castle), his pioneering work as a painter came to an end about this time. The couple changed their political attitudes from those of ardent radicals to becoming champions of national values. So it was something of a paradox that it should be precisely the down-to-earth painters known as "Fynboerne" (the Funen Artists) who became the object of their anger and contempt. These artists included Peter Hansen (1869–1928) and Fritz Syberg (1862–1939), who portrayed their native region, its people, and the rhythm of the seasons in a simple, direct manner on the basis of a naturalist vision and with emphasis on coloristic qualities. In 1907 the Slott-Møllers made a vehement attack on the Funen Artists, leading to a great and bitter polemical debate in Danish newspapers and periodicals. With this, the Slott-Møllers dissociated themselves from society and were frozen out of Danish artistic life.

<div align="right">E.F.</div>

LITERATURE: Bodil Busk Laursen and Susanne Thestrup Andersen, *Naturen og kunsten, Bondemalerstriden 1907*, Faaborg Museum 1986; Bodil Busk Laursen, *Agnes Slott-Møller og Harald Slott-Møller, mellem kunst og idealer*, Kunstforeningen, Copenhagen 1988; Birgit Jenvold, in *Weilbach*, vol. 7, Copenhagen 1998.

HARALD SLOTT-MØLLER
1864–1937

III. *Summer Day*, 1888
(Sommerdag)

Oil on canvas, 48½ x 70 in. (123 x 178 cm)

Signed bottom right: HARALD SLOTT.MØLLER. 1888

PROVENANCE: Jens Udsen, cinema manager, hotelier, Hotel Postgaarden, Slagelse; Winkel & Magnussen, Auction 343 (Jens Udsen), 1948, lot 360, ill. p. 39; Bruun Rasmussen, Auction 688, 2000, lot 1481, ill. p. 151.

EXHIBITED: Foreningen for National Kunst, Charlottenborg, *Memorial Exhibition, Agnes and Harald Slott-Møller*, 1938, no. 68 (described as *Sommerdag*, owner Jens Udsen).

LITERATURE: Francis Beckett in Karl Madsen (ed.), *Kunstens Historie i Danmark,* Copenhagen 1901–07, p. 420; Harald Slott-Møller, *Erindringer,* unpublished, The Royal Library, manuscript department; Peter Storm, *Når det igen blev sommer i Danmark,* in Vends, Årbog for Vends Herred, 1998, pp. 19–26 (on Damgaard); Patricia G. Berman, *In Another Light, Danish Painting in the Nineteenth Century,* New York 2007, p. 166, ill. p. 168–169.

Sommerdag is an unusual painting, which on its incorporation into the Loeb collection can be given its rightful place in the history of art. In brilliant sunshine one warm and slightly damp summer day, two young women are paddling in the shallow water at the edge of a fjord. They are portrayed very simply, almost schematically, in a small number of colors, most of them in the figure on the right, whose summer dress—striped in pink, bluish green, and white—corresponds coloristically to the landscape; there are nowhere near so many in the more distant figure on the left, in whom few details are to be seen. A good deal of energy is expressed in their movements and their contact with each other, in which there is a suggestion of some situation, some action in contrast to the tranquil expanse of water behind the figures and the distant landscape, a view bathed in a sparkling light of striking beauty.

It is remarkable how Slott-Møller consciously has worked here with a simplification bordering on abstraction, the diametrical opposite of contemporary figure painters such as Carl Thomsen or Paul Fischer. By means of large coherent areas of the same color he has partly abandoned the spatial quality of naturalism. This is seen in the forested coastlines and their reflection in the water but especially clearly in the dark green area below the boat on the right, in the blue shadows cast by the figures, and in their reflections in the water, painted in green ochre. With this, Slott-Møller is anticipating the metaphor that gained acceptance in the 1890s, emphasizing the flat quality of the pictures and approaching a manner of painting resembling that of Johan Rohde (1856–1935) from the 1890s.

Sommerdag was painted shortly after the artist's wedding in May 1888. Harald and Agnes Slott-Møller (1862–1937) had decided that they should go to Italy for their honeymoon, but before this they wanted to take advantage of the Danish summer, as they had done in previous years. So they went to Jutland to find landscapes that could inspire each of them, deciding on the beautiful area south of Fredericia with views across to Funen. Here they rented rooms in Henneberg Ladegaard, which belonged to the Damgaard estate, the owner of which, *Kammerherre* Thyge de Thygeson (1807–1905), soon invited the young couple to dinner. This was the start of a relationship lasting for many years, as de Thygeson and his adoptive daughter, Charlotte Trap de Thygeson (died 1934), were deeply interested in art and hospitably invited the artists

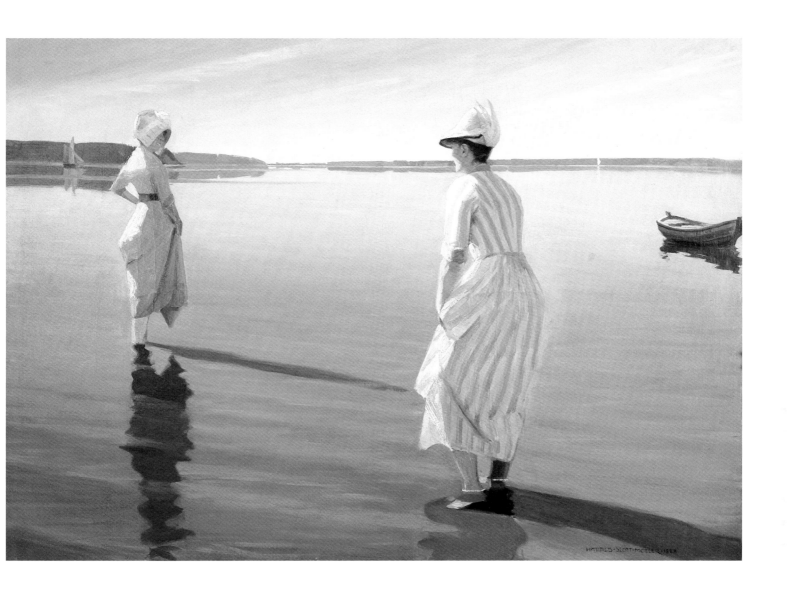

to extended visits to Damgaard. After 1900, the composer Carl Nielsen (1865–1931) and his wife, sculptor Anne Marie Carl Nielsen (1863–1945), of whom Slott-Møller incidentally painted several portraits, were frequent guests in the house. Damgaard is particularly beautiful, situated close to Kolding Fjord, with meadows stretching down to Lillebælt, which at this point is very narrow, and a view across Funen and the island of Fænø.

Harald Slott-Møller decided to paint this fine landscape. From a letter dated 26 June 1888 from Agnes to Johan Rohde it emerges that Harald was making good progress.[1] He writes, "I had started on a picture of two young girls 'paddling' by the water's edge in the gentlest bright summer's day—but alas, the summer did not provide enough summer's days for me to be able to complete the quite large painting in the open air, as was the narrow and dogmatic demand of the time."[2] Harald did not consider the picture to be completely finished, as Agnes also told Johan Rohde on 29 August, which can explain the slightly schematic character of the two figures.

We know that the two female figures, whose facial features are anonymous, are the artist's wife Agnes on the right and on the left the young painter Marie Triepcke (1867–1940), who became Mrs. P. S. Krøyer the following year. She is wearing the idiosyncratic sun hat also seen in P. S. Krøyer's 1891 portrait of her and her mother sewing in the garden at Skagen (Museum für Kunst und Kulturgeschichte der Hansestadt Lübeck). Agnes and Marie had become friends some years before, and as the older of the two, Agnes was keen to encourage Marie's progress. Marie's friendship with Harald, which had begun as a youthful infatuation, dated back even further. As very good friends, the newly married couple had agreed that Marie should live with them for some time this summer of 1888. Therefore the contact between the two young women at the water's edge is so comfortable.

E.F.

[1]The Royal Library, Manuscript Department.

[2]Harald Slott-Møller, *Erindringer*, The Royal Library, Manuscript Department.

HANS LUDVIG SMIDTH

NAKSKOV 1839 – FREDERIKSBERG 1917

Edvard Philip Smidth and Karen Catharine Berg had three sons. One became a doctor and died young; one became an engineer and industrialist, the founder of a firm known throughout the world under his own name, F. L. Smidth; and one was to have been a doctor like his eldest brother but suddenly broke off his medical studies to become a painter.

Hans Smidth was born in Nakskov in the west of the island of Lolland, where his father was an attorney. In 1848 the family moved to Kerteminde in northern Funen and then six years later to the town of Skive, south of the Limfjord, the area that was home to Christen Dalsgaard, and where Smidth's father had been appointed judge.

Smidth went through the cathedral school in Viborg, the ancient city just under twenty kilometres to the south, and in 1859 he started to study medicine at Copenhagen. Until then, according to all accounts, he had never evinced any desire to draw and paint, but a winter's teaching in the architect Ferdinand Jensen's school of drawing opened the way to the Royal Danish Academy of Fine Arts to the scarcely twenty-two-year-old Hans Smidth. The year 1864 found him in the life school, with Wilhelm Marstrand, Jørgen Roed (1808–1888), and Niels Simonsen (1807–1885) as his teachers.

But then Smidth was called up for military service, though he never had to take an active part in the fighting. After being demobilized with the rank of lance corporal, he returned to the life school but was soon compelled to break off his training, presumably for financial reasons, and return home to Skive. The following year Hans Smidth looked for motifs while walking in the Limfjord region. In the modest circumstances obtaining at the time, he lodged with farmers and fishermen, accompanying them in their everyday lives and their festivities and becoming their friend. In Sallingland, on the island of Fur, and in the extensive moorland areas south and southwest of Skive he drew and, more especially, painted landscapes, interiors, figures, and animals. His paintings were inspired by Dalsgaard's art especially in its earnestness, but Smidth's figures are not wearing national costumes, and his portrayals of everyday life are devoid of any anecdotal content. They are human beings in their own sober realism, portrayed with understanding, respect, and warmth, and sometimes also with a touch of humor. Later, Smidth painted in the area around Aarhus and on the west coast of Jutland.

From 1867 he started sending paintings to the exhibitions at Charlottenborg, and this he continued to do every year from then on. About 1871 he took part in Vilhelm Kyhn's so-called Cave Academy with August Jerndorff and Karl Madsen (1855–1938). In 1875 Hans Smidth entered the Neuhausen Competition. His Gæssene drives hjem (The Geese Are Driven Home) *did not win the main prize but was given a consolation award. Two years later, in the following competition, he achieved the desired prize on the basis of a slightly more staged work,* En fremmed spørger om vej i bondegården på heden (A Stranger Asks the Way at a Moorland Farm), *thus gaining the official recognition of the Academy.*

Nevertheless, Smidth was forgotten as an artist for more than twenty years. His unadorned portrayals of the frugal existence of the ordinary people and the farmers' and fishermen's closeness to nature found no resonance in the turbulent artistic life of Copenhagen, where the national Romantic movement was on its way out and the French-oriented international painting was gaining ground. Smidth was not at home in either of these groups. He went his own way, had never been a Romantic, and was not recognized as a modernist although many of his portrayals of real life had points in common with realism. Smidth could not have been ignorant of the new trends. We know that he was acquainted with the painter and art historian Karl Madsen and the painter Theodor Philipsen (1840–1920), both of whom were interested in the French plein air painting by the 1880s. We also know that in 1895 he lived and worked with Christian Mourier-Petersen, who more than ten years previously had established a friendship with Vincent van Gogh (1853–1890) in Arles and the Impressionists in Paris.

After the father's death in 1878, the family moved to Copenhagen, from where Hans Smidth worked every winter after this. At first, he and the eleven-years-younger Frederik Læssøe Smidth (1850–1899) lived with their mother—even after Frederik had started a family. When their mother died in 1895, Hans Smidth continued sharing a home with his brother and sister-in-law and their children, for whom he became a much-loved uncle. He spent almost all his summers in Jutland.

He is known to have found motifs in the area surrounding Arresø Lake and Hillerød in about 1880—including, perhaps, that for the Loeb collection's charming picture of the stagecoach—and in Funen. His first and only journey abroad took him to the formerly Danish town of Flensburg during this period. In the middle of the 1890s he started illustrating the stories of the Danish Golden Age author Steen Steensen Blicher (1782–1848), stories set in the moorland regions Smidth knew so well. He now often stayed at Ry near Silkeborg in central Jutland, Vilhelm Kyhn's favorite area, and then at Skjeldal near Salten Langsø in the same region. Here he built a Norwegian log cabin by about 1898.

Toward the end of the century and until his death, Hans Smidth turned to larger and more complicated figure compositions, such as busy market scenes and dramatic episodes from the Convicts' War. This subject, in which Christen Dalsgaard had also been interested, was related to the deep sense of emergency among Jutlandic farmers who were preparing to defend themselves against convicts rumored in 1848 to have been freed by the Germans at Rendsburg in Schleswig and thought to be on their way north, pillaging and burning down property. Smidth also painted scenes reflecting Blicher and portraying fires in the night. In the case of these latter, he found inspiration in the Netherlandish masters, especially Aert van der Neer, (1603/04–1667) in the Royal Collection of Paintings.

In 1900 his breakthrough came at last. After Smidth had shown a few works in several prestigious exhibitions, including the Nordisk Kunstudstilling in 1883 and 1888 and the world fairs in Chicago in 1893 and Paris 1900, in all of which he achieved a modest success, the Kunstforening, at the suggestion of the painter August Jerndorff, arranged an extensive retrospective exhibition encompassing 300 works by Hans Smidth.

Both critics and the public had their eyes opened to the artist's unusual talent. His paintings, at

once bold and sensitive in colors, fascinated everyone who saw them. About 290 works were sold. "All these immediately coloristically pure and radiant works with quite ordinary and sensitively conceived motifs were a breath of fresh air in a period dominated by Hammershøi and the Symbolist painters" (Sthyr, 1933).

In 1905, Hans Smidth received the annual Academy medal, and in 1906 he was awarded the Eckersberg Medal, at the same time becoming a member of the Academy Plenary Congregation. At his death in 1917 he left more than 1,000 paintings and countless drawings. We know very little indeed of Hans Smidth the man. He was taciturn, shunned all publicity and art politics, and never took part in social events, but even while he was still alive, his art was respected and admired, not least by fellow artists.

S.L.

LITERATURE: Karl Madsen in *Politiken* 21.3.1886; Carl V. Petersen in *Kunstbladet* 1909–10, p. 243; Carl V. Petersen in *Tilskueren*, 1915, I, pp. 169–84; Sigfred Lauritzen in *Skivebogen*, 1913, pp. 155–71; Jørgen Styhr, *Malerier af Hans Smidth*, Copenhagen 1933; Johannes V. Jensen, *Jyske Folkelivsmalere*, Copenhagen 1937; J.O. Lefèvre, *To malere fra Skiveegnen*, 1976; Hans Edvard Nørregård-Nielsen, *Hans Smidth 1839–1917*, Skive 1989; C. M. Smidt, *Maleren Hans Smidth*, 1989; Folke Kjems in *Weilbach*, vol. 7, Copenhagen 1998.

HANS SMIDTH
1839–1917

112. *The Stagecoach, 1884*
(Diligencen)

Oil on canvas, 19½ x 24½ in. (50 x 62 cm)

Signed and dated lower left: H. S. 84

On the stretcher, a contemporary label with the artist's signature, the title of the painting, and the price of 250 kroner.

PROVENANCE: Winkel & Magnussen, Auction 67, 1929, lot 170 (described as *Postvognen*); Bruun Rasmussen, Auction 688, 2000, lot 1506, ill. p. 175.

In 1883, Hans Smidth painted a large picture from the Hillerød area entitled *The Coach Drives Through the Village* (Fig. A). A barefoot young cowherd tending a pair of mottled cows is being hailed by the coachman and the passengers crowded together in the coach as it passes him. The Loeb collection's *The Stagecoach*, with a similar motif and painted the following year, is very reminiscent of the earlier work, but it is smaller and livelier. From 1893 there is a third picture of a heavily laden, horse-drawn carriage swaying along an uneven road, closely pursued by shouting children and a barking dog tearing off at great speed in front of the frightened horses.[1]

These last two paintings are very similar to each other. The measurements are almost the same; the children and the dog appear to be the same, and both scenes are played out against a background of a radiant evening sky colored by the glow of the sunset. All three works have various elements in common and are composed on similar lines. The coach is driving toward the observer along a road running diagonally from the background down to the right-hand corner of the picture. In each of the works, a distant mill with spreading sails is placed at the vanishing point of the road, and in all the paintings the road divides in the middle distance with a narrower fork going off to the left. It appears that none of these pictures was exe-

FIG. A Hans Smidth
The Coach Drives Through the Village,
1883 *(Dagvognen kører gennem
landsbyen)*
Oil on canvas, 27⅕ x 37⅗ in.
(69 x 95.5 cm), Nordjyllands
Kunstmuseum, Aalborg

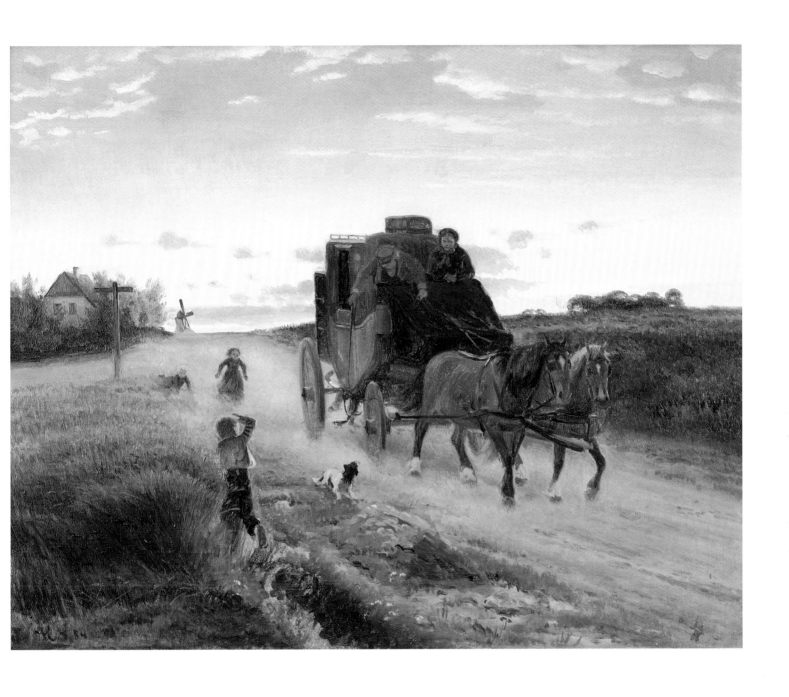

cuted on the spot. They were presumably painted in the artist's studio on the basis of visual experience and perhaps some hastily drawn sketches—one version of the coach based on the other.

There are many vehicles in Hans Smidth's oeuvre, encompassing every conceivable type, from roomy wagonettes laden with the artist's merrymaking nephews and nieces to ordinary carts filled with serious moorland peasants. Drawn by snorting horses or staid bullocks, the vehicles rock along in the paintings' universe, creaking and jolting on dusty roads or sandy, heather-covered tracks.

Here in the reddish-violet dusk after the heat of a summer's day, three children are capering wildly after the coach, the arrival of which is the recurrent high spot of the day. A boy has hung on to the rear of the vehicle, and his trouser leg and dancing feet are all we see of him; a little girl is rushing behind, half-blinded by the cloud of dust thrown up in the wake of the coach; a smaller, fair-haired child is stumbling and almost falling over in his eagerness to keep up. At the roadside, a fourth, rather bigger boy is shading his eyes and looking up toward the coachman and a woman sitting on the box. The little black and white dog is yapping shrilly and preparing to rush in between the horses' legs and bite their hocks. The coachman is leaning forward, hitting out at the animal with his long whip.

We are confronted with an episode, seen en passant as though from the window of a train; a brief vision that will soon have vanished like the sinking sun. There is no anecdote but merely a glimpse of reality caught and retained in the suggestive form of a sketch and intensified by means of strong green and reddish-brown colors forming a contrast with each other and enclosed in a profusion of violet and golden light reflections.

A new age in painting was on the way.

S.L.

[1]Oil on canvas, 19⁷⁄₁₀ x 24⁴⁄₅ in. (50 x 63 cm), present owner unknown.

436]

LUDVIG AUGUST SMITH

COPENHAGEN 1820 – COPENHAGEN 1906

Ludvig August Smith entered the Royal Danish Academy of Fine Arts in Copenhagen at the age of fourteen, studying there for seven years, partly under Professor J. L. Lund (1777–1867). He completed his training in 1841 having won the major silver medal but without competing for the gold medal. He also studied as a private pupil of C. W. Eckersberg for three years around 1841.

It was Smith's ambition to become a historical painter, and the first work he exhibited was a family scene in 1840. Until 1887 he exhibited regularly at Charlottenborg, not only genre scenes but also figure pictures representing events from Danish history. In his 1869 letter to Weilbach's Kunstner-leksikon, *he draws special attention to three paintings that are unknown today:* A Bachelor, Supplicants *and* A Grocer's Family. *In addition he painted a number of portraits, including one of the painter J. V. Gertner (1818–1871), which is now in Thorvaldsens Museum.*

Although Smith had learned the craft of painting, he did not succeed in making a name for himself among the painters of the Golden Age, and like so many others he had to live on occasional assignments. For instance, he was commissioned by the firm of E. Bærentzen & Co. to execute a considerable number of portrait drawings that were used as the bases of lithographic prints. Before photography became widespread there was a great demand for such portraits of famous men. Smith specialized in portraying public servants and officers but also drew a small number of famous personalities, such as the poet Adam Oehlenschläger (1779–1850). In addition, he gave lessons in drawing.

Smith took part in the City Hall Exhibition of 1901 and is represented in Copenhagen City Museum and Vejle Kunstmuseum. There are drawings by him in the Collection of Prints and Drawings in Statens Museum for Kunst.

E.F.

LITERATURE: Hanne Jönsson in *C. W. Eckersberg*, Statens Museum for Kunst 1983; Kasper Monrad, *Hverdagsbilleder*, Copenhagen 1989; Marianne Saabye in *Den nøgne Guldalder*, Den Hirschsprungske Samling, 1994, pp. 122–127; Peter Nørgaard Larsen in *Weilbach*, vol. 7, Copenhagen 1998.

L. A. SMITH
1820–1906

113. *Female Model Before a Mirror,* 1841
(Kvindelig model foran et spejl)

Oil on canvas, 47¼ x 36⅗ in. (120 x 93 cm)

Signed: *L Smith 1841* (according to Bruun Rasmussen)

PROVENANCE: Bruun Rasmussen, Auction 727, 2003, lot 1225, ill.

EXHIBITED: *Den nøgne Guldalder*, Den Hirschsprungske Samling, 1994, cat. no. 58 ill. p. 127; Scandinavia House, New York, *Danish Paintings from the Golden Age to the Modern Breakthrough, Selections from the Collection of Ambassador John L. Loeb Jr.*, 2013, no. 34.

LITERATURE: Marianne Saabye (ed.), *Den nøgne Guldalder, Modelbilleder af C. W. Eckersberg og hans elever*, Den Hirschsprungske Samling 1994 (English translation and summary), pp. 27–45 (by Emma Salling), pp. 122–127 (by Marianne Saabye); Philip Conisbee, Kasper Monrad, Lene Bøgh Rønberg, *Christoffer Wilhelm Eckersberg 1783–1853*, National Gallery of Art, Washington 2003, p. 154; Patricia G. Berman, *In Another Light, Danish Painting in the Nineteenth Century*, New York 2007, p. 56.

This painting is closely related to a painting by C. W. Eckersberg, which is one of the most-loved pictures from the Danish Golden Age, since 1895 belonging to Den Hirschsprungske Samling in Copenhagen. In fact L. A. Smith worked side by side with Eckersberg and other students, all of them painting the same motif: a three-quarter figure of a female model standing in front of a mirror with her back to the viewer and with a length of material draped around her hips.

The dating of the Eckersberg painting and the circumstances surrounding the genesis were unknown until the exhibition *Den nøgne guldalder* at Den Hirschsprungske Samling in 1994. This exhibition was centerd on Eckersberg's studies of nude models and started out from Eckersberg's painting. It presented the results of intensive research into Eckersberg's thirty-five-year-long career as a teacher in the Royal Danish Academy of Fine Arts, based on a close study of the artist's copious diaries and the Academy archives. As a result, it was revealed that Eckersberg's painting of this model was not the only one with this motif, for it was a product of his summer classes with a group of Academy students, including L. A. Smith, in the late summer of 1841.

In 1822, Eckersberg and his colleague, Professor J. L. Lund (1777–1867), took the initiative to expand the Life School at the Academy so students could work with live models in daylight during the summer. A new feature was that from 1833 it was occasionally possible to work with a female nude. Since his appointment as professor in the Royal Danish Academy of Fine Arts School of Painting in 1818, Eckersberg had had an official residence at the home of the institution, Charlottenborg Palace on Kongens Nytorv, in the heart of Copenhagen. This was where he saw many of the students he taught over the years. They were both Academy students and others coming from outside. Here the model was occasionally a female.

In 1823 the Academy announced a competition for a small cash prize, in which the model was to be portrayed in "suitable surroundings." The students were themselves to arrange the pose of the model. The aim was to learn how to see the model in interplay with the surroundings, subject to the given light and perspective. The nude paintings resulting from this teaching are thus very different from the ordinary classes in the Academy Life School.

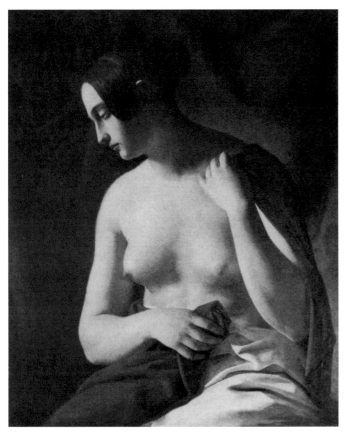

FIG. A L. A. Smith
Seated Nude, Florentine, 12.7.-7.8.1841
Oil on canvas, 35⅖ x 20⅘ in. (90 x 53 cm)
Signed: *L. A. Smith*
Arne Bruun Rasmussen, Auction 458, 1984, lot 221

From 1839, Eckersberg ran summer classes in the Academy working mainly with female models, and he devoted a great deal of personal energy to this work. Together with the students he himself would often paint the chosen model in a small format while the students produced larger paintings. This was the case in 1841, when L. A. Smith painted the model portrait now in the Loeb collection.

Smith took part for the first time in the summer of 1840, when the classes started on June 21 with Nathalia Stahl as model. No paintings from this class are known today. From 20 August to 1 September and from 14 to 19 September, they worked with a new model with the unusual and rather poetical Christian name of Florentine. She was a well-built young woman whose powerful hips and sculptural form were well suited to nude studies. Some drawings by Eckersberg show her gracefully standing with one leg on the scales and with her arms extended. Together with a circular painting also by Eckersberg (Fyns Kunstmuseum), the sensual qualities of which are quite atypical for a nude study in the Denmark of this time, they are the only surviving results from that session.

Florentine was again engaged in 1841, and from July 12 to August 7, she posed seated with two lengths of fabric draped around her. In L. A. Smith's painting, which is the only one surviving from this class, she is portrayed almost frontally, but her face is seen in profile. It is obvious that Smith, too, appreciated Florentine's gracefulness (Fig. A).

From August 9 to September 16, Florentine was painted standing in a room in front of a beautifully framed mirror, her hand on a table, lightly fingering a necklace lying there. She is holding her chignon in her right hand and turning her head obliquely down to the left. The draping around her hips has classical

forebears and shows that her right leg must be resting on a box. The use of the mirror is a familiar feature in painting. From Eckersberg's diary it is known that Smith took part in the class along with Carl Dahl (1812–1865), who became known as a marine painter, H. J. Hammer (1815–1882), who became a genre and landscape artist, Salomon (Sally) Henriques (1815–1886), who painted genre scenes and later became a decoration painter, and his brother Nathan Henriques (1820–1846), known for his many portraits of Copenhagen's Jewish bourgeoisie.

Three paintings have survived from this class, those of Eckersberg, L. A. Smith, and Sally Henriques. It is not known whether the other participants completed the task. It is both rare and interesting to be able to compare the three paintings. They at once give an insight into the demands made by the exercise and into the different artists' abilities, the possibilities before them, and choices they made. The painting by the experienced master, Eckersberg (Fig. B), is naturally the most harmonious, both in disposition and color and also in the distribution of light and shade. A particularly sophisticated feature is the fact that in the mirror he shows more of the naked model than would be revealed if she had been wearing a low dress. At the same time she is made anonymous, as her arm covers the lower part of her face in the mirror. Eckersberg's painting is the most serene in its composition, as the rear wall is parallel to the surface of the picture. But at the same time he has created dynamism in the painting by stressing the turn of the model's head and the raised right leg. She is apparently standing with her weight on the left leg in the classical position known as *contrapposto*.

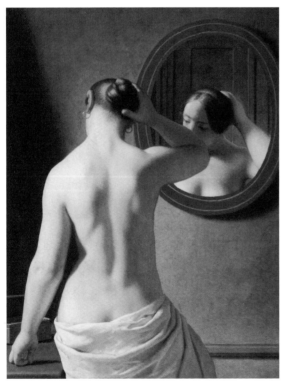

FIG. B C. W. Eckersberg
Female Model Standing Before a Mirror, 1841
Oil on canvas, 13⅕ x 10¼ in. (33.5 x 26 cm)
Not signed or inscribed.
Den Hirschsprungske Samling

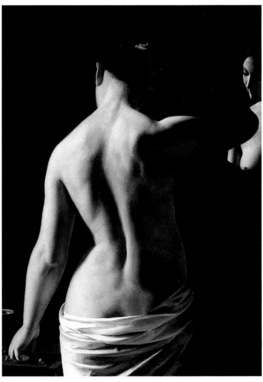

FIG. C Sally Henriques
Female Model Standing Before a Mirror, 1841
Oil, 34⅗ x 24⅖ in. (88 x 62 cm)
Signed: *Sally Henriques 20.10.41*
Bruun Rasmussen, Auction 712, 2002, lot 1419
This painting was unknown before this auction.

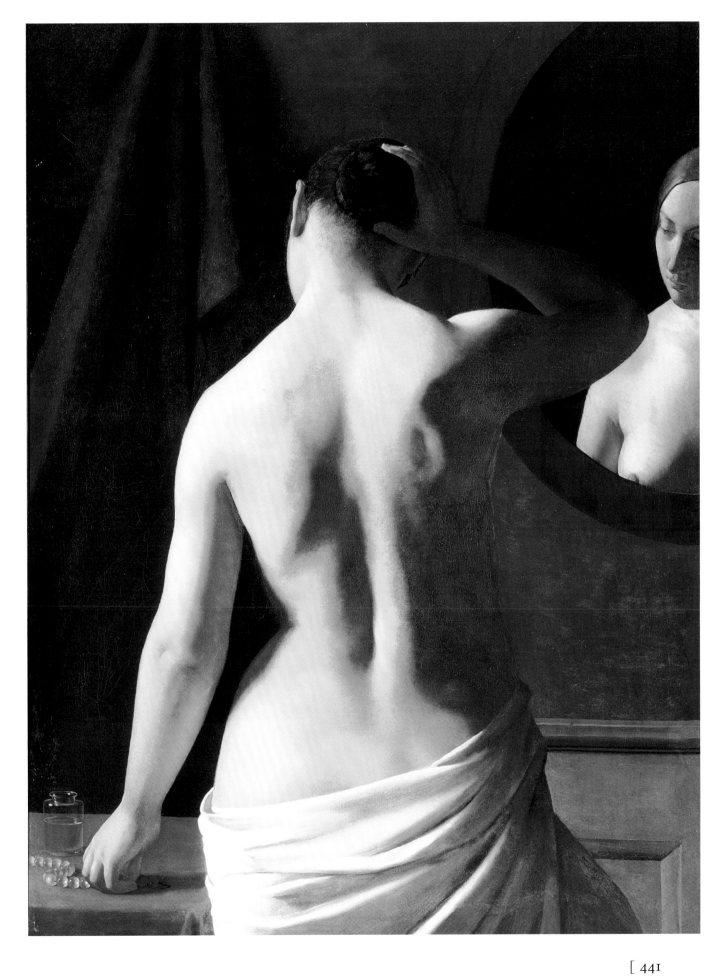

Smith was seated just to the right of the professor, more obliquely in relation to the model and slightly closer to her. From this position he had no other choice but to let the model's torso dominate the painting. He was unable to read and exploit the elegant position of her legs. Instead, he concentrated on portraying her broad back, powerful shoulders, and rounded hips, concluding with the white drapery. As a counterbalance, another piece of drapery can be seen in the left background, a green piece of fabric hanging there—unseen in the other two paintings. In addition, the whole of the model's face is visible in the mirror from Smith's position, as is her left breast. Smith's coloring is darker than Eckersberg's, and his treatment of shape is richer in contrasts, so his concept of the motif seems to be more dramatic.

The farther to the right the painter was sitting, the deeper were the shadows on the model's back. From the Henriques painting (Fig. C) it can be seen that he had been sitting to the right of Smith, so that the conditions under which he was painting were still more difficult. The light from the window dazzled him, so his nude is characterized by sharp contrasts between light and shade. Nevertheless, he succeeded in creating life on the shaded side of the torso, which is illuminated indirectly, and in the white drapery. By leaving the background in darkness, the reflection in the mirror plays a bigger part in the composition. It reproduces roughly the same image as Smith's version.

In other words, Eckersberg himself chose the viewpoint that—artistically speaking—assured him of the best result, and for reasons that we must assume were didactic, he gave his students far more difficult tasks to work with. On the other hand, the nudes of both L. A. Smith and Sally Henriques are more modern in character, something that makes one think of Eckersberg's successors, Wilhelm Marstrand and especially Carl Bloch.

E.F.

CHRISTIAN FRIEDRICH (FRITZ)
WILHELM HEINRICH SYBERG

FAABORG 1862 – PILEGÅRDEN NEAR KERTEMINDE 1939

His friends called him "the Baron," a friendly bit of teasing referring to the German origin of Fritz Syberg's father. Franz Friedrich Anton Ernst (Freiherr von) Syberg, a distillery manager, was of a German aristocratic family but a man of slender means without contact with the family from which he was descended. He died in an explosion of steam at his workplace while Fritz was quite small, leaving the mother and two small children in dire poverty. Fritz lived through some extremely difficult years as a child in Faaborg. From his ninth year he worked in a tobacco factory while attending school. At the age of about thirteen he became a swineherd on a country estate, and the following year (1876) he was apprenticed as an artisan painter, at the same time attending classes in the Technical School in Faaborg, where one of his teachers was the decorative painter Peter Syrak Hansen (1833–1904).

In 1882, Fritz Syberg qualified as a journeyman and was given a job at Syrak Hansen's workshop. This was at the invitation of Syrak Hansen himself, and Syberg worked for him the following three summers. During the winters he attended classes in the Technical School in Copenhagen under Holger Grønvold (1850–1923). In 1885, after a very brief period at the Royal Danish Academy of Fine Arts and a summer working as a painter in Funen, Syberg became a pupil of the artist Kristian Zahrtmann (1843–1917), who that year had become the head of Kunstnernes Frie Studieskoler. He remained a pupil of Zahrtmann until 1891. In 1889, Fritz Syberg also received instruction in woodcut technique.

The contact with Peter Syrak Hansen and his family in Mesterhuset in Faaborg was of crucial importance to the young Syberg. The journeymen were treated as members of the family, where art and music were a natural part of everyday life. Syrak Hansen himself had been trained as a decorative painter at the Academy in Copenhagen, and his sons Peter (1868–1928) and Syrak (1866–1961), and his daughters Marie and Anna, became Syberg's friends for life. In 1894, Syberg married Anna, who developed into a distinctive and talented painter. After her tragic death in 1914, when he was left with seven children, Fritz married her elder sister, Marie.

Syrak and Peter also became pupils in Zahrtmanns Skole, where together with Fritz they mixed with like-minded young artists, including a merchant's son from Kerteminde by the name of Johannes Larsen (1867–1961), who soon became a close friend and a valued guest in Mesterhuset. It was this inspiring environment that led to the formation of the group of artists known as Fynboerne, the Funen Artists.

Fritz Syberg showed paintings in the committee-approved Charlottenborg exhibitions from 1887 to 1892. From 1893 he was a member of Den frie Udstilling, though interrupted by a year's participation in the rebellious artists' association Grønningen, 1916–17. His motifs were unadorned, penetrating scenes of everyday life from the area around Faaborg. Among the most important are Dødsfaldet (The Death), 1890–92 (Statens Museum for Kunst), Foråret (Spring), 1891–1893 (Den Hirschsprungske Samling), and

his main work Aftenleg i Svanninge Bakker *(Evening Games in the Svanninge Hills), 1900 (Faaborg Museum). In addition, he painted and drew portraits—including many of his wife Anna and their rapidly increasing family—as well as marines and, in particular, landscapes. Like Johannes Larsen, Fritz Syberg produced several works of illustrations, the best-known and probably most moving of which are the eighteen pen drawings for Hans Christian Andersen's* The Story of a Mother, *which he made between 1895 and 1898 (The Royal Collection of Prints and Drawings, Statens Museum for Kunst).*

Fritz Syberg took a number of journeys abroad. He went to Berlin and Flensburg with Anna in 1894 in the vain hope of being able to earn a living as an artisan painter. In 1899 he went to Småland in Sweden with his family to visit Johannes Larsen and his wife Alhed Larsen (1872–1927), who was also an artist. In 1902 he was again in Germany, and 1905 saw him in Florence along with another Funen artist, the painter Jens Birkholm (1869–1915). Three years later, he was in Amsterdam. Here he was joined by Anna, after which the couple went on to Paris, visiting the Louvre many times. In the Durand-Ruel salon on the rue Lafitte, they saw canvases by Monet (1840–1926), Renoir (1841–1919), Manet (1832–1883), Sisley (1839–1899), Degas (1834–1917), and Cézanne (1839–1906).

In 1910, the patron of the Funen artists, tinned-goods manufacturer Mads Rasmussen (1856–1916), established a museum for the painters in Faaborg. Five years later the present museum, financed by Mads Rasmussen and designed by the architect Carl Petersen (1874–1923), was opened. Rasmussen bought the works for his collection from the still unacknowledged artists and thereby ensured help for them and even enabled them to make extended visits abroad. In the case of the Syberg family, this led to a period of three years at Pisa in Italy from 1910 to 1913.

Apart from the time spent in Pisa, which resulted in a series of beautiful watercolors, Fritz Syberg painted almost exclusively in Funen. During their early years, he and Anna lived in the little town of Svanninge near Faaborg, after which "Pilegården" near Kerteminde became his home for the rest of his life. Much of both Anna's and Fritz Syberg's work also derives from the family's regular summer visits to Fyns Hoved at the top of the peninsula north of Kerteminde.

"The Peasant Painters" was the name accorded to the Funen artists as the result of a number of critical and derogatory articles in 1907 in the daily newspaper Politiken, *written partly by the husband-and-wife artists Agnes and Harald Slott-Møller. The art historian Karl Madsen (1855–1938) defended the Funen painters, as did the author and poet Johannes V. Jensen (1873–1950), who on that occasion became personally acquainted with Peter Hansen and became a friend and champion of the entire group of artists.*

Fritz Syberg was awarded various grants by the Academy during his first difficult years. As the years went by, he also received many important marks of distinction, including the Thorvaldsen Medal in 1927. In 1902–1903 Fritz Syberg was a teacher in the school of painting for women and from 1910–1937 he was a member of the board of management of Faaborg Museum.

S.L.

LITERATURE: Poul Uttenreitter, *Fritz Syberg*, Copenhagen 1935; Herman Madsen, *Fritz Syberg*, 1937; Bente Scavenius, *Historien om en moder*, Faaborg Museum 1985, pp. 40–49; Vera Rasmussen, *Fritz Syberg*, Faaborg Museum 1992; Karin Meisl, *Bondemaler og baron*, 1992; Vera Rasmussen in *Weilbach*, vol. 8, Copenhagen 1998; Erland Porsmose, *Fritz Syberg, kunsten, natauren, kærligheden*, Copenhagen 2010.

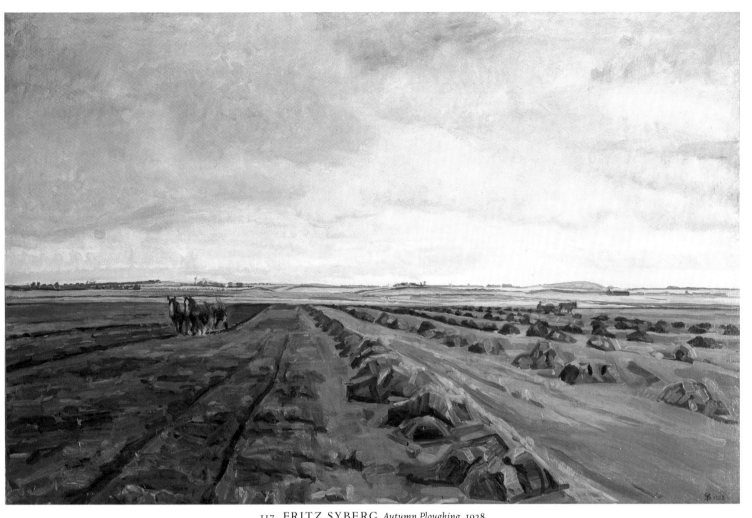

117. FRITZ SYBERG *Autumn Ploughing,* 1928

FRITZ SYBERG
1862–1939

117. *Autumn Ploughing,* 1928
(Efterårspløjning)

Oil on canvas, 53¼ x 81½ in. (135 x 207 cm)

Signed and dated lower right with monogram 1928

PROVENANCE: Generalkonsul Ernst Carlsen (1961); Arne Bruun Rasmussen, Auction 138, 1961, lot 23, ill p. 55; Arne Bruun Rasmussen, Auction 453, 1983, lot 183, ill. p. 61.

Fritz Syberg was one of the principal figures in the group known as *Fynboerne* (the Funen Artists), a common name for a number of painters born—for the most part—on the island of Funen and who began to make names for themselves in the 1890s gradually achieved a reputation that still lives on with undiminished importance in the history of Danish art. Typical of their work was a certain social realism combined with the use of strong colors and a blunt-stroked painting they developed with teacher Kristian Zahrtmann (1843–1917) and later artist Theodor Philipsen (1840–1920), the man responsible for promoting French Impressionism in Denmark.

The Funen Artists were plein air painters, and they found most of their motifs in the landscapes around the Funen towns of Faaborg and Kerteminde and in the home life they knew from their families and friends. The most important works of all the Funen Artists can be seen in Faaborg Museum, which was opened in 1910. The best known of them are Peter Hansen (1868–1928), Fritz Syberg, Johannes Larsen (1867–1961), and Poul S. Christiansen (1855–1933).

During their youth, most of the male artists earned a living as artisan painters during the summer months; during the winter they went to Copenhagen to follow instruction by the painter Kristian Zahrtmann, who ran the Artist's Free Study Schools (*Kunstnernes Frie Studieskoler*) from 1885. These had been established in reaction to the Royal Danish Academy of Fine Arts, where in many people's opinion the teaching had congealed in theories and narrow rules that were no longer applicable. Subsequently, the Funen Artists became members of Den Frie Udstilling (the Free Exhibition), created in 1891 as a counter to the spring exhibitions in the Academy, where all submissions were subject to expert approval.

In 1902 Fritz Syberg and his family moved from a house in Svanninge near Faaborg in southern Funen to Kerteminde in the northern part of the island, and this became his home for the following 37 years. There he could observe the alternating seasons and constantly paint the changes that were repeated year after year. *Autumn Ploughing* was undoubtedly created in this fertile coastal region, where the reflected light from the Kattegat in the west and Storebælt in the east illuminates the harvest fields and the heavy brown plowed earth in a broad swath of light.

S.L.

FREDERIK HANSEN SØDRING

AALBORG 1809 – HELLERUP 1862

Frederik Sødring, whose father was a merchant and shipowner from Aalborg in northern Jutland, became apprenticed to an artisan painter in Copenhagen. From 1825 he was a pupil at the Royal Danish Academy of Fine Arts, where he proceeded through all the schools in the Academy, though without winning any medals. He was nevertheless given a proxime accessit *as a landscape painter in 1828. From 1830 he was a pupil of J. P. Møller, and he received a few lessons in perspective drawing from C. W. Eckersberg in 1835.*

Sødring made his first appearance at Charlottenborg in 1828 with two replicas after Norwegian landscape motifs by J. C. Dahl, (1788–1857), whose pictures he admired throughout his life. He then exhibited in the Paris Salon in 1843 and at Charlottenborg almost every year until 1847 and again in 1858. At the beginning of the 1830s, he went in search of landscape motifs to the island of Møn and southern and central Sweden. In the summer of 1833 he visited Norway, as he also did the following year, part of the time in the company of J. C. Dahl.

In 1836 Sødring was given a grant for two years by the Fonden ad Usus Publicos, and this enabled him to stay in Germany, mainly in Munich with various excursions to Bavaria and the Taunus Mountains, until summer 1838. His style of painting was here strongly influenced by German Romanticism. In 1840–1841 he again traveled in Germany, this time in the Rhineland, in order to make a collection of studies. He was in Paris in 1843.

In 1842 he was accorded recognition by the Royal Danish Academy of Fine Arts in Copenhagen, and two years later he made a painting to mark his membership in the Academy, but he then withdrew it because it had been the subject of severe criticism.

Sødring painted a small number of views of Copenhagen and the surrounding area, but he otherwise concentrated on landscapes, especially Swedish and Norwegian, but later also German—with increasing emphasis on dramatic and sublime subjects far from the Danish tradition.

F. Sødring died in spring 1862 after leaving his estate to the Academy for the establishment of Det Sødringske Opmuntringslegat for unge Landskabsmalere *(The Sødring Scholarship for the Encouragement of Young Landscape Artists).*

S.L.

LITERATURE: Lilian Vestergaard, Landskabsmaleren Frederik Sødring, *Kunstmuseets Årsskrift* 1977–1980, pp. 48–82; Jens Peter Munk, *Købke, Sødring og atelieret på Toldbodvejen,* Den Hirschsprungske Samling, Copenhagen 1985; Jens Peter Munk in *Weilbach,* vol. 8, Copenhagen 1998; Jens Peter Munk, *Sødring, borgruiner og vilde vandfald,* Den Hirschsprungske Samling, Copenhagen 2000.

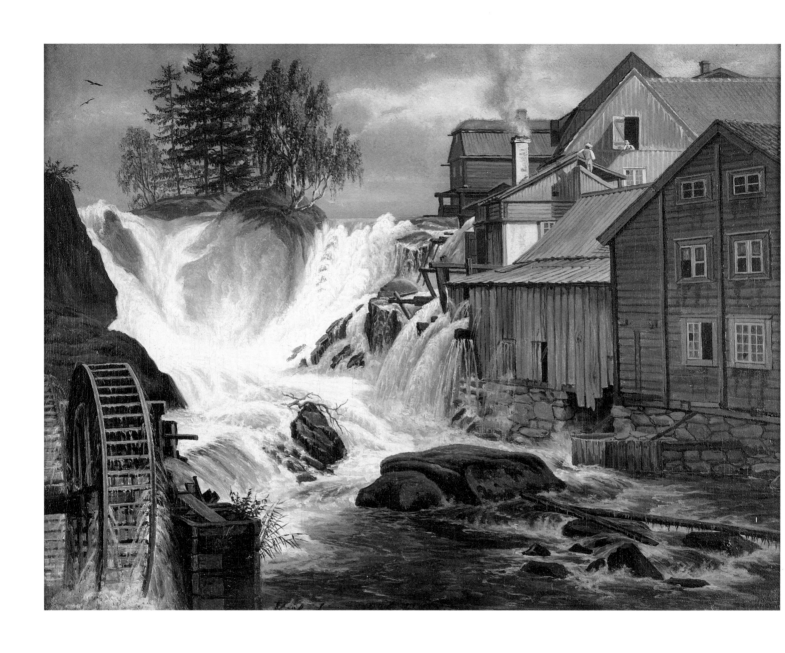

F. SØDRING
1809–1862

114. *Rønneby[1] Waterfall at Blekinge, Sweden, 1836*
(Rønneby vandfald i Blekinge, Sverige)

Oil on canvas, 12 x 16 in. (30.5 x 40.5 cm)

Signed and dated at bottom: Kjöbenhavn 1836 F. Sødring

PROVENANCE: The Auction of the Estate of Emil Wulff 30.3.1926, lot 6; Bruun Rasmussen, Vejle, Auction 7, 1991, lot 715 (described as *Prospekt af norsk fos med vandfald, figurer og bygninger*).

EXHIBITED: Den Hirschsprungske Samling, Copenhagen, *Sødring, Borgruiner og vilde vandfald*, 2000–2001, no. 16.

LITERATURE: Lilian Vestergaard, Landskabsmaleren Frederik Sødring in *Kunstmuseets Årsskrift*, 1977–1980, pp. 48–82, p. 64, no. 73 (described as *En vandmølle ved en norsk fos*); Jens Peter Munk, *Kunstnerkammerater* on Christen Købke's portrait in *Landskabsmaleren Frederik Sødring*, folder accompanying the above exhibition in Den Hirschsprungske Samling, Copenhagen 2000; Patricia G. Berman, *In Another Light, Danish Painting in the Nineteenth Century*, New York 2007, ill. p. 102.

There is a fascinating history to this work by Frederik Sødring, and no final conclusion has yet been reached about it.

The work is a replica made in Copenhagen by the artist himself after a painting he executed in southern Sweden in 1831 and exhibited the following spring at Charlottenborg under the title of *View of Rönneby Waterfall in Blecking, Painted on the Spot from Nature, in the Light of Midday (Prospeckt af Rönneby Vandfald i Blecking, malet paa Stedet efter Naturen, Middagsbelysning)* (Lilian Vestergaard no. 31).

Rönneby, in the Swedish province of Blekinge, is close to the Baltic, halfway between the towns of Karlshamn and Karlskrona. Kunstforeningen (The Copenhagen Art Society) immediately purchased Sødring's southern Swedish landscape, after which, in the annual lottery, it went to a Lieutenant Nehus from Altona. According to all accounts there is in existence a rather smaller preparatory work for this painting, a simple study of the actual waterfall in Ronneby, painted in oil on cardboard (Lilian Vestergaard no. 32).

The present whereabouts is not known of either of these two works. Two other works with the same motif by Frederik Sødring exist in public collections. The first is an india ink drawing made for the Copenhagen Art Society archives after the painting disposed of by lottery and now belonging to the Nationalmuseum in Stockholm (Lilian Vestergaard Drawings No. 7, Fig. A). The second is a lithograph of the same motif in the Royal Library in Copenhagen, Department of Maps, Prints and Photos (Lilian Vestergaard, Graphic Works No. 1, Fig. B).

This does not, however, complete the documentation relating to the Loeb collection portrayal of the Swedish waterfall.

One of the best known and best loved works in the history of Danish art, Christen Købke's portrait *The Landscape Artist Frederik Sødring* (Fig. C) contains information that is extremely interesting in the present connection but has hitherto been overlooked: behind Sødring, there is a mirror in an oval frame. In accordance with European art tradition, the mirror reflects details from the room facing it, details that are outside the actual motif. The picture space is thus expanded before the viewer, and various more or less definable descriptive details are added to the narrative implicit in the painting. It has recently been realized

that the painting seen in the mirror, partly hidden by a couple of letters pushed in between the frame and the glass, are these very Rønneby reminiscences by Sødring. A closer examination shows the cascading waterfall and the silhouette of the mill wheel in a laterally reversed version—fragmentary but unmistakable.

At the beginning of the 1830s, the two young artists shared a studio in Toldbodvejen, present-day Esplanaden, in Copenhagen. The portrait of Frederik Sødring was a birthday present to him from his friend Christen Købke. The iconography in Købke's famous portrait has been meticulously studied and described by Jens Peter Munk of the Hirschsprung collection. Likewise, it is he we can thank for determining the correct identity of the Loeb collection work by Sødring—and for the discovery of the mirror image in the first version of Sødring's beautiful painting.

FIG. A F. Sødring
Rønneby Waterfall, Bleking, Sweden, 1831
Pen, brown ink, and wash on white paper, 7⅕ x 9½ in. (183 x 243 mm), Nationalmuseum, Stockholm

Prospect af Rønnebye-Vandfald
i Bleking i Sverrig

FIG. B F. Sødring
Prospect of Rønneby Waterfall, Bleking, Sweden, (1832)
Lithography, 8⅘ x 13⅔ in. (225 x 345 mm), Royal Library, Copenhagen

There is a little further embellishment to the story of *Rönneby Waterfall in Blekinge:* Frederik Sødring's Swedish work has been in the possession of a certain *Konferensraad*[2] Martin Lehmann. We know this because about 1856 it was hanging in Lehmann's sitting room in Gothersgade in Copenhagen, together with a number of other unidentified gold-framed paintings. Here again we find the Blekinge motif, this time placed above a door in the background in Edvard Lehmann's painting *Musikaften i det Lehmann'ske hjem (Musical Evening in the Lehmann Family Home)* (Fig. D). Here too the picture concerned is Sødring's earliest version from 1831, though whether we are talking here about the replica from the Loeb collection cannot be determined with any certainty. The painting from the sitting room in Gothersgade is assumed (after Martin Lehmann's death) to have been inherited by his son, the famous Danish politician Orla Lehmann, in the auction of whose effects it appears in 1871.

FIG. C Christen Købke (1810–1848)
The Landscape Painter Frederick Sødring, 1832
(Landskabsmaleren F. Sødring)
Oil on canvas, 22 x 15 in. (42.2 x 37.9 cm), Den Hirschsprungske Samling, Copenhagen

FIG. D Edvard Lehmann (1815–1892)
Musical Evening in the Lehmann Family Home, c. 1856
(Musikaften i det Lehmann'ske hjem)
Oil on canvas, 17 x 20½ in. (43 x 52 cm), Musikhistorisk Museum, Copenhagen

If we compare the drawing, the lithograph, and the painting in the Loeb collection, we can note some minor differences in the execution of the three works. The drawing is the most exact reproduction of the now-vanished *Prospeckt af Rönneby Vandfald i Blecking* from 1831, as it was made that same year at the request of the Copenhagen Art Society. In conformity with this, Lilian Vestergaard suggests that the lithograph must also have been made after the painting from 1831. The possibility cannot, however, be excluded that Sødring used the drawing as the model for it. As we do not know the earliest painting, we must be content to note a few differences between the drawing and the lithograph, such as the number and height of the trees, the distribution of various details in the appearance of the houses, and small differences in the water's course and the amount of the vegetation.

What is interesting in the context of the Loeb collection is that according to the evidence in both the drawing and the lithograph, Frederik Sødring has made certain more radical changes in his latest Rønneby work, of which the most striking is a somewhat different arrangement of the entire group of trees at the top left and the addition of some extra billowing smoke from the chimney in the middle of the building complex.

If we look at the Loeb collection version in clear daylight, we can take pleasure in various subtle qualities in the painterly treatment, such as complementary colors in green and brick red, numerous finely varied shades of brown and gray and pink verging on purple, as well as the blue of the sky, with the many shades of white in the clouds and cascading water.

Thanks to the exquisite little work in the Loeb collection, the first version of Rønneby waterfall Sødring painted on the spot might possibly again come to light—perhaps even in the ownership of the Hirschsprung collection, where it belongs side by side with Christen Købke's portrait of the landscape artist Frederik Sødring.

<div align="right">S.L.</div>

[1]Rønneby is the Danish spelling of the word; Rönneby is the Swedish spelling.

[2]An ancient honorary title that cannot be translated.

CARL FREDERIK SØRENSEN

BESSER 1818 – COPENHAGEN 1879

C. F. Sørensen was the son of a merchant and skipper from the little town of Besser on the island of Samsø in the Kattegat. Originally apprenticed as an artisan painter, in 1834 he was admitted to the Royal Danish Academy of Fine Arts in Copenhagen, where he learned decorative painting. In 1844 he was awarded the minor silver medal for an ornamented stove screen, and the following year he received two months of instruction in perspective drawing by C. W. Eckersberg.

Sørensen exhibited at Charlottenborg from 1839 to 1879, though not every year. He also exhibited in the Paris world fairs of 1855 and 1878 and in Vienna in 1873 (two vases with seascapes for the Bing & Grøndahl porcelain manufactory). He worked as a decorative painter during his studies at the Academy, but in time replaced decorative with marine painting. In 1846 he was given permission to sail on a Danish frigate on an expedition to the Mediterranean. After this he took part in voyages almost every year, in 1853–1854 to Germany, Holland, Belgium, France, and England, in 1864 to Italy, and in 1874 to Iceland (accompanying King Christian IX).

C. F. Sørensen was a frequent visitor to Eckersberg's home, but only to a minor extent was he influenced by Eckersberg's style of painting. Sørensen's impressive seascapes gained him great popularity that spread outside Denmark. His pictures from Iceland are topographically interesting and artistically more subdued than the earlier works, but they are considered to be among the best in his oeuvre. During the war of 1848–1850 Sørensen accompanied the North Sea Squadron around Heligoland (1849) and the Baltic Squadron (1850), the result of which was a series of paintings portraying the Danish fleet at the war.

In 1869 C. F. Sørensen was given the title of professor and was accorded a considerable number of official marks of honor during his lifetime. Among his clients were the kings of Denmark and members of the courts in St. Petersburg, London, and Athens.

S.L.

LITERATURE: Philip Weilbach, *Dansk Konstnerlexikon*, Copenhagen 1877–78; Hanne Jönsson (ed.), *C. W. Eckersberg og hans elever*, Statens Museum for Kunst, 1983; Mona Christensen and Jan Faye, *Marinemaleren C.F. Sørensen*, Helsingør Kommunes Museer, Marienlyst 1991; Jens Peter Munk in *Weilbach*, vol. 8, 1998.

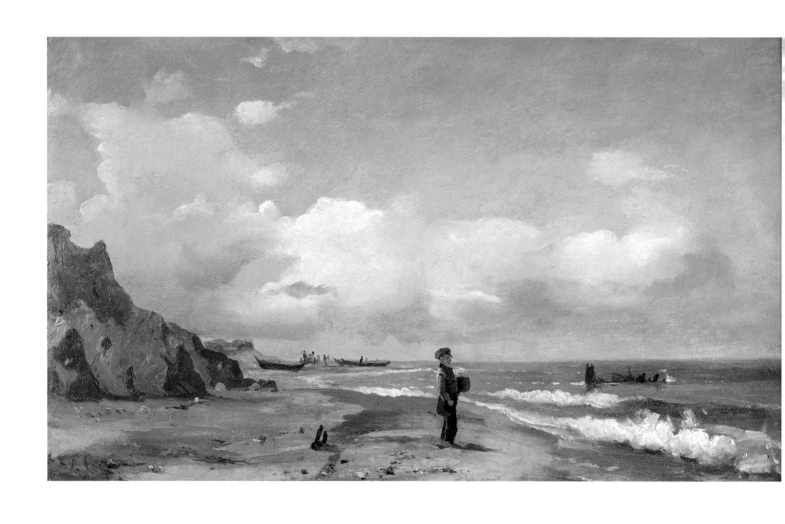

C. F. SØRENSEN
1818–1879

115. *Coast with Steep Cliffs; in the Foreground, a Fisher Boy*
(Kystparti med stejle klinter, i forgrunden fiskerdreng)

Oil on panel, 9¾ x 16¼ in. (25 x 41 cm)

Signed with initials lower left: C.F.S.

PROVENANCE: Arne Bruun Rasmussen, Auction 427, 1981, lot 252; Bruun Rasmussen, Auction 526, 1989, lot 439, ill. p. 103.

EXHIBITED: Marienlyst, Elsinore, *Marinemaleren C.F. Sørensen*, 1991, no. 1111.

LITERATURE: Mona Christensen and Jan Faye, *Marinemaleren C. F. Sørensen*, Marienlyst, Elsinore 1991, p. 171.

> *O, well, it's not so bad; but you must still go out,*
> *still go out into nature; first on the shore, then in a boat. . . .*

These were the words of encouragement once uttered by Carl Frederik Sørensen to one of his pupils, the poet and painter Holger Drachmann (1846–1908), from whose hand we have a lively description of Sørensen as both man and artist.[1] The exhortation originally came from C. W. Eckersberg, who had taught his pupils to work out in nature directly in front of their motifs. With him, marine painting in Danish art had gotten seriously underway. On the basis of a large number of drawn sketches and through intensive studies of available construction calculations, he acquainted himself with the structure of the ships down to the least detail. Then, on the basis of meticulous perspective measurements, he calculated the precise positions in which to place the vessels in his composition, taking into account the direction of the winds, the water currents, and the sea floor conditions in the relevant places. Only after this could the process of painting commence.

But Sørensen's painting style developed in a very different way from that of Eckersberg, who executed his brilliant and strictly composed idealized portrayals of life at sea methodically and with scientific thoroughness; C. F. Sørensen worked spontaneously. For him it was a matter of capturing the character of the sea and its many moods. With his quick brush and often very broad strokes, he caught the ever-changing movements on the surface of the sea, the play of light on the waves, and the vagaries of the weather.

It is not known where this wonderful plein air study was painted, and the dating also appears to be uncertain. The scene with the lone fisher boy watching on a wet shore one radiant morning at ebb tide could have been painted in southern England (the artist spent the summer of 1854 at Dover and Hastings).

S.L.

[1]Holger Drachmann, Nogle Erindringsord in *Ude og Hjemme*, no. 70, 1879.

456]

C. F. SØRENSEN
1818–1879

116. *View of the Sound; in the Background Tibberup Mill and Kronborg; in the Foreground Women Washing,* 1878

(Parti fra Øresund, i baggrunden Tibberup Mølle og Kronborg, i forgrunden koner, der vasker)

Oil on canvas, 35½ x 52¼ in. (90 x 133 cm)

Signed lower right: C. Frederik Sørensen 1878

PROVENANCE: Arne Bruun Rasmussen, Auction 486, 1986, lot 41, ill. p. 33; Bruun Rasmussen, Auction 600, 1994, lot 27, ill. p. 31.

EXHIBITED: Marienlyst, Elsinore, *Marinemaleren C.F. Sørensen*, 1991, no. 884.

LITERATURE: Mona Christensen and Jan Faye, *Marinemaleren C. F. Sørensen*, Marienlyst, Helsingør 1991, p. 24, ill. p. 143.

Sørensen's oeuvre fell into two categories: the outdoor sketches and small studies executed on the spot, and the bigger, carefully composed compositions commissioned by his ultimately large circle of clients—or intended for exhibition, as was the case with the present painting. He usually signed works from the two groups in different ways. The first category was signed with a monogram "CFS" or as "C F Sørensen," while the studio paintings were usually signed "C Frederik Sørensen" followed by the year. The Loeb collection has one of each.

The locale of this painting is Tibberup, situated near Humlebæk, not far from the present-day Louisiana Museum of Modern Art. Kronborg in Elsinore, to the north, is the castle in which Shakespeare set *Hamlet*. Sørensen painted this picture the year before his death. It radiates the artist's usual delight in painting, and the style is as always brilliant and honest.

In the splendid monograph and catalogue of works on C. F. Sørensen the painting in the Loeb collection is reproduced in color alongside another work from the same period,[1] on which Mona Christensen and Jan Faye make the following comment:

> At this time, Sørensen paints a couple of impressive landscapes, completely without drama or sentimentality. The paintings immediately show how a lovely sunlit summer's day could be experienced on the Danish and Swedish sides of the Sound coast respectively. There is an almost serene peace about both paintings, created by the vast open and radiant surfaces of the sea, and only the dark, heavy clouds on the horizon seem to threaten the idyll. At the same time, Sørensen has managed to express superbly the great distance between the earth and the vast vault of heaven.

S.L.

[1] *Havnemolen ved Höganäs*, 1877 (*The Harbor Mole at Höganäs*), private collection.

CARL CHRISTIAN THOMSEN

COPENHAGEN 1847 – COPENHAGEN 1912

Carl Thomsen originally started studying at the University, but broke off to go to the Royal Danish Academy of Fine Arts, where he was admitted in 1866 and qualified in 1871. Here he had Frederik Vermehren (1823–1910) and Wilhelm Marstrand as his professors and was thereby among the last Academy pupils to be taught the techniques of the Eckersberg school and fashioned by the ideals of the Golden Age. The Academy was strongly conservative during this period, but especially Wilhelm Marstrand managed to bring about a renewal of figure painting on which the younger artists could build further. As was the custom, Thomsen went to Italy to complete his training through a direct encounter with painting in practice. Then, although he was in Paris in 1878 and 1881, important years during the period when others were falling under the influence of the new currents of the day, Thomsen found inspiration in the acknowledged traditional manner of painting, especially the historical genre pictures that were so popular in the Salon, a range of motifs that Marstrand, too, in his later years had cultivated intensively.

Thomsen exhibited for the first time at Charlottenborg in 1869 and continued showing there. With his well composed and always carefully finished works, he was at the same time a participant in all major official Danish exhibitions abroad until his death. He very often took his motifs from the history and literature of the 18th and early 19th centuries and was fond of depicting episodes from the lives of authors. Among his most important works mention can be made of Digteren Johannes Ewalds møde med Arendse (The Poet Johannes Ewald's Meeting with Arendse), *1876, private collection;* Middag efter en bispevisitats (Dinner after a Visitation by the Bishop), *1888, Statens Museum for Kunst, which won many prizes in exhibitions abroad;* Knud Lyne Rahbek ved sin hustrus dødsleje (Knud Lyne Rahbek at the Deathbed of His Wife), *1895, Statens Museum for Kunst; and* Grundtvig i Udby Kirke (Grundtvig in Udby Church), *from 1901.*

Other challenges taken up by Carl Thomsen were altarpieces and other kinds of religious art. In keeping with the spirit of the age that was predominant in his youth, he remained loyal to what he had learned and found a lasting example in Marstrand's lively figure compositions. Meanwhile, he achieved his greatest popularity as an illustrator. His works for books and cultural periodicals are numerous, and a whole series of graphic reproductions were produced and published in folders that were well known and loved in his day. His masterful technique comes into its own in this medium, and his independent contribution is seen to its full extent.

E.F.

LITERATURE: Sigurd Müller, *Nyere dansk Malerkunst,* Copenhagen 1884; Peter Christiansen, *Carl Thomsen som Illustrator,* Copenhagen 1939; Peter Michael Hornung in *Ny dansk kunsthistorie,* vol. 4, Copenhagen 1993; Kirsten Nannestad in *Weilbach,* vol. 8, Copenhagen 1998.

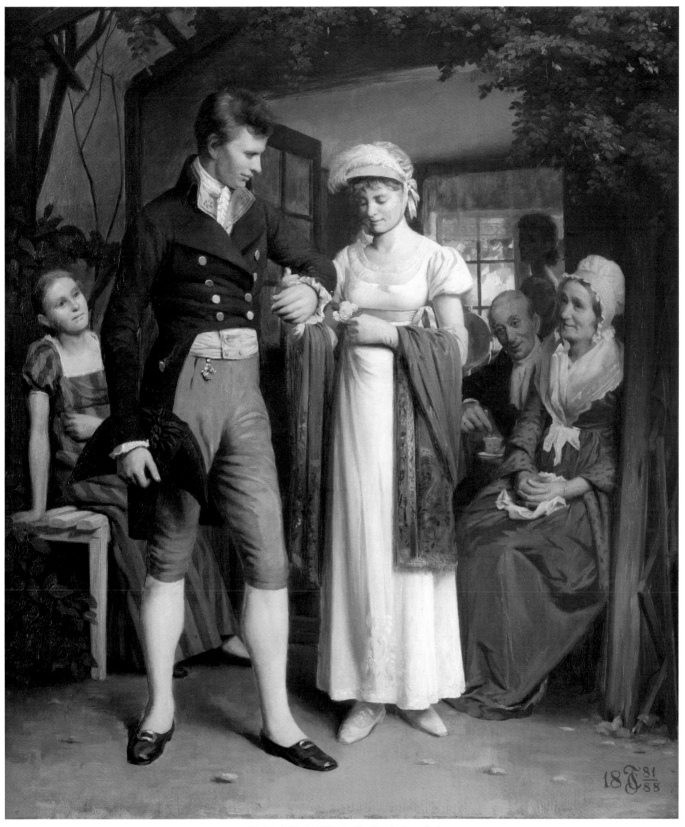

118. CARL THOMSEN *The Newly Betrothed*, 1888

CARL THOMSEN
1847–1912

118. *The Newly Betrothed*, 1888
(De nyforlovede)

Oil on canvas, 21¼ x 26 in. (54 x 66 cm)

Signed and dated lower right: 18 CT (monogram) 81/88; inscribed on reverse: *Nørrebrogade 9.*

PROVENANCE: Overretssagfører Mygind (1901); Kunsthallen, Auction 434, 1993, lot 125, ill.

EXHIBITED: Town Hall, Copenhagen, *Raadhusudstillingen,* 1901, no. 1775 (inscribed in catalogue *Replica of the painting from 1881*); Bruce Museum of Art and Science, Greenwich, Connecticut, and The Frances Lehman Loeb Art Center, Vassar College, New York, *Danish Paintings of the Nineteenth Century from the Collection of Ambassador John L. Loeb Jr.,* 2005, no. 17, ill.

Carl Thomsen was one of Marstrand's last group of pupils and like Marstrand himself was interested in genre-like paintings. He was also deeply interested in literature, so he often sought his motifs in the literature and figures of the Danish Golden Age. In addition, he created a number of illustrations for books from the same period.

In *The Newly Betrothed* we encounter features relevant to all these factors. The genre motif is seen in the narrative content of the picture, which as always invites the viewer to elaborate on the situation depicted, in this case the portrayal of the handsome young couple apparently surrounded by a small group of family members. There is the admiring younger sister on the bench to the left and the blissfully smiling parents, also seated, the father holding a cup of coffee in his hand. At the back, in semidarkness, the other sister, perhaps spurned, stands with a sorrowful face, almost in silhouette against a window opening on to a sun-drenched garden.

The figures are wearing costumes from the first half of the 19th century, and stylistically the scenery is reminiscent of Thomsen's drawings illustrating a new edition of Johan Ludvig Heiberg's cycle of poems *De Nygifte (The Newlyweds),* which, however, was not published until 1891.[1]

Carl Thomsen painted this motif both in 1881 and 1888, as he carefully makes clear in the monogram-like form of the signature. The first version of the painting was exhibited at Charlottenborg in 1881, no. 248, and was purchased by the Copenhagen Art Society, Kunstforeningen. It was then disposed of by lottery to the solicitor's clerk H. Hansen, reappearing in the Winkel & Magnussen Auction 330, 1946, lot no. 289, ill. p. 25.

S.L.

[1] Johan Ludvig Heiberg (1791–1860) was an important literary figure in the Danish Golden Age. His works included vaudevilles such as *Kong Salomon og Jørgen Hattemager (King Solomon and Jørgen the Hatter)* (1825) and plays of such varying nature as *Elverhøj (The Elfin Mound,* 1828) and *En Sjæl efter Døden (A Soul after Death,* 1840). For a number of years Heiberg was the director of the Royal Theatre, and from 1831 he was married to the leading actress in the theatre, née Johanne Luise Pätges (1812–1890).

KURT HENNING TRAMPEDACH

HILLERØD 1943 – SARE, PYRÉNÉES-ATLANTIQUES, FRANCE 2013

The son of a typographer, the painter, sculptor, and graphic artist Kurt Trampedach was born and grew up in the northern Zealand town of Hillerød, well known in Denmark on account of the magnificent Frederiksborg Castle, which so often figured in paintings of the Danish Golden Age and today serves as the museum of national history.

However, it was not the national paintings of the 18th century that interested the young Trampedach. After finishing his apprenticeship as an artisan painter in 1963 he became a journeyman and was admitted to the Royal Danish Academy of Fine Arts in Copenhagen. Here he studied until 1969 under two influential painters and graphic artists in Danish art, Professors Dan Sterup-Hansen (1918–1995) and Søren Hjorth Nielsen (1901–1983).

Trampedach made his first appearance as early as 1962 in Kunstnernes Efterårsudstilling and very soon discovered his preferred circle of motifs, self-portraits and figure paintings—starting out with his own facial features, using at first such sublime models as Rembrandt (1606–1669) and Goya (1746–1828). But Trampedach was also fascinated by artists in the more recent Nordic tradition, such as the Danish painter Vilhelm Hammershøi and the Norwegian Edvard Munch (1853–1944). Gradually his attention was drawn to contemporary foreign artists such as the Swiss Alberto Giacometti (1901–1966)—of whose work there was a major retrospective exhibition in the Lousiana Museum of Modern Art in 1965—as well as the English artist Francis Bacon (1909–1992) and the Americans George Segal (1924–2000) and Edvard Kienholz (b. 1927).

Kurt Trampedach was from the start a loner who might well have been inspired by the works of other artists but who used his artistic intuition to form a completely personal idiom. In the 1960s and throughout the 1970s, Trampedach's work was dominated by self-portraits influenced by the textuality and chiaroscuro technique of Rembrandt, painted in ashen-gray and earth-brown colors. These were at first in the form of insistent, almost invasive, studies of facial landscape and later of larger figure portraits in which the artist pictured himself in rapid motion, parallel with the plane of the picture, appearing to move away from the gaze of the viewer. Over the years Trampedach has returned to this latter motif in many different versions, including the watercolor of his son Jonas in the Loeb collection.

At the beginning of the 1970s Kurt Trampedach made a number of tableaux in barrier-breaking realism. They were painted plaster casts after living persons—including the artist himself—with human hair on their heads, naked or dressed in ordinary clothing, and placed in environments taken from the world of reality. By placing these figures in his own and his viewers' everyday environments, the artist was able to create a series of what could be called various kinds of participants in life emanating a disturbing presence, rather than artistic objects amenable to classification and judgment in the usual way.

[461

In 1978 he moved to an outlying area near the town of Sare in the southern French Basque country, protected by mountains and impressive scenery. Before this he had an apartment and studio in New York, where it was possible for him to live in complete anonymity. It was here that Trampedach found the artistic freedom that enabled him to find his way to his next quite original idiom.

His later works are still based on the self-portrait, but their form and coloring have been radically changed. We are now confronted with strange, staring creatures who seem to have been drawn up into the light from the deepest and most secret layers of the human mind in the form of chubby children or dwarfs. Their silent appearance is at once violently repulsive and strangely moving; their behavior seems intended to symbolize various stages of life. The small, grotesque figures are backed like a relief with color to form a compact mass that sometimes belongs together with its background, and sometimes they have developed into free-standing, painted plaster figures of fascinating lifelikeness.

Trampedach's new painting glows with shades of red, orange, yellow, and deep blue. In recent years green has been added. Along with the original earth color scale and various engravings of mysterious signs and animal figurations referring to primitive and classical Greek mythology, these colors—reminiscent of church windows—contribute to the works' ambiguous emanations of forebodings and premonitions. The artist has applied the same coloring to a number of interesting portraits, of which one of the latest and most eagerly discussed is the double portrait of Prince Joachim and Princess Alexandra from 1997 (Schackenborg).

In addition to paintings and sculptures, Trampedach has produced a large number of drawings; special mention should be made of a series of illustrations for Bob Dylan's "Ballad of Frankie Lee and Judas Priest" published in 1970,[1] along with the series Blade fra min dagbog (Pages from My Diary), *which includes the* Tegninger fra Baskerlandet (Drawings from the Basque Country) *referred to above, from 1979–1980.*

Since 1970 Kurt Trampedach was a member of the association of artists known as Decembristerne. He took part in many international group exhibitions, including the FIAC in the Grand Palais in Paris (see the Loeb collection poster from this), and he had solo exhibitions in Fyns Kunstmuseum (1971) and various galleries, of which mention can be made of the Galerie Asbæk in Copenhagen (first in 1978) and the Allan Stone Gallery, New York (first in 1987). Kurt Trampedach is represented in various Danish museums, the Sundsvall Kunstmuseum in Sweden, and the Antwerp Sculpture Park in Belgium. In 1969 he received the State Foundation for the Arts one-year grant in addition to the Queen Ingrid Roman Scholarship. In 1984, Kurt Trampedach was awarded the Eckersberg Medal. He died in southern France in 2013.

S.L.

LITERATURE: Klaus Rifbjerg. *Kurt Trampedach,* Copenhagen 1978; Mikael Wivel, *Kurt Trampedach, Tegninger fra Baskerlandet 1979–1980,* Copenhagen 1981; Rolf Læssøe, *Kurt Trampedach* (Dansk Nutidskunst 7), Copenhagen 1990; Peter Michael Hornung, *Dansk Billedkunst, De utilfredsstillede,* Copenhagen 1995, pp. 159–161; Mikael Wivel, *Kurt Trampedach,* Allan Stone Gallery, New York 1995; Mikael Wivel in *Weilbach,* vol. 8. 1998; Mikael Wivel, *Kurt Trampedach,* Copenhagen 2001.

[1] Bob Dylan's "Ballad" was translated and made understandable for Danish music lovers by a well known contemporary and esteemed Danish poet, Poul Borum. The song was originally published in 1968 in the record *John Wesley Harding.* Mikael Wivel, *Kurt Trampedach,* Copenhagen 2001, p. 34.

KURT TRAMPEDACH
1943–2013

119. *Jonas, the Artist's Son, 1982*
(Jonas, kunstnerens søn)

Watercolor, 59½ x 49½ in. (151 x 126 cm)

Signed and dated on right side: Trampedach 82

PROVENANCE: Galerie Asbæk, Copenhagen, 1983.

EXHIBITED: The American Scandinavian Society of New York at Privatbanken Gallery, *Selections of Contemporary Danish Art*, 1989, no. 1.

Almost the whole of Kurt Trampedach's oeuvre is based on the presentation of figures, usually of an autobiographical nature. Throughout his life he has used his own body and his own face as the starting point for his art, and at a very early stage in his production two elements emerged in his creative idiom that constantly reappear in his works: one is the withdrawn Giacometti-inspired figure striding across the surface of the picture from edge to edge as though on his way away from the framed universe; the second is the reluctance of the figures portrayed to remain where they have been placed, an element in their psyches that makes them rebel by—for instance—extending a hand out across the edge of the picture. Or they might materialize in groups as living beings dressed in ordinary clothes and surrounded by furniture and everyday implements of reality. Or by virtue of pastose layers of plaster and paint, they might be leaning imploringly from the walls as though in an attempt to liberate themselves from the material of which they are made.

Something similar is found in this poetic pictorial account of Jonas, the artist's son, which rather than being only a portrait of a delicate, long-haired boy in jeans and sneakers may possibly also be the father's recollection of himself as a child, still with the dreams and indeterminate longings of childhood intact. This large, beautiful watercolor is provided with a painted frame on either side and at the top, but the bottom is open. The boy is seen in profile, as are many of Trampedach's earlier walking figures, but he is standing quite still—almost silhouetted against a light background that is both uniformly flat and also rather like a piece of thin material that barely hides the view of an infinite universe.

The boy is on the borderline between the space of the picture and reality, possibly mature enough to fly, ready to plunge into the unknown but standing hesitantly with hands in his sweater pockets, jacket thrust out in back, almost like the wings of a fledgling bird. There is something both demonic and innocent about the little chap, and perhaps also something hopeful—for he has his life before him.

S.L.

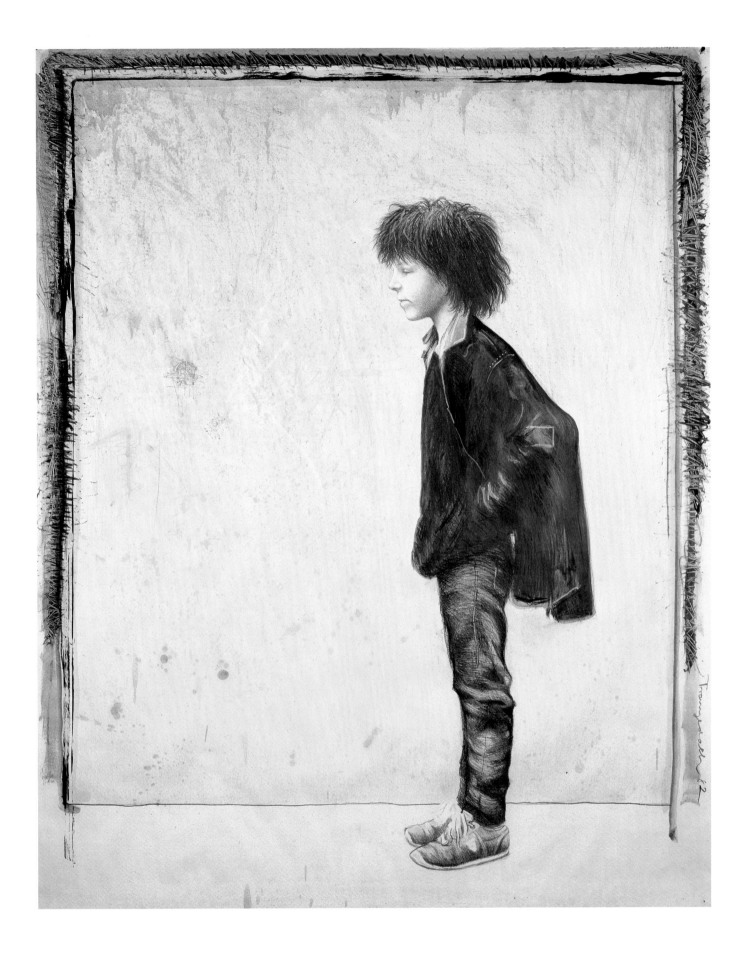

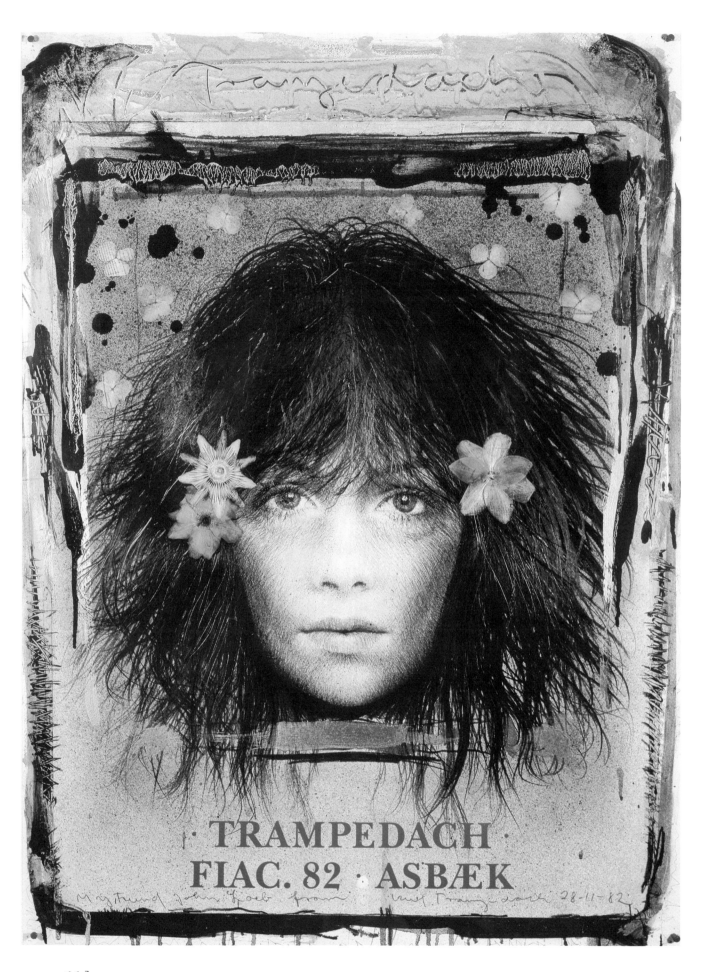

KURT TRAMPEDACH
1943–2013

120. *Woman*, 1982
(Kvinde)

Poster, 66¾ x 46¾ in. (170 x 119 cm)

Inscribed at bottom: My friend John Loeb from Kurt Trampedach 28–11–82

PROVENANCE: Gallerie Asbæk, Copenhagen, 1982.

In about 1982, Trampedach made a series of serigraphs on which he worked farther in oil paint after print-ing. (See the Loeb collection *Portrait III.*)

This poster for the international art exhibition FIAC 82 in the Grand Palais in Paris was presumably made in a similar way, after which the finished result was presumably reproduced photographically.

S.L.

KURT TRAMPEDACH
1943–2013

121. *Portrait III*

(Portræt III)

Serigraphy/oil on canvas, 66¾ x 46¾ in. (170 x 119 cm)

Signed on right side: Trampedach

PROVENANCE: Galerie Asbæk, Copenhagen 1983.

EXHIBITED: The American Scandinavian Society of New York at Privatbanken Gallery, *Selections of Contemporary Danish Art*, 1989, no. 3.

In November/December 1980, the Galerie Asbæk in Copenhagen mounted its second exhibition of Kurt Trampedach's works, this time a group of autobiographical drawings titled *Pays Basques*. Two years before this, the artist had left Denmark and isolated himself in a house on a mountainside in a desolate area of the Pyrenees close to the Spanish border. Here, during the dark hours of the night, he executed a series of carefully planned, self-revelatory examinations of the mirror image of his own face. This process was an act of purification, a kind of catharsis meant to renounce doubt and angst, an almost hateful but necessary self-recognition from which he had long drawn back.

The manner of *Portrait III* is far removed from the brutal sensitivity characterizing these drawings, but the young woman's face, with wild hair and a dark, intense stare, has been brought to the very front of the picture plane in the same way as the self-portraits from the Basque country. She is glaring at the artist and herself[1] as though she were a reflection of his soul, and we suspect that she belongs to the demons in his mind.

While the Loeb collection portrait of a woman stands as a muted echo of the drawings from the Basque Country, we cannot exclude the possibility that this pretty girl is intended to be a specific artistic identity. One's first response to this picture may be that what we see is an exploration of the borderland between kitsch and art. But looking more deeply, behind the woman's apparently flawless appearance we can see the embers of a deeper, archetypal motif similar to that often manifested in the great Norwegian painter Edvard Munch's (1863–1944) love-hate relationship with women. Munch's famous erotically charged portrayals of the dualism between prostitute and madonna might have inspired Trampedach.

The art historian Rolf Læssøe has demonstrated that in several of his self-portraits Kurt Trampedach combines his own face with Medusa's ghastly head. According to Greek myth, Medusa was a beautiful young woman famed for her long silken hair. But because she committed adultery in one of Athena's temples, the goddess punished her by changing her magnificent hair into a terrifying confusion of live snakes. Medusa was transformed into a horrific monster whose eyes turned to stone anyone who looked into them. Only by holding up a mirror to Medusa's face could the evil from her eyes be neutralized. This is what the hero Perseus did with the help of the goddess Athena, who lifted her highly polished shield up in front of the monster. By looking only at the mirrored image on Athena's shield, Perseus was able to cut off Medusa's head. The image became permanently etched on Athena's shield. From Medusa's blood arose the beautiful winged horse Pegasus—in more recent times the symbol of poetical inspiration.

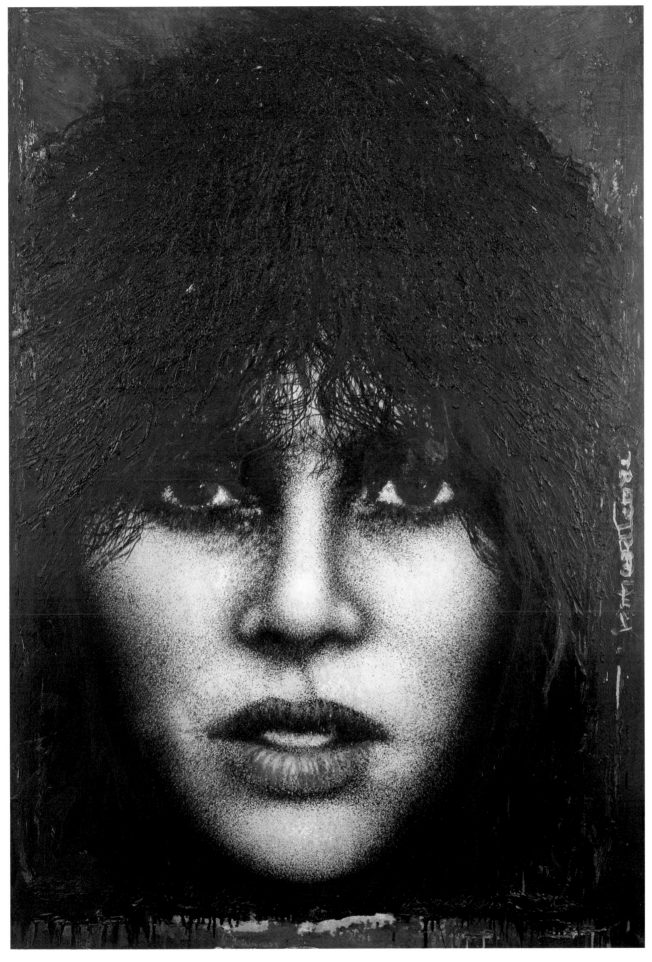

Both the symbol of Medusa and the Pegasus figuration often appear in Trampedach's work. Medusa's staring eyes lost their dangerous power in the reflection, and her severed head was transformed into an instrument to keep evil at bay. Perhaps, like the drawings from the Basque country, *Portrait III* can be interpreted as yet another artistic self-portrait, this time in the shape of a woman.

In Frederiksborg Castle in Hillerød, Trampedach's native town, there is a fire screen well known in the history of Danish art decorated with a painting from 1785 titled *Lykkens Tempel* (*The Temple of Happiness*), executed by the painter Nicolai Abildgaard. As the only decoration in the semicircular top of the screen, Medusa's head can be seen with a half-open mouth and a piercing look, encircled by snakes and crowned with the wings of Pegasus.

<div align="right">S.L.</div>

[1]Here I compare the portrait of the young girl with Trampedach's self-portraits, and it is natural to think of her/him looking at her/his own face in the mirror.

LAURITS REGNER TUXEN

COPENHAGEN 1853 – COPENHAGEN 1927

Laurits Tuxen became the portraitist for the royal families of Europe and in his day was famous far beyond the borders of Denmark. His great group portraits are found hanging in Christiansborg Palace in Copenhagen, the Royal Collection at Windsor Castle and Buckingham Palace in London, and the Hermitage Museum in St. Petersburg. As a young man in the 1870s, he was one of the rebels taking their training in France and striving for a new artistic mode of expression. In 1879, in opposition to the Royal Danish Academy of Fine Arts, he was given state funding to provide a free alternative training for young Danish artists according to the French model. From 1882, the Kunstnernes Studieskole in Copenhagen was a reality, with Tuxen, P. S. Krøyer, and Frans Schwartz (1850–1917) as teachers, and the school became an important factor in the 1880s transformation of Danish art known as the Modern Breakthrough. The results achieved by the school led to the formation in 1891 of Den Frie udstilling, which betokens a breach of the monopoly of the official Charlottenborg exhibitions.

Tuxen's international career began early in the 1880s, when he was living in Paris with his Belgian wife and traveling a great deal. He had an impressive capacity for work, and his paintings were shown in the major exhibitions of the time, both at home and abroad. The status he achieved, thanks especially to the royal commissions, led to his occupying many positions of trust; for instance, with Krøyer, he was a commissioner for the large-scale exhibition of French art in Copenhagen in 1888 organized by the brewer Carl Jacobsen (1842–1914) of Carlsberg Breweries, and he was adviser to the Danish exhibition in the Guildhall in London in 1907. During his second marriage, he again settled in Copenhagen, where he resumed his teaching, this time as professor in the Royal Danish Academy of Fine Arts, which to a large extent had adapted to the demands of the new age. In close collaboration with Viggo Johansen (1851–1935), Valdemar Irminger (1850–1938), and Julius Paulsen (1860–1940) he was until 1920 a highly regarded teacher during the difficult period when yet another modernism deriving from France brought about a radical change in the techniques and aesthetics of painting.

Tuxen's talent for painting was revealed at an early age, and he did not lack encouragement, although he also had excellent academic abilities. He originally wanted to be a marine artist, for his childhood in the Christianshavn district of Copenhagen, where his father was a naval officer and director of the naval dockyard, was spent in close proximity to large numbers of ships. Among the family's friends were several of the cultural personalities of the time, among whom was the marine artist and poet Holger Drachmann (1846–1908), who became one of his first advisers. At the age of fifteen he left Vilhelm Kyhn's school for the Royal Danish Academy of Fine Arts, where he took the classical academic training with the Golden Age painters Wilhelm Marstrand and Jørgen Roed (1808–1888) as his professors in the life class. They convinced him that he ought to aim at a future as a figure painter.

Meanwhile in 1875, the first painting he exhibited, Redningsbåden går ud (The Lifeboat is

Launched), *was on a maritime subject. The money he earned from it was used for a trip abroad that took him to London and St. Malo in Brittany. From there he went to Paris, where with financial support from his parents he followed classes in Léon Bonnat's (1833–1922) famous school during the winters of 1875–1876 and 1877–1878. Here Tuxen became acquainted with new ideals and techniques, especially what was known as value painting, and became a figure painter in earnest.*

In 1879, Tuxen's Susanne i badet (Susanne in the Bath), *painted in the international academic style, caused a stir in Copenhagen. Four allegorical ceiling paintings for the Museum of National History at Frederiksborg Castle, which he was then commissioned to execute, are just as strongly influenced by French Salon art. In autumn 1882 he was given the task of painting a group portrait of Christian IX, "the father-in-law of Europe," and his queen, Louise, surrounded by their entire large family in the garden salon at Fredensborg Palace (now hanging in Christiansborg Palace, Copenhagen). This task, demanding and indicative of great honor as it was, was brilliantly carried out, and Tuxen's reputation was thereby established. While he was working on it, he was commissioned by Queen Victoria to paint a corresponding portrait of herself and her family at Windsor on the occasion of her Golden Jubilee. This enormous and successful canvas was finished by 1887. For the next many years Tuxen was constantly on the move, busy with sketches and paintings portraying weddings and coronations, especially in the English royal family and that of the Russian czar.*

After his second marriage in 1901, Tuxen moved to Denmark and bought a house in which to spend his summers in Skagen, which he had visited as a young man, close to the houses owned by his friends Drachmann and Krøyer. The local countryside inspired him, and he became one of the Skagen Painters. In 1908, together with his fellow artists, he founded Skagens Museum, and it was very largely due to his organizational talent, his negotiating skills, and his connections that it was possible for the museum to open twenty years later, equipped with a large collection in a new building erected for the purpose.

During his final years, Tuxen was three times in the United States. In 1918, accompanied by his wife and daughter Nina, he aimed to paint President Woodrow Wilson (1856–1924), but he was refused. From the East Coast they traveled to California, where he painted a number of successful studies of the exotic landscapes and of oil wells. The couple spent 1923–1924 in California, and on their third visit in 1925 they sailed home via the Panama Canal and the Caribbean.

Tuxen made his first appearance at Charlottenborg in 1875 and in the Salon in Paris in 1878, and he represented Denmark in a large number of official exhibitions.

E.F.

LITERATURE: Laurits Tuxen: *En Malers Arbejde gennem tredsindstyve Aar fortalt af ham selv: Malerungdommen tilegnet*, Copenhagen 1928; Karl Madsen: *Skagens Malere og Skagens Museum*, Copenhagen 1929; Lise Svanholm: *Laurits Tuxen, Europas sidste fyrstemaler*, Copenhagen 1990; Lise Svanholm in *Weilbach*, vol. 8, Copenhagen 1998; Mette Bøgh Jensen and Tine Nielsen Fabienke (eds.), *Tuxen, Color, Countryside and Crown*, Skagens Museum and Fuglsang Kunstmuseum 2014.

LAURITS TUXEN
1853–1927

122. *Preparatory study for "Digging for Worms on the Beach" from 1880, Cayeux-sur-Mer*

(Forarbejde til "Ormegravere på stranden")

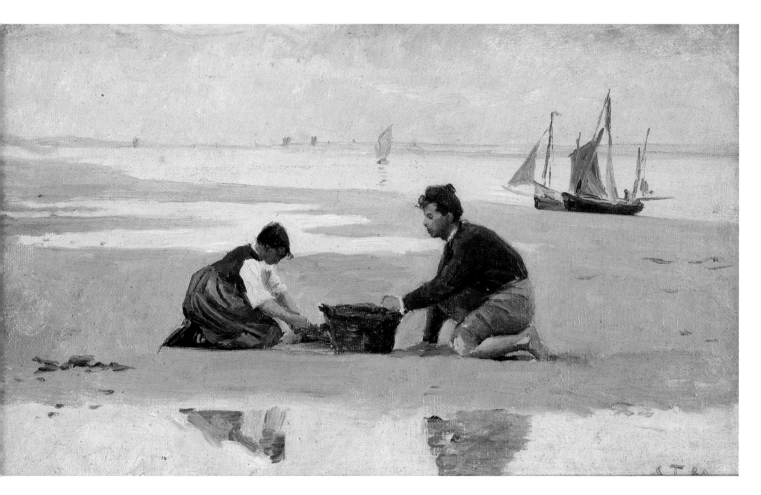

Oil on panel, 7¾ x 12½ in. (20 x 32 cm)

Signed bottom right: LT. 80

PROVENANCE: Bruun Rasmussen, Børge Nielsen,Vejle, Auction 7, 1991, lot 719, ill. p. 12 (described as *Muslingesamler fra Bretagne*).

EXHIBITED: Busch-Reisinger Museum, Harvard University Art Museums, *Danish Paintings of the Nineteenth Century from the Collection of Ambassador John Loeb Jr.*, 1994, no. 28; Skagens Museum and Fuglsang Kunstmuseum, *Tuxen, Color, Countryside and Crown*, 2014–2015, no. 19, ill. pp. 162–163.

LITERATURE: Lise Svanholm, *Laurits Tuxen*, 1990, oeuvre no. 174, titled *Muslingesamlere fra Bretagne (Mussel Collectors from Brittany)*; Peter Nisbet, *Danish Paintings of the Nineteenth Century from the Collection of Ambassador John Loeb Jr.*, Busch-Reisinger Museum, Harvard University, Cambridge, Massachusetts 1994, ill. and discussed pp. 11–12; on the motif, Laurits Tuxen: *En Malers Arbejde gennem tredsindstyve Aar fortalt af ham selv*, Copenhagen 1928, p. 97; Bo Wingren, *Tillbaka till Normandie, nordiska konstnärer i Normandie 1850–1900*, Stockholm 1992, pp. 219–223.

During his youth Tuxen frequently painted the sea and the shore, and in the 1870s he made repeated visits to the coasts of northern France. Here, the plein air artists had found motifs which at that time

were particularly popular among the French, English, American, and Scandinavian artists of the day. In 1875 and 1877, Tuxen worked at St. Malo in Brittany. He made this sketch at Cayeux-sur-Mer in Picardy in 1880 as a preparatory work for a painting of people digging for worms on the shore which, as far as is known, was first exhibited in the memorial exhibition of Tuxen's work in 1929. The flat landscape around Cayeux had only recently been discovered by artists.

Tuxen himself says the following about the motif in his memoirs: *At the end of May, I went with Rosenstand to Cayeux s. mer, a fishing village and bathing resort at the mouth of the Somme. It was a cold, wet June, and it started with my sitting wrapped up in the hotel reading Dumas' "Le chevalier de la maison rouge." When the weather brightened up I went out on the beach to look at motifs, of which there were plenty. Women and girls spent a lot of time at low water on the flat sandy beach, partly to fish for prawn and partly to dig for worms for bait. Their dresses were good, and so were the types. When they came home from catching prawn, dressed in trousers and rags, with the great prawn nets over their shoulders, in groups of 4 or 5, that certainly awoke my urge to paint. I ended by settling for a motif: two women digging for worms on the beach, and I finished it during the course of the summer.*

In the sketch, Tuxen has concentrated on the two figures digging for worms. Their reflections in the water left on the beach by the tide is crucial to an understanding of the motif and the characterization of the place. The weather is generally overcast. In the finished picture the girl and boy digging for worms are certainly the central feature, but the other figures in the group also attract our attention, especially the fisher girl standing with her back to us. And on the right of the group, other fishermen are emptying a boat that has been drawn up on the beach. The boat, which in the sketch is seen at the water's edge on the right, has in the finished picture been placed far out on the left in the limited area where the sun is lighting up the water, the sand, and the sails of the boats. The contrasting effect is typical of these coasts, well known from classical Dutch seascapes and landscapes.

Tuxen's painting is reminiscent, not only in the sense of motif, of works by the Swedish artist August Hagborg (1852–1921), who enjoyed great success with his motifs of fisherfolk from Cayeux, but there is nothing to indicate any contact between the two. The same summer in Cayeux, Tuxen painted a wave, which is not known today.

E.F.

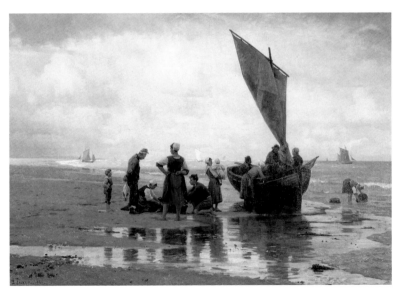

FIG. A Laurits Tuxen *Digging for Worms on the Beach*, 1880
22⅖ x 81½ in. (57 x 81.5 cm), signed L. Tuxen 1880, private collection. (Lise Svanholm 1990, no. 178, described as *Franske fiskere* [*French Fishermen*], ill. p. 37).

LAURITS TUXEN
1853–1927

123. *Collecting Mussels at Low Tide at Le Portel, France*, 1888
(*Muslingesamlere ved ebbe i Le Portel, Frankrig. 1888*)

Oil on canvas on wood, 20⁹/₁₀ x 37⅓ in. (53 x 74 cm)

Signed and dated bottom left: L.T. 88.

PROVENANCE: Arne Bruun Rasmussen, Auction 175, 1965, lot 203, ill. p. 45; Bruun Rasmussen, Auction 510, 1988, lot 76, ill. p. 65; Bruun Rasmussen, Auction 721, 2003, lot 1126, ill.

EXHIBITED: Kunstforeningen, Copenhagen 1897 (no catalogue); Musée des Beaux-Arts de Caen, France, *Peintres du nord en voyage dans l'ouest, modernité et impressionisme 1860–1900*, 2001; Ateneum, Helsinki, *Landet bortom havet*, 2001; Bruce Museum of Art and Science, Greenwich, Connecticut, and The Frances Lehman Loeb Art Center, Vassar College, New York, *Danish Paintings of the Nineteenth Century from the Collection of Ambassador John L. Loeb Jr.*, 2005, no. 18, ill.; Scandinavia House, New York, *Danish Paintings from the Golden Age to the Modern Breakthrough, Selections from the Collection of Ambassador John L. Loeb Jr.*, 2013, no. 35; Skagens Museum and Fuglsang Kunstmuseum, *Tuxen, Color, Countryside and Crown*, 2014–2015, no. 25, ill. p. 164.

LITERATURE: Lise Svanholm, *Laurits Tuxen, den sidste fyrstemaler*, Copenhagen 1990, work no. 309, ill. p. 75 (the information that the painting was exhibited at Charlottenborg and the indicated catalogue number [450] applies to the related painting discussed below); Éric Eydoux and others (eds.), *Peintres du nord en voyage dans l'ouest, modernité et impressionisme 1860–1900*, Musée des Beaux-Arts de Caen 2001, p. 68, ill. p. 67; *Landet bortom havet*, Ateneum, Helsinki, 2001, p. 68, ill. p. 67; Patricia G. Berman, *In Another Light: Danish Painting in the Nineteenth Century*, New York 2007, p. 163, ill.

The northern coast of France overlooking the English Channel immediately attracted Tuxen's interest when, as a young man, he visited Saint Malo in Brittany. At that time it was his ambition to become a marine artist, and before this first visit abroad he had painted several different stretches of the Danish coast: the cliffs of Bornholm, the dune landscapes at Skagen, and the west coast of Jutland, with its violent breakers. His first picture to be shown in the Charlottenborg exhibition in 1875 was of a lifeboat going out in a strong gale. While Tuxen was training in Paris during the following years, concentrating on the prestigious academic figure painting, he pursued his interest in plein air painting at the coast during the summer. In 1877 he again painted at Saint Malo in the company of P. S. Krøyer. In 1878 and 1880, he was at Cayeux-sur-Mer.

The whole of the north French coast, where cliffs alternate with sandy beaches, provides a grandiose natural landscape marked by huge tides of more than 33 feet (10 metres) and very changeable weather, with gales and rain. Despite the difficult natural conditions, the coasts of Brittany and Normandy and the area farther north contain a number of harbors of historical importance. The coastal population has lived on fishing and the large stocks of shellfish, especially oysters and mussels. For the painters, the extensive north coast offered rich possibilities for both figure and plein air painting. At the end of the 19th century, increasing numbers of painters went there from the towns, and coastal tourism led to the emergence of holiday resorts like Dieppe and Trouville. Among the French artists who worked on the north coast, Eugène Boudin (1825–1898) and Claude Monet (1840–1926) deserve special mention. Tuxen was by no means the only Scandinavian painter who felt attracted by the north coast of France; the most productive of the Scandinavians was the Swede August Hagborg (1852–1921).

Tuxen was already known for his major commissions for European royal families when he married a Belgian woman, Ursule de Baisieux, in 1886. The couple had a permanent address in Paris and went to the

coast with their children in the summer. In 1886 and 1887 they chose Le Portel, just south of Boulogne-sur-Mer, where Tuxen executed both figure paintings and also paintings of the coast and the sea. Numerous studies are known, but there are also some larger paintings intended to be shown in exhibitions. A large composition with returning fishermen on the shore was exhibited in Copenhagen in 1887. In the background of that painting we see the fort of l'Heurt, which played a part when Napoleon was gathering his troops at Le Portel in 1803 with a view to attacking England.

The painting in the Loeb collection is an informal portrayal of the coast at Le Portel at low tide in dramatic moonlight. The main feature is the wide, sandy beach in the foreground, which is underwater for half the day. The moon is reflected so intensely in the wet sand that it looks almost like sunlight. We see the shore at a time when the never-ending cycle means that the tide is out, leaving seaweed and mussels in the sand. It is these latter the fishermen's families are gathering. Above them the unbroken row of houses in the town stands in shadow like a diffuse, dark-blue silhouette in contrast to both the shore and the bright sky.

This unusual picture of nature with its dramatic disposition of elements was painted with a broad brush in a sketchlike idiom showing how Tuxen had adopted the technique of the Impressionists. He has tried to capture the color and the quite unusual light.

Standing on the same spot, he also painted a rather larger picture of the motif, with a cart and a fisherman's wife with a child in the foreground (Fig. A). This was the painting, and not the one in the Loeb collection, that was on show at the Charlottenborg Exhibition in 1890.[1] Later this related painting appeared several times at Charlottenborg: at the auction of the artist and his sister Nicoline held there. November 18.-19, 1920 (no. 144, *Ved Ebbetid i nærheden af Boulogne* [*At Low Tide Near Boulogne*]), and at Tuxen's memorial exhibition in 1929 (cat. no.109).[2]

E.F.

FIG. A Laurits Tuxen
At Low Tide on the Coast of France, 1888
(Ved ebbetid på kysten af Frankrig)
Oil, 26 x 34⅗ in. (66.3 x 88 cm)
Inscribed: L. Tuxen 1888
Owner unknown

[1]Lise Svanholm 1990, no. 303. The Charlottenborg catalogue number indicated, no. 90, is wrong; the correct number is 450.

[2]Also in Viggo Jastrau, *Laurits Tuxen,* Copenhagen 1929, p. 34.

HANS MOGENS VOIGT STEFFENSEN

B. COPENHAGEN 1941

Hans Voigt Steffensen started out as a carpenter and attended the Copenhagen Advanced College of Building Technology (Byggeteknisk Højskole) from 1971 to 1972, after which he went on to train as an architect at the Royal Danish Academy of Fine Arts in Copenhagen until 1974.

He is self-taught as a painter, but he exhibited for the first time in the Kunstnernes Efterårsudstilling in 1965. At that time he was painting somber cityscapes of the Nørrebro and Vesterbro districts in Copenhagen. However, he soon developed his delight in bright colors by adding elements of yellow, orange, and green, concentrating more on reproducing the green areas of his city neighborhoods rather than their shabbiness.

In 1976 Voigt Steffensen visited the United States. On his return he included photograph collages in his exhibitions, but it was visits to Hungary and later in the 1970s to Poland, the Soviet Union, and Bulgaria that gave him the greatest inspiration and developed his artistic universe to the stage it has reached. Voigt Steffensen was fascinated by the life and dress of the people of the Balkans, and his palette underwent a total transformation. Blue, violet, and numerous shades of red and yellow were applied to the canvas in pastose layers, and clear primary colors, inspired by the early German Expressionists and the French Fauvists, were begun to be used.

It was now the human figure in movement that became the pivotal point in Voigt Steffensen's artistic universe. He has painted folklore from the Balkans, Spanish flamenco dancers, and circus acrobats. At the same time he has gradually extended the circle of his motifs also to include depictions of more exotic regions, for instance Bali.

In the 1980s Voigt Steffensen's motif took on a rather lighter shade, but in both his watercolors and his sometimes large-scale paintings he retained a sensuous expressionistic relationship to color. Hans Voigt Steffensen has undertaken several large decorative commissions for places, including the TV-byen television center in Gladsaxe, the Citroën factories in Copenhagen, and the passenger ferry Kong Olav V.

He has exhibited in numerous places in Denmark and abroad, both with other artists and on his own. Exhibitions in this latter category were in Den frie Udstilling in 1970, 1972, and 1975; Galerie Asbæk in Copenhagen 1978, 1980, 1983 (when the Loeb collection painting was purchased), 1987, and 1991; Sønderjyllands Kunstmuseum 1980; Djakarta, Indonesia, 1993; Kunsthaus Lübeck 1995, and the Herbert von Karajan Center, Vienna, 1998. Voigt Steffensen has received many grants and marks of distinction, beginning with the Statens Kunstfond Working Grant in 1969. In 1987 he was awarded the Danish Labour Organisation's Culture Prize and in 1990 the Danish Master Painters' Color Prize.

S.L.

LITERATURE: Sam Besekow (foreword), *Hans Voigt Steffensen*, Viborg 1991; Alex Steen, *Hans Voigt Steffensen*, Galerie Asbæk, undated; Ulla Grut in *Weilbach*, vol. 9, Copenhagen 2000.

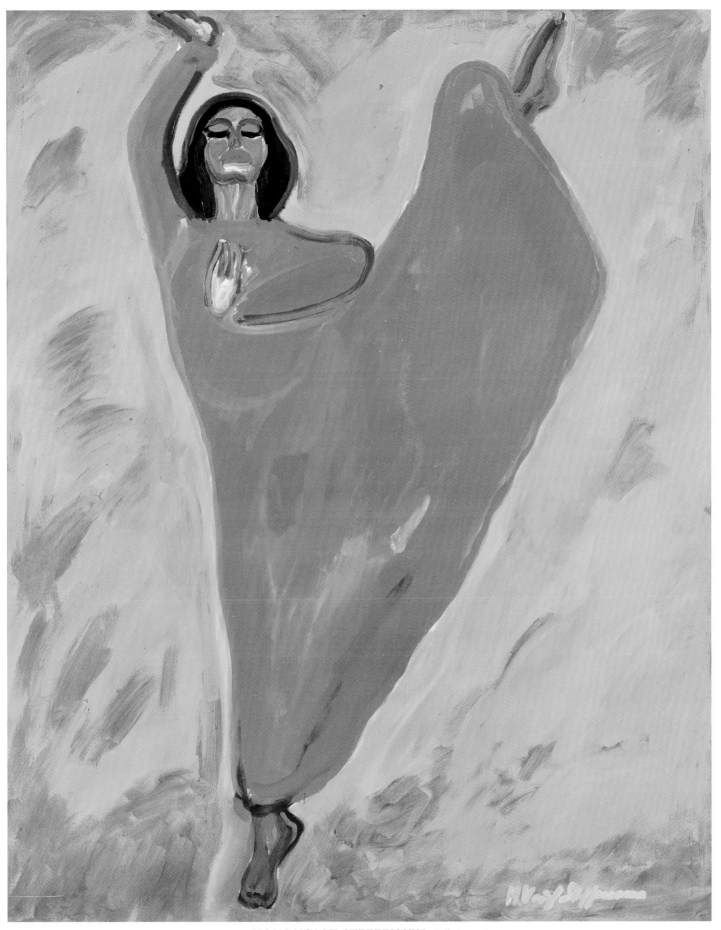

124. HANS VOIGT STEFFENSEN *Ballerina, 1983*

HANS VOIGT STEFFENSEN
B. 1941

124. *Ballerina*, 1983
(Ballerina)

Oil on canvas, 59 x 47¼ in. (150 x 120 cm)

Signed lower right: H. Voigt Steffensen

PROVENANCE: Galerie Asbæk, Copenhagen 1983.

EXHIBITED: Galerie Asbæk, Copenhagen 1983, no. 38 (described as *Red Dancer*); The American Scandinavian Society of New York at Privatbanken Gallery, *Selections of Contemporary Danish Art,* 1989, no. 4 (described as *Red Dancer*).

LITERATURE: Sam Besekow (foreword), *Hans Voigt Steffensen*, Viborg 1991, p. 19, ill.; *Fogtdals Kunstleksikon*, vol. 12, Copenhagen 1992, p. 90, ill.

The trumpets of color sound at full blast over Hans Voigt Steffensen's landscapes and pictures of popular life, which are not merely a coloristic game, but equally fanfares of enthusiasm and temperament. His painting is a declaration of love to life and beauty, to all the good in humanity. They are brimful of optimism and faith in the values of life . . .

Thus the art critic Alex Steen starts his little book on the painter.

The fiery red-costumed ballerina with coal black hair and turquoise eyelids is caught in the midst of a pirouette in which she almost seems to be doing a split to the sound of exciting music. We can imagine the artist with his sketchpad somewhere in the darkness outside the dance floor and understand that he is preserving the experience to make pictures of later. Once at home in his studio in front of a canvas with tubes of paint at the ready, he chooses the brightest colors to fill the painting with the rhythms he remembers and the dancer as she takes her next floating steps.

S.L.

BERTHA WEGMANN

SOGLIO, GRAUBÜNDEN CANTON, SWITZERLAND, 1847 – COPENHAGEN 1926

*Unlike most women artists of her day, Bertha Wegmann was fortunate in having a father who sup-
ported her in her desire to train as a painter. In the Denmark of the 1860s, only men had access to
the Academy of Fine Arts. So, as the family had its roots in Switzerland, it was natural that
Bertha should be sent to Munich, one of the most important art centers of the day. In Germany she
acquired the technique and use of colors in vogue there, and she developed her choice of subjects
and contents. She thus painted a number of genre scenes and pictures of poor children in the
mountains, entirely conforming to the ideals current at the time.*

*When Paris developed into the center for the most advanced artistic trends of the time, she
went there in 1881 with the Swedish painter Jeanna Bauck (1840–1925). Inspired by contemporary
French artists, she changed her manner of expression, making way for a gentler use of the brush
and lighter coloring. This is seen both in her landscapes and the portraits she subsequently painted.
She returned for prolonged visits to France throughout the 1880s.*

In 1880 she was rewarded with a Mention honourable *at the Paris Salon and in 1882 received
a gold medal for a portrait of her sister. The following year this painting was awarded the exhibi-
tion medal at Charlottenborg, becoming the first woman to be given a seat in the Royal Danish
Academy Assembly, and she was also represented in Statens Museum for Kunst. With this, Bertha
Wegmann's success was established. She settled in Denmark and received so many commissions for
portraits that it became her career. Throughout her life she exhibited regularly in the Charlotten-
borg spring exhibition. At the same time she participated in numerous major official exhibitions in
Scandinavia and Europe as well as the world fairs in Paris 1889 and 1900 and Chicago in 1893; she
also exhibited in the ground-breaking Women's Exhibition in Copenhagen in 1895. Her paintings
are found in the Hirschsprung Collection and at the Museum of National History at Frederiksborg
Castle.*

*Bertha Wegmann played an active part in the struggle for women's rights, partly as a member
between 1887 and 1907 of the governing body of the School of Drawing for Women. Like so many
female artists of the time, she laid great store by her freedom to develop professionally, and she never
married.*

*It was Bertha Wegmann's tragedy that she never gained the recognition in Denmark to which
her ability entitled her. Despite her formal success, she was never accepted as one of the painters
of the 1880s Breakthrough, while in the 1890s her naturalistic method was no longer relevant. Her
art was seen as alien, as is indeed still the case today. If she had not chosen to move back to
Denmark, she could doubtless have created an international career for herself as a painter.*

E.F.

LITERATURE: Sigurd Müller, *Nyere dansk Malerkunst,* 1884; Lise Svanholm in Louise Robbert (ed.), *De drogo till Paris,* Liljevalchs Konsthal,
Stockholm 1988, pp. 213–218; Elisabeth Fabritius in *Weilbach,* vol. 8, Copenhagen 1998; Lise Svanholm, *Bertha Wegmann på Øregaard,* Øregaard
Museum, Copenhagen 1998.

482]

BERTHA WEGMANN
1847–1926

125. *Interior with a Bunch of Wildflowers, Tyrol*, c. 1882

(Interiør med en markbuket, Tyrol)

Oil on canvas, 35¾ x 41⅔ in. (91 x 105 cm)

PROVENANCE: Kunsthallen, Auction 29.4.1947, lot 34, ill. p. 12; Bruun Rasmussen, Auction 679, 2000, lot 285, ill.

EXHIBITED: Scandinavia House, New York, *Danish Paintings from the Golden Age to the Modern Breakthrough, Selections from the Collection of Ambassador John L. Loeb Jr.*, 2013, no. 36.

The motif is reminiscent of one of the artist's main works, *Fra en kunstners kvistkammer (From an Artist's Attic Room)*, from 1882, and the dating must be assumed to be close to that. Here, too, there is great play on the contrast between the interior and the cheering view out toward the open countryside. The radiant, fresh bunch of flowers is likewise similar to the one found in the portrait of the painter Jeanna Bauck, dated Paris 1881 (Nationalmuseum, Stockholm). So we must assume that it was painted during the happy period that Bertha Wegmann spent in France becoming acquainted with the new ideas in painting.

With the arrangement of letters, the photograph, the beautiful bunch of wildflowers, and the glass of milk, the artist tells us at once about the place and the person who has settled in the room, which must be Bertha Wegmann herself, as one of the letters on the table clearly bears her name on the envelope. The interior is consequently not merely a portrayal of reality but a story of absence, about her own personage. As a result of her training over many years, Bertha Wegmann was naturally familiar with older European painting. The emblematic still life was especially popular in 17th-century Netherlandish painting, and this work can be interpreted as a modern variant.

Bertha Wegmann's oeuvre has still been so little researched that is impossible to identify this painting in exhibitions or auction catalogues, although it bears a label from the Charlottenborg exhibition.

E.F.

BERTHA WEGMANN
1847–1926

126. *A Young Woman, Marie Triepcke, Sitting in a Boat,* c. 1884

(En ung pige, Marie Triepcke, siddende i en båd)

Oil on canvas, 50 x 42¼ in. (127 x 107 cm)

PROVENANCE: Auction, P. S. Krøyer's estate, Charlottenborg 1910, lot 535 C (described as *En ung Pige siddende i en Have [A Young Woman Sitting in a Garden]*); Merchant F. Zachariae, Fredensborg; Winkel & Magnussen, Auction 205 (F. Zachariae), 1936, lot 223 (described as *Portræt af Frk. Triepcke, senere Maleren P.S. Krøyers Hustru [Portrait of Miss Triepcke, Subsequently the Wife of the Painter Krøyer]*); Bruun Rasmussen, Vejle, Auction 27, 1993, lot 996, ill. on cover.

EXHIBITED: Charlottenborg, *Bertha Wegmann, Mindeudstilling,* 1926, no. 106 (described as *1887 Portræt af Fru P.S. Krøyer som ung Pige, siddende i en Baad,* Gross. Zachariae, Fredensborg); Liljevalchs Konsthal, Stockholm, *De drogo till Paris,* 1988, no. 214 (described as *Marie Triepcke som ung pige*); Gammel Holtegaard and Skagens Museum, *Portrætter fra et ægteskab, Marie og P.S. Krøyer,* 1997, no. 1; Øregaard Museum, Copenhagen, *Bertha Wegmann på Øregaard,* 1998, no. 26 (described as *Maleren Marie Triepcke, g. Krøyer, 1884*); and Kvindemuseet, Århus, 1999; Bruce Museum of Art and Science, Greenwich, Connecticut, and The Frances Lehman Loeb Art Center, Vassar College, New York, *Danish Paintings of the Nineteenth Century from the Collection of Ambassador John L. Loeb Jr.,* 2005, no. 14, ill.

LITERATURE: Lise Svanholm, *Marie Krøyer,* Skagen monografier, no. 2, Copenhagen 1987, ill. p. 11; Tonni Arnold, *Balladen om Marie, en biografi om Marie Krøyer,* Copenhagen 1999, p. 13, ill p. 12 (dating 1883–84); Patricia G. Berman, *In Another Light: Danish Painting in the Nineteenth Century,* New York 2007, p. 166, ill. p. 167.

Female beauty and youthful grace constitute the motif in this picture, which is one of Bertha Wegmann's most important works. It is at the same time a portrait of Marie Triepcke (1867–1940), who herself became an artist but was best known as the wife of the painter P. S. Krøyer. The painting was formerly in the possession of the Krøyer family. The feminine element manifests itself strongly in the smart pink-checked dress and the model's coy posture beneath the willow tree's low-hanging leaves, making it emblematic of a young girl. This interpretation does not correspond to Bertha Wegmann's own, for according to her, she was painting momentary situations. Her conception of the narrative aspects of the picture meanwhile differs from the norm in Denmark; her work was indelibly marked by her German training.

Doubts have been raised as to the year in which the picture was painted, although in the catalogue accompanying the memorial exhibition for the artist in 1926 it is dated 1887. Dates are rarely found in Bertha Wegmann's exhibition and auction catalogues, which could indicate that this is a reliable date.

The dating of c. 1884 has appeared in literature from recent years and is based on some memoirs jotted down by Marie Krøyer a few years before her death in 1940. Here she says of the picture's genesis: "I was a model for Bertha Wegmann for a large portrait, which was painted in Tivoli's Garden, down by the moat — at that time, that setting was not part of the public space for Tivoli's guests, but it was idyllic with tall trees, water lilies, ducks, and where only a few were allowed in. My sitting time stretched over a half of a year, and I confided in Bertha Wegmann, that my goal was to try to become a painter, and she saw my work and motivated me and promised me to write to Krøyer and ask him to teach me."[1] There can be various views as to whether this source provides decisive support for the earlier dating, as Marie Krøyer repeatedly reinterpreted and romanticized her memoirs throughout her unhappy life, in which her marriage to Krøyer broke down and she left him and her daughter for another who also failed to give her happiness. But now we know for sure that the model and the artist were in contact from 1883 to 1885, when Marie Triepcke, who

wanted to become a painter, was a pupil of Bertha Wegmann during the winters of those years.[2] This and the youthfulness of the model in the picture support the 1884 date.

The painting is a conclusive example of the skilled, professional style of painting that Bertha Wegmann mastered. There is coloristic subtlety in the contrast between the figure, the green foliage, and the area beneath, where the brushstrokes have been accorded their own life on the surface of the painting. E.F.

[1]Cited by Lise Svanholm 1987, p. 22f.

[2]Elisabeth Fabritius, *Skitser af Marie Krøyer og Anna Ancher,* Michael og Anna Anchers Hus, 2002, p. 5f.

BERTHA WEGMANN
1847–1926

127. *Portrait of Moses Melchior*
(Portræt af Moses Melchior)

Oil on canvas, 34⅗ x 33½ in. (88 x 85 cm)

PROVENANCE: Niels Lindeskov Hansen og Hustrus Familiefond, no. 43; Bruun Rasmussen, Vejle, Auction 59, 1998, lot 158.

LITERATURE: Lise Svanholm, *Bertha Wegmann på Øregaard*, Copenhagen 1998; Lise Svanholm in Mirjam Gelfer-Jørensen (ed.), *Danish Jewish Art*, Copenhagen 1999.

A scion of the widely respected Melchior family, Copenhagen exporter, and lifelong bachelor, Moses Melchior (1825–1912) was but one of many Melchiors to sit for portraitist Bertha Wegmann, for she was a good friend of several members of this well-known family.

One admires the technical skill with which Wegmann deftly separates the tone and texture of two very dark backgrounds—the rich black of the subject's suit against the dark blue plush of the settee. We are aware that through the contrast of the dark fabric and the warm flesh tones of the subject, she brings our attention immediately to Melchior's reserved but benevolent face, which broadcasts intelligence and composure. We do not find it hard to believe that this is not only a successful businessman but also a dedicated philanthropist, one who shares money and personal time for countless committees of charitable organizations.

A Wegmann portrait of Moses's older brother and business partner, Moritz Gerson Melchior, hangs in the Fredriksborg Museum today. He, his wife Dorothea, and their daughters provided friendship to the artist; Moritz provided financial support as well during Wegmann's early student days in Munich.[1] These two brothers were the grandsons of the prolific Moses Marcus Melchior (1736–1817), who arrived in Copenhagen in 1750 from Germany to establish a healthy wholesale business and to produce fourteen offspring and sixty-three grandchildren, of whom Moses and his brother Moritz were but two. It is understandable that the family progenitor should find the environment hospitable in Copenhagen: although it wasn't until 1814 that Jews were given full civic rights in Denmark, their business acumen was more than accepted by the Danes many years prior to that.

The brothers Melchior were shipping merchants, and it is known that Moses trained with Jacob Holm & Sons from 1841 to 1843. Thereafter, he joined his father's firm, Moses and Son G.M. in Copenhagen and in 1850 became a partner with his brother Moritz. Moses led this business until his death in 1912.

The company exported Danish agricultural products. From 1853–1855 they set up (but subsequently closed) a branch in Australia. They established trade in the Danish West Indies and other islands nearby. Sugar and rum were shipped to Europe. Food and building materials were brought back to Denmark. The ships also transported mail from the Danish government on the Islands to the Americas for further routing. After the Spanish-American War, Moses & Son G.M. established a branch in New York called Armstrong, Melchior, and Dessau.

More recent members of the Melchior family have continued the tradition of community and religious leadership in Denmark. Moses's first cousin twice removed (their paternal grandfathers were cousins) was

Marcus Melchior (1897–1969). It was Marcus Melchior who, in 1943, warned of the upcoming arrest of Danish Jews, urging them to go into hiding among non-Jewish friends and prepare to flee to Sweden. As Chief rabbi of Denmark from 1947, Marcus Melchior worked to promote understanding among all religious trends in Judaism while personally advocating modern orthodoxy. He spent ten years exposing the lies of Nazism to the Danes, preaching the values of tolerance and democracy.

Rabbi Marcus Melchior's son, Rabbi Bent Melchior, born in 1929, is very active in the International Jewish community and the author of many books. Rabbi Michael Melchior, grandson of Rabbi Marcus Melchior and an eighth-generation Danish rabbi, is currently the Minister of Israeli Society and the World Jewish Community.

<div align="right">B.H.</div>

[1]According to Lise Svanholm's catalogue of the Bertha Wegmann exhibition at Øregaard Museum, 1998.

JOHANNES MARTIN FASTING WILHJELM

BARTOFTEGAARD 1868 — COPENHAGEN 1938

Johannes Wilhjelm was deeply affected by the scenic impressions he received as a child in Lolland, an island off southern Denmark, where he grew up in rural surroundings. After studying for a short time at the Polyteknisk Læreanstalt (College of Advanced Technology), he registered in 1888 as a pupil in Harald Foss's (1843–1922) school of drawing and then attended the Royal Danish Academy of Fine Arts for two years. From 1892 to 1894 he was a pupil at Kunstnernes Studieskole, where he had P. S. Krøyer as his teacher. In addition, he came into contact with Kristian Zahrtmann (1843–1917), whose teaching was of crucial significance to a large number of leading younger painters. Wilhjelm felt attracted by Zahrtmann's work but did not at that time dare to become his pupil, something that only took place in 1903–1904, when he was more confident of his own means of expression.

It appears that Wilhjelm had a good instinct for what would benefit his development. In 1893 Den Frie Udstilling in Copenhagen held, quite exceptionally, a large-scale exhibition of paintings by Paul Gauguin (1848–1903)—who was married to a Dane—and his friend Vincent van Gogh (1853–1890), both of them painters then considered to be outsiders. Wilhjelm was among the few people who were fascinated by this new art and bought two of Gauguin's paintings, which he had before him every day afterward. That same year he benefited greatly from a visit to Zahrtmann in Civita d'Antino in northern Italy, where a fertile artist's colony had emerged around him.

In 1894, Wilhjelm married the Norwegian-born Johanne Marie Klöcker, with whom he quickly had four daughters and later a son. Until 1897 the family lived in Italy, partly in Florence, where Wilhjelm studied the Tuscan countryside and coloring on his own and its art under the guidance of the Danish art historian Julius Lange (1838–1896). He became extremely knowledgable about early Renaissance painting, which came to play a crucial role in his own sense of form. His main works from this period are Bøn om regn, 1895 (Prayer for Rain, Statens Museum for Kunst) and Vinhøst i Abruzzerne, 1896 (Wine Harvest in the Abruzzi), in a private collection. At this time it may well be that Wilhjelm's technique and treatment of color were already indebted to Zahrtmann, but in respect to composition he is more in keeping with contemporary artists such as the symbolists Ejnar Nielsen (1872–1956) and Harald Slott-Møller.

After returning home, Wilhjelm abandoned the composed figure pictures and turned to landscapes, which on occasion, and more informally, are populated with figures. He painted a good deal in Norway, but at the beginning of the 20th century he discovered the area around Svinkløv in Vendsyssel, which he portrayed over several summers in a series of striking, somewhat somber pictures in a particular dark color, betraying his interest in Hans Smidth. He also related to the work of Jens Vige (1864–1912), with whom he was acquainted.

Around 1910, Wilhjelm began painting at Skagen, where the light fascinated him, and about 1912 he bought a house close to the Brøndum Hotel, where he then spent the summers with his family. With

[489

artists like Einar Hein (1875–1931) and William Stuhr (1882–1958), Wilhjelm was one of the "younger" Skagen painters, who in the manner of and in understanding with the already well-known artists explored the light and coloring of the area. A portrait of Wilhjelm is thus to be found in the frieze in the Brøndum Hotel dining room, and his work is represented in Skagens Museum. With his constant and lively interest in the development of art, Wilhjelm was an inspiring figure around whom the younger artists could rally. His painting became lighter and simpler in later years, when he lived in Provence during the winter and established links with Norwegian colorists and J. F. Willumsen (1863–1958).

E.F.

LITERATURE: Kai Flor, *Johannes Wilhjelm*, Copenhagen 1937; Jan Zibrandtsen, *Johannes Wilhjelm 1868–1938*, Charlottenborg 1968 (exhibition catalogue); Hanne Honnens de Lichtenberg, *Zahrtmanns Skole*, Copenhagen 1979; Hanne Honnens de Lichtenberg in *Weilbach*, vol. 9, 2000.

JOHANNES WILHJELM
1868–1938

128. *Young Girls at Skagen Beach,* 1916
(Unge piger på Skagens Sønderstrand)

Oil on canvas, 27¾ x 37½ in. (71 x 95 cm)

Signed bottom right: J. Wilhjelm 1916.

PROVENANCE: Bruun Rasmussen, Auction 679, 2000, lot 277, ill.

EXHIBITED: Charlottenborg 1917, no. 626 (described as *Unge Piger paa Stranden*).

LITERATURE: Kai Flor, *Johannes Wilhjelm,* Copenhagen 1937, in oeuvre catalogue (without numbers).

Sønderstrand at Skagen was already a well known and well tried motif when Johannes Wilhjelm arrived in Skagen in 1910. Nevertheless, he and others of his generation were able to paint the shore, sea, sun, and atmosphere in a different way from the original Skagen painters, and as he had a summer cottage at Skagen, he often returned to this motif. It might, as here, be one of young girls enjoying the sun and the air, or children paddling. In other pictures he shows the view along the shore toward the west, seen slightly from above with walking figures seen from behind in the foreground.

In this painting the shore is portrayed in such powerful backlight that it can almost be felt as being dark. Wilhjelm convincingly reproduces the broad shore, with the boats drawn up and the dancing sea and the afternoon sun reflected in the water inside the harbor breakwater. At this point in his career, Wilhjelm had become freer in his use of the brush, and he would often use strongly accented splashes of color as here in the girls' dresses, where areas of green, red, and violet are seen in the shaded areas.

The young girls are his own daughters, who often figure in his pictures of the shore, not as portraits but as figures in the landscape.

The frame is the original from the Kleis Kunsthandel in Copenhagen.

E.F.

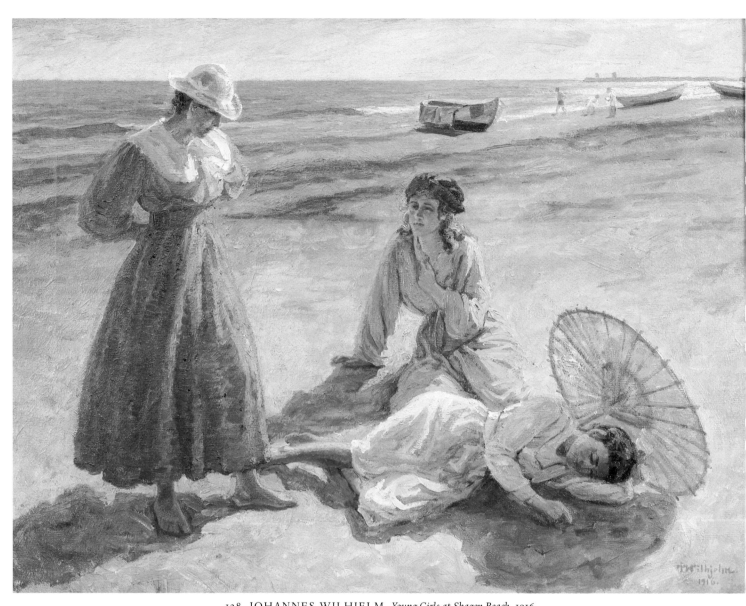

128. JOHANNES WILHJELM *Young Girls at Skagen Beach*, 1916

APPENDICES

An Overview of Danish Royal and Secular Art Collections, Exhibitions, Museums, and Art Associations in Denmark

Art Collections

Den kongelige Malerisamling/Statens Museum for Kunst (The Royal Collection of Paintings/The National Museum for Art)

Danish monarchs have collected art ever since the Renaissance, though many of the early works were lost in the first Christiansborg fire in 1794. The Royal Collection of Paintings was made accessible to the public in a new palace in 1827, given the status of a museum, and continued to be expanded.

With the end of absolutism in 1849, most of the collection became public property, although the kings retained some pieces for themselves. The second Christiansborg palace was destroyed by another fire in 1884, when part of the collection was again lost. A new national gallery named The National Museum for Art (*Statens Museum for Kunst*) was then built in Sølvgade in Copenhagen and opened in 1896. Subsequently redesigned and expanded, this museum still serves its original purpose.

Statens Museum for Kunst, Den Kongelige Kobberstiksamling (National Museum for Art—Department of Prints and Drawings)

Until 1835, the royal collections of prints and drawings formed part of the Royal Library. Subsequent to a reorganization, the collection was opened to the public in 1843, first in the Prince's Palace (*Prinsens Palais*) in Copenhagen and later as part of the National Museum for Art (*Statens Museum for Kunst*).

Den Moltkeske Malerisamling (The Moltke Painting Collection)

This large collection of chiefly Dutch paintings was brought to Denmark by Count Adam Gottlob Moltke (1710–1792), a prominent Danish politician and landowner in the service of King Frederik V. From 1804, this art collection was displayed in Thotts Palæ at Bredgade 15 in Copenhagen, with admission to the public once a week. The catalogue pertaining to the collection appeared in several versions, some with a foreword by the art historian N. L. Høyen (1798–1870).

Although the collection was of great cultural significance, it was auctioned off by Winkel & Magnussen in Copenhagen in September 1931. Unfortunately, Statens Museum for Kunst was able to acquire only a limited number of the paintings.

Thorvaldsens Museum (Thorvaldsen's Museum)

In 1837, the world-famous sculptor Bertel Thorvaldsen decided that his works and collections should belong to the city of Copenhagen. The temple-shaped building, designed by G. Bindesbøll, has since served this purpose on a site donated by King Christian VIII.

Ny Carlsberg Glyptotek [1] (Ny Carlsberg Glyptotek)

In 1877 the brewer Carl Jacobsen began to acquire a large private collection of paintings and especially sculpture, initially modern French and Danish works. In 1888 he donated the collection to Denmark. A museum designed by architect Vilhelm Dahlerup (1836–1907) was built near Tivoli in Copenhagen and completed in 1897.

Jacobsen continued to expand the collection for the museum with antique artifacts and in 1906 he quadrupled the museum area. Thanks to the large endowment he left, the museum has continued to expand the collections of, for instance, Golden Age paintings and French impressionism. The building has been expanded several times.

[1] Ny Carlsberg is the name of the brewery and cannot be translated. Glyptotek is Greek for "collection of sculpture."

Den Hirschsprungske Samling (The Hirschsprung Collection)

During the 1860s, tobacco manufacturer Heinrich Hirschsprung began to collect Danish art, especially that of the Golden Age. In time he also turned to the young French-inspired Skagen painters as well as the symbolists and the Funen artists. Hirschsprung took special interest in P. S. Krøyer and actually supported him for a time.

When the collection was put on public display in 1902, it was considered to be daringly modern, and Emil Hannover wrote of its national significance: "To my knowledge there is nowhere in the world a private collection that gives so extensive and clear a picture of the art of a single country." That year, Hirschsprung donated the collection to the Danish nation which, as part of the agreement, built a museum that is now a listed monument. It was opened in 1911.

Exhibitions

Charlottenborg udstillingen (Charlottenborg Exhibition)—from 1807

From the end of the 18th century, the Royal Danish Academy of Fine Arts arranged exhibitions in Charlottenborg Palace, which was the home of the academy. These were the so-called "Salons" and were held in 1769, 1778, 1794, and 1815. From 1807 on, a spring exhibition was held every year. In 1883, a large exhibition building linked to Charlottenborg was opened, and the annual spring exhibition continued to be called the Charlottenborg Exhibition. An autumn exhibition was introduced in 1922. The annual spring and autumn exhibitions are still being held.

From 1871 to 1895 an unjudged December exhibit, known also as the Christmas Exhibition, was organized by the artists themselves. Some of the income went to social objectives, including help for elderly painters who had participated at one time in the Charlottenborg exhibition.

The Charlottenborg Exhibition building was frequently used for art auctions and today is a center for all types of art exhibitions.

Den Frie Udstilling (The Free Exhibition)—from 1891

As a result of censorship by the art judges in the Charlottenborg Exhibition, young artistic rebels felt a need for an alternative venue, independent of the Royal Danish Academy of Fine Arts. Organizing as an association, they founded the Free Exhibition in 1891. Subsequent to the establishment of *Den Frie Udstilling* (The Free Exhibition) a large number of artists' associations arose among like-minded artists, such as *Foreningen for National Kunst* (The Association for National Art) from 1913; *Grønningen* from 1915; *Decembristerne* from 1928; *Corner* from 1932; *Linien, 1934–37* and 1939, *Kammeraterne* from 1935; *Arme og ben* (Arms and Legs) 1976–1980; *Ny abstraktion* 1976–88; and *Den gyldne* (The Golden) from 1991.

Kvindernes Udstilling (The Women's Exhibition)—1895

In 1895, inspired by the success of their participation in the 1893 World's Fair in Chicago, Danish women arranged a major exhibition demonstrating their abilities in many areas, including art. The exhibition was a victory for the incipient women's movement, and starting in 1920 female artists have arranged similar exhibitions, though less ambitious.

Raadhusudstillingen (The City Hall Exhibition)—1901

This first major retrospective exhibition of Danish art was arranged in the large new City Hall in Copenhagen, still in use today. The exhibition provided an overview of the development of Danish art, which came to be of great importance to the history of Danish art.

Grants and Prizes

Fonden ad Usus Publicos (Foundation for the Benefit of the Public)—1765

This foundation was established under absolutism in 1765 and in time was given the task of supporting the arts and sciences. It achieved its greatest importance after 1814 when, for a long time, it enjoyed the favor of the art-loving Prince Christian Frederik (later King Christian VIII). During this period painters received preferential treatment, and the funds provided by the foundation were of great importance in supplementing the scholarships awarded by the Royal Danish Academy of Fine Arts. By the time the foundation was terminated in 1842, support for the arts was relatively greater than at any time later, though it continued under another aegis.

De Neuhausenske Præmier (The Neuhausen Prizes)—1812

The will of master painter Jens Neuhausen provided for these prizes in 1812 but were not awarded until 1837. Originally distributed by the Royal Danish Academy of Fine Arts as a prize in a competition arranged every second year, they were discontinued in 1976.

Thorvaldsen Medaljen (The Thorvaldsen Medal)—1837

Also known as *Udstillingsmedaillen* (The Exhibition Medal), this award was established in 1837 to commemorate the return of Thorvaldsen's works from Rome to Copenhagen. It is awarded by the Royal Danish Academy of Fine Arts as the Academy Council's supreme token of recognition for painters and sculptors.

Ingenio et Arti (Science and Arts)—1841

This award was created in 1841 by King Christian VIII as a mark of distinction for both Danish and foreign scientists and artists. It is awarded by the king (now queen) on his/her own initiative and is the most rarely awarded royal medal in Danish history.

Among the recipients have been the Danish painter Anna Ancher (1913), Russian ballerina Anna Pavlova (1927), Danish sculptor Anne Marie Carl Nielsen (1927), Danish painter Agnes Slott-Møller (1932), Danish-American opera singer Lauritz Melchior (1936), Danish author Karen Blixen (Isak Dinesen)(1950), Danish-American actor Jean Hersholt and British actress Margaret Rutherford (1955), Danish producer Sam Besekow (1961), Danish film director Carl Th(eodor) Dreyer (1963), Danish ballet master Harald Lander (1969), American choreographer Martha Graham (1986), Danish Louisiana Museum founder Knud W. Jensen (1986), Danish art historian Erik Fischer (1990), and Danish artists Bjørn Nørgaard (1999), and Per Kirkeby (2001). There have been no medals granted since 2001.

Eckersberg Medaljen (The Eckersberg Medal)—1883

Originally called *Akademiets Aarsmedaille* ("The Annual Academy Medal"), the award was created February 2, 1883, the 100th birthday of C. W. Eckersberg.

Statens Kunstfond (The Danish Arts Foundation)—1964

With the establishment of this foundation, state support for the arts was provided with more money and more consistent rules for awards. The three-year working grants are of particular importance to young talents. The foundation is administered by nonpolitical specialist committees whose members are regularly replaced.

Institutions and Schools of Art

Det kongelige danske kunstakademi (The Royal Danish Academy of Fine Arts)—1754

This school of art was founded in 1754 and was housed in the Charlottenborg Palace on Kongens Nytorv at the heart of Copenhagen. Under Danish absolutism, French art was considered the *desideratum* so King Frederik V commissioned French artists to direct the academy, formulate the curriculum, the rules, and in general emulate the French Academy of Fine Arts. For the first decades the biannual examinations took the form of competitions, first for silver medals and then, at the end of the students' classwork, for gold medals. This procedure was changed in 1863.

Kunstforeningen i København (The Copenhagen Art Society)—1825

The society was established in 1825 with the aim of "disseminating a sense of art and encouraging the artists." Among the founders were Professor C. W. Eckersberg, J. P. Møller, and art historian N. L. Høyen; Prince Christian Frederik, subsequently King Christian VIII, was its patron. The society arranged exhibitions of Danish and foreign art, including older art. Competitions were arranged for young artists who sold their works to the society in the exhibitions, after which the society sold them in an annual lottery. For several years the society published graphics and biographies of important Danish artists. It celebrated its 175th anniversary in the year 2000. Since then many art societies were established throughout Denmark. From 2004 this institution has been called "Gammel Strand," referring to its residence in the center of Copenhagen.

De Frie Studieskoler (The Free Study Schools)—1882

In the 1870s, young artists rebelled against the regimented, traditional Academy teaching and started attending private schools of art in France, where they learned different methods and techniques. From 1882, a group of young painters belonging to the Modern Breakthrough were given state support for alternative teaching methods, and The Free Study Schools, later to be called The Artists' Free Study Schools, were established by P. S. Krøyer, Laurits Tuxen, and Frans Schwartz (1850–1917). Here the novice students had the opportunity of being able to paint from life when they first enrolled. The schools ultimately achieved great importance, with Kristian Zahrtmann (1843–1917) and Johan Rohde (1856–1935) as teachers.

APPENDIX B
Significant Dates in Danish History, Danish Art, Exhibitions, and Museums
Dating from 1746

1746 Frederik V ascends the throne as king of Denmark, Greenland, Iceland, Norway, the Faroe Islands, and the Danish West Indies and becomes the duke of Schleswig and Holstein.

1754 The Royal Danish Academy of Fine Arts is founded by King Frederik V.

1766 Christian VII (son of King Frederik V) ascends the throne but proves to be insane, a catastrophic situation because in absolutism all governmental power is vested in the king.

1770 The king's physician, Dr. J. F. Struensee, assumes the insane king's power and implements a large number of controversial reforms.

1772 Struensee is accused of usurping power and of an intimate relationship with Queen Caroline Mathilde; he is condemned to death by the king. She is exiled to the town of Celle in the Duchy of Hannover in the north of Germany, where she dies in 1775 at the age of 24.

1777 *Great and Good Deeds by Danes, Norwegians and Holsteiners* by Ove Malling is published and is later translated into English.

1778 Nicolai Abildgaard is appointed as a professor at the Royal Danish Academy of Fine Arts and starts painting a series of historical paintings for the royal palace of Christiansborg I in Copenhagen.

1784 Crown Prince Frederik takes power from his stepmother Queen Juliane Marie in a coup d'état. Artist Jens Juel becomes a professor at the academy.

1791 Abildgaard's decoration of Christiansborg Palace is completed.

1794 The Christiansborg Palace is destroyed by fire; the royal family moves to the Amalienborg palaces.

1795 The second great fire of Copenhagen occurs; a big church, the town hall, and almost a thousand houses are destroyed.

1801 As a result of Denmark's armed neutrality agreement with Sweden and Russia, England sends a fleet to Copenhagen but is stopped in the Battle of Copenhagen.

1807 Denmark enters an alliance with France; England declares war on Denmark. Copenhagen is bombarded by the English, who confiscate the Danish fleet. Battle of Sjællands Odde (the spit of Zealand) against the British fleet takes place.

1808 Napoleon's armies move into Jutland. Crown Prince Frederik becomes King Frederik VI.

1813 Denmark declares a state of bankruptcy as a result of industrial competition and loss caused by the war. The art-loving Prince Christian Frederik, son of King Frederik VI's half brother, becomes vice regent of Norway, where he supports the Norwegian independence movement.

1814 Denmark cedes Norway to Sweden.

1818 Artist C. W. Eckersberg is appointed professor at the Royal Academy.

1819 The Museum for Danish Antiquities, later the National Museum of Cultural History *(Nationalmuseet)*, is opened to the public.

1820 H. C. Ørsted, one of the world's great physicists, discovers electromagnetism.

1825 The Copenhagen Art Society *(Kunstforeningen i København)* is founded.

1828 Building of the Christiansborg II Palace with C. F. Hansen as architect is finished.

1829	August Bournonville becomes ballet master at the Royal Theatre, for which he choreographs a number of ballets still performed today.
1835	Hans Christian Andersen publishes his first collection of stories.
1838	Prince Christian Frederik becomes president of the Royal Danish Academy of Fine Arts and the Royal Danish Academy of Sciences and Letters.
1839	Prince Christian Frederik ascends the throne as King Christian VIII.
1843	Søren Kierkegaard publishes his first major philosophical work, *Enten-Eller* ("Either-Or"). Tivoli Gardens opens.
1844	The first folk high school *(højskole)* opens, permitting ordinary people of any age and with no prior education to attend lectures on history, literature, and politics and to learn a foreign language, promoting dialogue and discussion and singing of national hymns. They start on private initiative, based on a religious protestant practice, named after N. F. S. Grundtvig, preaching charity and tolerance. Following the depression after the state bankruptcy the idea was to make "free schools for life," preparing the citizens for democracy in respect of human rights. The Danish tradition of consensus, tolerance, solidarity, and respect for the views of others are indebted to these schools, as well as the democratization of government systems. A typical saying by Grundtvig was that the ideal society would be one where "few have too much and the majority not too little."
1844	Artist Bertel Thorvaldsen dies. Artist Constantin Hansen decorates the entrance hall to Copenhagen University with the history of the ancient Greek goddess of science, Pallas Athene and Apollon, the soothsayer, painted in al fresco; both are still in existence.
	The art critic N. L. Høyen delivers the famous lecture in which he encourages Danish painters to create a national art to portray the country and the people.
1848	Frederik VII, son of Christian VIII, ascends the throne and becomes a popular monarch despite his morganatic marriage to a woman to whom he has given the title of Countess Danner. The Constituent Assembly meets and prepares the democratic constitution.
	Thorvaldsens Museum is opened to the public.
1848–51	The First Schleswig War occurs. The Danish king goes to war to gain control of the Southern Jutland duchies of Schleswig and Holstein, where he is Duke and where local rebels fight in vain for freedom. Several Danish artists take part.
1849	Absolutism is abolished and Denmark's democratic constitution is passed.
1850	H. C. Ørsted publishes *Aanden i Naturen* ("The Spirit in Nature"); it is translated into many languages.
1853	A cholera epidemic in Copenhagen costs more than 4,000 lives, including that of artist C. W. Eckersberg. Artist Vilhelm Kyhn founds the Danish Etchers' Association *(Den danske Radeerforening)*.
1859	Frederiksborg Castle in Hillerød in northern Zealand is destroyed by fire, and most of the old royal collection of portraits is lost. With the initiative and financial support of the brewer I. C. Jacobsen, of the Carlsberg Breweries, the castle is rebuilt and a museum of national history is created, sponsored by the brewer.
1863	Christian IX ascends the throne and founds the Glücksborg dynasty. His daughter Alexandra later becomes queen of England and empress of India; his daughter Dagmar becomes the czarina of Russia and his son Vilhelm becomes King George I of Greece. Thus King Christian IX becomes known as "the father-in-law of Europe." He gathers his royal family together each summer at Fredensborg Palace.

1863–64 The Second Schleswig War results in Denmark's having to cede the duchies of Holstein, Schleswig, and Lauenborg to Prussia and Austria-Hungary.

1867 The World's Fair takes place in Paris. Among the Danish artists represented are Elisabeth Jerichau Baumann, Christen Dalsgaard, F. C. Kiærskou, Otto Bache, C. F. Sørensen, Carl Bloch, and Julius Exner.

1871 Georg Brandes delivers his seminal lectures at Copenhagen University, "Main Currents in 19th-Century Literature," where he brings up issues for discussion then considered extremely controversial. In Danish society then characterized by nationalism, romanticism, and a strong Protestant church, he advocates the revolutionary ideas of the Age of Enlightenment, personal freedom, women's rights, independence of religion, and most important freedom of thought, speech, and print. He starts a cultural revolution in Scandinavia, and is denounced by official Denmark, his Jewish extraction often being referred to as the reason for his temperament and revolutionary spirit. Brandes becomes the hero of the artists of the Modern Breakthrough, and his ideas play an important part in discussions even today.

1875 Hans Christian Andersen dies. The Society of Danish Women (Dansk Kvindesamfund) is founded. The society initiates a professional drawing school for women (Tegneskolen for Kvinder).

1878 The Paris World's Fair. Among the Danish artists are Elisabeth Jerichau Baumann, Carl Bloch, Vilhelm Marstrand, Anton Melbye, O. D. Ottesen, Vilhelm Rosenstand, Christen Dalsgaard, Julius Exner, P. C. Skovgaard, Vilhelm Kyhn, and young P. S. Krøyer. The Museum of National History at Frederiksborg Castle opens.

1879 The artists' colony at Skagen is established.

1882 P. S. Krøyer visits Skagen for the first time; the Skagen artists' colony soon becomes known abroad. The brewer Carl Jacobsen, son of I. C. Jacobsen, opens his private collection in his house at the brewery Ny Carlsberg to the public. The Free Study Schools (De Frie Studieskoler) are given state support.

1883 Nordic exhibition and meeting of Scandinavian artists in Copenhagen.

1885 Kristian Zahrtman becomes head of The Artists' Study Schools (Kunstnernes Studieskoler).

1888 Nordic exhibition and meeting of Scandinavian artists at Copenhagen is held close to Tivoli. Nearby, the brewer Carl Jacobsen arranges a major exhibition of modern French art, also near Tivoli. (The buildings for both exhibitions were temporary and torn down afterwards.) Brewer Carl Jacobsen donates his art collections (mostly classical antiquities and modern French art) to the public. The Art School for Women (Kunstskolen for Kvinder) opens as a department in the Royal Danish Academy of Fine Arts.

1889 World's Fair in Paris. The painters of the Modern Breakthrough dominate the Danish exhibition; among them are P. S. Krøyer, Laurits Tuxen, Carl Thomsen, Michael Ancher, Anna Ancher, Vilhelm Hammershøi, L. A. Ring, August Jerndorff, and Bertha Wegmann.

1891 The Free Exhibition (Den Frie Udstilling) opens for the first time.

1893 The World's Colombian Exhibition in Chicago where several Danish painters, including women artists, become known in the United States, among them Otto Bache, Paul Fischer, Anna Ancher, Bertha Wegmann, Michael Ancher, L. A. Ring, Laurits Tuxen, Vilhelm Kyhn, and Hans Smidth.

1893–94 The symbolist periodical Taarnet ("The Tower") is published.

1895 A collection of paintings by Scotland's Glasgow School and Danish artists are exhibited in Chicago and St. Louis.

1896 Winner of the contest for the Sherman Monument in Washington, DC, Danish-born sculptor Carl Rohl-Smith starts the modeling. The artist, who was already famous in America, dies in 1900 and the monument is completed by a number of Scandinavian artists.

1897	Opening of the museum building of the Ny Carlsberg Glyptothek opposite Tivoli, still in use today.
1900	World's Fair in Paris. Among the artists represented are P. S. Krøyer, Anna Ancher, Michael Ancher, August Jerndorff, Vilhelm Kyhn, Vilhelm Hammershøi and Ludvig Find.
1901	City Hall in Copenhagen, retrospective exhibition of Danish art.
1905	Norway becomes independent when the union with Sweden is dissolved; a Danish royal prince is elected as king.
1906	Frederik VIII ascends to the Danish throne.
1907	Exhibition of works by Danish painters at Guildhall, London.
1908	Skagens Museum is founded.
1910	Faaborg Museum opens as a museum for the Funen artists *(Fynboerne)*, including the painter Fritz Syberg.
1911	The Hirschsprung Collection opens to the public. It includes painters from the Golden Age, landscape and genre painters from 1850–1880, as well as Skagen painters, Hammershøi, and the Funen artists.
1912	Christian X ascends to the throne. During his summer holidays in Skagen, he, the queen, and two sons often visit the painters there. Exhibition of contemporary Scandinavian art is held under the auspices of the American-Scandinavian Society of New York.
1914-18	The First World War begins and ends. Denmark remains neutral.
1915	Danish women are given the right to vote and to be elected to parliament.
1922	Danish physicist Niels Bohr receives the Nobel Prize.
1937	Danish writer Karen Blixen (pen name Isak Dinesen) publishes *Out of Africa*.
1940	Denmark is occupied by Germany.
1943	The resistance movement, comprising many ordinary Danes, helps Danish Jews to escape to neutral Sweden.
1945	Denmark is liberated by Allied forces, though the island Bornholm, east of Denmark's mainland, is not freed until 1946.
1947	Frederik IX, father of the present monarch, ascends the throne.
1949	Denmark joins NATO.
1957	Architect Jørn Utzon wins the contest for the design of the Sydney Opera House.
1958	Knud W. Jensen opens the Louisiana Museum of Modern Art at Humlebæk not far from Elsinore in the Northern Zealand.
1961	The Experimental School of Art *(Eks-skolen)* is founded in Copenhagen.
1967	The museum Michael and Anna Ancher's House in Skagen is opened to the public.
1972	Queen Margrethe II ascends to the throne. Denmark becomes a member of the European Communities.
1982	An exhibition of Scandinavian modern art, 1880–1980, tours the United States. An exhibition called "Northern Light, Realism and Symbolism in Scandinavian Painting, 1880–1910" also tours the United States.
1984	The exhibit "The Golden Age of Danish Painting" tours London, Los Angeles, and New York.
1986	The exhibit "Dreams of a Summer Night, Scandinavian Painting at the Turn of the Century" tours London, Düsseldorf, Paris, Oslo, and Copenhagen.
1994	"The Golden Age of Danish Painting" exhibit again tours Los Angeles, and New York.

1998 Opening of the ambitious bridge and tunnel of Storebælt *(Great Belt)* connecting Zealand and Funen. Traveling between the east and west in Denmark becomes hours faster.

2000 Opening of the bridge and tunnel of Øresund (The Sound) connecting Zealand and the Copenhagen area with the southern provinces of Sweden, which until 1658 were Danish land.

After ten years' work 11 tapestries, handmade at the Gobelin Manufactories in Paris, are received by Queen Margrethe II as a gift from the Danish trades and industries, a present for her 50th birthday in 1990. Designed by artist Bjørn Nørgaard (b. 1947) they tell the story of Denmark and the world since the Viking Age, around year 1000, to the present. This being the most ambitious public Danish decoration for ages, the tapestries are made to adorn the banqueting hall of Christiansborg. The Queen immediately donates the tapestries to the Danish people.

Kronborg Castle of Elsinore is inscribed on UNESCO's world heritage list.

E.F. and S.L.

SUGGESTED FURTHER READING

Albertsen, Leif Ludwig, *On the Threshold of a Golden Age, Denmark Around 1800*, Copenhagen, 1979

Danish Artists in Italy, Paintings from the Royal Museum of Fine Arts on Loan during Rebuilding, Thorvaldsens Museum, 1968

Danish Art Treasures Through the Ages, Victoria & Albert Museum, London, 1948

Fabritius, Elisabeth, *P. S. Krøyer's Photographs* in M. Saabye (ed.), *P. S. Krøyer's Photographs*, Den Hirschsprungske Samling, Copenhagen, 1990

Gelfer-Jørgensen, Mirjam (ed.), *Danish Jewish Art, Jews in Danish Art*, Copenhagen, 1999

Gunnarsson, Torsten, *Nordic Landscape Painting in the Nineteenth Century*, Yale University Press, New Haven & London, 1998

Hornung, Peter Michael, *The Modern Breakthrough in Danish Painting 1870–1890*, in Kasper Monrad (ed.), *Golden Days in Copenhagen*, Copenhagen, 2002

Johnston, Catherine, Helmut Börsch-Supan, Helmut R. Leppien, and Kasper Monrad, *Baltic Light: Early Open-Air Painting in Denmark and North Germany*, Yale University Press, New Haven, 1999 (catalogue for exhibition at the National Gallery of Canada, Ottowa 1999–2000, Hamburger Kunsthalle, Hamburg 2000, Thorvaldsens Museum, Copenhagen, 2000)

Kent, Neil, *The Triumph of Light and Nature, Nordic Art 1740–1940*, London, 1987

Larsen, Peter Nørgaard, *Fear of Loss and Longings for Arcadia, The Afterlife of the Danish Golden Age c. 1850–75*, in *Journal*, vol. 4, Statens Museum for Kunst, Copenhagen, 2000, pp. 94–121

Lederballe, Thomas and Rebecca Rabinow (eds.), *The Age of Impressionism*, Ordrupgaard, Copenhagen, 2002 (catalogue for exhibition at the Metropolitan Museum, New York, Walters Art Museum, Baltimore, and the Museum of Fine Arts, Houston)

Ludvigsen, Suzanne, *Danish Paintings of the Golden Age*, Artemis Fine Arts, Inc., New York, 1999

Monrad, Kasper (ed.), *Danish Painting, The Golden Age*, National Gallery, London, 1984

Monrad, Kasper (ed.), *The Golden Age of Danish Painting*, Los Angeles County Museum of Art 1993 (with essays by Philip Conisbee, Bjarne Jørnæs, Kasper Monrad, Hans Vammen)

Nørregård-Nielsen, Hans Edvard, *The Golden Age of Danish Art, Drawings from the Royal Museum of Fine Arts, Copenhagen*, Alexandria, Virginia, 1995 (catalogue for exhibition in Frick Collection, New York, and Art Services International)

Norman, Geraldine, *Biedermeier Painting 1815–1848*, London, 1987

Platou, Inga Rockswold, *The Art Colony at Skagen, Its Contribution to Scandinavian Art*, a thesis submitted to the University of Minnesota, Ann Arbor, Michigan, University Microfilms Inc., 1974

Rønberg, Lene Bøgh, Kasper Monrad, and Ragni Linnet (eds.), *Two Golden Ages, Masterpieces of Dutch and Danish Painting*, Copenhagen 2001 (catalogue for exhibition at Statens Museum for Kunst, Copenhagen, 2001, Rijksmuseum, Amsterdam, 2001)

Rosenblum, Robert, *Danish Golden Age Painting: an International Perspective*, in *Meddelelser fra Thorvaldsens Museum* (Thorvaldsens Museum Bulletin), 1997, pp. 45–58

Scavenius, Bente (ed.), *Krøyer and the Artists' Colony at Skagen*, National Gallery of Ireland, Dublin, 1997 (with essays by Claus Olsen, Bente Scavenius, Marianne Saabye, Annette Johansen, and Elisabeth Fabritius)

Sloan, Thomas la Brie, *Neoclassical and Romantic Painting in Denmark, 1754–1848*, Ann Arbor, 1972

Svanholm, Lise, *Northern Light, The Skagen Painters*, Copenhagen, 2004

Vad, Poul (translated by Kenneth Tyndall), *Vilhelm Hammershøi and Danish Art at the Turn of the Century*, Yale University Press, New Haven and London, 1992

Varnedoe, Kirk, *Northern Light: Nordic Art at the Turn of the Century*, Yale University Press, New Haven and London, 1988

Werenskiold, Marit, *Expressionism and Denmark*, Oslo, 1984, pp. 143–64

Wivel, Matthias, *Face to Face, On Eckersberg's and Købke's Discovery of the Modern*, in *Journal*, vol. 5, Statens Museum for Kunst, Copenhagen, 2001 , pp. 50–73

E.F. and S.L.

COPYRIGHTED COMPARATIVE ILLUSTRATIONS

The copyrighted comparative illustrations in this catalogue are through the courtesy of:

No. 5. Fig. A. Statens Museum for Kunst, SMK Foto
No. 6. Fig. A. Statens Museum for Kunst, DOWIC Fotografi
No. 16. Fig. A. Courtesy Den Hirshsprungske Samling
No. 16. Fig. B. Kirsten Bille, Copenhagen
No. 16. Fig. C. Courtesy Bruun Rasmussen Kunstauktioner, Copenhagen
No. 18. Fig. A. Courtesy Bruun Rasmussen Kunstauktioner, Copenhagen
No. 18. Fig. B. Danmarks Kunstbibliotek
No. 22. Fig. A. Ribe Kunstmuseum, Finn Lydom
No. 22. Fig. B. Danish National Art Library
No. 22. Fig. C. Danish National Art Library
No. 22. Fig. D. Danish National Art Library
No. 23. Fig. A. Statens Museum for Kunst, SMK Foto
No. 23. Fig. B. Statens Museum for Kunst, Hans Petersen
No. 27. Fig. A. Danish National Art Library
No. 36. Fig. A. Statens Museum for Kunst, Hans Petersen
No. 36. Fig. B. Lars Bay, Silkeborg
No. 36. Fig. C. Danish National Art Library
No. 36. Fig. D. Danish National Art Library
No. 42. Fig. A. Statens Museum for Kunst, Hans Petersen
No. 52. Fig. A. Kirsten Bille, Copenhagen
No. 52. Fig. B. Danish National Art Library
No. 65. Fig. A. H. P. Christoffersen, Skagen
No. 69. Fig. A. Royal Academy of Fine Arts, Copenhagen
No. 72. Fig. A. Courtesy Forlaget Fogtdal, Copenhagen
No. 73. Fig. A. Museum of National History at Frederiksborg Castle, Hillerød, Kit Weiss
No. 73. Fig. B. Skagens Museum
No. 73. Fig. C. Michael and Anna Ancher's House, Skagen
No. 73. Fig. D. Skagens Museum
No. 76. Fig. A. Danish National Art Library
No. 82. Fig. A. Den Hirschsprungske Samling, Hans Petersen
No. 100. Fig. A. Statens Museum for Kunst, Hans Petersen
No. 105. Fig. A. Royal Academy of Fine Arts, Copenhagen
No. 107. Fig. A. Nationalmuseum, Stockholm
No. 112. Fig. A. Nordjyllands Kunstmuseum, Aalborg
No. 113. Fig. A. Courtesy Bruun Rasmussen Kunstauktioner, Copenhagen
No. 113. Fig. B. Den Hirschsprungske Samling, foto Hans Petersen
No. 113. Fig. C. Courtesy Bruun Rasmussen Kunstauktioner, Copenhagen
No. 114. Fig. A. Nationalmuseum, Stockholm, Erik Cornelius
No. 114. Fig. B. Det Kongelige Bibliotek, Kort- og Billedafdelingen, Copenhagen
No. 114. Fig. C. Den Hirschsprungske Samling, Hans Petersen
No. 114. Fig. D. Musikhistorisk Museum, Copenhagen Ole Woldbye and Pernille Klemp
No. 122. Fig. A. Courtesy Lise Svanholm
No. 123. Fig. A. Danish National Art Library
No. 131. Fig. A. Ribe Kunstmuseum
No. 141. Fig. B. Statens Museum for Kunst
No. 143. Fig. A. Vejle Kunstmuseum
No. 143. Fig. B. Vejle Kunstmuseum
No. 146. Fig. B. Ordrupgaard, Pernille Klemp
No. 147. Fig. A. Den Hirschsprungske Samling
No. 147. Fig. B. Den Hirschsprungske Samling
No. 147. Fig. C. Skovgaard Museet, Viborg